PHOTOGRAPHY Barbara London Upton with John Upton Fourth Edition

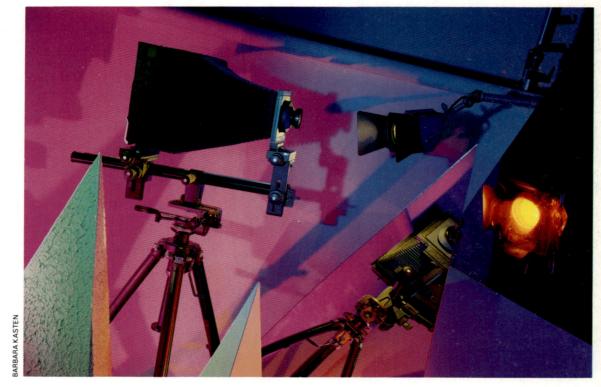

HarperCollinsPublishers

LIBRARY OF CONGRESS

Library of Congress Cataloging-in-Publication Data London, Barbara

Photography : adapted from the Life Library of Photography/ Barbara London Upton, with John Upton.—4th ed. Bibliography: p. Includes index. ISBN 0-673-39842-0 1. Photography. I. Upton, John. II. Title. TR145.L66 1989 770—dc19 88-21143 CIP

Copyright © 1989 by BL Books, Inc., and John Upton

All rights reserved. No part of this book may be reproduced in any form or by any electronic or mechanical means including information storage and retrieval systems without permission in writing from the publisher, except by a reviewer who may quote brief passages in a review.

4 5 6 7 8 9 10-FED-94 93 92 91

Printed in the United States of America

The Camera, © 1970 Time-Life Books Inc.; The Camera, Revised Edition, © 1981 Time-Life Books Inc.; Caring for Photographs, © 1972 Time-Life Books Inc.; Caring for Photographs, Revised Edition, © 1983 Time-Life Books Inc.; Color, © 1970 Time-Life Books Inc.; Frontiers of Photography, © 1972 Time-Life Books Inc.; The Great Themes, © 1970 Time-Life Books Inc.; Light and Film, © 1970 Time-Life Books Inc.; Light and Film, Revised Edition, © 1982 Time-Life Books Inc.; Photographer's Handbook, © 1970 Time-Life Books Inc.; Photographer's Handbook, © 1970 Time-Life Books Inc.; Photographer's Handbook, © 1971 Time-Life Books Inc.; Photographing Nature, © 1971 Time-Life Books Inc.; The Print, © 1970 Time-Life Books Inc.; The Print, Revised Edition, © 1982 Time-Life Books Inc.; Special Problems, © 1971 Time-Life Books Inc.; Special Problems, Revised Edition, © 1982 Time-Life Books Inc.

About the title page photograph by Barbara Kasten

Give Barbara Kasten a few mirrors and some lights with colored filters, and she can transform prosaic reality into a spectacular visual display. Her title page photograph (overleaf) began with an arrangement of some ordinary studio equipment: a roll of background paper, a view camera on a tripod, and one light. Two triangular mirrors reflect another side of the camera and a light that is outside the set. Two pyramid-shaped props complete the arrangement.

The objects on the set are level; Kasten has angled her own camera to give the scene its dizzying tilt. The opulent colors come from gels (colored filters) placed over lights that mostly are outside the image area; the objects themselves are plain white or black. Even a slight shift of the angle at which you view the setup completely alters the reflections in the mirrors, so an onlooker can't really see Kasten's final image. It exists only on the ground-glass viewing screen of her camera and in her photograph. An interview with Barbara Kasten appears on pages 10–11.

Picture Credits:

Cover photograph of camera: © Clint Clemens 1984; Ken Kay (inset).

Title page photograph, Camera Construct, by Barbara Kasten, 1988.

Chapter 1 vi: Margaret Bourke-White / Life Magazine © 1936, 1964 Time Inc. 1: Courtesy Margaret Bourke-White Estate. 2: © Bruce Davidson / Magnum / courtesy Eli Lilly and Company: Dana Duke, 3: © Bruce Davidson / Magnum / courtesy Johnson & Johnson. 4: Jeff Rotman; Urs Mockli. 5: Jeff Rotman. 6: © Susan Meiselas / Magnum; Matthew Naythons / Gamma-Liaison. 7: © Susan Meiselas / Magnum. 8: Clint Clemens; Vito Aluia. 9: Clint Clemens. 10: Barbara Kasten; Kurt Kilgus. 11: Barbara Kasten. 12: Bob Peterson, from multi-image show Heart Attack, produced by Watts-Silverstein for Physio-Control Corp.; Dick Taylor. 13: Bob Peterson, from multiimage show Heart Attack, produced by Watts-Silverstein for Physio-Control Corp. 14-15: Lisl Dennis. 16: Joyce Wilson; Bill McIntosh. 17: Joyce Wilson. 18: Lois Gervais; Pete Newman. 19: Lois Gervais / Atlantic Richfield Company. 20: Carl Fleischhauer / American Folklife Center; Howard W. Marshall, 21: Carl Fleischhauer / American Folklife Center. 22: Matt Weinberg; Doug Stelck. 23: Matt Weinberg. 24: Lois Bernstein; Sherita Hairston, 25: Lois Bernstein, 26: Walter looss, Jr.; Dan Jenkins, Jr. 27: Walter looss, Jr. 28: Courtesy Virginian-Pilot and Ledger Star, Norfolk, Virginia;

Robert B. Goodman. 29: Mel Scott; Edmund Yankov; Dave Eliot.

Chapter 2 30: Andreas Feininger / Life Magazine © 1955 Time Inc. 33: M. Woodbridge Williams / National Park Service (upper left); courtesy Nikon, Inc. (lower left); Barbara London (top row); Fredrik D. Bodin (center row); Jack Sal / Michael Belenky BL Books, Inc. (bottom row). 34: Ken Kay; Sinar Bron, Inc. 35: E. Leitz, Inc.; Ken Kay. 36: Canon USA, Inc.: Ken Kay, 37: Mamiya: Ken Kay, 38: Ken Kay. 39: Fil Hunter. 40: Ken Kay; John Upton. 41: John Upton. 42-43: Barbara London. 45: Ken Kay / Harold Zipkowitz, 46: Duane Michals: Harold Zipkowitz (lower right). 47: Duane Michals; Harold Zipkowitz (lower left). 48-49: George Krause. 50: Anthony Donna; Jack Sal / Michael Belenky / BL Books, Inc. 51: Anthony Donna; Jack Sal / Michael Belenky / BL Books, Inc. 52-53: Jack Sal / Michael Belenky / BL Books, Inc.

Chapter 3 54: André Kertész. 56–58: Ansel Adams. 59: Harold Zipkowitz. 61: John Senzer. 62: © Bruce Davidson / Magnum. 63: © Henri Cartier-Bresson / Magnum. 64: Jack Sal / Michael Belenky / BL Books, Inc. 65: Walter Iooss, Jr. 66: William G. Larson. 67: David Hume Kennerly / White House. 68: John Neubauer. 69: Robert Packo. 70: Margaret Bourke-White / Life Magazine © Time Inc. 71: Mark Kauffman. 72: Harold Zipkowitz. 73: Frederik D. Bodin. 74: © Elliott Erwitt / Magnum. 75: U.S. Department of Agriculture. 76: Jack Sal / Michael Belenky / BL Books, Inc. 77: Henry Horenstein. 78–79: David Arky. 80: Andreas Feininger / Life Magazine © Time Inc. 81: Art Kane. 82: Frank Siteman / Stock, Boston; Barbara London. 83: George Constable; Gerald Jacobson; Alan Oransky. 84: Harold Zipkowitz.

Chapter 4 86: Charles Harbutt / Archive. 89: Courtesy Minor White Archive / © 1982 Trustees of Princeton University. 90: Arthur Taussig. 91: Ken Kay. 93: Fil Hunter. 95: © 1970 Imogen Cunningham Trust. 96: Robert Lebeck. 97: James Drake. 98–99: Leonard Soned. 101: Duane Powell; Russell Hart. 102: Alan Ross. 103: Joe Wrinn. 104: John Senzer. 105: Donald Dietz. 106: Robert Walch.

Chapter 5 108: Gelatin-silver print ($7\frac{1}{2} \times 9\frac{1}{2}$ ") by Tina Modotti / collection of Museum of Modern

(Credits continued on page 412)

Photography is essentially a means of visual communication. Just as a typewriter can be used for correspondence, poetry, or a scientific dissertation, so a camera can be used for anything from objective documentation to fantasy. Whatever *your* interest is in photography, this book is designed to teach the skills that you will need in order to use the medium confidently and effectively.

The emphasis of this fourth edition continues to be in two major areas technique and visual awareness. The technical material helps you learn how to control the photographic process, or as Ansel Adams put it, to "understand the way that the lens 'sees' and the film 'sees.'" Equally important, this book can help *you* see by showing you the choices that other photographers have made and that you can make when you raise a camera to your eye.

Basic black-and-white photography is covered completely in Chapters 2–8: camera, lens, film, exposure, developing, printing, and mounting. Chapters 9–13 cover special techniques (such as close-up photography), color photography, lighting, view camera use, and a specialized method of exposure and development—the Zone System. What Went Wrong? sections in various chapters describe potential technical problems, their causes and prevention. See, for example, Troubleshooting Camera and Lens Problems, page 83.

Photographs themselves provide a vital teaching force in this book. Throughout the book you will find many illustrations by the best photographers showing how they have put to use various technical concepts. See, for example, the two photographs illustrating perspective on pages 80–81 or how one photographer uses simple lighting setups on pages 270–271. In addition, Chapter 1 features interviews with thirteen photographers who have each de-

veloped a successful career. Chapter 14, Seeing Photographs, deals with composition, tonality, sharpness, and other visual elements that will help you make better pictures and that will help you see other people's photographs with a more sophisticated eye. Chapter 15 surveys the history of photography. Chapter 16 has a selection of outstanding photographs of various types.

A considerable amount of new material has been added to this edition, much of it at the request of users. Many people requested more about photojournalism, so in addition to more photographs by photojournalists throughout the book, Chapter 1 has been expanded to include new interviews with a newspaper photographer, Lois Bernstein, and a sports photographer, Walter looss, Jr. More people now have cameras with automatic focus, so Chapter 2, Lens, has new material on autofocus-when it works well and what to do when it doesn't. Chapter 6, Developing the Negative, has increased coverage of push processing. Chapter 11, Lighting, has been extensively revised with many new and expanded topics. Chapter 14, Seeing Photographs, has new material on how to look atand talk about-photographs (pages 348-349). The book has been technically updated throughout.

This book makes the information you will need as accessible and as easy to use as possible. The book is organized so that each two facing pages completes a single idea, skill, or technique. The key topics appear in the text in boldface type, making it easy to pick out the main concepts. Topics are explained using words, drawings, charts —but especially pictures, hundreds of them, the best of many different styles. The inside front cover lists a sampling of the types of photographs in the book and the pages where you can find them.

This fourth edition of Photography has been a collaborative effort. Instructors, students, photographers, manufacturers, editors, gallery people, and many others participated in it. They fielded queries, made suggestions, responded to material, and were unfailingly generous with their time, energy, and creative thinking. Many thanks to all those who made this new edition possible. Many instructors reviewed the previous edition of *Photography* and made suggestions for this one. In addition, Russell Hart and Jack Sal contributed suggestions to the book overall. Alma Davenport de la Ronde, Dave Freund, and Robin Jacobsen reviewed the new spread on looking at and talking about photographs. Jim Stone updated the Bibliography. Caroline Grimes and Jim Marron at Eastman Kodak Company clarified many technical points.

Without editorial and production assistance, a book of this size and complexity would have been impossible to complete. Ellen Fitzpatrick and Jane Tufts offered constant encouragement and editorial expertise. Robin Jacobsen brought order to the hundreds of picture permissions needed. Andrea Cava was a genius at organizing the massive amount of production work involved in this revision.

A generation of photographers has used *Photography* since its first edition in 1976. Some of the people who contributed to this edition used the book themselves when they were studying photography, and still had their original, now dog-eared copy. As you work with the book, you may have suggestions on how to improve it. They will be sincerely welcomed.

Dedicated to all the people who have used this book and who are a part of this new edition.

Contents

1 Photographers at Work 1

Corporate Photography: Bruce Davidson 2 Freelance Photography: Jeff Rotman 4 Documentary Photography: Susan Meiselas 6 Advertising Photography: Clint Clemens 8 Artist: Barbara Kasten 10 Multi-Image Productions: Bob Peterson 12 Travel Photography: Lisl Dennis 14 Portrait and Wedding Photography: Joyce Wilson 16 Photographic Illustration: Lois Gervais 18 Cultural Research: Carl Fleischhauer 20 Industrial Photography: Matt Weinberg 22 Newspaper Photography: Lois Bernstein 24 Sports Photography: Walter looss, Jr. 26 Showing Your Work to Editors and

Others 28

2 Camera 31

The Anatomy of a Camera 32 The Major Types of Cameras 34 View Camera 34 Rangefinder/Viewfinder Cameras 35 Reflex Cameras 36 Focusing Systems 38 The Shutter as a Controller of Light 40 The Shutter as a Controller of Motion 42 The Aperture as a Controller of Light 44 The Aperture as a Controller of Depth of Field 46 Using Shutter and Aperture Together 48

Keeping the Camera Steady 50 Choosing a Camera 52

3 Lens 55

Why Lenses Are Needed 56
A Pinhole to Form an Image 56
A Lens to Form an Image 58
Types of Lenses 60
Lens Focal Length 60
The Normal Lens 62
The Long Lens 64
The Short Lens 66
Special-Purpose Lenses 68
Focus and Depth of Field 70
Controlling Depth of Field 72
More About Controlling Depth of

Field 74 Automatic Focus 76 Using Focus and Depth of Field 77

Perspective 78

Using Perspective 80

Getting the Most from a Lens 82 What Went Wrong? 83

Choosing Lenses 84 Caring for Your Camera and Lens 85

4 Light and Film 87

Making an Image in Silver 88 Characteristic Curves: How Films Respond to Light 90 Choosing a Film 92

Film Speed and Grain 93 For Maximum Detail—Slow and Medium-Speed Films 94 When Speed is Essential—Fast Films 96

How Black-and-White Film Sees Color 98

Infrared Film: Seeing Beyond the Visible 100

Instant-Print Film 102 Using Filters 104

A Polarizing Filter to Reduce Reflections 106 More About Filters 107

5 Exposure 109

How Exposure Meters Work 110 Built-in Meters 112 Automatic Exposure 113 How to Meter 114

An Overall Reading for an Average Scene 114 Metering Scenes with High Contrast 116 Exposing for Specific Tones 118 Spot Meters 120 Substitution Readings 121

Hard-to-Meter Scenes 122 Using Exposure 124

6 Developing the Negative 127

How to Process Roll Film Step by Step 128 Handling Chemicals 130 Preparing Chemicals and Film 132 Getting the Film into the Developer 134 Stop Bath and Fixer Steps 136 Washing, Drying, and Protecting the Film 138 Processing Roll Film—A Summary 139 How Developer and Fixer Affect a Negative 140 How Time and Temperature Affect Development 142 Exposure and Development: Under, Normal, Over 144 Push Processing 146 The Importance of Proper Agitation and Fresh Solutions 148 The Need for Careful Washing and Drying 149 Intensification and Reduction 150 What Went Wrong? 151

7 Printing the Positive 153

The Darkroom 154

The Enlarger: Basic Tool of the Printmaker 156 Printing Papers 158

How to Process Prints 160

The Contact Sheet: A Whole Roll at Once 160 Preparing the Negative for Enlargement 164 Making a Test Print 166 The Final Print 168 Processing Prints—A Summary 171

How to Judge a Test Print 172 Papers That Control Contrast 174 *Graded-Contrast Papers 174*

Variable-Contrast Papers 174

Dodging and Burning In 178 Cropping 180 What Went Wrong? 181 Toning for Color and Other Effects 182 Archival Processing for Maximum Permanence 183

Platinum Prints: Beauty and Permanence 184

8 Finishing and Mounting 187

Drying Your Prints 188 Spotting to Remove Minor Flaws 189

How to Dry Mount 190 Cutting an Overmat 193

9 Special Techniques 197

The World in Close-Up 198

How to Use Supplementary Lenses 199 How to Use Extension Tubes and Bellows 200 How to Use Macro Lenses 201 Close-Up Exposures: Greater than Normal 202

Copying Techniques 204 Special Printing Techniques 206

A Photogram: A Cameraless Picture 206 A Sabattier Print—Part Positive, Part Negative 208

Techniques Using High-Contrast Film 210

A Line Print 213 A Posterization 214

Using Special Techniques 216 Digital Image Processing 217 Multiple Imagery 218

10 Color 221

Color: Additive or Subtractive 222 Color Photographs: Three Image Layers 224 Choosing a Color Film 225 Color Balance 226 Matching Film to the Light Source 226 Filters to Balance Color 228 Color Casts 230 Color Changes Throughout the Day 232 Shifted Colors from Reciprocity Effect 235 Exposure Latitude: How Much Can Exposures Vary? 236 Processing Your Own Color 238 Making a Color Print from a Negative 240 Materials Needed 240 Exposing a Test Print 242 Processing 244 Judging Density in a Print Made from a Negative 247 Judging Color Balance in a Print Made from a Negative 248 More About Color Balance/Print

Finishing 250

Making a Color Print from a Transparency 252 Judging a Print Made from a Transparency 254 Instant Color Film 256

11 Lighting 259

Direction of Light 260 Degree of Diffusion: From Hard to Šoft Light 262 Light as You Find It—Outdoors 264 Light as You Find It—Indoors 265 The Main Light: The Most Important Source 266 The Fill Light: To Lighten Shadows 268 Simple Portrait Lighting 270 Multiple-Light Portrait Setups 272 Lighting Textured Objects 274 Lighting Reflective Objects 275 Lighting Translucent Objects 276 Lights and Other Lighting Equipment 277 Lighting with Flash 278 Flash Equipment 280 Using Automatic Flash 281 Controlling Flash Exposure Manually 282 Basic Flash Techniques 284 Flash Plus Daylight 286 What Went Wrong? 288

Using Lighting 289

12 View Camera 291

Inside the Modern View Camera 292 View Camera Movements 294 *Rise and Fall 294 Shift 296 Tilt 298 Swing 300* Controlling the Plane of Focus 302 Controlling Perspective 304 Dealing with Distortion 306 What to Do First—and Next 307 Loading and Processing Sheet Film 308 Using a View Camera 310

13 Zone System 313

The Zone System Scales 314 Using the Zone Scale While Metering 316 How Development Controls Contrast 318 A Full-Scale Print 320 Using the Zone System 322 Putting It All Together 324

14 Seeing Photographs 327

Basic Choices: Content 328 Basic Choices: Framing the Subject 330 Basic Choices: Backgrounds 332 Basic Design: Spot/Line 334 Basic Design: Shape/Pattern 336 Basic Design: Emphasis/Balance 338 More Choices: Using Contrasts of Sharpness 340 More Choices: Using Contrasts of Light and Dark 342 More Choices in Framing 344 More Choices: Perspective and Point of View 346 Looking at-and Talking About-Photographs 348

15 History of Photography 351

The Invention of Photography 352 Daguerreotype: "Designs on Silver Bright'' 354 Calotype: Pictures on Paper 356 Collodion Wet-Plate: Sharp and Reproducible 358 Early Portraits 360 Images of War 362 Early Travel Photography 364 Gelatin Emulsion/Roll-Film Base: Photography for Everyone 366 Time and Motion in Early Photographs 368 The Photograph as Document 370 Photography and Social Change 372 Photography as Art in the 19th Century 374 Pictorial Photography and the Photo-Secession 376 The Direct and Unmanipulated Image 378 The Quest for a New Vision 380 Photography as Art in the 1950s and Beyond 382 Photojournalism 384 History of Color Photography 388

16 Portfolio 391

Glossary 413 Bibliography 418 Index 423

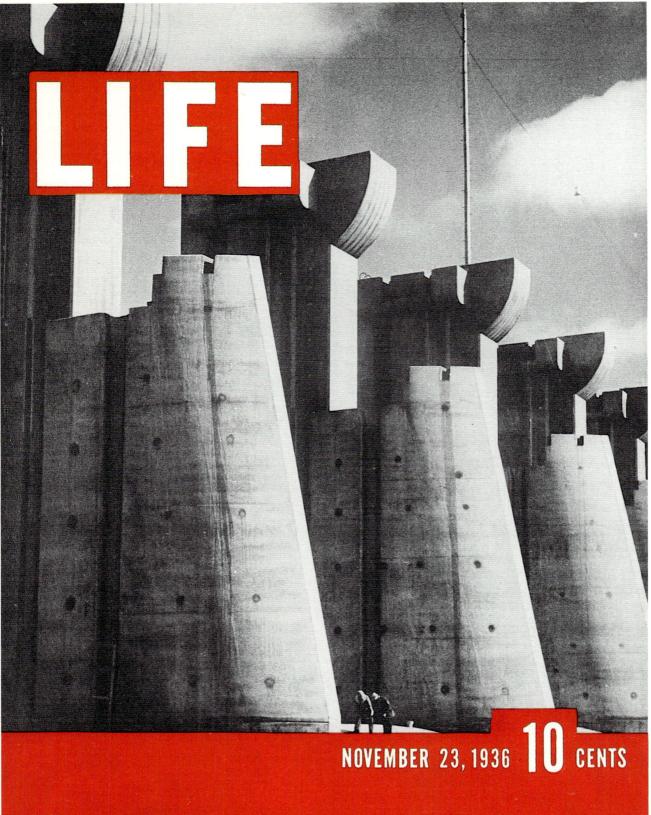

G. U. S. PAT. OF

MARGARET BOURKE-WHITE: Fort Peck Dam, Montana, 1936. First issue of Life magazine

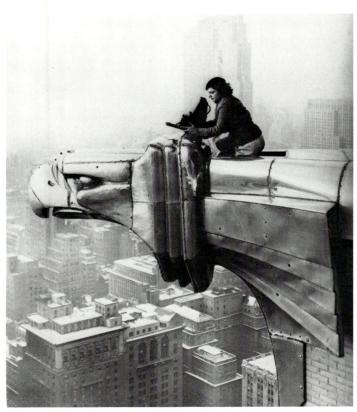

OSCAR GRAUBNER: Margaret Bourke-White, 1934

Margaret Bourke-White, shown above, photographing New York City from her perch on a Chrysler Building eagle, was renowned as a photoiournalist from the 1930s to the 1950s. In 1936 her picture story on Fort Peck Dam was featured in the first issue of Life magazine, with her photograph of the dam on the cover (opposite). Her industrial photographs, like this one, often emphasized visual impact and had a bold and simplified composition. Her work was wide ranging, including scenes of the American 1930s Depression, World War II action, Nazi concentration camp victims, and Korean War guerillas. She was harddriving and intensely committed to her work, so much so that it was said she would get up at daybreak to photograph a bread crumb.

No matter what you know about a photographer's work or how a photograph was taken, it is important to stop and look just at the picture itself. What do you actually see when you look at a print? Are any photographic techniques evident? What associations does the print call to mind? Throughout this book, background information and possible interpretations are given for many of the pictures, but your own reactions are equally important. You may see a photograph in a different way altogether; that is to be expected. You will also find that people may have unpredictable reactions to your own pictures. Responding to photographs is a very personal art.

Photographers at Work

Corporate Photography: Bruce Davidson 2 Freelance Photography: Jeff Rotman 4 Documentary Photography: Susan Meiselas 6 Advertising Photography: Clint Clemens 8 Artist: Barbara Kasten 10 Multi-Image Productions: Bob Peterson 12 Travel Photography: Lisl Dennis 14 Portrait and Wedding Photography: Joyce Wilson 16 Photographic Illustration: Lois Gervais 18 Cultural Research: Carl Fleischhauer 20 Industrial Photography: Matt Weinberg 22 Newspaper Photography: Lois Bernstein 24 Sports Photography: Walter Iooss, Jr. 26 Showing Your Work to Editors and Others 28

This chapter describes the careers that 13 photographers have made in photography. These people like what they do and get enormous satisfaction from their work. When so many people think of their work as something they have to get through before they can relax or play, it is refreshing and encouraging to talk to others who have found work that satisfies them deeply.

You don't have to earn your living in photography to be a good photographer. Even if you don't want to pursue photography as a career and just want to learn how to make better pictures, the people interviewed for this chapter can help you. They spend their days with photography, working at it and thinking about it, and they have a lot to say about it.

The advice they offered about how to improve was surprisingly consistent. "Photograph more and more." "Take more pictures." "Shoot, shoot, shoot." "Try different ways of doing things." "Try to make the next picture better." "Persevere." "Just keep after it; you can't help but improve if you do." If this sounds like obvious advice—no secrets or inside information it seems to be obvious advice that works. These photographers volunteered such comments often and with feeling. They knew how they had improved their skills, and they knew what you must do to get better, too.

If you do someday want to show your work to a magazine, agency, client, museum, or gallery, you will be meeting people like those interviewed on pages 28–29. They tell what they are looking for and the best way to present it to them.

Corporate Photography: Bruce Davidson

Bruce Davidson is well known for his personal projects of documentary photography, such as East 100th Street and The Brooklyn Gang (see photograph, page 62). He is also well known in another arena: photography for corporate annual reports. Planning for an annual report starts long before the first day of shooting. One purpose of the report is to convey a specific image of a company, an image that can range from high tech to humanistic. Davidson has to be sure that he, the graphic designer of the report, and the chairman of the company understand one another completely. "I may never see the chairman," Davidson says, "so the designer is a critical link. A good designer creates a graphic point of view that is compatible with the chairman's business notions for that year. Until that's reached and agreed on, you're in dangerous water, because you can come back with pictures that are brilliant but not what the chairman needs or wants."

Davidson's clients include corporations such as Eli Lilly and Company, Occidental Petroleum, H. J. Heinz Company, and Metropolitan Life Insurance Company. He also does editorial illustration for magazines such as *Fortune* and *Vanity Fair*. Davidson's clients hire him because they are familiar with and want his personal style, which does not rely on any tricks, distortion, or other special effects. "I always try for a deeper, more penetrating view, not just a slick graphic solution, whether I am photographing people or products."

Although his commercial style is not unlike his personal work, he thinks about the two differently. "For a client, I'm working more as a craftsman than as an artist. For an annual report, I'm thinking along the lines of the chairman of the board. For an editorial assignment, I'm thinking about what a particular editor or story requires. But when I'm doing my personal work, I'm only trying to come to grips with my own sensibility."

An assistant and ten cases of equipment accompany Davidson on most assignments, and his control over his craft is formidable, but he says that technique isn't everything. "Diplomacy is very important because I have to get people to do what I want. I alert the contact at a location the night before that we are coming. I bring my other annual reports and I show them that a doublepage picture *is* something."

Davidson has worked on movies, and he thinks of his shots as scenes. Like a casting director, he looks for the right type of person for a particular shot, not simply using whoever happens to be at a factory or plant when he arrives. He looks at each location as if it were a set. "You can't just go in and make candid shots when they are going to end up as double-page pictures that will be scrutinized. Shooting is really a small part of the work. Time and energy go into creating the scene, very much like directing a movie. We're building to a shot that will have action, drama, story."

Davidson sees himself and his assistant as a team. His assistants must have some experience before he will hire them. "I don't take apprentices from nothing and train them because there are too many mistakes they can make, but once they work with me, they are learning constantly. They usually stay three or four years and then go off on their own. Good assistants are another pair of eyes. They'll let me know if they see something that isn't quite right."

On location, a work day can be 18 hours long, but "there's nothing greater than when my assistant and I realize that we're getting a really fantastic photograph. If you are not working very hard and not enjoying the work at the same time, there's something wrong."

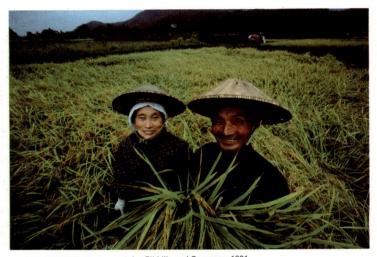

BRUCE DAVIDSON: Photograph for Eli Lilly and Company, 1981

Bruce Davidson often emphasizes the human element in his photographs for corporate reports. Above: one of the products made by Eli Lilly and Company is a fungicide that controls blast, a devastating rice disease. For a Lilly corporate report, Davidson photographed a Japanese farm family that actually uses the fungicide. Opposite: the product itself can be made subtly evident, as here for a Johnson & Johnson corporate report.

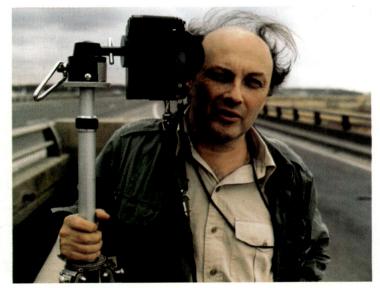

DANA DUKE: Bruce Davidson, 1981

BRUCE DAVIDSON: Photograph for Johnson & Johnson, 1974

Freelance Photography: Jeff Rotman

Jeff Rotman begins his day at his apartment in Jerusalem by opening the mail. Rotman is a freelance photographer who shoots various types of assignments but whose specialty is underwater photography. Today his mail contains a check from Geo magazine for a story about caves in the Red Sea; a query from a picture researcher working on a biology text asking for pictures of sea turtles; a note from a writer who is coauthoring an article with Rotman, asking about a picture of two Bedouins slaughtering a goat; and a letter from a magazine rejecting an article he proposed on crocodiles. The phone rings with a call from Life magazine: they are not interested in his idea for a story on the cocaine trade in Bolivia but want to know what pictures he has of oil spills.

By the end of the day, he will have sent five slides of sea turtles to the picture researcher, given the writer information on the Bedouins and the goat, made a phone call about the crocodile story to another potential publisher, and worked on a new idea for a story on women in the Israeli army.

Rotman feels he has to both photograph and sell. For every hour he spends in the field shooting, he spends at least as much time developing ideas and promoting them to potential clients. He recently mailed a list of his stock photos and some sample reproductions to 3,000 picture researchers, art directors, editors, agents, and others who might be interested in his work.

His photographic skills are important, but he says his most valuable skill is persuasiveness in dealing with clients. "I don't want to sell something to someone if they don't want it, but I have to make them see the light. As soon as most editors hear 'fish,' they think it belongs in a wildlife magazine, but many of my pictures can go into *Vogue*; they can go anywhere. You have to believe in your work and then go out and sell it." Rotman has been very successful persuading people that they need his work. He is one of the few freelancers who make a good living doing mostly underwater shooting.

Lately he has been going after other kinds of assignments. "I don't want to spend eight months a year in the water anymore because I don't want to lose my edge. I want to be hungry when I go in that water. I want to be excited and if I stay dry for two or three months. I can't wait to get in the water." He looks for stories on land that he really wants to do. "If there's one thing that I like about my work, it's that I'm doing what I like to do. I've lived for years near the Bedouins by the Red Sea, and I was always curious about them, but I never had an excuse to go out and live with them. Doing a magazine story on the nomads of the desert-that was the excuse."

There are drawbacks to Rotman's line of work that most people don't see, such as the paperwork involved in labeling slides and preparing captions for them. "Pictures sell better with good labeling and captions. I have farmed out the paperwork more and more, but I can't eliminate it." Even the shooting, which he loves, has its drawbacks. "Clients have a romantic vision of me at work. They see me coming in with a tan, but they don't see the hours I put inmaybe eight or ten hours a day in the water. They don't see me camping out for long periods, eating out of cans and packages, and working in a remote area where I'm 16 hours from a hospital if I have an accident. Underwater equipment is extremely expensive, probably as much as a fashion photographer's full rig, but I don't get the fees that a top fashion photographer gets. So all the more reason why it's important to love the work."

JEFF ROTMAN: Training Antiterrorist Commandos, 1986

In addition to his underwater photography, Rotman increasingly has been shooting land-based stories. His photographs on Israeli antiterrorist training were published extensively. Directed by the instructor at left, an attack is simulated on a terrorist stronghold to free hostages. A smoke bomb adds to the realism.

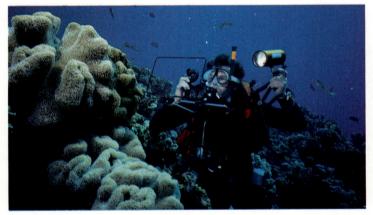

URS MOCKLI: Jeff Rotman, Red Sea, 1982

Jeff Rotman says that before you try to photograph underwater, you should be an excellent diver. "You have to be able to concentrate on the shooting, and to do that you can't worry about your diving." Rotman is using a Nikonos III underwater camera fitted with a 28mm lens and a frame that helps position the camera for closeups. His right hand is adjusting a light meter. His left hand holds an underwater strobe.

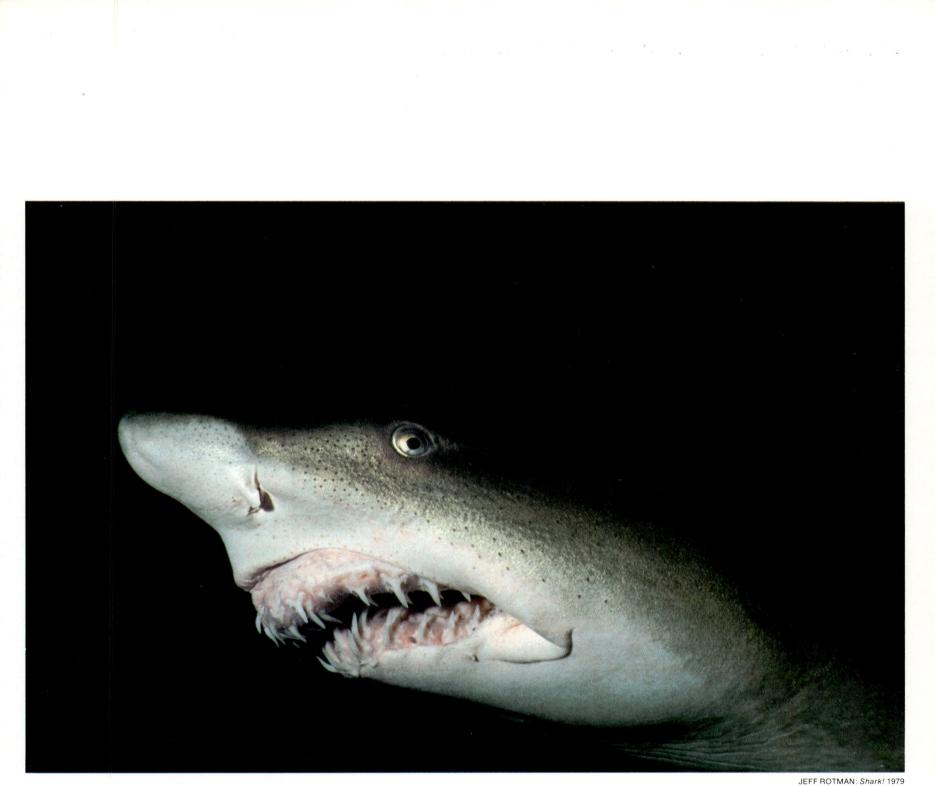

This 10-ft sand tiger shark lives in the large ocean tank at the New England Aquarium. It would be almost impossible to get a shot like this in open waters—and bring home the film. In the ocean, the shark can be dangerous, but in the tank it has become accustomed to divers. Rotman shot from about 2 ft away. "I am very aggressive underwater.

If I am going to take a picture of a shark, then I go in close, head-on with it. I am not going to make it look gentle. I'm going to take its strongest trait and color it up." The photograph epitomizes what most people have in mind when they think of sharks; Rotman has sold it more than twenty times for use in magazines and books.

6

Documentary Photography: Susan Meiselas

For Susan Meiselas, there is no typical day in Central America. If the region is quiet, she concentrates on pictures that are not linked to a specific news event. But in a country where fighting is taking place, she says, "You get up at 6:30, have breakfast, talk to people, call around, and if nothing is happening you still get on the road. You just go, even if you don't know where you are going and you don't know what you will find. If there is some action, if a town has been taken or an offensive is beginning, obviously that directs the day."

Meiselas went to Central America in 1978 on her own to make some pictures of life in Nicaragua. By chance, she arrived just a few months before the country went into open revolt against the Somoza regime then in power. When the war heated up, Meiselas was at the center of the action. International attention turned to Nicaragua, and her photographs began appearing in newspapers and magazines all over the world.

Unlike many news photographers, Meiselas did not go to photojournalism school or work on a daily newspaper. She thinks of herself primarily as a documentary photographer, and even though she now gets assignments from *Time* magazine, the *New York Times*, and other periodicals, she avoids working strictly in terms of stories. Her interest is in documenting the ongoing history of the region, so she tries to cover what she perceives as important, not just what she has been assigned to photograph.

Part of what is important in Central America today is conflict. Meiselas has often been in the midst of gunfire, trekked deep into ambush country, and waited out tense periods at barricades. Part of her survival kit is her intuition about when to move forward and when —if she has the choice—to go back. "Obviously, I feel fear. I always watch the people who are alongside the road. You get clues from their faces, or you can feel the anxiety if people won't talk to you." She says it is important to work with people who respond to situations the way you do and with whom you are free to say how you feel. "You have to listen to that inside place. If you are afraid, you are afraid. But you also have to evaluate to what extent those fears are reasonable, or things can become larger than they are so that you paralyze yourself."

She enjoys working with a writer and for a magazine, if they provide an accurate context for her pictures. A photojournalist may have little control over how pictures are used; they may even be used to illustrate the opposite of what actually took place. But ideally, the photographer and writer can form a team in which each complements and extends the meaning of the other's work.

Meiselas does not photograph when she thinks people are posing or performing for her camera. Instead, she tries to wait until she feels people are behaving naturally. She wants them to be comfortable with her presence rather than intruding on them to "take" the pictures she wants. "I know that I affect a situation, but I don't want the picture to be about me or about a relationship the subject has to me." She never asks people to re-create something she has seen them do because doing it for the camera would be doing it for a different purpose. "I don't even like to ask people to move someplace else. I try to work myself around them instead."

Her advice to beginning photographers is to become involved with someone, some place, and live close to it. She says she is very fortunate to be part of a living history. "It is an extraordinary experience, a very privileged position."

SUSAN MEISELAS: Soldiers Searching Bus Passengers, Northern Highway, El Salvador, 1980

Susan Meiselas's photographs of the political conditions in Central America have been used in many magazines and newspapers. Her work is often more complex than the straightforward news picture that conveys its story without requiring much effort from the viewer. The photograph above is not one a news photographer would typically make because it does not reveal itself immediately. It is a very powerful image, but, as Meiselas says, "You have to live with it a while before you emotionally connect with it."

MATTHEW NAYTHONS: Susan Meiselas, Nicaragua, 1979

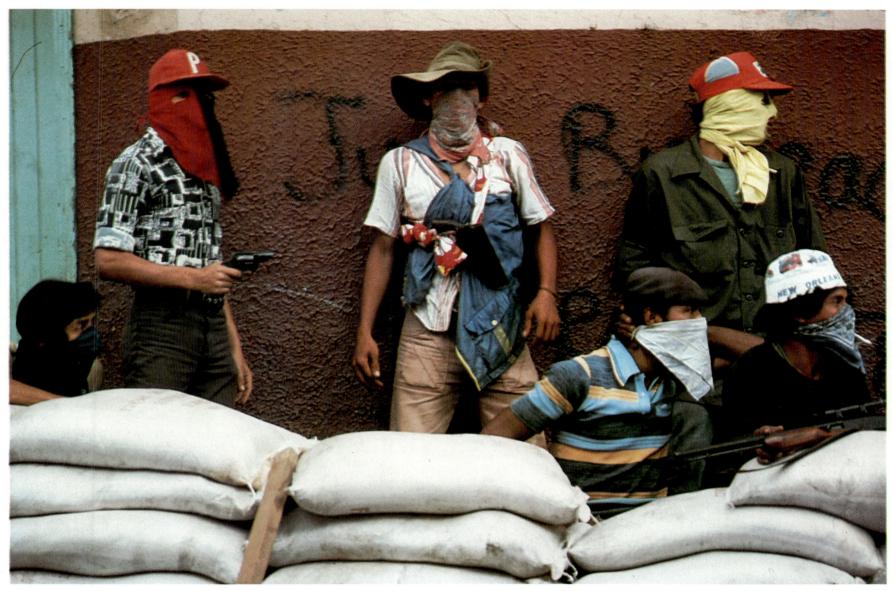

SUSAN MEISELAS: Awaiting Counterattack by the Guard, Matagalpa, Nicaragua, 1978

During the early days of open fighting in Nicaragua in 1978, Susan Meiselas photographed these men at a barricade awaiting counterattack by government troops. She had to decide whether to stay and continue photographing or to leave to get the pictures on a plane to New York in time to make the deadline for publication that week. "As a documentary photographer, I would have liked to stay, but I had to leave to get the pictures out. It was the first time that I realized what it means to be a photojournalist and deal with a deadline."

Advertising Photography: Clint Clemens

What makes a good advertising photograph? For Clint Clemens, the answer is simplicity, and he thinks that many photographers lose sight of that. "They complicate it too much," he says. "Too often there isn't a simple statement or any purity of thought or elegance." He believes that to get an advertising message across effectively you have to understand the psychology of your audience: how people perceive themselves and what intangibles the product might supply to them. For example, imparting a feeling of sleek luxury to the pen and lighter at right is as important as showing their design.

Lighting can be dramatic in Clemens's pictures, but it always looks natural. "In nature, there is only one source of light—the sun. Lighting in a photograph should have that singlesource feeling, whether it is indoors or outdoors." Clemens likes to give light a direction so that it comes from one area and moves across the picture. A viewer's eye tends to go to the lightest part of a picture first, which means that light, especially when it contrasts with a darker background, can direct attention where the photographer wants it to go.

Clemens always visualizes a photograph before he begins to shoot. He has a clear idea in advance of how the product should be presented, how it should relate to the type in the ad, how the picture will be cropped for the layout, and so on. "You have to be able to see the picture beforehand and be able to describe it to others. You would drive everyone crazy if you didn't have a good idea of what you wanted it to look like." He isn't rigidly tied to his ideas and will take advantage of something that happens spontaneously, but often the final picture is exactly what he visualized.

Clemens feels that advertising is a very personalized business. He gets to know his clients and lets them know that their job is the most important one he has. More than that, he makes sure that every job *is* his most important one. "You never, never blow a job. You always have to give it your best, and that requires preplanning and constant attention to detail, especially when you are shooting. But don't get so bottled up and rattled that you can't think. You have to be willing to take chances, too."

Clemens's studio is in Boston. Like his photographs, he knew in advance what he wanted in the studio and had it built to his exact specifications. He says that spending money for the tools you need is a worthwhile investment. Among his lighting tools is an 8 \times 8foot light box hung from a motorized rigging in the ceiling of the huge central shooting area (right). The box has total mobility from floor to ceiling at any angle, with output that can be set from a powerful 18,000 watt-seconds down to only 400. His studio staff includes four full-time photographic assistants. an administrator who schedules bookings and makes other arrangements, and two bookkeepers. He keeps two freelance set stylists busy enough not to work for anybody else and provides most of a set builder's business. Clemens also takes on apprentices for sixweek stints. The apprentices get no pay, work intensely, and get the kind of experience that is impossible to get in a school or from a book.

Clemens says that if you want to be an advertising photographer, you have to be businesslike: "You have to learn how to deal with people, how to go out and get work, how to present and promote yourself, what to put in a portfolio, and many other things." But the most important attribute is a desire to understand every aspect of photography. "I can teach anybody anything, but you have to want to learn. That is absolute."

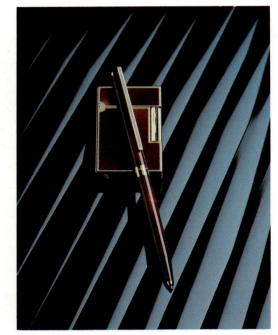

CLINT CLEMENS: Photograph for S. T. Dupont, 1982

For an ad photograph for a company that manufactures luxury lighters, pens, and watches, Clint Clemens placed two products on highly reflective black window blinds. Then he adjusted the blinds and his light until he got the striped reflection he wanted.

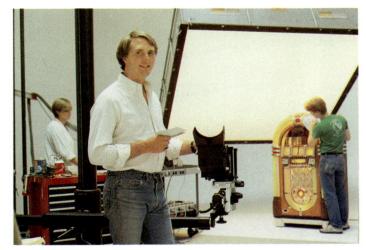

VITO ALUIA: Clint Clemens in His Studio, 1984

CLINT CLEMENS: Photograph for Tech HiFi, 1982

Camera angle is one way to affect a viewer's attitude. To look down on someone is often condescending. To look up can make someone appear impressive or bigger than life. In a photograph for an audio equipment store's catalog, Clemens placed the camera very low, which created an intimacy with the child because the viewer is joining his world rather than looking down on him from the usual adult point of view. (See also the Clemens photograph on page 256.) "You have to take the viewer's mind," Clemens says, "and put it where you want it."

Artist: Barbara Kasten

Barbara Kasten is an artist who makes photographs of constructions that she creates for the purpose of photographing them. In her studio she arranges objects such as mirrors, solid forms, and flat surfaces into what could be called extremely large still lifes, big enough to walk into (right, bottom). She lights the construction, then rearranges and rephotographs it until she arrives at a final image. She also photographs away from her studio at various architectural sites, bringing camera, lights, mirrors, and a crew of assistants to transform the site into her own abstract image (opposite).

Kasten starts a studio construction with a simple problem, such as using several circular and rectangular mirrors that she had cut. She puts the first objects in place, sets up a view camera, then goes back and forth between arranging objects and seeing how they appear in the camera's ground glass. Eventually she makes color Polaroids to see what the image looks like in a print. At first she works only with objects, concentrating on their composition, then she lights them and adds color from lights covered with colored filters. Away from the studio, at architectural sites, the cost of the crew and the equipment rental means she has to know in advance what she wants to do. She visits each location several times to make sketches and test shots. Until she brings in the lights, however, she can't predict exactly what they will do, so there is some improvising on the spot.

When she is satisfied with a setup, she shoots a color transparency from which she has a custom printer, Michael Wilder, make Cibachrome prints, some as large as 50 x 60 inches. She and Wilder have the traditional relationship of artist and master craftsman working together to make a final print. "Although an artist should have technical knowledge to discuss a process, I don't feel I need to make the print myself.'' Kasten also photographs at a special Polaroid studio that makes 20 \times 24 instant prints.

Kasten originally studied painting, then made fiber sculptures. She began making photograms (photosensitive paper exposed under layers of various materials), eventually was adding paint to them, then making photographs of constructions. She feels her work is still evolving and that her main interest has always been in manipulating and using space, whatever medium she uses.

While many artists are unable to earn their living from their art and must take jobs teaching or doing other types of work, Kasten has reached a point where her art is her major source of income. She sells many of her photographs through the John Weber Gallery in New York City, which exhibits her photographs, keeps an inventory of her work to show interested collectors, and handles the details of placing her work in exhibitions outside the gallery. A typical gallery commission is 40 to 50 percent of the selling price. Kasten has also received grants from organizations such as the Guggenheim Foundation and has done commissions for advertising.

A few years ago, Kasten moved from California to New York City. She could make her art anywhere, but in New York she is part of an intensely active art world where she meets other artists, museum curators, critics, and collectors. Kasten's suggestion for anyone interested in developing a career as an artist: perseverance. "Do more and more work. Try new ways of doing what you have done before. Take your work to galleries, as painful as it can be to trudge around, leave a portfolio, and then get a smile and a rejection. Art reguires a real commitment. A bit of luck helps, too."

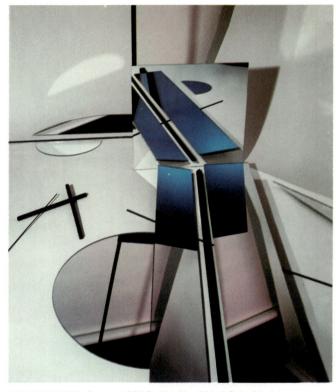

BARBARA KASTEN: Construct PC/5-B, 1981. 20 × 24-inch Polaroid print

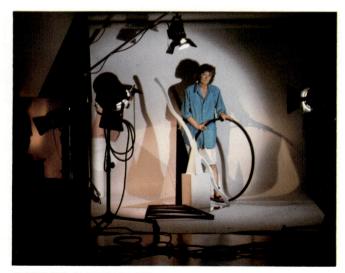

KURT KILGUS: Barbara Kasten, 1984

BARBARA KASTEN: Architecture Site 8, December 21, 1986. Loyola Law School, Los Angeles

Just as she arranges objects in her studio to create abstract images, Kasten freely changes the visual space of architectural sites. She tilts the camera, uses intensely colored lights, and positions mirrors that reflect other parts of the scene that she also lights. "I want to change a viewer's perception of the space, and these things do that by disorienting you, especially with an architectural subject, which you expect to be upright and realistic. They reorganize your preconceived idea of what the space should look like."

Multi-Image Productions: Bob Peterson

If having an audience pay rapt attention to your work and if seeing your images 30 feet wide appeal to you, then you might like to try what Bob Peterson does: multi-image productions. A multiimage show is a fancy cousin of a slide show with sound. It uses 35mm slide projectors, from 2 to 30 or more. Three projectors plug into a dissolver, a device that tells each projector when to change slides and when to turn on and off. Each dissolver is cued by pulses from a tape recording, which also contains a sound track. A typical user for such a show is a corporation that wants an exciting presentation for a sales meeting or conference.

The advantages of a multi-image show are its size (Peterson recently did a nine-projector show onto a 10×30 foot screen), its sound (a taped stereo sound track, powerful amplifier, and big speakers produce better portable sound than most movie theaters have permanently installed), and its cost (inexpensive compared with what you would need to get comparable size and sound in a film). The individual slides do not make a movie, of course, but the show creates a compelling display as images on different parts of the screen fade, dissolve, or rapidly change.

Peterson began his career as a newspaper photographer, then shot for several years for magazines such as Life, Time, and Sports Illustrated. Later he did advertising work. His style has always been strongly journalistic, and that is the type of assignment he has always gotten. "When I went into advertising, people didn't hire me to do a still life of an apple and a pie. They hired me to go out and be with the apple pickers and show what the pickers go through to bring that wonderful apple to you." His journalist's style adapts readily to the storytelling that is part of many multi-image shows.

The size, sound track, and pacing of a multi-image show make it easy to attract and direct an audience's attention and to arouse emotions. If a company's goal is to create an enthusiastic atmosphere at a sales meeting, a multiimage show is far more effective than speeches by corporate officials. The show can give an idea of what some future project will be like-Peterson did one show for a company that was leasing space in an office building that had not been built yet. It is relatively easy to tailor a show to different audiences, such as different ethnic groups, by replacing a few pictures or a sound track.

Peterson says the market is strong for people who do good work. "If you can compose something nicely, if you can tell a story, if you have the intellect to make a medium work for you and communicate something, then you will always be able to get a job." Technical skills are vital, he believes, because not having them will detract from your ability to do what you want to do. He also suggests going to movies-good and bad ones-imagining how various directors would shoot a scene; going to industrial films and other people's slide shows; and looking at art in museums. You may not be able to apply a technique directly, but each will make your eve more sophisticated.

Peterson finds multi-rewards in his work. The financial return is good. He enjoys working in collaboration with other people, as he did in his journalism days. He likes the audience response he gets; once he received a standing ovation at the end of a show. And, especially, he enjoys making things work: "When you get the images into the projector trays, and you have the rough sound track together—the first time you run a show, you do get a little bit of a thrill."

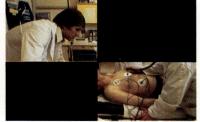

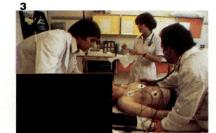

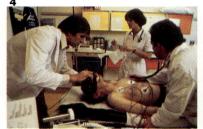

BOB PETERSON: From multi-image show, Heart Attack, 1983

The use of multiple projectors in a multi-image show makes special effects possible, such as image build (above). The sequence of partially blocked slides was shown rapidly using several projectors so that the scene seemed to increase in size as the viewer watched. Below, Bob Peterson usually works with projectors in multiples of three because the dissolve unit that controls the projectors coordinates up to three at a time.

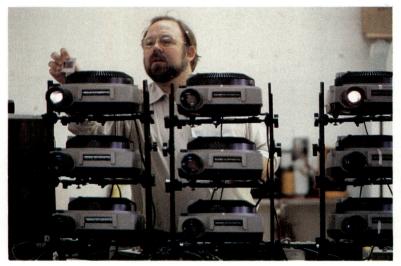

DICK TAYLOR: Bob Peterson at Work, 1983

For a company that manufactures defibrillators, devices that can regulate heartbeat, Bob Peterson did a show that dramatized how such a device saved a man's life. Images within a multi-image show have to relate to each other, so shots are made to create a movielike continuity. Far right, a cutaway, a close-up of an object, a shot used for emphasis or as a transition from one shot to another.

After a stressful day at the office, the man has an equally stressful drive home. Long exposures (center) and zooming during the exposure (far right) streaked the lights of cars, adding to the impression of frenzy as well as creating interesting visuals.

The man has a heart attack. As it progresses, the images change on screen from full color to black and white as a visual indication that his life is slipping away.

Paramedics rush in carrying the device that will save the man's life. Blurred shots used in rapid sequence can give the illusion of speed and movement. As in a movie, Peterson often shoots the same scene several times, in long shots, medium shots, and close-ups or from different points of view.

The sound track of the show consisted of sound effects, music, and realistic dialogue spoken by the actors. The only narration came with the last slide in the show (far right), to give one mention of the product's name: "Physio-Control. When it has to work, it has to work."

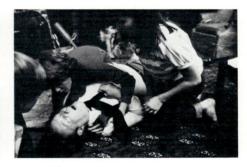

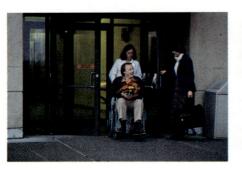

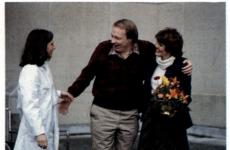

BOB PETERSON: From multi-image show, Heart Attack, 1983

Travel Photography: Lisl Dennis

Imagine two photographers, a photojournalist and a travel photographer, shooting on Broadway. One seeks out pictures of the tawdry glitz and sleaze; the other tries to convey something of the bright lights and excitement. The photojournalist might shoot either one, but you can bet your passport that the travel photographer will always come back with pictures of the latter. (See Lisl Dennis's picture of Broadway on page 123.)

The purpose of travel photography is not to show the dark side of life but, as Lisl Dennis says, "to show whatever is good or beautiful or positive about a place. It is a kind of gratitude for the good time you have had and a desire to share your experiences with others. After all, people don't travel to have a miserable time. That's not the purpose of a vacation."

Lisl Dennis traces her love of travel to her childhood, when she enjoyed wandering through the rural New Jersey countryside near her home. When she began to photograph, she realized that the camera was a kind of passport for her. "It was my introduction and my gateway, my justification for probing and being involved with the world." She has logged more than 18 years of travelrelated photography for articles, books, and advertising, often working with her husband, Landt Dennis, a writer. She teaches at her Travel Photography Workshop in Santa Fe, New Mexico, and writes for Popular Photography.

She says that the travel industry tends to publish rather conventional pictures, ones that do not demand much of the viewer. She always supplies clients with the standard shots that she knows will be accepted, but in addition she seeks to expand her personal style and the definition of travel photography in general. "After you have photographed open-air markets in 20 different countries, a pile of oranges in Senegal begins to look not too different from one in the south of France. The person behind the pile of oranges will have on a different outfit, but he or she isn't going to be doing anything too different." Her solution is to look for unusual ways of approaching a subject (see opposite).

She believes that the barter system that finances many travel articles contributes to the conventionality of travel writing and illustrations. The fees for travel material tend to be relatively low, so photographers and writers often try to arrange for "hospitality," such as free transportation, lodging, or tour arrangements. They get part of their expenses paid, the publisher gets a less expensive article, and the airline or hotel gets free publicity. The catch is that you must come back with a favorable, publishable article or you won't be offered hospitality again. (Some newspapers, such as the New York Times and the Washington Post, will not publish an article if hospitality was accepted.)

The open-air market of travel publishing is the Society of American Travel Writers. At its regional and national meetings, editors, writers, and photographers meet representatives of national tourist bureaus, airlines, hotels, and other travel-related businesses and discuss ideas and projects. For anyone interested in professional travel photography, membership in SATW is a must. A substantial travel record is needed to qualify for membership.

Much hard work and persistent effort have given Lisl Dennis a successful career, but she suggests that if you enjoy travel photography, have some means of financial support available while you are getting started—and possibly forever. The career is worth millions in memorable experiences, but not always in dollars.

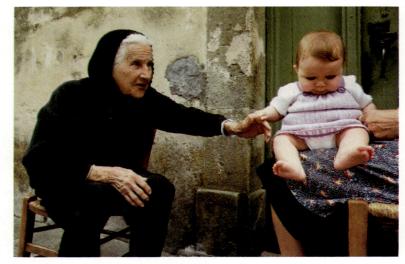

LISL DENNIS: Canal du Midi, France, 1982

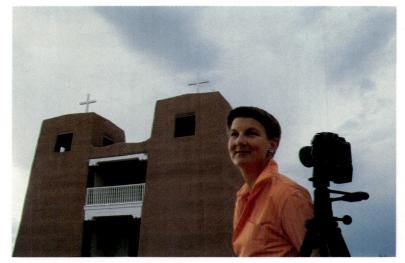

LISL DENNIS: Self-Portrait, New Mexico, 1984

On a trip to the south of France, Lisl Dennis bicycled along the tow paths of an inland waterway, photographing people she encountered along the way. Here, an 85-year-old woman is trying to animate her disgruntled great-granddaughter. Dennis feels she developed a considerable social flexibility during the two years she spent with the Boston Globe as a newspaper photojournalist. At the Globe she photographed everything from drug rehabilitation centers to society teas, and in doing so she learned how to be at ease in any situation. She also learned how to be comfortable working in close with a wideangle lens; she is about 4 ft from the people shown in this photograph.

Lisl Dennis's travel photographs are often less literal than the standard travel image. Here, only segments of the surfboards, sail, sand, sea, and palm tree are visible. "Compared to conventional travel photography," she says, "my work is more detail oriented. My pictures are apt to be tighter visions of places or things rather than overall views. They are graphic interpretations, but ones that still deal with a sense of place."

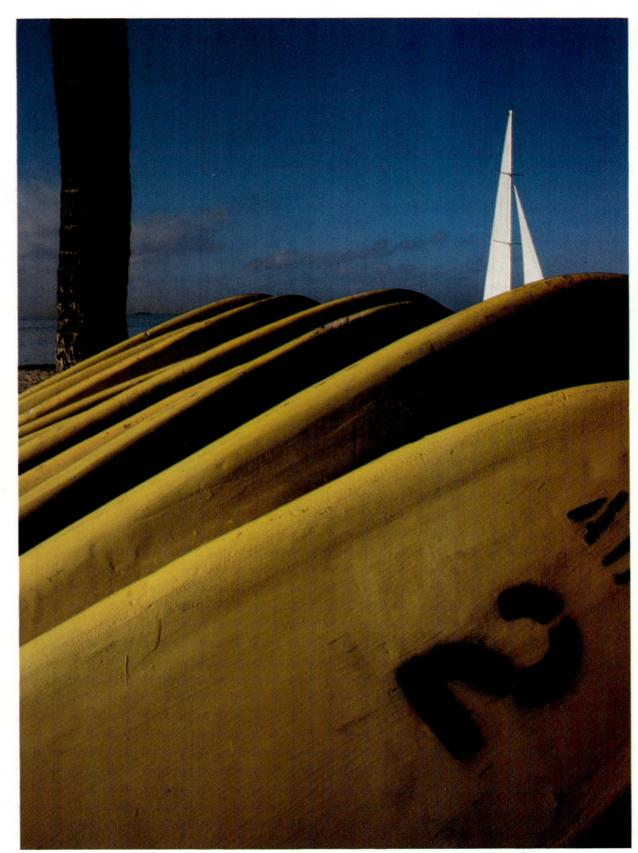

LISL DENNIS: Waikiki, Hawaii, 1979

Portrait and Wedding Photography: Joyce Wilson

If you have ever had your picture taken while sitting on Santa's lap, you will know something about Joyce Wilson's first job in photography: she was Santa's helper and pushed the button on the camera. After her first year as a helper, she got an offer to do the Santa concession herself and, knowing almost nothing about photography, decided she had better learn more about it. As her skills increased, she began to branch out. At first she photographed only children. In time, she opened a fullscale portrait-wedding studio, became well known in her field, and today teaches photography workshops. With her husband, she operates a studio in Indianapolis, Wilson-Holt Photography.

Wilson loves to take portraits. She describes herself as an extrovert and as someone who likes people and enjoys bringing out the best in them. "I can be depressed and mad at the world, but after about ten minutes into a portrait sitting, I am a totally different human being," Wilson says. "I am having a wonderful time and when it is over, I am on an adrenaline high that just won't quit."

Portraits are the mainstay of Wilson's business. Even though there is a camera in almost every home, many people still go to a professional photographer to have their portrait made. She believes that people respect quality and will pay for it. Many of her clients want a portrait to give to someone else, such as a spouse or other family member. "Grandmothers. If we didn't have grandmothers we'd be out of business. They are always demanding family groups. Snapshots are fine, but they want something to frame and put in the living room or bedroom."

Wilson shoots portraits in the studio and on location in a wooded area behind her studio or at a client's house or office. She discusses the session with clients in advance to fit the style of the portrait to their lifestyle. "You get some people who are very structured, and it wouldn't fit them at all if you tried doing them in casual clothing outdoors." She believes that to get people to look natural, you have to relax and act natural yourself. At the same time, you have to know what you are doing technically so that you don't fumble with the lights or camera. You can't be creative and relate to a client, she says, until you are thoroughly at home with your equipment.

Weddings are also a part of Wilson's business, and she says it is especially important for the photographer to be relaxed and confident at a wedding because other people are likely to be excited. She prices her wedding packages rather high because she prefers portrait photography, but for the price she gives clients 70 prints. One strategy has made portraits and weddings more profitable: instead of giving clients proof prints to take home, she shows them slides of their sitting or wedding in her studio. Clients make their decisions in the studio and no longer have to be hounded to return proofs and place their orders.

Wilson does not market her services as aggressively as some other studios do. She displays prints at various local business establishments and also relies on repeat business from clients and on their recommendation of her to others. She says she enjoys making pictures most of all, so she wants her business to remain small enough for her to spend most of her time photographing rather than managing. "It's important to make money and to run a business efficiently, but that's not my entire purpose. My motivation is my self-gratification and my need to express myself. I feel that because the motive is right, the business is successful."

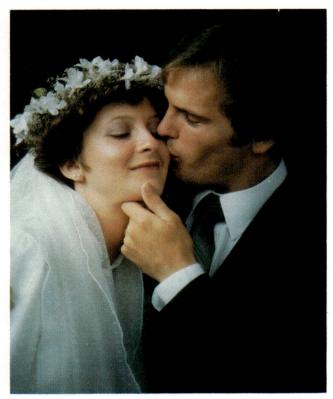

JOYCE WILSON: Bride and Groom, 1982

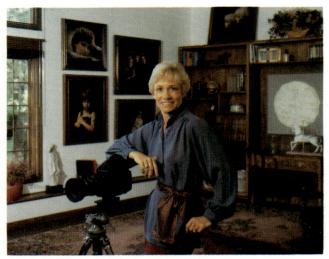

BILL McINTOSH: Joyce Wilson in Her Studio, 1983

 When Joyce Wilson does a wedding, in addition to making the standard candid and posed shots she likes to add a photograph that looks romantic but believable.

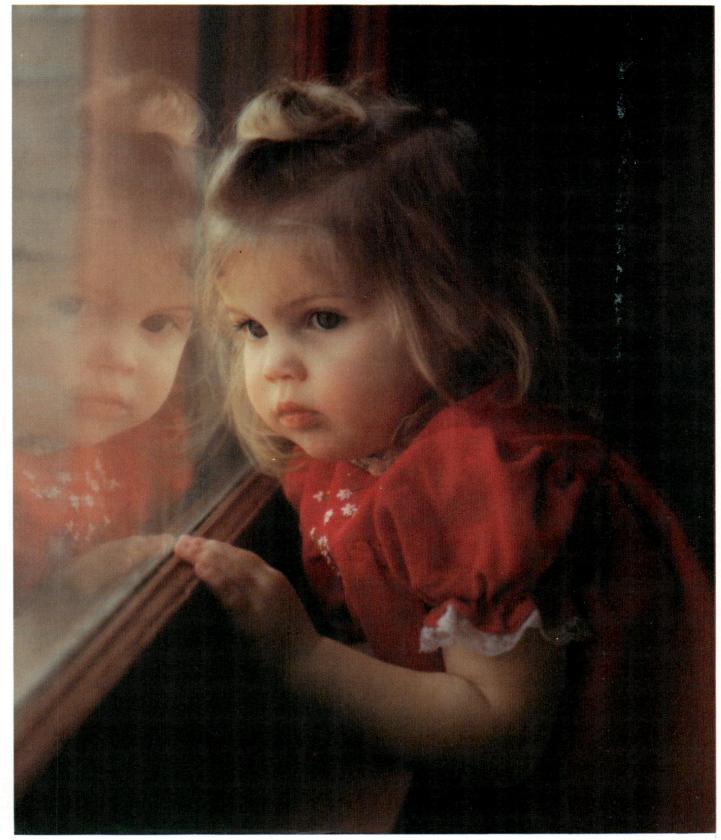

The viewer has no clues that this portrait was actually taken in a cramped corner of a small room. Wilson often does portrait sittings in clients' homes and has become adept at finding settings for her subjects.

Photographic Illustration: Lois Gervais

In the seven years that Lois Gervais worked for Atlantic Richfield Company, she photographed everything from oil rigs to executive portraits in every location from Alaska to the company's home base in Los Angeles. Eventually she decided to move out on her own, and she now does corporate, editorial, and advertising work for a variety of clients.

Her schedule can be as varied as photographing at a refinery in the morning and at a ballet performance in the evening. A corporate client might want pictures for an annual report, calendar, or brochure. A magazine might want pictures of offshore oil drilling, an executive's portrait for a business story, or a travel photo. Her advertising work is more likely to be about concepts than products; for example, an assignment for a new wine had to be not simply a picture of the wine, but a photograph that conveyed a pleasurable mood.

Gervais's specialty is photographic illustration, the creation of photographs that visually interpret or present an idea. "It is making a photograph," she says, "not just taking one of whatever happens to be there." She is responsible for the technical execution of the photograph-how it will be made-and often for its conception-what the picture will show. She frequently works as part of a team that includes an art director and a writer. Sometimes they simply ask her to work from a shooting list or layout, they may ask her for advice on how to technically carry out a photograph, or they may ask her for help with the concept itself. People may have different ideas about what will work, but when it comes to executing a photograph, she is the one who knows how to do it, and in most cases the art director or writer will take her advice.

When Gervais is on the road, she travels with three 35mm camera bodies, six lenses, two electronic flash setups including stands and umbrellas, Polaroid gear, meter, film, and miscellaneous items. Some equipment she always carries with her, and the rest fits into a case on wheels that is almost liftable. While working she wears a camera vest so she can keep her hands free (see right, bottom). At a factory or other location where people are working, an on-site contact is essential; she needs someone who has the authority to ask people to stop work and pose and who understands how various jobs are performed so that the scene looks authentic when photographed.

Gervais says that she tries to get the people she photographs involved in the process so that they feel relaxed and at ease. "Most people are hams when they loosen up, and that can really help me. When I am adjusting my lighting, I make a Polaroid photograph and give that to them. I ask them if there is any way to make it better. People don't like to be 'taken.' I always tell them, 'I am not taking a photograph of you, I am *making* one, and we are going to construct it together.' "

She feels that the fact that she is a woman can help when people are nervous about being photographed. When they have been expecting a male photographer and a 5'2" female arrives instead, she at least has their attention. "People tend to watch what I am doing very closely. I often get comments like, 'It is really interesting to watch you work.' They may be reserved, but they usually don't feel threatened anymore."

Gervais likes going to places that she wouldn't see otherwise, like drilling rigs at sea. Another satisfaction is the essence of photographic illustration itself: solving the problem of how to interpret a concept photographically (see above right and opposite).

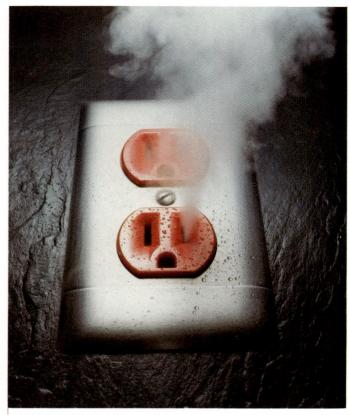

LOIS GERVAIS: Geothermal Energy, 1977

PETE NEWMAN: Lois Gervais, 1983

 To illustrate the concept of geothermal energy (energy from the earth), Lois Gervais started with a piece of oiled, black, textured vinyl that resembled a rock surface. In it she mounted the faceplate of a wall outlet with sockets that she had painted red. Underneath she placed a chunk of dry ice in a covered paper cup with a straw coming through the lid, positioning the top of the straw so that it fed into one of the sockets. When she added water to the cup, the dry ice forced a steamy-looking vapor out of the straw. She sprinkled on some water to simulate condensed steam, and lit the whole setup with electronic flash. Gervais credits this shot, which she conceived on her own, as being one of the factors that caused Atlantic Richfield to hire her.

For a brochure promoting one of Atlantic Richfield Company's analytical labs, Lois Gervais combined a long exposure to record the computer screen with a flash exposure for the rest of the scene. First, she composed the picture with the camera on a tripod. She selected the lens aperture she needed to get enough depth of field to have the entire scene sharp —f/16. Then, using Polaroid film, she tested for the exposure time that the screen would need at that aperture—6 min. Finally, she adjusted her flash distance and power so that it would give a correct exposure for the overall scene with the camera lens set to f/16. The combined exposure was made on 35mm transparency film.

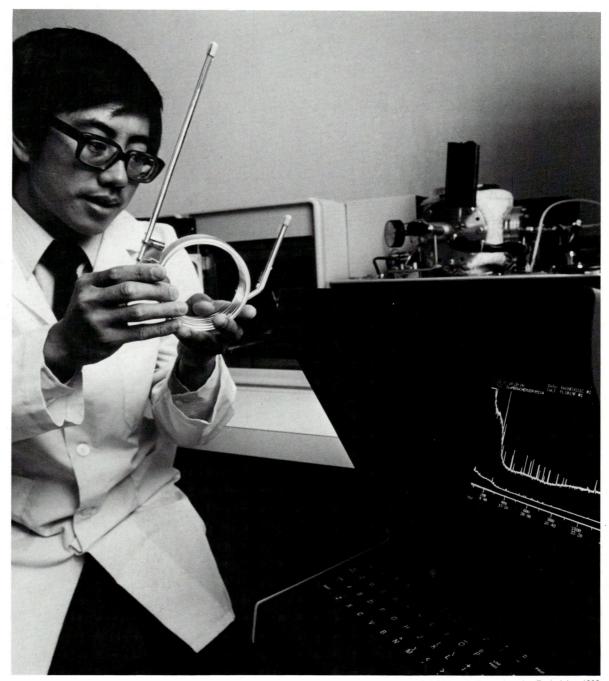

LOIS GERVAIS: Bioengineering Technician, 1982

Cultural Research: Carl Fleischhauer

Whether he is making a photograph of a buckaroo roping a calf in Nevada (opposite page) or of a man showing his blue tick hound in Georgia (right), Carl Fleischhauer has two possible goals. He looks for images that have visual impact and appeal, but, even more important, he seeks to collect and record information about how people live. Fleischhauer is a photographer and folklife specialist for the American Folklife Center at the Library of Congress in Washington, D.C. His work there satisfies his long-term interest both in photography and in folklife-traditional arts, skills, and customs that are passed down from one generation to the next. "I don't think of myself as purely a maker of images," he says. "I think of myself as a person who is curious about culture."

The American Folklife Center coordinates activities related to folk culture, such as working with the Illinois State Art Council to survey ethnic arts in Chicago neighborhoods or with the National Park Service to document traditional life along the Blue Ridge Parkway. Fleischhauer works with teams that may include several folklorists, an anthropologist, an archaeologist, an ethnomusicologist, and others. Folklorists can be interested in all sorts of things. For instance, one project on cowboy life in northern Nevada documented shoeing a horse, branding-iron designs, bunkhouse construction, saddles, storytelling, and local history.

Fleischhauer's work is somewhat like photojournalism, except that he usually covers a subject more completely than a photojournalist would. For example, he records every step in shoeing a horse rather than making just one or two pictures of the process. He photographs details, such as the types of corn cribs or church pews in a region. He takes overall shots to provide a context for more specialized information. He photographs other members of the team at work, such as one of the folklorists conducting an interview, as a way of showing how material is gathered.

Fleischhauer often photographs people in their homes, and to do this effectively he has to gain their confidence and cooperation. "One mark of a professional is to be able to enter a situation and find a way to make the pictures you want. You have to feel confident and show it. If you are, people are comfortable with you. If you are uneasy, which is natural, you won't build confidence in response. This is not necessarily a natural gift, but a skill that you can work on and improve."

As an agency of the Library of Congress, the American Folklife Center makes the photographs and other materials it gathers accessible to anyone. Consequently, there are some things the center does not record, such as illegal activities. Some people continue to make moonshine whiskey very much the way their grandparents did, but Fleischhauer does not incriminate them by photographing it. Furthermore, even if an activity is legal, some people might not choose to bring it forward. "We want to find out how the people themselves value parts of their lives," he says, "and which parts they choose to present to strangers."

In addition to photographing, Fleischhauer writes, edits, supervises the organization and documentation of all the center's photographs, and, for some projects, hires freelance photographers. The pay for freelancers is not high, and because prints are available free from the Library of Congress, the photographers get no income from later sales of stock photographs. However, the work will live as part of the library's collections, and that has a value of its own.

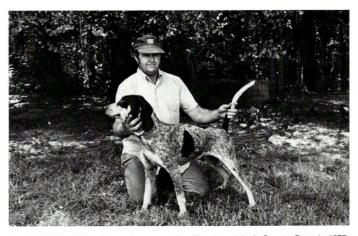

CARL FLEISCHHAUER: Carlton Lupo and a Blue Tick Hound, Irwin County, Georgia, 1977

Storyteller Luther A. Bailey, sometimes known as "Lying" Bailey, told about one of his hound dogs on the track of a very fast raccoon. "He struck this durn coon and that coon went right out and across the open field. And they just looked like he was going, going to catch that coon every minute. He was just biting at him. Woof, woof. And he quit. And he never did bark no more. I took my lantern and went out across there, see could I find him, find out what was wrong. That dog was laying out there dead. And do you know—that coon was running so fast until them rings on his tail slipped off from his tail and went over that dog's neck and choked him to death." (Story collected as part of the South-Central Georgia Folklife Project, 1977)

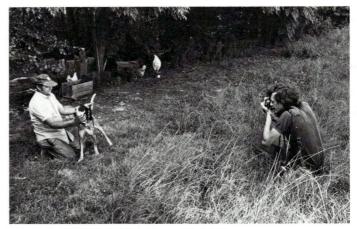

HOWARD W. MARSHALL: Carl Fleischhauer at Work, 1977

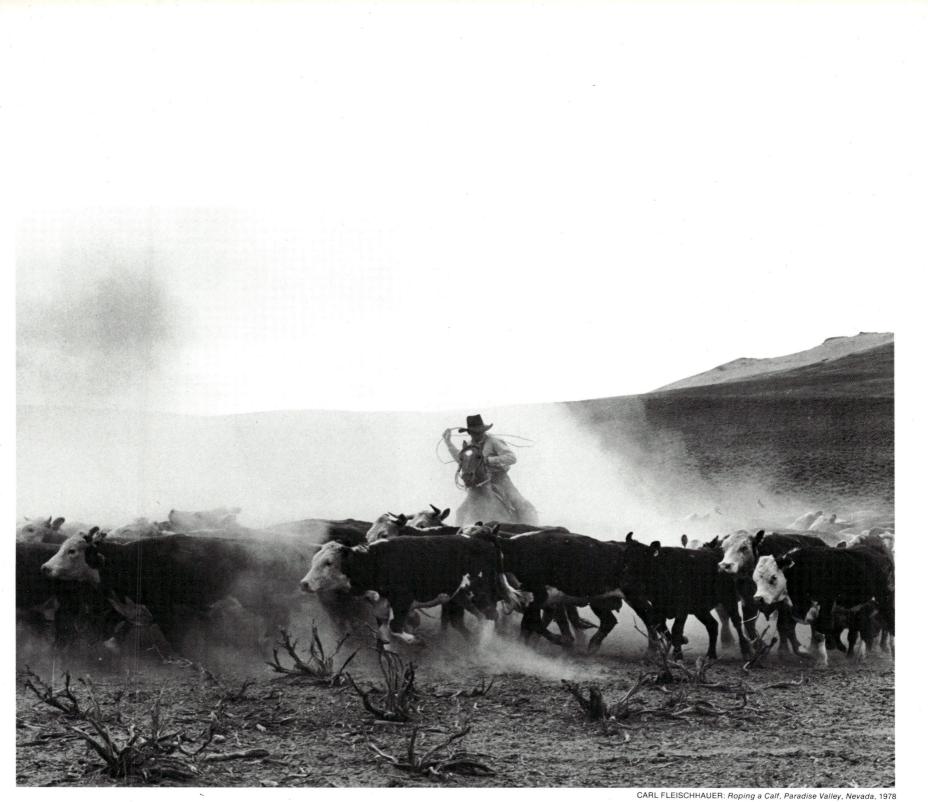

Carl Fleischhauer photographed cattle branding in northern Nevada for an American Folklife Center project. The photograph above was used on the cover of a book on the project, Buckaroos in Paradise. (Buckaroo is the local term for a cowboy, from the Spanish vaquero, cowperson. The

Paradise is Paradise Valley, Nevada.) The picture was made inside a corral but looks like a trail drive because of the dust being kicked up. "I knew at the time that the picture would have impact," Fleischhauer says, "beyond the information it gave about branding activities."

Industrial Photography: Matt Weinberg

To Matt Weinberg, the most interesting part of his job is working out a way to record what someone else needs to see. Weinberg is part of the Photographic Services Department at Santa Barbara Research Center, a subsidiary of Hughes Aircraft Company. SBRC designs, develops, and manufactures infrared sensing components and electro-optical systems used in weather satellites and other advanced systems.

Typically, an engineer who is working on a system comes to Weinberg's department to request photographic assistance, such as seeing a particular component in an extreme enlargement or examining its reaction under stress. The camera is the last thing Weinberg brings out because first he has to understand exactly what the engineer needs. Only then can he devise a way to record that information photographically.

Among the techniques at Weinberg's command is photography using infrared and ultraviolet radiation. For example, you can detect hairline cracks too small to be seen even with a microscope if you immerse an object in fluorescent dye, wash off the dye, and then expose the object to ultraviolet radiation. Dye will seep into cracks or other faults and fluoresce under ultraviolet radiation to reveal any damage on film. Critical examination of this kind is vital for certain satellite components in which even the slightest defect can disrupt functioning.

Weinberg also makes high-speed still photographs (to stop motion) and highspeed motion pictures (to slow down motion). One satellite component oscillates at a very high speed and in space is subjected to rapid temperature changes from extremely hot to extremely cold. Weinberg made highspeed motion pictures at various temperatures to test how the component would perform in space. If you project movie film slower than the rate at which you expose it, any motion on the film will appear slower than normal. The normal projection rate for 35mm film is 24 frames per second; Weinberg has shot film as fast as 5,000 frames per second for such tests, and even faster speeds are possible.

Weinberg frequently makes photomacrographs (greatly enlarged photographs made with a camera lens) and photomicrographs (even greater enlargements made with a microscope). Scanning electron microscopes are available for extreme enlargements, as much as $300,000 \times$ life size.

Weinberg goes to the component if the component cannot come to him. One satellite had a problem deep in its core, and to photograph it he had to work inside the clean room in which the satellite was being assembled. After donning clean-room garb, including a jumpsuit that covered him from head to toe, he and his equipment were vacuumed off for dust. He was scanned with ultraviolet light, being checked for even the smallest dust particle, and then particle counters within the room kept further tabs on the cleanliness of the operation.

In high school, Weinberg became fascinated with photography the first time he saw a black-and-white image come up on a piece of printing paper. A broad technical training in photography gave him the background he needed for his job. He is pleased to have a job that pays him to do exactly what he likes to do-take more pictures. His advice to any photography student: "Shoot pictures—as many as you can. To be really good you have to have a lot of experience, about 50,000 pictures' worth. It is important to have the pride in your work that makes you try to do better every time."

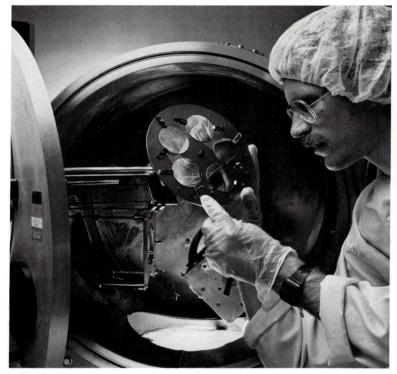

MATT WEINBERG: Engineer Loading Vacuum Chamber, 1983

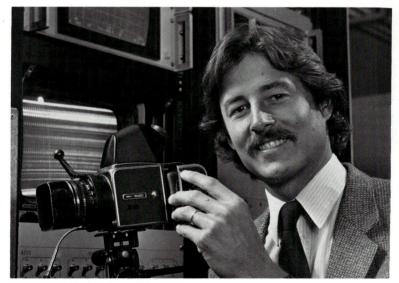

DOUG STELCK: Matt Weinberg at Work, 1984

MATT WEINBERG: Disc with Scratch-Resistant Coating, 1983

In an experiment to develop a scratch-resistant material for high-tech applications, an engineer (opposite page, top) loads five sapphire discs into a holder prior to putting them into a vacuum chamber where they will be coated with a diamondlike carbon substance. The coated disc has a mirrorlike surface that appears very smooth (this page, left). Extreme magnification lets engineers study the textured surface of the coating (this page, right) and any flaws (arrow).

Surface of disc magnified 50 \times

Surface of disc magnified 200 imes

Newspaper Photography: Lois Bernstein

At the age of 24 and just two weeks into her job as intern photographer for the Norfolk Virginian-Pilot/Ledger-Star newspapers, Lois Bernstein stumbled onto a photograph that got her more attention than she expected or, at times, wanted (this page, top). The picture made the front page of her own newspaper and was featured in Life magazine and numerous other publications, but it also generated considerable discussion as to whether or not it invaded the privacy of the people in it. Donald G. Naden, one of the editors at Bernstein's newspaper, was among those responsible for the final decision to publish it. "News is the unexpected," he says, "the unusual, the important, a moment of life most of us don't experience." Bernstein's job is to try to photograph that every day.

Lois Bernstein has been taking pictures since the first grade — a lot of pictures. When one of her brothers or sisters would shoot a whole roll of film on a family trip, Lois would shoot 12 rolls. As a high-school senior, she knew she was going to college but could not decide what to take. When someone suggested photography, it was a revelation: "Do something for your job that you like!"

She graduated from a college photo program, then freelanced for several newspapers. After about a year she decided that although her pictures were technically acceptable, something was missing. In the master's program in photojournalism at Ohio University she learned what was missing - how to tell a story. "I had spent a whole day photographing a women's professional football team. When I showed my pictures to one of the instructors, he commented that you can't tell that these are women. There were no pictures that said these are women football players. I went back to their next game and shot a really nice little story about them. Looking at the difference between my first shoot and the second one was when I realized what a story is and how to tell it in pictures." After graduation, the Norfolk papers offered her an internship and then a staff job.

Bernstein, like most newspaper photographers, gets a variety of assignments. Spot news is something that happens unexpectedly, like an accident (*this page, top*). General news is something for which you can plan ahead, like the Navy homecoming (*opposite*). With either type of news photograph Bernstein says, "You are not manipulating the event, but you have to see what is around you, what the story is about, and how to show it."

She also is given illustration assignments, which are pictures to accompany articles on food, fashion, health, or similar subjects. For example, for a food article on pearl onions she made a "fashion" picture of the onions strung into a necklace as if they were pearls. When she covers a sports event, she likes reaction pictures even better than general action ones. "I love faces," she says. It is fortunate that she does, because newspaper photographers frequently make portraits. "Often you are doing a story on something after the fact," she says, "like someone who won the lottery and gave all his money away. You have to find some way to make an interesting picture of them." And when there is nothing else to do, she goes cruising, looking for feature pictures or "enterprises," as they are sometimes called, pictures that stand alone and are not hooked to any particular story.

Bernstein now works at the Sacramento (California) Bee, a paper that commits considerable time and resources to news photography. There is a lot of important news happening, she says — and she wants to be part of it.

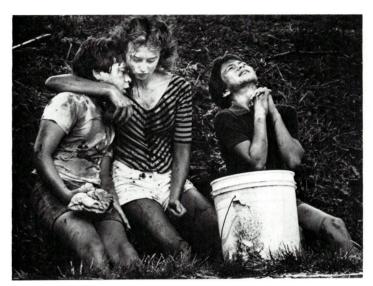

LOIS BERNSTEIN: Roadside Prayer for a Friend, Chesapeake, Virginia, 1985

Lois Bernstein was on her way to an assignment when she saw people gathered at an auto accident. "I saw these three kids sitting by the road, made several pictures, then saw the boy raise his hands in prayer. I knew it was the best news picture I had ever shot." It is not up to her to decide whether or not to publish such a picture; that is the job of her newspaper's editors. The photograph has received blame as an unnecessary intrusion into what is already a traumatic situation for the accident victims. And it has received praise, including several awards, as a moving record of a dramatic human event.

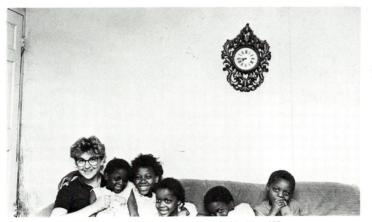

SHERITA HAIRSTON: Lois Bernstein and Friends, Norfolk, Virginia, 1987

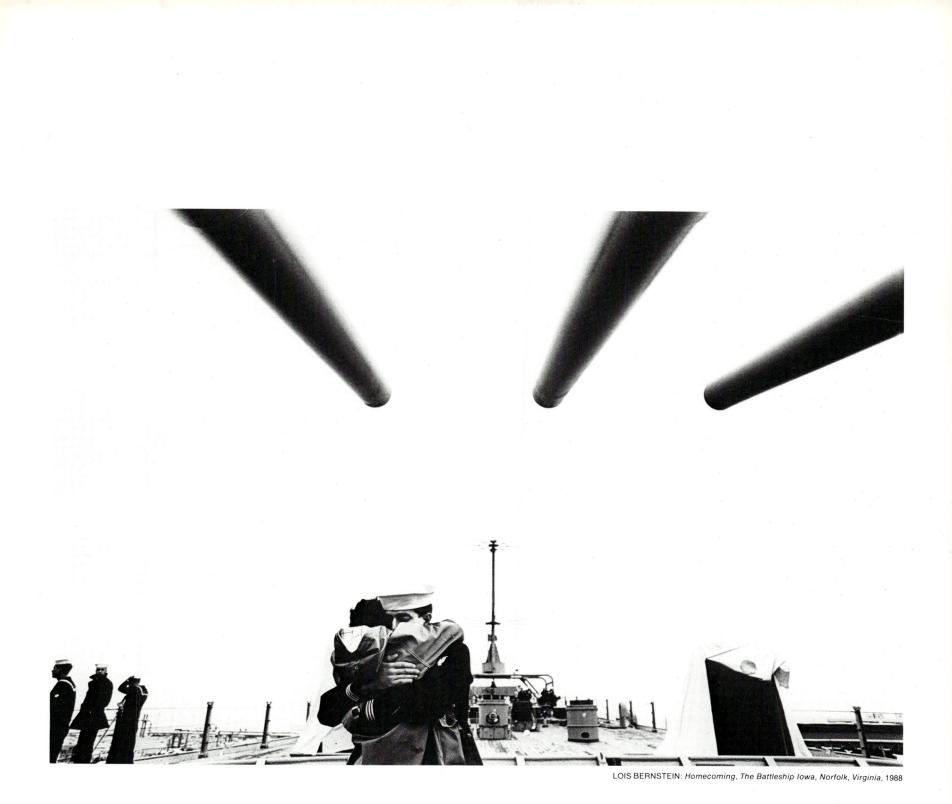

When the battleship lowa returned to its home base in Norfolk harbor after a six-month cruise, Lois Bernstein was there to cover the reunion of sailors and their families. She had already shot people on the dock waving flags and waiting for the ship, and she knew she had at least one good picture. That removed some pressure, so she was able to look around for something different. When she saw a couple hugging by the guns, she ran into position to get both people and guns, dropping to her knees as low as she could to show the guns looming overhead. What Bernstein would never do is arrange such a picture. "I never set up a news picture, even though some other photographers do so all the time. I'd never say, 'This could be a good location. Let me get a couple to hug here.' I am known for not doing that — which is good, because it means no one questions the integrity of my pictures."

Sports Photography: Walter looss, Jr.

Don't be surprised if Walter looss comes up to you at your next baseball game and offers to exchange his pass to the press box for your seat. He does this from time to time because the press box is the last place he likes to sit that's where all the other photographers are.

looss looks for something to make his sports photographs more than simple action shots. Maybe it is the graphic interest of an unusual point of view (photo opposite). Maybe it is human interest (this page, top). Maybe it is an interesting background against which, if he is lucky, some action will happen or against which he can position a player. He has been willing to gamble a whole game on that, waiting in a particular spot for the action to move to just the place he wants. He often goes to a stadium the day before a game to see where the light is best or what setting might be good. "I really enjoy going to places that photographers have been to time and again - and finding a picture that no one has taken before.'

Many sports photographers stay in predictable positions because they know they will get at least something from there: at a basketball game they stay right under the basket or just to one side of it; at a baseball game they keep to the first-base or third-base lines. looss prefers to take the chance he will find something even better elsewhere. "I have always been interested in what goes on at a sport's perimeters - the sidelines, a vendor, the fans not just a guy sliding into third base." If he is going to be with a team for several days, he likes to move in gradually. He talks to a few players, tells them what he's doing so the word filters around. Professional sports figures are used to photographers, but they still may need to loosen up and relax, especially if you are trying to pose them. "The first roll or two may not be very good until they feel comfortable with you."

As a boy, looss went to baseball games with his father, who was a photography hobbyist. His father often made pictures from the stands, and when looss was 15 he used his father's camera to shoot his first roll of film. "We processed it, and that was the end of his camera. It was mine." looss began photographing his friends playing ball; even as a beginner he intuitively went for the look of the picture, not just the action. He spent the next summer learning fundamentals at a photography school. That was a major commitment for him: "At the time, I loved baseball more than anything on earth. I gave up playing stickball for the whole summer to go to that school." Sports Illustrated published one of his photographs soon after, and he has been making sports pictures ever since. He has been a regular contributor to magazines for many years and now does sports-based advertising work as well.

looss says that you don't have to go to professional games to make great sports pictures. "Go to a kids' football game. It's late in the afternoon, the light is terrific, you have kids crying, screaming, sweating — and their parents doing the same. It's better than professional football." Spring training in baseball is another good time to photograph. It is open to anybody, and you often have opportunities there to be with the players.

His advice if you are interested in sports photography: "You have to shoot constantly. If you look at top performers — athletes or photographers — they do what they do all the time. I'm always working, shooting, thinking pictures. If you are really interested in doing well at anything, you have to give yourself to it."

WALTER IOOSS, JR.: After the Game, 1980

Human interest (above) and graphic interest (opposite) are both part of what makes sports photography interesting to Walter looss, Jr.

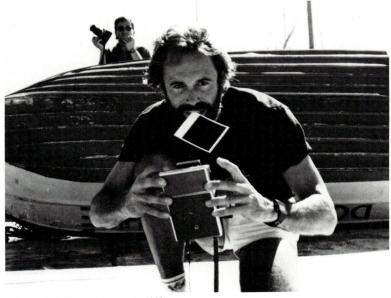

DAN JENKINS, JR.: Walter looss, Jr., 1985

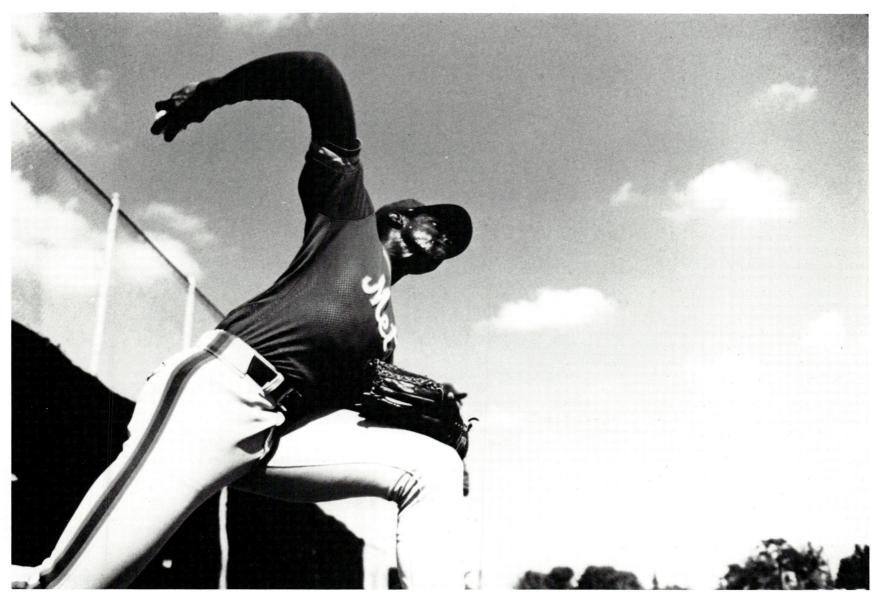

Walter looss calls his 35mm high-speed camera his "ace piece of equipment." At 14 frames per second, it give him an edge in getting what he wants with fast action. This picture was taken at spring training warm-up, a time when photograWALTER IOOSS, JR.: Dwight Gooden's Fast Ball, 1986

phers can get close to the players. He talked to the coach, talked to the player, and persuaded them to let him lie on the ground right next to the pitcher. He shot 14 frames per second at 1/2000 second shutter speed. "I wanted him frozen."

Showing Your Work to Editors and Others

Suppose you decide to show your work to an editor, agency, potential client, gallery, or museum. What kind of work should you show? Editors, agents, and clients are looking for specific types of work, and you should tailor your portfolio to show them pictures they can use. Gallery and museum people, on the other hand, want to see your personal point of view. All of them give the same advice: Don't pad your portfolio. Putting mediocre pictures in with good ones produces a mediocre portfolio.

Sean Callahan, Founding Editor (1978– 1988), American Photographer. "Photographers often ask me," Callahan says, "what I am looking for. My stock answer is 'I don't know, but I know what I'm not looking for—something that I've seen before.' "

American Photographer runs portfolios by individual photographers, especially those who have made a name in fashion, advertising, photojournalism, and fine-art photography. Many portfolios are submitted to the magazine, and the editors look at all of them, although they seldom have time to meet with the photographers who bring them. Callahan cautions that editors at any magazine often remember bad photographs more than good ones and may judge a portfolio accordingly. "Editors deal with a lot of good photographers," he says, "and they expect work to be good." If a photographer has ten strong pictures, then puts in ten lesser ones to make a portfolio look bigger, the result can be to create doubt in the editor's mind about the photographer's work overall.

Callahan reports a phenomenon often seen by magazine editors. "If I ran a water-skiing article, the following month people would send me waterskiing pictures, exactly what I didn't need." He advises photographers to "do your homework." Study the magazines you are interested in, then supply them with something you think they could actually use.

Bob Lynn, Graphics Director, The Virginian-Pilot and The Ledger-Star, Norfolk, Virginia. Lynn (above, right) is in charge of photography and graphics for all editions of these newspapers. When he opens a portfolio, he hopes he will find surprises, not clichés or even good but standard imagery. "I want someone who can see ordinary events in a different way or who can capture ironies in human behavior that others don't see." He suggests that photographers show only work of which they are especially proud. People often try to prove to him that they can shoot sports, spot news, general features, and every other photojournalism category, and as a result they include lesser pictures. When they do, he wonders if they can tell good work from bad. "If you don't have it, don't show it."

Brigitte Barkley, Foreign Correspondent, Geo. Geo. a German magazine, publishes illustrated articles about new developments or life styles in countries around the world, new discoveries in the sciences, and adventurous, unusual, or exotic happenings. Geo maintains an office in New York, where Barkley's job is to screen material before submitting it to the main office in Hamburg. She wants to see photojournalism, not travel pictures, and she wants a story, not individual photographs. "I want to see how you visually tell a story with a well-defined focusthat you are a photojournalist, not just a picture shooter." Too many photographers say they can do a story but don't show her any examples. "The best find something that interests them and then submit at least the beginning of a good story."

John Hair, Art Director, Pan Am Clipper. This monthly magazine is the one you find on the airplane in the pocket of the seat in front of yours. Hair is looking for evocative photographs that capture the essence of a place without looking like a postcard or snapshot view. He wants variety in a story, everything from a shot that conveys the overall feeling of a city to a close-up of the local food. Rather than a straightforward story on a place, he wants some kind of a tie-in or concept; for example, an exotic railroad trip that you get to via Pan Am.

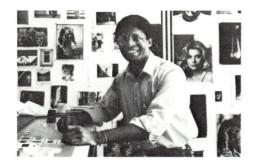

Mel Scott, Freelance Picture Editor, Formerly an Assistant Picture Editor at Life magazine, Scott now works on a variety of picture-editing assignments. "Never," Scott advises, "pad a portfolio. Show your absolute best, not your whole life's work. Don't show one great landscape with ten mediocre ones; the bad ones will only dilute the impact of the great one." He says that photographers should show the kinds of pictures the magazine uses. For example, Life is now a monthly magazine that publishes very little news, so there is no point in showing them news pictures. Professionalism is important; editors' days are tightly scheduled, so arrive on time if you are given an appointment.

Scott files a 3 \times 5 card for every photographer he sees and then uses that file as a source of names when looking for a photographer. Picture editors often pass names on to each other, so he says not to be discouraged if no work comes right away.

Jennifer B. Coley, Director, Gamma-Liaison. This picture agency handles three types of work: corporate and business, entertainment, and news features -each of which tends to attract a different type of photographer. Corporate and business photographs might be used in a company brochure or a business magazine, like Fortune. A photographer has to know how to set up single shots, such as a portrait of a company executive or a factory interior. An entertainment photographer also sets up single shots, but with a different awareness of how to deal with the subject. "You don't tell the head of IBM that he's looking great," Coley says, "but you would say that to Jane Fonda." A feature photographer has to be able to tell a story and create a sequence of pictures, not just one good shot. Coley needs to know what a photographer wants to do and then see evidence that he or she can do it. A corporate or entertainment photographer should supply 20 great photos; a feature photographer should show an extended story.

Coley hopes for work that will surprise her, either in subject matter or execution. "I have seen so many photographs that I see mediocrity instantly and pass it by. I see the unique instantly, too." The biggest mistake photographers make, she says, is to wait for other people to tell them what to do. "If you want to do something, go for it. I have seen many photographers improve their work because they have persisted. If you want something enough, you get it."

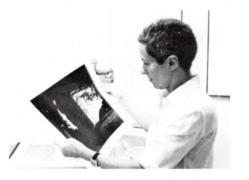

Evelyne Daitz, The Witkin Gallery. This long-established New York gallery deals in photography as an art form, with an emphasis on conservative work: "straight" landscapes, still lifes, portraits, and pictures of the human condition. Daitz gets so many requests to look at work that she now looks at portfolios only by photographers who are recommended to her by someone she knows, such as another photographer or curator. Once you get an appointment, however, Daitz, unlike many others, meets with you personally.

Daitz is looking for individual and creative work, not work that is cloned from some other source. She sees many young photographers whose work still shows the influence of their teachers or other photographers. "You must keep working on your own viewpoint. Don't let success or failure influence you. It's your own sense of creativity that is most important." She wants to see "fine" prints, that is, ones with the highest quality printing and presentation. She advises photographers to show their work to as many people as possible; many photographers need outside opinions to help them see their work objectively.

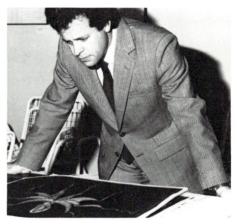

Arthur Ollman, Executive Director, Museum of Photographic Arts, San Diego. Showing your work to a museum (and many galleries) almost always involves a drop-off. You bring or mail your portfolio to the museum, then get it back in a day or two, usually without any personal comment. The experience may feel cold, but, says Ollman, the problem is time. He receives about 40 portfolios a month and looks at all of them. He doesn't have the time to meet with each photographer, nor does he feel it is his job to critique work. He does include a standard thank-you letter when he returns a portfolio; some museums don't do that much.

Ollman looks for a distinctive body of work that focuses on some idea with intensity. He feels many photographers show work without having first employed much self-criticism. Museum and gallery people are thoroughly familiar with the history of photography. "It's not enough to show work that looks like Ansel Adams's. You have to produce your own ideas." He advises photographers to show only their best, and not to get discouraged. "I'm only one person, and if I don't like it, I could be wrong."

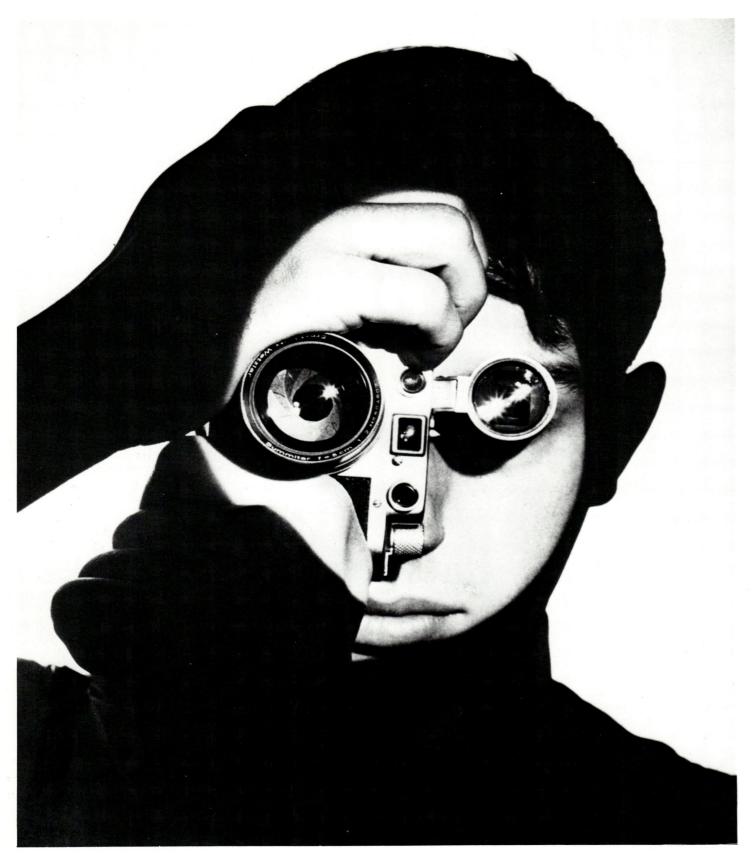

ANDREAS FEININGER: *Photojournalist*, 1955 30

2 Camera

The Anatomy of a Camera 32 The Major Types of Cameras 34 View Camera 34 Rangefinder/Viewfinder Cameras 35 Reflex Cameras 36 Focusing Systems 38 The Shutter as a Controller of Light 40 The Shutter as a Controller of Motion 42 The Aperture as a Controller of Jepth 44 The Aperture as a Controller of Depth of Field 46 Using Shutter and Aperture Together 48 Keeping the Camera Steady 50 Choosing a Camera 52

Why do you need to know how a camera works? Much of modern camera design is based on one of the earliest camera slogans—"You press the button, we do the rest." Automatic-exposure cameras set the shutter speed or aperture for you. Automatic-focus cameras adjust the lens focus. Automatic features such as these are increasingly built into the most popular of cameras—those that use 35mm film. However, no matter what technological improvements are claimed to make a camera "foolproof" or "easy to use," there are still choices to make at the moment a picture is taken. If you don't make the choices, the camera does, based on what the manufacturer calculates will produce the best results for an average scene. But the results may not be what you want. Do you want to freeze the motion of a speeding car or let it race by in a blur? Bring the whole forest into sharp focus or isolate a single flower? Only you can make these decisions, and the more pictures you take, the more you will want to decide deliberately rather than leave it all to the camera.

Automatic features can be useful, but if you are learning photography, many instructors recommend using manual operation at first. Many professional photographers still use the completely nonautomatic camera that has served them well for years. If you do have a camera with automatic features, this book tells not just what those features do, but even more important, when and how to override an automatic mechanism and make the basic choices for yourself. (See in particular Automatic Focus, page 76, and Automatic Exposure, page 113.) The time you spend learning what camera equipment can do and how to control its effects will be more than repaid whether you make a snapshot, a portrait, a commercial illustration, a news photograph, a personal statement about the world, or any other kind of photograph.

One of the great technical experts of photography, Andreas Feininger has written many books on the subject. Opposite, he completely merges a photographer and his camera. Notice how the dark shadows isolate and emphasize the important part of the picture. "Making a good photograph requires genuine interest in the subject," he said. "Without it, making a photograph sinks to the level of boring routine."

The Anatomy of a Camera

All **cameras** are basically alike. Each is a box with a piece of film in one end and a hole in the other. The hole is there so that light can enter the box, strike the light-sensitive surface of the film, and make a picture. Every camera from the most primitive to the most sophisticated works this way. The job is always the same: to get light onto film to form an image. The differences are in how this is done. The basic parts of any camera are shown on this page. The effects that the most important camera controls can have on a photograph are shown opposite.

There are so many different kinds of cameras because they are asked to do many different things under such a wide variety of conditions that they have become specialized. While a bulky view camera is ideal for taking architectural photographs, it is not as good as a smaller camera for taking unposed pictures of people on a crowded street. All cameras fit into one of four main categories according to the viewing system they use. Cameras with viewfinders and small single-lens reflex cameras are generally used at eye level; you put them up to your eye and use them as a direct extension of your vision into the scene in front of you. Viewing with the somewhat larger twin-lens reflex camera is usually done by looking down onto a ground-glass screen. You also look at a ground glass with the largest camera, the view camera, which provides the most precise-and the slowest-viewing and composition.

The next few pages describe these four types of cameras in more detail. Understanding how they work will help you decide which type is best for you.

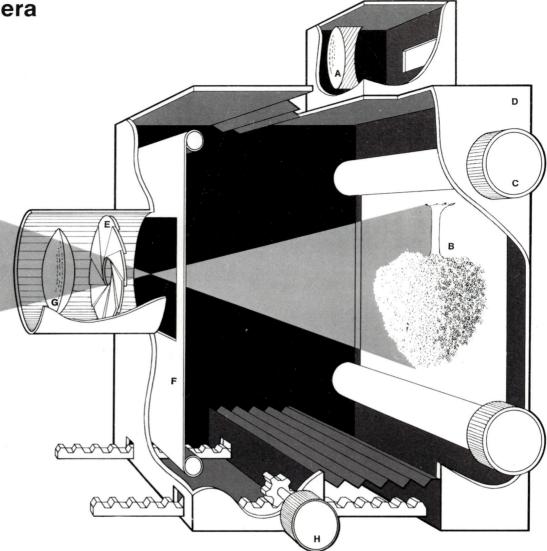

Basic camera parts

- A | The viewing system lets you aim the camera accurately. It shows the scene through the picture-taking lens or through a separate opening (as illustrated here).
- **B** | **The film** records the scene on its light-sensitive surface.
- C | The film advance winds into place a fresh section of a roll of film after a picture is taken. In cameras that use sheets of film, the sheets are put into film holders, which are then inserted in the camera one at a time.
- D | The camera body houses the various parts of the camera and protects the film from light except that which enters through the lens when a picture is taken.
- E | The diaphragm, a circle of overlapping metal leaves, forms an adjustable hole, or aperture. It

can be widened to let more light pass through the lens or partially closed—stopped down—to let through less light.

- F | The shutter keeps light from the film until you are ready to take a picture. Pressing the shutter-release button opens and closes the shutter to let in a measured amount of light. The shutter mechanism is shown here schematically as a simple opening in a curtain.
- **G** | **The lens** focuses the light rays from a subject into a reversed, upside-down image on the film at the back of the camera.
- H | The focusing control moves the lens or parts of it forward or back to create a sharp image of objects at various distances. The system shown here shifts the whole camera front; more commonly the lens alone moves by turning like a screw.

The focusing control adjusts the lens so that a given part of the scene is as sharp as possible. In the camera's viewfinder you see the scene that will be recorded on the film and that part of the scene that is focused most sharply. More about focus on pages 70-71 and 76-77. Many viewfinders also display exposure information, here the shutter speed and aperture. See pages 40-41 and 44-45 for details on how the shutter speed and aperture affect exposure.

The shutter-speed selector controls the length of time that the shutter remains open. The shorter that time is, the less likely a moving object will appear blurred. See pages 42-43 for more about shutter speed, motion, and blur.

The aperture selector adjusts the size of the lens opening, the diaphragm. The smaller the aperture opening, the greater the depth of field (the more of the scene from near to far that will be sharp). More about aperture and depth of field on pages 46-47 and 70-73.

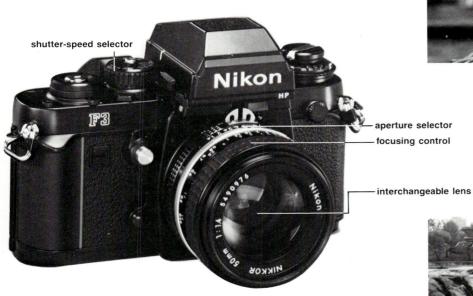

Interchangeable lenses let you select the lens focal length, which controls the size of objects in the picture and the extent of the scene recorded on the film. See pages 60-61 for information about lens focal length.

A 35mm single-lens reflex camera and (shown clockwise from top left) how it can control focus, the representation of motion, depth of field (sharpness from near to far), and the size of an object. On some cameras, push-button controls and digital readout replace the numbered dials and rings that this model has.

The Major Types of Cameras

View Camera

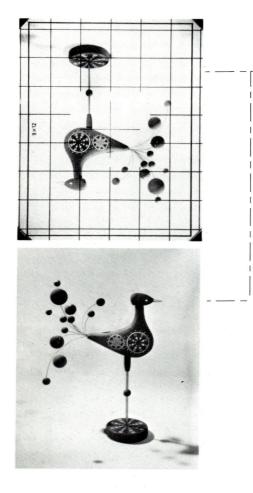

One of the oldest basic designs for a camera—direct, through-the-lens viewing and a large image on a translucent viewing screen—is still in use today. A **view camera** is built somewhat like an accordion, with a lens at the front, a **ground-glass** viewing screen at the back, and a flexible **bellows** in between. You focus by moving the lens, the back, or the entire camera forward or back until you see a sharp image on the ground glass.

Advantages of the view camera: The image on the ground glass is projected

In a view camera, the light comes directly from the subject, through the lens, and falls on a ground-glass viewing screen (a) at the back of the camera. The image that the photographer sees comes directly from the lens, so it is reversed and upside down, as the upper bird photo shows. Otherwise it is identical to what will appear on the film (lower photo). As an aid in composing pictures, the ground glass of this camera is etched with a square grid of hairlines.

by the picture-taking lens, so what you see is exactly what will be on the negative; there can be no parallax error (as in a rangefinder camera, *opposite*). The ground glass is large, and you can examine it with a magnifying glass to check sharpness in all parts of the picture. The film size is also large (4×5 , 5×7 , 8×10 inches or larger), which produces sharp detail. The camera parts are adjustable, and you can change the position of lens and film relative to each other so that you can correct problems of focus or distortion.

Each picture is exposed on a separate piece of film, so you can give negatives individual development.

Disadvantages: The most serious are the bulk and weight of the camera and the necessity of using a tripod. Second, the image projected on the ground glass is not very bright, and to see it clearly you must put a **focusing cloth** over both your head and the back of the camera. Finally, the image appears reversed and upside down on the viewing screen. You get used to this, but it is disconcerting at first.

Rangefinder/Viewfinder Cameras

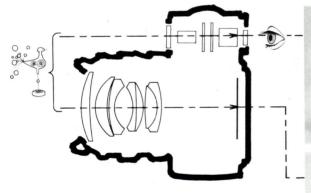

parallax

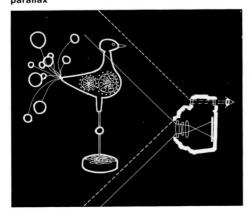

In a rangefinder or viewfinder camera, the image goes from the lens to the film but through a separate viewfinder to the eye (diagram, above left). The difference between these two viewpoints creates parallax. When the viewfinder shows the whole bird (broken lines in diagram, bottom left), the lens may not (solid lines); here, the bird's head will be out of the picture. Better models correct for parallax (photos above), except for subjects that are very near.

In a **viewfinder camera** the scene to be photographed is viewed through a small window (the **viewfinder**) equipped with a simple lens system that shows an almost—but not quite—exact view of what the picture will be. Many inexpensive point-and-shoot cameras have a viewfinder plus automatic focus. A **rangefinder camera** has a viewfinder, plus a device called a **coupled rangefinder** (*page 39*) that lets you focus the camera manually instead of only relying on automatic focus. Most rangefinder and viewfinder cameras use 35mm film; a few use other film sizes.

Advantages of the rangefinder or viewfinder camera: The camera is compact, lightweight, and fast handling. Compared to a single-lens reflex camera, it has few parts that move during an exposure, so it tends to be quieter and, less subject to vibration during operation. A high-quality rangefinder camera has a bright viewfinder image, which makes it easy to focus quickly, particularly at low light levels where other viewing systems may be dim.

Disadvantages: Because the viewfinder is in a different position than the lens that exposes the negative, the camera suffers from an inherent defect called parallax (left) that prevents you from seeing exactly what the lens sees. The closer the subject to the camera, the more evident the parallax. A highguality camera like the one shown here automatically corrects for parallax except when the subject is within a few feet of the camera. Because complete correction is difficult at close range, sighting through the viewfinder is awkward for carefully composed close-up work. Even when the edges of the picture are fully corrected for parallax, the alignment of objects within the picture will always be seen from slightly different angles by the viewfinder and the lens that exposes the film.

Reflex Cameras

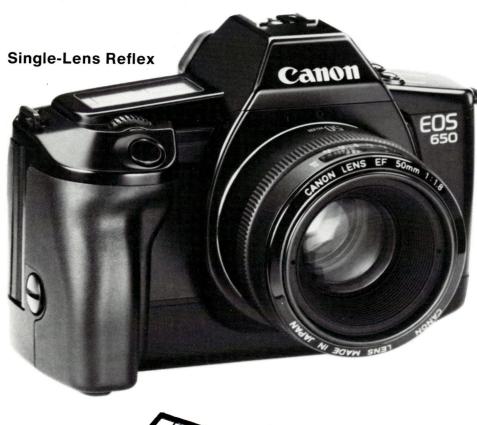

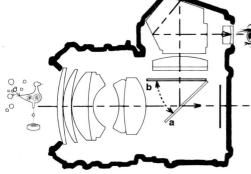

The viewing system of a single-lens reflex camera is built around a mirror (a). Light coming in through the camera lens is reflected by this mirror (hence the name, reflex) up to a viewing screen, then usually through a five-sided pentaprism that turns the inverted image around so it appears the correct way to the eye. When a picture is taken, the mirror swings up momentarily (b), permitting light to strike the film at the back of the camera. The image viewed through the lens with a pentaprism is virtually identical with the image produced on the film (bird pictures at right).

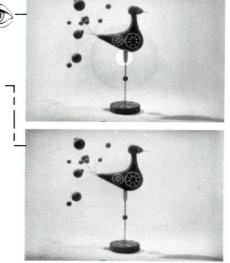

The best way to see what the camera sees is to look through the camera lens itself. This way you can frame the subject exactly and see how much of the scene, from foreground objects to distant background, will be sharp. You cannot evaluate the relative sharpness of objects at different distances with a rangefinder or viewfinder camera, because it shows you a sharp image of the entire scene, but you can with a singlelens reflex camera. This camera has a mirror and pentaprism (diagram, left) to let you use the lens for composing and focusing. Most such cameras take 35mm film, but medium-format sizes for 21/4-inch film are also popular.

Advantages of the single-lens reflex: It eliminates parallax and so is excellent for close-up work. It is easy to focus. Since the viewing system uses the camera lens itself, it works well with all lenses—from wide angle to supertelephoto; whatever the lens sees, you see. An exposure meter built into the camera is usually designed to measure the light passing through the lens, with the area being metered defined in the viewfinder. This means you can see the exact area the meter is reading.

Disadvantages: A single-lens reflex is heavier and larger than a rangefinder camera that uses the same size film. The camera is relatively complex, with more components that may need repair. Its moving mirror makes a comparatively loud click during exposure, especially in medium-format models; this is a drawback if you are stalking wild animals or self-conscious people. When the mirror moves up during exposure, it momentarily blacks out the viewing image, also a distraction in some situations. And the motion of the mirror and shutter may cause vibrations that make the camera more difficult to hold steady at slow shutter speeds, although better models all but eliminate vibration.

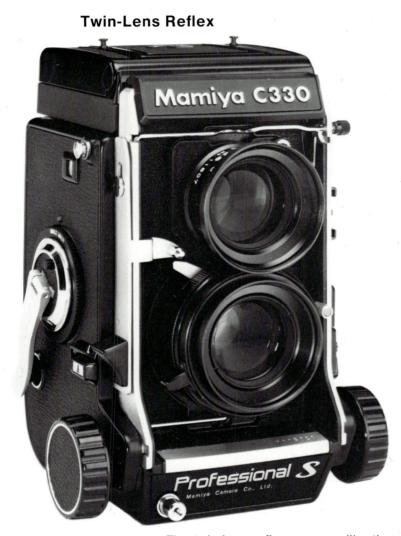

The **twin-lens reflex camera**, like the single-lens reflex camera, uses a mirror that reflects an image of the scene upward onto a viewing screen. But its mirror is fixed, and there is one lens to expose the film and another one for viewing. The lenses are coupled mechanically so that when one is focused sharply, the other is also.

A twin-lens reflex camera combines characteristics of the larger view camera and the smaller rangefinder camera. Advantages of the twin-lens reflex: A twin-lens reflex has separate viewing and pic-

A twin-lens reflex has separate viewing and picture-taking lenses stacked one over the other. The lower lens conducts light to the film. The upper one, coupled to the lower for focusing, conducts light to a mirror (a) set at a 45° angle, where it is reflected upward to a ground-glass viewing screen (b). Like all mirror reflections, the image appears reversed left to right, as shown in the top photo. The top photo also shows a grid of hairlines, etched on the viewing screen, that can be used to align elements in the scene.

The fixed mirror means simple, rugged construction and quiet operation, and the relatively large ground glass makes viewing easy. Because you usually look into this camera from the top, you can lower it to waist level or even place it on the ground for photographing from a low angle, an awkward position for an eye-level viewfinder. The camera gives you a medium-format film size for a relatively low price.

Disadvantages: The principal problem is parallax—the viewing lens does

not see exactly the same picture as the taking lens. Some twin-lens reflexes have automatic parallax correction, but not for objects at very close range and not for the alignment of objects within the picture. The image projected on the viewing screen is reversed left to right, which can make it difficult to follow moving objects. The larger size of the twin-lens reflex makes the camera somewhat cumbersome, and it is awkward to use at eye level. Lenses are not interchangeable on all models.

Focusing Systems

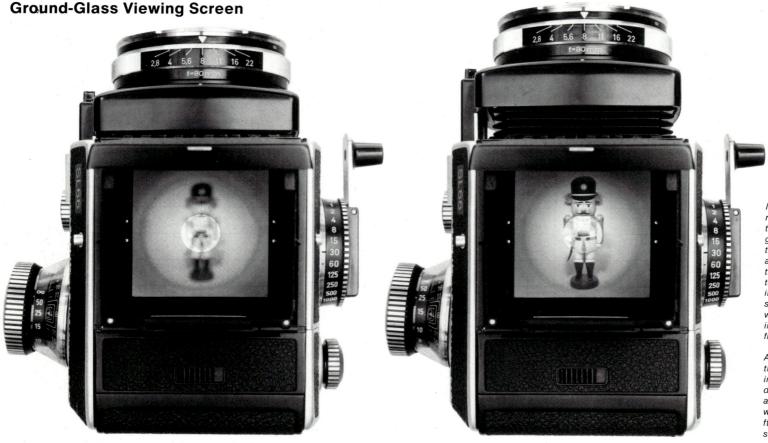

All cameras with adjustable focus have some means of showing you when you have focused a subject sharply. A ground-glass viewing screen is found on single-lens reflex, twin-lens reflex, and view cameras. Light from the camera lens hits a pane of glass that is etched, or ground, to be translucent. This ground glass creates a surface on which a viewer, looking at it from the other side, can see an image (above) and focus it. The image on a ground glass is not as bright as that in a viewfinder; in dim light you may not be able to see readily whether the image is sharp.

A coupled rangefinder (opposite)

may be easier to use in dim light because you only have to line up a double image, or two parts of a split image. The focusing mechanism of the lens is coupled with the rangefinder so that they focus at the same time.

Don't confuse the function of a rangefinder with that of a viewfinder. The viewfinder shows the view the camera will take. The rangefinder (usually built into the viewfinder) finds the range or distance of an object and shows when it is sharply focused.

A **microprism** focusing aid may accompany a ground-glass or split image, especially on a single-lens reflex camera. A central spot or collar around the

split image shimmers or appears broken when the subject is unfocused.

With **automatic focus**, found on many point-and-shoot cameras and increasingly on single-lens reflex cameras, you don't turn a focusing knob or ring to adjust the lens yourself. Instead, pressing down on the shutter-release button causes the camera to focus the lens sharply on whatever object is at the center of the viewfinder image. A focus confirmation symbol usually appears in the viewfinder when focus is set. Some cameras also beep to let you know when focus is found. In this reflex camera a mirror reflects the image from the lens upward onto a ground-glass screen. Since the ground glass at the top and the film at the back of the camera are the same distance from the lens, the image that falls on the screen will be sharp only when the lens is also focusing the image sharply on the film plane.

At left, the focusing knob on the left side of the camera is incorrectly set at 25 ft, producing an unclear image of a toy soldier 15 ft away. But when the knob is set for 15 ft (right), the image is more sharply defined.

Coupled Rangefinder

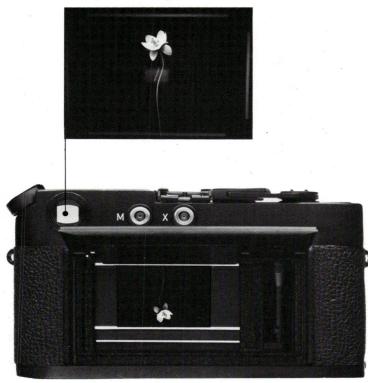

A rangefinder operates by superimposing two images of the same subject as seen from different angles (diagram, below). One image passes through a viewfinder (on the left side of the camera shown here); the other image is reflected by a rotating prism (right side of camera) and is superimposed on the viewfinder image. The movement of the prism is mechanically linked to the focusing movement of the lens. If the subject is not in focus, the viewfinder will show a split image; part of the flower stem will be to the left of where it belongs (top photograph). This happens because that part has been deflected by the rotating prism.

When the image is sharply focused, the rotating prism is turned to the correct angle to superimpose its image directly over the viewfinder image so that the two images appear to be one. As with other cameras, the subject-to-camera distance is indicated in feet or meters on a band on the lens barrel so that the lens can also be focused by measuring the distance from subject to camera and then turning the lens to the appropriate distance.

The Shutter as a Controller of Light

To expose film correctly, so that your picture is neither too light nor too dark, you need to control the amount of light that reaches the film. Two controls do this: the shutter, described here, and the aperture (*pages 44–45*).

The shutter controls the amount of light by the length of time it remains open. Each shutter setting is half (or double) that of the next one and is marked as the denominator (bottom part) of the fraction of a second that the shutter remains open: 1 (1/1 or one second), 2 ($\frac{1}{2}$ second), 4 ($\frac{1}{4}$ second), and so on through 8, 15, 30, 60, 125, 250, 500, and on some cameras 1000, 2000, and 4000. You may find a different sequence on older equipment: 1, 2, 5, 10, 25, 50, 100, 200. B or bulb setting keeps the shutter open as long as the release button is held down. T or time setting opens the shutter with one press of the release, closes it with another. Electronically controlled shutters can also operate at any speed, for example, 1/38 second. These stepless speeds are set by the camera in automatic exposure operation; you usually can't dial them in yourself.

A leaf or between-the-lens shutter is generally located in the lens itself (a). It consists of a number of small overlapping metal blades powered by a spring. When the shutter release is pushed, the tension on the spring is released and the blades open up and then shut again in a given amount of time. In the examples at right, the blades are just beginning to swing open at (1) and very little light is hitting the film. At (2), with the shutter open farther, the blades are almost completely withdrawn, and at (3) light pours in. Then the blades begin to close again, admitting less and less light (4, 5). The total amount of light admitted during this cycle produces the fully exposed photograph (6). Leaf Shutter

3

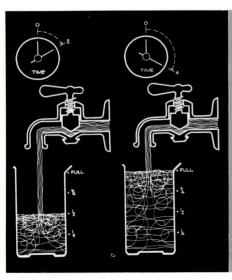

The amount of light that enters a camera, like the amount of water that pours from an open faucet into a glass, depends on how long the flow of light continues. If a glass is filled halfway in 2 sec, it will be filled to the top in 4 sec. In the same way, if the shutter is left open twice as long, the film will be exposed to twice as much light.

There are two principal types of shutters: the leaf shutter (opposite) and the focal-plane shutter (this page). A focalplane shutter is built into the camera body itself-just in front of the film, or focal, plane-while a leaf shutter is usually located between the lens elements. Interchangeable lenses for a camera with a focal-plane shutter can be less expensive, since a shutter mechanism does not have to be built into each lens. One drawback to the focal-plane shutter on some cameras is that it cannot be used with electronic flash at very fast shutter speeds. The maximum speed with flash with a 35mm camera may be as slow as 1/60 second, up to 1/250 second with some models. At faster shutter speeds the slit in the focal-plane shutter does not completely uncover the film at any one time; before the first part of the shutter is fully open, the second part starts to close (right). Also, since the slit exposes one end of the film frame before the other, objects moving rapidly parallel to the shutter may be distorted; this is rare, but it can happen.

A **leaf shutter** is quieter than a focalplane shutter and can be used with flash at any shutter speed. But since the leaf shutter has to open, stop, and then reverse direction to close again, most have top speeds of 1/500 second. The focal-plane shutter has a simpler mechanism that moves in one direction and permits speeds of up to 1/4000 second.

Focal-Plane Shutter

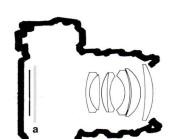

The focal-plane shutter is located directly in front of the film (a). The shutter consists of two overlapping curtains that form an adjustable slit or window. When the shutter is released, the window moves across the film, exposing the film as it moves. The series at left shows how the film is exposed at fast shutter speeds. The slit is narrow and exposes only part of the film at any one time. Picture (6), below, shows the effect of the entire exposure, with all sections of the film having received the proper amount of light. At slow shutter speeds, one edge of the slit travels across the film until the film is completely uncovered; then the other edge of the slit travels in the same direction, re-covering the film. The shutter shown here moves from side to side across the length of the film. The Copal Square type of focal-plane shutter moves from top to bottom across the film.

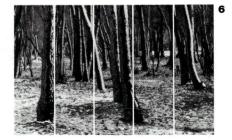

The Shutter: continued

The Shutter as a Controller of Motion

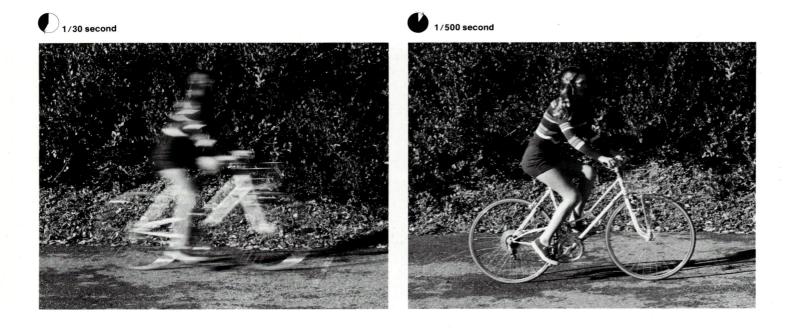

A blurred image can occur when an object moves in front of a camera that is not moving, because the image projected onto the film by the lens will move. If the object moves swiftly or if the shutter is open for a relatively long time, this moving image will blur and be indistinct. But if the shutter speed is increased, the blur can be reduced or eliminated. You can control this effect and even use it to advantage. A fast shutter speed can freeze a moving object, showing its position at any given instant, whether it be a bird in flight or a football player jumping for a pass. A slow shutter speed can be used deliberately to increase the blurring and accentuate the feeling of motion.

The effects of varying shutter speed and camera movement are shown above. In the picture at far left the bicycle moved enough during the relatively long 1/30-second exposure to leave a broad blur on the film. In the next photograph a shutter speed of 1/500 second stopped the motion so effectively it is hard to tell whether the bicycle was moving at all. A moving subject may vary in speed and thus affect the shutter speed needed to stop motion. For example, at the peak of a movement that reverses (such as the peak of a jump just before descent), motion slows, and even a relatively slow shutter speed will record the action sharply.

The amount of blurring in a photograph, however, is not determined simply by how fast the object itself moves. What matters is how far an image actually travels across the film during the exposure. In the third photograph, with the rider moving directly toward the camera, the bicycle remains in virtually the same position on the film. Thus, there is far less blurring even at 1/30 second. A slow-moving object close to the camera, such as a bicycle 10 feet away, will cross more of the film and appear to blur more than a fast-moving object far away, such as a jet in flight. A telephoto lens magnifies objects and makes them appear closer to the camera; it will blur a moving subject more than a normal lens used at the same distance.

The photograph at far right shows the effect of panning. The camera was moved in the same direction the bicycle was moving. Since the camera moved at about the same speed as the bicycle, the rider appears sharp while the motionless background appears blurred. Successful panning takes both practice and luck. Variables such as the exact speed and direction of the moving object make it difficult to predict exactly how fast to pan. Decide where you want the object to be at the moment of exposure, start moving the camera a few moments before the object reaches that point, and follow your motion through as you would with a golf or tennis stroke. The longer the focal length of the lens, the less you will need to pan the camera; with a telephoto lens, a very small amount of lens movement creates a great deal of movement of the picture image. (Focal length is explained on page 60.)

1/30 second, camera panned

direction the subject is moving

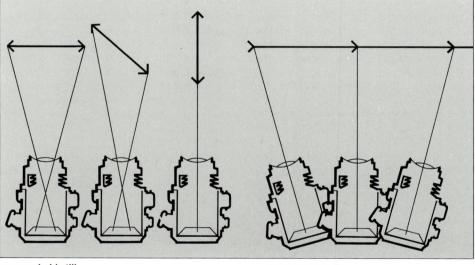

The diagram at left shows how the direction of a moving object affects the amount of blur that will result. When the object is traveling parallel to the plane of the film (first arrow), all the movement is recorded on the film. If it is moving at an angle to the film (second arrow), less sideways movement will be recorded and, as a result, less blur. When the object moves directly toward or away from the camera (third arrow), there is no sideways movement at all and hence a minimum of blur. When the camera is panned or moved in the same direction as the object (right arrows), the object will be sharp and the background blurred.

camera held still

camera panned

The Aperture as a Controller of Light

Changing the size of the **aperture**, the lens opening through which light enters the camera, can change the exposure, the amount of light that reaches the film. The shutter speed changes the length of time that light strikes the film; the aperture changes the brightness of the light.

The aperture works like the pupil of an eye; it can be enlarged or contracted to admit more light or less. In a camera this is done with a **diaphragm**, a ring of thin, overlapping metal leaves located inside the lens. The leaves are movable: they can be swung out of the way so that most of the light reaching the surface of the lens passes through. They can be closed so that the aperture becomes very small and allows little light to pass (*see opposite*).

The size of an aperture is indicated by its **f-number** or **f-stop**. On early cameras the aperture was adjusted by individual metal stop plates that had holes of different diameters. The term "stop" is still used to refer to the aperture size, and a lens is said to be "stopped down" when the size of the aperture is decreased.

The standardized series of numbers commonly used on the f-stop scale runs as follows: f/1.4, f/2, f/2.8, f/4, f/5.6, f/8, f/11, f/16, f/22, f/32, f/45, f/64. The largest of these, f/1.4, admits the most light. Each f-stop after that admits half the light of the previous one. A lens that is set at f/4 admits half as much light as one set at f/2.8 and only a quarter as much as one set at f/2. (Notice that fstops have the same half or double relationship that shutter-speed settings do.) The change in light over the full range of f-stops is large; a lens whose aperture is stopped down to f/64 admits less than 1/2000 of the light that comes through a lens set at f/1.4.

No lens is built to use the whole range of apertures. A general-purpose lens for a 35mm camera, for example, might run from f/1.4 to f/22. A camera lens designed for a large view camera might stop down to f/64 but open up only to f/5.6. The widest possible aperture at which a particular lens design will function well may not be a full stop from a standard setting. So a lens's f-stops may begin with a setting such as f/1.8, f/4.5, or f/7.7, then proceed in the standard sequence.

Lenses are often described as **fast** or **slow.** These terms refer to how wide the maximum aperture is. A lens that opens to f/1.4 opens wider and is said to be faster than one that opens only to f/2. (In the same way, the faucet on the left in the diagram below is said to be running faster than the faucet on the right.)

The term **stop** is used to refer to a change in exposure, whether the aperture or the shutter speed is changed. To give one stop more exposure means to double the amount of light reaching the film (either by opening up to the next larger aperture setting or by doubling the exposure time). To give one stop less exposure means to cut the light reaching the film in half (stopping down to the next smaller aperture setting or halving the exposure time). More about f-stops is explained on pages 46–49.

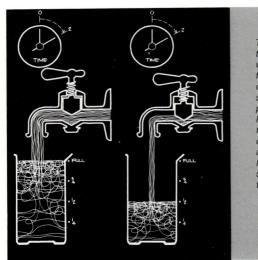

The flow of light into a camera can be controlled by aperture size just as the flow of water into a glass can be controlled by the faucet setting. Here a faucet running wide open for 2 sec fills a glass. If it runs half shut, it fills only half a glass in that time period. The same is true for light. In a given length of time, an aperture opened to any f-stop admits half as much light as one opened to the next larger f-stop. Thus the aperture setting controls the rate at which light enters the camera—in contrast to shutter setting, which controls how long the light flow continues.

On the le go from aperture f-stop or turned u arrow. Y partway diaphrac

On the lens below, the aperture settings or f-stops go from f/2.8 to f/22, with the actual size of the apertures shown in the seven circles. To select an f-stop on this lens, a movable ring on the lens is turned until the desired setting is opposite a white arrow. You can set the ring exactly on an f-stop or partway in between. Turning the ring adjusts the diaphragm inside the lens.

Here the camera is set at f/8. Each f-stop setting lets in half (or double) the light of the next setting. The effect of decreasing the light by stopping down is shown in the diagrams at left. It takes four circles the size of an f/5.6 aperture to equal the size of an f/2.8 aperture. Notice that the lowest f-stop numeral (2.8) lets in the most light. As the numerals get larger (4, 5.6, 8), the aperture size and light admitted decrease.

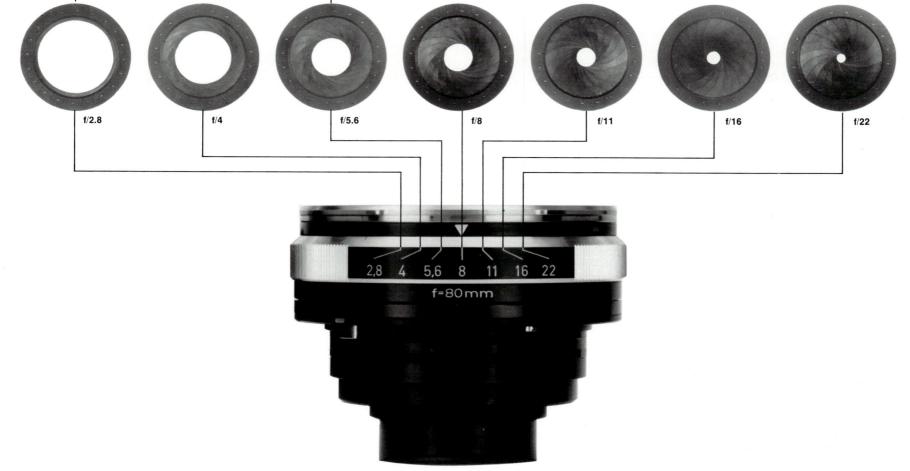

The Aperture: continued

The Aperture as a Controller of Depth of Field

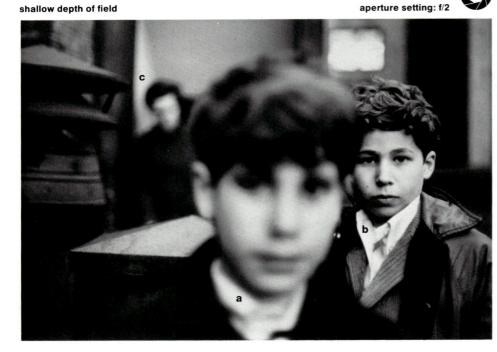

Res line

depth of field: 1 foot

h

A change in aperture size affects the sharpness of the image as well as the amount of light entering the camera. As the aperture is stopped down and gets smaller, more of the background and foreground in a given scene becomes sharp. The area of acceptable sharpness in a picture is known as the **depth** of field. (See also pages 70–75.)

The two large photographs shown on these pages were taken under identical conditions but with different aperture settings. In the photograph above, the diaphragm was opened to its widest aperture, f/2, and the lens was focused on the boy (b) about seven feet away (see side view of the photographer and his subjects, above right). The resulting photograph shows a shallow depth of field; only the middle boy (b) is sharp, while both the boy in front (a) and the man behind (c) appear out of focus. Using a small aperture, f/16, gives a different picture (*opposite page*). The lens is still focused on the middle boy but the depth of field is now great enough to yield sharp images of the other figures as well.

With a view camera or a single-lens reflex, checking depth of field is relatively simple. A view camera views directly through the lens. As the lens is stopped down, the increasing sharpness is visible on the ground-glass viewing screen. A single-lens reflex camera also views through the lens. Most models automatically show the scene through the widest aperture, and so with the least depth of field. But some also provide a **depth-of-field preview button** that stops down the lens so you can see the depth of field at the Depth of field is the area from near to far in a scene that is acceptably sharp in a photograph. As the aperture changes, the depth of field does too. If your lens has a depth-of-field scale, you can use it to estimate the extent of the depth of field. On this lens, the bottom ring shows the aperture (fstop) to which the lens is set. The top ring shows the distance on which the lens is focused. The paired numbers on the middle ring show the nearest and farthest distances the depth of field covers when the lens is set at various f-stops.

Here, the lens is focused on the middle boy (see side view of scene above), who is at a distance of 7 feet. The lens is set to its widest aperture, f/2. The depth of field extends from more than 6 ft to less than 8 ft; only objects within that distance will be acceptably sharp. If depth of field is shallow, as it is here, a lens can be sharply focused on one point and still not produce a picture that is sharp enough overall. distance (feet)

depth-of-field scale (f-stops)

aperture (f-stops)

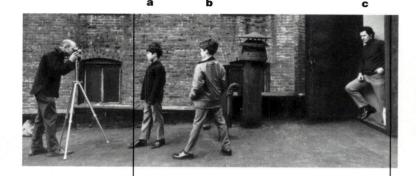

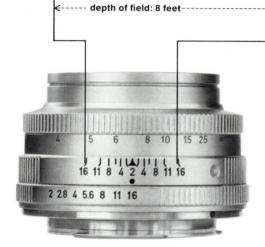

When the lens is stopped down to its smallest aperture, f/16, the depth of field increases. Almost the entire scene—everything between about 5 ft and 13 ft is now sharp at the same focusing distance of 7 ft.

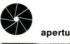

aperture setting: f/16

increased depth of field

aperture to which you have set the camera. However, in very dim light or at a very small aperture, the image may be too dark to be seen clearly once the lens is stopped down.

Examining depth of field is somewhat more difficult with a twin-lens reflex camera or a camera with a simple viewfinder window. A twin-lens reflex shows the scene only at the widest aperture of the viewing lens. There is no way to stop it down to check depth of field at other apertures. Through a simple viewfinder, objects at all distances appear equally sharp.

A **depth-of-field scale** is a way to predict depth of field in place of or in addition to visually checking through the lens. This scale often appears printed on the lens as paired numbers that bracket the distances of the nearest and farthest points of the depth of field. As the lens is focused and the f-stop set, the scale shows what part of the picture will be in focus and what part will not. On the lenses at left, the bottom row of numbers shows the f-stops. The top row shows the distance from the lens to the object on which it is sharply focused. The middle row shows the nearest and farthest distances within which objects will be sharp at various apertures. (This lens shows the distances only in feet; many lenses also show them in meters.) The greatest distance on the lens appears as the symbol ∞ . This infinity mark stands for all distances at that point or farther from the lens. When the camera is focused on infinity or when infinity is within the depth of field, all objects at that distance or farther will be in sharp focus.

Using Shutter and Aperture Together

The quantity of light that reaches a piece of film inside a camera depends on a combination of aperture size (f-stop) and length of exposure (shutter speed). In the same way, the water that flows from a faucet depends on how wide the valve is open and how long the water flows. If a 2-sec flow from a wide open faucet fills a glass, then the same glass will be filled in 4 sec from a half-open faucet. If the correct exposure for a scene is 1/30 second at f/8, you get the same total amount of exposure with twice the length of time (next slower shutter speed) and half the amount of light (next smaller aperture)—1/15 sec at fil1.

Both shutter speed and aperture affect the amount of light that enters the camera. To get a correctly exposed negative (one that is neither too light nor too dark), you have to find a **combination of shutter speed and aperture** that will let in the right amount of light for a particular scene and film. (Chapter 5, Exposure, tells in detail how to do this.) But shutter speed and aperture also affect sharpness, and in this respect they act quite differently: shutter speed affects the sharpness of moving objects; aperture affects the depth of field, the sharpness from near to far.

Once you know any single combination of shutter speed and aperture that will let in the right amount of light, you can change one setting as long as you change the other—in the opposite way. Since each aperture setting lets in twice as much light as the next smaller size, and each shutter speed lets in half as much light as the next slower speed, you can use a larger aperture if you use a faster shutter speed, or you can use a smaller aperture if you use a slower shutter speed. The same amount of light will be let in by an f/22 aperture at a 1-second shutter speed, f/16 at $1/_2$ second, f/11 at $1/_4$ second, and so on.

The effects of such combinations are shown in the three photographs at right. In each, the lens was focused on the same point, and shutter and aperture settings were balanced to admit the same total amount of light into the camera. But the three equivalent exposures resulted in three very different photographs.

In the first picture, a small aperture produced considerable depth of field that rendered background details sharply; but the shutter speed needed to compensate for this tiny aperture had to be so slow that the rapidly moving flock of pigeons appears only as indistinct ghosts. In the center photograph, the aperture was wider and the shutter speed faster; the background is less sharp but the pigeons are visible, though still blurred. At far right, a still larger aperture and faster shutter speed sacrificed almost all background detail, but the birds are now very clear, with only a few wing tips still blurred.

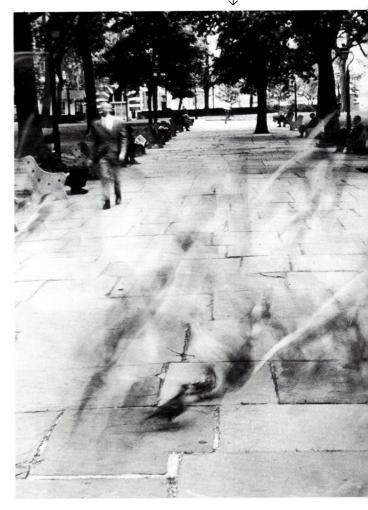

A small aperture (f/16) produces great depth of field; in this scene even distant trees are sharp. But to admit enough light, a slow shutter speed (¹/₈ sec) was needed; it was too slow to show sharply the pigeons in flight.

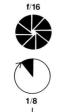

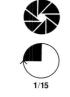

f/11

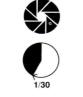

f/8

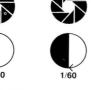

f/5.6

f/A

f/2.8

f/2

Each combination here of f-stop and shutter speed produces the equivalent exposure (lets in the same amount of light) but produces differences in depth of field and motion.

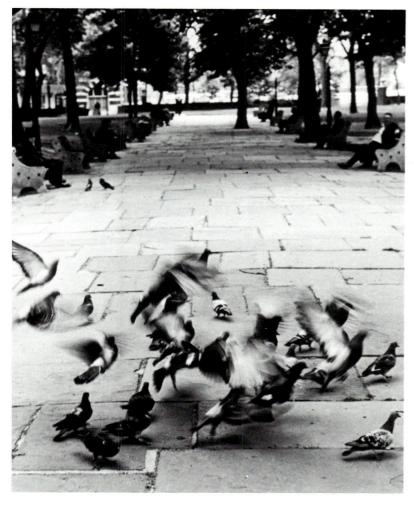

A medium aperture (f/4) and shutter speed (1/125 sec) sacrifice some background detail to produce recognizable images of the birds. But the exposure is still too long to freeze the motion of the birds' wings.

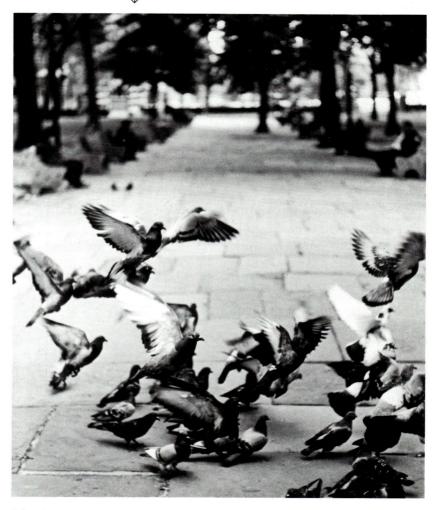

A fast shutter speed (1/500 sec) stops the motion of the pigeons so completely that the flapping wings are frozen. But the wide aperture (f/2) needed gives so little depth of field that the background is now out of focus.

Keeping the Camera Steady

Even with the finest camera and lens, you won't be happy with the pictures you take if you don't keep the camera steady enough during exposure. Too much camera motion during exposure will cause sharpness problems ranging from a slight lack of sharpness to hopeless blurring. But how much camera movement is too much? That depends partly on how much the image is enlarged, since any blur is more noticeable in a big enlargement. It also depends on the shutter speed and the focal length of the lens. The faster the shutter speed, the less you have to worry about camera movement. The longer the focal length of the lens, the more movement becomes apparent because longer lenses magnify objectsand camera movements-more.

As a general rule, if you are handholding a camera, use a shutter speed that is faster than the focal length of the lens: $\frac{1}{60}$ second or faster with a 50mm lens, $\frac{1}{250}$ second or faster with a 200mm lens, and so on. When handholding, squeeze the shutter release gently and smoothly. If you can, brace your body in some way—put your back against a wall or your elbows on a table, fence, or other object (see opposite, top left). Photographers Judy Dater and Walter looss, Jr., show how.

Putting the camera on a **tripod** and using a **cable release** to trigger the shutter is the best way to prevent camera movement (*opposite, right*). Be sure the tripod is sturdy enough for the camera; if you balance a large, heavy camera on a flimsy, lightweight tripod, your camera can end up on the floor. Miniature tripods are sometimes useful; their very short legs can be steadied on a table, car fender, or even against a wall. A monopod (single-leg support) or a hand grip gives extra stability if you have to keep moving, for example, along a football sideline.

holding an eye-level viewing camera

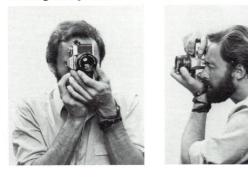

For a vertical picture, some people hold an eyelevel camera with the film advance lever down (left). Your right hand supports the camera, the right index finger works the shutter release, and the right thumb advances the film. The left hand adjusts focus and f-stops. You may prefer to have the film advance lever up (right). Support the camera on the heel of your left hand, with fingers free to adjust focus and f-stops. holding a waist-level viewing camera

The bigger viewing screen of a large-format reflex camera lets you focus with your eye some distance from the screen (left). To shoot over a crowd (right), try holding the camera at arm's length, upside down.

To steady an eye-level camera, press one arm (or preferably both) against your body. Keep the camera strap around your neck or wound around one wrist to quard against dropping the camera.

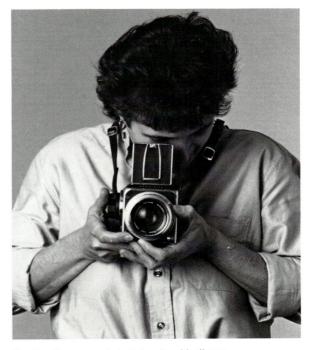

Cradling the camera in both hands, with elbows against sides, is a standard position for working with a large-format reflex camera. Your entire body helps steady the camera, which is held close to the eve for precise composition and focusing.

holding a camera with a long lens

With a long lens, such as this 200mm one, attached to your camera, try to find some extra support such as a stool, chair, or other steady object to brace yourself against. Kneeling, you can brace your elbow on one knee.

Place yourself in as stable a position as possible when kneeling without any additional support (left). For a standing shot with a long lens (right) tuck your elbow firmly against your ribs to hold camera and lens steady. Particularly when using a long lens and slow shutter speed, be careful to squeeze the shutter release gently to avoid jerking the camera. using a tripod

A tripod is the best way to prevent unwanted camera movement. Camera height is adjusted by raising or lowering the tripod legs or center shaft; camera angle is adjusted by tilting or swiveling the tripod head. Some tripods have a center shaft that can be removed and reversed; the tripod head and camera then hang upside down and the camera can photograph from a low angle.

A cable release lets you trigger the shutter release without jarring the camera. Leave a little slack in the cable instead of pulling it taut. Some cameras do not accept a cable release but may have a selftimer delay switch that can be used instead.

Choosing a Camera

Choosing a camera will be easier if you first decide what kind of pictures you want to take-then think about which basic camera design best fits your needs. If your picture taking consists of occasional snapshots of family, friends, or sightseeing views, then an inexpensive, nonadjustable, point-and-shoot camera will be satisfactory. You simply aim it at the subject by looking through a viewfinder window and then push the shutter release to make the exposure. But the very simplicity of this type of camera limits the things you can do with it, and as soon as you begin to be more than casually interested in photography, your needs outstrip the camera's potential.

If you are a photography student, a serious amateur, or just someone who would like to learn more about photography, you will want an adjustable camera. A camera may have automatic features, but at a minimum it should also give you the option of selecting the focusing distance and either the shutter speed or aperture, preferably both. The major types of cameras are shown and described at right.

Once you have decided on a basic design and are ready to buy, shop around to compare prices, accessories, and service. Try handling various cameras; if you wear glasses, make sure you can see the entire image. You may be able to find a good used camera at a considerable saving. But look over used equipment carefully: avoid cameras with dents, scratched lenses, rattles, or gouged screw heads that could indicate a home repair job. If a dealer is reputable, you will be able to exchange a camera, new or used, if your first roll of film is unsatisfactory. Examine that first roll carefully for scratches, soft focus, or other signs of trouble.

Electronic still photography is the latest technical innovation in camera design. Instead of recording an image on film, the camera uses a video floppy disk. Pictures can be played back on a TV set or monitor, or turned into hard copy (prints) on a video printer. They can be sent over phone lines via a transceiver (like a computer modem). They can be fed into a computer-graphics system to be internally altered, recolored, or otherwise manipulated (see page 217).

Electronic still photography already has some commercial applications, particularly in photojournalism (imagine the advantages of instantly transmitting news pictures direct to a newspaper's home office from any location in the world where you can get to a telephone). But it currently has some major problems, the most important being poor print quality; even the simplest amateur camera using conventional film produces a much finer print in terms of sharpness and image detail. Price is still very high. For the foreseeable future, it is not a threat to standard camera systems.

Rangefinder cameras have a viewfinder for sighting, plus a rangefinder

for manually focusing the image. A **viewfinder camera** does not have a rangefinder; you simply sight through the viewfinder, and the camera does the focusing. Both types of cameras have eye-level viewing and are compact, lightweight, durable, and quiet in operation. Most use 35mm film; a few, such as those made by Fuji and Plaubel, are designed for larger roll-film sizes.

A high-quality 35mm rangefinder camera, such as the Leica, has long been—and still is—a favorite of photographers who want to work inconspicuously and quickly; they value the camera's dependability and its precise focusing even at low light levels.

Viewfinder cameras with automatic focus dominate the low-priced pointand-shoot end of the market. Many are autoeverything: they read the speed of the film you put in the camera, advance it to the first frame, focus, calculate exposure, advance the film after each exposure, and rewind at the end of the roll. Warning beeps and signals are part of their repertoire, such as when light level is low and flash is required. Some only function automatically; a better choice is a model that has optional adjustable controls. Canon, Konica, Minolta, Nikon, and Pentax are some of the 35mm brands.

Disadvantages include some parallax error, which is unavoidable in viewfinder sighting, especially at close range. It is also impossible to evaluate depth of field visually. This type of camera is not your best choice if you want to make extreme close-ups, align objects within the picture precisely, or experiment with special filters or other optical effects.

Single-lens reflex cameras offer the greatest variety of interchangeable lenses plus options such as throughthe-lens metering, automatic exposure, automatic focus, and motorized film advance. Since these cameras let you view directly through the lens, you see an exact view of what will appear on the film, an advantage with close-ups, microphotography, or other work where you want to see in advance exactly how the image will look.

Most single-lens reflex cameras use 35mm film, although some are designed for larger film sizes. The 35mm format produces a rather small negative, $1 \times 1\frac{1}{2}$ inches (24×36 mm). It is quite possible to make large-size, high-quality enlargements from 35mm negatives, but you need carefully exposed and processed negatives to do so. Many types of film, both black-and-white and color, are available in 35mm, and this format also has the advantage of being relatively inexpensive.

The single-lens reflex is the most popular camera when a buyer moves beyond snapshot level. Many brands are available, including Canon, Konica, Leica, Minolta, Nikon, Olympus, Pentax, Rollei, and Yashica.

The larger single-lens reflex cameras using 21/4-inch film are popular with photographers who want a negative larger than 35mm plus the versatility of a single-lens reflex-fashion or advertising photographers, for example. Not only are lenses interchangeable but the camera's back is as well: you can expose part of a roll of black-and-white film, remove the back, and replace it with another loaded with color film. Size, weight, and noise of operation are all greater than with a 35mm single-lens reflex-and so is the price. Most cameras make a $2^{1/4}$ -inch-square (6 \times 6 cm) negative; a few models have a rectangular format such as 21/4 x 15/8 inches (6 x 4.5 cm) or $2\frac{1}{4}$ \times $2\frac{3}{4}$ inches (6 \times 7 cm). Bronica, Fuji, Hasselblad, Mamiya, Pentax, and Rollei are some of the brands.

Twin-lens reflex cameras are less versatile than single-lens reflexes. Most do not have interchangeable lenses (with the exception of the Mamiya), although supplementary lenses are available for close-up or long-range work. What you see on the ground-glass viewing screen is almost—but not exactly—what you get on the negative, since the viewing lens is positioned just above the taking lens.

What you do get is a relatively large negative (2¹/₄-inches square) and durability for a reasonable price. The twinlens reflex camera is good for portraits, landscapes, better-quality snapshots, and similar fairly conventional photographic situations. But don't expect it to be as fast as a rangefinder or as flexible as a single-lens reflex. Most manufacturers have ceased making twin-lens reflexes, but used models are still available. Mamiya and Rollei continue to market new cameras.

View cameras give the utmost in control over the image, even control over the apparent shape and perspective of objects (see pages 291-306). The largesize negatives (4 \times 5 inches and larger) make prints of maximum sharpness and minimum grain. Ordinarily, each picture is shot on a separate sheet of film, but roll film adapters are available. The view camera is unsurpassed for architectural work, product photography, studio work-anything where the photographer's first aim is carefully controlled, technically superior pictures. What you sacrifice are automatic features (there aren't any), size and weight (enough to make a tripod a necessity), and speed of operation (slow). Burke and James, Calumet, Cambo, Deardorff, Linhof, Omega, Plaubel, Sinar, Toyo, and Wista are among the brands.

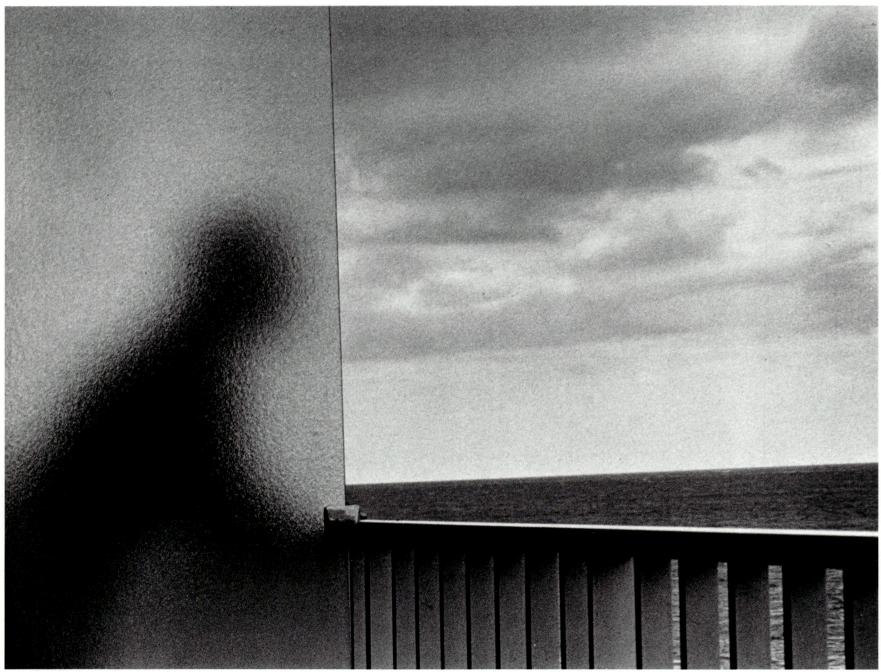

ANDRÉ KERTÉSZ: On Martinique, 1972

3 Lens

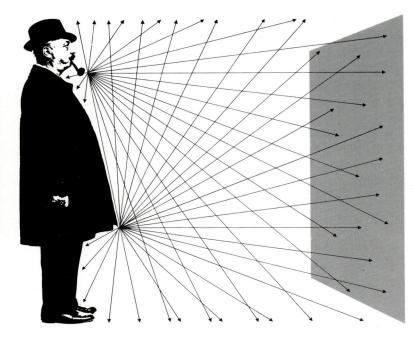

Uncontrolled light rays, shown reflected from two points—the subject's pipe and the bottom of his coat—travel in straight lines in almost all directions toward a sheet of film placed in front of the subject. Rays from the pipe strike the film all over its surface, and so do rays from the coat; they never form an image of pipe or coat at any place on the film. The result is not a picture but totally exposed film.

On the island of Martinique, an anonymous figure looks out over an anonymous ocean. Glass, sky, ocean, and railing divide the scene in a geometry of angles and gray shapes that the eye takes pleasure in comparing and measuring. The print is relatively grainy, echoing the granularity of the glass. The scene is quite understandable—we have all seen figures or shapes behind translucent glass but the picture invites other associations. Landscapes by the surrealist painter Rene Magritte come to mind, and one can imagine that just out of sight a giant rock is floating across the sky. Why Lenses Are Needed 56 A Pinhole to Form an Image 56 A Lens to Form an Image 58 Types of Lenses 60 Lens Focal Length 60 The Normal Lens 62 The Long Lens 64 The Short Lens 66 Special-Purpose Lenses 68 Focus and Depth of Field 70 Controlling Depth of Field 72 More About Controlling Depth of Field 74 Automatic Focus 76 Using Focus and Depth of Field 77 **Perspective 78 Using Perspective 80** Getting the Most from a Lens 82 What Went Wrong? 83 Choosing Lenses 84 Caring for Your Camera and Lens 85

Light must be controlled if our eyes or our cameras are to form images of objects. You can't simply place a square of sensitized film in front of a man and hope that an image of him will appear on the film. The rays reflecting off the man would hit the film in a random jumble, resulting not in a picture but in a uniform exposure over the entire surface of the film. For simplicity's sake, the drawing at left shows only a few rays coming from only two points on the man, his pipe and his coat tip, but their random distribution over the entire film makes it clear that they are not going to produce a useful image. The rays from the pipe, for example, will hit the film all over its surface, never creating in any one place an image of the pipe. What is needed is some sort of light-control device in front of the film that will select and aim the rays, putting the pipe rays where they belong and the coat rays where *they* belong, resulting in a clear picture.

All photographic lenses do the same basic job: they collect light rays coming from a scene in front of the camera and project them as images onto a piece of film at the back. This chapter explains how this happens and how you can use lens focal length (which controls the magnification of a scene), lens focus (which controls the sharpest part of an image), lens aperture, and subject distance to make the kinds of pictures you want.

Why Lenses Are Needed A Pinhole to Form an Image

Although all the light rays reflected from an object cannot produce an image on a flat surface, a selection of rays can. Suppose there is a barrier with a small hole in it, like that in the drawing below. All but a few rays from each point are deflected by the barrier. Those few rays that do get through, traveling in straight lines from object to film, can make an image.

For example, the few rays from the man's pipe that get through the hole all fall on a certain spot near the bottom of the film. Only that one spot on the film registers an image of a pipe. Similarly, rays from the coat, the shoes, the ear, the hat brim—from every point on the man—travel to other specific points on the film. Together they form a complete image, but one that is inverted. Everything that was at the top of the man appears at the bottom of his image on the film and everything at the bottom appears at the top. Similarly, left becomes right and right becomes left.

The image-making ability of the pinhole was first put to use—long before the invention of photography—as part of the **camera obscura**, a darkened room whose only light source is a small hole in one wall. Light rays coming through the hole form on the opposite wall an image of the scene outside. The camera obscura is, in fact, a room-size primitive camera. Shrink the room down to shoebox size, reduce the hole to 1/50 inch (0.5 mm) in diameter, place a piece of film at the end opposite the hole, and it will make a recognizable

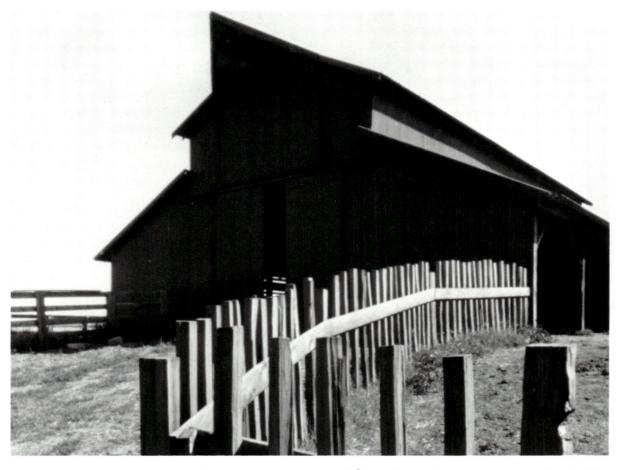

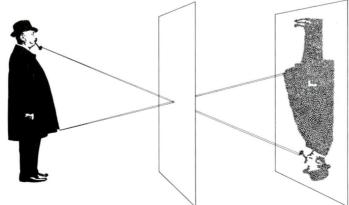

To take this picture of a fence and barn in California, photographer Ansel Adams replaced the lens of an ordinary camera with a thin metal disk pierced by a pinhole with 1/so-inch diameter. The film was exposed for 6 sec. The way the pinhole produced an image is illustrated in the diagram at left. Only a few rays of light from each point on the subject can get through the tiny opening, and these strike the film in such tight clusters that blurring is reduced to a minimum. The result is a soft but acceptably clear photograph.

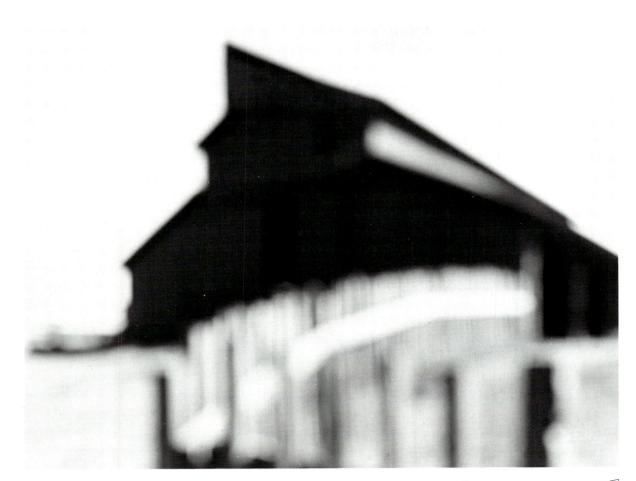

For a second photograph of the same scene, Adams increased the size of the opening to ¼ inch, which meant reducing the exposure time to ¼s sec. The result is an extremely out-of-focus picture. As shown in the diagram at right, the larger hole permits a greater number of rays from each point on the subject to enter the camera. These rays spread before reaching the film and are recorded as large circles. Because of their size, these circles tend to run into one another, creating an unclear image.

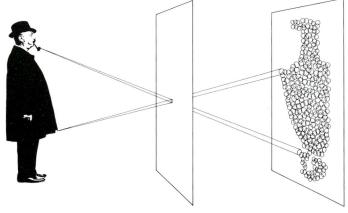

picture; the photograph opposite was made with such a camera. The trouble with this **pinhole camera** is its tiny opening, which admits so little light that very long exposures are needed to register an image on the film. If the hole is enlarged appreciably, the picture it makes becomes much less sharp, like the photograph on this page. Why this happens is explained in the two drawings.

The image in the drawing on the opposite page is actually composed of a great many tiny circles known as circles of confusion. This is because the hole, small though it is, actually admits a cluster of light rays. Coming at slightly different angles, these rays continue through the hole in slightly different directions. They fan out, and when they hit the film they cover a small circular area on it. If the hole in the barrier is made larger (drawing below), a larger cluster of light rays will get through to the film and cover a wider circle. The larger the circles are, the more they will overlap their neighbors and the less clear the picture will be.

To get sharp pictures, the circles of confusion should be as small as possible. But the only way to achieve that with a pinhole camera is to use a very small opening, which admits little light and requires long exposure times. To admit more light and to make a sharper picture, a different method of image formation is needed. That is what a lens provides.

A Lens to Form an Image

Four centuries ago a Venetian nobleman named Daniele Barbaro found a new and better way to convert light rays into images in the camera obscura of his day. He enlarged the opening of his room-size camera obscura and fitted into it a convex **lens** taken from the spectacles of a farsighted man. To his delight, the lens projected images superior to those previously supplied by the simple pinhole opening.

Several hundred years later, with the advent of photography, this discovery proved even more significant. For not only can a camera with a lens provide sharper images than a pinhole camera, but it admits enough light to take a picture in a fraction of a second.

Most modern photographic lenses are based on the convex lens, the type used by Barbaro. Thicker in the middle than at the edges, the convex lens can collect a large number of light rays from a single point on an object and refract, or bend, them toward each other so that they converge at a single point (diagram, right). This point of convergence, the focal point, falls on a surface called the focal plane. In a camera, a strip of film is stretched across the focal plane, which is now the film plane. The film records an image formed by light rays from an infinite number of points on the object, focused by the lens into an infinite number of tiny circles of confusion.

How does a lens **refract** (bend) light to form an image? When light rays pass from one transparent medium, such as air, into a different transparent medium, such as water or glass, the rays may be bent, or refracted. Look at the shape of a spoon half submerged in a glass of water and you will see a common example of refraction: rays of light reflected by the spoon are bent by the water and glass so that part of the spoon appears displaced.

Photographed this time through a convex lens, Ansel Adams's barn scene is as good as—or better than—the one on page 56 taken with a pinhole camera. Its exposure time, instead of being 6 sec, was only 1/100 sec. This is because the lens is much bigger than a pinhole and thus admits far more light. The diagram at left shows how the lens handles all this light by collecting many rays reflected from a single point and redirecting them to a corresponding single point on the film or focal plane.

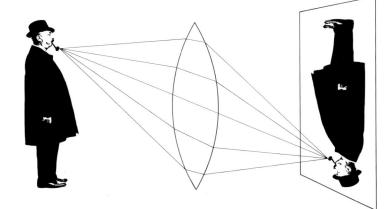

For refraction to take place, light must strike the new medium at an angle. If it is perpendicular to the surface when it enters and leaves the medium (*diagram*, 1), the rays pass straight through. But if it enters or leaves at an oblique angle (2), the rays will be bent to a predictable degree. The farther from the perpendicular they strike, the more they will be bent.

When light strikes a transparent medium with a curved surface, such as a lens, the rays will be bent at a number of angles depending on the angle at which each ray enters and leaves the lens surface. They will be spread apart by concave surfaces (3) and directed toward each other by convex surfaces (4). Rays coming from a single point on an object and passing through a convex lens (the simplest form of camera lens) will cross each other—and be focused —at the focal point.

A modern compound lens, as this cutaway view shows, is usually a single convex lens sliced in two with some other lens elements placed in between to correct the aberrations or focusing defects that in any single lens affect the sharpness and sometimes the shape of the image. The front half of the convex lens (a) has a 2-piece element of special color-correcting glass (b) behind it. Farther back is another color-correcting element (c) and finally the back half of the convex lens (d). The use of optical glass manufactured with certain chemicals, such as fluoride, also improves lens performance.

How refraction works is shown in the diagram (right) of beams of light passing through four glass blocks. The beams, entering from the left, strike the first block head on and are therefore not refracted. But the next block has been placed at an angle, so that the rays are refracted, resuming their former direction on the other side. The concave surfaces of the third block spread the beams apart, but the last block—a convex lens like the basic light-gathering lenses used in cameras draws the rays back together so that they cross each other at the focal point.

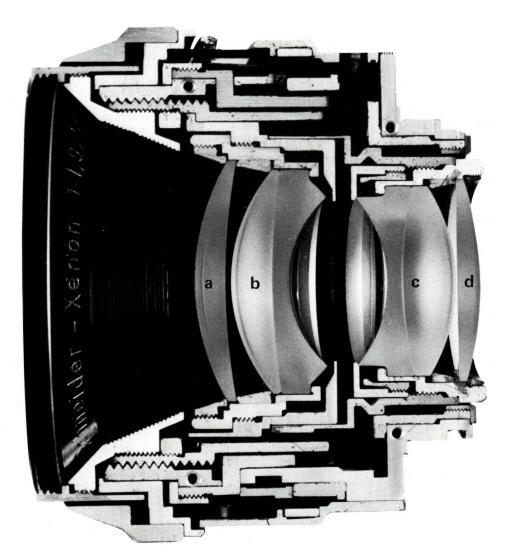

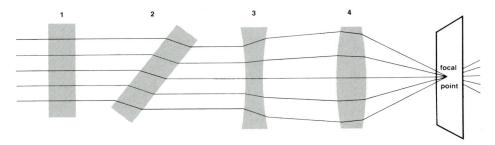

Types of Lenses Lens Focal Length

Since most cameras can be used with interchangeable lenses, a photographer can choose which lens to buy or use. The most important way lenses differ is in their **focal length**. Focal length is the distance between the lens (technically, from its rear nodal point) and the focal plane when the lens is focused on infinity (a far distance from which light reaches the lens in approximately parallel rays). A lens is often described in terms of its focal length (a 50mm lens, a 12-inch lens) or its relative focal length (short, normal, or long).

Focal length controls magnification (the size of the image formed by the lens) and angle of view (the amount of the scene shown on a given size of film). The effect of focal length on magnification is diagrammed at right. A lens of short focal length bends light sharply. The rays of light focus close behind the lens and form a small image of the object (top diagram). The longer the focal length, the less the lens bends the light rays, the farther behind the lens the image is focused, and the more the image is magnified (bottom diagram). The size of the image increases in proportion to the focal length; if the subject remains at the same distance from the lens, the image formed by a 25mm lens will be half as big as that from a 50mm lens.

A lens of long focal length forms a larger image of an object, so it includes on a given size of film less of the scene in which the object appears. If you make a circle with your thumb and forefinger and hold it close to your eye, you will see most of the scene in front of you. If you move your hand farther from your eye, the circle will be filled by a smaller part of the scene: you have decreased the angle of view seen through your fingers. In the same way, the longer the focal length, the smaller the angle of view seen by the lens.

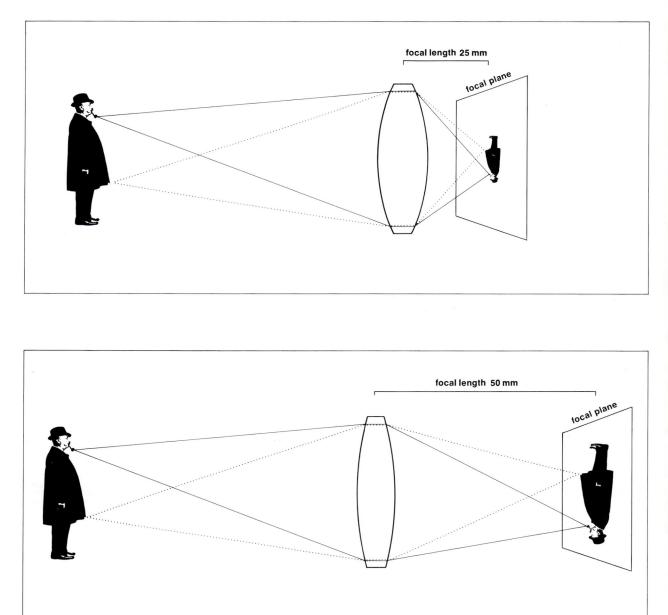

7.5mm fisheye

50mm

28mm

105mm

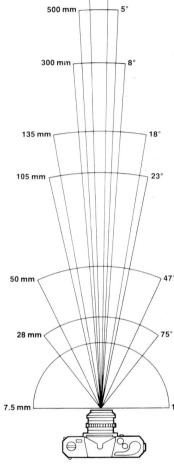

The diagram above shows the angle of view of some of the lenses that can be used with a 35mm camera. The examples at left show the effect of increasing focal length while keeping the same lens-to-subject distance: a decrease in the angle of view and an increase in magnification. Since the photographer has not changed position, the sizes of objects within the scene remain the same in relation to each other.

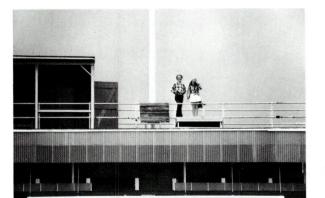

500mm

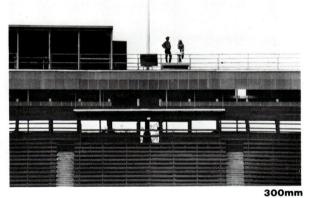

The Normal Lens

If the focal length of a lens (dotted line) is about the same as the diagonal measurement of the film (broken line), the lens is considered to be of normal (or standard) focal length for that film size. It collects light rays from an angle of view of about 50° —the same as the human eye—and projects them onto the film within the same angle. A normal focal length lens for a 4 × 5 camera is 150 mm. An 80mm lens is normal for a camera using $2^{1/4} \times 2^{1/4}$ -inch film; a 50mm lens is normal for a 35mm camera.

Bruce Davidson used a 50mm lens on his 35mm camera for the picture at right, part of a photo essay on a Brooklyn teenage gang, the Jokers. BRUCE DAVIDSON: The Brooklyn Gang, 1959

You can create significantly different effects simply by switching to a lens of a different focal length (see page 61), but one of the greatest of modern photographers almost never changed lenses. Henri Cartier-Bresson, who once described the camera as "an extension of my eye," usually did his work with a normal-focal-length lens, also called a standard-focal-length lensone that approximates the impression human vision gives. In his picture opposite, the angle of view is about the same as what the eye can see clearly from one position, and the relative size of near and far objects seems normal.

But a lens that is a normal focal length for one camera can be a long

focal length for another camera. Film size determines what will be a "normal" focal length. The larger the size of the film format, the longer the focal length of a normal lens for that format. A camera using 35mm film takes a 50mm lens as a normal focal length; a camera using 4×5 -inch film requires a 150mm lens. Usage varies somewhat: for example, lenses from about 40mm to 58mm are also referred to as normal focal lengths for a 35mm camera.

A lens of normal focal length has certain advantages over lenses of longer or shorter focal length. Most normal lenses are faster, that is, they open to a wider maximum aperture, and so can be used with faster shutter speeds or in dimmer light than lenses that do not open as wide. They often are less expensive, more compact, and lighter weight.

Though a 50mm lens is called normal for a 35mm camera, that doesn't necessarily mean it is the one you will usually want to use on your camera. Some photographers habitually use a shorter focal length because they want a wide angle of view most of the time; others prefer a longer focal length that narrows the angle of view to the central objects in a scene. If you have a 35mm camera, a 50mm lens is a good focal length to start with, but the lens that turns out to be normal for you will be a matter of personal preference.

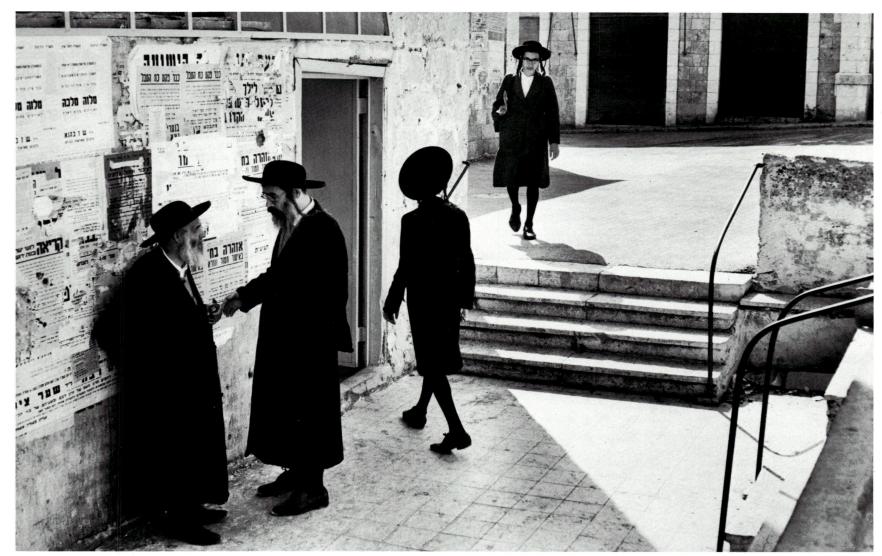

HENRI CARTIER-BRESSON: Jerusalem, 1967

This photograph of Hasidic Jews in Jerusalem shows Henri Cartier-Bresson's characteristic use of a normal-focal-length lens. The photographer was at a medium distance, so all four figures appear to be of normal size and perspective relative to each other. There is no distortion of perspective as there might have been had a shorter lens been used up close or a longer lens been used from far away. Most of the scene is sharp because at a medium distance a normal-focallength lens provides considerable depth of field.

The Long Lens

A lens is considered long for a camera if its focal length (dotted line) is appreciably greater than the diagonal of the film format (broken line). It then collects light over an angle that is narrower than that covered by human vision, producing an enlarged view of a restricted area. For a 35mm camera, a popular and useful long focal length is 105 mm; for a 2¹/₄ × 2¹/₄ reflex the comparable focal length is 150 mm; and for a 4 × 5 view camera, about 300 mm.

A long-focal-length lens provides an enlarged image of an object. Its angle of view is narrower and its magnification greater than that of a normal lens. Long lenses are excellent for situations where you cannot or do not want to get close to the subject, as in the picture opposite, where the photographer seems to be in the middle of the action even though he is standing on the sidelines. Long lenses make it possible to photograph birds and animals from a distance. They are excellent for portraiture; most people get self-conscious when a camera is too close to them and their expressions become artificial. A long lens also avoids the kind of distortion that occurs when shorter lenses used close to a subject exaggerate the size of whatever is nearest the camera -in a portrait, usually the nose (above).

long lens, moderate distance

There are also subtler qualities that can be exploited when you use a long lens. Because a long lens has less depth of field, objects in the foreground or background can be photographed out of focus so that the sharply focused subject stands out clearly and powerfully. Also, a long lens can be used to create an unusual perspective in which objects seem to be closer together than they really are (see opposite and page 80).

Long lenses have some disadvantages, and the longer the lens the more noticeable the disadvantages become. Compared to a lens of normal focal length, they are somewhat heavier, bulkier, and usually more expensive. Because of their shallow depth of field, they must be focused accurately. They usually do not open to a very wide apershort lens, up close

A moderately long lens (such as an 85mm or 105mm lens on a 35mm camera) used at least 6 ft from the subject (above left) makes a better portrait than a shorter lens used close to the subject (above right). Compare the sizes of nose and chin in the pictures. Photographing a person at too close a lens-to-subject distance makes features nearest the camera appear too large and gives an unnatural-looking dimension to the head.

ture; a maximum aperture of f/4 is typical for a 200mm lens. And they are difficult to use for hand-held shots since they magnify lens movements as well as subject size. The shutter speed for a medium-long lens, such as a 105mm lens on a 35mm camera, should be at least 1/125 second if the camera is hand-held; otherwise camera movement may cause blurring. A tripod or some other support is even better.

Photographers commonly call any long lens a **telephoto**, or tele, although not all long lenses are actually of telephoto design. A true telephoto does not require full focal length distance from lens to film plane. A **tele-extender** or teleconverter contains an optical element that increases the effective focal length of a lens. It attaches between lens and camera like an extension tube.

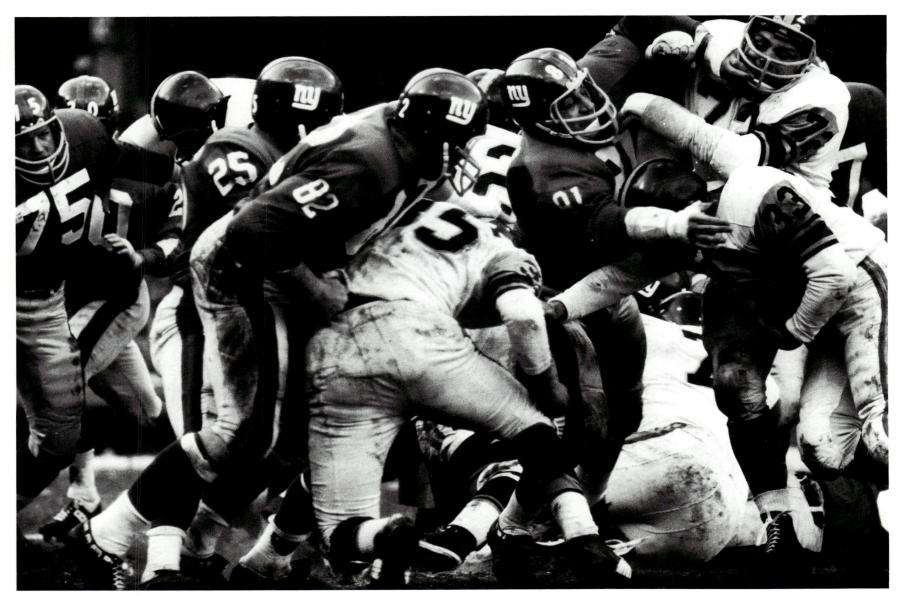

WALTER IOOSS, JR.: Giants' Defense, 1963

This photograph of the New York Giants' defense line stopping Number 33 also shows two characteristics of the long lens. Although the photographer was standing on the sidelines, a 400mm lens on his 35mm camera includes only a 6° angle of view, magnifying the image to fill the frame with action. The long lens also seems to compress the space, making the players appear to be in even more of a crunch than they actually are.

The Short Lens

In the diagram above, the focal length of the lens (dotted line) is about $\frac{3}{9}$ of the film diagonal (broken line). This makes it a wide-angle lens; it produces a viewing angle of 75°, or about 50 percent more than the eye could see clearly if focused on the same subject. The focal length of a commonly used wide-angle lens for a 35mm camera is 28 mm; for a $\frac{21}{4} \times \frac{21}{4}$ reflex it is 55 mm, and for a 4×5 view camera, 90 mm.

A short-focal-length lens shows more of a scene than a normal lens used from the same position. This is of special importance if you are physically prevented (as by the walls of a room) from moving back as much as necessary to take the picture with a normal lens. The short lens (commonly called a **wide-angle** lens or sometimes a wide-field lens) increases the angle of view and thus reduces the size of the image compared to the image formed by a normal lens.

Wide-angle lenses also have considerable depth of field. A 24mm lens focused on an object 7 feet away and stopped down to f/8 will show everything from 4 feet to infinity in sharp focus. News photographers or others who work in fast-moving situations often use a moderately wide lens, such as a 35mm lens on a 35mm camera, as their normal lens. They don't have to pause to refocus for every shot because so much of a scene is sharp with this type of lens. At the same time it does not display too much **distortion**, which is the wide-angle lens's other main characteristic.

Pictures taken with a wide-angle lens can show both real and apparent distortions. Genuine aberrations of the lens itself such as curvilinear distortion are inherent in extremely curved or wide elements made of thick pieces of glass, which are frequently used in wide-angle lenses. While most aberrations can be corrected in a lens of a moderate angle of view and speed, the wider or faster the lens, the more difficult and/or expensive that correction becomes.

A wide-angle lens can also show an apparent distortion of perspective, but this is actually caused by the photographer, not the lens. An object that is close to a lens (or your eye) appears larger than an object of the same size The exaggerated size of the model's hand, her rapidly receding arm, and her unnaturally undersized body were all created by photographing an average-size model with the camera close to her outstretched fingertips. This kind of apparent distortion is a result of the short distance from lens to subject and is easy to achieve—intentionally or otherwise—with a wide-angle lens, which can be focused very close to a subject.

A wide-angle lens is useful for photographing in confined areas, whether a small room or the president's helicopter. There is some distortion of the arm closest to the camera, but it is partly shadowed and not as noticeable as the model's arm in the photograph at left. During President Ford's term in office, David Kennerly was his personal photographer and had access to him during many informal moments. This particular moment pairs a serious president with a well-known symbol of America, the Washington Monument. The pairing is almost too obvious; the photograph may have been unposed but somehow has an edge of contrivance to it. One imagines Kennerly saving. "Could we circle around the monument one more time, Mr. President?'

that is farther away. Since a wide-angle lens can be focused very close to an object, it is easy to get this kind of exaggerated size relationship (*photograph, above*). The cure is to learn to see what the camera sees and either minimize the distortion, as in the photograph at right, or use it intentionally. More about how to control perspective and apparent distortion is on pages 78–81.

A lens of very short focal length requires some design changes for use in a single-lens reflex camera, because the lens is so close to the film plane that it gets in the way of the mirror used for viewing. A retrofocus (reversed-telephoto) lens solves this problem with a design that is the reverse of that of a telephoto lens. The result is a lens of very short focal length that can be used relatively far from the film plane and out of the way of the viewing mirror.

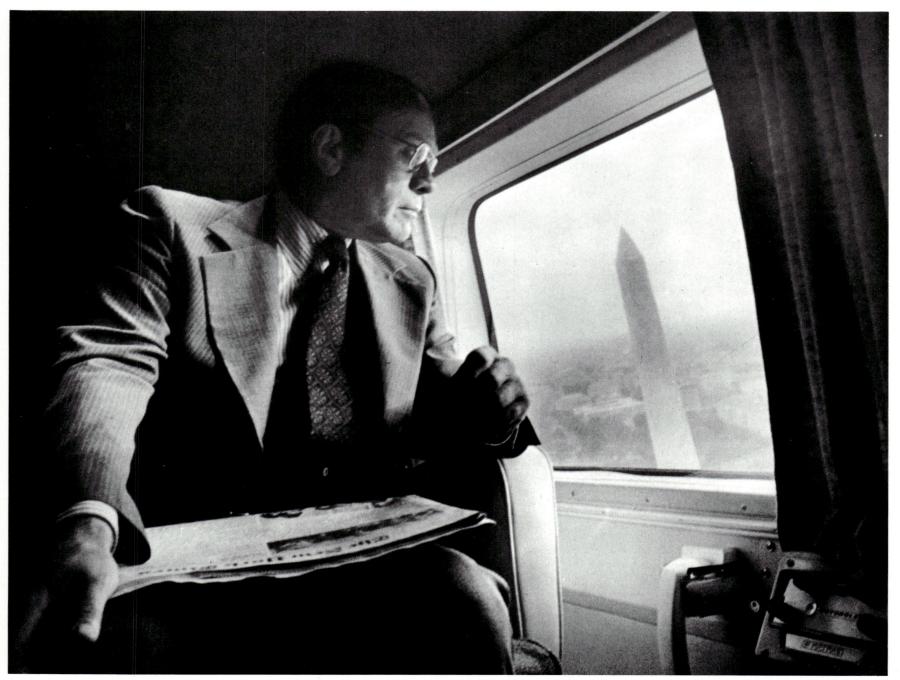

DAVID HUME KENNERLY: President Gerald Ford Looking Down on the Washington Monument from His Helicopter, 1974

Special-Purpose Lenses

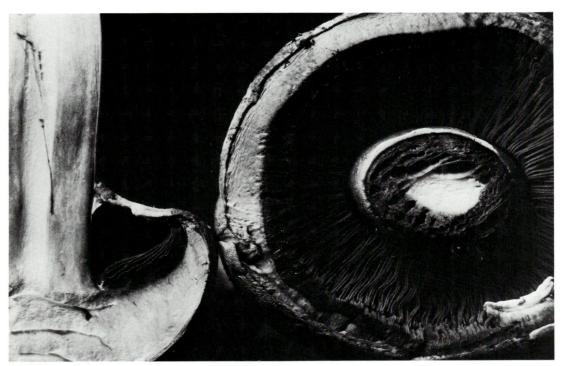

A macro lens is useful for photographing very close to a subject without having to use other accessories such as extension tubes (more about close-ups on pages 198–203). When you photograph close to a subject, depth of field is very shallow—only a narrow distance from near to far will be sharp. Here, to make the photograph sharp, the photographer sliced and positioned the mushrooms so that their front surfaces lined up evenly, parallel to the film plane.

JOHN NEUBAUER: Le Champignon, 1979

For the widest of wide-angle views, consider the **fisheye lens** (*opposite*). It is not a lens for every situation, but it can produce startling and effective views. Its angle of view and depth of field are enormous—and so is its barrel distortion, an optical aberration that bends straight lines into curves at the edges of an image.

A catadioptric lens or mirror lens is similar in design to a reflecting telescope, incorporating curved mirrors as well as glass elements within the lens. The result is a long-focal-length lens that is much smaller and lighter than a lens of equivalent focal length that uses only glass elements. A cat lens has a fixed aperture, usually rather small—f/8 or f/11 is typical. And the front mirror in the lens has the unusual effect of causing out-of-focus highlights to take on a donut shape rather than the usual disk shape produced by an ordinary lens.

A zoom lens can be used at a variety of focal lengths. It works by having some of its optical elements movable in relation to one another; this changes the focal length and therefore the size of the image. It is convenient to be able to frame the image merely by zooming to another focal length rather than by changing camera position or changing lenses. A zoom lens is particularly useful for making color slides, since cropping the image later is not easy. But it is necessary to weigh the convenience of a zoom lens against its disadvantages. among which are increased cost, size, and weight and somewhat decreased image quality and speed. The greater the zooming range, the more these disadvantages increase. The best prices and sharpest images are found over a modest zooming range, from 35mm to 70mm, for example.

A macro lens is useful for extremely close shots such as that of the mushrooms above. The lens is built into a lens barrel that can be extended extra far so the lens can be focused at very close range. It is corrected for the aberrations that occur at close focusing distances. The lens is occasionally called, somewhat inaccurately, a *micro* lens.

Aberrations may be deliberately introduced in a **soft-focus lens**, sometimes called a portrait lens, to produce an image that will soften details such as facial wrinkles.

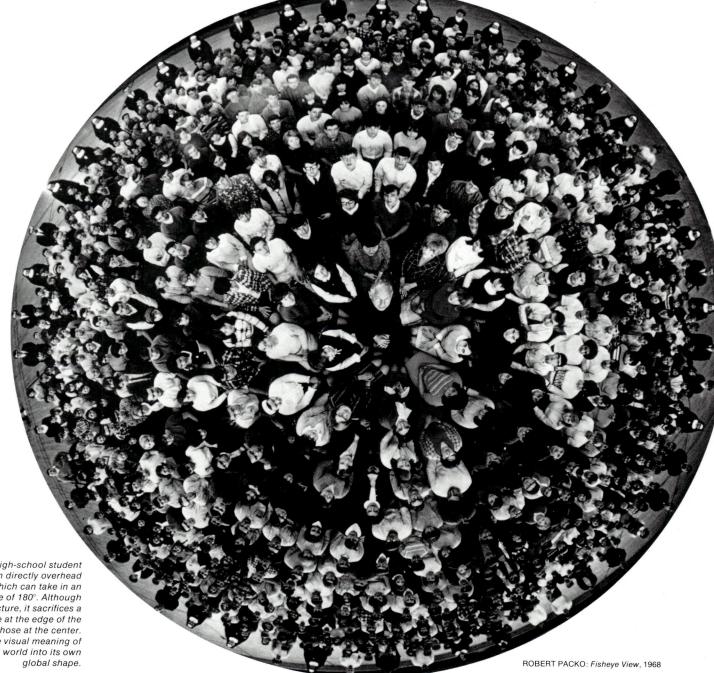

This "crystal-ball" view of a high-school student body and faculty was shot from directly overhead with a 7.5mm fisheye lens, which can take in an enormously wide viewing angle of 180°. Although it gets everybody into the picture, it sacrifices a great deal in perspective; those at the edge of the picture are tiny compared to those at the center. The round format adds to the visual meaning of the picture, forming a school world into its own global shape.

Focus and Depth of Field

When part of a picture is sharp and part out of focus (or soft), a viewer looks first at the sharply focused area. In the picture opposite, your eyes are immediately drawn to the woman—the photographer has made her the most important part of the photograph. In another situation, however, a photographer might want to have the entire scene sharp (*photograph this page*). What exactly is sharpness, and how much can it be controlled?

When you focus a lens by rotating its focusing ring (or when an automaticfocus camera focuses itself), the lens moves nearer to or farther from the film. The closer an object is to a lens, the farther the lens has to be from the film to focus that object sharply. A lens can focus on only one distance at a time, and all other distances will be less sharp. If your lens is focused on an object 10 feet away, anything else 10 feet away will be sharp, but anything nearer or farther than 10 feet will not be as sharp.

However, in most cases, objects within a certain distance range in the scene appear to be sharp. The acceptably sharp area in a photograph, the **depth of field**, includes the **plane of critical focus**, that part of the scene on which you focused, plus portions of the scene in front of and behind that plane that are also sharp.

Think of a subject as being composed of an infinite number of tiny points lo-

Imagine the distance on which you are focused to be like a pane of glass parallel to the camera, stretching across the scene in front of you. Everything at this distance (the plane of critical focus) will be sharp in the photograph. In front and in back of the plane lies the depth of field, the area that will be acceptably sharp in the photograph. The farther from the plane of critical focus that objects are, the less sharp they will be. Notice that the depth of field is unevenly distributed. At normal shooting distances, about ½ of the depth of field lies in front of the plane (toward the camera), and about ⅔ lies behind it (away from the camera).

70 3/Lens

cated at various distances from the lens. When a single subject point is critically focused, it appears in the image as a point. But since a lens can focus on only one distance at a time, another point located in front of or behind the critically focused one will not be focused entirely sharply. The lens will cause it to appear not as a point, but as a very small disk, a circle of confusion. The farther that points are from the sharply focused distance, the larger the circles-and the more out of focus that part of the image will be. But, if the circles are small enough, the eye will see them as points, and that part of the image will appear to be sharp; it will be within the depth of field.

Depth of field can be shallow, with only a narrow band across the scene appearing to be sharp, or it can be deep, with everything sharp from near to far. To a large extent, you can control just how much will be sharp (the next pages tell how). There are no definite endings to the depth of field; objects gradually change from sharp to soft the farther they are from the sharply focused area (*photograph opposite*).

In general, the more a print is enlarged, the less sharp it appears. But sharpness is also affected by viewing distance: a mural-size print placed high on a wall and viewed at a distance of 20 feet may appear sharp even though the same print viewed up close may not.

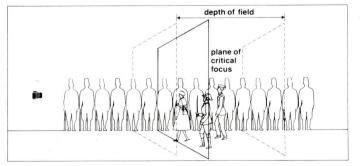

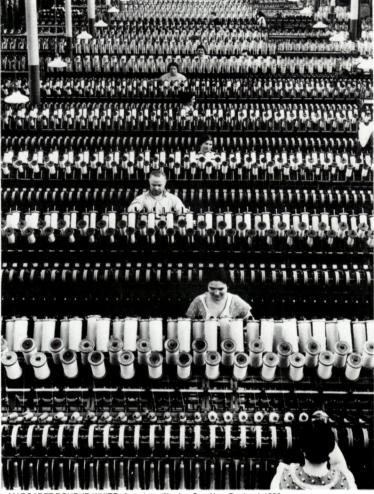

MARGARET BOURKE-WHITE: American Woolen Co., New England, 1935

The depth of field—the area in a scene in which objects appear sharp—can be deep or shallow. In the photograph above, everything is sharp from the nearest woman to the farthest spindle. In the photograph opposite, the depth of field includes only a few soldiers, the princess, and the officers, while other parts of the scene are increasingly out of focus the farther they are from the plane of critical focus.

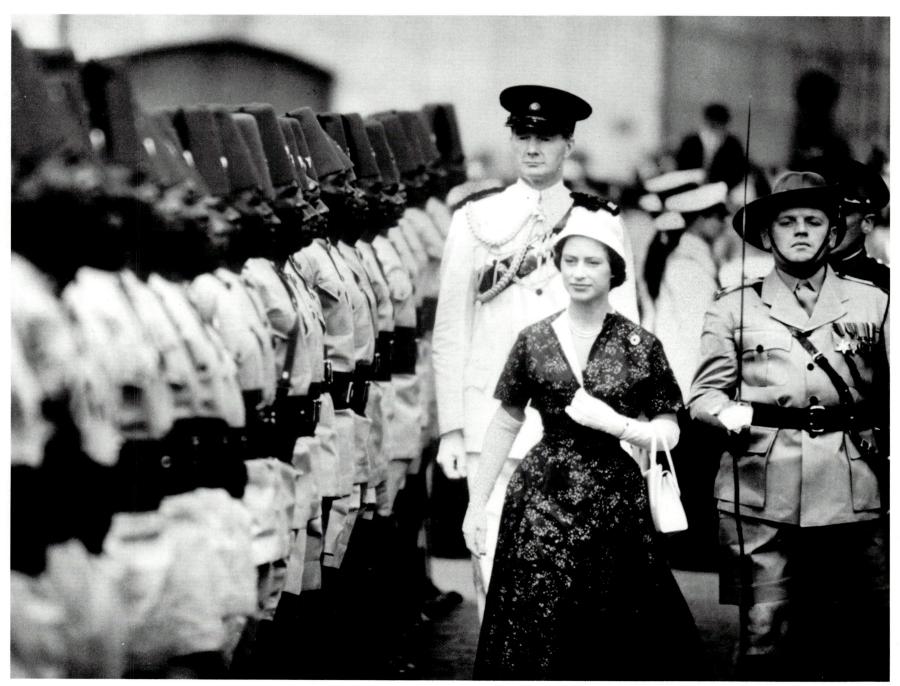

MARK KAUFFMAN: Princess Margaret Inspecting King's African Rifles, Mauritius, 1956

Controlling Depth of Field

There are several ways to control the depth of field, the distance between the nearest and farthest points in a scene that appear sharp in a photograph. If you want to increase the depth of field so that more of a scene is sharp, setting the lens to a small aperture is almost always the first choice. This is the case even though you have to use a correspondingly slower shutter speed to maintain the same exposure, which can be a problem if you are photographing moving objects. You can also increase the depth of field by changing to a shorter focal length lens or stepping back from the subject, but that will change the picture in other ways as well (*opposite*). To decrease the depth of field and make less of the scene sharp, use a wider aperture or a longer lens, or move closer to the subject.

Why does a lens of longer focal length produce less depth of field than a shorter lens used at the same f-stop? The answer relates to the diameter of the aperture opening. The **relative ap**- erture (the same f-stop setting for lenses of different focal lengths) is a larger actual opening on a longer lens than it is on a shorter lens. For example, f/8 on a 50mm lens is an aperture of larger diameter than f/8 on a 28mm lens. The diagram below shows why this is so. Since at the same f-stop setting, the aperture diameter of the longer lens is larger than that of the shorter lens, the circles of confusion for the longer lens will also be larger and the image will have less depth of field.

The smaller the aperture, the preater the depth of field. Here

the photographer focused on the mooring buoy. Near right: with a wide aperture, f/2, the depth of field was relatively shallow; only objects that were about the same distance from the lens as the mooring buoy are sharp: other objects that were nearer or farther are out of focus. Far right: only the aperture was changed, to a much smaller one-f/16. Much more of the scene is now sharp. Changing the aperture is usually the easiest way to change the depth of field.

50mm lens

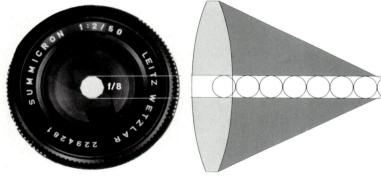

Any f-stop—for example, f/8—requires a larger aperture diameter for a longer-focal-length lens than for a shorter lens. The two lenses, left, are both set at f/8, but the actual opening in the 50mm lens (top). is larger than the opening in the shorter 28mm lens (bottom). As focal length increases, the amount of light that reaches the film decreases. Therefore, a long lens will form a dimmer image than a short lens unless more light is admitted by the lens.

The sizes of the aperture openings are adjusted so that at a given f-stop the same amount of light reaches the film no matter what the focal length of the lens. The f-stop number, also called the relative aperture, equals the focal length of the lens divided by the aperture diameter:

f-stop = $\frac{lens focal length}{aperture diameter}$

If the focal length of the lens is 50mm, at f/8 the actual diameter of the aperture will be 6.25 mm:

 $8 = \frac{50}{6.25}$

For a 28 mm lens, at f/8 the actual diameter of the aperture will be only 3.5 mm.

 $f/8 = \frac{28}{3.5}$

The diagrams, by actually lining up eight aperturesized circles and fitting them into the focal length of each lens, show the larger aperture diameter for the longer focal length.

The shorter the focal length of ► the lens, the greater the depth

of field. Near right: with a 200mm lens, only two gravestones are sharp. Far right: with a 35mm lens set to the same aperture and focused on the same point as the previous shot, a bigger section of the cemetery is now sharp. Notice that changing the focal length changes the angle of view (the amount of the scene shown) and the magnification of objects in the scene. The kind of picture has changed as well as the sharpness of it.

The greater the distance from ► the subject, the greater the depth of field. Near right: with the lens focused on the horse about 5 ft away, only a narrow band from near to far in the scene is sharp. Far right: stepping back to 15 ft from the horse and refocusing on it made much more of the scene sharp. Stepping back has an effect similar to changing to a shorter focal length lens: more of the scene is shown.

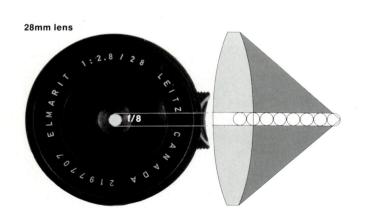

more depth of field

aperture

wider aperture

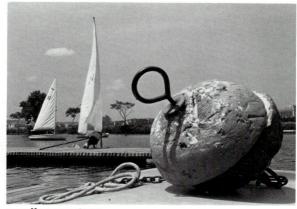

smaller aperture

shorter focal length

farther from subject

200mm lens

longer focal length

shorter focal length

longer focal length

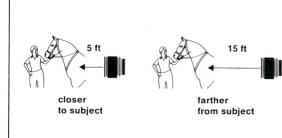

closer to subject

More About Controlling Depth of Field

How much of a scene should be sharp? You won't always want everything to be sharp. A distracting background is much less conspicuous if it is soft and out of focus instead of crisply detailed. But something that obviously should be sharp but isn't can be equally distracting. Pages 72-73 present basic techniques for controlling depth of field. Two other techniques are shown here. For these techniques you need a lens with a depth-of-field scale (the scale is described in detail on page 47). A zoom lens may not have one; a fixed-focallength lens usually will. You also need a camera that can be focused manually, not one that only works automatically.

When you want to be able to shoot rapidly without refocusing, **zone focusing** lets you set the depth of field in advance of shooting. This is useful if you can predict approximately where, but not exactly when, action will take place. It is also useful if you want to be relatively inconspicuous and don't want to spend time with your camera to your eye focusing (for example, when photographing strangers on the street). To zone focus, use the depth-of-field scale on your lens to find the f-stop and distance setting you will need to use in order to get adequate depth of field. Everything photographed within the near and far limits of that depth of field will be acceptably sharp; the precise distance at which something happens will not be important because the general area will be sharp (see explanation, below).

Sometimes you will want maximum depth of field, with everything sharp from the foreground to the far distance. When a scene extends into the distance, you may find that you rather automatically focus on a far part of the scene. In photographic terms, you have focused on **infinity**, which, depending on the lens, extends from about 40 feet or so to as far as the eye can see. (Infinity is marked ∞ on the lens distance scale.)

But for maximum depth of field in a scene that extends to a far distance, don't focus on infinity. Instead, turn the focusing ring so that the infinity mark falls just within the farthest limits of the depth of field for the f-stop you are using. You are now focused on a distance that is closer to the lens than infinity (the **hyperfocal distance**). Everything from the infinity distance and farther will still be sharp, but more of the foreground will be in focus (see *illustration, opposite*).

ELLIOTT ERWITT: Sunday in Hungary, 1964

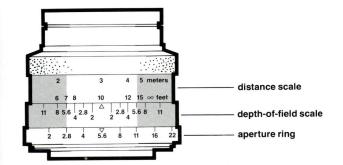

Zone focusing is a way of using a lens's depth-offield scale so you can be ready to shoot without focusing before every shot. Suppose the nearest point you want sharp is 7 ft away and the farthest is 15 ft away. Turn the focusing ring until those distances on the distance scale fall opposite a matched pair of f-stops on the depth-of-field scale. If you set your lens aperture to that f-stop, objects between the two distances will be in focus. Here, the two distances fall opposite a pair of f/5.6's. With this lens set to f/5.6 or a smaller aperture (f/8 or f/11), everything between 7 ft and 15 ft will be sharp. No further focusing need be done as long as the action stays between these distances.

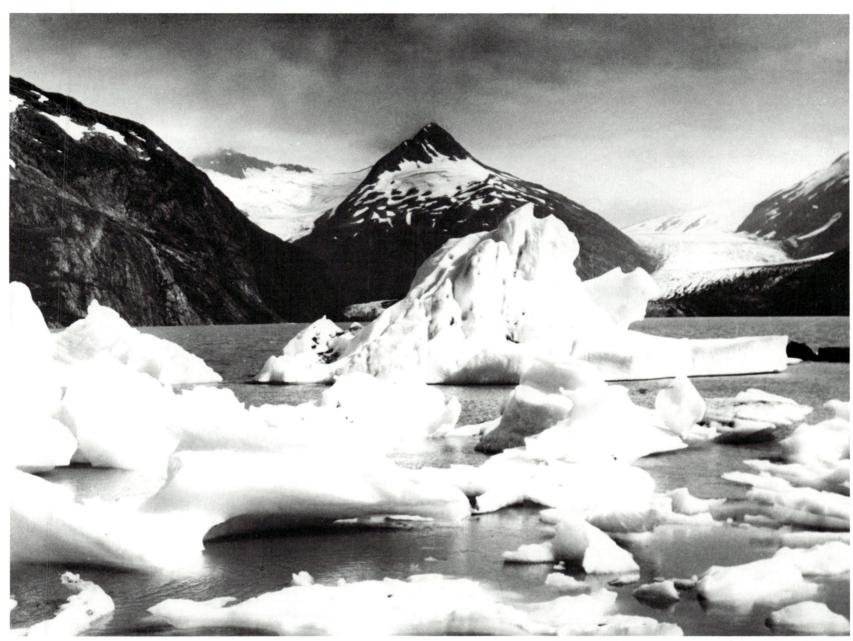

PHOTOGRAPHER UNKNOWN: Upper area of Mendenhall Glacier, Alaska, 1968

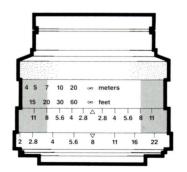

For maximum depth of field in a scene that extends to the far distance—infinity, in photographic terms (marked ∞ on the lens distance scale), don't focus on the infinity mark, as has been done with the lens at left. With this lens, if the aperture is f/8 and the lens is focused on infinity, everything from 20 ft to infinity will be sharp.

Instead, set the distance scale so that the infinity mark lines up opposite your f-stop on the depthof-field scale (lens, right). Now, with the lens still set to f/8, everything from 10 ft to infinity will be sharp.

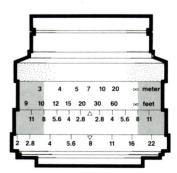

Automatic Focus

More and more cameras are coming equipped with automatic focus. When you push down the shutter-release button, the camera adjusts the lens to focus sharply on whatever object is at the center of the image. At first, just some point-and-shoot cameras had automatic focus, but now it appears increasingly on 35mm single-lens reflex cameras. Automatic focus works well in straightforward, simple scenes where the subject is in the center of the frame. Some autofocus cameras, when used with specially designed flash units, can focus in total darkness; the flash sends out a beam of infrared light that lets the camera focus the subject, even when you can't see it.

No automatic system functions well in every situation. Just as with automatic exposure, there will be times when you should override the automatic focusing mechanism or use the camera in its manual mode. If you have a camera with an autofocus option, don't let it do all the focusing for you. Don't buy a camera that cannot be focused manually unless it is to be used only for the simplest snapshooting.

The problems that you encounter with automatic focus depend on the system used in your camera. Some cameras, like the Polaroid Spectra, focus by sending out a burst of highfrequency sound. Sensors then count the time until an echo of the sound reflected by the subject returns to the camera; the longer the time, the farther away the subject. However, the sound will bounce back from a pane of glass if one is between you and your subject. So, for example, if you are on the street and want to photograph a holiday display inside a shop window, the camera will focus on the window pane and not on Santa's helpers, unless you focus manually.

An autofocus 35mm single-lens reflex camera has different problems. It uses photocells to analyze the contrast or other characteristics of the image formed by the lens and may not work well if a subject has very low contrast or is in very dim light. Also, the camera focuses on an area at the center of the viewfinder image (marked by the small brackets in the middle of the photos at right) on the assumption that most subjects are more or less centrally located. But not all subjects are, and for those you need to override the automatic focusing system as shown at right.

In some cases, the time required for focusing can create difficulties. An automatic-focus camera can take as long as two seconds between the first pressure on the shutter-release button and the actual beginning of the exposure. If the subject is moving so fast that you can't keep it within the focusing brackets for the time that the lens needs to adjust itself, the lens will "hunt" back and forth, unable to focus or maybe focusing on some part of the background. In single-shot or focus-priority operation, the shutter button will not operate at all until focus is set. In continuous- or servo-focusing operation, the camera will fire away, even if the lens is completely unfocused.

The point of all these cautions is not to say that you should never use automatic focus, but only that you should evaluate each situation. Override the automatic focus system when it is better to do so, rather than assuming that simply because you are set for automatic focus that the right part of the picture is going to be sharp. If you have enough depth of field and you set your lens manually, you can get a sharp photograph even if you haven't focused specifically on any particular object; pages 74–75 tell how.

Automatic-focus cameras focus on the center of a scene. This can make the main subject (or subjects) out of focus if it is off to one side and at a different distance from whatever is at the center. Here, small brackets at the center of the viewfinder indicate the focused area.

To correct this in autofocus mode, first focus by placing the autofocus brackets on the main subject; this can be done with many cameras by holding down the shutter button part way. Lock the focus by keeping partial pressure on the shutter release.

Then reframe your picture while keeping partial pressure on the shutter release. Push the shutter button all the way down to make the exposure. You can get the same results—a sharply focused main subject—by simply focusing the camera manually.

Using Focus and Depth of Field

Having this jockey who has just lost a race appear sharp, in contrast to the horse's disappointed trainer and owners who are out of focus, underscores the gulf between them. Horenstein had been looking for several days for a photograph to illustrate the excuses that jockeys make when they

HENRY HORENSTEIN: Jockey's Excuse, Keeneland, 1985.

lose a race. He positioned himself in the passageway that the jockeys used after a race and waited for something to happen. When it did, he knew he had a good picture, and remembers putting an X on the film cassette to remind himself to treat this roll of film with extra care.

Perspective

It is vital to learn to see things the way the camera sees them, since the camera image can appear surprisingly different from reality. A long lens used far from the subject gives a so-called **telephoto effect**—on page 71, for example, the line of soldiers seems compressed, with the soldiers in impossibly close formation. A short lens used close to the subject produces what is known as **wide-angle distortion**—on page 66 it apparently stretches a human form to unnatural proportions. See also the photographs on pages 80 and 81.

Those photographs seem to show distortions in **perspective**—in the relative size and depth of objects within the image. Actually, perspective is controlled not by lens focal length but by the lens-to-subject distance. How perspective changes when lens-to-subject distance changes is shown at right.

David Arky often photographs studio still lifes for advertising and corporate clients. He took the three pictures in the top row from the same distance but with lenses of different focal lengths. The shortest lens produced the widest view of the scene; the longest lens gave the narrowest view, simply an enlargement of part of the original picture. Eggs, bird, and cage all increased in size the same amount as lens focal length increased.

He took the three pictures in the bottom row with the same lens but from different distances. The closer he came, the bigger the foreground objects (eggs and nest) appear relative to the background one (cage). The nest is smaller than the cage in the first picture, bigger than the cage in the last picture. The brain judges depth in a photographed scene mostly by comparing the size of objects, so the depth seems to increase as the camera moves closer. Compare the illusion of depth in the two pictures at far right.

Top row: three views of the same still life, each shot from relatively far away, show how lenses of different focal lengths change the size of all the objects in a scene but not the size of one object compared to another. The first picture was taken with a short-, the next with a medium-, and the third with a long-focal-length lens.

short-focal-length lens, far from subject

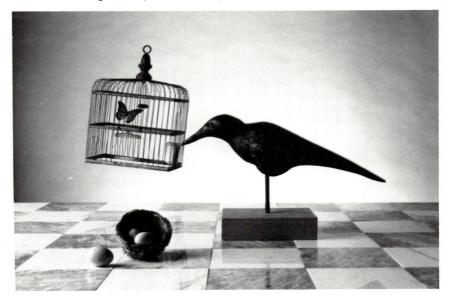

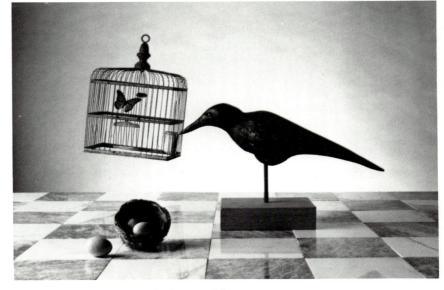

short-focal-length lens, far from subject

Bottom row: changes in a lens's distance from a scene change the relative size of near and far objects. As the lens came closer to the scene, foreground objects enlarged more than back-ground ones to give three different perspectives.

medium-focal-length lens, far from subject

long-focal-length lens, far from subject

short-focal-length lens, medium distance from subject

short-focal-length lens, close to subject

Using Perspective

ANDREAS FEININGER: Cemetery, New York, 1948

You can exaggerate the perspective, the impression of depth in a photograph, simply to add impact to an image or to communicate an idea visually. What is known as telephoto effect seems to compress the objects in a scene into a crowded mass. It occurs when a long-focal-length lens is used far from a subject. Left, the tombstones in a New York cemetery appear to be as densely packed as the current residents of New York City are.

A short-focal-length lens used up close increases the apparent size of the part of the subject that is closest to the camera, producing what is called wideangle distortion. Like telephoto effect (shown opposite), this is caused by the distance of the lens to the subject, not by the lens itself. Right, the fists that brought the world heavyweight championship to Joe Louis are emphasized in this brooding portrait taken after the fighter had lost his title and fallen on hard times.

types of flare

Getting the Most from a Lens

A modern compound lens is a complex structure of glass and metal designed to give precise focusing and a sharp image. Lens performance can be improved or degraded by how you handle and care for a lens.

Stopping down the lens aperture often improves the image by eliminating rays from the edges of the lens where certain aberrations occur. Even a well-designed lens may have some aberrations that were impossible to overcome in manufacture. This is especially so if it is a zoom, extremely wideangle, or telephoto lens or if it has a very wide maximum aperture or is used very close to the subject.

There is a limit to the improvement that comes with stopping down. As light rays pass across a sharp, opaque edge, like the edge of the diaphragm opening, the rays bend slightly. As the lens is stopped down and the aperture becomes smaller, this edge bending or diffraction can cause a point of light to appear as a blurred circle and the whole image to appear very slightly less sharp. The optimum aperture at which most lenses perform best is two or three f-stops stopped down from the widest aperture. This is enough to minimize aberrations but not enough to cause noticeable diffraction. Of course, in a particular situation you may prefer the increased depth of field that results if the lens is stopped down all the way.

Ordinarily you will want to avoid **flare** —the reflection and scattering of light within the lens and camera—although it is sometimes deliberately used for a special effect. **Ghosting** (*right*, *top*) occurs when you include a strong light source, such as the sun or a bright bulb, in the picture. Ghosting is difficult to cure since its cause is within the picture itself. Sometimes you can change your position so that some object comes between the lens and the light source. Even when the light source is not actually in the picture, light rays hitting the front surface of the lens at an angle can scatter within the lens and cause an overall **fogging** of the image (*right, bot-tom*).

Avoid flare by using a **lens shade** or lens hood. This will block any light outside the lens's angle of view that might be shining at an angle on the lens surface. Be sure the lens shade is matched to the focal length of the lens you are using. The shorter the focal length of the lens, the wider the angle the lens sees and the wider the shade must be to avoid becoming part of the scene itself and **vignetting** or blocking the light from the edges of the image (*opposite*).

Lens coatings also reduce flare. Since some reflection and scattering of light take place at every glass-to-air surface of the lens, including those within the lens, manufacturers coat lens surfaces with a very thin layer of a metallic fluoride. This coating helps reduce reflections and subsequent flare. The coatings are extremely thin—as little as 0.0001 mm—and relatively delicate. Treat them with care when cleaning the lens.

A clean lens performs better than a dirty one. Dust, grease, and drops of moisture all scatter the light that passes through a lens and soften the sharpness and contrast of the image. However, although a lens should be kept clean, too frequent or too energetic cleaning can produce a maze of fine scratches or rub away part of the lens coating. See box, page 85, for how to keep your lens and camera in peak condition.

ghosting

fogging

Stray light bouncing around inside the lens caused the two effects seen above. Top, the photographer included the bright sun directly in the image. Light reflecting from the various lens elements caused multiple images in the shape of the lens diaphragm, as well as star points (streamers of light around the sun itself). Although it was not actually in the picture below, the sun caused flare in the image by shining on the front glass surface of the lens. To prevent this type of flare use a lens shade designed to match your lens's focal length. Too long a shade will vignette the image (see opposite, bottom).

What Went Wrong?

double exposure

light streaks

lens shade

lens shade

vignetting

Troubleshooting Camera and Lens Problems

All photographers occasionally encounter problems with their pictures, sometimes owing to equipment failure, sometimes to human failure. If your negatives don't look the way you expected, see below. See also Troubleshooting Negative Problems (page 151), Print Problems (page 181), and Flash Problems (pages 288).

Picture not sharp

Cause: Too slow a shutter speed will blur a moving subject or blur the picture overall due to camera motion. Too wide an aperture will make the scene sharp where you focused it, but not in front of or behind that part.

Prevention: Faster shutter speed or smaller aperture (see pages 42–43 and 46–49). Hold camera more steadily (see pages 50–51).

Dark streaks in negative, light in print or slide

Cause: Exposure to unwanted light before film is developed and fixed. Sections of streaks across the width of the film are caused by opening the back of a loaded camera. A damaged cameraback or bent film cassette can cause light streaks along one edge of the film (illustration, center), as can opening the developing tank before the film is completely fixed. Either type of streak can be caused by loading the camera in bright light.

Prevention: Avoid loading camera in bright light; keep undeveloped rolls of film away from light. One roll of light-struck film is an accident; repeated problems are probably equipment failure.

Vignetting (image dark around the edges)

Cause: A lens shade or filter or combination of them that extended too far forward of the lens front, obscuring part of the image (illustration, bottom). In large-format cameras, this can be caused by a lens with inadequate coverage of the film format (see page 292).

Prevention: Lens shades are made in sizes to match lens focal lengths. Use the correct size shade for your lens. Check for vignetting if you are using a wide-angle lens with both a filter and lens shade. The filter can move the lens shade just far enough forward to be seen.

Double exposures

Entire roll double exposed.

Cause: The same roll of film was run through the camera twice.

Prevention: Rewind an exposed roll of film, including the film leader, entirely back into the film cassette. If part of the leader hangs out, you may later mistake an exposed roll for an unexposed one.

One frame double exposed.

Cause: Probably the film rewind button was inadvertently pushed, which would let you expose some or all of the same frame twice (see illustration, top).

Prevention: Check the way you grip the camera. It is difficult to push the rewind button without intending to do so, but it is possible.

Frames frequently overlap.

Cause: Probably a failing film-advance mechanism.

Prevention: Camera repair.

No picture at all

Image area and edges of film (except for film frame numbers) are both clear.

Cause: Film was not exposed to light. If the entire roll of film is blank, an unexposed roll may have been processed by mistake. If you are sure you took pictures with the film in the camera, it probably did not catch on the film-advance sprockets and so did not advance from frame to frame. If only some frames are blank, the lens cap could have been left on during exposure, the flash failed to fire, the shutter failed to open, or the mirror in a reflex camera failed to move out of the way of the film.

Prevention: Check for equipment failure if this is a recurring problem.

Image area of film is very dark, edges are clear (except for film frame numbers).

Cause: Massive overexposure of film in the camera. In very bright light, the aperture failed to stop down, shutter failed to close, shutter mistakenly set to B, or exposure calculated using much too low a film speed.

Prevention: Check for equipment failure if you are sure the film speed and exposure were correctly set.

Image area and edges of film are both very dark.

Cause: The entire roll of film was accidentally exposed to light—for example, by turning on the room lights after the film had been spooled onto the developing reel but before it was put into a light-tight developing tank.

Image area and edges are both clear. Film frame numbers do not show.

Cause: The film was put into fixer before it was developed.

Prevention for both of the above: *Try not to do it again.*

Choosing Lenses

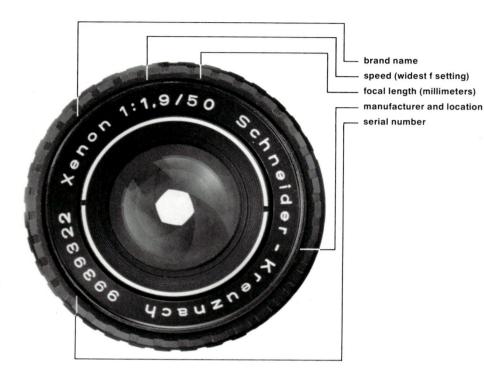

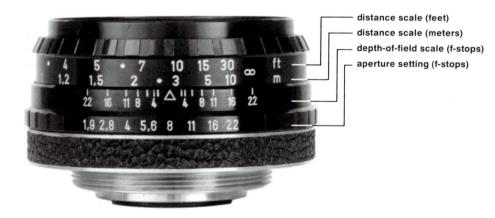

Learn to read the information about a lens that is marked on it. On its front (top photograph) are its brand (Xenon), its speed (maximum aperture of f/1.9), its focal length (50 mm), its maker's name and location (Schneider, Kreuznach, Germany), and its serial number (9939322). Distance, depth of field, and aperture scales are marked on the side of the lens. Since buying a lens can involve a considerable investment of money, it pays to invest a little time in deciding exactly what lenses you need.

The "speed" of a lens affects its price. Lenses made by reputable manufacturers can be assumed to be reasonably good. And yet two lenses of the same focal length, perhaps even made by the same company, may vary widely in price. This price difference probably reflects a difference in the speed of the lens. One will be faster-it will have a wider maximum aperture and admit more light than the other. The faster and more expensive lens can be used over a wider range of lighting conditions than the slower one but otherwise may perform no better. It may, in fact, perform less well at its widest aperture because of increased optical aberrations.

Following are some guidelines for **buying camera lenses**.

1. If you are getting a camera with interchangeable lenses, start with a normal lens. (This is the one that ordinarily comes with the camera anyway.) Don't buy more lenses until you feel a strong need to take the different kinds of pictures that other focal lengths can provide.

2. Get your lenses one at a time and think ahead to the assortment you may someday need. Begin by buying lenses in increments of more or less two times the focal length; for example, a good combination for a 35mm camera is a 50mm normal lens for general use, a 28mm wide-angle lens for close-in work, and a 105mm long lens for portraits and for magnifying more distant subjects. Be wary of ultra-wide-angle (24mm or below) and extra-long (above 200mm) lenses. They may be considerably more expensive than the less extreme types and are so specialized that their usefulness is limited. Adjustable-

Caring for Your Camera and Lens

length zoom lenses are popular, although they are more expensive and may not produce as critically sharp an image as conventional lenses.

3. Don't spend money on extra-fast lenses unless you have unusual requirements. A couple of extra f-stops may cost you an extra couple of hundred dollars. With modern high-speed film, a lens that can open to f/2.8 is adequate in all but the dimmest light.

4. Consider a secondhand lens. Many reputable dealers take used lenses in trade, and they may be bargains. But look for signs of hard use, such as a dented barrel, scratched lens surface, or a slight rattling that may indicate loose parts, and be sure to check the diaphragm to see that it opens smoothly to each f-stop over the entire range of settings.

5. Test your lens. The only sure way is to take pictures with it in your own camera at various f-stops, so insist on a trial period or a return guarantee. If you plan to buy several lenses eventually, a good investment is a standardized test chart that can give an accurate reading of a lens's sharpness.

6. A lens shade is a very desirable accessory to attach to the front of the lens to prevent flare (*see page 82*). Buy one that is matched to the focal length of the lens; too wide a shade is inefficient, too narrow a shade will cut into the image area (*see vignetting, page 83*).

	film size used by camera			
	35mm	$2^{1\!/_{\! 4}}\times2^{1\!/_{\! 4}}$ inch	$2^{1/4} \times 2^{3/4}$ inch	4×5 inch
short focal length	35mm or shorter	55mm or shorter	75mm or shorter	90mm or shorter
normal focal length	50mm	75mm, 80mm	100mm	150mm (6 inch)
long focal length	85mm or Ionger	120mm or longer	150mm or longer	250mm (10 inch) or longer

Cameras and lenses are rugged, considering what precision instruments they are. Commonsense care and a little simple maintenance will help keep them running smoothly and performing well.

Protect from dust and dirt. The best way to keep equipment clean is not to get it dirty in the first place. Cases and bags protect cameras and lenses from bangs and scratches as well as keep them clean. Keep a cap on the lens when it is not in use, and if you take a lens off a camera, protect both front and back lens surfaces either by placing the lens in a separate lens container or by capping both ends. Sand is a particular menace; clean the camera well after using it on the beach.

Protect from moisture. Most modern cameras are packed with electronic components that can corrode and malfunction if exposed to excessive humidity or moisture, especially salt water. On a boat or at the beach, keep equipment inside a case when it is not in use. If you use it where salt spray will get on it, wrap it in a plastic bag so just the lens pokes out.

Protect from temperature extremes. Excessive heat is the worst enemy. It can cause parts to warp, lubricating oil inside the camera to get where it shouldn't be, and film to deteriorate. Avoid storage in places where heat builds up: in the sun, inside an auto trunk or glove compartment on a hot summer day, or near a radiator in winter.

Excessive cold is less likely to cause damage but can make batteries sluggish. If you photograph outdoors on a very cold day, keep your camera warm inside your coat until you are ready to use it. Moisture can condense on a camera, just as it does on eyeglasses, if metal or glass that has gotten cold outdoors meets warm, humid air when it comes indoors. Keep a cold camera wrapped up until it comes to room temperature.

Protect during storage. If you won't be using the camera for a while, release the shutter, make sure the meter is off, and store in a clean, dry place. If

humidity is high, ventilation should be good to prevent a buildup of moisture on electronic components. Cock and release the shutter once in a while; it can become balky if not used for long periods of time. For long-term storage, remove batteries to prevent possible damage from corrosion.

Batteries provide the power for a camera's metering system, viewfinder readout, automatic functions, and sometimes the shutter. Check the battery strength regularly (see manufacturer's instructions).

How to clean a lens. Gently. Blow or gently brush any dust particles from the lens surface. Be especially careful with granular dirt, like sand, which can scratch the lens surface badly. To clean grease or water spots from the lens, wad a clean piece of camera lens tissue into a loose ball and moisten it with a drop or two of lens cleaner solution. Don't put drops of solution directly on the lens. They can seep along the edges of the lens to the inside. Wipe the lens gently with a circular motion. Dry it by wiping gently with another clean piece of wadded lens tissue. Don't use any products designed for cleaning eyeglasses.

How to clean a camera. If you are cleaning the lens or changing film, also check inside the camera for dust that can settle on the film and cause specks on the final image. Blow or gently dust along the film path, particularly around the winding mechanisms, but with a single-lens reflex be careful not to damage the shutter curtain in the body of the camera or the film pressure plate on its back. The shutter curtain is particularly delicate, and it is best not to touch it at all unless absolutely necessary.

Professional care is recommended for all but basic maintenance. Never lubricate any part of the camera yourself or disassemble anything for which the manufacturer's manual does not give instructions. Cameras are more difficult to put back together than they are to take apart.

The chart at left gives some typical focal lengths for cameras using various sizes of film. Focal lengths are sometimes stated in inches, sometimes in millimeters. There are approximately 25 mm to an inch.

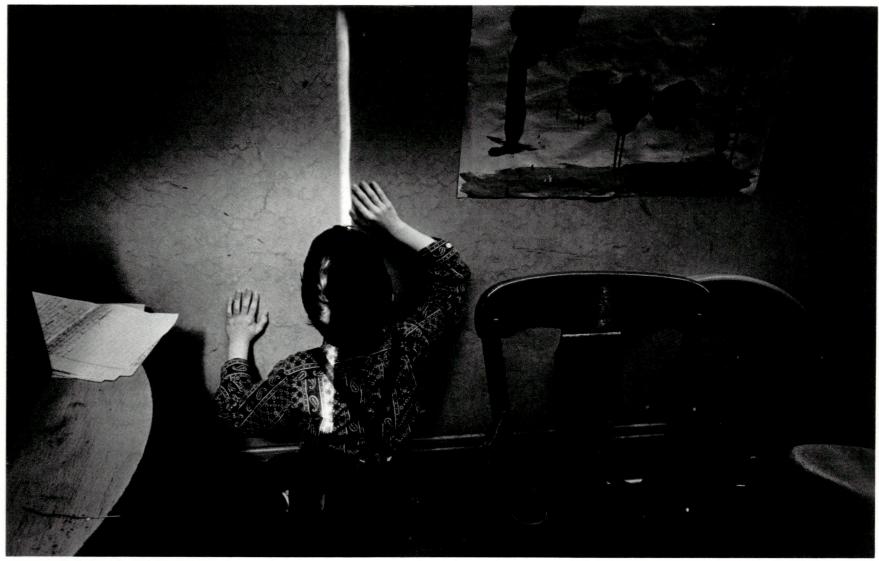

CHARLES HARBUTT: Blind Boy, New York City, c. 1960

The spectrum contains heat as well as light, and you can feel the sun even if you can't see it. Charles Harbutt's photograph is an interesting picture even without the title. But the words add a poignant meaning that greatly strengthens the photograph; without the words there is no clue that the child can't see. This picture is one of a series Harbutt made of children at The Lighthouse in New York City, an institution for the blind. Harbutt had noticed that every day the boy used his hands to feel for the warmth created by the rays of sunlight that threaded the narrow space between two buildings each afternoon at about the same time.

4 Light and Film

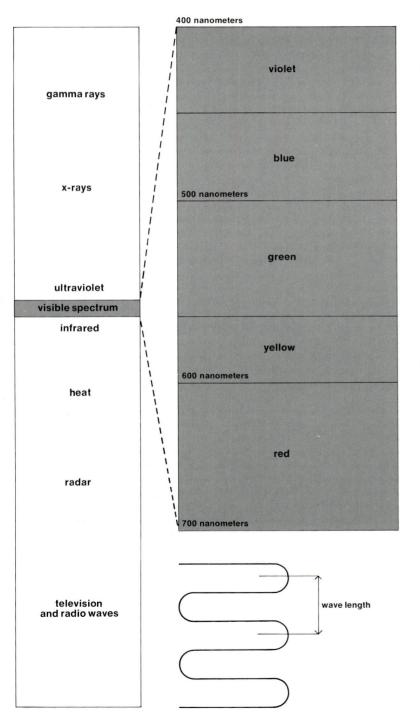

Making an Image in Silver 88 Characteristic Curves: How Films Respond to Light 90 Choosing a Film 92 Film Speed and Grain 93 For Maximum Detail—Slow and Medium-Speed Films 94 When Speed Is Essential—Fast Films 96 How Black-and-White Film Sees Color 98 Infrared Film: Seeing Beyond the Visible 100 Instant-Print Film 102 Using Filters 104 A Polarizing Filter to Reduce Reflections 106 More About Filters 107

The light that we see and that we use to form an image on film is only a small part of a tremendous range of energy called the **electromagnetic spectrum** (*diagram*, *left*), which also includes X-rays, heat, radar, and television and radio waves. This energy can be described as waves that spread from a source in the same way that ripples spread when a stone is dropped in a pond of water. The waves can be measured; the distance from crest to crest (wavelength) ranges from 0.000000001 millimeter for some gamma rays to six miles for some radio waves.

The human eye is sensitive to a very small group of waves near the middle of the spectrum whose wavelengths range from about 400 nanometers (billionths of a meter) to 700 nanometers. When waves in this **visible spectrum** strike the retina of the eye, the brain senses light; each wavelength or combination of wavelengths produces the sensation of a different color, and a mixture of all the wavelengths produces colorless or "white" light. For most purposes, films are manufactured to be sensitive to about the same range of wavelengths that the eye sees.

Making an Image in Silver

Black-and-white film is usually only about 0.005 inch thick, but it is made up of a number of layers, as shown above. The surface is a thin protective coating to prevent scratches on the emulsion layer below. This emulsion layer—the region where the image is formed—consists of about 60 percent gelatin and 40 percent light-sensitive crystals. (Chromogenic film also contains dye couplers in the emulsion.) Beneath the emulsion is an adhesive that binds it to the next layer. The film base is a firm but flexible plastic, which provides support. The base is backed, by means of another adhesive bond, with an antihalation coating, which prevents light from reflecting back through the emulsion ter.

scratch-resistant coating
gelatin
adhesive
cellulose-acetate base
adhesive
anti-halation coating

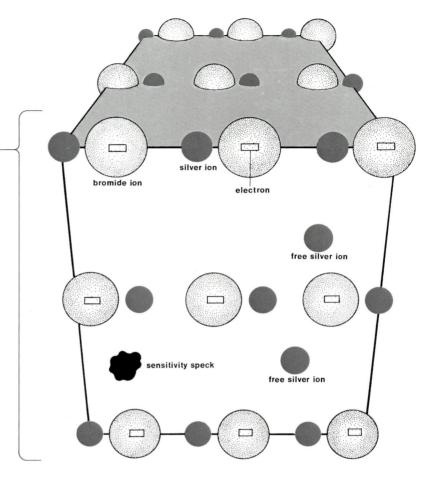

The process that creates a picture on a piece of film involves a reaction between light and the silver-halide crystals spread through the gelatin of the emulsion layer. Each crystal is a compound of silver plus a halogen such as bromine, iodine, or chlorine, held together in a cubical arrangement by electrical attraction. If a crystal were a perfect structure lacking any irregularities, it would not react to light. However, a number of electrically charged silver ions are also in the structure and move about when light strikes the emulsion, eventually forming an image. The crystal also contains impurities, such as molecules of silver sulfide, that play a role in the trapping of light energy.

As shown in the diagrams opposite, an impurity—called a sensitivity speck —and the free-moving silver ions build a small collection of uncharged atoms of silver metal when the crystal is struck by light. This bit of metallic silver, too small to be visible even under a microscope, is the beginning of a latent image. Developing chemicals use the latent image specks to build up **density**, an accumulation of enough metallic silver to create a visible image.

A chromogenic film is somewhat different from the conventional silverhalide film described above. A chromogenic emulsion contains dye couplers as well as silver halides. During development, the presence of silver that has been exposed to light leads to a proportional buildup of dyes. The original silver is then bleached out, leaving the dyes to form the visible image. Most color materials use chromogenic development to produce the final color image, as does one type of black-andwhite film, which produces black dye instead of colors. A silver bromide crystal (above) has a cubic structure somewhat like a jungle gym, in which silver (small balls) and bromine (large balls) are held in place by electrical attraction. Both are in the form of ions—atoms possessing electrical charge. Each bromide ion has an extra electron (small box) that is, one more electron than an uncharged bromine atom, giving it a negative charge; each silver ion has one electron less than an uncharged silver atom and is positively charged. The irregularly shaped object in the crystal represents a "sensitivity speck." In actuality, each crystal possesses many such specks, or imperfections, which are essential to the image-forming process (diagrammed at right).

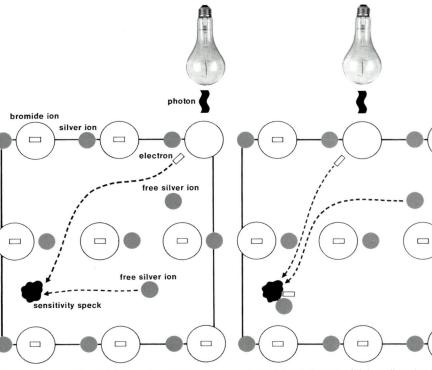

When a photon of light strikes a silver bromide crystal, image formation begins. The photon gives its energy to a bromide ion's extra electron, lifting it to a higher energy level. Then the negatively charged electron can roam the structure of the crystal until it reaches a sensitivity speck. There its electrical attraction pulls a positively charged free silver ion to it. As additional photons of light strike other bromide ions in the crystal and release electrons, more silver migrates to the sensitivity speck. The electrons join up with the silver ions, balancing their electrical charges and making them atoms of silver metal. However, if the crystal were examined through a microscope at this stage, no change would be seen.

The presence of several metallic silver atoms at a sensitivity speck constitutes a latent image—an invisible chemical site that will serve as the starting point for the conversion of the whole crystal to silver during development. The developer enormously magnifies the slight chemical change caused by light energy and creates the visible photographic image.

MINOR WHITE: Negative Print of Feet, San Francisco, 1947

A conventional black-and-white negative is formed when millions of exposed crystals are converted to silver metal by the developer. The result is a record of the camera's view in which the film areas struck by the most light are darkened by metallic silver, while the areas struck by no light remain transparent after processing, since they contain no silver. The intermediate areas have varying amounts of silver, creating shades of gray.

When this very ordinary scene was printed as a negative image, the feet became not quite real. They seem to float above the surface of the floor, as if the subject is stepping off into space. The skin tones resemble an X-ray, so that one looks not just at the feet but into them. The diagonal lines of the floorboards add a visual tension to the picture, repeating at an angle the rectangular shape of the print format.

Characteristic Curves: How Films Respond to Light

The more light that reaches film, the denser with silver (or dyes), and so the darker, the developed negative will be. The pictures opposite were all taken at the same aperture and shutter speed. As more and more light bulbs shine on the head of Buddha, the negatives (*bottom row*) become darker. The negatives are the opposite of their positive prints (*top row*); the darkest parts of the negative are the lightest in the print.

The response of a particular film to light can be diagrammed as its **characteristic curve**, which shows to what degree silver density increases as the amount of light reaching the film increases. The graph on the next page represents the characteristic curve for the film used in taking those pictures.

The curve shows graphically something you can also see if you look closely at the pictures—the density of the negatives did not increase in exact proportion to the amount of light reaching the film. Although the light was doubled for each exposure, the negative densities increased slowly for the first few exposures (the **toe** of the curve), increased more rapidly for the middle exposures (the **straight-line** portion), then leveled off again for the last exposures (the **shoulder**).

Here the characteristic curve plots seven different pictures. But imagine the seven pictures as all part of the same scene, each representing an object of a different tone ranging from a dark, shadow area (*Buddha at left*) to a brilliant, highlight area (*Buddha at right*). If you take a picture of such a scene, the film will record different densities depending on the lightness or darkness of the various objects and on the portion of the characteristic curve in which they fall.

In the straight-line portion of the curve, an increase in light will cause a proportionate increase in density, but in the toe and shoulder portions an increase in light will cause a much smaller increase in density. This means that in the straight-line portion, tones that were different in the original scene will look that way in the final print. The tonal separation will be good for these areas and the print will seem to represent the scene accurately.

When film is **underexposed**, it receives too little light. The tones move toward the toe of the curve, where only small increases in silver density occur. With considerable underexposure, shadow areas and midtones are thin, tonal separation poor, and detail lost. Only light areas of the original scene are on the straight-line portion and show good tonal separation and detail. Tones are reversed in the positive print, so a print will tend to be too dark.

When film is considerably **overex-posed**, it receives too much light. The tones move too much toward the shoulder of the curve. Midtones and bright values are too dense with silver; they "block up" without tonal separation, and details again are lost. Only the shadow values show tonal separation and detail. A print will tend to be too light.

Exposure is not the only process that affects the density of a negative. The developer used and the time and temperature of development also affect density, especially for bright areas in the original scene. The Zone System is one method used by some photographers for controlling densities in a negative by making adjustments in exposure and development (pages 313-325). Some adjustments can also be made to an image during printing, but a very thin or very dense negative will never make a print with the richness and clarity of a print made from a properly exposed negative with good tonal separation.

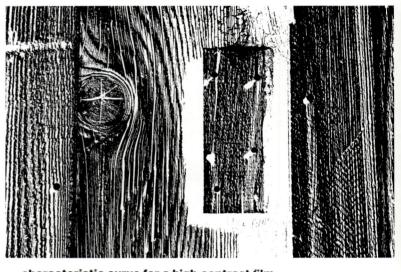

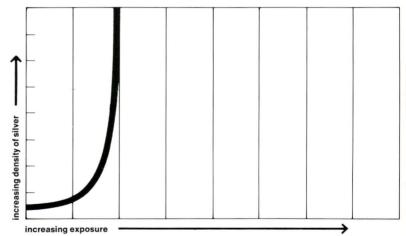

Different films have different characteristic curves. The negative above, made with high-contrast film, consists of two tones, maximum black and maximum white. High-contrast film has a curve that rises almost straight up. Silver density increases rapidly in the negative so that tones above a certain light level are recorded as very dense areas; they will appear in a print as white. Tones below a certain light level are recorded mostly as clear areas in the negative; they will appear in a print as black. Compare this to the curve for the normal-contrast film at right, in which density increases gradually and many midtones are produced.

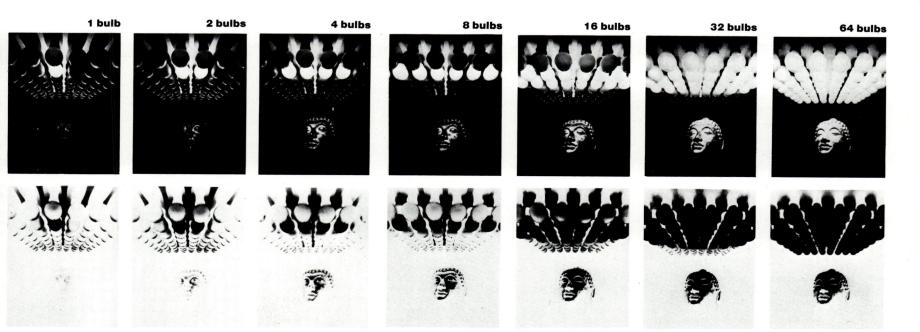

characteristic curve for a normal-contrast film

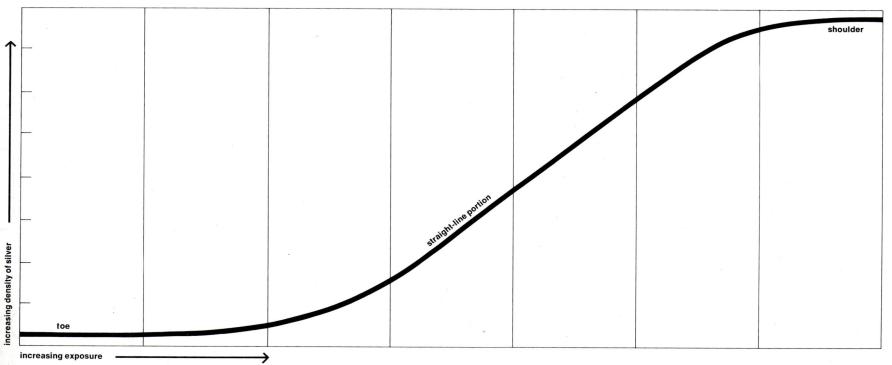

What film speed do you need? The faster a film, the less light is required to produce an image; therefore, faster film can be used in dimmer light or with faster shutter speeds or smaller apertures. Faster films tend to produce grainier pictures (see opposite), so theoretically you will get the best results by selecting the slowest film usable in each situation. In practice, however, it is inconvenient and unnecessary to work with several types of film. Some photographers use a moderately fast film, such as ISO/ASA 400, for almost all their work. One type of film may not be enough, but two-a slow, fine-grain one and a fast one-are enough for most photographers.

Storage and handling affect film performance. Heat affects any film badly, so don't leave film where temperatures may be high, such as in a car's glove compartment on a hot day or near a heater in winter. Film keeps well in the refrigerator or freezer if it is in a moisture-proof wrapping. Let it warm to room temperature before unwrapping it so that moisture does not condense on the surface.

When buying film, check the expiration date on the side of the film package; there is a steady decline in quality and speed after the expiration date. Make sure that the dealer has refrigerated the film if that is recommended by the manufacturer, as it is for professional color film and infrared film.

Load and unload your camera out of strong light and put exposed film where strong light won't reach it. Light can ruin your pictures by fogging them with unwanted exposure if the light leaks around the edges of the film spool or into the light-trap opening out of which the film feeds. Airport security X-ray machines can also fog film, so ask to have film examined by hand rather than passing it through the machine.

Film Characteristics

Negative film. Produces an image on the film in which the tones (or colors) are the reverse of those in the original scene—light areas in the scene are dark in the negative, dark areas are light. Later the negative is printed, usually onto paper, to make a positive image, with tones the same as in the original scene.

Reversal film. Produces a transparency, a positive image on the film, with tones (or colors) the same as those in the original scene. Most reversal films are color, but a few black-and-white films can be given reversal processing.

Instant films. No need to go into the darkroom to develop these films. The film packaging itself contains the chemicals to process each picture. Polaroid makes them for their own cameras, such as the Spectra, as well as for use in 35mm cameras and view cameras. For more about instant black-and-white films, see pages 102–103; for instant color films, pages 256–257.

High-contrast film. Produces two tones, a clear film base and a very dense deposit of silver (see illustration, page 90, and pages 210–215).

Infrared film. Responds to infrared wavelengths that the human eye cannot see (see pages 100–101).

Color film. More information in Chapter 10, Color, pages 221–257. See Choosing a Color Film, page 225.

Chromogenic black-and-white film. Ilford XP1, a chromogenic black-and-white film, produces a dye image rather than a silver one. It has great exposure latitude, which means that you can expose individual frames on the same roll of film at different film speeds and get printable negatives in all cases, unlike most conventional films, which should be exposed at a single film speed. Frames exposed at about ISO/ASA 100 will have finer grain, but frames on the same roll of film can be exposed at speeds as high as ISO/ASA 800. Unfortunately, the film must be developed as if it were a color negative (in Kodak's C-41 chemistry or Ilford's version of the same process), which is not as simple or as inexpensive as conventional blackand-white development.

Professional films. The word "professional" in a film name sometimes means the film has certain characteristics that meet the needs of professional photographers, although you don't have to be a professional to use one. Sometimes the use of the term is merely a marketing strategy. Professional black-and-white films differ from general-purpose black-and-white films in relatively minor ways. Tri-X Pan Professional Film, for example, has a film base that can be retouched. Its response to light is somewhat different from that of regular Tri-X Pan Film; Kodak recommends it particularly for lowflare studio lighting conditions, but it can be used with any type of lighting. The differences between professional and nonprofessional color films are more important (see box, page 225).

Format. The size of film to buy naturally depends on the size your camera accepts. 35mm film is packaged in cassettes and produces up to 36 $1 \times 1^{1/2}$ -inch negatives. Some 35mm films can be purchased in 100-foot rolls, then loaded into separately purchased cassettes. This reduces the cost and, if you use a great deal of film, can be worthwhile. Roll film is wound around a spool and is backed with a separate strip of opaque paper to protect it from light. (The term "roll" is also used in a general sense to refer to any film that is rolled rather than flat.) 120 roll film makes 12 $2^{1/4} \times 2^{1/4-1}$ inch negatives or 8, 10, or 16 rectangular negatives, depending on the camera. Some cameras accept 220 roll film, which has paper only on the end, reducing the thickness of the roll so that twice as much film can be loaded on the roll. Sheet film or cut film for use in view cameras is made in 4 \times 5-inch and larger sizes. It is packed 10 or more sheets to a box and must be loaded in film holders before use.

Film speed. The higher the number in a given rating system, the faster the film—the less light it needs for a correct exposure. There are several rating systems. An ASA rating (common in the United States) doubles each time the speed of the film doubles. A film rated at ASA 200 is twice as fast as ASA 100 film. The ASA 200 film requires only half the exposure that the slower ASA 100 film does to produce the same negative density. A DIN film speed rating (used in Europe) adds 3 to the rating each time the film speed doubles: ASA 100 equals DIN 21, ASA 200 equals DIN 24, and so on.

An **ISO** (International Standards Association) rating combines ASA and DIN, such as ISO 100/21°. A shortened version uses only the ASA part of the combined rating, ISO 100. An **EI** or exposure index rating is similar to an ISO or ASA rating, for example, EI 100.

Don't worry too much about this numerical soup. Almost all film and equipment sold in North America uses an ASA, short ISO, or El rating, which are identical. Slow films are about ISO/ASA 50 or less; medium-speed films about ISO/ASA 100; fast films about ISO/ASA 400; ultrafast films ISO/ASA 1000 or more. Some cameras set the film speed automatically if the film has DX coding, a checkered code on the film cassette that is read by sensors in the camera.

Film Speed and Grain

ISO/ASA 32 film speed

ISO/ASA 400 film speed

ISO/ASA 1000 film speed

The segments at left were enlarged from three different photographs similar to the one at right. Each photograph was made on a film of a different speed. The segments show how graininess increases as film speed increases.

The faster the film, the more visible its **grain**, its particles of silver—to the extent that very fast films reproduce what should be uniform gray areas not as smooth tones but with distinct specks. Fast films (which contain larger silver halide crystals) produce coarser grain than slower films (which have smaller crystals), because when the faster films are developed, they yield larger bits of silver or, in the case of color or chromogenic black-and-white films, dyes.

The relationship between speed and graininess can be seen in the enlarged segments of photographs shown at left. Films of different speeds were used for the negatives from which the enlargements were made. Each increase in speed also increased graininess. If maximum sharpness and minimum graininess are your desire, select the slowest film that the situation will permit. Extreme grain is not always something to be avoided; it can be used for special effect.

Certain film and developer combinations enhance fine grain; for example, Kodak Technical Pan 2415 film used with Technidol LC developer produces extremely fine grain and high resolution of detail. The film lets you make very big enlargements without loss of quality, so much so that an enlargement from a 35mm frame of film can almost look as if it were made from a 4 \times 5-inch negative.

Recent advances in technology have changed what used to be a fairly straightforward relationship between film speed and grain. The silver-halide crvstals of some newer films, such as Kodak's T-Max films, have been altered to make them more sensitive to light; film speed is increased but grain remains relatively fine. The result is film with significantly reduced grain for its speed. Subtle differences remain a factor, however. Although Kodak Tri-X (ISO/ASA 400) doesn't have as fine grain as Kodak T-Max 400 (same film speed), Tri-X continues to be a popular film because, for example, it tends to maintain detail in bright highlights more readily than T-Max 400 does.

For Maximum Detail—Slow and Medium-Speed Films

A **slow film**, ISO/ASA 50 or less, is useful when you want to show very fine detail or want to enlarge a negative considerably with a minimum of grain. A slow film has very small silver halide crystals and a thin emulsion, both of which increase its ability to render detail sharply. (A thin emulsion reduces the internal reflection of light among the crystals, reflections that soften edges and decrease apparent sharpness.)

The film is slow because smaller crystals yield less silver, and so the film requires more light to build up printable silver density. If you have bright daylight or enough artificial light to illuminate the subject, however, or if you can make a long enough exposure, this will not be a problem.

A medium-speed film, around ISO/ ASA 100, has larger grain than slow film but maintains good sharpness. Since the film is of moderate speed, you may be able to use a relatively fast shutter speed and hand-hold the camera, whereas a slower film may require a tripod to hold the camera steady during a longer exposure of the same scene. The extra film speed can be important if there are moving objects in the scene or if you want to maximize depth of field by using a small aperture.

Grain has been improved so much in newly introduced medium-speed films that slow films are likely to have a reduced role in the future. For example, Kodak T-Max 100, with a film speed of 100, has grain and sharpness comparable to Kodak's slower Panatomic-X (ISO/ASA 32) and is very likely to replace it.

> Imogen Cunningham made a number of close-ups of plant forms in the 1920s. Commonplace objects such as flowers and leaves were photographed in heroic terms, oversize and isolated in the picture and explored for their design and structure, not as strictly botanical specimens. Edward Weston's Pepper No. 30 (page 379) is a similar image. The photograph at right has a gently expressed voluptuous quality. Cropping into the graceful curves of the petals enfolds the viewer in the photograph much as the petals enfold the cone of the stamen and pistil. The light shines through the petals as well as on them and they are luminous with delicate tones of gray. Fine gradations of tonality are usually rendered best with slower films.

IMOGEN CUNNINGHAM: Magnolia Blossom, 1925

Choosing a Film: continued

When Speed Is Essential—Fast Films

ROBERT LEBECK: Funeral of Robert Kennedy, 1968

A **fast film**, about ISO/ASA 400 or higher, is an asset when photographing in dim light. Because a fast film needs less light to produce a printable image, it makes photography easier indoors, at night, or in other low-light situations (such as for the picture above). If you "push" a fast film, you can increase even more the speed at which you shoot it. Expose the film as though the film speed is higher than the one designated by the manufacturer, and then give the film increased development (see pages 146-147).

Even when light is not dim, a fast film is useful for stopping motion. Since it requires less light than a slower film, you can use a faster shutter speed,

JAMES DRAKE: World Series, 1963

which will record a moving subject more sharply than a slow shutter speed will. In the photograph above, the photographer used a fast film. Even though he was using a long lens, which has a relatively small maximum aperture, he was able to shoot at a fast enough shutter speed to stop umpire, ballplayers, and hat in midplay.

Fast films are getting faster. Kodak's T-Max P3200 film, for example, has a film speed of 3200. Its speed can readily

be pushed to 6400, up to 25,000 if you are adventuresome. A fast film may show increased grain and loss of image detail, especially if you push the film, but the advantages of fast film often outweigh its disadvantages.

How Black-and-White Film Sees Color

Different types of black-and-white film react differently to colors in a scene (see illustrations at right). Colors are produced by specific wavelengths of light, and silver halide crystals (the light-sensitive part of photographic emulsion) do not respond equally to all wavelengths.

The first photographic emulsions responded only to the shorter wavelengths of light, from ultraviolet through blue-green. In 1873, **orthochromatic film** was introduced. It had a dye added to the emulsion that extended the response to green and yellow wavelengths. In a way that is still not completely understood, the dye absorbs these slightly longer wavelengths and transfers their energy to the silver halide crystals.

Panchromatic film was a further improvement, and it is now used for almost all ordinary photography. Dyes enable the film to record all colors seen by the human eye, although the film's response is still not exactly like that of the eye. Panchromatic film is still slightly more sensitive to short wavelengths (bluish colors) than to long wavelengths (reddish colors). Sometimes in a print, a blue sky may appear too light or red apples may have almost the same tone as green leaves. This final imbalance can be corrected with filters (*pages 104–107*) if desired.

Special dyes have also been devised to make films respond to invisible infrared wavelengths in addition to all the visible colors, with unusual and often beautiful results (*far right and following pages*).

orthochromatic film

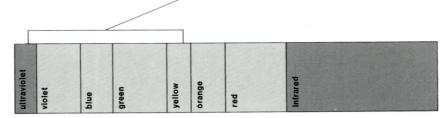

In a photograph made on orthochromatic film, some of the fruits and vegetables above come out looking darker than they would to the human eye because the film responds only to shorter wavelengths—toward the violet end of the spectrum (above)—and is insensitive to reddish colors. The orange, red pepper, and apple (upper right) and the red onion (lower left) all appear unnaturally dark.

panchromatic film

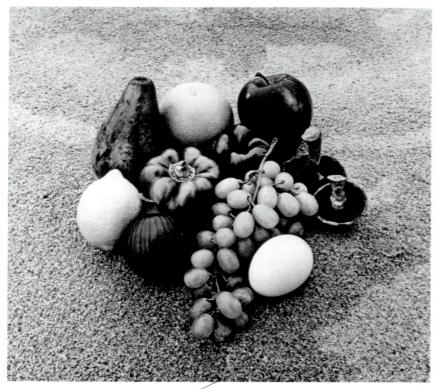

infrared film

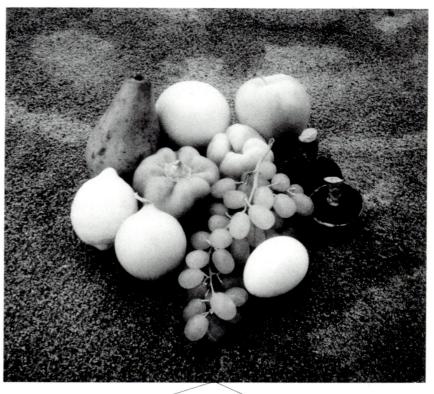

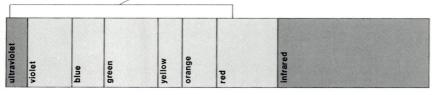

When panchromatic film is used, the tones of reddish objects are more natural in appearance because the film records almost all colors, red through violet and into the ultraviolet (above), that are seen by the eye. The egg looks even whiter than it does in the orthochromatic picture because it has added the light energy of the longer wavelengths to its blend of reflected colors.

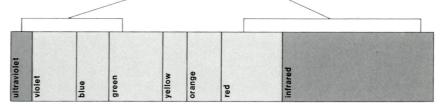

Infrared film records visible colors as well as some longer wavelengths that are not visible. Although most natural objects strongly reflect infrared rays, there is no consistent relationship between the color of an object and the amount of infrared rays that are reflected. In the picture above, only the avocado (upper left) and the mushrooms do not reflect infrared strongly; thus they appear darker than the other objects.

Infrared Film: Seeing Beyond the Visible

Infrared film can produce unusual black-and-white photographs. In a land-scape, blue sky will appear very dark, with green foliage unexpectedly light (*see opposite, bottom and page 411*). In a portrait, skin tones will have a luminous, almost unearthly, glow (*see opposite, top*). Infrared color film produces interesting color variations but not always with such visually appealing results as black-and-white infrared film.

Infrared films are sensitive to visible light and also to invisible infrared wavelengths that are just slightly longer than the visible waves of red light. These "near-red" waves often create unusual photographic effects because they are not absorbed or reflected in the same amounts as visible light. Objects that appear lightest to the eye may not reflect the most infrared radiation, so infrared images may have unexpected, even surreal, tonal relationships. When a deep-red filter on the lens is used to block most visible wavelengths, so that the photograph is taken principally with infrared waves, these effects become particularly evident.

Leaves, grass, and skin in an infrared photograph will be white because they reflect infrared very strongly. Water particles in clouds also reflect infrared, making clouds very light. But blue sky becomes very dark, because its blue light is mostly blocked by the deep red filter. The film has a grainy look that softens surface detail and can give an overall texture. Details are also softened by halation, a diffuse, halolike glow that surrounds very light objects, especially with overexposure.

Sometimes photographers use infrared film and a red filter for longdistance views on hazy days. Haze is caused by the scattering of visible light by very small particles of water and smoke in the air—an action that does not affect infrared radiation. Instead of being scattered by these particles, infrared waves reflected off the scenery can pass right through them as if they did not exist; a hazy scene photographed with infrared film thus looks perfectly clear.

Using Infrared Film

Storage. Exposure to heat will fog infrared film with unwanted exposure. Buy infrared film only if it has been refrigerated by the dealer, and keep it under refrigeration yourself as much as possible. Let the film come to room temperature before opening the package.

Handling. Even slight exposure to infrared radiation will fog the film, so load and unload the camera in total darkness, either in a darkroom or in a changing bag (a light-tight cloth sack into which you put your hands, the camera, and the film). The slot through which 35mm film leaves its cassette does not block infrared radiation, so only open the film's can to take out the cassette in total darkness. Put exposed film back in the can before you bring it into the light.

Focusing. A lens focuses infrared wavelengths slightly differently than it focuses visible light; so if you focus sharply on the visible image, the infrared image will be slightly out of focus. With black-and-white film, focus as usual, then rotate the lens barrel very slightly forward as if you were focusing on an object just a little closer. Most lenses have a red indexing mark on the lens barrel to show the adjustment needed. Make this correction if depth of field is very shallow, for example, if you are using a long-focal-length lens at a wide aperture or if you are focusing on a point very close to the lens. But the difference is so slight that you don't need to adjust for it otherwise; the depth of field will be adequate to keep the image sharp, even if the critical focusing point is slightly off. No adjustment is necessary with color infrared film.

Filtration. See manufacturer's instructions. Kodak recommends a #25 red filter for general use with black-and-white infrared film. This increases the infrared effect by absorbing the blue light to which the film is also sensitive. Kodak recommends a #12 minus-blue filter for general use with color infrared film.

Exposure. Infrared wavelengths are not accurately measured by ordinary light meters, whether built into the camera or hand-held. You can try setting a film speed of 50, metering the scene, then bracketing. If your meter is built into the camera, meter without a filter over the lens. Kodak recommends the following manually set trial exposures for average, front-lit subjects in daylight.

Kodak High-Speed Infrared black-and-white film used with #25 filter: distant scenes—1/125 sec at f/11; nearby scenes—1/30 sec at f/11.

Kodak Ektachrome Infrared color film used with #12 filter: 1/125 sec at f/16.

Flash exposures. You can use infrared film with flash simply by putting a red filter on the lens and using your flash in the usual way. Or you can cover the flash head with a #87 filter, which passes only infrared radiation. You can also buy a special infrared flash unit that emits mostly infrared light. Make a series of trial exposures to determine the best starting exposure with your unit.

Bracketing. Consider any infrared exposure as an estimate that should be bracketed. Start with four additional exposures: $\frac{1}{2}$ stop more exposure, 1 stop more, $\frac{1}{2}$ stop less, and 1 stop less. Even greater bracketing can be useful: all of the above exposures plus $\frac{1}{2}$ and 2 stops more exposures, $\frac{1}{2}$ and 2 stops less. Once you have some experience with the film, you may be able to reduce the amount of bracketing.

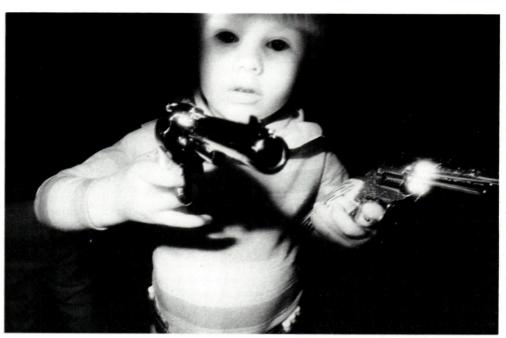

DUANE POWELL: Cameron, Carbondale, Illinois, 1981

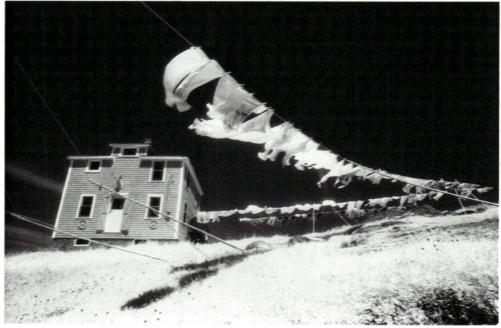

RUSSELL HART: Infrared Landscape, Nova Scotia, 1979

Infrared black-and-white film makes skin tones very light and luminous. Sometimes veins just below the skin can be seen, although not in this photograph. Duane Powell photographed his son, Cameron, brandishing a pair of toy pistols. The boy's skin appears very light, which contrasts with his large, dark eyes. A wide-angle, 20mm lens exaggerated the size of the pistols, especially the one closest to the camera. The combination produced a distinctive and oddly intense portrait.

A red filter on the lens increases the characteristics of infrared film. The filter blocks most blue light; as a result the sky is very dark. Green grass reflects infrared light strongly, so it appears very light. Russell Hart used a shutter speed of 1/500 sec to stop the motion of the laundry, which was snapping rapidly in the breeze. Tilting the camera upward at the house distorts the perspective and causes the house to appear to lean backward (the illustration and caption on page 304, right, explain why).

Instant-Print Film

In the ordinary photographic process, film is exposed, later developed to produce a negative, and then, even later, printed to make a positive. **Instantprint film**, however, gives you a visible image almost at once. The Polaroid film diagrammed at right has both a negative emulsion and positive paper in one package. After the picture is exposed, the negative and positive are tightly sandwiched together by being pulled between two metal rollers. The image is transferred from the negative to the positive by chemicals at the center of the sandwich.

Polaroid makes instant materials in many formats. In addition to pack film, individual sheets of 4 \times 5-inch or 8 \times

10-inch film can be used (with a special film holder) in a view camera. Polaroid instant 35mm transparency film can be exposed in any 35mm camera and then, using a special processor, be completely processed in about three minutes to make color or black-and-white slides. (See pages 256–257 for more about instant color films.)

Instant film is often used by professional photographers to make a quick check of a setup. An exposure can be made and evaluated on the spot to avoid a mistake when the picture is taken with standard film. Many photographers also use Polaroid film as an end product.

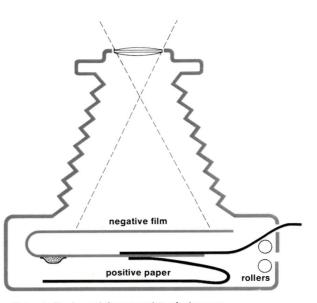

Polaroid film in pack form consists of a box containing flat sheets of negative and positive materials that is snapped into the back of the camera. First, the picture is exposed (above). The negative is then turned upside down to meet the positive paper. This is done by pulling on a white tab (below).

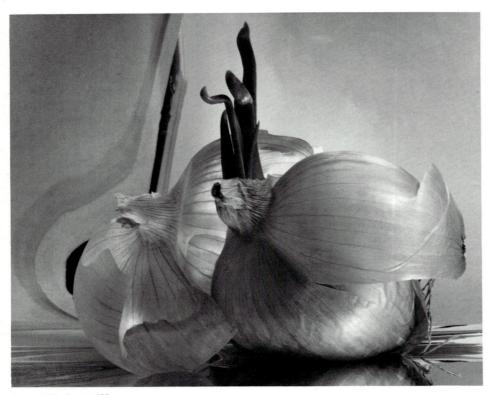

When the white tab is pulled, the exposed negative turns upside down and is brought close to the steel rollers (the positive paper has not yet moved). Next, a yellow tab is pulled, drawing both the negative and the positive through the rollers and breaking the pod of chemicals in the process (below). The chemicals are thus spread evenly within the sandwich to develop and fix the picture.

Instant-print materials can produce extraordinarily beautiful images. Polaroid Polapan Type 52 4 × 5 film has very fine grain and a very smooth gradation of tones. An original Type 52 print can have a subtle luminosity that is almost impossible to achieve with conventional black-and-white materials. The reproduction at left only hints at the quality of the original.

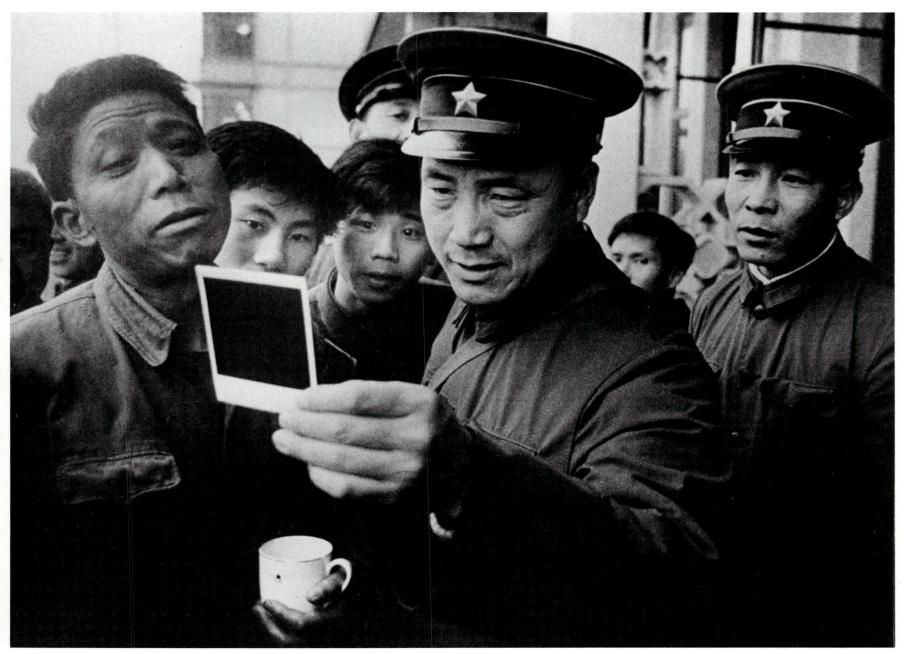

JOE WRINN: Their First Polaroid, Canton, 1979

The special pleasure of instant photography: a group of Chinese soldiers in Canton sees for the first time a Polaroid SX-70 picture as it develops its image. The Polaroid photograph is of the soldiers themselves, taken by a Western tourist just a few moments before. This scene has a naturalness and ease that is not always easy to get when the photographer is obviously a foreigner. The soldiers have forgotten the photographer and become engrossed in the instant magic of the instant picture—objects taking shape, colors brightening and getting richer while they watch.

Using Filters

Attach a filter to the front of a lens, and you change the light that reaches the film. The name—*filter*—describes what most filters do: they remove some of the wavelengths of light reflected from a scene and so change the way that the scene looks in a photograph.

Colored filters let you control the relative lightness and darkness of tones in a black-and-white photograph. They absorb light of certain colors and thus make objects of those colors appear as darker tones of gray. The more light the filter absorbs, the less light reaches the film, and the darker those colors will appear to be. It is easier to predict the effect of a colored filter if you think of it as subtracting (and darkening) colors. not adding them. For example, if you look through a red filter, it seems to tint the entire scene red. But the filter isn't adding red; it is removing blue and green. As a result, blue and green objects will appear darker.

A colored filter absorbs its **complementary color**, the color or colors opposite it on a color wheel (see color wheel illustrated on page 248): a yellow filter absorbs blue, a green filter absorbs red and blue, and so on. A colored filter can appear to lighten objects of its own color, but this is because it makes other colors darker, and by comparison, objects that are the color of the filter seem lighter.

Contrast filters are colored filters that change the relative brightness of colors that would otherwise be too similar in tone in black and white. In color, red apples contrast strongly against a background of green leaves, but in black and white the apples and leaves can be almost the same gray tone. A green filter, which absorbs red, darkens the apples so that they look more natural (see illustrations, right).

Correction filters are colored filters designed to correct the response of film

so that it shows the same relative brightnesses that the human eye perceives. For example, film is more sensitive to blue and ultraviolet wavelengths than the eye is. A blue sky photographed without a filter can look too light in a black-and-white photograph, almost as light as clouds that appeared at the scene to be much lighter. A yellow or red filter, which absorbs blue, darkens the blue part of the sky so that clouds stand out (see opposite page).

Neutral-density filters absorb a quantity of all wavelengths of light. They reduce the overall amount of light that reaches the film while leaving the color balance unchanged; they can be used with either black-and-white or color film. Their purpose is to increase the exposure needed for a scene, so that you can use a slower shutter speed (to blur motion) or a larger aperture (to decrease depth of field).

A **polarizing filter** can be used with either black-and-white or color film to remove reflections, darken skies, and intensify colors (*see page 106*).

In addition to filters that absorb light, **lens attachments** produce special effects. A cross-screen attachment causes streamers of light to radiate from bright lights such as light bulbs. A soft-focus attachment softens details and makes them slightly hazy.

Filters are made of gelatin or of glass in various sizes to fit different lens diameters. **Gelatin filters** are taped to the front of the lens or placed in a filter holder. They are inexpensive and come in many colors, but they can be damaged relatively easily. Handle them by the edges only. **Glass filters** screw or clamp onto the front of the lens. They are convenient to use and much sturdier than gelatin but are more expensive. You will need to increase the exposure for a filtered scene; page 107 tells how to do this.

Colors that appear very different to the eye can be confusingly similar in tone in black and white, such as the red apples on the green leaves, above. A colored filter can correct this by absorbing certain colors and making those colors darker in a black-and-white print.

A green filter #58, used to take the picture below, absorbs much red light, making the red apples darker than the leaves, a natural-looking appearance

One of the most common uses for a filter in blackand-white photography is to darken a blue sky. Colored filters work for this purpose only when the sky is actually blue. They do not darken the sky on an overcast or hazy day.

Without any filter, the sky in this photograph appears very light, with clouds barely visible. Black-and-white film is very sensitive to blue and ultraviolet light; this often causes skies to appear too light in a black-and-white photograph.

A yellow filter #8 absorbs some of the sky's blue light, making the sky in the picture at right appear somewhat darker than it does above.

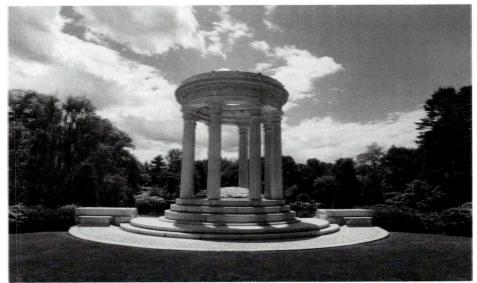

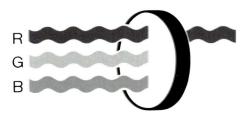

A red filter #25 absorbs nearly all blue as well as green light, making the sky in the picture at right much darker than it normally appears and also darkening foliage. Shadows, too, appear darker than in the unfiltered view, because they are illuminated largely by blue light from the sky that the red filter blocks.

A Polarizing Filter to Reduce Reflections

Reflections from a shiny surface can be a distracting element in a photograph. With a **polarizing filter**, you can remove or reduce reflections from water, glass (*top photo*), or any smooth surface except metal. This is possible because light waves ordinarily vibrate in all directions perpendicular to their direction of travel. But light reflected from nonmetallic smooth surfaces has been polarized—the light waves vibrate in only one plane.

A polarizing filter contains submicroscopic crystals lined up like parallel slats. Light waves that are parallel to the crystals pass between them; waves vibrating at other angles are blocked by the crystals (*center diagram*). Since the polarized light is all at the same angle, the filter can be turned so as to block it.

To use a polarizing filter, look through it and rotate it until the unwanted reflection is reduced as desired (*bottom photo*). Then place the filter in the same position over the lens. (With a single-lens reflex or view camera, the filter can be adjusted while it is in place over the lens.) Because of the partial blockage of light by the filter, the exposure must be increased by $1\frac{1}{3}$ stops.

Tiny particles of dust and water in the atmosphere also reflect light and can make a distant scene look hazy. A polarizing filter will decrease such reflections, darken the sky, and make a distant scene look more distinct and more vividly colored. It is the only filter that will darken the sky in a color picture without changing the color balance.

The photograph at top was taken without any filter. The reflection in the window was removed in the picture below by adjusting a polarizing filter (or polarizer) over the lens. The drawing shows how the polarizer works. It is adjusted to pass only those light waves (black) oriented parallel to its picketlike aligned crystals and to screen out all other light waves (gray) angled across the pickets.

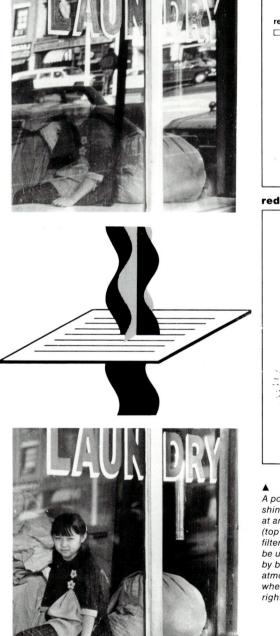

reducing reflections from shiny surfaces

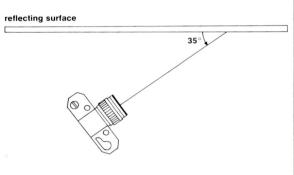

reducing reflections from atmosphere

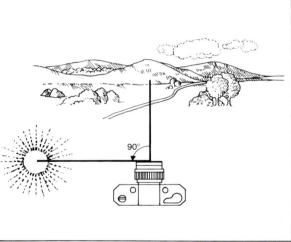

A polarizing filter used to block reflections from a shiny surface like glass or water is most efficient at an angle of about 35° to the reflecting surface (top diagram). Directly in front of the surface, the filter has little or no effect. A polarizing filter can be used to darken a blue sky and to reduce haze by blocking light reflected from particles in the atmosphere. In this case, the filter works best when you are taking pictures at approximately a right angle to the sun (bottom diagram).

More About Filters

Filters absorb part of the light that passes through them, so you need an **exposure increase** when using a filter or the film will be underexposed. The chart shows the effect of various filters on black-and-white film and the number of stops to increase the exposure with them. For each full stop of exposure increase, change the shutter to the next slower speed or the aperture to the next wider setting. Use the aperture to make fractional changes. With an automatic exposure camera, do this in manual exposure operation (*see page 113*).

If you have a camera that meters through the lens, it would be convenient if you could simply meter the scene through the filter and let the camera set the exposure. But some types of meters do not respond to all colors, so you may get an incorrect reading if you meter through a filter, particularly through a dark filter. A #29 deep red filter, for example, requires 4 stops additional exposure, but some cameras only produce a $2\frac{1}{2}$ stop increase when they meter through that filter—underexposing the film by $1\frac{1}{2}$ stops.

You can meter through a filter if you run a simple test first. Select a scene with a variety of colors and tones. Meter the scene without the filter and note the shutter speed and aperture. Then meter the same scene with the filter over the lens. Compare the number of stops the camera's settings changed with the number of stops that they should have changed according to the chart. Adjust the settings as needed whenever you use that filter. Some sources list the exposure increase needed for a filter not directly in stops, but as a **filter factor**. The end result is the same, but the calculation is a little different. The factor tells how many times the exposure should 'be increased. A factor of two means the exposure should be doubled (the same as a one-stop change), a factor of four means the exposure should be increased four times (a two-stop change), and so on. See bottom of chart.

In the chart, the increase for tungsten light (from light bulbs) is different from the increase for daylight because tungsten is more reddish, while daylight is more bluish. Specific films may vary somewhat from these listings; see film instructions. See page 229 for filters used with color film.

number or		physical effect								exposure increase for black-and-white film					
designation	color or name			practica	practical use						daylight	tungs	ten		
8	yellow	Absorbs ultravio and blue-violet			, ,	ng out clouds. Increases contrast by darkening blu- bluish haze.							²∕₃ sto	р	
15	deep yellow	Absorbs ultravio violet, and most	,	blue sky	Lightens yellow and red subjects such as flowers. Darkens blue water and blue sky to emphasize contrasting objects or clouds. Increases contrast and texture and reduces bluish haze more than #8 filter.					1 ¹ / ₃ stops	⅔ stop				
25	red	Absorbs ultravio blue-violet, blue, green		Increase	Lightens yellow and red subjects. Darkens blue water and sky considerably. Increases contrast in landscapes. Reduces bluish haze more than #15 filter. Used with infrared film.						3 stops	ps 2 ¹ / ₃ stops			
11	yellowish green	Absorbs ultravio violet, blue, and red	making	Lightens foliage, darkens sky. For outdoor portraits, darkens sky without making light skin tones appear too pale. Balances values in tungsten-lit scenes by removing excess red.						2 stops	2 stop	S			
47	blue	Absorbs red, yell green, and ultrav	Lighten	Lightens blue subjects. Increases bluish haze.						2 ² / ₃ stops	32/3 st	ops			
1A or UV	skylight ultraviolet	Absorbs ultravio	Absorbs ultraviolet			Little or no effect on black-and-white scenes. Used by some photographers to protect lens surface from damage.						0	0		
ND	neutral density		bosorbs equal quantitiesIncreases required exposure so camera can be set to wider aperture or slowerlight from all parts ofshutter speed. Comes in densities from 0.01 (½ stop more exposure) to 1.00e spectrum(3½ stops more exposure).						varies wi	th densit	y				
	polarizing	eling in certain p	Absorbs light waves trav- eling in certain planesReduces reflections from nonmetallic surfaces, such as water or glass. Pene- trates haze by reducing reflections from atmospheric particles. Darkens sky at some angles.							1 ¹ / ₃ stops	11⁄3 st	ops			
If filter has a fa	actor of e the exposure (in st	1 0005) 0	1.2 1⁄3	1.5 ⅔	2 1	2.5 1½	3 1⅔	4	5 2½	6 2⅔	8 3	10 3½	12 3²⁄3	16 4	32 5

Filters for Black-and-White Film

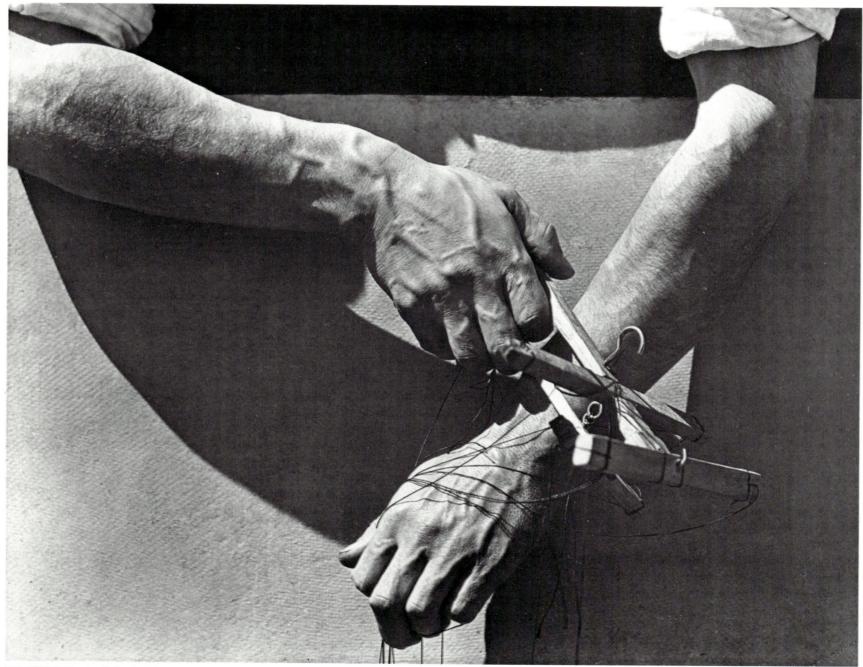

TINA MODOTTI: Number 29: Hands of Marionette Player.

5 Exposure

How Exposure Meters Work 110 Built-in Meters 112 Automatic Exposure 113 How to Meter 114 An Overall Reading for an Average Scene 114 Metering Scenes with High Contrast 116 Exposing for Specific Tones 118 Spot Meters 120 Substitution Readings 121 Hard-to-Meter Scenes 122 Using Exposure 124

Most negative films have a tolerance, or latitude, for a certain amount of exposure error; they allow for a range of exposures all of which will produce satisfactory negatives. However, the best prints, especially if enlargements are made, are produced from properly exposed negatives. Greatly overexposed negatives are difficult to print and produce grainy and unsharp prints. Badly underexposed negatives show no detail in the shadows —something that cannot be remedied when the negative is printed. Color reversal films have very little latitude, especially for overexposure; as little as one stop overexposure makes a distinctly inferior color slide.

Cameras with automatic exposure, especially 35mm cameras, have become common in recent years. Built-in meters measure the intensity of the light; electronic circuitry sets the lens aperture and shutter speed automatically. But personal judgment is still important. Most equipment is programmed for "average" conditions, so you may have to change the recommended settings if you are photographing a backlit scene, a snowy landscape, or other non-average situation. This chapter tells when you can rely on automatic exposure and when you need to override it.

One of the best cures for exposure problems is experience. The most expensive meter or camera, complicated exposure strategy, or detailed charts will never replace the sureness you will have when you photograph something for the second—and, even better, the third or fourth—time.

Tina Modotti photographed during the 1920s, at a time when photography was still freeing itself from the notion that photography could only be art if it was manipulated so that it resembled other art forms such as charcoal drawings or etchings. In contrast to this, Modotti was a "straight" photographer, who produced sharply focused, unmanipulated images. "I consider myself a photographer," she wrote, "nothing more. I try to produce not art but honest photographs, without distortions or manipulations." More about photography as an art form and straight photography on pages 376–379.

How Exposure Meters Work

An **exposure meter**, commonly called a light meter, is an essential piece of equipment because it enables you to produce consistently accurate exposures. Meters built into the camera are popular because they are so convenient. Yet many photographers still prefer a separate hand-held meter for its greater control over exposure.

The light-sensitive part of an exposure meter is a photoelectric cell. Selenium, then cadmium sulfide (CdS) cells were commonly used. Now the cell is likely to be a gallium photodiode (GPD), silicon photodiode (SPD), or silicon blue cell (SBC). The cell converts the energy of light into a measurable quantity of electrical energy. A basic meter. like the one opposite, uses the energy to move a needle across a scale. A more sophisticated meter converts this analog signal to a digital one that is used by a built-in central processing unit to calculate the correct exposure for a given film speed. The meter then displays an f-stop and shutter speed combination, and in an automatic camera sets the camera accordingly.

Some hand-held meters (and a few cameras) also display an **exposure value (EV)** scale of comparable shutter speeds and apertures. EV 1, for example, is equal to f/1.4 at 1 second, and all other combinations of f-stops and shutter speeds that deliver the same amount of light. Currently, the scale is mainly used in product descriptions to tell the metering range. A camera that meters from EV 1 to EV 19 with ISO/ASA 100 film has an accurate metering range for exposures from f/1.4 at 1 second to f/22 at 1/1000 second with that film.

Light meters differ in the way they are used to measure light. Most hand-held meters and all those built into cameras are **reflected-light meters**; they measure **luminance**, the light reflected from (or emitted by) the subject. The meter is pointed at the subject—or at the particular part of the subject the photographer wants to measure at close range and the reading is made. The lightadmitting opening of a hand-held reflected-light meter is restricted by a hood, baffle, or faceted lens so that the angle of view of the meter approximates that of a normal camera lens, about 30° to 50°. In a variation of this type of meter, a spot meter (*page 120*), the angle may be reduced to as little as onehalf degree so that readings of very small areas can be made.

Incident-light meters are hand-held. They have a much wider angle of view (about 180°) and measure **illuminance**, the light incident on (falling on) the subject. This wider angle is made possible by a translucent dome of white glass or plastic placed over the light-measuring cell to diffuse the light. An incident-light meter is pointed not toward the subject but toward the camera from the position of the subject, so that it receives the same light as is falling on the subject.

Some meters, such as the one shown on the opposite page, are designed to make both reflected and incident readings. When the sensing cell is open to direct light, it is a reflected-light meter; when the dome-like diffuser is slid into position over the sensing cell, it becomes an incident-light meter.

Most meters are designed to measure a continuously burning source of light, such as a tungsten lamp or the sun, but **flash meters** measure the output from the brief burst of light from electronic flash. **Color temperature meters** measure the color temperature of light rather than its intensity and are used to determine the filtration needed when a specific color balance is required.

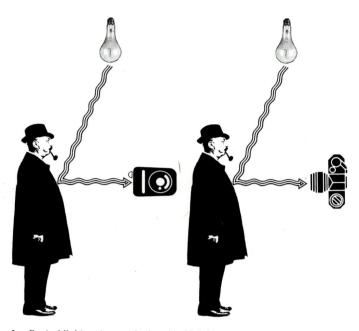

A reflected-light meter can be hand-held (left) or built into a camera (right) and is aimed at a subject to make a reading. It measures the luminance (commonly called the brightness) of a subject here, the light reflected from the man's coat.

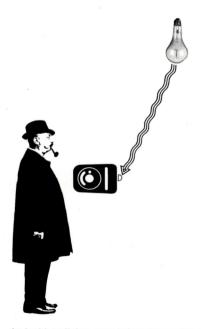

An incident-light meter is faced toward the camera from the position of the subject. It measures the light falling on a subject as seen from the direction of the camera.

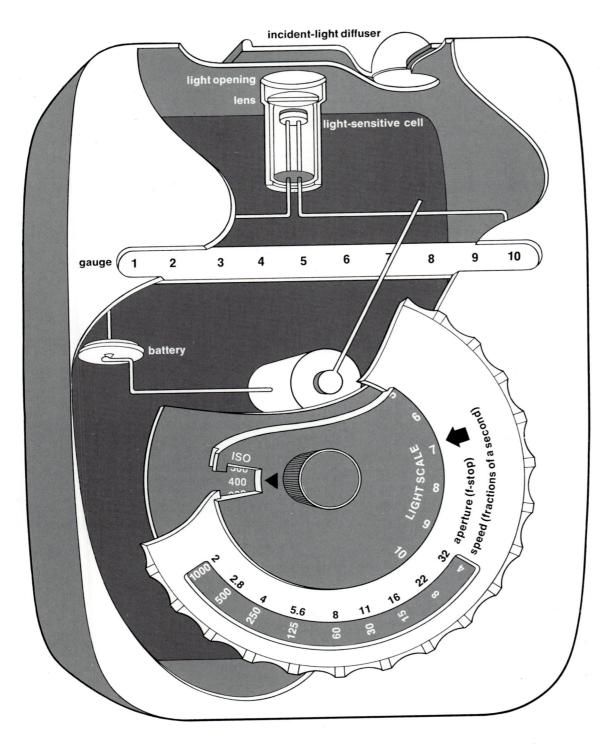

An exposure meter measures the amount of light and then for a given film speed computes shutter speed and f-stop combinations. Meters are calibrated on the assumption that the average of all the tones being read will equal a middle-gray tone. This is true for most scenes—but not all of them. Moreover, the meter doesn't know what it is reading or how light or dark you want the subject to be in the photograph. For these reasons, you sometimes have to override the meter's recommended exposure settings. The following pages contain more about how and when to do this.

Measuring the light. The hand-held meter at left is set to measure reflected light. The domed diffuser, used to make an incident reading, has been slid away from the opening over the light-sensitive cell. To make a reading, the cell is pointed at the subject and the meter activated. How much light strikes the cell determines how much current reaches the needle that moves across the measuring gauge.

The numbers on this gauge are one stop apart: each number indicates a light level twice as high as the preceding number. In this case, the reading is slightly over 7—about twice the light level at 6, about half the level at 8.

Film speed. The speed of the film being used must be set into the meter. Here the center knob is turned until an ISO/ASA rating of 400 is shown in the small window near the center of the dial.

Computing the exposure. To convert the light measurement into an exposure setting, the large outer dial of this meter is turned until its arrow points to the number indicated by the gauge needle. This matches apertures (f-stops) with shutter speeds at the bottom of the dials to recommend an exposure for the light intensity measured; f/32 at 1/4 sec, f/22 at 1/8 sec, or any other combination shown would give the same exposure. Here the dial shows the shutter speed in fractions of a second: 1/8 sec is shown on the dial as 8, 1/4 sec is shown as 4, and so on. The shutter-speed dial continues on into full seconds, minutes, and, on some meters, hours of exposure time. Many meters provide a direct digital readout of shutter speed and f-stop combinations, light intensity measured in foot-candles, or other data.

Batteries. Many hand-held meters and all meters built into cameras are battery powered. Check batteries regularly (see manufacturer's directions for how to do this). A worn-down or exhausted battery can give an inaccurate reading and eventually will cease functioning altogether.

Built-in Meters

Even some professional photographers who used to feel that only hand-held meters were accurate enough, now may also use exposure meters built into cameras. Built-in meters, like hand-held, reflected-light meters, measure the light reflected or produced by objects in their view and then calculate an exposure setting. To use a built-in meter, you look through the camera's viewfinder while pointing the meter at the scene or at the part of the scene that you want to meter. The viewfinder shows the area being metered, and most viewfinders also display shutter speed and/or aperture settings (right, bottom). An automatic camera contains circuitry that sets the shutter speed, aperture, or both for you based on the meter reading (see opposite page).

Many built-in meters are **averaging meters** and are **center-weighted**: the meter averages all the light in the scene but weights its average to give more emphasis to the area at the center of the viewfinder than to the surrounding area. This system is based on the assumption—usually correct—that the most important part of the subject is in the center of the scene. A centerweighted meter can give an inaccurate reading if the subject is at the side of the frame, for instance, and the surroundings are much lighter or darker than it is. Some cameras have **multizone metering.** They make individual readings from different parts of the viewfinder image, instead of averaging together readings from all parts of the image. These cameras are programmed by the manufacturer to adjust for some potential exposure problems, such as a backlit subject.

Some scenes can cause any reflected-light meter to produce the wrong exposure. All such meters are designed to indicate exposure for scenes including both light and dark areas in a more or less equal balance that averages out to a middle gray tone. If a scene is uniformly light (such as a snow scene), the meter still calculates an exposure as if it were reading middle gray. The result is not enough exposure and a photograph that is too dark. The following pages tell how to identify such scenes and how to set your camera for them. The rings drawn on the picture below indicate the way built-in meters can give different emphasis to different parts of an image in gauging light. This meter is center-weighted. It is most responsive to light reflected from the area of the scene inside the central ring; response falls off sharply from there outward. The meter averages together the weighted readings from the different parts of the scene to calculate the final exposure.

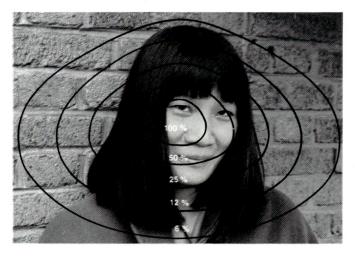

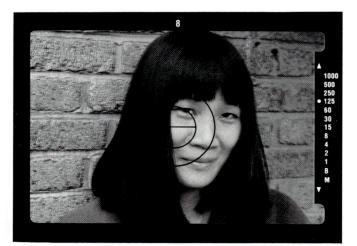

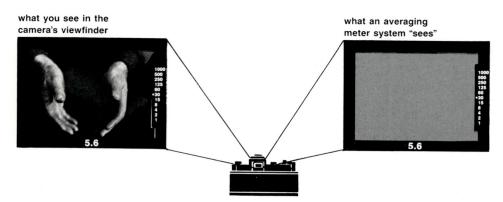

In a camera's viewfinder, you can see details of the area that a built-in meter is reading. Most metering systems, however, average together light

from all the parts of a scene and as a result "see" only the overall light level.

The viewing screen (above) of a 35mm single-lens reflex camera gives information from the built-in meter. With this camera, the number at top shows the lens aperture, f/8. The scale at right shows the shutter speeds, and the lighted dot indicates that at f/8, the meter has chosen a shutter speed of 1/125 sec. When the camera is set for manual operation, a lighted dot appears next to "M," with another dot next to the recommended shutter speed to be set manually. If the arrow at the top of the scale lights up, the scene is too bright for exposure at the chosen aperture. A lighted arrow at the bottom shows need for exposure longer than 1 sec. The center circles are focusing aids.

Automatic Exposure

Overriding Automatic Exposure

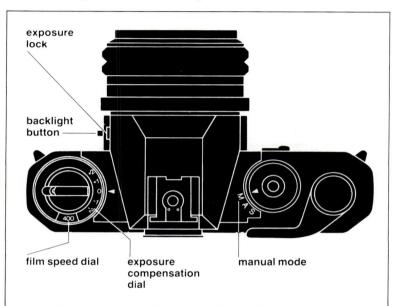

Automatic exposure works well much of the time, but for some scenes you will want to alter the exposure set by the automatic circuitry. You may want to increase the exposure to lighten one picture or decrease the exposure to darken another. Most cameras have one or more of the following means of allowing you to do so. Camera design and operation vary, so see the manufacturer's instructions.

Manual mode. An option on many automatic cameras. You adjust both shutter speed and aperture settings to lighten or darken the picture as you wish.

Exposure compensation dial. Moving the dial to +1 or +2 increases the exposure one or two stops and lightens the picture (some dials say $\times 2$ or $\times 4$ for comparable settings). Moving the dial to -1 or -2 ($\times \frac{1}{2}$ or $\times \frac{1}{4}$ on some dials) decreases the exposure one or two stops and darkens the picture.

Backlight button. May be on the camera if an exposure compensation dial is not. Depressing the button adds a fixed amount of exposure (usually one to one and a half stops) to lighten a picture. It cannot be used to decrease exposure. As its name indicates, it is useful for backlit scenes in which the main subject is against a much lighter background.

Exposure lock. The switch temporarily locks in a shutter speed and aperture combination. You move close to meter the most important part of the scene, lock in the settings, then recompose the picture and photograph the entire scene at that exposure.

Film speed dial. Resetting the film speed dial causes the camera to give the film less or more exposure than normal. To lighten a picture, decrease the film speed: halving an ISO/ASA film speed (for example, from 400 to 200) increases the exposure by one stop. To darken a picture, increase the film speed: doubling the film speed (for example, 400 to 800) decreases the exposure by one stop. Remember to reset the film speed dial to the normal rating when you are finished.

Many cameras today come equipped with automatic exposure. If your camera is an automatic one, a meter built into the camera measures the average lightness or darkness of the scene in your viewfinder. Electronic circuitry within the camera automatically calculates an exposure that would be correct for an average scene, and then sets shutter speed, aperture, or both, based on the speed of the film you are using. Some cameras are more sophisticated. Their multizone meters compare readings from different parts of the scene, then adjust the exposure or warn you of possible problems.

The basic modes of automatic exposure are listed in the box below. Your camera may operate in only one of these modes or in several. See the manufacturer's instructions for details.

For most scenes (those with an average distribution of light and dark

tones), automatic exposure works well. There are, however, situations when automatic exposure will underexpose or overexpose your subject because it is giving you an "average" exposure rather than one that is best for a specific scene. A typical example is when a subject is against a much lighter background. Many automatic systems will underexpose such a scene, just as any non-automatic system will if you simply make an overall reading. Unless your camera has a metering system that adjusts for such scenes, you will have to override the automatic exposure mechanism to get the exposure you want. Various means to do this are listed at left. See pages 114-115 for how to meter an average scene, and pages 116-119 and 122-123 for how to identify a nonaverage scene and what to do about it.

Exposure Modes

Aperture-priority automatic. You select the aperture and the camera adjusts the shutter speed.	You set aperture Camera adjusts shutter speed	f/5.6 1/250 sec	f/8 f/11 1/125 1/60
Shutter-priority automatic. You select the shutter speed and the camera adjusts the aperture.	You set shutter speed Camera adjusts aperture	1/250 sec f/5.6	1/125 1/60 f/8 f/11
Programmed (fully) automatic. The camera adjusts both shutter speed and aperture based on a built-in program. Depending on the program, the camera may select the fastest possible shutter speed, or go to slower shutter speeds rather than opening the lens to the widest aperture.	Camera adjusts aperture Camera adjusts shutter speed	f/5.6 1/250 sec	f/8 f/11 1/125 1/60
Manual. You set both shutter speed and aperture. The camera's built-in meter still can be used to calculate the correct settings.	You set aperture You set shutter speed	f/5.6 1/250 sec	f/8 f/11 1/125 1/60

How to Meter An Overall Reading for an Average Scene

How do you get a good exposure—that combination of f-stop and shutter speed that lets just the right amount of light reach the film, so that your picture is not underexposed and too dark or overexposed and too light? For many scenes, the correct exposure is easy to calculate: you use a reflected-light meter to make an **overall reading** of the objects in the scene (*opposite, left and center*). If you have an incident-light meter, you make a reading of the overall amount of light falling on the scene (*opposite, right*).

An overall reading works very well for metering average scenes, where light and dark tones are of more or less equal distribution and importance, especially if the scene is evenly illuminated, either by light that is coming from behind the camera or by light that is evenly diffused over the entire scene. But a meter is only a measuring device-it cannot interpret what it reads, nor does it know whether a scene is average or if you want the subject to be light or dark. So in some cases you have to think for the meter and override the settings it recommends. The following pages will tell when to do so.

A **reflected-light meter** (built into the camera or hand-held) typically acts as if the scene it is metering is **middle gray**. It averages all the tones in its angle of view and then calculates a combination of f-stop and shutter speed that will produce middle gray in a print. The assumption is that the average of all the tones from light to dark in a scene will be a middle gray, so an exposure for middle gray will be approximately correct for the entire scene. This method actually does give a good exposure in a large number of situations.

A reflected-light meter averages the luminances in a scene—the light reflected or produced by all the objects in the meter's angle of view—so you have to make sure that the meter is reading only the light you want it to read. If your meter is built into the camera, you can see in the viewfinder the area that the meter is reading. Some hand-held meters have a small viewfinder through which you look at the scene, but if yours does not, you can estimate the area the meter is covering. For most reflectedlight hand-held meters, the angle is 30° to 50°, about the coverage of a normal focal length lens.

You may get a deceptively high reading (and subsequently a too-dark picture) if the scene contains very light areas like a bright sky or light sources like the sun or a lamp. Your reading may be too low (and the resulting picture too light) if a very large dark area surrounds the subject. Pages 116–117 tell how to handle such scenes.

Since an **incident-light meter** reads only the light falling on a subject, its reading does not include surrounding dark or light areas. An incident-light meter is preferred by many commercial photographers to balance the illumination in studio setups where lights can be arranged at will. It is also quick and easy to use and therefore useful in fastmoving situations. However, it cannot measure the tones of individual objects in a scene, and it cannot give an exposure for an object that is itself emitting light, such as a neon sign or a lamp.

To use an incident-light meter, point it in the direction opposite from the one the lens is pointing (see opposite, right). This aligns the meter so that it receives the same amount of light as is falling on the subject as seen from camera position. Move close enough to the subject so that you do in fact read the same light that is falling on it. Indoors, for example, don't take a reading near a sunny window if your subject is standing in a dark corner.

WALKER EVANS: Hale County, Alabama, 1936

Most exposure meters are designed on the assumption that the scene you are metering contains an "average" distribution of tones from light to dark. A meter reading of the overall scene produces a good exposure if this, in fact, is so, and if light and dark areas are of more or less equal importance. You can make an overall reading with a meter built into the camera or one that is handheld (see opposite).

using a meter built into a camera

- 1 Set the film speed dial of the camera to the ISO/ ASA rating of the film you are using.
- 2 Set the exposure mode of the camera, if you have a choice: (a) aperture-priority automatic, (b) shutter-priority automatic, (c) programmed automatic, or (d) manual.
- **3** Look at the scene through the camera's view-finder and activate the meter.
- 4a In aperture-priority automatic operation, select an aperture small enough to give the desired depth of field. The camera will adjust the shutter speed. If your subject is moving or if you are hand-holding the camera, check the viewfinder readout to make sure that the shutter speed is fast enough to prevent blur. The wider the aperture you select, the faster the shutter speed that the camera will set. (Remember that a wide aperture is a small number: f/2 is wider than f/4.)
- **4b** In shutter-priority automatic operation, select a shutter speed fast enough to prevent blur. The camera will adjust the aperture. Check that the aperture is small enough to produce the desired depth of field. The slower the shutter speed you select, the smaller the aperture will be.
- **4c** | In programmed automatic operation, the camera will adjust both shutter speed and aperture.
- **4d** In manual operation, you select both shutter speed and aperture. You can use the camera's built-in meter or a hand-held meter to calculate the settings.

using a hand-held, reflected-light meter

- 1 Set the meter to the ISO/ASA rating of the film you are using.
- 2 Point the meter's photoelectric cell at the subject from the direction of the camera. Activate the meter.
- 3 Line up the number registered by the meter's indicator needle with the arrow on the calculator dial. (Not necessary with meters that automatically provide shutter-speed and f-stop combinations.)
- 4 Choose one of the combinations of shutter speed and f-stop shown on the calculator dial or provided as digital readout, and set the camera accordingly. Any combination shown by the meter lets in the same amount of light and produces the same exposure.

using an incident-light meter

- 1 Set the meter to the ISO/ASA rating of the film you are using.
- 2 Point the meter's photoelectric cell away from the subject, in the opposite direction from the camera lens. Activate the meter. You want to measure the amount of light falling on the subject, so make sure that the meter is in the same light as the subject. For example, don't shade the meter if your subject is sunlit.
- 3 Line up the number registered by the meter's indicator needle with the arrow on the calculator dial. (Not necessary with meters that automatically provide shutter-speed and f-stop combinations.)
- 4 Choose one of the combinations of shutter speed and f-stop shown on the calculator dial or provided as digital readout, and set the camera accordingly. Any combination shown by the meter lets in the same amount of light and produces the same exposure.

Metering Scenes with High Contrast

Although a simple overall reading works well much of the time, it does not work for some scenes, especially those with high contrast, in which the light parts of the scene are so much lighter than the dark parts that the range is bevond the recording capability of the film. The most common situation in which overall metering does not work is a subject against a much lighter background, for example, a portrait outdoors with a bright sky in the background. Suppose you are using a reflected-light meter, either built into the camera or hand-held, one that averages all the tones in its angle of view. If you meter the scene overall, the bright sky will increase the entire reading too much. The meter will calculate an exposure that will underexpose the main subject and make it too dark.

Preventing this is easy: if a subject is against a much lighter background, such as a bright sky, a very light wall, or a bright window indoors during the day, move in close enough so that you are metering mostly the main subject rather than the lighter background. Set the aperture and shutter speed from the upclose reading before you move back to take the picture (*this page and opposite, top*). Similarly, try not to include light sources, such as the sun or a lighted lamp, in a meter reading.

If you are metering a landscape, cityscape, or other distant scene, tilt the camera or meter down to exclude most of a bright sky from the reading; the lower reading will give a more accurate exposure for the land elements in the scene (*opposite, bottom*). Of course, if your main subject is the sky itself, such as a cloud formation, take your reading directly from the sky.

Less common, but sometimes a problem, is a subject against a much darker background, especially if the subject occupies only a small part of the image. Metering such a scene overall with a reflected-light meter would produce a reading that is too low and an overexposed and too-light picture. Prevention is the same: move in close to meter mostly the main subject.

How do you use an automatic camera to expose a picture with a background much lighter or darker than the subject? You can't simply meter the scene up close and then step back to take the picture. The camera will automatically recalculate the exposure from farther away, including the light or dark background that you want to exclude from the metering. You can change from automatic to manual operation, if that is possible with your camera, so that you can set both shutter speed and aperture yourself. Or use one of the other means of overriding automatic exposure described on page 113.

Suppose you want to use an automatic camera's exposure compensation dial or film speed dial, which lets you change the exposure by a fixed amount. How much should you change it? First meter the scene as you want to shoot it and note the f-stop and/or shutter speed shown in the viewfinder. Then meter with the background excluded. Count the number of stops difference between the two readings and adjust the exposure accordingly. Every change from one shutter speed to the next or from one f-stop to the next counts as one stop.

If you are using an incident-light meter to determine the exposure for a scene that has both brightly lit and shaded areas, decide whether the light or dark areas are more important. If shaded areas are more important, make your reading in the shadows or with the meter shaded by your body or hand. If brightly lit areas are more important, make a reading with the meter held in the light.

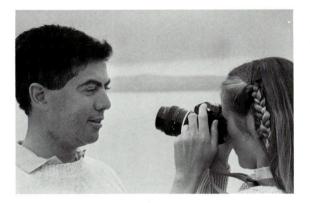

Metering from up close gives good results when contrast is high and the most important part of the scene is much darker or much lighter than its surroundings. With a meter built into a camera, move in until the main subject fills the viewfinder (be careful not to block the light on the subject). Make the reading, set the shutter speed and aperture, then move back to the original position to take the picture. With an automatic camera, set the camera for manual operation or override the automatic exposure (see page 113).

With a hand-held, reflected-light meter, move in close enough to meter mostly the main subject, but not so close that you block the light. A spot meter (page 120), which reads a very narrow angle, can be used to meter a small part of a scene from farther away.

move in close to meter a subject against a much lighter background

When an overall exposure reading was made of this scene, a large expanse of light sky was included in the area metered, so the reading indicated a relatively high level of light. But the figure of the man was much darker than the sky; he did not receive enough exposure and came out very dark.

To meter for a subject against a much lighter background, come close enough so that the meter reads mostly the subject, but not so close that you cast a shadow on the area you are metering.

Having set the correct exposure, return to the original position to make the photograph. The face was more accurately rendered by this method. A camera that automatically sets f-stops or aperture must sometimes be manually overridden, as it was here, if a correct exposure is to be made.

tilt the meter down to exclude a bright sky when you meter a landscape

In a landscape or cityscape, so much light can be metered from the sky that the reading produces too little exposure for the land elements in the scene. Here the sky is properly exposed but the buildings are too dark and lack detail.

For a proper exposure for the buildings, light reflected from them should be dominant when the reading is made. This is done by pointing the camera or separate meter slightly down so that the meter's cells "see" less of the sky and more of the buildings.

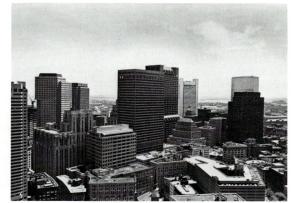

Having set the correct exposure by measuring the light reflected from the buildings, tilt the camera up once again, returning to the original composition. This time the buildings are lighter and reveal more detail. The sky is lighter also, but there is no significant detail there at either setting. Light areas, such as the sky, can easily be darkened during printing.

Exposing for Specific Tones

Another method of calculating exposure that can be even more precise than making an overall reading, either from a distance or up close, involves using a reflected-light meter to measure the luminance of one important area, then finding the exposure that will render that area as dark or as light as you want it to be in the final print.

How is it possible to decide in advance what tone an important area will have in the final photograph? It is easy if you know that for any area of uniform tone, a reflected-light meter will recommend an exposure that will render that area as **middle gray** in the print. If you take three meter readings to make three different photographs—first of white lace, then of medium-gray tweed, and finally of black satin—the meter will indicate three different exposures that will record each subject as middle gray (photographs, this page).

However, you can choose how light or dark an area will appear by adjusting the exposures indicated by the meter. If you give more exposure than the meter indicates, the area metered will be lighter than middle gray in the final print. Less exposure will make an area darker than middle gray. For example, if you want the white lace to appear realistically as very light but still show substance and texture, expose two stops more than the meter recommends. (Snow scenes are a typical situation in which you might want to increase the exposure a stop or two because an overall reading can make the scene too dark.) If you want the black satin to appear rich and dark with full texture, expose two stops less than the meter recommends.

One area often metered when calculating exposures for a portrait is **skin tone.** While clothing and background can vary from very light to very dark, most people's skin tones are realistically rendered within only about a three-stop spread. Dark skins seem natural when they are printed as middle gray or slightly darker. Average lighttoned skins appear natural one stop lighter than middle gray. Extremely light skins can appear as light as two stops above middle gray. To use a skin tone as the basis for exposure, meter the lighter side of the face (if one side is more brightly lit than the other). For dark skin, use the exposure indicated by the meter; for medium light, give one stop more exposure; for unusually pale, give two stops more.

The other area often metered to determine exposure is the darkest **shadow area** in which it is important to retain a full sense of texture and detail. In the photograph opposite, this is the woman's hair and the shadowed part of the wall to her right. If you want a major shadow area to appear very dark but with objects and details still clearly visible, meter the shadow area and then expose two stops less than the meter indicates.

When you change the exposure indicated by the meter, you must meter specific areas carefully. Changing the exposure affects all the values in the print, not just the one you meter. One area will stay relatively lighter or darker than another—the woman's face (right) will always be lighter than her hair or the wall-but all will be either lighter or darker as the scene is given more or less exposure. When shooting negative film, it is worse to underexpose the film than overexpose it. Detail in slightly overexposed highlights can be printed in, but detail that is missing from underexposed shadow areas cannot be added later on. (The opposite is true with color slides; see page 236.) See Chapter 13, Zone System, for a method of controlling tones by adjusting exposure and development.

white lace given exposure suggested by meter

gray tweed given exposure suggested by meter

black satin given exposure suggested by meter

A reflected-light meter measures the average luminance (the amount of light) from an area, then indicates an exposure that will render that luminance as middle gray in the final print (see photographs above left). If you want a specific area to appear darker or lighter than middle gray, you can measure its luminance and then give less or more exposure than the meter indicates (above right). The gray scale and chart (opposite) show how much to change the meter reading to get a specific tone. The chart is based on material developed by Ansel Adams.

more exposu

black satin given 2 sto less exposu

Exposing Black-and-White Film for Specific Tones

Five stops more exposure than indi- cated by meter. Maximum white of the paper base. Whites without texture, glaring white surfaces, light sources.	
Four stops more exposure. Near white. Slight tonality, but no visible texture. Snow in flat sunlight.	
Three stops more exposure. Very light gray. Highlights with first sign of tex- ture, bright cement, textured snow, brightest highlights on light skin.	
Two stops more exposure. Light gray. Very light surfaces with full texture and detail, very light skin, sand or snow acutely sidelit.	
One stop more exposure. Medium-light gray. Lit side of average light-toned skin, shadows on snow in a scene with both shaded and sunlit snow.	
Exposure indicated by meter. <i>Middle gray. The tone that a reflected-light meter assumes it is reading. Neutral gray test card, dark skin, clear north sky.</i>	
One stop less exposure. Medium-dark gray. Dark stone, average dark foliage, shadows in landscape scenes, shadows on skin in sunlit portrait.	
Two stops less exposure. Dark gray. Shadow areas with full texture and de- tail, very dark soil, very dark fabrics with full texture.	
Three stops less exposure. Gray-black. Darkest gray in which some suggestion of texture and detail appears.	
Four stops less exposure. Near black. First step above complete black in the print, slight tonality but no visible tex- ture.	
Five stops less exposure than indicated by meter. Maximum black that paper can produce. Doorway or window opening to unlit building interior.	

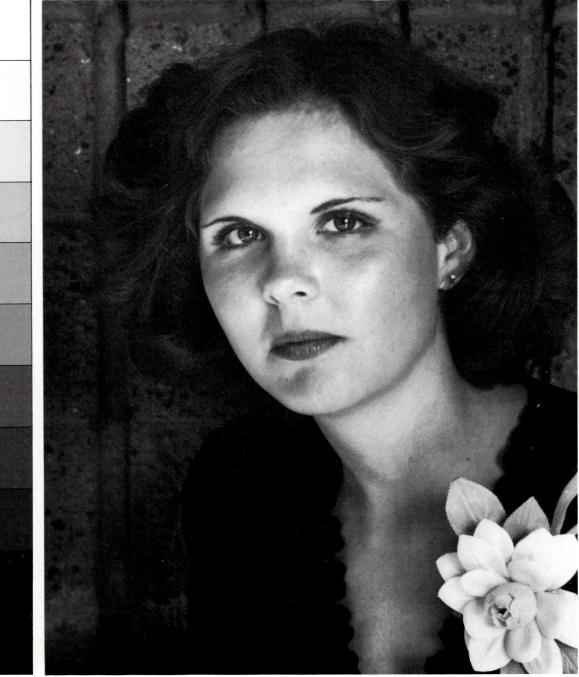

Spot Meters

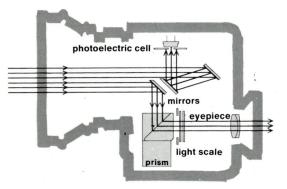

The operating principle of a spot meter such as the one below is shown in the greatly simplified diagram above. Part of the light entering through the focusing lens is redirected by a mirror and prism to pass through the exposure scales and eyepiece lens, so that you can aim the meter at the subject. The rest of the light is reflected toward a photoelectric cell. In front of the cell is a shield with a small opening; this shield blocks most of the light; only the small fraction reflected by a small part of the scene gets through to be measured. The reading is visible over the scene as it is viewed through the eyepiece.

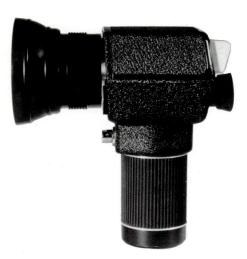

There are times when you will want to meter only a small part of a scene. A spot meter measures reflected light. but of only a very small section of the scene in front of it. Where an ordinary reflected-light meter measures light over an angle of 30° to 50°, a spot meter can measure a 1° angle or less. It can read large objects at a great distance or very small objects close up. The side of a building from several blocks away, a person's face at 20 feet, or a dime at one and a half feet can all be read with a 1° spot meter. It can be an expensive tool, one that is used primarily by professional photographers and advanced workers, but because the objects in a scene can vary considerably in tone, it is useful when precise meter readings of key areas are needed.

Looking through the viewfinder of one type of spot meter, you see a part of the scene (*right*) through an optical system that magnifies the image. A small circle in the center of the viewing screen indicates the area being measured. Some meters built into cameras can make a spot reading, although seldom one as narrow as a hand-held spot meter.

A spot meter is particularly useful when you want to base your exposure on one important tone in a scene, such as the sunlit side of a person's face. It can be difficult to get close enough with an ordinary meter to take an accurate reading without shading the area with the meter or part of your body. A spot meter can make an accurate reading of a small, back-lighted subject by reading only the subject and excluding the lighter background. Even areas that are relatively large can be read more accurately with a spot meter since there are often variations in surface luminance. such as small but very bright reflections, that can influence an ordinary meter's reading too much.

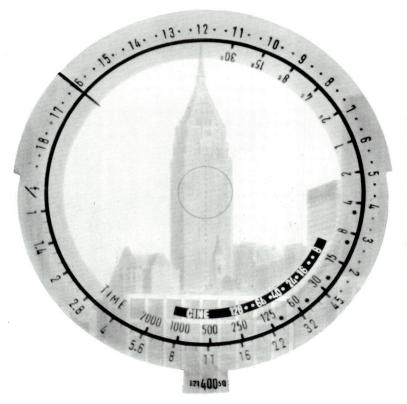

The spot meter's lens takes in a small section of the photographic scene and magnifies that image in the eyepiece. The actual area measured for reflected light (small circle) is a very small part of the visible scene, covering just 1°. To use this particular meter, you set the outer dial to the film speed rating (bottom) and point the instrument so that the small aiming circle is on the area to be measured; the inner dial then moves automatically to line up the proper aperture—shutter speed combinations. The short, innermost scale lists framesper-second settings for motion-picture cameras.

Substitution Readings

For photographing fast-moving situations such as street scenes, metering the palm of your hand makes a quick substitution reading. Hold your palm so that the light on it is about the same as on the people or objects you want to photograph. If your skin is an average light tone, expose one stop more than the meter indicates.

An accurate exposure can be calculated by metering the light reflected from a standard-gray test card. Place the card at the same angle to the light as the front of the subject. Meter the card from the direction that the camera will be when you are shooting. Don't meter at an angle if the camera will be shooting head on. When you meter any object at close range, hold the meter or camera so that it does not cast a shadow on the subject. What do you do if you can't get close enough to the subject to make a reading and you don't have a spot meter that can make a reading at a distance? The solution is a **substitution reading.** Suppose you are photographing a boat, but water between you and it makes it impossible to walk over to make a reading directly. You can often find an object with a similar tone and in similar light nearby to meter instead.

One object always with you that can be metered is the palm of your hand. Average light-toned skin is about one stop lighter than the middle-gray tone for which meters calibrate an exposure, so if your skin is light, give one stop more exposure than the meter indicates. If the skin of your palm is dark, use the indicated exposure. Even better, calibrate your palm: meter it, then meter a gray card (described below) and see how much the readings differ.

Another useful substitution reading is from a gray card, a test card of a standard gray tone. This is a piece of 8 \times 10-inch cardboard with a gray side that reflects 18 percent of the light falling on it and a white side that reflects 90 percent of the light. Since light meters are calibrated for a middle-gray tone of about 18 percent reflectance, a reading from a gray card produces an accurate exposure if the card is placed so that it is lit from the same angle as the subject. If the light is very dim, make a reading from the white side of the card; it reflects five times as much light as middle gray, so increase the indicated exposure five times (two and one-third stops).

A gray card is often used to balance the light in a studio setup or when copying an object such as a painting. It is also useful in color photography as a standard against which the color balance of a print can be matched.

Hard-to-Meter Scenes

If there is light enough to see by, there is probably light enough to make a photograph, but the light level may be so low that you may not be able to get a reading from your exposure meter. Try metering a white surface such as a white paper or handkerchief; then give about two stops more exposure than indicated by the meter.

If metering is not practical, the chart at right (*top*) gives some starting points for exposures with ISO/ASA 400 film. Since the intensity of light can vary widely, **bracket your exposures** by making at least three pictures: (1) using the recommended exposure, (2) giving one to two stops more exposure, and (3) giving one to two stops less exposure. One of the exposures should be printable, and the range of exposures will bring out details in different parts of the scene.

If the exposure time is one second or longer, you may find that the film does not respond the same way that it does in ordinary lighting situations. In theory, a long exposure in very dim light should give the same result as a short exposure in very bright light. According to the photographic law of reciprocity, light intensity and exposure time are reciprocal; an increase in one will be balanced by a decrease in the other. But in practice the law does not hold for very long or very short exposures.

Reciprocity effect occurs at exposures of one second or longer (and at exposures shorter than 1/1000 second); you get a decrease in effective film speed and consequently underexposure. To make up for the decrease in film speed, you must increase the exposure. The exact increase needed varies with different types of film, but the chart at right (*bottom*) gives approximate amounts. Bracketing is a good idea with very long exposures. Make at least two exposures: one as indicated by the chart, plus one more giving at least a stop additional exposure. Some meters are designed to calculate exposures of several minutes' duration or even longer, but they do not allow for reciprocity effect. The indicated exposure should be increased according to the chart.

Very long exposure times cause an increase in contrast since the prolonged exposure has more effect on highlights than on shadow areas. This is not a problem in most photographs. since contrast can be controlled when the negative is printed. But where contrast is a critical factor, it can also be decreased by decreasing the film development time. The amount varies with the film; exact information is available from the film manufacturer or see the chart below. Kodak's T-Max films require no development change. The reciprocity effect in color film is more complicated since each color layer responds differently, changing the color balance as well as the overall exposure. See pages 234-235.

Exposing Hard-to-Meter Scenes

situation	approximate exposur ISO/ASA 400 film	re for
stage scene, sports arena, circus event	1/60 SEC	f/2.8
brightly lighted downtown street at night, lighted store window	1/60 SEC	f/4
city skyline at night	1 sec	f/2.8
skyline just after sunset	1/60 SEC	f/5.6
candlelit scene	1/8 sec	f/2.8
campfire scene, burning building at night	1/60 SEC	f/4
fireworks against dark sky	1 sec (or keep shutter open for more than one display)	f/16
fireworks on ground	1/60 SEC	f/4
television image:		
focal-plane shutter speed must be ½ sec or slower to prevent dark raster streaks from ap- pearing in photographs of the screen	1/8 SEC	f/11
leaf shutter speed must be 1⁄30 sec or slower to prevent streak	1⁄30 sec	f/5.6

Preventing Reciprocity Effect: Corrections for Long Exposures

	with most black-and-white films					with Kodak T-Max films			
indicated exposure	open up aperture	or	increase exposure time to	also	decrease development time	open up aperture	or	increase exposure time to	
1 sec	1 stop more		2 sec		10%	1/3 stop more		no increase	
10 sec	2 stops more		50 sec		20%	1/2 stop more		15 sec	
100 sec	3 stops more		1200 sec		30%	1½ stops more with T-Max 400; 1 stop more with T-Max 100		300 sec with T-Max 400; 200 sec with T-Max 100	

At exposure times of 1 sec or longer, film does not respond exactly as it does at shorter shutter speeds. One unit of light falling on film emulsion for 1 sec has less effect than 10 units of light falling on the same emulsion for 1/10 sec. This reciprocity effect during long exposure times means that exposures must be increased or the film will be underexposed, particularly in shadow areas. To compensate for this, increase the indicated exposure as shown in the chart above. Highlights are less subject to reciprocity effect during long exposures with some films, so to prevent too dense highlights when you increase exposure, decrease development time if shown in the chart.

LISL DENNIS: Broadway at Night, 1982

On Broadway at night, Lisl Dennis took a preliminary meter reading off the stone of the statue base because she wanted to make sure that the inscription would show. From that point, she "bracketed like a bandit." The original of this picture was on color transparency film, which has very little tolerance for under- or overexposure, so Dennis bracketed in half-stop increments. Larger increments are satisfactory with black-and-white film. The backward tilt to the statue and the buildings comes from angling a short-focal-length lens upward.

Using Exposure

Before making an exposure, stop for a moment to visualize how you want the final print or slide to look. Do this especially if you are using a camera in an automatic exposure mode. Using most automatic exposure cameras is like using a hand-held reflected-light meter to make a reading of the overall scene. If the scene has an average tonal range, an overall reading produces a good exposure. But many scenes (like the one on this page) do not have an average range of tones. You can use automatic exposure or make an overall reading when an overall exposure will work well; when it won't, make the metering decisions yourself.

There are other scenes for which you might want an out-of-the-ordinary interpretation, like the silhouette (*opposite*), which is produced by underexposing part of a scene. Terminology like "underexposed" implies that there is a "correct" exposure. There is—when you want it that way. Don't let anything stop you from experimenting or doing something differently if that is what you want.

RAY McSAVANEY: Ladder and Oven, Taos Pueblo, New Mexico, 1987

If a scene is light overall, the reading recommended by a hand-held reflected-light meter or by a meter built into a camera will probably make the scene too dark. Meters calculate exposures based on the assumption that the tones in a scene average out to middle gray. If a scene has many very light tones (such as a snow scene) or if you want most of the tones in a scene to appear lighter than average in a print, try giving one or two stops extra exposure. Bracket the exposures if you are not sure.

In a silhouette, the subject is underexposed against a much lighter background. In the photograph above, light was shining on the wall, but not on the part of the subject visible from camera position. The wall was actually a glaring white, but exposing it as a middle-gray tone caused the subject to be grossly underexposed. Four stops more

JOHN LOENGARD: Portrait of Bill Cosby, 1969

exposure would have produced a normal rendering of the person against an almost white background. This is a deliberate version of the same effect that makes a subject very dark if a very light background such as the sky is included during metering (see page 117).

PAUL CAPONIGRO: Negative Print, 1963

Developing the Negative

How to Process Roll Film Step by Step 128 Handling Chemicals 130 Preparing Chemicals and Film 132 Getting the Film into the Developer 134 Stop Bath and Fixer Steps 136 Washing, Drying, and Protecting the Film 138 Processing Roll Film—A Summary 139 How Developer and Fixer Affect a Negative 140 How Time and Temperature Affect Development 142 Exposure and Development: Under, Normal, Over 144 Push Processing 146 The Importance of Proper Agitation and Fresh Solutions 148 The Need for Careful Washing and Drying 149 Intensification and Reduction 150 What Went Wrong? 151

In one sense, the moment the camera shutter exposes the film, the picture has been made. Yet nothing shows on the film; the image is there but it is latent or invisible. Not until it has been developed and printed is the image there to be enjoyed. How enjoyable it will be depends to a great extent on the care you use in darkroom work, for there are many opportunities in developing and printing to control the quality of the final photograph.

This control begins with the development of the negative. The techniques are simple and primarily involve exercising care in following standard processing procedures and in avoiding dust spots, stains, and scratches. Control also includes the ability to adjust the developing process, when necessary, perhaps to "push" the film.

This chapter describes both basic development techniques and somewhat more advanced material to give you greater control over your negatives. The skills needed to develop good negatives are quickly learned and the equipment needed is modest, but the reward is great—an increased ability to make the kind of pictures you want.

Printing a photograph as a negative image instead of as a positive one often makes the literal recording of a scene less important (as with the spring wildflowers, opposite) and strengthens the graphic elements of line and form. The dark shadow areas in the original scene (or in a positive print) become light so that light seems to come from behind or within the subject. The dark objects in this print (light-toned flowers in the original scene) appear to float on the surface of the print. Compare Minor White's negative print, page 89.

How to Process Roll Film Step by Step

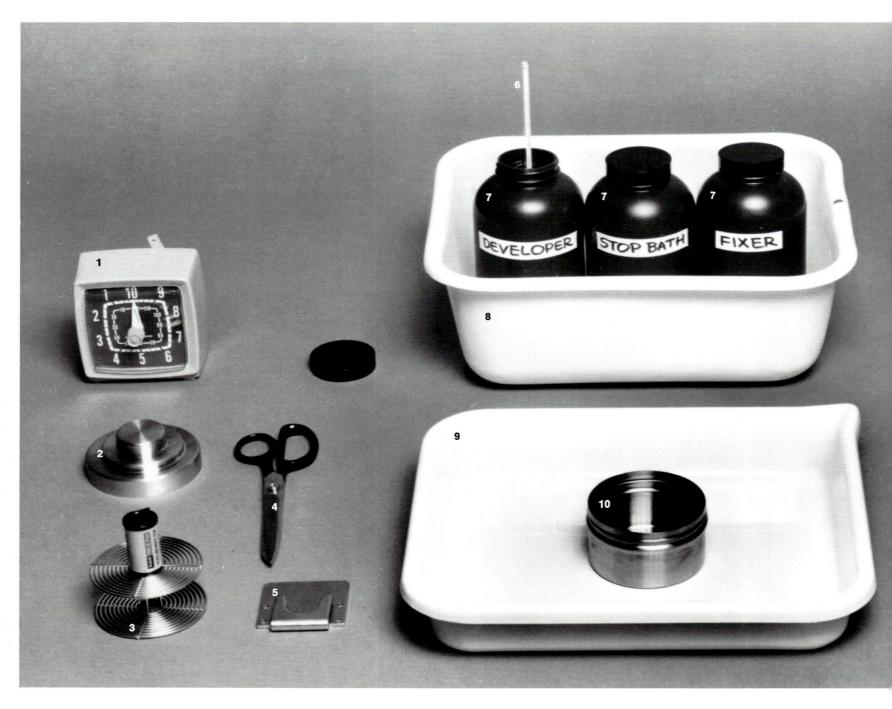

- 1 interval timer
- 2 developing tank cover and cap
- 3 developing reel
- 4 scissors
- 5 | film cassette opener (or bottle cap opener)
- 6 thermometer
- 7 chemical solutions
- 8 temperature control pan
- 9 temperature control tray
- 10 developing tank
- 11 1-quart graduate
- 12 washing hose
- 13 photo sponge
- 14 film drying clips (or clothespins)

Orderliness will make development simpler. Developing your first (and all future) rolls of film will be simplified if you arrange your equipment in an orderly and convenient way. The process starts in total darkness and, once begun, moves briskly. **Consistency** also pays off: if you want to avoid too dense, too thin, unevenly developed, or stained negatives, you need to mix solutions accurately, adjust their temperatures within a degree or two, agitate film during development at regular intervals, and watch processing times carefully.

If you are about to develop your first roll of film, practice loading a junked roll of film onto the developing reel. After you get a feeling for how to do this, practice with your eyes closed. Loading the film onto the reel has to be done in total darkness, so practice until the procedure feels comfortable. (See steps 3 to 8, pages 132–134.)

Processing chemicals include a developer to change the latent (still invisible) image on your exposed film to a visible one. Pick one easily available,

all-purpose developer and become familiar with it before experimenting with other types. You will also need a stop bath (either diluted acetic acid or water) to halt the action of the developer, and a fixer (sometimes called hypo) to dissolve unexposed silver compounds, which will darken in time unless removed. See page 130 for an explanation of how to mix and dilute chemicals and page 139 for a summary of chemical processing.

Check the recommended **time and temperature** for the film and developer combination you are using (*step 1, page 132*). 68° F (20° C) is generally the preferred temperature, but you may have to use a higher temperature (and a correspondingly shorter development time) if your tap water is warm. Running water is used to wash the film, and the temperatures for all solutions including the wash water should be within one or two degrees of each other because excessive temperature changes can cause increased graininess and other problems in the film.

Handling Chemicals

Handling Chemicals—A Summary

Record keeping. After processing film, write down the number of rolls developed on a label attached to the developer bottle—if you are not using a one-shot developer (see below). The instructions that come with developers tell how many rolls can be processed in a given amount of solution and how to alter the procedure if the solution is reused. Each succeeding roll of film requires either extra developing time or, with some developers, addition of a replenisher. Also record the date the developer was first mixed, because even with replenishing most developers deteriorate over time. Check the strength of the fixer regularly with a testing solution made for that purpose.

Replenishing developers. Some developers can be used repeatedly before being discarded if you add additional chemicals to them to keep the solution up to full strength. Carefully follow the manufacturer's instructions for replenishment.

One-shot developers. These developers are designed to be used once and then thrown away. They simplify use (in that no replenishment is needed), and they can give more consistent results than a developer that is used and saved for a long time before being used again.

Mixing dry chemicals. Add dry chemicals to water at the temperature suggested by the manufacturer. Stir gently until dissolved. If some of the chemicals remain undissolved, let the solution stand for a few minutes. Be sure the solution has cooled to the correct temperature before using.

Stock and working solutions. Chemicals are often sold or mixed first as concentrated liquids (stock solutions). When the chemical is to be used, it is diluted into a working solution, usually by the addition of water. The dilution of a liquid concentrate may be given on an instruction sheet as a ratio, such as 1:3. The concentrate is always listed first, followed by the diluting liquid. A developer to be diluted 1:3 means 1 part developer and 3 parts water. To fill a 16-oz (500-cc) developing tank with such a dilution, use 4 oz (125 cc) developer and 12 oz (375 cc) water.

Adjusting temperatures. To heat up a solution, run hot water over the sides of the container (a metal one will change temperature faster than glass or plastic) or place it in a pan of hot water. Placing a container in a tray of ice water or in a refrigerator will cool down a solution in just a few minutes; cooling by running tap water over the container can take a long time unless the tap water is very cold. Stir the solution gently from time to time; the temperature of the solution near the outside of the container will change faster than at the center.

Avoid unnecessary oxidation. Oxygen speeds the exhaustion of most chemicals. Don't use the "cocktail shaker" method of mixing chemicals by vigorously shaking the solution; this adds unwanted oxygen. Store all chemicals in tightly closed containers to prevent their exposure to air. Accordionlike collapsible bottles that leave no room for unwanted air are made. Developers are also affected by light and heat, so store them in dark-colored bottles at temperatures around 70° F (21° C), if possible.

Contamination—chemicals where they don't belong—can result in a plague of darkroom ills. Fixer on your fingers transferred to a roll of film being loaded for development can leave a neat tracery of your fingerprints on the film. A residue of the wrong chemical in a tank can affect the next solution that comes into contact with it. Splashes of developer on your clothes will slowly oxidize to a brown stain that is all but impossible to remove. These problems and more can be prevented by taking a few precautions:

Rinse your hands well when chemicals get on them and dry them on a clean towel; be particularly careful before handling film or paper. It isn't enough just to dip your hands in the water in a temperature control pan or print holding tray; that water may also be contaminated.

Use paper towels for drying, since cloth ones quickly become loaded with chemicals. If you are conservation minded, use a cloth towel, but wash it frequently.

Rinse tanks, trays, and other equipment well both before and after use. Be particularly careful not to get fixer or stop bath into the developer; they are designed to stop developing action, and that is exactly what they will do. Make sure reels, especially plastic ones, are completely dry before loading film.

Wear old clothes or a lab apron in the darkroom.

Keep work areas clean and dry. Wipe up spilled chemicals and wash the area with water.

Handling Chemicals Safely

Photographic chemicals, dry or in solution, should be handled with care, like all chemicals. The following guidelines are designed to prevent accidents and to minimize injury if accidents occur.

General cautions

1. Read labels carefully before using a new product.

2. Use protective gear such as rubber gloves and a waterproof apron when mixing solutions, plus safety goggles when handling concentrated acids or strong alkalies. Some chemicals, particularly those in developers, can cause allergic skin reactions; wearing rubber gloves and using print tongs can prevent problems.

3. If chemicals are accidentally splashed into the eye, immediately flood the eye with running water for at least 15 minutes. Then call a doctor. Keep a hose attached to a cold water tap in the chemical mixing area.

4. Keep chemicals out of the mouth. Wash hands before eating. Do not eat in a room where chemicals are used.

5. Adequately ventilate areas where chemicals are used.

6. Do not smoke where chemicals are used. Some chemicals are flammable or explosive.

7. Store chemicals and solutions safely, out of the reach of children. Do not store them in a refrigerator that is used for food.

8. Dispose of used chemicals safely. Unless otherwise instructed, pour used chemicals down the drain, followed by a generous quantity of water.

Handling acids

Be cautious when using any acid, particularly in a concentrated form, and be prepared to deal with emergencies.

 Remember the basic rule when diluting acids: ADD ACID TO WATER, NEVER WATER TO ACID.
 For external contact with a concentrated acid: flush with cold water immediately—do not scrub —until the area is completely clean. Do not use ointments or antiseptic preparations. Cover with a dry, sterile cloth until you can get medical help.
 For eye contact: immediately flood the eye with running water for at least 15 minutes. Then always get medical help.

4. For internal contact: do not induce vomiting. Instead, drink a neutralizing agent such as milk or milk of magnesia. Get medical help.

SCOTT GOLDSMITH: Bruce Springsteen in Concert, 1984

In order to photograph Bruce Springsteen in concert, Scott Goldsmith had to make both development and exposure choices. Concert lighting is often too dim for an adequately fast shutter speed, so Goldsmith used an ISO/ASA 400 film, which he planned to push to a film speed of ISO/ASA 800. That is, he would expose the film as if it were one stop more sensitive to light than it actually was, then make up for the resulting underexposure by overdeveloping the film (see pages 146-147 for more about how to push film). This would let him use a shutter speed one stop faster than if he did not push the film.

To meter the scene, Goldsmith did not make an overall reading that averaged all the tones of the scene, because that would have given unpredictable results. The picture could have been too light because of the dark stage areas behind the performers, or the picture could have been too dark because the meter might be overly influenced by the bright lights visible behind them. To prevent both of these problems, he made a spot reading of Springsteen's face and based his exposure on that.

How to Process Roll Film Step by Step: continued

Preparing Chemicals and Film

1 set timer, adjust chemical temperatures

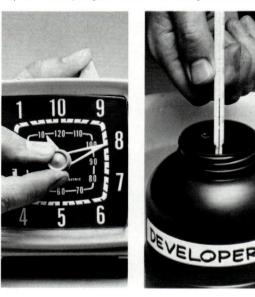

The correct development time depends on the kind of film plus the kind of developer and its temperature. Charts that accompany films and develpers list suggested combinations. If a chart lists different times for large tanks and small tanks (sometimes called reel-type tanks), use the smalltank times. Select a time and temperature for your film and developer, and set—but don't start—the interval timer.

Check the temperatures of the developer, stop bath, and fixer (rinse the thermometer between chemicals). Adjust the temperature of the developer exactly; the temperatures of the other solutions should be within 1 or 2 degrees of the developer. Ideally, there should be no more than 2 degrees difference in temperature between any of the solutions.

Fill the temperature control pan and tray with water at the developing temperature. Leave the bottles in the pan; the water keeps the chemicals in them at the correct temperature. The shallower tray will be used to maintain the temperature of the developer once it has been poured into the developing tank (step 9, page 134). 2 set out materials for loading film

Arrange in a dry, clean, light-tight area the materials you will need to load the film onto the developing reel: film cassette, scissors, reel, plus a dry, clean developing tank with—very important—its cover. The film is loaded onto the reel in the dark and has to be put into the tank and covered before you can turn the lights on again. For opening the cassette, also set out an opener like the one shown on page 128 or a bottle cap opener.

Be sure you have a completely dark area in which to load the film. A room is not dark enough if you can see objects in it after staying 5 minutes with all lights out. If you cannot find any completely dark area, a changing bag can be used to reel the film; your hands fit inside the light-tight bag, along with film, opener, scissors, reel, and the empty tank and its cover.

3 open the film cassette

Lock the door and turn out the lights. In the dark, open the roll of film.

To remove film from a standard 35mm cassette, find the spool end protruding from one end of the cassette. Pick up the cassette by this end, then pry off the other end with the cassette opener or a bottle cap opener. Slide the spool out.

With larger sizes of roll film, which are not contained in cassettes, break the paper seal and unwind the paper until you reach the film. Let the film roll up as you continue unwinding the paper; when you reach the other end of the film, gently pull it free of the adhesive strip that holds it to the paper. To open a plastic cartridge used in an instant-loading camera, twist the cartridge apart and remove the spool. Do not unroll film too rapidly or you may generate static electricity—a tiny bit of light, but enough to streak the film.

Try to handle the film by the edges only. If you touch the surface, particularly the emulsion side, your skin can leave oil that can cause uneven development or pick up dust.

With the scissors, cut off the half-width strip at the beginning of a roll of 35mm film. Film base is quite tough, so cutting the film is better than trying to tear the end off.

5 loading film on a stainless-steel reel

Each side of the stainless-steel reel shown is made of wire in a spiral starting at the core of the reel (a) and running to the outside; the space between the spirals of wire forms a groove that holds the film edge. You have to correctly align the film in one hand and the reel in the other to get the film to slip into the grooves.

Hold the spool of film in either hand so that the film unwinds off the top. Unwind about 3 inches and bow it slightly between thumb and forefinger. Don't squeeze too hard or you may damage the film.

Hold the reel vertically in your other hand and feel for the blunt ends (b) of the spirals at the outside edge of the reel. Rotate the reel until the ends are at the top, then point the ends so they face toward the film.

Now insert the squared-off end of the film into the core of the reel. Some reels have a clip in the core to grip the film end. Rotate the top of the reel away from the film to start the film into the innermost spiral groove.

Other types of reels are available, like the plastic reel shown in step 7, page 134. See step 7 or manufacturer's instructions for loading. 6 finishing loading a stainless-steel reel

To finish winding film on a stainless-steel reel, rest the reel edgewise on a flat surface. Keep one hand on the reel so it doesn't get away from you. Continue to hold the film spool as before with thumb and forefinger, bowing the film just enough to let it slide onto the reel without catching at the edges. Now unwind a short length of film and push the film so that the reel rolls forward. As it rolls it will draw the film easily into the grooves. (You can, if you prefer, gently rotate the reel with one hand, drawing the film into the spirals.) When all the film is wound on the reel, cut off the spool and the tape that attaches it to the film.

Check that the film has been wound into an open spiral with each coil in a separate groove. (Before loading your first roll of film, use a junked roll to feel how much a 36-exposure roll of film, or whatever you will be processing, fills up the developing reel when it is correctly loaded.) If, after loading an exposed roll, you find more—or fewer—empty grooves than the length of your film allows for, gently unwind the film from the reel, rolling it up as it comes, then reload. Unless the reel is correctly loaded, sections of film may touch, preventing development at those points (page 151). low to Process Roll Film Step by Step: continued

Getting the Film into the Developer

Alternate procedure 7 | loading film on a pla<u>stic reel</u>

Plastic reels are a popular alternative to stainlessteel reels. They are easier to load, especially for peginners, although not as durable or as easy to plean as stainless reels. Make sure before attemptng to load film that the reel is completely dry.

o load 35mm film on this reel, open the cassette nd square off the film end (steps 3 and 4, pages 32 and 133.) Cut between the sprocket holes, not hrough them or the film may not load properly. To est for a proper cut, run your finger along the squared-off end of the film. (Remember, you are loing this in the dark.) If you feel a snag, make nother cut close to the end of the film. When the end feels smooth, the cut is correct.

I lod the film in either hand so that the film inwinds off the top. Hold the reel vertically in your other hand with the entry flanges at the top, evenly aligned and pointing toward the film. Insert the end of the film just under the entry flanges at the outermost part of the reel. Push the film forward about half a turn of the reel. Now hold the reel in oth hands (as shown above) and turn the two nalves of the reel back and forth as far as they will to in opposite directions to draw the film into the reel. 8 put the reel into the tank and cover it

Place the loaded reel in the tank and PUT ON THE TANK COVER. The film is shielded from light when' it is inside the tank with cover in place, so you can now turn on the lights or take the tank to the developing area. Keep the cover in place as you add and remove chemicals through the light-tight pouring opening in the tank cover. The tank shown here has a small cap for the pouring opening so chemicals do not spill out during agitation.

Alternate procedure. The reeled film is placed in a tank that is already filled with developer. The advantage is that the developer hits the film all at the same time, which conceivably could produce more uniform development than adding the developer through the small pouring opening; the disadvantage is that, before you can turn the lights on, you have to grope around in the dark to get the film into a liquid-filled tank, the tank covered, and the timer started.

9 add the developer and start the timer

Now actual development can begin, and you have to do two things in rapid succession: pour developer into the small pouring opening in the tank's cover and start the timer. If you hold the tank at an angle, it may accept the liquid faster.

Time the development period either from the time you begin to pour in the developer to the time you begin to pour in the next chemical (stop bath) or from the time the tank is filled with developer to the time it is filled with stop bath. Either is fine, but be consistent.

10 agitate

Start agitation as soon as the tank is filled with developer and the timer is started. Put the cap over the pouring opening in the tank cover. Hold the tank so its cover and central cap won't come off.

First, rap the bottom of the tank sharply against the sink or counter several times to dislodge any air bubbles that may have attached themselves to the film.

Then begin the regular agitation pattern to be followed throughout the development time: gently turn the tank upside down, then right side up again 5 times, with each inversion taking about 1 sec. Repeat every 30 sec, with the tank resting in the temperature control tray between agitation times.

Some tanks cannot be inverted without leakage. One type has a crank in the lid that agitates the film by turning the reel in the solution. Others have to be used in the dark so the film can be agitated by moving the reel up and down in the developer. 11 remove cap from the pouring opening

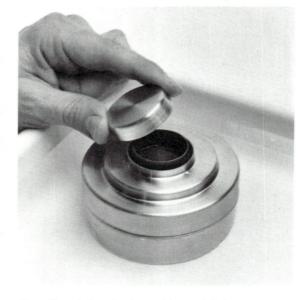

About 15 sec before development is completed, get ready to empty the developer from the tank. Remove the cap from the center pouring opening —BUT DO NOT REMOVE THE TANK COVER ITSELF. 12 pour out the developer

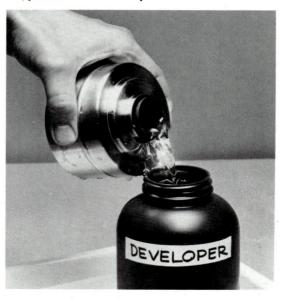

Hold the tank so the cover cannot fall off. A few seconds before the timer signals that development is completed, start pouring the developer from the tank into the developer bottle. If the bottle has a small mouth, or if the tank does not pour out smoothly, use a funnel to speed pouring. As soon as the tank is empty, proceed immediately to the next step, pouring in the stop bath. (One-shot developers are not saved; see page 130.)

Stop Bath and Fixer Steps

13 fill the tank with stop bath

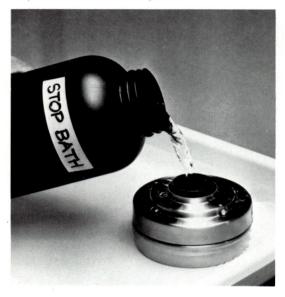

Quickly pour stop bath into the tank through the central pouring opening of the cover. DO NOT REMOVE THE TANK COVER. Fill the tank just to overflowing to make sure the film is entirely covered. On some tanks the light baffle in the opening is arranged so that the tank must be held at a slight angle to speed the filling.

14 agitate

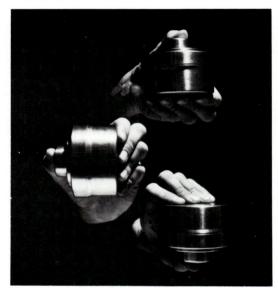

After replacing the pouring opening cap, agitate the tank gently for about 30 sec.

15 pour out the stop bath

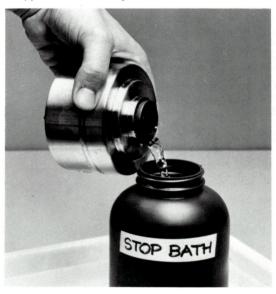

Empty the tank of stop bath. DO NOT REMOVE THE TANK COVER. Some photographers throw out used acetic acid stop bath, since it is inexpensive and easier to store as a concentrated solution. If you are using water instead of acetic acid as a stop bath, simply discard the water.

16 | fill the tank with fixer

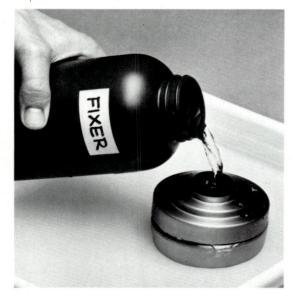

With the tank cover still on, pour fixer through the pouring opening in the cover. Fill to overflowing.

17 set the timer

Turn the timer pointer to the fixing time recommended in the chemical manufacturer's instructions. Be sure to use the figures specified for film; most fixing solutions can also be used to process prints, but the dilutions and times required are different.

18 agitate

Agitate the fixer-filled tank continuously for the first 30 sec, then at 1-min intervals during the fixing period. When the timer signals that the period is up, pour the fixer back into its container. The entire cover of the tank may now be removed since the film is no longer sensitive to light.

A general rule is to fix for twice the time it takes to clear the film of its milky appearance. About halfway through the fixing period, you can open the tank to take a quick look at the end of the roll to see if the film no longer looks milky. If the film takes longer than half the recommended time to clear, the fixer is weak and should be discarded. Refix the film in fresh fixer.

Washing, Drying, and Protecting the Film

19 wash the film

An optional but highly recommended step before washing is to treat the film with a washing aid solution. This greatly reduces washing time and removes more of the fixer (hypo) than water alone can remove. Follow the manufacturer's directions for use.

Adjust faucets to provide running water at the development temperature. Leave the reel in the open tank in the sink and insert the hose from the tap into the core of the reel. Let the water run fast enough to completely fill the container several times in 5 min. If one is available, you can use a specially designed—and more efficient—washing tank. Empty the water and refill several times; fixer is heavier than water and may settle at the bottom of the tank. About 30 min of washing is needed to prevent later deterioration of the image. Much less wash time is needed if a washing aid is used.

After washing, treat the film in a wetting solution, such as Kodak Photo-Flo, to help prevent water spots. Follow the manufacturer's directions for use. 20 dry the film

Unwind the film from the reel and hang it up to dry immediately. Unwind gently; the wet emulsion is soft and easily scratched. Resist the temptation to examine the negatives until they are dry; dust quickly accumulates on damp film. Attach a clip or clothespin to one end of the film and hang it in a dust-free place where the temperature will remain constant during the drying period—1 or 2 hours at average room temperature. A film-drying cabinet is the best place. At home, a good dust-free location is inside a tub or shower enclosure with shower curtain or door closed. Attach a weighted clip to the bottom of the film. The wetting agent should cause water to sheet off the film so that it dries without spotting. If spotting is a problem, try removing excess water from the surface by very gently drawing a damp, absolutely clean photo sponge, held at a 45° angle, down both sides of the film.

21 protect the dry negatives

When the film is dry, cut it into appropriate lengths to fit into protective sleeves. Don't cut the film into separate frames; that will make it difficult to handle during printing. Hold film only by its edges to avoid fingerprints and scratches. Careful treatment of negatives now will pay off later when they are printed.

Processing Roll Film—A Summary

	chemicals needed	procedure			
preparationYou will need 3 basic chemical solutions: devel- oper, stop bath, and fixer. Additionally, a washing aid is recommended; a wetting agent is optional. Details below.		Mix the chemical stock solutions needed and di- lute to working strength. Carefully follow manufac- turer's recommendations for development time and temperature.	Ideally, the developer should be exactly at the rec- ommended temperature, with the other solutions no more than 1 or 2 degrees different. See page 130 for more on mixing and storing chemicals.		
loading film		In total darkness, load film onto developing reel. Put reeled film into empty, dry tank and close with light-tight cover before turning on lights.			
water presoak (optional)		Before adding developer, fill tank with plain water at the same temperature as the developer. Agitate gently for one minute, then drain and fill tank with developer. You may have to extend development time by 10 percent to compensate for the time it takes for the water that has soaked into the emul- sion to be replaced by developer.	Although this optional step is commonly used, Kodak reports some possible problems. The ad- vantages are that the water washes off any dust that may be on the film, and it wets the emulsion uniformly, which in some cases may help prevent uneven development or air bells. However, Kodak not only doesn't recommend presoaking of roll films, it warns that in some cases (such as with Technical Pan 2415 film) a presoak can <i>cause</i> un- even development.		
development	Use a developer suitable for film. All-purpose developers (such as Kodak D-76, HC-110, or T-Max; Ilford ID-11, Ethol UFG, Edwal FG7) work well for most uses. High-energy developers (such as Acu- fine and Diafine) are useful for push processing (see pages 146–147). Fine-grain developers (such as Kodak Microdol-X, Ilford Microphen, and Edwal Super-20) produce finer grain but with possible loss in contrast and apparent sharpness; some di- lutions cause a loss in film speed. See manufactu- rer's data.	Fill tank with developer. Begin development by rapping the bottom of the tank on a hard surface to dislodge air bubbles. Agitate by inverting the tank 5 times, with each inversion taking about 1 sec. Repeat the inversion procedure once every 30 sec. Shortly before development time is over, pour out developer through pouring opening of cover. DO NOT REMOVE COVER UNTIL FILM IS FIXED.			
stop bath	Some photographers use a plain water rinse for a stop bath; others prefer a dilute solution of acetic acid (about 1 oz 28% acetic acid per quart of water). An indicator-type stop bath is available that changes color when it is exhausted, but many pho- tographers simply mix the stop bath fresh each time.	Quickly fill tank through pouring opening with stop bath. Replace cap over pouring opening and agitate for 30 sec. Pour out. DO NOT REMOVE THE ENTIRE COVER YET.			
fixing	Use a fixer with hardener. Use a rapid fixer with T- Max films. Fresh fixer will process about 25 rolls of film per quart of working solution (fewer rolls with T-Max films). The age of the solution also affects its strength. An inexpensive testing solution is available that indicates when fixer should be dis- carded.	Fill tank through pouring opening with fixer. Agi- tate for 30 sec, then at 1-min intervals for the rec- ommended time. Keep the cover on until at least halfway through the fixing time.	The film should have lost its milky appearance about halfway through the fixing time.		
washing aid (recommended)	A washing aid (also called hypo neutralizer or clearing agent) promotes more effective washing in less time than washing in water alone. Discard after about 10 rolls of film have been treated per quart of working solution (or as directed).	Rinse in running water for 30 sec, then follow man- ufacturer's data for treatment. With Kodak Hypo Clearing Agent: 2-min immersion with agitation for first 30 sec, then occasional agitation thereafter.	· · · · · · · · · · · · · · · · · · ·		
washing	After washing, a wetting agent, such as Kodak Photo-Flo, is an optional treatment that helps pre- vent water spots, especially in hard-water areas. Mix with distilled water.	Wash 30 min (much less if a washing aid is used; follow manufacturer's data). Then immerse in a wetting agent for 30 sec.	Water should run at least fast enough to com- pletely fill the container several times in 5 min. Dump water several times as well.		
drying		Hang to dry in dust-free place with clip on bottom of film to prevent curling.	When dry, cut film into convenient lengths and store in negative envelopes.		

How Developer and Fixer Affect a Negative

Photo supply stores sell a variety of developers that only need to be dissolved in water; all the chemicals have been added in the proper amount. But a general knowledge of developer chemicals is useful background information since you may sometimes mix a developer from a formula.

The most important ingredient in any developer formula is the reducing agent, also called the developing agent. Its job is to free metallic silver from the emulsion's crystals so it can form the image. These crystals contain silver atoms combined with halides such as bromine in light-sensitive compounds, in this case silver bromide. When struck by light during an exposure, the silver bromide crystals undergo a partial chemical change. The exposed crystals (forming the latent image) provide the developing agent with a ready-made working site. The reducer cracks the exposed crystals into their components: metallic silver, which stays to form the dark parts of the image (see pictures, this page), and bromine, which unites chemically with the developer. In a chromogenic film, the silver is later replaced by dyes, but the original silver development is the same.

Some reducing agents are used alone, but often two together assist each other. Many formulas consist of a combination of the compounds Metol and hydroquinone (called M.Q. formulas). The Metol improves film speed and tonal gradation while the hydroquinone increases density and contrast. Some other reducing agents are glycin and para-aminophenol (in fine-grain formulas) and phenidone (like Metol but less irritating to the skin).

Since most reducing agents work only in an alkaline solution, an alkaline salt such as borax or sodium carbonate is usually added as an accelerator. Some developers are so active that they will develop the unexposed as well as the exposed parts of the emulsion, thus fogging the negative; to prevent this, a restrainer, usually potassium bromide, is added to some formulas. The bromide that is released by the reducing agent from the silver bromide crystals also has a restraining effect. Finally, since exposure to oxygen in the atmosphere causes a developer to lose its effectiveness, a preservative such as sodium sulfite may be added to prevent oxidation.

undeveloped silver bromide crystals

developed 10 seconds

developed 1 minute

Electron microscope pictures of emulsions show how exposed crystals of silver bromide (magnified $5,000 \times$) are converted to pure silver during development. At first (top) the crystals show no activity (dark specks on some crystals are caused by the microscope procedure). After 10 sec, parts of two small clusters (arrows) have been converted to dark silver. After a minute, about half the crystals are developed, forming strands of silver. In the bottom picture all exposed crystals are developed; undeveloped crystals have been removed by fixer, and the strands now form the negative image.

developed 5 minutes and fixed

not enough fixing

normal fixing

After the developer has done its work, the image on the negative is visible but very perishable. If exposed to light, the entire negative will turn dark. To prevent this, the **fixer** sets the image permanently on the film.

The fixing agent is needed because the negative image contains leftover crystals of silver bromide. These crystals were mostly part of shadow areas in the image, so were not exposed, but they are still light sensitive and, if allowed to remain, will darken the negative (*above left*). The fixer prevents this by dissolving these crystals out of the emulsion.

The active agent in fixer is sodium thiosulfate. (The early name for this substance was sodium hyposulfite, and **hypo** is still a common name for fixer.) Ammonium thiosulfate, a fast-acting fixer, can also be used. A **hardener** is generally part of the fixer solution. This prevents the film emulsion from becoming so soft or swollen that it is damaged during the washing that follows fixing. A **rapid fixer** needs less time to work than a standard fixer. Kodak recommends using a rapid fixer with T-Max

films to facilitate complete fixing. Follow fixer instructions carefully. If used correctly, the fixer dissolves only the unexposed crystals of silver bromide and does not affect the metallic silver making up the image itself. But if film is left too long in the fixer the image eventually bleaches (*above right*).

Ordinarily, however, the danger is not too much fixing but too little. If the film is not left in the fixer long enough, if it is not agitated during fixing, or if the fixer is exhausted, silver bromide crystals are left undissolved and will later darken the film.

How Time and Temperature Affect Development

The longer the developer is allowed to act on the film, the greater the number of crystals converted to metallic silver and the darker the negative becomes. The pictures on the opposite page show that the **density** of silver in an image does not increase uniformly. Increasing the development time causes a great deal of change in those parts of the negative that received the most exposure (the bright areas in the original scene). It causes some changes in those areas that received moderate exposure (the midtones), but only a little change in areas that received little exposure (the shadow areas). In any negative, lengthening or shortening development time has a marked effect on contrast-the relationship between light and dark tones.

Development time controls contrast and density because of the way that film emulsion is constructed. The crystals of silver bromide that will develop into the negative image lie both on and below the surface of the emulsion. As exposure increases, the number of exposed crystals and their depth in the emulsion also increase. When the developer goes to work, it gets at the surface crystals immediately but needs extra time to soak into the emulsion and develop the crystals below the surface, as illustrated on this page. Thus the total amount of time the developer is allowed to work determines how deeply it penetrates and how densely it develops the exposed crystals, while the original exposure determines how many crystals are available to be developed. See pages 144-145.

The rate of development changes during the process, as is shown in the examples opposite (*left column*). During the first seconds, before the solution has soaked into the emulsion, activity is very slow; the strongest highlights have barely begun to show up (*top*). Soon the solution soaks in enough to develop many of the exposed crystals; during this period a doubling of the development time will double the density of the negative (*center*). Still later, after most of the exposed crystals have been developed, the pace slows down again so that a tripling, or more, of the time adds proportionately less density than it did before (*bottom*).

Developer temperature also affects the rate of development. Most photographic chemicals and even the wash water take longer to work as their temperatures drop. All solutions work faster at higher temperatures, but at around 80° F (27° C), the gelatin emulsion of the film begins to soften and becomes very easily damaged. The effects of temperature on the rate of development are shown on the opposite page.

Time-and-temperature charts that accompany films and developers show suggested development times at various temperatures—the higher the temperature, the shorter the development time needed (see chart at right). The temperature generally recommended is 68° F (20° C); this temperature combines efficient chemical activity with the least softening of the film emulsion and is a practical temperature to maintain in the average darkroom. A higher temperature can be used when the tap water is very warm, as it is in many areas during the summer.

A chart may list one set of times for small or reel-type tanks and another for large tanks. A **small tank** holds from one to four reels and is agitated by inverting it (as shown in step 10 on page 135) or by cranking a handle that rotates the reel. A **large tank** is agitated by lifting the reels out of the developer on a central spindle. developed for 2 minutes developed for 5 minutes developed for 15 minutes

Grains of silver, enlarged about $2,500 \times$ in this cross section of film emulsion, get denser as development is extended. Grains near the surface (top) form first and grow in size. As developer soaks down, subsurface grains form.

KODAK T-MAX 400 Professional Film

El (Film	Kodak Developer	Developing Times (Minutes)—Roll Film									
		Small Tank (Agitation at 30-Second Intervals)				Large Tank (Agitation at 1-Minute Intervals)					
Speed)	Developer	65°F (18°C)	68°F (20°C)	70°F (21°C)	72°F (22°C)	75°F (24°C)	65°F (18°C)	68°F (20°C)	70°F (21°C)	72°F (22°C)	75°F (24°C)
400	T-Max	NR	7	61/2	61/2	6	NR	7	61/2	61/2	6
400	D-76	9	8	7	61/2	51/2	10	9	8	71/2	61/2
400	D-76 (1:1)	141/2	121/2	11	10	9		-		-	- 1
320	HC-110 (Dil B)	61/2	6	51/2	5	41/2	8	7	61/2	6	5
200	MICRODOL-X	12	101/2	9	81/2	71/2	13	111/2	10	9	8
320	MICRODOL-X (1:3)	NR	NR	20	181/2	16	_	_	_		_

Note: The primary development times are in bold face. NR–Not recommended

A time-and-temperature chart for development is provided by film and developer manufacturers. 68° F (20° C), shown in boldface type, is the recommended temperature for most of the developers listed on this chart. The exceptions are T-Max developer and Microdol-X diluted 1:3, for which the recommended temperature increases to 75° F (24° C). A change in temperature of even a few degrees can cause a significant change in the rate of development and therefore requires a change in the development time. Note that the EI (film speed), shown in the chart's far left column, decreases with some developers.

changing time

changing temperature

negative developed for 45 seconds

negative developed at 40° F

negative developed for 71/2 minutes

negative developed at 68° F

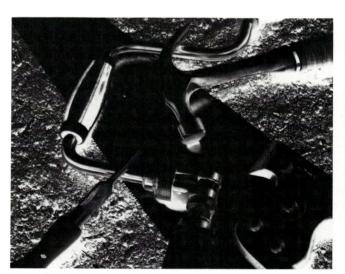

negative developed for 30 minutes

negative developed at 100° F

Development time and temperature need to be monitored carefully because the longer the film is in the developer at a given temperature, the darker the negative image becomes (photos, left). The negative also becomes darker if development takes place at higher temperatures, if development time stays the same (photos, right). A correctly exposed and properly developed negative will make your next step —printing—much easier. You are likely to produce a printable negative if you simply follow the manufacturer's standard recommendations for exposure (film speed) and development (time and temperature). But, after you have a grasp of the basic techniques, you may want to adjust your exposure or development. If you are just beginning in photography, you can come back to this material after you have had some experience printing.

To evaluate a negative, you need to look at its density and contrast. Density is the amount of silver built up in the negative overall or in a particular part of the negative. Thin negatives have low density overall. The thinnest parts of any negative correspond to the darkest areas in the original scene; the film received little light from those parts of the scene and developed little silver density there. **Dense** negatives have a heavy buildup of silver overall. The densest parts of any negative correspond to the lightest areas in the original scene; the film received a large amount of light from those areas and developed a heavy silver density there.

Contrast is the difference in density between the thinner parts of the negative (such as shadow areas) and the denser ones (bright highlights). A contrasty or high-contrast negative has a great deal of difference between these areas: the highlights are very dense and the shadows very thin. If you want a normal-looking print from a high-contrast negative, you have to print it on a lowcontrast (#1 or lower) paper. A flat or low-contrast negative, on the other hand, has highlights that are not very much denser than the shadows. To make a normal print from a lowcontrast negative, you must print it on a high-contrast (#3 or higher) paper. (The relation between negative contrast and printing paper contrast is shown on page 175.)

The amount of exposure and development affects the negative, but in different ways, as expressed in the old photographic rule of thumb: Expose for the shadows, develop for the highlights. Changing the development time has little effect on shadow areas, but it has a strong effect on highlight areas. The longer the development at a given temperature, the denser the highlights become; the contrast also increases due to the greater difference between the density of the highlights and that of the shadows. The reverse happens if you decrease development time: the less the difference between highlights and shadows, and the flatter the negative.

Changing the exposure affects both highlight and shadow areas: the greater the exposure, the denser they both will be. But exposure is particularly important to shadow areas because increasing the development time does not significantly increase the density of shadow areas. They must receive adequate exposure if you don't want them to be so dark that they are without detail in the print.

The practical application of these relationships lets you alter exposure or development if you have persistent difficulty printing your negatives. The illustrations opposite show a negative with good density and contrast (center) plus negatives that are thin, dense, flat, and contrasty—and what to do if many of your negatives look that way. You may have to adjust a manufacturer's standard recommendations to suit your own combination of film, camera, darkroom equipment, and so on.

You can also adjust exposure and development for individual scenes. A high-contrast scene (for example, a

sunlit street scene in which you want to see people in both lit and shaded areas) can easily have a nine-stop or greater range between shadows and highlights -too much for details to show in both light and dark areas. In such a situation, you can give enough exposure to maintain details in the shadows, then decrease the development to about threefourths to two-thirds the normal time to keep highlights from being overly dense. A low-contrast scene (such as one outdoors on a heavily overcast day) may have only a three-stop or less range. If you want more contrast than this, you can decrease the exposure about a stop and increase the development to one and one-half to two times normal. (Kodak T-Max films respond more rapidly to changes in development time than other films do, so smaller time adjustments are needed to produce comparable changes.) If you want to maintain the existing high or low contrast in a scene (for example, if you want to keep the flat gray look of a landscape on a foggy day), use normal exposure and development.

Changing the development for individual scenes is easiest with a view camera, which accepts single sheets of film. With roll film you have to develop the entire roll in the same way. Also, increasing development time with small-format roll film may increase the grain more than you want, which is not a problem with larger-format sheet film.

You can adjust contrast during printing by using a higher or lower contrast grade of paper, but also adjusting the contrast of the original negative gives you even more control over the final results. See Chapter 13, Zone System, for more about controlling density and contrast by adjusting exposure and development.

Thin. Little detail in shadow areas, somewhat low contrast overall, printing times very short. If negatives are often thin, increase exposure by setting camera to a lower film speed. Divide film speed by two to increase exposure one stop.

Normal density and contrast. Good separation of tones in highlight, midtones, and shadows (with a scene of normal contrast). Prints on normal-contrast paper. Normal grain for film.

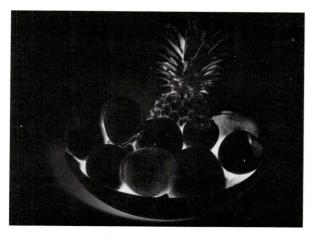

Dense. Highlights too dense, more than adequate density in shadows, printing times very long, grain increased. If negatives are often dense, decrease exposure by setting camera to a higher film speed. Multiply film speed by two to decrease exposure one stop.

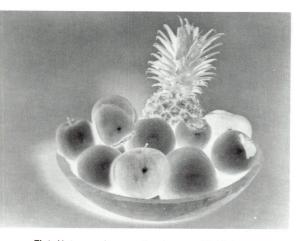

Flat. Not enough separation between highlights and shadows, needs high-contrast paper for normal print. If negatives are often flat, increase film development; try developing for one and one-half times the normal time.

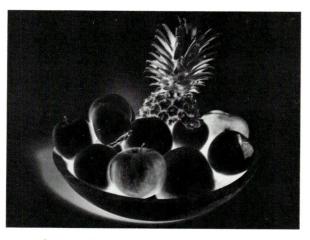

Contrasty. Too much difference between highlights and shadows, needs low-contrast paper for normal print, grain increased. If negatives are often contrasty, decrease film development; try three-fourths the normal time.

Push Processing

What do you do when the light is too dim for a reasonably fast shutter speed, even when you are using a fast film? For example, suppose you are shooting indoors and have loaded ISO/ASA 400 film in the camera. With the lens wide open you might still have to use a shutter speed of only 1/30 second, not quite fast enough to hand-hold the camera without risk of camera motion blurring the picture. Your solution: push the film -shoot at a higher-than-normal film speed and then increase the film development. In this case, you could shoot as if your film was ISO 800 (one stop faster), which would let you shoot at 1/60 second, fast enough to hand-hold the camera more confidently.

Even a very fast film may not give enough speed without pushing. Sports events, especially in local playing fields at night or in school gyms, are often dimly lit-at least as far as photography is concerned. Furthermore, if the photographer is on the sidelines, a long lens is a necessity, and the longer the lens, the smaller the maximum aperture; f/4 or f/5.6 is typical for a 400mm lens. Given the problem of dim light, a relatively small aperture, and the need for a fast shutter speed to stop action, the answer is an ISO 3200 film, such as Kodak T-Max P3200, maybe pushed one stop to ISO 6400 or two stops to 12,500.

Pushing film is useful for any moving subject in dim light, such as at a concert, a political meeting, or on the street when light is low—any situation when you don't want to or can't use flash. Pushing is so commonly used by photojournalists that some push all of their film unless they are in bright sunlight or using flash.

Push processing does not actually increase the film speed. You are, in effect, underexposing and overdeveloping the film. This produces a negative with more contrast and grain than a normally exposed, normally developed negative. Increased contrast means that you can expect some loss of detail, especially in dark areas, compared to normal exposure and development (in the pair of photographs opposite, top right, notice how much darker the floorboards are in the pushed photograph). The more you push the film (the higher you rate the film speed), the more contrast and grain you will have. The greater the enlargement, the more this is noticeable. But these disadvantages are offset by the increase in working film speed when you need it.

There are limits to the amount that film can be pushed. A one- to two-stop push is generally practical. A three-stop or greater push creates a definite loss in image quality but can be acceptable if your only other choice is a blurred image. Because of the loss of image quality, it isn't a good idea to push a film unnecessarily. For instance, don't push ISO 400 film to ISO 3200, unless you are stuck without access to the faster film. You'll get better results if you simply use the higher-speed ISO 3200 film at its normal rating.

To develop pushed film, you can either increase the development time or temperature so that it is greater than normal or use a special high-energy developer such as Acufine, Diafine, or Microphen. Some standard developers can be used at concentrations that permit shooting at higher-than-normal film speeds—Edwal FG7 diluted 1:3, for example. In general for a push of one stop, increase the normal development time 25–50 percent; for a two-stop push, double the development time (Kodak T-Max films need less increase in development time). See chart, opposite, and manufacturer's instructions, but for best results make your own tests.

Sometimes you can push film one stop simply by underexposing it. For example, an ISO 400 film might be exposed at ISO 800 and then developed normally. Kodak recommends this for a one-stop push for their T-Max 400 and Tri-X films. They feel that these films have enough exposure latitude to tolerate one stop of underexposure without the need for extra development.

Pushing color films is also possible. You will get some color shifts, as well as the increase of contrast and grain that comes with pushing black-andwhite film. Color slide films such as Kodak Ektachrome 400 or Fujichrome 400 that are processed in E-6 chemicals can be pushed by extending time in the first developer. You can do this yourself if you process your own color film (see manufacturer's recommended times) or a commercial lab will do it. A one-stop push produces relatively little loss in quality. Ektachrome P800/1600 and Fujichrome P1600D are color slide films that are designed for pushing. They have a normal film speed of ISO 400, but can readily be pushed one to two stops (to ISO 800-1600), or as much as three stops (ISO 3200) if greater loss of quality is acceptable. Kodak recommends that Kodachrome films not be pushed.

Color negative films cannot be chemically pushed because they develop fully with normal processing. But because color negative film has some exposure latitude, you can simply underexpose one stop with relatively little loss in quality, two stops with more loss.

Pushing Black-and-White Films

film (normal speed ISO 400)	developer	to push film speed 1 stop to 800	to push film speed 2 stops to 1600
Kodak T-Max 400	Kodak T-Max 75° F (24°C)	develop normally 6 min	8 min
	Kodak D-76 68°F (20°C)	develop normally 8 min	10½ min
Kodak Tri-X	Kodak T-Max 75°	develop normally 5½ min [or increase time to 6½–7 min]	8 min
	Kodak D-76 68°	develop normally 8 min [or increase time to 9½–11 min]	13 min
llford HP5	llford Microphen 68°	8 min	9½-12 min
Fuji Neopan 400	Kodak T-Max 75°	5¼ min	8 min
film (normal speed (ISO 3200)	developer	to push film speed 1 stop to 6400	to push film speed 2 stops to 12,500
Kodak T-Max P3200	Kodak T-Max 75°	11 min	12½ min

The chart shows some manufacturers' development recommendations for pushing film. The development times shown are a starting point from which you should experiment to determine your own combinations. Many photographers, for example, increase development when Tri-X is pushed to ISO 800 [times shown in brackets], even though Kodak says no increase is needed.

<section-header>

Pushing film gives you a higher working film speed when taking pictures in dim light. You deliberately underexpose the film by using a film speed that is double or more the normal rating, then compensate for the underexposure by film pushed two stops

increasing the film development (see chart). Pushing increases graininess and contrast, but it is valuable when more film speed is needed than normal processing can provide.

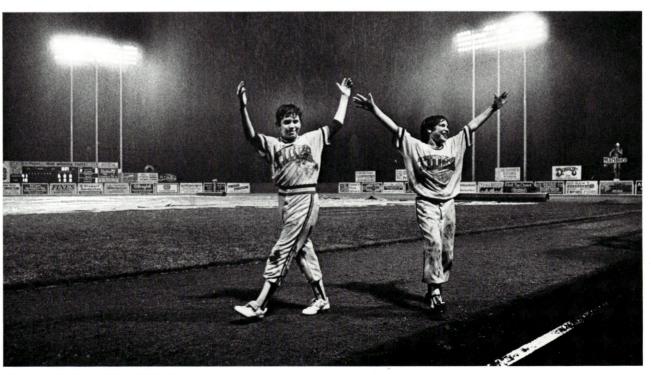

On assignment for the newspaper The Virginian-Pilot, Michele McDonald often photographed baseball at the Metropolitan Stadium in Norfolk, Virginia. The stadium's lighting—or lack of it makes pushing film a standard procedure for photographing night games there. At right, rain had canceled a game, which gave two bat boys a chance to enjoy acting like big stars—even though they were playing to empty stands.

MICHELE McDONALD: Rainy Night Stars, 1984

The purpose of **agitation** (as in *step 10*, *page 135*) is to move the solution inside the developing tank so that a steady supply of fresh chemicals reaches the emulsion at regular intervals. Agitation is vital while the film is in the developer and is also important during later processing stages. Too little or too much agitation can cause problems, as shown in the pictures below.

Inadequate agitation in the developer causes the chemicals next to the emulsion, after performing their share of the chemical reaction, to stop working and form a stagnant area where development activity slows down and eventually stops. This is particularly likely to happen in areas of the film that received a large amount of exposure, because many silver-halide crystals need to be reduced there. Exhausted chemicals are heavier than the rest of the solution and will slowly sink to the bottom of the tank, causing what is called bromide drag—streaks of uneven development as the exhausted chemicals slide down the surface of the film (*below left*).

Too much agitation creates problems even more often than too little agitation. In addition to general overdevelopment, turbulence patterns can force extra quantities of fresh developer along the edges of the film, causing uneven development (*below right*).

To avoid these problems, agitate gently at regular intervals. A pattern often recommended is to agitate for 5 out of every 30 seconds. Follow the manufacturer's directions if another pattern is recommended for a specific product. If possible, agitate in two or more different directions during each agitation period. This avoids setting up a repetitive pattern of flow across the face of the film. If you are developing one reel of film in a two-reel tank, put in an extra empty reel so that the loaded one does not bounce up and down excessively.

You may be tempted someday to try to process one or two more rolls or sheets of film in exhausted developer or fixer rather than remixing fresh solutions, but doing so is a mistake, as shown on the opposite page. A properly exposed negative can be damaged or completely ruined because the chemicals in the solutions are exhausted from overuse or aging. Prevention is easy enough: never use exhausted developer or fixer. Developer manufacturers specify how much film may be processed per quart of solution and, usually, how long the solution can be stored. Fixers can be checked for strength with an inexpensive testing solution.

An exhausted developer produces underdeveloped negatives; there is just not enough active developing agent left to build up density. With partially exhausted developer, details, particularly in shadow areas, may be weakened, but with greater exhaustion the image is seriously damaged (opposite, left). Damage may be worse than that caused by underdevelopment because impurities in the exhausted solution may stain the negative.

too little agitation in developer

The photographs above show some of the problems caused by poor agitation of film during development. Above left, the film was not agitated enough. Exhausted chemicals from dense areas of the negative (the white letters in the positive print shown here) slid down the surface of the film,

causing streaks of uneven development below the letters. Above right, a roll of film was agitated too much and too vigorously. Fresh developer forced through the film's sprocket holes caused the edges of the film to be overdeveloped (denser in the negative) and consequently lighter in the print.

An exhausted fixer produces a negative (opposite, left) that seems overdeveloped compared to a normal one. The solution is unable to dissolve unexposed silver bromide crystals from the negative. These leftover crystals turn dark and increase density in the negative. As shadow areas (in the model's hair, for example) darken, the overall image grows flat; details such as individual strands of hair are obscured and a grayish density fogs the entire negative, even clouding unexposed borders.

The Need for Careful Washing and Drying

developer exhaustion

negative developed in exhausted solution

negative developed in fresh solution

Film can fade or turn yellow if it is not thoroughly washed after fixing. The cause of this damage is the fixer itself. The fixing solution contains dissolved sulfur compounds that tarnish the silver image of the negative if they are not removed. It is exactly the same kind of reaction that causes silverware to tarnish. The unexposed silver compounds that are dissolved in the fixer will tarnish too. Worse still, the tarnish often becomes soluble in the moisture in the air, gradually causing the negative image to dissolve and fade.

Another cause of damage to negatives—one that shows immediately—is careless drying (*shown below*). Justwashed film is delicate and easily scratched. Dust clings to wet film, sometimes implants itself in the emulsion, and can be impossible to remove even with rewashing.

Careful washing and drying is worth

the effort involved. Water for washing must be clean, near the temperature of the earlier solutions, and kept constantly moving across the surface of the film to flush away fixer that has soaked in. Dump the water and refill the tank often; fixer is heavier than water and accumulates at the bottom of the tank. Although much of the fixer can be washed away with water alone if the film is washed long enough, it is best to use a washing aid (also called hypo neutralizer or clearing agent). In addition to working more efficiently than plain water, it greatly reduces washing time and avoids the swelling caused by a long washing period.

Damage during drying is even easier to avoid. Handle the film as little as possible while it is wet and hang to dry in a clean place free from drafts and temperature changes.

fixer exhaustion

negative fixed in exhausted solution

negative fixed in fresh solution

carelessly handled negative

Intensification and Reduction

A completely processed negative (top right) that is too dense or too thin to make an acceptable print can sometimes be improved. Thin negatives can be made darker (middle right) by a process called intensification. A very dense negative can be thinned down (bottom right) by a solution called a reducer (not the same as the reducing agent in film developer). The processes are relatively easy since they are carried out with regular room lighting. There are, however, disadvantages. Intensification increases grain-quite noticeably in an enlargement from a small negative. And both processes involve some danger of staining or otherwise ruining the negative. Unfortunately, the only negatives worth the trouble of intensification or reduction are usually so important that ruining them is worse than having a poor print. Making the best print you can before you treat the negative in any way is good insurance against total loss.

Intensification strengthens density by adding minute particles of another metal (such as chromium) on top of the silver that already forms the negative image. The amount of intensification is usually proportional to the existing amount of silver, which means that the denser (highlight) areas will be intensified more than the thinner (shadow) areas. The result is a greater separation between light and dark parts of the negative and an increase in contrast. Intensification improves a negative that is thin because of underdevelopment or moderate underexposure. It probably won't help a negative that is seriously underexposed, since it can't put back detail that isn't there in the first place.

Reduction decreases the density of a negative by dissolving some of the metallic silver that forms the image. A cutting or subtractive reducer removes approximately equal amounts of silver from all parts of the image and has little or no effect on contrast; it is useful for treating fogged or overexposed negatives. A proportional reducer decreases density in proportion to the existing amount of silver, thus reducing contrast; this is useful for a negative that has too much contrast because of overdevelopment. A super-proportional reducer removes much more silver from the dense areas than it does from the thin areas, thus reducing contrast without affecting the thinner areas of the negative; this would improve an overdeveloped negative of a contrasty subject.

You can purchase intensifiers and reducers or mix them yourself. Farmer's Reducer, for example, is a subtractive reducer, available in photo supply stores, that can be used either for allover reduction of negative density or for local reduction of smaller areas in negatives or prints. Many types of reducers and intensifiers, including Farmer's Reducer, can be mixed from formulas; the Photo-Lab-Index (see Bibliography) gives a number of these.

normally developed negative

underdeveloped negative

intensified negative

reduced negative

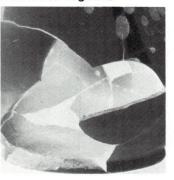

overdeveloped negative

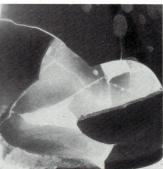

What Went Wrong?

film stuck together

not enough developer

reticulation

Troubleshooting Negative Problems

If spots, stains, or other ailments cause problems with your negatives, check below. You may find a simple way to prevent such problems from happening again. See also Troubleshooting Camera and Lens Problems (page 83), Print Problems (page 181), and Flash Problems (page 288).

Opaque patches in negative (light in print) or clear in negative (dark in print)

Cause: Winding two loops of film onto one loop of developing reel (not hard to do with a stainless-steel reel) or squeezing reeled film (possible with either a stainless-steel or plastic reel) so that one loop remains in contact with another. This keeps chemicals from reaching the film emulsion at the point of contact. Most often the area will be totally unprocessed and opaque (see illustration, top). It will be clear if the film separates during fixing.

Prevention: Wind film on the developing reel carefully. If winding onto a stainless-steel reel doesn't proceed smoothly, unwind a few loops and start again.

Crescent-shaped marks, dark in the negative, light in a print

Cause: Crimping or creasing the film while loading it onto the developing reel.

Prevention: Handle film with care, especially if you have trouble loading it onto a developing reel and have to reel it on and off several times. Spotting (page 189) can improve a print that shows marks.

Static marks, dark in the negative, light in a print

Cause: In the darkroom, pulling undeveloped roll film rapidly away from its paper backing or passing film rapidly through your fingers can cause static marks in beadlike or other shapes. In the camera, winding film rapidly on a very cold, dry day can cause lightninglike marks.

Prevention: In the darkroom, handle film without rapid, friction-producing motions. When humidity is very low, avoid snapping the film advance lever forward or otherwise advancing or rewinding film extremely rapidly.

Every frame on the roll only partially developed, with part lighter than rest of negative image, darker in print.

Cause: Not enough developer to cover film (see illustration, center).

Prevention: Check amount of developer needed to cover reel (or reels, in a tank that holds more than one) or fill tank to overflowing when you add developer.

Small, round clear spots in negative, dark spots in print

Cause: Air bells—bubbles of air on surface of film.

Prevention: Tap the tank vigorously at start of development period (see page 135, step 10).

Reticulation (image appears crinkled or cracked overall)

Cause: Extreme variations in temperatures of processing solutions, such as very warm developer and very cold fixer (see illustration, bottom). Lessextreme variations can cause increased grain.

Prevention: Keep all solutions, from developer to wash, at or within a few degrees of the same temperature.

Faint, watery looking marks

Cause: Uneven drying or water splashed on film during drying.

Prevention: Treat film in a wetting solution, such as Kodak Photo-Flo, just before hanging up to dry. Don't let water from one roll of film drip onto another when hanging to dry. Rewashing the damaged film or spotting the print may help.

Specks, scratches, fingerprints

Cause: Dust and dirt, careless handling (see page 149).

Overdeveloped areas around sprocket holes, dark on film, light in print

Cause: Too much agitation in developer (see page 148).

Uneven, streaky development

Cause: Too little agitation in developer (see page 148).

Thin-looking, too-light negative

Cause: Probably underexposed film but could be exhausted developer (see page 148), developer time too short, or temperature too low (see pages 142–143). See pages 144–145 for the effects of changing exposure versus development.

Dense-looking, too-dark negative

Cause: Probably overexposed film but could be developer time too long or temperature too high (see pages 142–143). See also pages 144–145.

Cloudy look to negative overall

Cause: Inadequate fixing (see pages 141 and 148), possibly old, light-struck, or X-ray–damaged film.

KEN JOSEPHSON: Matthew, 1965

Kenneth Josephson often plays with what he calls the "special reality of photographs." Here a child is transforming a picture of himself into a camera so that he can play photographer. Josephson, in addition to making a charming photograph of a child, brings to our attention some grown-up make-believe. We often unthinkingly look at photographs as if they were substitutes for reality, so that a picture of Michael Jackson, for example, replaces seeing the performer in person. But when the photograph of this child replaces part of his face, it becomes more difficult to ignore that both are abstractions: the picture of the boy is no more real than the picture of the snapshot of the boy.

Printing the Positive

negative

positive

The Darkroom 154 The Enlarger: Basic Tool of the Printmaker 156 Printing Papers 158 How to Process Prints 160 The Contact Sheet: A Whole Roll at Once 160 Preparing the Negative for Enlargement 164 Making a Test Print 166 The Final Print 168 Processing Prints—A Summary 171 How to Judge a Test Print 172 Papers That Control Contrast 174 Graded-Contrast Papers 174 Variable-Contrast Papers 176 Dodging and Burning In 178 Cropping 180 What Went Wrong? 181 **Toning for Color and Other Effects** 182 Archival Processing for Maximum Permanence 183 Platinum Prints: Beauty and Permanence 184

Printmaking is one of the most pleasurable parts of photography. Unlike film development, which requires rigid control, printmaking lends itself to leisurely creation. During printing you make a number of decisions that determine how the print will look. Mistakes are inevitable at first, but a wrong choice can be easily corrected by simply making another print.

Like film, printing paper is coated with a light-sensitive emulsion containing crystals of silver atoms combined with bromine or chlorine atoms or both. Light is passed through the negative and onto the paper. After exposure, the paper is placed in a developer where chemical action converts into metallic silver those crystals in the emulsion that have been exposed to light. A stop bath halts the action of the developer; a fixer removes undeveloped and unexposed crystals; finally the print is washed and dried.

The negative is a reversal of the tones in the original scene. Where the scene was bright, the negative contains many dense, dark grains of silver. These dense areas hold back light from the paper, prevent the formation of silver in the paper's emulsion, and so create a bright area in the print corresponding to the bright area in the scene. Where the scene was dark, the negative is thin or even clear. It passes much light to the paper so that dark silver is formed in the emulsion, resulting in a dark area in the print. Compare the illustrations on this page.

The Darkroom

dry side of darkroom

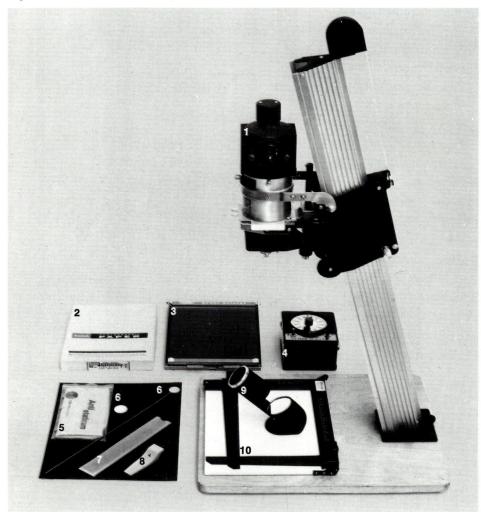

- 1 enlarger
- 2 printing paper
- 3 contact-printing frame
- 4 enlarger timer
- 5 antistatic cleaning cloth
- 6 dodging and burning-in tools
- 7 negatives
- 8 antistatic cleaning brush
- 9 magnifier
- 10 printing-paper easel

Darkrooms are usually set up with dry and wet sides, although printmaking procedures vary somewhat depending on whether you are using your own equipment or sharing facilities in a school.

On the **dry side** (*materials shown above*), photographic paper is exposed to make a print. Cleanliness as well as dryness is important because chemical

contamination can create even more problems in printing than in negative development. A typical printing session involves trips from enlarger to developing trays and back again, and traces of chemicals can end up where they don't belong, causing streaks, spots, and other problems.

The commonest problem on the dry side is **dust**. Every dust speck on your

negative produces a white spot on your print. Remove dust with an antistatic brush or a rubber air blower. Handle negatives by their edges to avoid fingerprints. If cleaning a negative is necessary, use a liquid film cleaner. Dust and fingerprints on enlarger lenses or condensers decrease the contrast and detail in a print. Clean them as you would a camera lens (page 85).

wet side of darkroom

- 11 | three 8 \times 10 trays, one 11 \times 14 washing tray
- 12 | blotters or other means of drying
- 13 safelight
- 14 safelight filter
- 15 chemical solutions
- 16 graduate
- 17 timer
- 18 washing siphon
- 19 sponge
- 20 squeegee
- 21 developer tongs
- 22 stop bath-fixer tongs

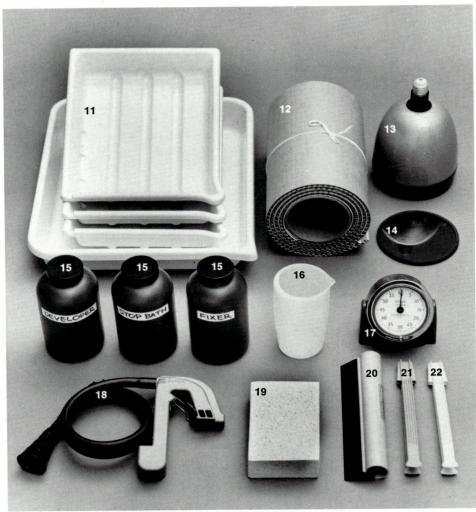

On the **wet side** of the darkroom (*materials shown above*), the exposed paper is processed in chemicals similar to those used for developing negatives. See page 171 for a summary of the process.

Printing paper is developed under **safelight**, not ordinary room light. The paper is sensitive to only a portion—usually the blue end—of the light spec-

trum. A relatively dim, amber safelight produces enough light for you to see what you are doing, but not so much that the paper becomes fogged with unwanted exposure. A suitable safelight for most papers is a 15-watt bulb in a fixture covered with a light amber filter (such as a Wratten OC) placed at least four feet from working surfaces. Check the manufacturer's instructions if you use any special-purpose papers; safelight filters vary for different materials.

A safelight is not bright enough for you to evaluate a print after it has been developed and fixed. You will want to do that under ordinary room light. If you carry a wet print away from the wet side of the darkroom, put it in an empty tray so it doesn't drip.

The Enlarger: Basic Tool of the Printmaker

An **enlarger** can produce a print of any size—larger, smaller, or the same size as a negative, so it is sometimes more accurately called a projection printer. Most often, however, it is used to enlarge an image. Although an enlarger is a relatively simple machine, it is a vital link in the photographic process; the best camera in the world will not give good pictures if they are printed by an enlarger that shakes when touched, has a poor lens, or tends to slip out of focus or alignment.

An enlarger operates like a slide projector mounted vertically on a column. Light from an enclosed lamp shines through a negative and is then focused by a lens to expose an image of the negative on printing paper placed at the foot of the enlarger column. Image size is set by changing the distance from the enlarger head (the housing containing lamp, negative, and lens) to the paper; the greater the distance, the larger the image. The image is focused by moving the lens closer to or farther from the negative. The exposure time is controlled by a timer. To regulate the intensity of the light, the lens has a diaphragm aperture with f-stops like those on a camera lens.

An enlarger should spread light rays uniformly over the negative. It can do this in several ways. In a **diffusion enlarger**, a sheet of opal glass (a cloudy, translucent glass) is placed beneath the light source to scatter the light evenly over the negative or the light rays are bounced within a mixing chamber before reaching the negative. In a **condenser enlarger**, lenses gather the rays from the light source and send them straight through the negative. Sometimes a combination of the two systems is used (see diagrams, right).

Condensers must be matched to negative and lens for even illumination.

Depending on the enlarger, this is done by changing the position of the negative or condensers or by using condensers of different sizes.

The most noticeable difference between diffusion and condenser enlargers is in contrast. A diffusion enlarger produces about one grade less contrast than a condenser enlarger (see pages 172-177 for more about contrast). A diffusion system has the advantage of minimizing faults in the negative such as minor scratches, dust spots, and grain by lessening the sharp contrast between, for example, a dust speck and its immediately surrounding area. Some photographers believe that this decreasing and smoothing of contrast can also result in a loss of fine detail and texture in a print, especially when a negative is greatly enlarged; however, many photographers find no evidence to support this. Many modern enlargers combine characteristics of both systems.

The focal length of the **enlarger lens** must be matched to the size of the negative, as shown in the chart at right. If the focal length is too short, it will not cover the full area of the negative, and the corners will be out of focus or, in extreme cases, vignetted and too light in the print. If the focal length is too long, the image will be magnified very little unless the enlarger head is raised very high.

The **light source** in an enlarger is usually a tungsten or quartz-halogen bulb, although in some diffusion enlargers a cold-cathode or cold-light source (fluorescent tubing) is used. Fluorescent light is usually not recommended for use with variable contrast papers (*pages 176–177*) or color printing papers. See page 240 for information on enlargers for printing color. In a diffusion enlarger, a sheet of cloudy glass or a mixing chamber scatters light from the lamp in many directions so that the negative will be uniformly illuminated. Many light rays overlap, so contrast in the print is softened.

A condenser enlarger uses two lenses to collect light and to concentrate it directly on the negative. Light rays go straight through and produce increased contrast.

A combination diffusion-condenser enlarger offers a compromise. Condenser lenses collect light and focus it through the negative; a sheet of ground glass diffuses the light somewhat and eliminates excessive contrast.

negative size	focal length of enlarger lens	
$\begin{array}{l} 35 \text{ mm} \\ 2^{1/\!\!/} \times 2^{1/\!\!/} \text{ inches} \\ 2^{1/\!\!/} \times 2^{3/\!\!/} \text{ inches} \\ 4 \times 5 \text{ inches} \end{array}$	50–63mm 75–80mm 90–105mm 135–165mm	

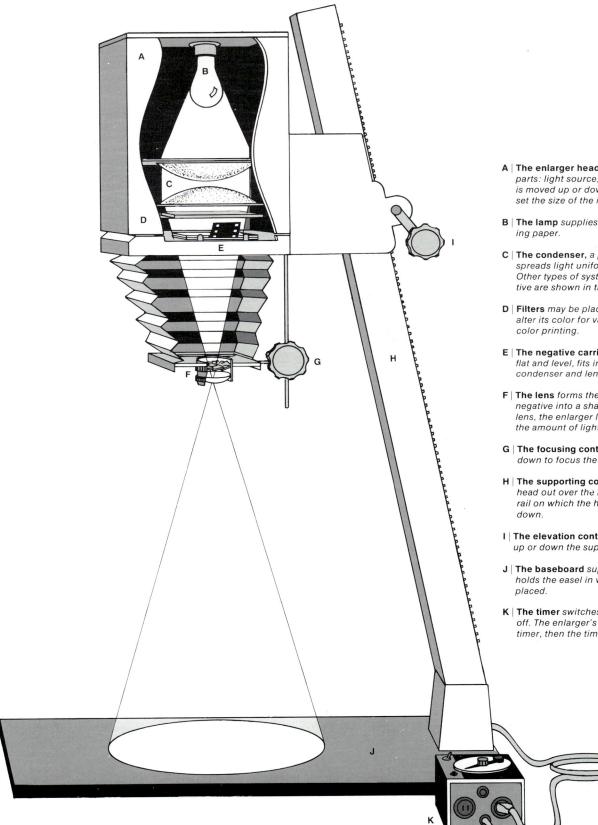

- A | The enlarger head contains the main working parts: light source, negative carrier, and lens. It is moved up or down the supporting column to set the size of the image.
- **B** | **The lamp** supplies the light to expose the printing paper.
- C | The condenser, a pair of convex lenses, spreads light uniformly over the negative. Other types of systems to illuminate the negative are shown in the diagrams opposite.
- D | Filters may be placed in the path of the light to alter its color for variable-contrast paper or for color printing.
- E | The negative carrier, which holds the negative flat and level, fits into an opening between the condenser and lens.
- F | The lens forms the light passing through the negative into a sharp image. Like a camera lens, the enlarger lens has an aperture to adjust the amount of light passing through it.
- **G** | **The focusing control** moves the lens up or down to focus the projected image.
- H The supporting column holds the enlarger head out over the baseboard and serves as a rail on which the head can be moved up or down.
- I | The elevation control moves the enlarger head up or down the supporting column.
- J | The baseboard supports the whole unit. It also holds the easel in which printing paper is placed.
- **K** | **The timer** switches the enlarger lamp on and off. The enlarger's power cord plugs into this timer, then the timer plugs into a wall outlet.

Printing Papers

reproduced from a glossy print

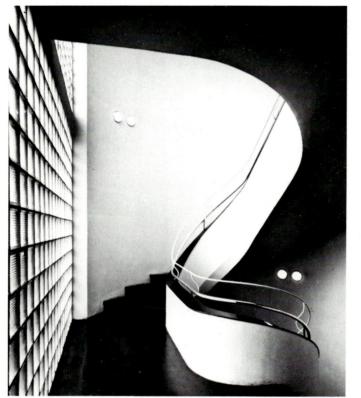

change contrast by changing the color of the enlarger light, so you will also need a set of variable-contrast filters or an enlarger with built-in filtration.

Many photographers prefer a **glossy** surface, smooth-textured paper because it has the greatest tonal range and brilliance. Prints are seen by reflected light, and a **matte** surface or rough texture scatters light and so decreases the tonal range between the darkest blacks and the whitest highlights.

Resin-coated (RC) papers require much less washing time than **fiberbase** papers. They are often used in school darkrooms and are also popular for contact sheets and general printing. However, many photographers do not use RC papers for their better prints because they prefer the tonality and surface quality of fiber-base papers. The latter are also better for long-term archival preservation, a factor primarily of interest if prints are sold to museums and photographic collectors.

Paper storage is important because stray light fogs unprocessed paper, giving it an overall gray tinge. Time and heat do the same. Store paper in a lighttight box in a cool, dry place. Open a package of paper only under darkroom safelight. Most papers last about two years at room temperature, considerably longer if kept refrigerated.

reproduced from a matte print

The difference between matte and glossy surfaces is shown in two prints of an architectural photograph. The picture at far left, reproduced from a glossy print, has denser blacks and therefore more contrast than the reproduction from a matte print a right.

paper will work well.

Black-and-white printing papers vary

in texture, color, contrast, and other

characteristics (see box, opposite).

Choices are extensive, but rather than

buying a different type of paper every

time, start with one type and explore its

capabilities before trying others. For

your first prints, a package of variable-

contrast, glossy, resin-coated (RC)

Variable-contrast paper is initially

more economical than graded-contrast

paper because you have to purchase

only one package of paper. Eventually

you may want to take advantage of the

greater variety and contrast range of

graded papers (see pages 174-177).

With a variable-contrast paper, you

Black-and-White Printing Paper Characteristics

Photographic characteristics

Printing grade. The contrast of the emulsion. Graded papers are available in packages of individual contrast grades ranging from grade 0 (very low contrast) through grade 5 (very high contrast). Grade 2 or 3 is used to print a negative of normal contrast. With variable-contrast papers, only one kind of paper is needed; contrast is changed by changing filtration on the enlarger. The range of contrast is not as great with variable-contrast papers as with graded papers—about the equivalent of grades 1 to 4 can be produced. See pages 172–177 for more about contrast.

Speed. The sensitivity of the emulsion to light. Papers designed solely for contact printing are slow—they require a large amount of light to expose them properly. Papers used for enlargements are faster since only a rather dim light reaches the paper during the projection of the image by the enlarger. Enlarging papers are also commonly used for contact prints.

Color sensitivity. The portion of the light spectrum to which the emulsion is sensitive. Papers are sensitive to the blue end of the spectrum; this makes it possible to work with them under a yellowish safelight. Variable-contrast papers are also somewhat green sensitive, with contrast being controlled by the color of the filter used on the enlarger. Panchromatic papers are sensitive to all parts of the spectrum; they are used to make black-and-white prints from color negatives.

Latitude. The amount that exposure or development of the paper can vary from the ideal and still produce a good print. Most printing papers (especially high-contrast papers) have little exposure latitude; even a slight change in exposure affects print quality. This is why test strips (pages 166– 167) are useful in printing. Development latitude varies with different papers. Good latitude means that print density (darkness) can be increased or decreased somewhat by increasing or decreasing development time. Other papers have little development latitude; changing the development time to any extent causes uneven development, fogging, or staining of the print.

Premium papers. A few papers, which cost more than conventional papers, contain extra silver in the emulsion. These papers are capable of producing richer blacks and a greater tonal range, but it takes some experience to utilize their capability fully. Brands include Agfa Portriga Rapid, Ilford Ilfobrom Galerie, Kodak Elite, and Oriental New Seagull.

Physical characteristics

Texture. The surface pattern of the paper. Ranges from smooth to slightly textured to rough. Some finishes resemble canvas, silk, or other materials. Smoother surfaces reveal finer details and any graininess of the negative more than rougher surfaces do.

Gloss. The surface sheen of the paper. Ranges from glossy (greatest shine) to luster (medium shine) to matte (dull). Fiber-base glossy papers can be ferrotyped (page 188) for maximum sheen; resin-coated glossy papers air-dry to a very high sheen. The dark areas of glossy papers appear blacker than those of matte papers; therefore the contrast of glossy papers appears greater. Glossiness shows the maximum detail, tonal range, and grain in a print. Very high gloss (as from ferrotyping) can cause distracting reflections.

Paper base tint. The color of the paper stock. Ranges from pure white to off-white tints such as cream, ivory, or buff.

Image tone. The color of the silver deposit in the finished print. Ranges from warm (brown-black) to neutral to cold (blue-black). Can be emphasized by the print developer used; a developer that helps produce a noticeably warm or cold tone indicates this on the package.

Weight. The thickness of the paper stock. Fiberbase papers are available in single weight and double weight. Single-weight papers are suitable for contact sheets and small prints. Double-weight papers are easier to handle during processing and mounting of large prints. RC papers come in a medium-weight base that is between single and double weight.

Size. 8×10 inches is a popular size. You can cut this into four 4×5 -inch pieces for small prints. Some commonly available precut sizes include $4 \times 5, 5 \times 7, 11 \times 14, 14 \times 17, 16 \times 20, and$ 20×24 inches. (Comparable European sizes range from 8.9×12.7 cm to 50.8×61 cm.)

Resin coating. A water-resistant, plasticlike coating applied to some papers. Resin-coated (RC) papers absorb very little moisture, so processing, washing, and drying times are shorter than for fiber-base papers. They also dry flat and stay that way, unlike fiber-base papers, which tend to curl. Too much heat during drying or mounting RC papers can damage the surface; see manufacturer's directions.

How to Process Prints The Contact Sheet: A Whole Roll at Once

A contact sheet or proof is useful when you want to choose a negative to enlarge. In contact printing, negatives are pressed against a sheet of photographic paper and the two are exposed to light. The result is a print that is the same size as the negative.

Don't be tempted to skip the contact printing stage and select a negative to be enlarged by looking at the film itself. Pictures are often difficult to judge as negatives, and small size compounds the difficulty with 35mm negatives. If you made several shots of the same scene, they may differ only slightly from one another, so make contacts carefully enough to compare similar pictures. A contact print of a 35mm negative is too small for you to judge sharpness critically, but you will be able to make a first assessment of sharpness as well as of exposure, lighting, and other factors.

Contact sheets are easy to make. An entire roll (36 negatives of 35mm film or 12 negatives of $2^{1}/_{4} \times 2^{1}/_{4}$ film) fits on a single sheet of 8 \times 10 paper. The contact sheet then becomes a permanent record of negatives on that roll. The procedure for making a contact print shown on the following pages uses an enlarger as a light source. Another method uses a contact printer—a box containing a light and having a translucent surface on which the negatives and paper are placed.

1 set out trays and tongs

Four trays are needed—one each for developer. stop bath, and fixer plus one filled with water to hold prints after fixing until they are ready for washing. If you use tongs, you will need two pairs:

information about chemicals.

one for the developer and one for stop bath and

fixer. Do not interchange them. See page 171 for

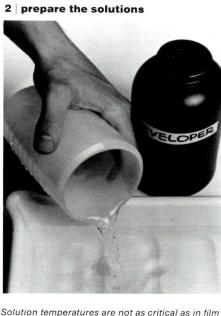

development. Manufacturers often recommend about 68° F (20° C) for the developer, 65° to 75° F (18° to 24° C) for stop bath and fixer.

3 assemble the negatives

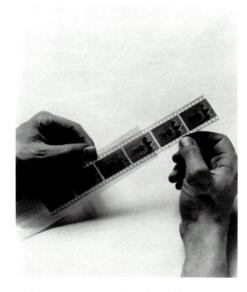

Collect the negatives to be printed. If you have used care in handling and storing them, they will be free of fingerprints and mostly free of dust.

4 dust the negatives

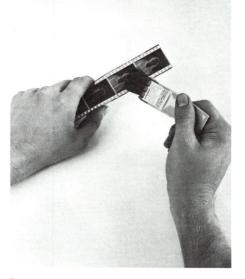

Remove any dust from negatives with an antistatic brush or compressed air. There should be no fingerprints, but remove them if necessary with film cleaner.

7 prepare to insert negatives

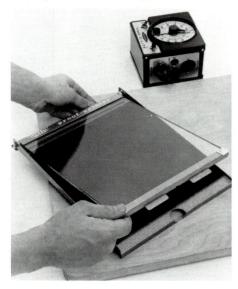

Open the cover of the contact frame all the way, taking care to keep your fingers from leaving marks on the glass; they may show on the print. Make sure no dampness remains from cleaning. 5 identify the emulsion side

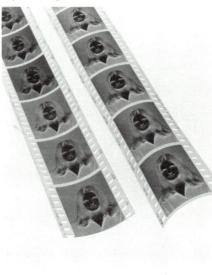

Film curls toward the emulsion, which has a duller sheen than the film base. The emulsion side must face the paper during printing.

8 place the negatives in the frame

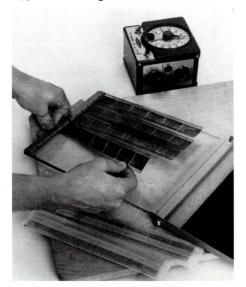

In this printing frame, strips of negatives snap under clips on the glass cover. Face the emulsion side away from the glass, toward the paper. 6 clean the contact frame

Clean the printing-frame glass with water or cleaner sold for this purpose. A plain sheet of glass can be used if a printing frame is not available; tape the edges for safety.

9 position the enlarger head

Switch on the enlarger lamp and raise the enlarger head until the light that is projected covers the entire contact frame. Switch the lamp off.

10 adjust the lens aperture

Open the diaphragm on the enlarger lens to f/8 as a trial exposure. After developing and evaluating the print, you may need to change to another setting.

13 | identify the emulsion side

11 | set the timer

For an 8 \times 10 test print of negatives of average density, turn the timer pointer to 5 sec as a starting point for a correct exposure.

14 | insert the paper into the frame

Paper emulsion must face the negatives. The emulsion side is shinier and, with glossy papers, smoother than the backing side. Fiber-base paper curls toward emulsion; RC paper curls little.

Slide the paper into the slot on the hinged side of the glass lid, making sure that the emulsion side of the paper faces the negatives.

12 | take a sheet of paper from the box

With room lights off and safelight on, remove from its box a sheet of printing paper. Use a variablecontrast paper without a filter in the enlarger or use a graded-contrast #2 paper. Close the box.

15 close the frame lid

Holding the printing paper in place with a finger, close the glass lid of the frame. Its weight holds it shut and presses negatives against paper.

16 make the exposure

After placing the frame under the enlarger, press the timer button. The timer shown provides power to the enlarger and automatically turns the enlarger lamp off after the exposure.

19 conclude development

Develop for the time recommended for the developer—usually about 2 min. Lift the paper out by a corner with the tongs and let it drain into the tray.

17 withdraw the paper

Take the printing paper out of the frame, but leave the negatives in place, ready for another attempt if the first print is not good.

20 transfer to stop bath, then fixer

Agitate in stop bath 30 sec (5–10 sec for RC paper). Fix for 5–10 min (2 min for RC paper), agi-

tating occasionally. View by white light after 2 min.

18 begin processing

Slip the paper smoothly into the developer, emulsion side up, immersing the surface quickly. Agitate the print by rocking the tray or with the tongs.

21 evaluate the print

If print is too light, make another giving more exposure; if too dark, give less exposure. If okay, wash and dry (steps 57–59) after fixing.

Preparing the Negative for Enlargement

Personal judgments count the most when selecting negatives for enlargement when you have many shots of the same scene. Which had the most pleasing light? Which captured the action most dramatically? Which expressions were the most natural or most revealing? Which is the best picture overall?

Technical points should be considered as well. For example, is the negative sharp? With a magnifying glass examine all parts of the contact prints of similar negatives to check for blurring caused by poor focusing or by movement of the camera or subject. If the negative is small-particularly if it is 35mm—even seemingly slight blurring in the contact print will be quite noticeable in an 8 imes 10inch enlargement because the defects will be enlarged as well. Extreme underexposure (shown on the contact as pictures that are very dark) or extreme overexposure (pictures that are very light) will make the negative difficult or even impossible to print successfully. Minor exposure faults, however, can be remedied during enlargement. Use a light-colored grease pencil to mark the contact sheet as a rough guide for cropping.

22 select a negative for printing

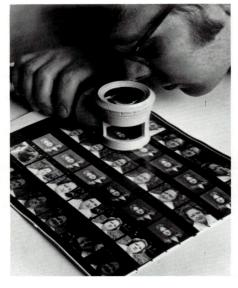

Under bright light, examine the processed contact sheet with a magnifying glass to determine which negative you want to enlarge.

23 extract the negative carrier

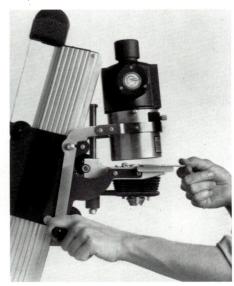

Lift up the lamp housing of the enlarger and remove the negative carrier—usually two sheets of metal that hold the negative between them.

24 insert the negative

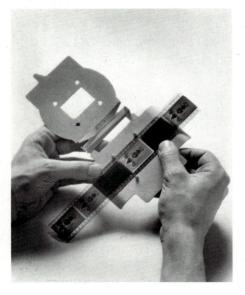

Place the negative over the window in the carrier and center it. The emulsion side must face down when the carrier is put in the enlarger.

25 clean the negative

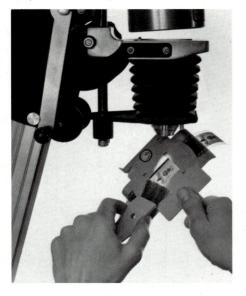

Before printing, hold the negative at an angle under the enlarger lens with the lamp on so that the bright light reveals any dust; brush it off. Dust may be easier to see with room lights off.

26 replace the negative carrier

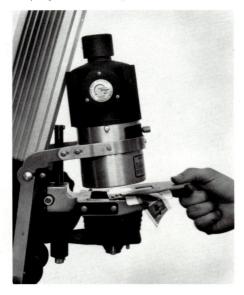

Tilt the lamp housing and place the negative carrier in position. Switch off room lights so that you can see the image clearly for focusing.

27 open the aperture

Open the enlarger's aperture to its largest f-stop to supply maximum light for focusing. The enlarger lamp should be on.

28 prepare for focusing

Insert a piece of white paper under the masking slides of the easel. Paper shows the focus more clearly than even a white easel surface.

29 adjust for print size

Adjust the movable masking slides on the easel, first to hold the size of paper being used (in this case, 8×10 inches) and later to crop the image.

30 | arrange the picture

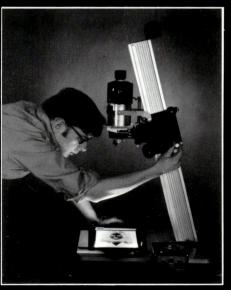

Raise or lower the enlarger head to get the lesired degree of image enlargement, adjusting he easel as needed to compose the picture.

31 | focus the image

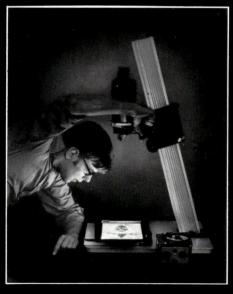

Focus by turning the knob that raises and lowers the lens. Don't shift the enlarger head except to readjust size if this is necessary.

32 | refine the focus

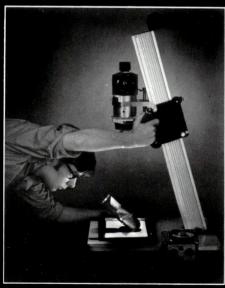

A magnifier helps to make the final adjustments in focus. Some types magnify enough for you to focus on the grain in the negative.

The best way to tell how long to expose an enlargement is to make a **test print**. This will look like a striped version of the final print (step 43, opposite). The strips are sections of the print, each strip exposed under the enlarger longer than its neighbor to the left. The test print is judged for density and contrast (pages 172–173). A full-sized sheet of printing paper is used here, but a smaller strip of paper placed across an important area is usually enough.

Time, rather than aperture setting, is generally changed when adjusting the exposure. If the negative is badly overexposed or underexposed, however, change the lens aperture to avoid impractically long or short exposure times. The method shown here exposes each strip 5 sec longer than its neighbor and produces strips exposed for a total of 5, 10, 15, 20, and 25 sec. Some photographers use a method that doubles the exposure for each strip and so produces a greater range of tones. For example, exposing the strips for $2\frac{1}{2}$, $2\frac{1}{2}$, 5, 10, and 20 sec gives total exposures of $2\frac{1}{2}$, 5, 10, 20, and 40 sec.

Make the exposure with the lens stopped down a few stops from its widest aperture. This gives good lens performance plus enough depth of focus to minimize slight errors in focusing the projected image.

35 | set the timer

Set the timer by turning its pointer to 5 sec. This test print will receive a series of 5 exposures of 5 sec each.

33 | close down the aperture

When focus is sharp, stop down the enlarger lens. Try f/8 or f/11 with a 50mm lens. A relatively small opening offsets slight focusing errors.

36 | first exposure

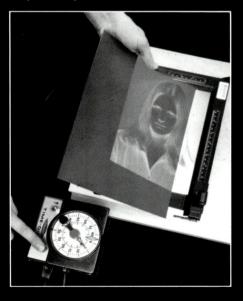

Cover four-fifths of the printing paper with a piece of cardboard. Expose the uncovered section for 5 sec.

34 | insert printing paper

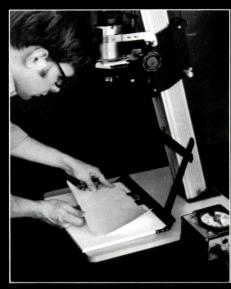

With room lights and enlarger lamp off, slip a piece of printing paper, emulsion side up, into the easel. Use a medium contrast (grade 2 or 3).

37 | second exposure

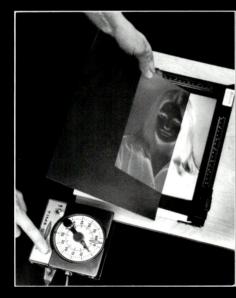

Slide the cardboard to cover only three-fifths of the paper. Expose for another 5 sec.

sure

love the cardboard and expose again. The first ection has now been given 15 sec of exposure, re second 10, and the third 5.

1 develop the test

Develop for the recommended time with constant, entle agitation. Various degrees of darkening the to the different exposures ware clearly visible

Make two more 5-sec exposures in the same manner, first revealing four-fifths of the paper, then exposing the entire sheet.

42 | transfer to the stop bath

Take the paper from the easel for development. It will now have strips bearing 5 different exposures that range from 5 to 25 sec.

43 | select the best exposure

Lift the print out of the developer with the developer tongs. Using only the stop bath-fixer tongs, immerse the print in the stop bath, anitating for 30

After fixing for about 2 min (washing is unnecessary), make sure paper box is closed, turn on roolights, and evaluate the test print (see pext page). zvaruate the test prim carefully. Before making he final print, examine the test under ordinary oom light. Darkroom safelight illumination makes prints seem darker than they actually are. Details on how to judge a test print appear on pages 72–173.

Exposure. Is one of the exposures about right not too dark or too light? Or should an entire series of longer or shorter test times be made?

Contrast. Is the test print too contrasty, with inky plack shadows, harsh white highlights, and little tetail showing in either? Or is the print too flat nuddy and gray with dingy highlights and dull shadows? If you change print contrast, the printng time may change, so make another test print or the new contrast grade.

Dodging and burning in. Most prints require some ocal control of exposure, which you can provide by holding light back (dodging) or adding light burning in). See page 178 for more information.

Recheck the focus. Set the timer to the exposure indicated by the test, insert fresh paper in the easel, and press the button for final exposure.

Dodging, or blocking light during part of the exposure, lightens areas that would otherwise print too dark. Often, shadow areas are dodged.

6 | burn in, if necessary

ome areas may need burning in (extra exposure darken them) A dark cardboard shiel (with a

47 develop the print

Slip the paper quickly into the developer, making

48 agitate gently

Rock the tray gently and continuously to agitate

49 | complete development

If the print develops too rapidly or too slowly, process for the standard time anyway. Then examine the print and change exposure as needed.

52 agitate

Keep the print immersed in the stop bath for 30 sec (5-10 sec for RC paper), agitating it gently. Use stop bath-fixer tongs in this solution.

50 drain off developer

Hold the print above the tray for a few seconds so that the developer solution, which contaminates stop bath, can drain away.

53 drain off stop bath

Again lift the print so that solution can drain into the stop-bath tray. Don't let stop-bath solution splash into developer.

51 | transfer to the stop bath

The stop bath chemically neutralizes the devel-oper on the print, halting development. Keep developer tongs out of stop bath.

54 | transfer to the fixer

Slip the print into the fixer and keep it submerged. The same tongs are used for stop bath and fixer, which are compatible solutions.

55 agitate

Agitate the print occasionally while it is in the fixer. Room lights can be turned on after about 2 min and the print examined.

Take time again at this point to evaluate the print. Don't be discouraged if the print is less than perfect on the first try. Often several trials must be made.

Exposure and contrast. Could the print be improved by adjusting the exposure or contrast? It is not always possible to tell from a test strip how all areas of the print will look. Skin tones are important if your print is a portrait. Give more exposure if skin tones look pale and washed out. Beginners tend to print skin tones too light, without a feeling of substance and texture.

Dodging and burning in. Examine the print again for areas that could be improved by dodging or burning in. Often several trials are needed to get all the tones just where you want them.

56 remove the print

After fixing, transfer the print to the washing tray. Follow manufacturer's fixing recommendations or the image may fade and stain.

57 wash

Wash for 60 min in running water; much less time is needed if a washing aid is used. RC papers need no washing aid and only 4 min washing.

58 remove the surface water

Place the print on a clean, overturned tray or sheet of glass or plastic and gently squeegee off most of the water from front and back.

A blotter roll is one way to dry fiber-base papers. You can dry RC papers simply by placing them face up on a clean surface. See page 188.

Processing Prints—A Summary

	chemicals needed	procedure	tips for better prints		
preparation You will need 3 basic chemical solutions: developer, stop bath, and fixer. Additionally, a washing aid is recommended.		Mix the chemical stock solutions needed. Dilute to working strength and adjust temperature as rec- ommended by manufacturer. (See page 130 for information on mixing and storing chemicals.) Resin-coated (RC) paper needs less fixing, no washing aid, and less washing than fiber-base papers; see manufacturer's instructions.	Temperature control is less critical for black-and- white printing than for negative development. 65° – 70° F (18° – 21° C) is ideal; 60° – 75° F (16° – 24° C) is acceptable. Below 65° F, chemicals take longer to work. Above 70° F, the developer more quickly fogs or grays the highlights, and the paper emulsion softens and is more easily damaged.		
development Use a developer suitable for papers. Neutral or cold-tone developers such as Kodak Dektol pro- duce a neutral or blue-black tone when used with neutral or cold-tone papers. Warm-tone devel- opers such as Kodak Selectol increase the brown- black tone of warm-tone papers. Discard devel- oper if it turns dark after about 20 prints have been processed per quart of working solution, or at the end of a printing session.		After exposing the paper, slip it quickly and com- pletely into the developer. Development times can range from 45 sec to 3 min (see manufacturer's directions). Agitate gently and constantly with tongs or by rocking the tray. If two or more prints at a time are processed, rotate individual prints from bottom to top of the stack in the tray.	Do not cut short the development time to salvage a print that darkens too rapidly; uneven develop- ment, mottling, and loss of contrast will result. If the print is too dark, make another with less expo- sure. Development time for some papers can be extended to slightly darken a too-light print, but this can also cause staining. If the print is too light make another with more exposure.		
selective development		You can darken part of a print during development by gently rubbing or breathing on the area while holding the print out of the tray or by pulling the print out of the tray, rinsing it with water, and gently swabbing the area to be darkened with cot- ton dipped in warm or concentrated developer.	Prints kept too long out of the developer will stain. Darkening individual areas by burning in during exposure works better.		
stop bath	Stop-bath solution. Discard after about 20 prints have been treated per quart of working solution or when a testing solution indicates exhaustion. An indicator-type stop bath changes color when ex- hausted.	Agitate prints in stop bath for 30 sec (5–10 sec for RC paper). Agitation during the first few seconds is important.	Drain developer from print for a few seconds be- fore putting print into stop bath. This will help keep the stop bath fresh. Also avoid getting stop bath or fixer into the developer; use developer tongs only in developer tray, stop bath-fixer tongs only in those trays.		
fixing	Fixing solution. Rapid fixer is similar but faster act- ing. Fixer with hardener helps prevent softening of print when water temperatures are high. Discard after about 20 prints have been fixed per quart of working solution or when a testing solution indi- cates exhaustion.	Fix for 5 to 10 min, agitating several times. If sev- eral prints are in the fixer at one time, agitate more often and rotate individual prints from bottom to top of the stack. If fixer becomes exhausted during a printing session, refix all prints in fresh fixer. RC paper fixes in 2 min.	The most complete and economical fixing uses two trays of fixer. Fix the print in the first tray for half the fixing time. Then transfer the print to the second tray for half the fixing time. When the fixer in the first tray is exhausted, replace it with the solution from the second tray. Mix fresh fixer for the second tray.		
holding until wash		After fixing, place prints in a large tray filled with water until the end of the printing session. Gently run water in tray or dump and refill frequently. Wash RC paper promptly for best results; ideally total wet time should not exceed 10 min.	Remove prints promptly from fixer at the end o the fixing time or they will take longer to wash may bleach or stain.		
washing aid ecommended)	Washing-aid solution, such as Kodak Hypo Clear- ing Agent. Discard after about 50 prints have been treated per quart of working solution (or as di- rected).	Rinse prints in running water for about 1 min (or as directed). Then agitate prints in the washing aid solution for the time indicated by the manufacturer —usually just a few minutes. Do not use a washing aid with RC paper.	While using a washing aid with fiber-base paper is optional, it is a very good practice. Prints treated with a washing aid will be washed cleaner of resid- ual chemicals than untreated prints and in much less time.		
washing		If a washing aid is used first, wash 10 to 20 min (or as directed). Otherwise, wash for at least 1 hr. Ad- just the water flow or dump and refill the tray so that the water changes at least once every 5 min. Wash RC paper 4 min; change water frequently.	If several prints are washed at one time, they must be separated or circulated so that fresh water con- stantly reaches all surfaces. Some print washers do this automatically. In a tray, it must be done by hand.		
drying		Sponge or squeegee off excess water. Fiber-base paper can be dried on racks, on a heated dryer, or between blotters. RC paper dries well on racks.	See page 188 for more about drying and optional glossing of prints.		

How to Judge a Test Print

Prints are judged for density and contrast. The goal during printing is usually to make a full-scale print-one that has a full range of tones (rich blacks, many shades of gray, brilliant whites) and a realistic sense of texture and substance (opposite page, top). You may deliberately depart from this goal at times, but first learning how to make a full-scale print will give you control over your materials so that later you can produce whatever kind of print you want. A test print like the one at near right helps in evaluating a print and deciding how to improve it. Do all your judging under ordinary room light because prints look darker under safelight.

Density refers to the overall darkness or lightness of the print (*opposite, bottom left*). It is controlled primarily by the amount of exposure given the paper the greater the exposure, the greater the density of silver produced and the darker the print. Exposure can be adjusted either by opening or closing the enlarger lens aperture or by changing the exposure time.

Contrast is the difference in brightness between light and dark areas within the print (opposite, bottom right). A low-contrast or flat print seems gray and weak, with no real blacks or brilliant whites. A high-contrast or hard print seems harsh and too contrasty: large shadow areas seem too dark and may print as solid black; highlights, very light areas, seem too light and may be completely white; texture and detail are missing in shadows, highlights, or both. The contrast of a print is controlled mainly by the contrast grade of the paper used or, with variable contrast paper, by the printing filter used (see the following pages).

Begin by judging the density. With some experience, you can judge both

density and contrast at the same time, but it is easier at first to adjust them in two steps. Examine the test print for an exposure that produced highlights of about the right density, especially in areas where you want a good sense of texture. If all strips in the test seem too light, make another set of strips with more exposure by opening the enlarger aperture two f-stops. If all seem too dark, make a test with less exposure by stopping down two f-stops.

Then check the contrast. When the highlights seem about right in one strip, examine the shadow areas. If they are too dark (if you can see details in the negative image in an area that prints as solid black), your print is too contrasty. Make another test print on a lower-contrast paper. If your shadow areas are too light and look weak and gray, your print does not have enough contrast. Make another test on a higher-contrast paper. If you are printing a portrait, the skin tones are important. Adjust the exposure so that the brightest skin area is about the right density, and then, if necessary, adjust the contrast.

When one of the tests looks about right, expose the full image using the exposure and contrast that you chose. It can be difficult to predict from a single strip in a test exactly how an entire print will look, so judge the density and contrast of the print overall. Examine the print for individual areas you may want to darken or lighten by burning in or dodging (*pages 178–179*). Prints, especially on matte-finish papers, tend to "dry down," or appear slightly darker when dry. Experience will help you take this into account when printing.

Black and white test patches can help you judge a print. To evaluate the density and contrast of a print, you need standards against which to compare the tones in your print, since the eye can be fooled into accepting a very dark gray as black or a very light gray as white. As much as one full grade of contrast can be involved, enough to make the difference between a flat, dull print and a rich, brilliant one. Two small pieces of printing paper, one developed to the darkest black and the other to the brightest white that the paper can produce, are an aid when you are first learning how to print as well as later when you want to make a particularly fine print.

By placing a black or white patch next to an area, you can accurately judge how light or dark the tone actually is. As a bonus, the black patch indicates developer exhaustion; the developer should be replaced when you are no longer able to produce a black tone in a print as dark as the black patch no matter how much exposure you give the paper. The white patch will help you check for the overall gray tinge caused by safelight fogging.

Make the patches at the beginning of a printing session when developer and fixer are fresh. Cut two 2-inch-square pieces from your printing paper. Use the enlarger as the light source to make the black patch. Set the enlarger head about a foot and a half above the baseboard. The patch should be borderless, so do not use an easel. Expose one patch for 30 seconds at f/5.6; do not expose the other. Develop both patches with constant agitation for the time recommended by the manufacturer or for 2 minutes. Process as usual with stop bath and fixer. Remove promptly from fixer after the recommended time, then store in fresh water. To avoid any possible fogging of the white patch, cut and process the paper in a minimum amount of safelight.

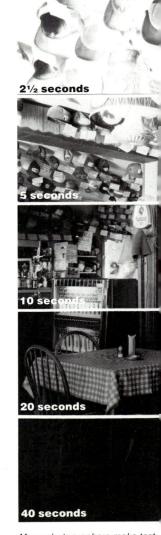

Many photographers make test prints like the one above to help them judge the density (darkness and contrast of a print. The exposures on this print range from 2 to 40 sec. First, the exposure is chosen that renders the highligi (in the lightest area you want to retain detail) at the right density Then the shadow values are examined: if they appear neither too dark and harsh nor gray and flat, then the contrast of the prinis correct.

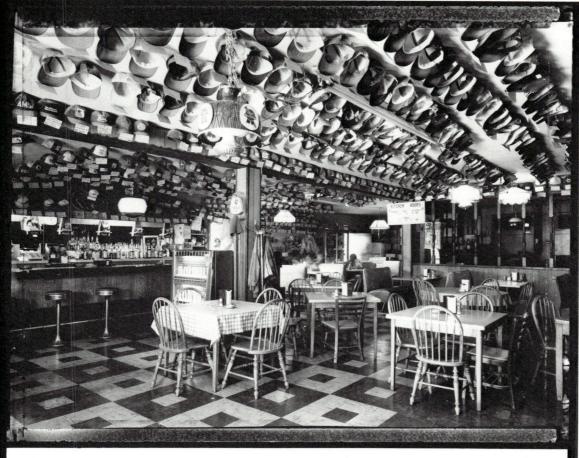

950 HATS, DON'S BAR : MEMPHIS, NEBRASKA

A full-scale print of normal density and normal contrast, with texture and detail in the major shadow areas and important highlights, is shown at left. Decreasing the exposure produced a lighter print; increasing the exposure gave a darker version (below left). Printing the same neg-ative on a lower-contrast grade of paper produced a flat print; printing on a higher-contrast grade

This photograph was made on Polaroid Type 55 4 \times 5 film, which produces both a positive print and a high-quality negative. Stone later reprints the negative in a 5×7 glass negative carrier so that the entire edge of the negative shows.

made a contrasty print (below right).

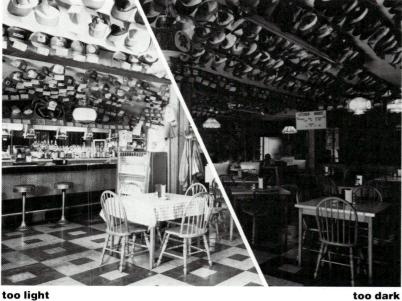

too light

density

normal density / normal contrast

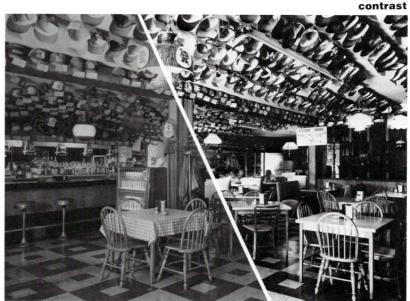

JIM STONE: Don's Bar, 1983

too flat

too contrasty

Papers That Control Contrast Graded-Contrast Papers

Contrast—the relative lightness and darkness of areas in a scene—is important in any photograph. Frequently you will want normal contrast—a full range of tones from black through many shades of gray to pure white. Sometimes, however, you may feel that a particular scene requires low contrast mostly a smooth range of middle grays (such as a scene in the fog). For another scene (perhaps a fireworks display) you may want high contrast—deep blacks and brilliant whites and limited detail in between.

By the time you are ready to make a print, the contrast of the negative has been set, mostly by the contrast in the subject itself, the type of film, and the way it was developed. But you can adjust the contrast of the final print with the contrast grade of the printing paper. As shown on the opposite page, a paper of normal contrast produces a print of normal contrast from a negative of normal contrast. A paper of high contrast increases the contrast; a paper of low contrast decreases it. This can help when printing a problem negative. A high-contrast paper increases contrast for scenes that may be too flat, such as those shot in dull light. A low-contrast paper decreases contrast, and can soften too-harsh shadows and highliahts.

These changes are caused by responses in the paper emulsion. With a paper of high contrast, only a small increase in exposure is needed to cause a relatively great increase in density in the paper emulsion. A low-contrast negative has relatively small differences between its thinnest and densest areas. If it is printed on a high-contrast paper, however, these small differences are enough to produce relatively large differences in lightness and darkness in the print, and therefore more contrast.

The reverse is true for a paper of low contrast. A large increase in exposure produces only a relatively small increase in print density. A high-contrast negative has great differences between its thinnest and densest areas; printed on a low-contrast paper, these differences become only moderate in the final print.

Other factors besides the printing paper affect contrast: the enlarger, the surface finish of the paper, and the type of paper developer (Kodak Selectol Soft, for example, lowers contrast). But the basic way of changing contrast in a print is to use a different contrast grade of paper.

There are two ways to do this. You can use a variable-contrast paper (see pages 176-177), with which you alter the contrast by changing the filtration of the enlarger light. Or you can use a graded-contrast paper, each grade of which has a fixed contrast. Many photographers prefer to work with graded papers, even though you have to purchase each contrast grade separately. Graded papers are made in a greater variety of surface finishes and a wider range of contrast grades than variable-contrast papers are. Gradedcontrast papers are available in grades 0 and 1 (low or soft contrast) through grade 2 (normal or medium contrast), grade 3 (often used as the normal contrast grade for 35mm negatives), and grades 4 and 5 (high or hard contrast). Not all papers are made in all contrast grades and not all manufacturers use the same grading system, so some experimentation may be needed with a new brand of paper.

Contrast is the relative lightness or darkness of different parts of a scene. Depending on the contrast grade of the printing paper used, a print will show more, less, or about the same amount of contrast as is present in the negative. Compare the range of tones in the three prints at far right. The normal print contains small areas of black and white plus a wide range of gray tones. A lowcontrast print has tones that cluster mostly around middle gray. A high-contrast print has large areas that are strongly black or brilliantly white but has relatively few gray tones in between.

low-contrast negative

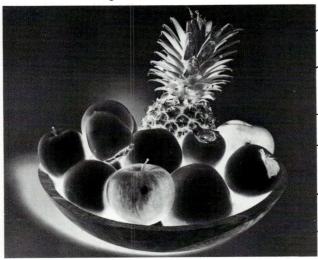

high-contrast negative

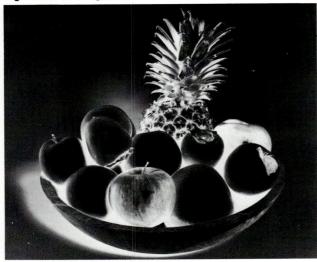

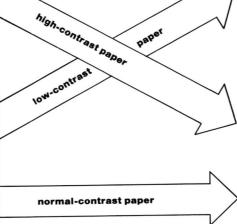

paper

normal-contrast paper

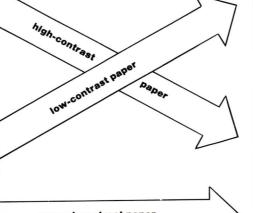

normal-contrast paper

low-contrast print

normal contrast print

high-contrast print

Variable-Contrast Papers

number 0 filter

number 1 filter

number 2 filter

no filter

You can use a single paper with adjustable contrast instead of paper that has separate contrast grades. A variablecontrast or selective-contrast paper is coated with two emulsions. One, sensitive to yellow-green light, yields low contrast; the other, sensitive to blueviolet light, produces high contrast. You change the contrast by inserting appropriately colored filters in the enlarger (far right). The filter affects the color of the light that reaches the printing paper from the enlarger light source and thus controls contrast. The lower the number of the filter, the less the contrast. If you have a dichroic enlarger head, used for color printing, you can dial in the filtration.

An advantage of variable-contrast paper compared to graded-contrast paper is the convenience and economy of working with only one kind of paper. You can get a range of contrast out of one package of paper and a set of filters instead of having to buy several different packages of paper. The filters come in half steps, so it is easy to produce intermediate contrast grades. You can also change the contrast in different parts of a photograph by printing them with different filters (shown at right).

The three versions at right of a New Hampshire 🕨 mill scene show how variable-contrast paper lets you print different parts of a scene using different degrees of contrast. In the version made with a number 3 filter (top), the water and sky print almost blank when the building is correctly exposed. The contrast range of the negative is so great that even burning in the sky and water does not produce significant detail. In the version made with a number 1 filter (bottom), the water and sky look good but the mill is too dark and flat and can't be dodged enough to retain sufficient detail.

The final print (opposite page) was made by exposing the mill with the number 3 filter while shielding the water and sky, then exposing the water and sky with the number 1 filter while shielding the mill. It is tricky to blend the lines where the different areas of contrast meet, but when done successfully a print can have a balance of contrast impossible to achieve with paper of a single contrast grade.

number 3 filter

number 4 filter

<section-header>

✓ Variable-contrast paper produces different degrees of contrast by filtering the enlarger light (photos, left). This particular filter set has eleven filters numbered 0, ½, 1, 1½, 2, and so on, rising by half steps to number 5. This is not the same as grades 0 to 5 in a graded-contrast paper. The entire set of filters is comparable to about four grades in a graded-contrast paper. The number 2 filter is about equal to a grade 2 in a gradedcontrast paper. You can also print with no filter in place, which with most variable-contrast papers produces about a grade 2 contrast.

Two ways of inserting filters in enlargers are shown below. A filter holder can be attached below the enlarger lens, and a gelatin filter slipped into the holder (top). Some enlargers have a filter drawer (bottom) between the lamp and the negative; an acetate filter is used here. This latter system is preferable. Since the filter is above the lens, it interferes less with the focused image.

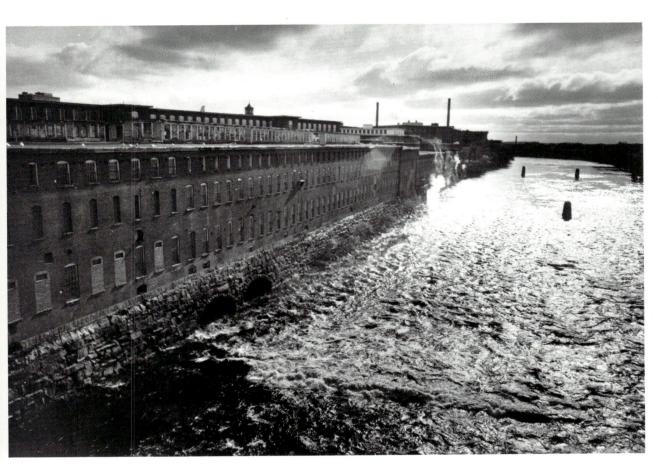

Dodging and Burning In

dodging

You can give different exposures to different parts of a print by dodging and burning in. Often, the overall density of a print is nearly right, but part of the picture appears too light or too dark an extremely bright sky or a very dark shadow area, for example.

Dodging lightens an area that prints too dark. That part of the print is simply shadowed during part of the initial exposure time. A dodging tool is useful; the one shown above on the left is a piece of cardboard attached to the end of a wire. Your hand (*opposite page*), a finger, a piece of cardboard, or any other appropriately shaped object can be used. Dodging works well when you can see detail in shadow areas in the negative image. Dodging of areas that have no detail or dodging for too long merely produces a murky gray tone in the print.

Burning in adds exposure when part of a print is too light. After the entire negative has received an exposure that is correct for most areas, the light is blocked from most of the print while the area that is too light receives extra exposure. A large piece of cardboard with burning in

a hole in it (*above center*) works well. A piece of cardboard can be cut to an appropriate shape (*opposite page*), or your hands can be used—cupped or spread so that light reaches the paper only where you want it to.

If you want to darken an area considerably, try flashing it-exposing it directly to white light from a small penlight flashlight. Unlike burning in, which darkens the image, flashing fogs the paper: it adds a solid gray or black tone. Tape a cone of paper around the end of the penlight so it can be directed at a small area. Devise some method to see exactly where you are pointing the light. Either do the flashing during the initial exposure or add the flashing afterward with the enlarger light on and an orange or red filter held under the lens. The filter prevents the enlarger light from exposing the paper but lets you see the image during the flashing. With variable-contrast paper, the filter may not block all the light that the paper is sensitive to, so keep the enlarger light on for a minimum of time.

Keep the dodging or burning tool, your hands, or the penlight in constant

flashing

Dodging (far left) holds back light during the basic printing exposure to lighten an area. Burning in (center) adds light after the basic exposure to darken an area. Flashing (near left) exposes part of the print to direct light and adds an overall dark tone wherever the light strikes the paper.

motion. Move them back and forth so that the tones of the area you are working on blend into the rest of the image. If you simply hold a dodging tool, for example, over the paper, especially if the tool is close to the paper, an outline of the tool will appear on the print.

Many prints are both dodged and burned. Depending on the print, shadow areas or dark objects may need dodging to keep them from darkening so much that important details are obscured. Sometimes shadows or other areas are burned in to darken them and make distracting details less noticeable. Light areas may need burning in to increase the visible detail. Skies are often burned in, as they were on the opposite page, to make clouds more visible. Even if there are no clouds, skies are sometimes burned in because they may seem distractingly bright. They are usually given slightly more exposure at the top of the sky area than near the horizon. Whatever areas you dodge or burn, blend them into the rest of the print so that the changes are a subtle improvement rather than a noticeable distraction.

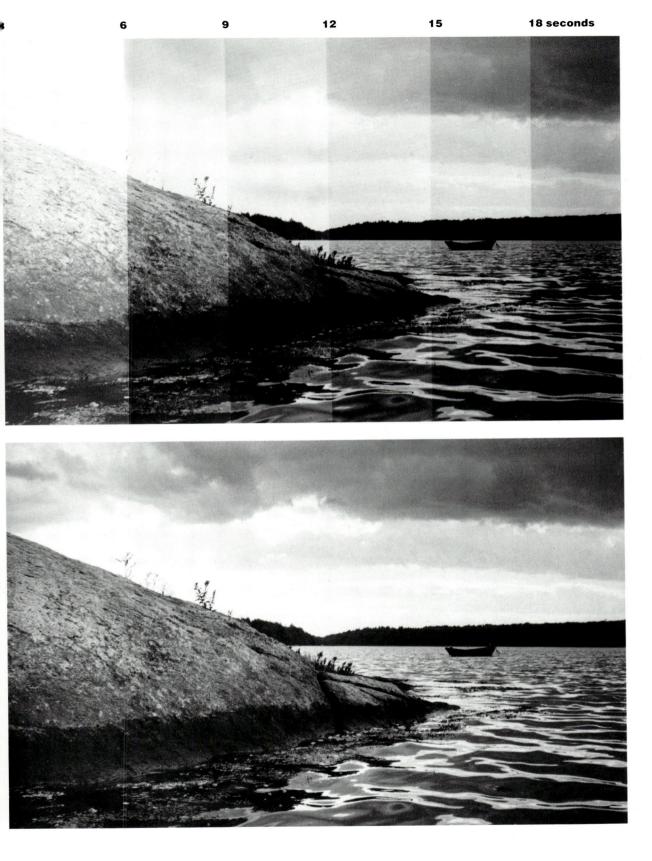

dodging

burning in

This photograph of a Maine inlet was dodged to lighten certain areas and burned in to darken others. The exposures for the test print (top left) ranged from 3 to 18 sec. The dark rock showed the best detail and texture at an exposure of about 6 sec, the water looked best at about 9 sec, and the sky needed about 18 sec of exposure to bring out detail in the clouds. The photographer gave the print a basic exposure of 9 sec, while dodging the rock for 3 sec (top right). Then the sky was burned in for another 9 sec while the rock and water were shielded from light with a shaped cardboard mask (above). In order to blend the tones of the different areas, the photographer's hand and the cardboard mask were kept moving during the exposures.

Cropping

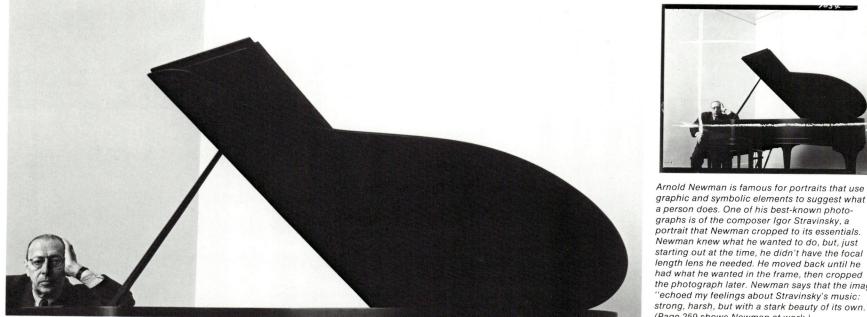

ARNOLD NEWMAN: Igor Stravinsky, 1946

a person does. One of his best-known photographs is of the composer Igor Stravinsky, a portrait that Newman cropped to its essentials. Newman knew what he wanted to do, but, just starting out at the time, he didn't have the focal length lens he needed. He moved back until he had what he wanted in the frame, then cropped the photograph later. Newman says that the image "echoed my feelings about Stravinsky's music: strong, harsh, but with a stark beauty of its own." (Page 259 shows Newman at work.)

Eventually you must make a decision about cropping-what to leave out and what to include along the edges of a photograph. Some photographers prefer to crop only with the camera; they use the ground glass or viewfinder to frame the subject, and do not change the cropping later. Most photographers, however, do not hesitate to crop while printing if it improves the image.

Sometimes cropping improves a picture by eliminating distracting elements. Sometimes a negative is cropped to fill a standard paper size; square negatives may be cropped so that when enlarged they fit a rectangular format. Cropping can direct the viewer's attention to the forms and shapes as the photographer saw them.

Enlarging a very small part of a negative can create problems because the

greater the enlargement, the more grain becomes noticeable and the more the image tends to lose definition and detail. But within reasonable limits, cropping can improve many photographs.

To help you decide how to crop a picture, make two L-shaped guides and place them over the photograph to try various croppings, as shown at right. Think of the photograph as a window and notice how the edges of the frame cut or encircle the objects in the picture. You can experiment to some extent on the contact sheet although the image there is small, but you will probably want to refine your cropping when you enlarge the image. Making an enlargement of the entire negative before doing any cropping can be useful because there may be potentials in the print you would not otherwise see.

Two L-shaped pieces of paper laid over a photograph can help you visualize different croppings.

What Went Wrong?

Troubleshooting Print Problems

If you have a technical difficulty with your prints, you may find the cause of the problem and its prevention below. See also Troubleshooting Camera and Lens Problems (page 83), Negative Problems (page 151), and Flash Problems (page 288).

White specks or small spots

Cause: Dust on the negative, printing-frame glass, or glass negative carrier. Fuzzy-edged spots may be due to dust on enlarger condensers.

Prevention: Dust these surfaces carefully before printing. Improve the print by darkening the spots with dyes (see page 189).

Black specks (pinholes) or small spots

Cause: Dust deposited on the film prior to exposure. See also Negative Problems, page 151, spots caused by air bells.

Prevention: Dust the inside of the camera. With sheet film, dust holders carefully and load film in a dust-free place. The spots can be etched or bleached to remove them (see page 189).

Dark scratch lines

Cause: Scratches on negative emulsion caused by rough handling. If scratches can be seen only on the print, not on the negative, the cause is abrasion of print emulsion.

Prevention: Handle film with extreme care and avoid cinching roll film, sliding sheet film against a rough surface, or otherwise abrading film in any way. Check the film path in the camera for grit or unevenness. Prevent abrasion of print emulsion by handling paper with greater care. If print tongs are used, don't slide them across the print surface; even light pressure can mark the surface of the print. Grip paper with tongs in the print margin so tong marks can be trimmed off if necessary.

Light scratch lines

Cause: Hairline scratches on the backing side of the negative.

Prevention: More careful handling or storing of the negative. An already scratched negative can be improved somewhat by a light coating of oil. An oily "scratch remover" is sold for this purpose. You can also rub your finger on your nose or forehead to pick up a light coating of oil. Then gently smooth the oil over any fine scratches that are visible. This should at least partially improve the next print by filling in the scratch. It works only with scratches that print as white. The oil attracts dust, so wipe the negative clean and store carefully.

Mottled, mealy, or uneven print development

Cause: Too little time or inadequate agitation in print developer. Use of exhausted developer.

Prevention: Develop prints with constant agitation in fresh developer for no less than the minimum time recommended by the manufacturer.

Fingerprints

Cause: Touching film or paper emulsion with greasy or chemical-contaminated hands. Fingerprints on negative will appear oversize in an enlarged print.

Prevention: Rinse and dry hands after they have been in any chemical solution. Be particularly careful to clean print fixer off hands before handling another piece of printing paper. Hold film and paper by edges.

Fading of prints

Cause: Prints that look faded immediately after washing were bleached by a too-strong or too-warm fixer or by too long a time in the fixer. Later fading is caused by inadequate fixing or washing.

Prevention: Review the recommended fixing and washing procedure (page 171), and follow it carefully.

Yellowish stains

Cause: Any number of processing faults—too long a time in the developer, exhausted or toowarm developer, contamination of developer with fixer, exposure of paper to air during development by lifting it out of developer too often, exhausted stop bath or fixer, delay in placing print into fixer, inadequate agitation or too short a time in fixer, inadequate washing. Inadequate fixing also causes brownish-purple stains.

Prevention: Review processing techniques on page 171 and information about contamination on page 130.

Overall gray cast in highlights or paper margins

Cause: Fogging of print by light leaking into darkroom from outside, by stray light from enlarger, by too strong a safelight, by too long or too close an exposure to a proper safelight, by storage of paper in a package that is not light tight, by too much time in developer, by room light on too soon after print is placed in fixer. **Prevention:** Check all of the above. Fogging affects highlights first, so prints may be reduced in brilliance before the cause becomes apparent in a definite tinge in print margins. This is because the light from very slight fogging may be too weak by itself to cause any visible response in the paper's emulsion. But when added to the slight exposure received by the highlights, it may be enough to make them grayish. Compare highlights that should be pure white in the print with the white test patch described on page 172.

Only part of negative image can be focused at any one time

Cause: Negative carrier of enlarger not parallel to baseboard or easel.

Prevention: Stopping down the lens may produce enough depth of focus to bring the image into acceptable focus, but aligning the enlarger is better.

Entire print out of focus, sharp negative image

Cause: Vibration of enlarger during exposure.

Prevention: Eliminate the source of vibration. Placing the paper in the easel can be enough to make a wobbly enlarger vibrate; pause a few seconds before exposure to let it come to a rest. Lightly press the button that starts the exposure, don't hit it. Avoid touching the enlarger during exposure.

Part of the print out of focus, sharp negative image

Cause: In contact printing, due to poor contact between negative and paper. In enlarging, due to negative buckling caused by heat generated during a long exposure time.

Prevention: In contact printing, even out or increase the pressure on the sandwich of glass, negative, paper, and backing. In enlarging, use a glass negative carrier, a cold-light enlarger, or a shorter exposure time.

Many prints too contrasty, even with low-contrast paper (or too flat, even with high-contrast paper)

Cause: Negatives too contrasty (or too flat), making them difficult to print.

Prevention: Adjust your film development time to adjust contrast in future negatives. See pages 144–145.

Toning for Color and Other Effects

Toning can be used to change the color of a print and to produce several other effects as well. Immersing a print in certain chemical toner solutions causes a distinct change in the color of the silver image, ranging from shades of sepia (yellowish brown), brown, red, or orange to blue or bluish green. Most toners combine with the silver to form silver-based compounds. The darker the silver deposit in the original print, the deeper the toned color will be.

Most toners help increase the life of a print. The silver in an image can deteriorate in much the same way that a piece of silver jewelry tarnishes. A toner increases the stability of the silver by combining it with a more stable substance, such as selenium. Toning for intensification is done with a selenium toner. For this purpose the print color is changed very little-just enough to remove the slight color cast present in most prints and to leave a neutral black image. In selenium toning the density of the dark areas of the print increases, which also increases the richness and brilliance of the print. You can easily see the effect by comparing a toned print to a similar, untoned one. A procedure for toning prints for intensification is described at the right.

Toning Black-and-White Prints

Paper and development. Changes during toning depend not only on the toner but on the type of paper, type of developer, development time, and even print exposure time. Sepia toners lighten a print slightly, so start with a slightly dark print. Bluish toners containing ferric ammonium citrate darken a print, so start with a slightly light print. Test the effect of a toner on your particular combination of paper and chemistry.

Fixing and washing. Prints will stain if they have not been properly fixed and washed before toning. Two fixing baths are recommended (see page 171). After fixing, prints on double-weight fiber-base paper are ready to be toned after a rinse in running water, treatment with a washing aid, and a 20min wash. Resin-coated paper needs no washing aid, only a 4-min wash.

Toning. Follow the manufacturer's instructions for diluting the toner. Set out three clean trays in a well-lighted area. Ideally, light should be similar to that under which the finished print will be viewed. A blue tungsten bulb will show the color under daylight viewing conditions. Place the prints in water in one tray, the diluted toner in the middle tray, and water in the third tray gently running, if possible.

Place a print in the toning solution. Agitate constantly until the desired change is visible. As a color comparison, particularly if you want only a slight change, place an untoned print in a tray of water nearby. Changes due to residual chemicals can take place after a print has been removed from the toner, so remove prints from toner just before they reach the tone you want.

Final Wash. After toning, treat fiber-base prints with fresh washing aid and give a final wash. Do not reuse the washing aid; it may stain other prints. Resin-coated prints need only a 4-min wash after toning.

Caution. Use gloves or tongs to handle prints in any toner. Use toners only in a well-ventilated area; fumes released during processing may smell bad or even be toxic if ventilation is inadequate. Read and follow manufacturer's instructions carefully.

GEORGE A. TICE: Grasses with Iris, Saddle River, New Jersey, 1968

How to Tone for Intensification

This formula for a selenium toner slightly deepens blacks and produces a rich, neutral black image. The formula incorporates a washing aid, which eliminates its use as a separate step. See also the general toning instructions above.

Dilute 1 part Kodak Rapid Selenium Toner with 10 to 20 parts washing aid (such as Kodak Hypo Clearing Agent) at working strength.

Some papers react more rapidly than others to toning, so adjust the dilution if you get too much—or inadequate—change.

Toning. Fix prints in a two-step fixing bath (see page 171). You can transfer prints directly from the fixer to the toning solution, but this is not always a workable procedure. Instead, prints can be rinsed thoroughly and held in a tray of water until a batch is ready for toning, or they can be completely washed and dried for later toning. Soak dry prints in water for a few minutes before toning. Keep RC prints wet for as little time as possible.

Place a print in the toning solution. Agitate until a slight change is visible, usually within 3 to 5 min. Very little change is needed—just enough so the print looks neutral or very slightly purplish in the middle-gray areas when compared to an untoned print. Immediately rinse the print in clean water. Wash for the recommended time.

Archival Processing for Maximum Permanence

Archival Print Processing

Following is one standard procedure for archival processing. Ilford has developed another method that shortens processing times considerably. Details can be found with Ilfobrom Galerie printing paper.

Paper. Use a fiber-base paper. RC papers are not recommended for archival processing because of the potential instability of the polyethylene that coats them.

Exposure and development. Expose the print with a wide border—at least 1 inch around the edges. Develop for the full length of time in fresh developer at the temperature recommended by the manufacturer.

Stop bath. Agitate constantly for 30 sec in fresh stop bath.

Fixing. Use 2 baths of fresh fixer. Agitate constantly for 3–5 min in each bath. You can agitate a print in the first bath and store it in gently running water (or in several changes of water) until a number of prints have accumulated. Then all prints can be treated for 4 min in the second bath by constantly shuffling one print at a time from the bottom to the top of the stack.

Protective toning. Use the selenium toner formula on page 182, which includes a washing aid. If no change in image tone is desired, mix toner at 1:20 to 1:40 dilution.

Washing. Rinse toned prints several times. Wash at $75^{\circ}-80^{\circ}$ F ($24^{\circ}-27^{\circ}$ C). Separate the prints frequently if the washer does not. Ideally, the water in the washer should completely change at least once every 5 min. Wash until the prints test acceptably free of hypo (see test procedure below), which will take 30 min to 1 hr or longer, depending on the efficiency of the washer.

Testing for hypo. *Mix the hypo test solution below or use Kodak's Hypo* Test Kit. Cut off a strip from the print's margin and blot dry. With a dropper, place a drop of test solution on the strip and allow to remain for 2 min. Blot off the excess and compare the stain that appears with the comparison patches in Kodak's Black-and-White Darkroom Dataguide, their publication *R-20.* The stain should be between the first and second patches.

Kodak Hypo Test Solution HT-2

750 ml (25 oz) distilled water

125 ml (4 oz) 28% acetic acid (3 parts glacial acetic acid diluted with 8 parts distilled water)

- 7.5 gm (1/4 oz) silver nitrate
- distilled water to make 1000 ml (32 oz)

Store in a tightly stoppered brown bottle away from strong light. The solution causes dark stains; avoid contact with hands, clothing, or prints.

Drying and mounting. Dry on fiberglass drying screens. Leave unmounted or slip print corners into white photo corners (used for snapshot albums) attached to mounting stock, then overmat (see pages 193–195). An archival-quality mounting stock is available in art supply stores; ask for 100% rag, acid-free boards. Separate prints with sheets of 100% rag, acid-free paper.

How long does a photograph last? Some very early prints, particularly platinum prints that were produced around the turn of the century, have held up perfectly. Platinum paper has a lightsensitive coating that contains no silver and produces an extremely durable and very beautiful image in platinum metal (*see page 184*). Other photographs not nearly so old have faded to a brownish yellow, their scenes lost forever.

Conventional prints, which have a silver-based image, have a long life if they are processed in the ordinary way with even moderate care. But today, many museums and individuals are collecting photographs, and, understandably, they want their acquisitions to last as long as possible.

Archival processing provides maximum permanence for fiber-base silver prints. Resin-coated (RC) paper is not recommended for archival purposes. Archival processing is not very different from the customary method of developing, fixing, and washing. It is basically an extension of the ordinary procedures and involves a few extra steps, some additional expense, and careful attention to the fine details of the work.

Archival processing eliminates residual chemicals, those that washing alone cannot remove entirely. Among the substances that are potentially harmful to a print are the very ones that create the normal black-and-white image: salts of silver, such as silver bromide or silver chloride. During development, the grains of silver salts that have been exposed to light are reduced to black metallic silver, which forms the image; but unexposed grains are not reduced and remain in other parts of the print in the form of a silver compound. If not removed, they will darken when struck by light and will darken the image overall. The chemical used to remove these unexposed grains is fixer, or hypo as it is sometimes called, which converts them into soluble compounds that can be washed away.

Fixer, however, must also be removed. It contains sulfur compounds, which if allowed to remain in a picture will tarnish the metallic silver of the image just as sulfur in the air tarnishes a silver fork. Also, fixer can become attached to silver salts and form complex compounds that are themselves insoluble and difficult to remove. When these silver-fixer complexes decompose, they produce a brown-yellow sulfide compound that may cause discoloration.

Protective toning converts the silver in the image to a more stable compound, such as silver selenide. This protects the image against external contaminants that may be present in air pollution. Selenium toner is used most often. Gold toners used to be recommended for maximum protection but are much more expensive than selenium, and there is now some evidence that they are not as effective as once believed. Experts don't always agree on which is the best method of archival processing. One widely accepted procedure is summarized at left. See the Bibliography for more information.

Platinum Prints: Beauty and Permanence

Platinum printing has produced some of the most beautiful and stable photographic images. Platinum paper has a light-sensitive coating that produces an image of platinum metal instead of silver. Its subtle gradations of tone give unsurpassed clarity and depth, and because platinum is chemically stable, the prints are extremely long lasting. Images produced around the turn of the century, when the platinum process was originally popular, still retain their exquisite richness and delicacy of detail.

The main disadvantage of platinum prints is cost. Platinum is more expensive than silver. Among the minor disadvantages is that the paper is not very sensitive to light, which means that only contact prints, and not enlargements, can be made.

Interest in platinum printing has increased in recent years (along with interest in a related process, palladium printing) because of its remarkable tonal range. Although you have to coat the paper yourself, platinum printing is surprisingly easy. An introduction to the process is given here, demonstrated by George Tice (*photograph, page 182*), who often prints in platinum. For more detailed references, see the Bibliography.

Platinum Printing

Negative. You will need a negative of the same size that you want your final print to be. If your original is too small, make an enlarged continuous-tone negative on Kodak Professional B/W Duplicating Film 4168. Ideally, the negative should have a long density range, that is, it should print well on the softest contrast grade of silver paper.

Paper. Use a top-quality 100% rag paper such as Crane's Kid Finish.

Brush. A soft brush about 2 inches wide is used to spread the sensitizing solution over the paper. If the bristles are set in metal, avoid contacting the metal with the sensitizing solution.

Light source. You will need a bright source of light that is high in ultraviolet rays, such as a sunlamp or sunlight. A sunlamp is more predictable than sunlight, but it takes longer—about 25 min versus about 1 min for bright, midsummer sun.

Chemicals. Available from chemical supply houses or from Photographers' Formulary, Box 5105, Missoula, Montana 59806.

Test strips. Unless you have unlimited funds, use a trimming from the coated paper for a test strip before you make a full-size print.

Sensitizing solution. Prepare three stock solutions, storing each in an amber, dropper-capped bottle. These quantities will coat about 30 8 \times 10-inch prints.

Solution 1: 0.5 gm oxalic acid, 8 gm ferric oxalate, dissolved in 30 ml (1 oz) 125° F (52° C) distilled water. Lasts about 6 months.

Solution 2: 0.5 gm oxalic acid, 8 gm ferric oxalate, 0.1 gm potassium chlorate, dissolved in 30 ml (1 oz) 125° F (52° C) distilled water. Lasts about 6 months.

Solution 3: 7 gm potassium chloroplatinite dissolved in 37 ml (1½ oz) 125° F (52° C) distilled water. Lasts indefinitely.

Just before using, combine desired quantities of the three stock solutions in a small glass. Proportions depend on the contrast desired in the print. These quantities will coat one 8×10 -inch print plus test strips.

	lowest contrast	moderately low contrast	average contrast	moderately high contrast	highest contrast
Solution 1	22 drops	18 drops	14 drops	10 drops	0 drops
Solution 2	0 drops	4 drops	8 drops	12 drops	22 drops
Solution 3	24 drops	24 drops	24 drops	24 drops	24 drops

Developer. *Mix* 454 gm (1 lb) potassium oxalate in 1.4 liters (48 oz) warm water. The developer lasts indefinitely and may even improve with age.

Clearing solution. *Mix* 30 *ml* (1 oz) hydrochloric acid (37%) into 1.8 liters (60 oz) water. (Caution: Always add acid to water, not water to acid.) Set out three separate trays of clearing solution. After processing a few prints through all three baths, discard the first bath. Make the second tray the first bath, and the third tray the second bath. Fill the empty tray with fresh solution, and make it the third bath.

Tips. Avoid contact of the sensitizing solution with metal; mix, store, and use chemical solutions only in glass or plastic containers. The surface of the print becomes rather delicate during processing, so process one print at a time, or at most two prints back to back.

Caution. Rubber gloves or tongs are recommended for processing; repeated contact with developer or clearing bath can cause skin problems.

1 mix the solutions

Use a balance scale to weigh the chemicals for the stock solutions, then prepare as explained in box, right. Tack the paper to a board. Dampen the ' brush in water, squeeze dry.

2 sensitize the paper

Working in subdued light (dim tungsten light is best), pour the sensitizer down the center of paper and spread evenly with the brush, stroking side to side, then up and down.

3 dry the sensitized paper

Hang by a corner to dry in a dark place. You can speed the drying with warm (not hot) air from a blow dryer. The dried surface will be pale yellow.

4 prepare to expose

Print as soon as the paper is dry. Trim paper to size and assemble in a printing frame so light can pass through the glass and negative to the coated side of the paper. Close the frame.

5 make the exposure

Expose under a sunlamp or in sunlight. Adjust the frame so it is evenly lit; then, if using a sunlamp, move away to avoid exposure of your skin and especially your eyes.

6 develop the print

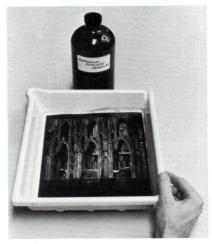

Agitate the print in the developer for about 1 min under normal room lights. Extra development will not darken the print; development ceases when chemical reaction is complete.

7 | clear residual chemicals

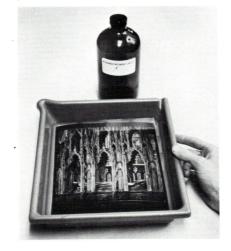

Agitate the print for 5 min in each of three successive clearing baths of dilute hydrochloric acid. The final bath should remain clear. If it does not, agitate the print in a fourth bath of fresh solution.

8 wash and dry the print

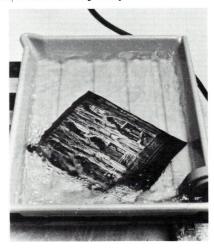

Wash for 30 min in a tray with a siphon or in an archival washer. Adjust water flow for a complete change of water every 5 min. Air-dry. If necessary, flatten in dry-mount press at low heat.

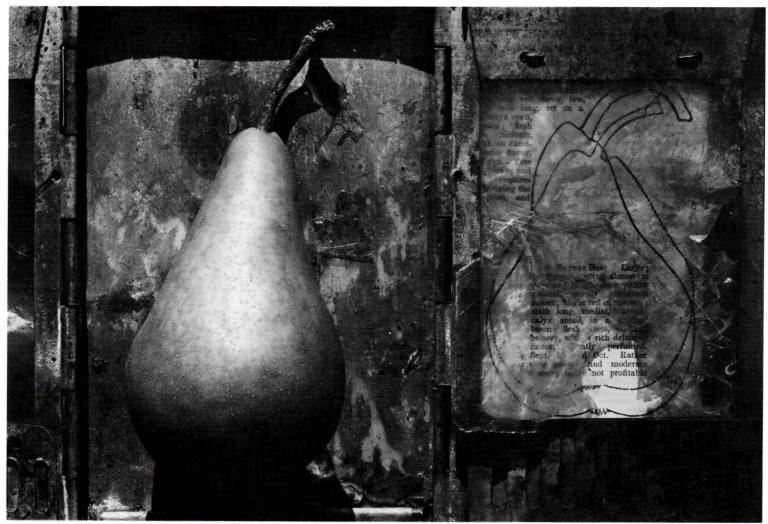

OLIVIA PARKER: Bosc, 1977

8 Finishing and Mounting

Drying Your Prints 188 Spotting to Remove Minor Flaws 189 How to Dry Mount 190 Cutting an Overmat 193

Although much pleasure lies in taking pictures, the real reward lies in displaying and viewing the results. Yet many photographers never seem to finish their images; they have a stack of dog-eared workprints but few pictures they have been willing to carry to completion. Properly finishing and mounting a photograph is important because it tells viewers the image is worth their attention. And you yourself will see new aspects in your photographs if you take the time to complete them.

Finishing a photograph requires several steps, some of them optional. All prints are eventually dried; the most important precaution is to dry them in a way that does not stain or otherwise damage them. Most prints need some spotting—minor repair of small white or black specks caused by dust.

Mounting a print on a stiff backing protects it from creases and tears and prevents curling of fiber-base papers. Dry mounting, using a special drymount tissue, is the most common method; when heated, the tissue attaches the print to the backing in a perfectly smooth bond. An overmat can also be cut to help protect the photograph. Your choice of mounting materials depends on the degree of permanence you want for a print. The gelatin, silver, and paper in a photographic print can be seriously damaged by contact with masking tape and other materials that deteriorate in a relatively short time and generate destructive by-products in doing so.

The best-quality and longest-lasting materials are the most expensive. Acid-free, archival-quality mounting stock (sometimes called museum board) is free of the potentially damaging acids usually present in paper. It is sold by better art supply stores or companies that specialize in archivalquality photographic materials. Less expensive but still good-quality stock can be found in most art supply stores. It won't last for a hundred years but will make presentable mounting for your print. Avoid long-term contact of prints with ordinary cardboard, brown wrapping paper, brown envelopes, manila folders, and most cheap papers, including glassine. (Archivally minded photographers would say to avoid *all* contact of prints with such materials.) Also avoid attaching to the print pressure-sensitive tapes, such as masking tape or cellophane tape, brown paper tape, rubber cement, animal glues, and spray adhesives.

Olivia Parker's still life, opposite, pairs a real pear with its abstracted outline and verbal definition. As in this assemblage, Parker often incorporates aged or weathered objects, illustrations, and type into the constructions that she then photographs. Not shown here is the delicate color she gets from "split toning" her black-and-white prints. She selenium tones silver-chloride contact printing paper (such as Kodak Azo), removing the print from the toner when it combines silvery gray and brown colors rather than having an overall brown tone.

Drying Your Prints

The goal in drving prints is to avoid damaging them and wasting all the effort that has gone into making them up to this point. The commonest source of trouble is that familiar enemy, contamination. One improperly washed print still loaded with fixer and placed on a dryer will contaminate every other print that is dried in the same position. And with contamination come stains-immediately or eventually. If blotters or cloths from heat dryers become tinged with yellow, they have been contaminated with fixer that was not completely washed from prints. Replace blotters and wash the dryer cloths, or they will stain other prints with which they come into contact. Wash fiberglass screening from time to time.

Fiber-base prints can be dried on a rack, in blotters, or on a heat dryer. If the prints curl during drying or afterward, they can be flattened in a minute or two in a heated mounting press. **RC prints** have a plasticlike coating that makes them resistant to water. Since water does not soak into the paper (as it does with fiber-base papers), RC prints dry well if surface water is simply sponged or squeegeed off and the print is placed face up on a clean surface such as a fiberglass screen. Drying can be speeded by blowing the print with a blow dryer set at low heat.

The drying method can affect the **surface gloss** of a fiber-base print. A glossy-surfaced, fiber-base print dries to a semigloss finish on a rack, in blotters, or in a heat dryer if the emulsion is against the dryer cloth. You can get a high gloss if the print is ferrotyped dried with the emulsion pressed against a smooth metal plate, usually the hot metal drum or plate of a heat dryer (soaking the print first in a glossing solution helps prevent sticking and uneven drying). Do not ferrotype RC papers; use an RC glossy surface.

- Blotters may be used for print drying, provided the blotting material is the kind sold expressly for photographic use and has not been contaminated by previous use.
- This flatbed dryer for fiber-base papers has an electrically heated metal surface on which prints are placed face up (face down for high-gloss ferrotyping). A cloth apron closes down over the prints to hold them flat. Heat drying is not recommended for RC prints.

A print is rolled into this rotary dryer by turning the large knob on the side. The cylinder's surface heats electrically while a cloth cover holds the print securely against the metal. It is not recommended for RC prints.

With a screen dryer, the prints are air-dried at room temperature on contamination-resistant fiberglass screens—fiber-base prints face down, RC prints face up. You can make your own racks from wood frames covered with fiberglass screening purchased at a lumberyard or hardware store.

Spotting to Remove Minor Flaws

spotting with dyes

White specks, lines, or even large spots can be blended into the surrounding tones of the print by spotting with dyes that darken the area. The dyes are used straight from the bottle for the darkest areas. diluted with water for lighter ones.

etching

Small black specks or scratches can be removed by etching the surface of the print with a sharp blade until the darkened silver of the speck is removed. The roughened surface of the print is not objectionable if the speck is small and if you etch gently. Your prints may have small imperfections that you would like to remove. Even after careful processing, it is almost impossible to produce a print without a few white specks caused by dust on the negative or paper during printing. Black specks or scratches can be very noticeable in a light-toned area. Spotting a print improves its overall appearance by removing these distracting marks. Most spotting is done after the print has been completely processed and dried; the exception is local reduction or bleaching, which is done while the print is still wet. Practice is essential with all these techniques; work on some scrap prints before you start on a aood print.

White spots are removed by adding dye to the print until the tone of the area being spotted matches the surrounding tone (top). Liquid photographic dves. such as Spotone, sink into the emulsion and match the surface gloss of unspotted areas. They are usually available in sets of at least three colors-neutral, warm (brown-black), and cool (blueblack)-so that the tones of different papers can be matched. You will need one or more soft, pointed brushes, size 00 or smaller (some people like a brush as small as size five zero, 00000), facial tissue to wipe the brushes, a little water, a small, flat dish to mix the colors, and a scrap print or a few margin trimmings to test them.

Pick up a drop of the neutral black on a brush and place it in the mixing dish. Spread a little on a margin trimming and compare the dye color to the color of the print to be spotted. If necessary, add some of the warmer or cooler dyes to the mixing dish until the spotting color matches the print. Spot first with

undiluted dye in any completely black areas of the print. Dip the brush into the dye, wipe it almost dry, and touch it gently to the print. Several applications with an almost dry brush will give better results than overloading the brush and making a big blob on the print. Spread out the dye in the mixing dish and add a drop of water to part of it to dilute the dye for lighter areas. Since the dyes are permanent once they are applied to the print, it is safer to spot with a light shade of dye-you can always add more. Spot from the center of a speck to the outside so that the dye doesn't overlap tones outside the speck.

Etching can remove a small or thin black mark that obviously doesn't belong where it is, such as a dark scratch in a sky area. Gently stroke the sharp tip of a new mat knife blade or a singleedge razor blade over the black spot (*bottom*). Use short, light strokes to scrape off just a bit of silver at a time so that the surface of the print is not gouged. Etching generally does not work as well with RC papers as with fiber-base papers.

Local reduction or bleaching lightens larger areas. Farmer's Reducer (diluted 1:10) or Spot Off bleaches out larger areas than can be etched and also brightens highlights in a print. Prints are reduced while they are wet. Squeegee or blot off excess water and apply the reducer with a brush (used for this purpose only), a cotton swab, or a toothpick wrapped in cotton. If the print does not lighten enough within a minute or so, rinse, blot dry, and reapply fresh reducer. Refix the print for a few minutes before washing as usual. Do not use reducer in combination with toner.

How to Dry Mount

- 1 metal ruler
- 2 mat knife
- 3 tacking iron
- 4 dry-mount tissue
- 5 print
- 6 mount board
- 7 mounting press
- 8 paper for cover sheet

Dry mounting is a fast method of providing a neat support for a print. Dry mounting uses dry-mount tissue, a thin sheet coated with an adhesive that becomes sticky when heated. The molten adhesive penetrates the fibers of both mounting board and print and forms a tight, perfect bond. To dry mount you will need a tacking iron to attach the tissue to the board and print, and a mounting press to dry the materials and bond the print to the board. The press has a heating plate hinged to a bed plate. In the press, the dry-mount tissue melts and is pressed into the board and print. If you don't have access to a press, you can use cold-mount tissue; it is pressure sensitive and needs no heat for bonding.

All materials should be absolutely clean and dry. Even a small dirt particle trapped between print and board causes an unsightly and permanent lump in the print. The mount board, print, and cover sheet should be bone dry before mounting. A fiber-base print, the mount board, and a cover sheet are placed in a heated press to drive out any residual moisture. An RC print does not have to be heated since it does not absorb atmospheric moisture.

RC prints are more sensitive to heat than fiber-base papers; their resin coating can melt at temperatures higher than 210°. If you are mounting RC prints, use a dry-mount tissue suitable for RC prints, one that bonds at temperatures lower than 210°. Notice (*step 1*, *this page*) that you set the mounting press to a lower temperature for RC paper than for fiber-base paper.

There are various ways to mount a print. The print shown here is bleed mounted—trimmed so that the edges of the image are even with the edges of the mounting board. A common method is to mount the print with a wide border around the edges (*see page 192*).

Bleed Mounting

A bleed-mounted print has no border. After mounting, the print is trimmed to the edges of the image. Page 192 shows how to mount a print with a border around the edges.

1 dry the materials

Heat the press to about 225° F (107° C) for fiberbase prints, 205° F (96° C) for RC prints, or as instructed with dry-mount tissue. Predry a fiberbase print and its mount board, with cover sheet on top, in the press for 30 sec. Do not predry RC prints.

2 tack the dry-mount tissue to the print

Heat the tacking iron (same temperature as in step 1). With the print face down and mounting tissue on top of it, tack the tissue to the print by moving the tacking iron from the center of the print to the sides. Do not tack at the corners. Trim off the excess mounting tissue.

3 tack the dry-mount tissue and print to the board

Place the print and tissue face up on the mount board. Slightly raise one corner of the print only. Tack the tissue to the board with a short stroke of the tacking iron toward the corner. Repeat at the diagonal corner, then the other two. Keep the tissue flat to prevent wrinkles.

5 trim the mounted print

Trim the edges of the mounted print with the mat knife, using the ruler as a guide. The blade must be sharp to make a clean cut. Several light slices often work better than only one cut. Press down firmly on the ruler so it does not slip—and be careful not to cut your fingers.

4 mount the print

Put the sandwich of board, tissue, and print (with cover sheet on top) into the press. With RC prints, quickly open and close the press several times to drive out any moisture. Then clamp in the press for about 30 sec (or longer).

6 the finished print

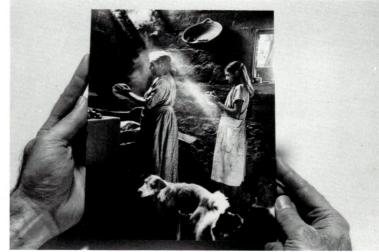

The print above is bleed mounted, trimmed to leave no border. Page 192 shows how to mount a print with a margin of mounting board around the edges of the print.

Mounting with a Border

To dry mount a print with a border of mounting board around the image, begin by following steps 1 and 2 on page 190: dry the materials in the heated mounting press and tack the dry-mount tissue to the print. Then follow the steps below.

1 | trim the print and dry-mount tissue

Place the print and dry-mount tissue face up. Use the mat knife, with a metal ruler as a guide, to trim off the white print borders, plus the tissue underneath. Cut straight down so that the edges of print and tissue are even. Watch your fingers.

3 tack the dry-mount tissue and print to the board

Without disturbing the position of the print, slightly raise one corner of the print only. Tack the tissue to the board with a short stroke of the tacking iron toward the corner. Repeat at the diagonal corner, then the remaining two. Keep the tissue flat against the board to prevent wrinkles. 2 position the print on the mount board

It is convenient to mount your prints on boards of the same size: 8×10 -in prints are often mounted on 11×14 -in or 14×17 -in boards. Position the print so the side margins are even. Then adjust the print top to bottom. Often the bottom margin is slightly larger than the top.

4 the finished print

Put the sandwich of board, tissue, and print (with cover sheet on top) into the heated press, as in step 4, page 191. You can test the bonding of the mounted print to the board by slightly flexing it after it has cooled to make sure it has securely adhered.

Cutting an Overmat

- 1 T square
- 2 metal ruler
- 3 art gum eraser
- 4 2 mount boards
- 5 mat cutter
- 6 single-edge razor blade
- 7 print
- 8 pencil

1 measure the image area

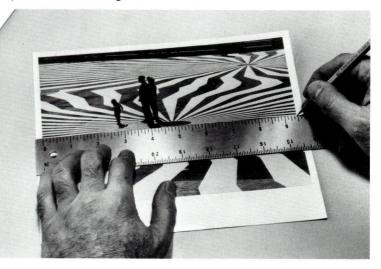

Decide on cropping and measure the resulting image. If the picture is not to be cropped, measure just within the image area so that the print margin will not show. This picture was cropped to 5³/₄-in high by 9¹/₂-in wide. The overmat crops the print; you don't have to cut the print down.

2 plan the mount dimensions

An overmat provides a raised border around a print. It consists of a cardboard rectangle with a hole cut in it, placed over a print that has been mounted to a backing board. The raised border protects the surface of the print emulsion, which can be easily scratched by something sliding across it-such as another print. If the print is framed, it prevents the print emulsion from sticking to the glass in the frame. Damage can still occur with a matted print but is less likely. Since the overmat is replaceable, a new one can be cut and mounted without damage to the picture if the original mat becomes soiled. One of the great pleasures of photography is showing your prints to other people-but one of the great irritations is having someone leave a fingerprint on the mounting board of your

best print. Prevent problems by handling your own and other people's pictures only by the edges.

It takes practice to cut the inner edges of an overmat with precision. It becomes easier after a few tries, so spend some time practicing with scrap board to get the knack of cutting perfectly clean corners. A mat cutter is a useful aid. A simple, heavy metal device designed to fit into the palm of the hand, it holds a knife blade that can be rotated to cut either a beveled (angled) or a perpendicular edge. Mat cutters, like the other tools and materials shown above, are available at most art or photographic supply stores. They are a worthwhile investment and can make the difference between a ruined board. cut freehand with an unbraced knife, and a perfectly cut mat.

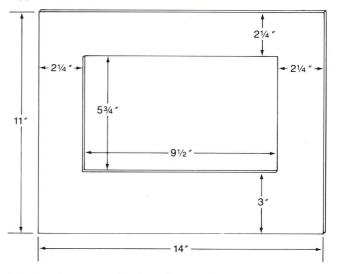

The print above mounted horizontally on an 11 \times 14-in horizontal board leaves a 2½-in border on the top and sides, a 3-in border on the bottom. The window in the overmat will be cut to the size of the cropped image. Two 11 \times 14-in boards are needed: one for the backing, one for the overmat.

3 mark the mat board

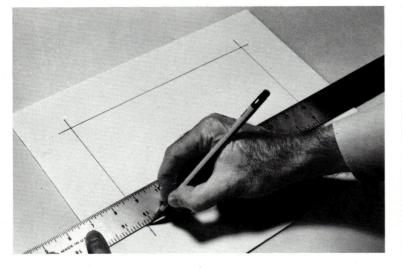

Mark the back of one board for the inner cut, using the dimensions of the image that will be visible. Measure with the ruler, but in drawing the lines use the T square firmly braced to align with the mat edge to be sure the lines are square.

5 cut the overmat

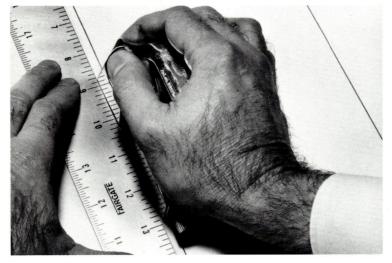

Get a firm grip on the mat cutter and brace it against the ruler. Cut each of the inside edges on a line, stopping short of the corners; finish the corners with the razor blade; do not cut too far, and take care to maintain the angle of the cut.

4 set the cutting blade

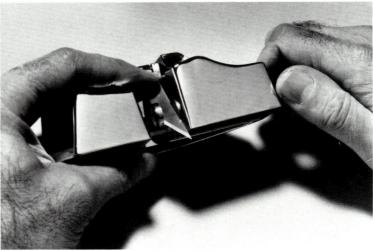

Insert the knife blade in the mat cutter, sliding it into the slot on the inner end of the movable bolt. Adjust the blade so that it extends far enough to cut through the board, then tighten, using the threaded knob on the bolt's outer end.

6 position and attach the print

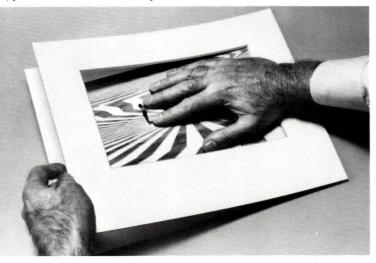

Ways of attaching the print to the backing board are shown at right. Slip the print between the backing board and the overmat. Align the print with the inner edge of the overmat. Then remove the overmat and attach the print.

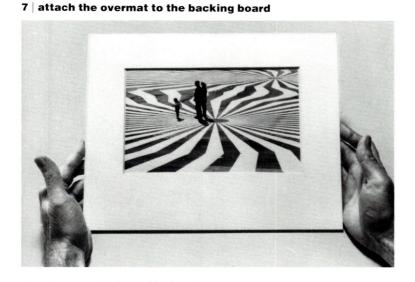

Hinge the overmat to the backing board with a strip of gummed linen tape (diagram below). Framing will hold the boards together without hinging. Handle any mounted print only by the edges. Use a gum eraser to clean the overmat if needed.

an overmatted print

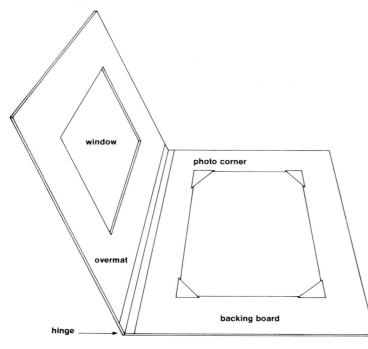

attaching an overmatted print to a backing board

Materials. Ideally, use archival-quality materials such as acid-free paper for the photo corners and gummed linen (Holland) tape or other pH-neutral tape for hinges. Less expensive but good-quality materials can be used when archival permanence is not required. If you value a print, do not hinge it with brown paper tape or pressuresensitive tapes such as masking tape or cellophane tape. These products deteriorate with age and will damage a print.

Dry mounting. Before positioning the print (step 6, opposite) tack a piece of mounting tissue to the back of the print and trim off the excess. After positioning the print, tack the print to the board and then mount. See detailed instructions, pages 190–192.

Cornering. Photo corners, like the ones used to mount pictures in snapshot albums, are a convenient means of mounting. The corners are easy to apply and are hidden by the overmat. The print can easily be slipped out of the corners if you need to remove it from the backing. You can buy gummed photo corners or make your own (see below) and attach them to the backing board with a strip of tape.

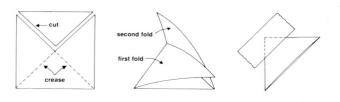

Hinging. Hinging holds the print in place with strips of tape attached to the upper back edge of the print and to the backing board.

A folded hinge is

is in place.

hidden when the print

A folded hinge can be

reinforced by a piece

of tape.

hidden if an overmat is used.

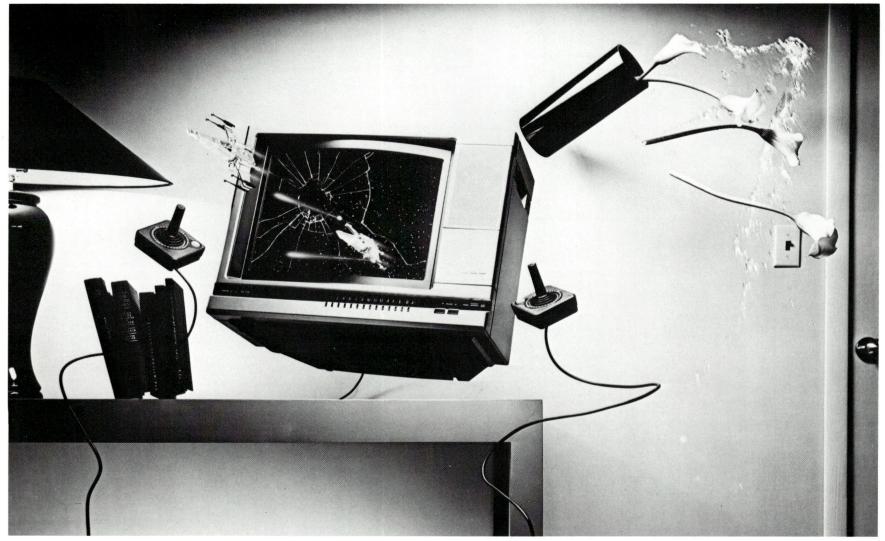

STEVE BRONSTEIN: Video Wars, 1982

9 Special Techniques

The ad agency for Mattel Electronics approached photographer Steve Bronstein with an idea they hoped would convey the excitement of home video games—a tongue-in-cheek ad to show that the games were so exciting they would even startle your TV set. The shoot began with getting the set built by a prop expert. The TV (gutted to reduce its weight) and the vase were suspended from the wall behind them. The flowers were hung from monofilament wire, which was later retouched out. Armature wire (which is sturdy but can be shaped) inside the game control cords gave them their wiggle.

The set was lit from above by a bank of three 2400 watt/second strobes, a 1200 watt/second unit on the floor, another strobe inside the set to separate the screen from its frame, a light on the water to highlight it, and another inside the lamp.

The water was the most difficult part. The set builder filled a turkey baster with water, rigged it to the metal wringer of a sponge mop, and then hid the contraption behind the vase. When an assistant behind the set wall pulled a string, it closed the wringer, which squeezed the baster so the water spurted out, mostly into a pail positioned out of the frame. "It was a mess nevertheless," says Bronstein. "The smartest thing we did was to Scotchgard the set beforehand." The World in Close-Up 198 How to Use Supplementary Lenses 199 How to Use Extension Tubes and Bellows 200 How to Use Macro Lenses 201 Close-Up Exposures: Greater than Normal 202 Copying Techniques 204 Special Printing Techniques 206 A Photogram: A Cameraless Picture 206 A Sabattier Print—Part Positive, Part Negative 208 Techniques Using High-Contrast Film 210 A Line Print 213 A Posterization 214 Using Special Techniques 216 Digital Image Processing 217 Multiple Imagery 218

In addition to standard photographic procedures, you can create images using special equipment or techniques. This chapter shows some of these alternative ways of taking photographs or making prints.

Close-up photographs produce effects beyond simple magnification. Close-ups can show objects enlarged for scientific study, but there is also pleasure and magic just in seeing something larger and in greater detail than it is ordinarily seen.

You can also manipulate a photograph and radically change the image formed in the camera (or make a print entirely without a camera) in order to make a print that is more interesting or exciting to you or to express a personal viewpoint that could not be conveyed by conventional methods. There are many techniques besides those described in detail here, for example, nonsilver processes such as cyanotyping and photo silk screening (*page 216*), digital image processing (*page 217*), and multiple imagery (*pages 218–219*).

Ultimately, the success of a photograph depends not on the technique used but on your taste and judgment in fulfilling its potential—whether through a straight, full-scale black-and-white print or a manipulated image. Probably the main pitfall in manipulating a print is changing it merely for the sake of change instead of making alterations that actually strengthen the image. But you will never know what the possibilities are until you have used different techniques with your own images.

The World in Close-Up

If you want to make a large image of a small object, you can, at the simplest level, enlarge an ordinary negative. However, this is not always satisfactory because image quality deteriorates in extreme enlargements. A much better picture results from using **close-up techniques** to get a large image on the negative to begin with.

A close-up subject is focused closer than normal to the camera. This is done by fitting a supplementary lens over the front of the regular lens (*opposite*), by increasing the distance from lens to film with extension tubes or bellows inserted between the lens and the camera back (*page 200*), or by using a macro lens that is designed for close-up work (*pages 68 and 201*). Each method can focus a larger-than-normal image on the film (*diagram below*).

Working close up is somewhat different from working at normal distances. After roughly focusing and composing the image, it is often easier to finish focusing by moving the entire camera or the subject farther away or closer rather than by racking the lens in or out. During shooting, a tripod is almost a necessity because even a slight change in

In normal photographic situations, the size of the image produced on the film is less than one-tenth the size of the object being photographed. Closeup images where the subject is closer than normal to the camera can range from about one-tenth to about 50 times life size. Beyond about 10 times life size, however, it is often more practical to take the photograph through a microscope. The term photomacrograph (or macrophotograph) refers to close-ups that are life size or larger. Pictures through a microscope are photomicrographs.

The relative sizes of image and subject are expressed as a ratio with the relative size of the image stated first: a 1:10 ratio means the image is one-tenth the size of the subject. Or the image size can be stated in terms of magnification: a $50 \times$ magnification means the image is 50 times the size of the subject. The magnification of an image smaller than life size (actually a reduction) is stated as a decimal: a .10× magnification produces an image one-tenth life size. lens-to-subject distance changes the focus. A highly magnified image readily shows the slightest camera movement, so a tripod also helps by keeping the camera steady.

Depth of field decreases as a subject is focused closer to the lens. Depth of field is very shallow at close working distances, so focusing becomes critical. A 50mm lens at a distance of about 12 inches from the subject has a depth of field of one-sixteenth inch when the aperture is set at f/4. At f/11 the depth of field increases—but only to one-half inch.

The depth of field is distributed differently, too. In a close-up it extends half in front and half behind the plane of focus. At normal working distances it is one-third in front and two-thirds behind the plane of focus.

Some cameras are better than others for close-up work. A single-lens reflex or view camera is good for close-ups, mostly because of its through-the-lens viewing. You can see exactly where the lens is focused and preview depth of field by stopping down the lens, an important ability with shallow depth of field. You can frame the image exactly and see just how the subject relates to the background. Many single-lens reflex cameras have through-the-lens metering, which can solve some closeup metering problems (see metering on page 202).

Twin-lens reflex and rangefinder cameras are less convenient because it is difficult to see the image exactly as the lens does. If you have a twin-lens reflex, you can buy twin supplementary lenses that fit over the camera's viewing and taking lenses; a built-in prism changes the angle of the viewing lens so it sees the same area as the taking lens (although from a slightly higher point of view, which changes the relationship of subject to background). It is also possible to measure the distance from the center of the taking lens to the center of the viewing lens, then raise the tripod head exactly that much; a tripod accessory is available for this.

Rangefinder cameras are even harder to use since the rangefinder mechanism will not focus at very close distances and the viewfinder will not show the exact area being photographed. You may be able to buy an accessory close-up rangefinder attachment.

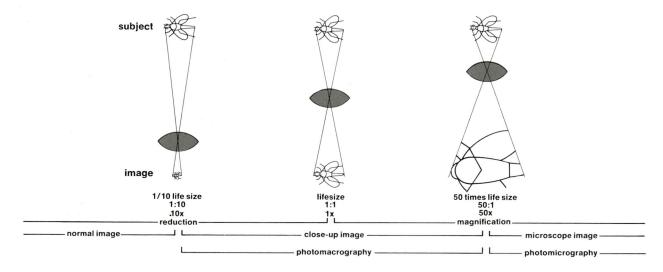

How to Use Supplementary Lenses

How supplementary lenses enlarge. Here, a cluster of petunias as seen by a 35mm camera with a 50mm lens. The lens, set at its closest focusing distance (about 18 inches), produces an image on the film about onetenth life size. (The pictures here are enlarged slightly above actual film size.)

With a +1.5 diopter supplemen-"ary lens, camera-to-subject distance is reduced to 15 inches for a larger image, about onefifth life size.

50mm lens and +1.5 diopter lens

50mm lens alone

50mm lens and +4.5 diopter lens

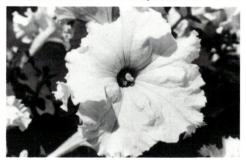

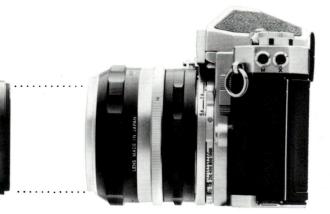

supplementary 35mm SLR camera with 50mm lens lens

Supplementary or **close-up lenses** let you make close-ups with any camera lens. They are magnifying glasses of varying powers that are attached to the front of regular lenses. Supplementary lenses enlarge an image in two ways: they add their own power to that of the regular lens, and they change the focusing distance of the regular lens so that it can move closer than normal to an object.

The power of a supplementary lens is expressed in diopters, an optical term used to describe both the focal length and the magnifying power of the lens. Thus a 1-diopter lens (expressed as +1) will focus on a subject one meter (100 cm, or 3.25 ft) away. A +2 diopter focuses at half that distance (50 cm) and magnifies twice as much; a + 3 diopter focuses at 33 cm and magnifies three times as much, and so on. Lenses of varying diopters can be added to each other to provide greater magnification, as long as the stronger lens is attached to the camera first. Image quality tends to suffer, however, when more than one supplementary lens is used.

When a supplementary lens is attached to a camera lens set at infinity, the new focusing distance will be the focal length of the supplementary lens. This is true no matter which camera lens is being used. For example, a +2diopter lens will always focus on a subject 50 cm (19.5 inches) away with a 50mm lens, a 135mm lens or any other lens—provided that the regular lens is set at infinity.

Image size, however, depends on the focal length of the camera lens. This happens because the degree of enlargement is determined by the diopter of the supplementary lens plus the magnifying power of the regular lens. Thus a + 2 diopter gives a bigger image with a 135mm lens than with a 50mm lens. Also, a supplementary lens gives varying degrees of enlargement depending on the distance setting of the lens. With the lens set for a distance closer than infinity, an object can be brought into focus closer than the regular diopter distance to create an even larger image. Charts provided with the supplementary lenses give details.

Supplementary lenses are useful but have some problems. They do not change exposure readings, which is convenient. Also, they are small and inexpensive and can be used with any kind of camera, including those without interchangeable lenses. Because of their design, however, the lenses provide acceptable sharpness only when used with small apertures. Their surfaces, not bonded to the regular lens, may cause reflections and other aberrations. And overall sharpness decreases at +5 diopters or stronger.

The World in Close-Up: continued

How to Use Extension Tubes and Bellows

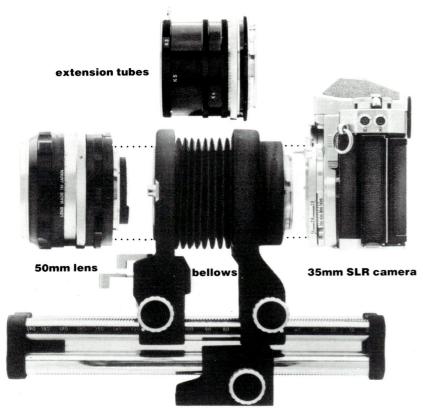

50mm lens on 35mm SLR camera

50mm lens and extension tubes

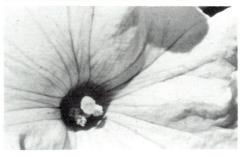

50mm lens reversed and extension tubes

50mm lens and fully extended bellows

Some different degrees of magnification using extension tubes and bellows are shown in the pictures at left. Here, a view of some petunias taken with a 50mm lens alone. The image on the film is about one-tenth the actual size of the flowers. (The pictures are enlarged slightly more than the film size.)

A picture taken with a set of extension tubes inserted between the lens and the camera. This let the lens be focusec closer to the flowers, which pro duced a life-size image of part of a single blossom. Increasing or decreasing the number of rings used in the tube set woull produce greater or lesser magnification.

Extension tubes and **bellows** are mounted between camera body and lens. They extend the lens farther from the film so the lens can be focused closer to the subject. The closer the lens comes to the subject, the larger its image size on the film. (Similarly, the closer you bring your eye to an object, the larger the object appears.) The main differences between extension tubes and bellows are in the ease with which they produce varying amounts of magnification and in their price.

Tubes are rings of metal. Most are rigid and extend the lens in predetermined, graduated steps depending on the length of each ring and how many of them are used. They are light, easily attached, and relatively inexpensive but not always as useful as bellows because they come in fixed lengths. A more expensive type of tube can be racked in or out like a lens barrel and so extended to variable lengths. A macroconverter is an extension tube with elements that optically improve sharpness when a conventional lens is used at close-up distances.

Bellows have a flexible center and can be expanded to different lengths. They provide continuously variable magnifications over their extendable range. A good-quality bellows is a precision instrument, more expensive but more versatile than an extension tube.

Tubes and bellows maintain better optical quality than supplementary lenses. They provide a wide range of magnifications, including high-quality, larger-than-life-size images. Disadvantages are due to inserting them between lens and camera body. Tubes and bellows can be used only with cameras that have interchangeable lenses. Unless specifically designed for a particular camera, they will interrupt automatic exposure functions if the camera has them, which means that shutter speed and aperture must be adjusted manually. Here the same extension tubes were used as above but with th 50mm lens reversed; the front end of the lens instead of the back was attached (with a reversing ring) to the tubes. At very close distances, many lenses perform better if reverse because of the asymmetrical design of the lens elements. Reversing also provides somewhat more magnification.

A picture taken with the reversed 50mm lens attached te a fully extended bellows. The lens was able to be focused so close that it showed just the center of a single flower magni fied to five times life size.

How to Use Macro Lenses

he magnifications produced by moving closer to a subject with a 55mm macro lens are shown at right. Here, the picture was aken from 5 ft away. The resulting image (slightly enlarged here) was about ½s life size.

Setting the lens to focus as close as possible and moving the camera 10 inches from a flower produced an image onehalf life size.

Adding an extension tube, which moved the lens to only 8 inches from the flower, produced a life-size image.

55mm macro at closest distance, 10 inches

55mm macro with extension tube, 8 inches

70-150mm macro zoom lens

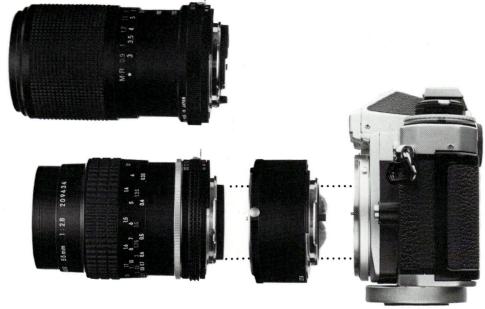

55mm macro lens

If you want to make close-ups, a macro

lens is probably the most useful piece

of equipment you can own. The lens

barrel of a macro is constructed so it

can be extended farther than normal,

which lets you focus closer than normal

to a subject. A 50mm macro lens with-

out any accessories will focus as close

as 9 inches and produce a one-half life-

size image. The size of the image can

be increased even more by inserting ex-

tension tubes or bellows between the

to prevent the aberrations that reduce

sharpness at close focusing distances,

so they give close-up images with edge-

to-edge sharpness superior to that pro-

duced by lenses of conventional de-

sign. They also perform well when used

for general photography. Macro lenses

are available in several fixed focal

lengths from 50mm to 200mm and as

macro zoom lenses in focal lengths

Macro lenses are optically corrected

lens and the camera body.

extension tube

35mm SLR camera

such as 28–85mm and 70–150mm. Most macro lenses connect directly to the camera body, retaining connections with the camera's meter or any automatic features.

One inconvenience is that a macro lens's widest aperture is relatively small: f/3.5 is a typical maximum aperture for a 50mm macro. Adding an extension tube or bellows also cuts the amount of light reaching the film. This means that in dim light or with slow film, a relatively slow shutter speed must be used.

Macro zoom lenses are popular because they let you produce different degrees of magnification without moving the camera. However, many lenses sold as macro zooms would be more accurately called close-focusing zooms; they are not fully corrected for working up close, and unless tubes or bellows are added, they produce an image only one-third to one-quarter life size.

Close-Up Exposures: Greater than Normal

Two possible exposure problems arise when photographing close up. One is getting an accurate light reading in the first place and the other is adjusting that reading when the lens is extended farther than normal from the film.

The small size of a close-up subject can make metering difficult. The subject is usually so small that you might meter more background than subject and so get an inaccurate reading. A spot meter is one solution; it can read very small objects with accuracy. Or you can make a substitution reading from a gray card (*page 121*). Another possibility is to use an incident-light meter to read the light falling on the subject.

You need to make an exposure increase with bellows or extension tubes. As the distance between lens and film increases, the intensity of the light that falls on the film decreases and the image becomes dimmer. Therefore, to prevent underexposure in close-up photographs, the exposure must be increased. Accessory bellows and extension tubes come with charts for this purpose, or you can calculate the new exposure yourself. Whichever method you use, it's a good idea to bracket your exposures. First make the exposure you think is correct, then make one or two more with increased exposure.

You don't have to do any calculating if your camera has a through-the-lens meter that reads the light that actually reaches the film, as many single-lens reflex cameras do. If the object is magnified enough to fill the viewing screen (or that part of the screen that shows the area being read), the meter will calculate a corrected exposure by itself.

If you are using a hand-held meter, there are several ways to find the exposure increase. One way is to use the dial of the meter, as shown in the diagrams

9/Special Techniques

202

at right. This is easier on a meter with movable dials rather than one with only digital readout.

If you want to do the arithmetic yourself, have the bellows extension (or extension tube length) and the lens focal length in the same units of measure either inches, centimeters, or millimeters (1 inch = 2.5 cm = 25 mm).

indicated f-stop	bellows extension		
adjusted f-stop	focal length of lens		

Meter the subject and choose an f-stop and shutter-speed combination. If the f-number indicated by the meter is f/16 at $\frac{1}{8}$ sec, the focal length of the lens is 2 inches, and the distance from the lens diaphragm to the film plane measures 10 inches, then:

$$\frac{16}{x} = \frac{10}{2}$$
 10x = 32 x = 3.2

The new exposure combination is f/3.2 (slightly larger than f/4) at the original shutter speed. Set f/3.2 opposite the shutter speed on the meter dial to read off equivalent combinations.

You can also calculate a bellows extension factor that tells how many times the exposure must be increased.

factor =
$$\frac{\text{bellows extension}^2}{\text{focal length}^2}$$

factor = $\frac{10^2}{2^2} = \frac{100}{4} = 25$

Increase the exposure about 25 times (about $4\frac{1}{2}$ stops).

Very long exposures also require additional exposure. You will need to compensate for reciprocity effect if your final shutter speed is longer than about 1 second (see page 122).

exposure increase for a close-up

For close-ups, you need to increase the exposure because the lens is farther than normal from the film and produces a dimmer-than-normal image. If you are using a hand-held meter, measure the bellows extension (or extension tube length), the distance from the rear of the lens to the film.

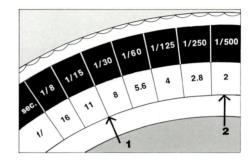

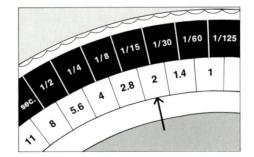

Meter the subject and calculate an exposure as you normally would. Now find two numbers on the f-stop scale on the meter dial to stand for (1) the bellows extension measured above and (2) the focal length of the lens. Have both measurements either in inches or in metric units (1 inch = 2.5 cm = 25 mm). Here the bellows extension was 10 inches (25 cm), and the focal length of the lens was 2 inches (5 cm).

Move the number on the f-stop scale that stands for the focal length to the position occupied by the number that stands for the bellows extension. Read off the new f-stop and shutterspeed combinations. If your meter has digital readout instead of movable dials, you can usually find a way to shift the f-stop setting, although probably not as readily as on a meter with dials.

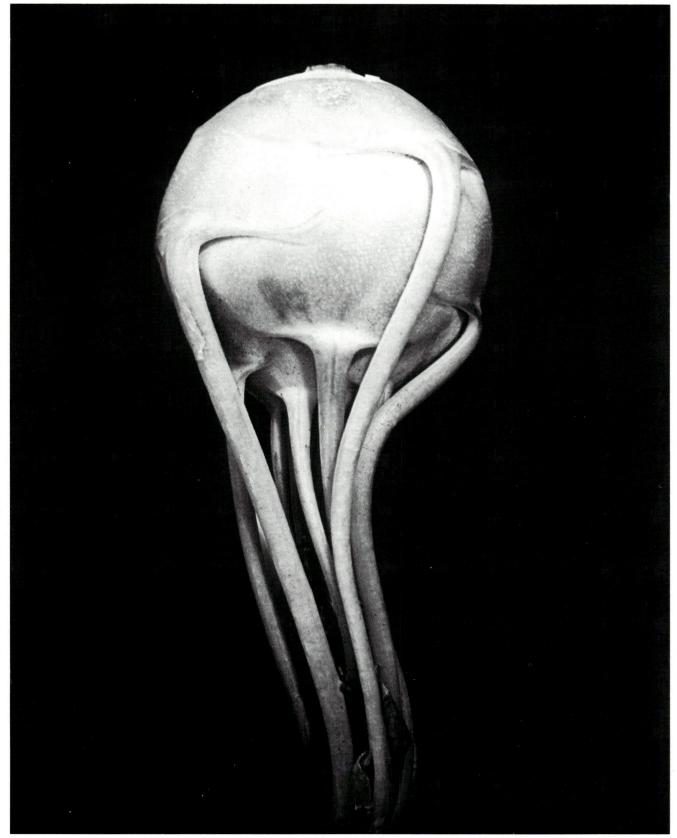

A kohlrabi is a prosaic root vegetable, but in this close-up Ralph Weiss has shown it in an uncommon way. Isolating it against black separates it and causes the viewer to examine its shape in detail. There are no visual clues to its actual size (though the caption will tell you), and it is shown upside down from the way it grows: the photograph presents it as a visual experience rather than as something to eat. It becomes a sea creature, with trailing tentacles undulating through dark waters.

RALPH WEISS: Kohlrabi, 1966; magnified 0.6 \times , here enlarged to 3.4 \times

Copying Techniques

Copying an old family portrait, for example, or some other flat object such as a painting or book page requires more than just casually snapping the picture. You will encounter many of the same technical concerns that you do with close-up photography—the need for considerable enlargement if your original is small, the need for camera support, and so on. Plus, you need to align the camera squarely and provide an even, shadowless lighting. The techniques are not difficult but do demand some attention to detail.

The **film** to use depends on whether the copy (the term for the original material that you want to reproduce) is continuous tone or line copy. Blackand-white **continuous-tone copy** has black, white, and gray tones. Ordinary photographs, pencil drawings, and paintings are examples. Fine-grain, panchromatic film is best for black-andwhite reproductions.

Black-and-white **line copy** has no gray tones, only black tones and white ones (*like* Little Red Riding Hood, *opposite*). Ink drawings, charts, and blackand-white reproductions in books are examples. The clean whites and crisp blacks of line copy are most easily reproduced using high-contrast lith film like Kodak Kodalith. If high-contrast film is not available, use ordinary blackand-white film processed for higherthan-normal contrast: underexpose the film by one stop, develop the film for 1½ times the normal development time, then print on contrasty paper.

If you want a color reproduction, select film balanced for your light source. Use tungsten film for ordinary tungsten lights, Type A film for 3400K photolamps (or tungsten film with an 81A filter on the camera lens), daylight film for daylight or flash.

Equipment needed for copying includes a camera, a steady support for it,

a means to hold the copy in place, and lighting. A camera with through-thelens viewing is best because it lets you accurately position the copy and check for glare and reflections. A 35mm or medium-format single-lens reflex is fine for most work. Use a view camera, which produces a 4 \times 5-inch or larger negative, when you want maximum detail. With an SLR, if the copy is small, you will need to use extension tubes, bellows, or a macro lens to enlarge the image enough to fill the film format. A view camera has its bellows built in. It is usually preferable not to use supplementary close-up lenses; they often display aberrations that are more noticeable in copy work than with ordinary close-ups.

A steady support for the camera, either on a tripod or copy stand, provides stability during preparation and exposure. Even a slight amount of camera motion creates unsatisfactory softness in copy work. A cable release to trigger the shutter prevents camera motion at the moment of exposure.

The copy and the camera must be exactly parallel to each other, otherwise your reproduction will be distorted. A copy stand (this page, top) holds the copy horizontally; once the camera is attached and leveled, it can be moved up and down the central column while the film plane of the camera remains parallel to the copy. Oversize objects can be hung on a wall (this page, bottom). Mount the copy flat against the wall. Move the camera close to the wall and adjust the tripod height so the lens is lined up with the center of the copy, then move the camera straight back from the wall. A view camera often has lines on the ground-glass viewing screen that let you check the squareness of the image's alignment. Some 35mm cameras let you replace the normal viewing screen with one that has

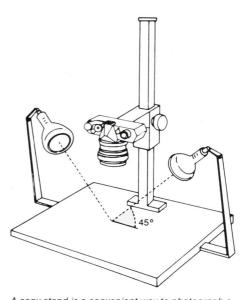

A copy stand is a convenient way to photograph a small object like a book or small print, which is placed flat on the baseboard. The camera mounts on the central column and can be moved up or down to adjust the framing of the image. Sometimes lights are attached to the sides to provide illumination at an angle to the baseboard.

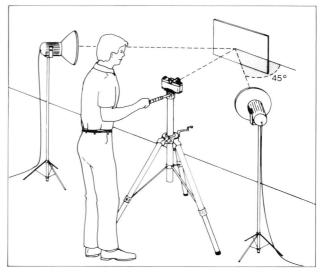

Wall mounting can be used for a larger item, such as a painting. The object to be copied is hung on the wall. The camera is positioned on a tripod squarely in front of the object. Lights on each side are at a 45° angle to the wall.

Line copy, such as an engraving (above), blackand-white book page, or ink drawing, has only black tones and white tones, no grays. Highcontrast lith film produces the best reproduction of it. A continuous-tone original, such as an ordinary black-and-white photograph or a pencil drawing, has a range of gray tones, as well as black and white, and should be copied on finegrain, general-purpose film.

If the object being copied is behind glass, you may see a reflection of your camera in the image. Eliminate the reflection by shielding the camera behind a large black card or cloth with a hole cut in it for the lens.

etched lines, or you can use the edges of the finder frame to check the alignment.

Your goal for lighting should be even, shadowless light over the entire surface of the copy. Although it is possible to use existing daylight if you have a bright area of diffused light to work in, it is usually more practical to set up lights. Position two identical lights, one on each side of the copy at about a 45° angle to it, aimed so the lighting overlaps at the center of the copy. Continuous light sources, such as photofloods, are easier to use than flash to judge the effect of the lighting. Ideally, the lights should be the same age because light output can weaken or change color as a bulb ages.

To check the evenness of the illumination, meter the four corners and the middle of the copy. With black-andwhite or color negative film, there should be no more than $\frac{1}{2}$ stop difference in any area, even less with color slides. You can use an incidentlight meter (held close to the copy and pointed toward the camera). Or you can use a reflected-light meter (pointed toward the copy). Take reflected-light readings from a gray card (*page 121*) and not from the copy itself so that the tones of the copy do not affect the readings.

You may need to place a piece of glass over your copy to hold it flat. If you do or if the copy itself is shiny, you may have to adjust the position of the lights so that you do not get light reflecting off the copy directly into the lens. A polarizing filter on the camera lens will eliminate most such reflections. In some cases, you may need to use polarizing screens on the lights plus a polarizing filter on the lens. You will also need to check for reflections of the camera itself in the glass. If you see them, hide the camera behind a piece of black card or cloth with a hole cut in it for the lens (*opposite, bottom*). Always look through the lens when checking for light or camera reflections. Even if you are right beside the camera, you may not see them.

Now that the copy is flat, the camera is square, the lighting is even, and you don't have any reflections of the lights or the camera, you are almost ready to make an **exposure**. Meter the copy using an incident-light meter, or a reflected-light meter and a gray card. Select a medium aperture. Depth of field is very shallow if your focusing distance is close, and a medium aperture provides enough depth of field to allow for slight focusing error. Also, you will get a sharper image at a medium aperture than at the lens's smallest one.

Once you have the basic reading, you will need to increase it if you are using extension tubes or bellows that extend the lens farther than normal from the film (see page 202). You also need to increase the exposure if you are using a polarizing filter (1¹/₃ stops). Is your exposure longer than 1 second? If so, another increase is neededfor reciprocity effect (see page 122). A reflected-light meter that is built into the camera and reads through the lens has the advantage of directly adjusting for everything but the reciprocity effect. If you are using an automatic camera, be sure that it is set to its manual exposure mode, and that you set the f-stop and shutter speed yourself.

Finally, once you have made the exposure, protect yourself by bracketing additional exposures: one stop more and one stop less with black-and-white film, one-half stop more and less with color film. If possible, leave your camera and the copy set up and develop a test exposure so you can reshoot, if needed, with minimum effort.

Special Printing Techniques A Photogram: A Cameraless Picture

A **photogram** is a kind of contact print, made by placing objects, instead of just a negative, on a piece of light-sensitive material and exposing it to light. In the 1920s, about 80 years after the first camera photographs were made, photograms and other print manipulations such as solarization became popular with the painter-photographers Man Ray and László Moholy-Nagy, who sought to explore the "pure" actions of light in space. In Man Ray's Rayograph (as he named his photograms) at right, he used the Surrealist technique of combining unrelated objects.

Any object that comes between the light source and the sensitized material can be used. You can try two-dimensional objects like cut paper, threedimensional ones, opaque objects that block the light completely, transparent or translucent objects like a pitcher or a plastic bottle that bend the light rays, objects laid on glass and held at different levels above the paper, moving objects, smoke blown over the surface of the paper during the exposurethe possibilities are limitless. All these objects are light modulators-they change the light on its way to the paper. Light can be added to the paper as well as held back: for example, a penlight flashed at the paper or suspended from a string and swung across the surface.

A photogram can be made on a piece of printing paper or on a negative that is then printed. Color photograms can be made by exposing color paper through different color filters or by using translucent, tinted objects to modulate the light.

MAN RAY: Rayograph, 1924

▲ Ordinarily a photographer uses a camera to select and frame a portion of an existing scene. But in a photogram, objects are arranged directly on lightsensitive material. The objects are transformed in shape or tonality and the photograph does not show them as they ordinarily look. The objects that are used are less important than what you see when you look at the picture.

Here a simple photogram is being made by placing a piece of marsh grass on a sheet of high contrast (grade 5) printing paper. The head of the enlarger is positioned far enough above the baseboard to light the paper completely. After exposure, the paper is developed, fixed, and washed in the usual manner to produce a life-size print of the grass. Experiment with different exposures longer ones will penetrate some objects more and create a different effect.

You can combine several layers to make a photogram or use just one. Jack Sal sandwiched together a matzo cracker and a piece of studio proof paper, a very slow printing-out paper that darkens on exposure to sunlight. He put the two in his window for about a month, then fixed the paper like an ordinary print to prevent further darkening. The holes in the cracker appear large because during the day the sun changed position in the sky and shone into the holes from different angles. Studio proof paper is no longer made, but the effect could be simulated by an ordinary printing paper with a much shorter exposure.

Man Ray arranged string, a toy gyroscope, and the end of a strip of movie film on a piece of photographic paper, then exposed the paper to light. The resulting image (opposite) is as open to interpretation as you wish to make it. You can see it simply as an assemblage of forms and tones. Or if you see the large black background as a person's head in silhouette (like the silhouetted head in the movie film), then the strip of film might be a dream seen by the internal gyroscope of the brain.

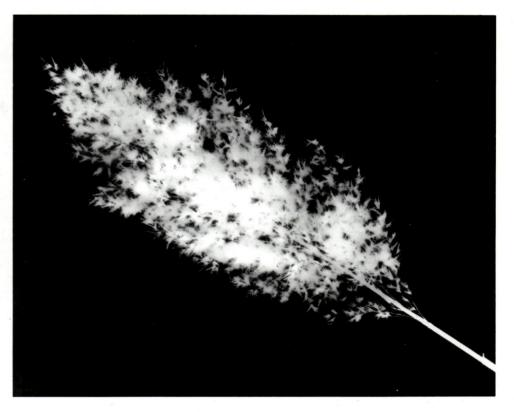

JACK SAL: No Title, 1978

A Sabattier Print—Part Positive, Part Negative

A **Sabattier print** is made by reexposing the paper to light during processing. This gives a print both negative and positive qualities and adds halolike Mackie lines between adjacent highlight and shadow areas (*see opposite*). The technique is commonly known as solarization, although, strictly speaking, **solarization** (which can look somewhat similar) takes place only when film is massively overexposed. The correct name for the phenomenon shown here is the Sabattier effect.

The unusual appearance of a Sabattier print results from a combination of effects. When the print is reexposed to light during processing, there is little effect on the dark areas of the print because most of the crystals there have already been exposed and reduced to black silver by the developing process. The bright areas, however, still contain many sensitive crystals that can respond to light and development. The bright areas therefore turn gray but usually remain somewhat lighter than the shadows. Between the light and dark areas, by-products remaining from the first development retard further development; these border regions remain light, forming the Mackie lines.

There are several ways to produce a Sabattier print. The simplest way, but the most difficult to control, is simply to turn on a light briefly while the print is in the developer. A procedure that gives much more control is described in the box at right.

Printing from a negative will give a positive image plus negative effects from the second exposure, as in the print opposite. You can also print from a positive color slide, which will give a negative image plus some positive effects. Black-and-white printing paper responds differently to colors in the slide: blue prints as black, yellow prints as white.

Making a Sabattier Print

Basic procedure

Materials needed. A negative of normal to high contrast. Normal print processing chemicals. High-contrast paper (prints opposite were made with Agfa Brovira grade 6; other high-contrast papers such as Kodabromide grade 5 also work).

First exposure. Put negative in enlarger and focus. Expose a test print with a slightly lighter than normal series of test exposures. (Test print opposite left, received first exposures of 5, 10, 15, and 20 sec.)

First development. Develop for the standard time in normal developer.

Rinse. Wash in water for 30 sec to remove the surface developer. Do not use an acid stop bath. Remove excess water from the front and back of the print with a squeegee or soft paper towels. Handle gently to avoid scratching the fragile surface of the wet print.

Second exposure. Remove the negative from the enlarger. Stop down the aperture about two stops. Reexpose the test print in strips at right angles to the first exposures. (Test print, opposite left, was given second exposures of 5, 10, 15, and 20 sec.)

Second development. Develop for the standard time in normal developer.

Finish processing. Treat print with stop bath and fixer; wash and dry as usual.

Final print. Examine the test print and choose the square that gives the desired effect. Note the combination of exposure times, apertures, and development times. Make a print under these conditions.

Set the enlarger slightly out of focus. This will broaden the Mackie lines without making the image noticeably out of focus. The Mackie lines will also be broader with a less contrasty negative. Develop for less than the standard time. Remove the print quickly from the developer when the desired effect is visible. Develop in a more dilute developer (if the normal dilution is 1:2, try 1:4, 1:10, or even greater dilutions to produce color shifts). Develop in two different developers. A cold-tone developer for one development and a warm-tone

Variations

Some photographers report better results if the print is aged at this point in a dark place (a photo blotter book works well). Aging times vary from 15 min to a week.

developer for the other will give color shifts.

See variations under first development.

Dodging or burning in during the first and/or second exposure will give different results. The Mackie lines can be lightened by bleaching. The reducing formula given by Ansel Adams in his book The Print is recommended. You can also try local reduction or an overall immersion in Farmer's Reducer (diluted 1:10).

This test for a Sabattier print was given first exposures of 5, 10, 15, and 20 sec (left to right). After a first development, the print was exposed again to light from the enlarger, but without the negative in place. The second exposures were 5, 10, 15, and 20 sec (bottom to top). The test was then developed again, fixed, and washed.

The exposures for the final print were chosen from the test print at left: a first exposure of 20 sec and a second exposure of 5 sec (the bottom right square of the test). The enlarger was deliberately set very slightly out of focus to broaden the Mackie lines, and the print was later bleached to lighten them.

Techniques Using High-Contrast Film

High-contrast materials can change a black-and-white picture in many ways. The pictures on the following pages show methods of using high-contrast materials to change the conventional portrait at right into a high-contrast print, a line sketch, a posterlike patchwork of grays, and finally color versions.

To start, the original negative is enlarged onto lith film, a high-contrast copying film sold under different trade names (Kodak Ultratec or Kodalith, Agfa Agfalith) for use in photo-offset printing. One of its properties is that it converts the range of tones in an ordinary image into solid black and pure white. This produces a dropout, an image with only black or white areas and no intermediate gray tones. Lith film enables the graphic artist or photographer to change any continuoustone picture, made on ordinary film, into a pattern of black and white. And by altering the exposure time in the copying process, you can produce images with differing amounts of blackeven to the extreme of a practically solid black image pierced only by the brightest highlights.

Because lith film produces blackand-white transparencies, several can be superimposed in printing to achieve a range of effects. Lith film lends itself to various color-printing techniques, including the use of color printing paper. Step-by-step demonstrations of techniques using these materials appear on the following pages.

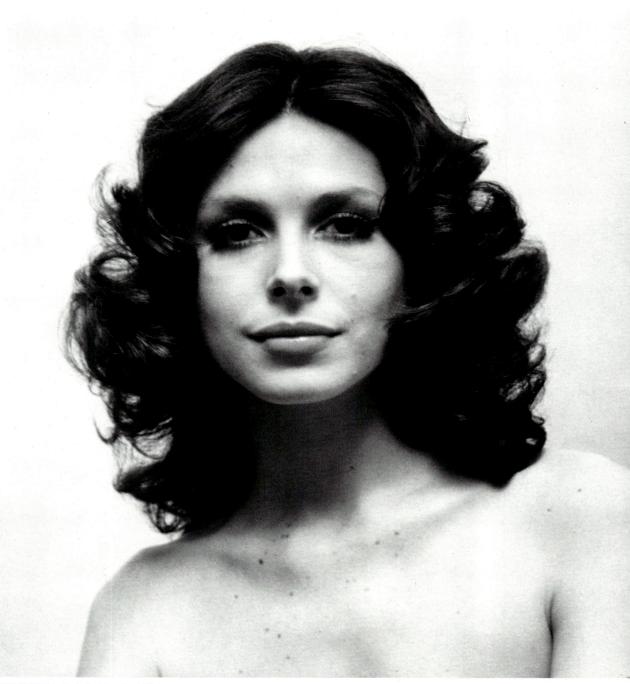

FRED BURRELL: Portrait of Ann Ford, 1971

To start off the printing processes shown on these pages, place the original negative within the enlarger's negative carrier, ready to be inserted in the enlarger for reproduction on high-contrast graphic arts (lith) film such as Kodalith Ortho Film 2556, Type 3. If the manufacturer describes the film as ortho or orthochromatic, it can be processed under red safelight; you will be able to see what you are doing and how the film is developing. Check the instructions.

The negative, projected onto the easel on the baseboard, is enlarged to fill an 8×10 sheet of film. The first reproduction will be a positive transparency and from that a negative will be contact printed. Try an exposure time of between 10 and 20 sec with the enlarger lens wide open; make a test strip to check the effects of different exposures—slight increases in exposure extend the dark areas.

Process like a conventional photographic film but use a developer designed for lith film. Check the instruction sheet for development time—with Kodalith Developer it is about $2^{3}/_{4}$ min at 68° F (20° C) with constant agitation. Agitate in fresh stop-bath solution for about 10 sec. Then agitate in fresh fixer for about 4 min. Wash for 10 min in running water at 65° – 70° F (18° – 21° C).

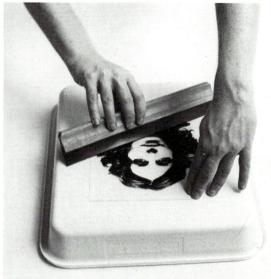

To prevent water spots or streaks, gently draw a squeegee or sponge across each side of the wet positive—placed on the bottom of an upturned tray—to wipe off most of the water. Or treat in a wetting solution. Then hang the positive up to dry, after which a high-contrast negative can be made from it (following pages).

Techniques Using High-Contrast Film: continued

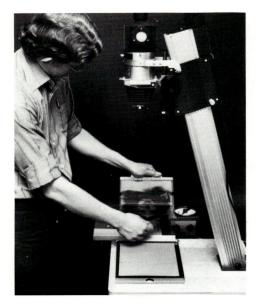

A negative can be produced from a positive transparency by using standard contact printing techniques (pages 160–163). First make sure the enlarger head is raised enough so the light will cover the contact frame. Then (above) clip the positive to the glass cover of a printing frame, emulsion side away from the glass. Insert, emulsion side up, an unexposed sheet of high-contrast copying film.

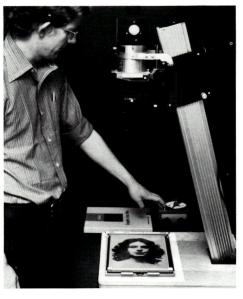

Try an exposure between 5 and 10 sec with the aperture wide open; a test strip will give an exact exposure. You may find in comparing the highcontrast positive to the high-contrast negative that the negative has dropped out more tones than the positive. If so, you can contact the negative onto another sheet of high-contrast film to make a positive that is an exact opposite of the negative: you'll need the positive if you want to make a line print.

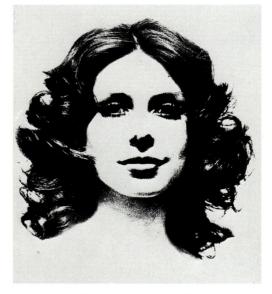

Above are the high-contrast positive and negative transparencies, ready for use in the printing processes demonstrated on the following pages. They have no middle-gray tones, only black and white.

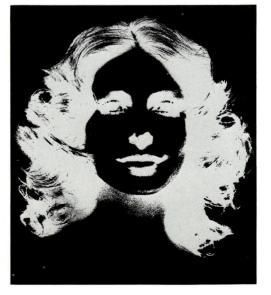

A Line Print

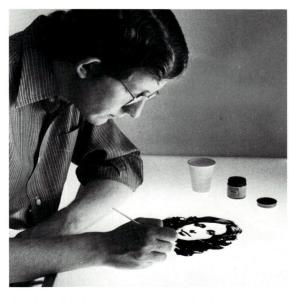

Check for pinholes—clear specks caused by dust on the film or by underexposure. Paint them out with a fine brush dipped in a gooey blocking-out material called opaque. Large areas can also be painted out, if desired. Black specks or large black areas can be removed with a strong solution of Farmer's Reducer, a chemical bleaching agent. A weak solution of Farmer's Reducer removes yellow processing stains.

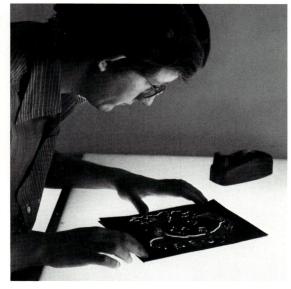

To make a line print—an image composed of dark lines on a white background or white lines on a dark background—place the positive and negative over a light and carefully align them so that the two images overlap exactly. The result, looked at straight on, will be solid black. However, light can pass through the two copies at an angle, along the outlines of the paired images. Tape the copies together.

Put the sandwich into a printing frame with an unexposed sheet of film. A lazy Susan or a turntable rotates the frame so that light can come in from all sides at an angle. The light source shown is a 100-watt frosted bulb placed at a 45° angle 3 ft above a rotating turntable for a 15-sec exposure. You could also rotate the printing frame by hand under an enlarger.

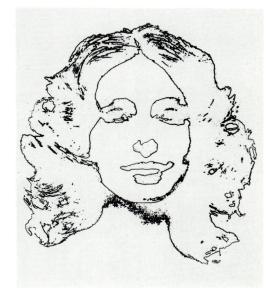

The line picture, a thin black outline of the subject on clear film, resembles a pen-and-ink sketch. A thin sheet of acetate or of unexposed, fully processed film between the negative and positive would have made thicker lines. The line picture can be copied directly onto another sheet of high-contrast film to make a clear-line-on-black-background transparency. Either image can be printed on printing paper to make an opaque, white or black image.

A Posterization

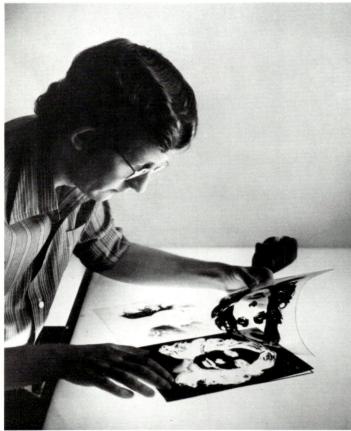

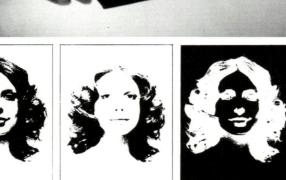

The two positive images above were produced on high-contrast film from the same negative (right). The first, which has more dark area than the second, simply received more exposure.

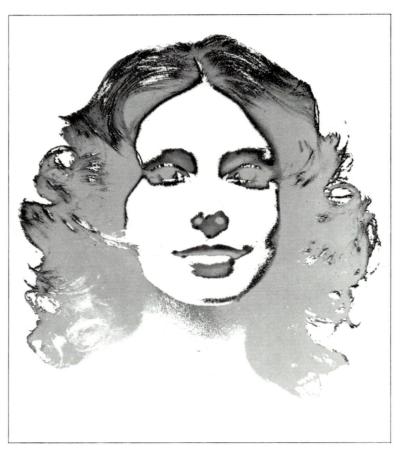

Posterization gives an image with tones that look like the flat shades of poster paints. The image above was made from the three high-contrast copies at left: two positives plus a negative, each having different dark areas. The three were carefully aligned, then fastened with tape hinges (above left) so that each positive could be laid over or lifted away from the negative. The negative at the bottom of this stack was then taped on two sides to the enlarger baseboard. Printing paper was slipped under the untaped sides, and a piece of glass held all the sheets flat.

Three exposures were made. The first exposure, for 60 sec, was through all three copies and gave the black tones of the final print. Then the darker positive was flipped back, and an exposure of 1 sec was made through the lighter positive and the negative so as to start the dark-gray tone. An exposure of 1 sec through the negative alone produced the light gray and completed the dark gray. The exposures were determined by test strips.

The starting point for the color posterization shown above is much the same as for the blackand-white examples on the opposite page (highcontrast copies, one negative and two positives of unequal dark areas), but the line image shown on page 213 is also used. The color is introduced by filtering the light from the enlarger so it shines colored light through the copies onto a sheet of color printing paper.

For this posterization, the line print and the lighter positive were used for an exposure with a blue filter, to get yellow. The darker positive was added next and three exposures were made, through red, green, and blue filters, for 3, 5, and 6 sec, respectively. The resulting color, mixed with the yellow, gave the russet hue. The final exposure, with the negative copy added, was through a red filter and produced cyan, which gave the greenish cast that is most visible in the features of the face.

Using Special Techniques

Starry Night III. 1975. Cyanotype with watercolors and applied stars

Blue Sky Variation and Erased, 1977. Vandyke print with pencil and watercolors

BETTY HAHN

Taos Sky, 1979. Lithograph

Starry Night Variation #2, 1977. Silkscreen

As a starting point for work that incorporates various printing processes, hand coloring, and other techniques, Betty Hahn used a publicity photograph of those mythic heroes the Lone Ranger and Tonto. The cyanotype and Vandyke processes, photographic printing processes invented in the 19th century, utilize light-sensitive iron salts to form the image. The lithograph and silk screen are traditional fine-art printmaking processes.

Each print is enjoyable in its own right, but when the versions are placed together, the eye jumps back and forth among them, comparing skies, colors, and other traces of the artist's intervention in the original photograph. A bonus is the cactus growing out of the Lone Ranger's head.

Digital Image Processing

TODD WALKER: Agave, Digitized, 1983. Lithograph

Digital image processing has become a major force in publishing and advertising, and it is now being used for some personal photography as well. In digitizing, a computer scans an image and reduces it to pixels (picture elements), tiny squares that are digitally coded for position, intensity, and color. The computer can alter a digitized image in any number of ways: it can change colors, change the position of all or part of an object; remove, add, or combine objects; increase or decrease contrast and blur.

At right, Todd Walker combined a digitized and photographic image in the same print. For many years, Walker has used media such as lithography and silkscreen to alter the color, tonality, and other characteristics of photographic images. Digitizing is merely one more tool that he can use to manipulate and reassemble images. "Some of the observations I make of this world seem important enough to pass along," he says, "more important than the reality from which they are extracted." Two other digitized images appear on pages 394 and 395.

An enlarged view of the pixels.

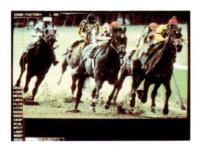

Multiple Imagery

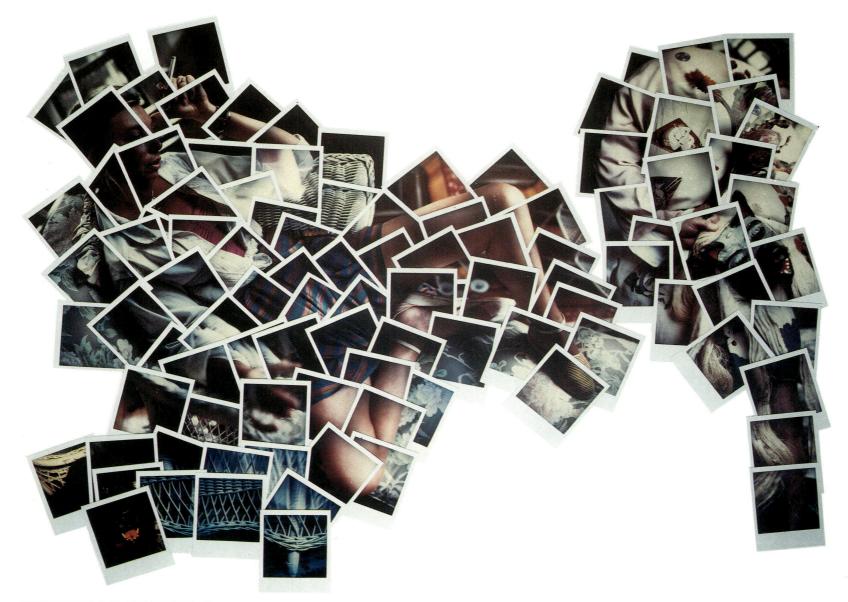

JOYCE NEIMANAS: Untitled #15, 1982. SX-70 collage

There are many ways to make a multiple image, such as exposing film in the camera two or more times, making multiple exposures in the darkroom (see opposite), or collaging prints. Above, Joyce Niemanas collaged numerous Polaroid SX-70 photographs. Each Polaroid image is a realistic fragment, but the assemblage fractures the reality of the scene into a complex and richly textured pattern.

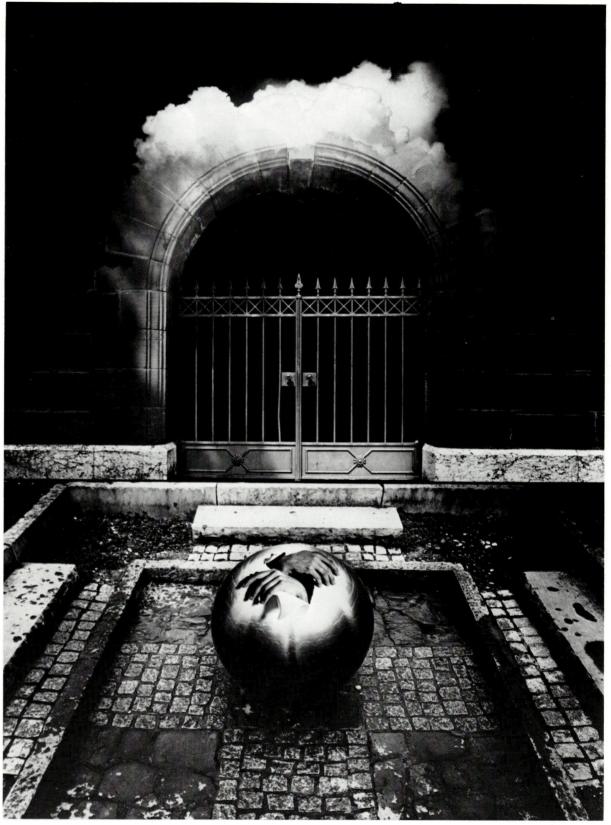

JERRY N. UELSMANN: Untitled, 1983

Jerry Uelsmann's negatives are only the starting point for his prints. In the darkroom he prints various combinations of different negatives, experimenting and making discoveries as he goes. He may block out part of a scene, print in part of another one, and generally merge objects that do not seem to belong together into the same image. The result is a universe of real-looking but impossible dreamscapes.

MICHAEL SKOTT: Ratatouille, 1987

10 Color

JOE POLIVKA: Pears with Chocolate Sauce, 1981

A realistic or at least pleasing color balance is important in food photography, where the intention is usually to appeal to the appetite by way of the eye. Stylists are often used in food photography to prepare the food, usually in multiple, so the photographer always has a fresh dish to shoot. Lighting, focus, composition, and non-wilting items are arranged before the food is ready, using a mock-up of the main dish. An image-perishable dish is the last thing to hit the set. Timing, coordination, and teamwork are critical, because the ideal is to photograph the food as soon as possible after it is done, before it melts, congeals, dries up, bleeds water, or otherwise visually deteriorates.

Left, every crumb was carefully arranged in this complex setting to illustrate a recipe for ratatouille (an eggplant, zucchini, and tomato stew). Above, the curving shapes and warm color of the pears are the main attraction. Color: Additive or Subtractive 222 **Color Photographs: Three Image Layers** 224 Choosing a Color Film 225 Color Balance 226 Matching Film to the Light Source 226 Filters to Balance Color 228 Color Casts 230 Color Changes Throughout the Day 232 Shifted Colors from Reciprocity Effect 235 Exposure Latitude: How Much Can Exposures Vary? 236 Processing Your Own Color 238 Making a Color Print from a Negative 240 Materials Needed 240 Exposing a Test Print 242 **Processing 244** Judging Density in a Print Made from a Negative 247 Judging Color Balance in a Print Made from a Negative 248 More About Color Balance/Print Finishing 250 Making a Color Print from a Transparency 252 Judging a Print Made from a Transparency 254 Instant Color Film 256

Color film takes advantage of the fact that any color can be produced by mixing only a few basic or primary colors. Color film is made with three color-sensitive layers, each of which records the wavelengths of light in a different third of the spectrum. When the three layers are combined, they form a full-color image of the original scene.

This sensitivity to color, which makes color photography possible, can sometimes produce unexpected results. The human eye tends to ignore slight shifts in color balance, but film can only record colors at a given moment. Consequently, color photographs may appear to be more reddish or bluish than seems natural, or flesh tones in a photograph can take on an unappealing color cast from nearby objects, such as light reflected from green leaves. The colors were probably there to begin with but are easy to ignore if you don't know what to look for. This chapter deals in depth with how to control color balance both when film is exposed and later during printing.

Color: Additive or Subtractive

There are two ways to create colors in a photograph. One method, called additive, starts with three basic colors and adds them together to produce some other color. The second method, called subtractive, starts with white light (a mixture of all colors in the spectrum) and, by taking away some colors, leaves the one desired.

In **additive** mixing (*right*), the basic or primary colors are red, green, and blue lights (each providing about one-third of the wavelengths in the total spectrum). Mixed in varying proportions, they can produce all colors—and the sum of all three primaries is white.

In the **subtractive** method (*opposite page*), the primaries are cyan (a bluish green), magenta (a purplish pink), and yellow, the pigments or dyes that absorb red, green, and blue wavelengths, thus subtracting them from white light. These dye colors are the complementary colors to the three additive primaries of red, green, and blue. Properly combined, the subtractive primaries can absorb all colors of light, producing black. But, mixed in varying proportions, they too can produce any color in the spectrum.

Whether a particular color is obtained by adding colored lights together or by subtracting some light from the total spectrum, the result looks the same to the eye. The additive process was employed for early color photography. But the subtractive method, while requiring complex chemical techniques, has turned out to be more practical and is the basis of all modern color films.

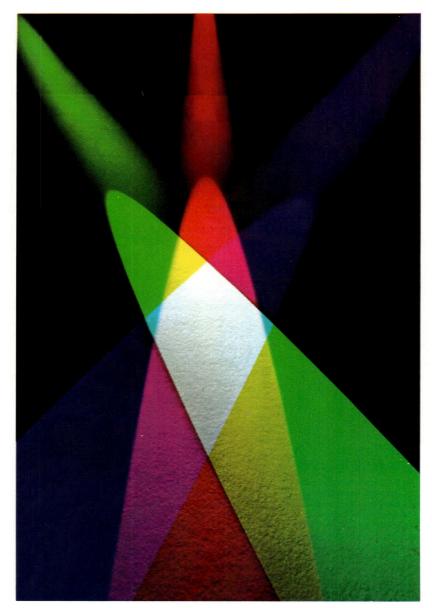

In the additive method, separate colored lights combine to produce various other colors. The three additive primary colors are green, red, and blue. Green and red light mix to produce yellow; red and blue light mix to produce magenta; green and blue mix to produce cyan. When equal parts of all three of these primary-colored beams of light overlap, the mixture appears white to the eye. A color television produces its color by the additive system. The picture tube consists of green, red, and blue phosphors that can be mixed in various combinations to produce any color, including white.

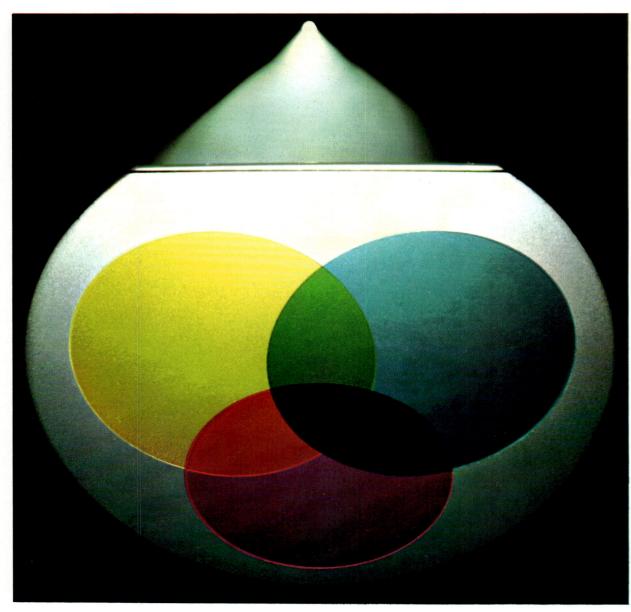

cyan filter blocks red

magenta filter blocks green

yellow filter blocks blue

White light is a mixture of all wavelengths. In the subtractive process, colors are produced when a dye (as in paint or color photographic materials) absorbs some wavelengths and so passes on only part of the spectrum. Above, the three subtractive primaries—yellow, cyan, and magenta—are seen placed over a source of white light. Where two overlap, they pass red, green, and blue light. Where all three overlap, all wavelengths are blocked. At right, each subtractive primary transmits two-thirds of the spectrum and blocks onethird. Notice that the color often called blue is named cyan.

Color Photographs: Three Image Layers

A color photograph begins as three superimposed black-and-white negatives. Color film consists of three layers of emulsion, each layer basically the same as in black-and-white film but responding to only one-third of the spectrum. The top layer is sensitive to blue light, the middle layer to green light, and the bottom layer to red light. When this film is exposed to light and then developed, the result is a multilayered black-andwhite negative.

The developer converts the light-sensitive silver halide compounds in the layers of emulsion to metallic silver. As it does so, the developer oxidizes and combines with dye couplers that are either built into the layers of emulsion or added during development. Three dye colors are formed-the subtractive primary colors of yellow, magenta, and cyan-one in each emulsion layer. The blue-sensitive layer of the film forms a yellow image, the green layer forms a magenta image, and the red layer forms a cyan image. A bleach then removes all the silver, and each layer is left with only a color image. This basic process is used in the production of color negatives, positive color transparencies (slides), and color prints (see illustrations, right).

Color film consists of three layers of emulsion, each sensitive to blue, green, or red (as diagrammed above by color dots over a film cross section). During exposure, light of each color of the moth shown above produces an invisible latent image on the emulsion layer or layers sensitive to it. Where the moth is black, no emulsion is exposed; where it is white, all three layers are exposed equally. This results in three superimposed latent images.

During development of the film, each latent image is converted into a metallic silver negative image. Thus, three separate negative images indicate by the density of the silver they contain the amount of each primary color in the moth. The images are shown separately here but are, of course, superimposed on the film. color negative

color transparency or print

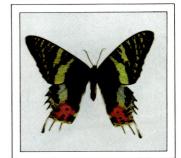

Choosing a Color Film

When exposed color negative film is developed, a colored dye is combined with each black-andwhite negative image. The dyes are cyan, magenta, and yellow—the complements of red, green, and blue. The silver images are then bleached out, leaving three layers of superimposed negative dye images (shown separately here). The color negative also has an overall orange color or "mask" (opposite, top) to compensate for color distortions that would otherwise occur in printing.

The positive color image of a transparency or slide is created in exposed film by a reversal process. After a first development, the emulsion is either exposed a second time to light or is treated with a chemical that produces the same effect. Silver is deposited by a second development to form blackand-white positive images in the emulsion. Dyes then combine with the metallic silver positive images to form three superimposed positive color images. In each layer the dye produced is the complement of the color of the light that was recorded there-yellow dye is formed in the bluesensitive layer, magenta in the green-sensitive layer, and cyan in the red-sensitive layer. The black-and-white silver images are then bleached out, leaving the positive color images in each layer (shown separately here).

To make a positive print from a negative, light is passed through a color negative onto paper containing three emulsion layers like those in film. Developing the paper produces three superimposed positive images of dye plus silver. The silver is then bleached out of the print leaving the final color image. In reversal printing, light is passed through a positive color transparency onto reversal paper; the result is a positive image. The look of **color films** is linked to film speed. Slower films appear sharper, have more saturated colors with a fuller range of tones, and have less apparent graininess. Faster films appear less sharp, with less color saturation and more apparent graininess. But even within the same speed range, different films produce different color balances. One film may have an overall warm reddish cast, while another may look slightly cooler and blue-green. It is useful to compare different films by exposing a roll of each to the same subject under identical conditions. This is particularly important with color slides because their tones cannot be manipulated after development as can a color negative when it is printed. Magazines such as *Popular Photography* and *Modern Photography* regularly feature such comparisons. The difference between films can be surprisingly large.

Color Film Characteristics

For characteristics such as format and film speed that are common to all films, see box, page 92.

Negative film. Produces an image that is the opposite in colors and density of the original scene. It is printed, usually onto paper, to make a positive color print. Color negative film often has "-color" in its name (Agfacolor, Kodacolor).

Reversal film. The film exposed in the camera is processed so that the negative image is reversed back to a positive transparency with the same colors and density of the scene. Positive transparencies can be projected or viewed directly and can also be printed onto reversal paper to make a positive print.

Color reversal film often has "-chrome" in its name (Ektachrome, Fujichrome), and professional photographers often refer to a color transparency, especially a large-format one, as a chrome. A slide is a transparency mounted in a cardboard holder so it can be inserted in a projector for viewing.

Professional films. The word "professional" in the name of a color film (Kodachrome 64 Professional Film) means that the film is designed for professional photographers, who often have exacting standards, especially for color balance, and who tend to buy film in large quantities, use it up quickly, and process it soon after exposure. Kodak manufactures its professional color films so that they are at optimum color balance when they reach the retailer, where—if the retailer is competent—the film will be refrigerated. Kodak makes its nonprofessional color films for a typical "amateur" or "consumer," who would be more likely to accept some variation in color balance, buy one to two rolls at a time, and keep a roll of film in the camera for days, weeks, or longer, making exposures intermittently. Thus Kodak nonprofessional color films do not have to be refrigerated unless room temperatures are high. In fact, they are manufactured to age to their optimum color balance sometime after they reach the retailer and after room-temperature storage.

Color balance. Daylight films produce the best results when exposed in the relatively bluish light of daylight or electronic flash. **Tungsten-balanced films** should be used in the relatively reddish light of incandescent bulbs. **Type A film** is made for the slightly different balance of 3400K tungsten photolamps. More about color balance on pages 226– 229.

Type S/Type L films. A few films are designed to produce the best results within certain ranges of exposure times, as well as with specific light sources. Type S films (S for "short"), such as Kodak Vericolor III Professional Film, Type S, are balanced for daylight or electronic flash at exposure times of 1/10 second or shorter. Type L films (L for "long"), such as Vericolor II Professional Film, Type L, are balanced for the warmer light of tungsten 3200K lamps and for exposure times of 1/50 second to 60 seconds.

Color Balance Matching Film to the Light Source

Color films sometimes record colors that the photographer did not see when the shot was made. Though the picture may look wrong, the film is not at fault. Although a white shirt looks white both outdoors in daylight and indoors in artificial light, light from ordinary tungsten bulbs has a different **color balance** more red wavelengths and fewer blue wavelengths—than daylight; thus the white shirt reflects more red light indoors than outdoors and has a golden cast. Color film records such subtle differences.

The balance of colors in light is measured as **color temperature** on the Kelvin scale. This scale is commonly used by physicists and serves as a standard comparative measure of wavelengths present in light (see chart, this page).

Different color films are made for different color temperatures. Daylight films are balanced for a 5500K light source, and so give good results with the relatively high color temperature of midday light, electronic flash, and blue flashbulbs. Indoor films are balanced for incandescent light sources of lower temperatures. Most indoor films are tungsten balanced-designed specifically for light of 3200K color temperature, but producing acceptable results in any tungsten light, such as ordinary light bulbs. A few (Type A) films have a slightly different balance for use with 3400K photolamps.

Color balance is more important with reversal films than with negative films. With a color reversal film, transparencies (such as slides) are made directly from the film that was in the camera, and they have a distinct color cast if the film was not shot in the light for which it was balanced or if it was not shot with a filter over the lens to balance the light (see opposite and page 228). With a color negative film, color balance can be adjusted when prints are made.

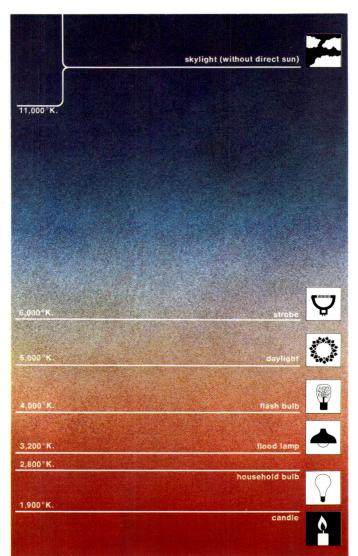

The chart above shows the approximate color temperatures of "white" light sources. The ordinary description of colors as warm or cool doesn't match their actual color temperature. Red is often called a warm color, but the color temperature of reddish light is low on the scale. Blue is called a cool color, but its color temperature is high on the scale. The pictures opposite illustrate how different types of color film record different colors when exposed to the same light. The top pictures were all taken in daylight (color temperature 5500K). Photographed with daylight film (left), the colors of the bus look normal. When shot with indoor (tungsten) film designed for 3200K (center), the bus takes on a heavy bluish cast. If a corrective 85B filter is used, however, the colors produced by the indoor film improve significantly (right).

The bottom pictures were all taken indoors in 3200K light. The bride looks normal when photographed with indoor film (left), but daylight film in the same light produces a yellowish cast (center). A corrective 80A filter produces a near-normal color rendition with the daylight film (right).

Since the filter blocks part of the light reaching the film, the exposure must be increased (about ²/₃ stop with an 85B filter, 2¹/₃ stops with an 80A filter). This can create inconveniently long exposures, so it is more efficient to use the correct type of film.

◄ 5500K daylight film

◀ 3400K Type A film◀ 3200K tungsten film

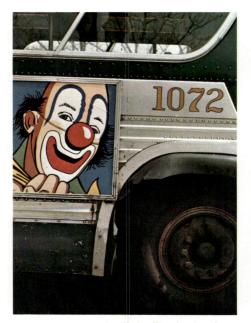

daylight film in daylight

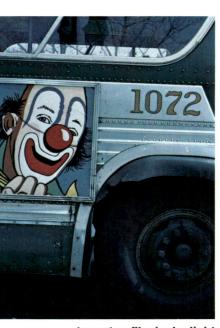

tungsten film in daylight

85B filter

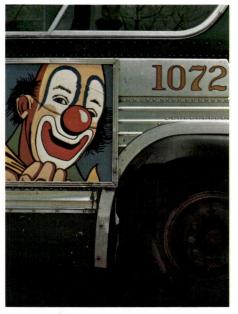

tungsten film in daylight with 85B filter

tungsten film in tungsten light

daylight film in tungsten light

daylight film in tungsten light with 80A filter

Filters to Balance Color

The penny arcade fortune-telling machine (left) was lighted mostly with fluorescent lights. The greenish cast in the picture is due to the concentration of green wavelengths in fluorescent lighting. A combination of pale filters—magenta (which absorbs greens) and blue (which absorbs reds and greens)—alters the light exposing the film so that the color image looks closer to normal (right). An FL (fluorescent) filter combines magenta and blue and improves the color balance for average scenes. It is difficult to give exact filter recommendations for fluorescent light because the color balance varies depending on the type of lamp, the manufacturer, how old the lamp is, and even voltage fluctuations.

color film in fluorescent light with FL filter

color film in fluorescent light

What happens if the color balance of light does not match the color balance of your film? Most color films are balanced to match the color temperatures of one of four possible light sources midday sunlight (or electronic flash) and two types of incandescent lamp. Any other lighting conditions may give an unusual color balance. Sometimes you may want this imbalance. If not, you can use **filters** to correct to a more standard color balance.

It is not unusual to encounter light

conditions that do not match the color balance of any film. For example, the light is reddish late in the day because the low-lying sun is filtered by the earth's atmosphere to a color temperature lower than 5500K. You may want to photograph this scene unfiltered to keep a reddish cast that looks like sunset.

In a picture of a field of snow having sunlit and shadowed areas, the shadows will be illuminated mainly by clear blue skylight of a very high color temperature. Shadowed snow comes out blue when photographed with ordinary daylight film. A pale "skylight" filter, designed to block some of the blue light, would reduce the bluish cast of the shadows as the film records it. Actually, if you look at a snowfield under such conditions, you can often see the bluish cast in the shadows—but ordinarily the brain adapts what the eye sees to what it expects the snow to look like.

A similar problem occurs when a light

number or designation	color or name	type of film	physical effect	practical use	increase in stops	factor
1A	skylight	daylight	Absorbs ultraviolet rays.	Eliminates ultraviolet that eye does not see but that film records as blue. Useful for snow, mountain, marine, and aerial scenes, on rainy or overcast days, in open shade.		
81A	yellow	daylight	Absorbs ultraviolet and blue rays.	Stronger than 1A filter. Reduces excessive blue in similar situations. Use with electronic flash if pictures are consistently too blue.	1/3	1.2
		tungsten		Corrects color balance when tungsten film is used with 3400K light sources.	1/3	1.2
82A	light blue	daylight	Absorbs red and yellow rays.	Reduces warm color cast of early morning and late afternoon light.	1/3	1.2
		Туре А		Corrects color balance when Type A film is used with 3200K light source.	1/3	1.2
80	blue	daylight	Absorbs red and yellow rays.	Stronger than 82A. Corrects color balance when daylight film is used with tungsten light. Use 80A with 3200K sources and with ordinary tungsten lights. Use 80B with 3400K sources.	2¼ (A) 2 (tungsten)	5 4
35	amber	Type A or tungsten	Absorbs blue rays.	Corrects color balance when indoor films are used outdoors. Use 85 filter with Type A film, 85B filter with tungsten film.	2⁄3	1.5
FL	fluorescent	daylight or tungsten	Absorbs blue and green rays.	Approximate correction for excessive blue-green cast of fluorescent lights. FL-D used with daylight film, FL-B with tungsten film.	1 2	
CC	color compensating			Used for precise color balancing. Filters come in various densities in each of six colors—red, green, blue, yellow, magenta, cyan (coded R, G, B, Y, M, C). Density indicated by numbers—CC10R, CC20R, etc.	Varies	
	polarizing	any	Absorbs polarized light (light waves traveling in certain planes relative to the filter).	Reduces reflections from nonmetallic surfaces, such as water or glass (<i>see page 106</i>). Penetrates haze by reducing reflections from atmospheric particles. The only filter that darkens a blue sky without affecting color balance overall.	11⁄3	2.5
ND	neutral density	any	Absorbs equal quan- tities of light from all parts of the spectrum.	Increases required exposure so camera can be set to wider aperture or slower shutter speed. Comes in densities from 0.10 ($\frac{1}{3}$ stop more exposure) to 1.00 ($\frac{3}{3}$ stops more exposure).	Varies with density	

Filters for Color Film

source does not emit a smooth distribution of colors across the spectrum but gives off concentrations of one or a few colors. Fluorescent lights are examples of this kind of discontinuous spectrum, having, in addition to other colors, large amounts of blues and greens. Although the brain compensates for such uneven distribution, there are no color films that do so. Filtration provides a partial correction (see illustrations, opposite).

It is particularly important to balance the light the way you want it when making color slides, because the film in the camera is the final product that will be projected for viewing. With color negative film used for color prints, exact balance is not so critical because corrections can be made during the printing process. Printing will be easier, though, with a properly balanced negative.

Some commonly used filters for color films are listed above; more detailed information is supplied by film and filter manufacturers. The color temperature is marked on photographic bulbs. Electronic flash units are more or less balanced for daylight films, although the light they emit may be somewhat bluish; a light yellow filter helps if flashlit pictures are often too blue. Color temperature meters are available if it is important to balance the light critically.

The examples opposite and on page 227 show the imbalance that occurs when films are not matched to the light. In each case, you can use a corrective filter to adjust the balance of the light.

Color Casts

Almost every photographer has, at one time or another, found that in a picture a subject has taken on the colors reflected by a nearby strongly colored surface, like a wall or drapery. The eye tends to see almost every scene as if it were illuminated by white light, whereas color film reacts to the true color balance of the light. **Color casts**, or shifts of color, are less noticeable on objects that are strongly colored but are easy to see on more neutral shades, such as skin tones or snow.

A color cast can be a desirable addition, as in the picture on the opposite page, where the bluish light adds an icy coldness to the snow, or on this page, where the photographer added gold tones to the light to enhance the naturally warm colors of the fruit.

But sometimes the color shift can be a problem, as in a portrait shot beneath a tree. People photographed under such seemingly flattering conditions can appear a seasick green because the sunlight that reaches them is filtered and reflected by the green foliage.

Colors can add the impression of heat or cold to a picture. Because they trigger mental associations, golden vellows and reds appear distinctly warm, while blues and yellowish greens seem cool. But the impressions go beyond mere illusions of temperature. Warm colors, especially if they are dark, can make an object seem heavy and dense. Pale, cool colors, on the other hand, give an object a light, less substantial appearance. Warm colors can appear to be farther forward, cool colors farther back. You can use this distance effect to increase the illusion of depth within a picture by placing warm-colored objects against a cool-colored background.

RICHARD STEINBERG: Fruit, 1970

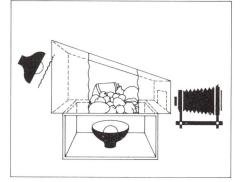

The photographer wanted to intensify the reds and yellows in the fruit above. To do so he enclosed the fruit in a specially constructed tunnel (diagram at left) lined with gold foil, which strongly reflected yellow and red wavelengths, to suffuse the entire scene with very warm golden light. Light entering at the far end of the tunnel was bounced down on the fruit from the slanting roof. A second light, positioned directly under the glass table supporting the fruit, illuminated the arrangement from below. He could also have used colorcompensating (CC) filters over the lens to shift the color balance.

Shadowed areas can appear surprisingly blue in a photograph, especially if the subject itself is not strongly colored. In this Yosemite landscape, the rocks and snow are shaded from direct light from the sun and are illuminated only by skylight, light reflected from the blue dome of the sky. Sunlight, direct rays from the sun, is much less blue. Com-

DAVID MUENCH: Reflection of El Capitan in Merced River, 1970

pare the skylit snow to the sunlit—and less blue granite outcropping of El Capitan, visible in the reflection in the water. Here, the contrast between the two tones adds interest to the picture, but for less of a bluish cast, a 1A (skylight) or 81A (light yellow) filter could have been used over the lens.

Color Changes Throughout the Day

EMIL SCHULTHESS and EMIL SPÜHLER: A Day of Never-setting Sun, 1950

Colors in your photographs will vary depending on the time of day that you made them. Photographing very early or late in the day can produce strikingly beautiful pictures simply because the light is not its usual "white" color.

In the earliest hours of the day, before sunrise, the world is essentially black and white. The light has a cool, shadowless quality. Colors are muted. They grow in intensity slowly, gradually differentiating themselves. But right up to the moment of sunrise, they remain pearly and flat.

As soon as the sun rises, the light warms up. Because of the great amount of atmosphere that the low-lying sun must penetrate, the light that gets through is much warmer in color than it will be later in the day—that is, more on the red or orange side because the colder blue hues are filtered out by the air. Shadows, by contrast, may look blue because they lack gold sunlight and also because they reflect blue from the sky.

The higher the sun climbs in the sky, the greater the contrast between colors. At noon, particularly in the summer, this contrast is at its peak. Film for use in daylight is balanced for midday sunlight, so colors appear accurately rendered. Each color stands out in its own true hue. Shadows at noon are more likely to be neutral black.

As the sun goes down, the light begins to warm up again. This occurs so gradually that you must remember to look for it; otherwise the steady increase of red in the low light will do things to your film that you do not expect. Luckily, these things can be beautiful. If the evening is clear and the sun remains visible right down to the horizon, objects will begin to take on an unearthly glow. Shadows lengthen, so surfaces become strongly textured.

After sunset there is a good deal of light left in the sky, often tinted by sunset colors. This light can be used, with longer and longer exposures, almost up to the point of darkness, and it sometimes produces pinkish or even greenish-violet effects that are delicate and lovely. Just as before sunrise, there are no shadows and the contrast between colors lessens.

Finally, just before night, with the tinted glow gone from the sky, colors disappear, and the world once again becomes black and white.

The sun never sinks below the horizon in this timelapse sequence of photographs taken on a Norwegian island far above the Arctic Circle during the summertime period of the midnight sun. The changing colors of light are clearly visible, however, as the sun rises and sets. Objects seem to be more realistically colored when the sun is high in the sky than when it is close to the horizon; compare the color of the water in the segments on this page with its color in the segments on the opposite page.

Dick Durrance takes advantage of the golden glow of sunset—and boosts it along even further. He often uses graduated filters, which are colored on one edge, clear on the other, with a gradual transition between the two halves. Since the colored part of the filter decreases the exposure as well as affecting color, Durrance uses the filter to balance lighter parts of a scene against darker ones. Here, he used two graduated yellow filters, one to intensify the color of the sky and reduce its brightness against the darker vineyard and one to color and reduce the brightness of the grassy foreground.

DICK DURRANCE II: Alexander Valley, California, 1980

DAVID MOORE: Torchlight Procession of Skiers, Australia, 1966

Color Balance: continued

Shifted Colors from Reciprocity Effect

The warm purple tint over the snow (left) and the two-toned sky (above) were produced by the reciprocity effect that causes shifts in color balance during exposures that are longer than about 1 sec. Both pictures were shot in the dim light of

At dusk, at dawn, sometimes indoors, the light may be so dim that exposure times become very long, even with the lens aperture wide open. Very long exposures with color film produce the same reciprocity effect that takes place with black-and-white films (page 122)the exposure must be increased even more or the film will be underexposed. Various types of color film react differently to long exposures; check the manufacturer's instructions for recommended exposure increases. Very long exposures are not recommended at all for some color films. In general, however, increase the exposure about one stop for a 1-second exposure, two stops for a 10-second exposure, three stops for a 100-second exposure. Bracket the

dusk and given lengthy exposures. David Moore exposed the film for the full five minutes it took the skiers to run the trail (the zigzag thread of light that bisects his picture).

exposures by making a shot at the calculated exposure plus another at onehalf stop more and a third at one stop more. When exposures are very long, underexposure is more likely to be a problem than overexposure.

Reciprocity effect with color films is even more complicated than with blackand-white films. Since color films contain three separate emulsion layers, each layer may be affected differently, and the varied speed losses will change the color balance of the film. The result is color shifts like those shown here. Often the shifts are pleasing, but if you want a more accurate color rendition, use the color filters listed in the film's instruction sheet.

Exposure Latitude: How Much Can Exposures Vary?

You will get the best results with any film if you expose it correctly, but accurate exposure is particularly important with color reversal film because the film in the camera becomes the final transparency or slide. Film that is reversed to make a transparency has very little exposure latitude; that is, it tolerates very little under- or overexposure. With as little as one-half stop underexposure, colors in a slide begin to look dark and murky; there is even less tolerance for overexposure before colors begin to look pale and washed out.

Color negative film has more exposure latitude, and a picture can be lightened or darkened when the negatives are printed. You will have a printable negative even with about one stop underexposure or one to two stops overexposure, although best results come from a correctly exposed negative.

In contrasty lighting, such as the sunlit scene at right, color film is not able to record color and details accurately in both very light highlights and very dark shadows because the range of tones in the scene is greater than the usable exposure range of the film. If the lightest areas are correctly exposed, the shadows will be too dark. If shadows look good, highlights will be too light. Try exposing for the most important part of the scene, then bracket additional exposures.

It is easier to get good exposures with color if lighting is flat, with relatively little difference between the lightest and darkest areas (see opposite page). With such a scene it is less likely that areas will be much too light or much too dark. Sometimes you can use a reflector or a flash unit to add fill light to even out the contrast in a scene (see pages 268-269 and 286-287).

small change in exposure makes a large change in the lightness or darkness of the picture. With about 11/2 stops underexposure, shadows are black, and middle tones, such as the awning's stripes, are unnaturally dark. Highlight details, such as the signs on the awning, show clearly.

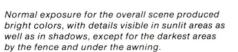

When exposing color transparency film, even a

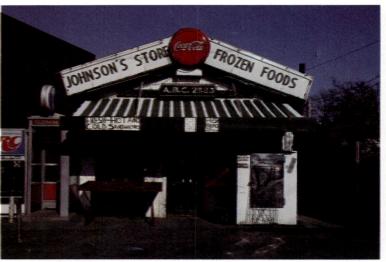

underexposure

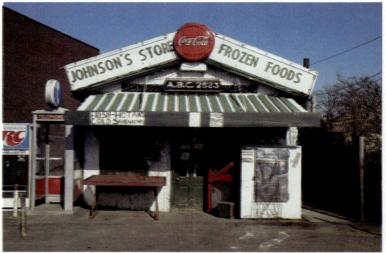

correct exposure

With about 1 stop overexposure in a transparency, colors are noticeably washed out and too light. The shadow areas, however, now show clearly.

overexposure

Shooting in soft, diffused light is a bit simpler than working in contrasty light, because the range of tones from light to dark is not so extreme. Diffused light is also kind to the human face, creating soft shadows that are often more complimentary than the hard-edged, dark ones of direct light.

EVE ARNOLD: Traditional Doctor, China, 1979

Processing Your Own Color

Processing color materials is similar to processing black-and-white materials except that any change in the processing has a greater effect on the final product. Color materials are more sensitive to changes in processing times, temperatures, and other variables; color balance and density shift significantly with even slight variations in processing.

Photographers are more likely to use a commercial lab for **developing color film** than they will for black-and-white film. Many feel that a commercial lab with sophisticated equipment for temperature control produces more consistent results than they could in their own darkrooms. In addition, some films, such as Kodak Kodachrome, have a complicated processing procedure that is designed for automated commercial equipment.

Nonetheless, some photographers prefer to do their own color film processing. Doing your own film processing may be less expensive than lab work. It may be faster than a lab if you are in a hurry to get your film developed. You may be able to maintain better quality control if your local lab is not geared for high quality. Some popular and readily available color negative films that you can develop are Kodak Vericolor III and all Kodacolor VR films. Among the reversal (slide) films that you can process yourself are Agfa Agfachrome, Fuji Film Fujichrome, and Kodak Ektachrome. See the film manufacturer's instructions for the processing chemicals and procedures to use.

The real advantage is in doing your own **color printing** from color negatives or transparencies. Although making color prints is somewhat more exacting than making black-and-white prints, it is not a difficult process to learn and you have the advantage of full control over the final image. Only the most expensive professional printing labs will give you color prints made to your specifications. A much less expensive alternative—and one that produces a print exactly to your taste—is to make your own.

HAROLD FEINSTEIN: Anthurium, 1981

Any subject—above and opposite, flowers—can be photographed in an infinite variety of ways. Above, Harold Feinstein boldly isolated one flower against the sky. He held the flower in one hand and a 35mm camera in another, then moved around to get the best lighting and pattern of clouds. Opposite, every petal and leaf in Michael Geiger's seemingly casual arrangement was carefully positioned. Geiger uses an 8 × 10 view camera because its larger viewing screen makes it easier to see and control the complex arrangements that are his specialty. Notice how Feinstein wholly enclosed his flower within the frame of the picture format, while the center of Geiger's picture is almost empty, with the action taking place at the edges.

MICHAEL GEIGER: Summer Lotus, 1982

Making a Color Print from a Negative Materials Needed

Once you have assembled the materials needed to make color prints (see box at right), the first step is to make test prints to establish a standard filter pack. The color balance of color prints is adjusted by inserting colored filters between the enlarger's beam of light and the paper. Paper manufacturers suggest combinations of filters to produce a print of normal color balance from an average negative or transparency. However, these suggestions are only a starting point for your own tests to determine a standard filter pack for your particular combination of enlarger, film, paper, processing chemicals, and technique. Personal testing is essential because so many variables affect the color balance of prints. Once your standard filter pack has been established, only slight changes in filtration will be needed for most normal printing.

You will need a negative (or a transparency, if you are using reversal materials) that is of normal density and color balance. It should be a simple composition and contain a range of familiar colors, flesh tones, and neutral grays. Do not use a sunset or other scene in which almost any color balance would be acceptable. Your aim is to find a filter pack that will be good as a first trial for most negatives.

Consistency is absolutely vital. The temperature of the developer is critical and must be maintained within the limits suggested by the manufacturer. The same pattern of agitation should be used for all tests and final prints. Even the time between exposure and development must be fairly uniform with some processes.

Pages 240–250 show how to produce and evaluate a print from a negative. Pages 252–254 show how to make a print from a positive transparency.

Color Printing: Materials Needed

Color printing paper and processing chemicals. Two basic types are available. Color prints can be produced from color negatives with negative/ positive processes such as Color by Beseler materials, Kodak Ektacolor papers with Ektaprint 2 chemicals, or Kodak Hobby-Pac Color Print Kit. Color prints can also be made from positive color transparencies by using processes such as Cibachrome materials or Kodak Ektachrome 22 paper with Ektachrome R-3000 chemicals. Not all processing chemistries can be used with all papers; make sure the paper and chemicals are compatible. See the manufacturer's instructions regarding storage of unexposed paper. Most papers should be stored in a refrigerator at 55° F (13° C) or lower. Remove the package from the refrigerator several hours before opening it to bring the paper to room temperature and prevent moisture from condensing.

Enlarger. Any enlarger that uses a tungsten or tungsten-halogen lamp may be used. A fluorescent enlarger lamp is not recommended.

Filtration. The color balance of the print is adjusted by placing filters of the subtractive primaries—yellow (Y), magenta (M), and cyan (C) —between the enlarger lamp and the paper. The strength of the filtration is indicated by a density number: the higher the number, the stronger the filter. For example, 20M means a magenta filter 4 times denser than an 05M filter.

If your enlarger, like the one shown here, has built-in dichroic filters, the strength of each color is adjusted simply by turning knobs or other controls on the enlarger to dial in the desired filtration. Without dial-in filtration, some means must be provided to hold filters in place.

If your enlarger has a drawer for holding filters between the lamp and negative, acetate color printing or CP filters can be used. Filters of the same color can be added to provide a stronger density of a color: 20Y + 20Y gives the same density of yellow as a filter marked 40Y. Any number of filters can be positioned above the negative to create the color balance desired, although the least number that is convenient should be used.

If your enlarger is an older model that does not have a filter drawer, a filter holder can be attached below the lens. In this position, acetate filters cause optical distortions, so the more expensive gelatin color compensating or CC filters must be used. To preserve good optical quality, do not use more than three CC filters below the lens at any one time. Kodak recommends the following CP or CC filters as a basic kit: one each 2B, 05Y, 10Y, 20Y, 05M, 10M, 20M; two each 40Y and 40R (a red filter equivalent to a 40Y + 40M). Occasionally you may need cyan filtration.

Heat-absorbing glass. The light sources of many enlargers give off enough heat to damage color negatives and filters unless some of the heat is absorbed. To prevent this, a piece of heatabsorbing glass is often placed in the enlarger head if it isn't built in. See enlarger manufacturer's instructions.

Voltage control. Electric current varies in voltage from time to time, and a change of less than 5 volts will cause a change in the color of the enlarger light—and a visible change in the color of the print being made. So although you can print without it, some type of voltage control is desirable. A voltage stabilizer or regulator automatically maintains a steady output of power if the line voltage fluctuates. A manually adjustable variable transformer is less expensive; you turn a control knob as necessary to maintain uniform voltage. Either type plugs into a wall outlet, then the enlarger plugs into it. Some enlargers have built-in voltage control.

Analyzers and calculators. A color analyzer is an electronic device that reads the density and color balance of a negative, compares it to a preprogrammed standard, then recommends exposure and filtration. Good ones are very expensive, and while they make printing easier, you can work without one. Another type of printing aid is a color matrix or subtractive color calculator. Some people find these useful, others do not. Briefly, you use this device to make a test print in which colors are scrambled to an overall tone. You compare this test to a standard tone to determine exposure and filtration.

Processing drum. A tube-shaped plastic processing drum is an inexpensive and popular device for color print processing. Each print is processed in small quantities of fresh chemicals, which are discarded after use. This provides economical use of materials as well as consistent processing. Once the drum is loaded and capped, room lights can be turned on so you don't have to work in the dark. See manufacturer's instructions for the correct method of sealing, filling, and draining solutions and for agitating.

Miscellaneous. Most of the other materials needed are also commonly used in black-andwhite printing: darkroom timer, accurate thermometer, trays, and so on.

- 1 color negative printing paper
- 2 enlarger with voltage regulator
- 3 dichroic color head or filters
- 4 | timer with sweep-second hand
- 5 focusing magnifier
- 6 printing-paper easel
- 7 color negatives
- 8 antistatic brush
- 9 | two masking cards for test prints
- 10 notebook for record keeping

- 11 processing drum
- 12 rubber gloves
- 13 photographic thermometer
- 14 | graduates for premeasuring solutions
- 15 print-processing chemicals
- ${\bf 16}\ | \ {\bf temperature\ control\ and\ washing\ tray}$
- 17 | squeegee or photographic sponge

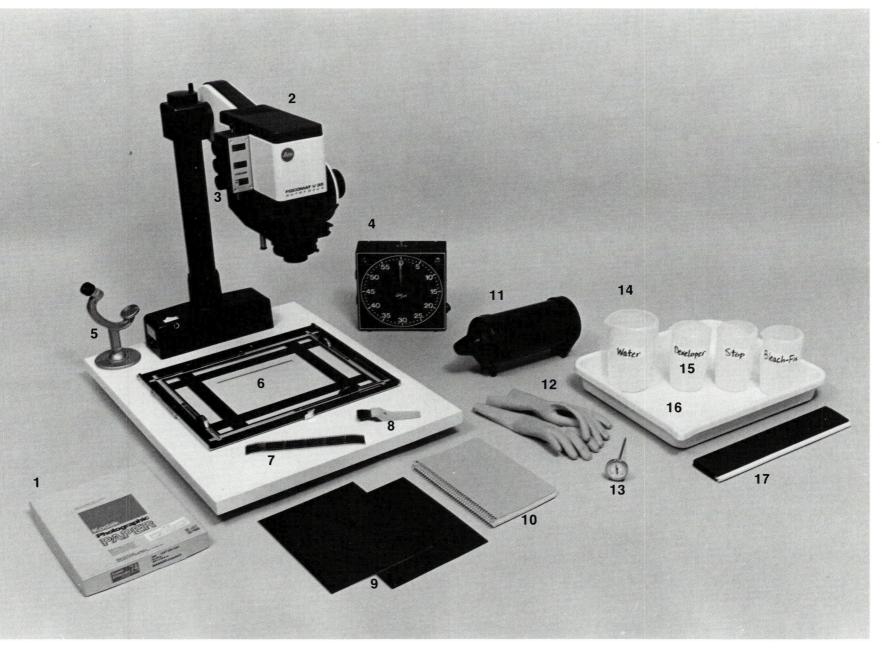

Exposing a Test Print

The following pages show how to make prints from a color negative on Kodak Ektacolor print paper processed in Ektaprint 2 chemicals. Other papers and developers also work well. Read the manufacturer's current directions carefully, because filtration, safelight recommendations, processing, and so on vary considerably with different materials and may change from time to time.

It is not difficult to work with the paper in total darkness, and once the paper is loaded in the drum, room lights can be turned on. If you need some light before then, the recommended safelight for Ektacolor 74 paper is a 7½-watt bulb with a Number 13 amber safelight filter used at least four feet from the paper for no more than three minutes. 1 clean the negative

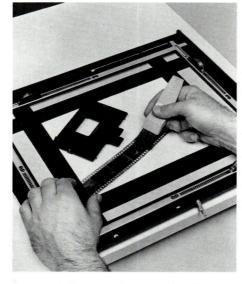

Clean dust off the negative and carrier. Place negative (dull, emulsion side toward paper) in carrier and insert in enlarger. Set out a clean, dry processing drum and its cap.

2 set up the enlarger

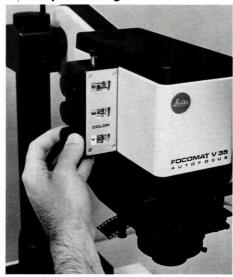

Insert the 2B (ultraviolet) filter and heat-absorbing glass, if required. Dial in filtration (or insert CP or CC filters) for the test: 40M (magenta) and 50Y (yellow).

Exposing a Test Print

Five exposures of the same negative are made in the test print shown at right, producing a range of densities from light to dark. See the manufacturer's suggestions for a starting point for filtration. For Ektacolor paper, Kodak recommends a starting filter pack of 40M + 50Y + 2B. (The 2B ultraviolet-absorbing filter is always part of the pack.)

When feasible, it is better to change the aperture while keeping the exposure time the same. This is because extremely long or extremely short exposures could change the color balance and make test results difficult to interpret (the same reciprocity effect that affects film, pages 234–235). In this test each successive strip received one additional full stop of exposure, but the best exposure for a particular negative is often between two of the stops. Exposure times between 5 sec and 30 sec generally do not create noticeable reciprocity effect, so after you get an approximate exposure you can fine-tune by changing the time.

Keep notes of time, aperture, and filtration for each print if you want to save time and materials at your next printing session.

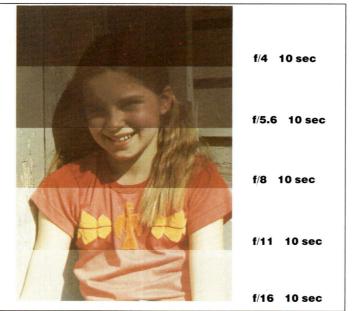

3 | adjust the image size

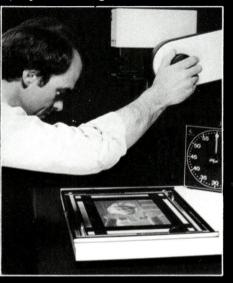

Turn off the room lights. Project the image onto a sheet of paper placed in the easel. Raise or lower the enlarger head until the image is the desired size—here 8 \times 10 inches.

6 | make the first test exposure

Hold a masking card over all but one-fifth of the paper and expose the first test wedge. Cover the first wedge with another card. Move the first card to uncover the next one-fifth of the paper. 4 focus the image

Looking through a focusing magnifier (if you use one), adjust the focus control of the enlarger until the image is sharp. Focus on the edge of an object since a color negative has no easily visible grain.

7 | reset aperture, complete the test

Open the aperture one stop. Reset the timer and expose the next wedge. Continue moving the cards, opening the aperture one stop and exposing until the last one-fifth of the paper is exposed. 5 | set the lens aperture

Stop down the lens to f/16. Set the timer for 10 sec. Turn off the enlarger light. Place a sheet of printing paper on the easel, emulsion side up.

8 load the paper in the processing drum

Insert the paper in the processing drum with the emulsion (exposed) side curled to the center of the drum. Put the cap on the drum and secure it carefully. Turn on the room lights.

Processing

With the exposed print stored in the drum away from light, prepare the chemicals for processing. Shown here is tube processing in Kodak Ektaprint 2 chemicals. Dilute the chemicals as the instructions direct. Color chemicals are stronger than black-and-white chemicals; read instructions and warnings carefully and protect your hands with rubber gloves. Contamination will cause trouble: don't splash one chemical into another or on the dry side of the darkroom. Kodak recommends mixing Ektaprint 2 Bleach-Fix using separate equipment since even very small quantities of it in other solutions will cause very large variations in the print. Wash mixing and processing equipment carefully after use.

Do not try to process a print using less than the recommended volume of a solution. Do not reuse any chemicals; discard after use. Make sure to drain the tube completely after each step. In order to empty some tubes, you have to tilt them 180°, then tilt back to the draining position. Before using a new type of tube, practice filling and draining it with water.

Double-check the manufacturer's directions about solution temperatures (particularly for the developer) during processing. With some processes, prints exhibit unpredictable shifts in color and density if the developer varies even slightly from the recommended temperature. If **temperature control** is critical, the best control is obtained from a processing drum that can be agitated while immersed in a constanttemperature water bath. In practice, however, you can deviate somewhat from the exact temperature if you do the same thing every time.

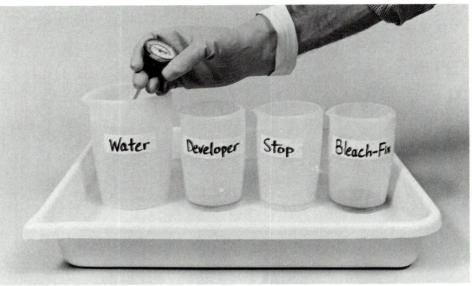

1 | mix solutions, measure quantities, and check temperatures

Wearing gloves, mix and measure out the required amounts of solutions. Use the same container each time for a solution to avoid contamination. Bring containers of solutions to the recommended

2 pour in prewet water

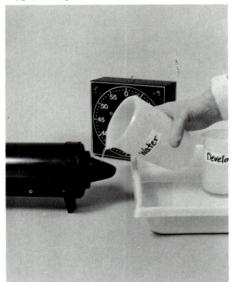

Set timer for prewet time. Fill drum with prewet water, start timer, and begin agitation. (Prewet warms up the paper and softens the emulsion so chemicals can penetrate easily.)

3 agitate during prewet

for each step

temperature and place them in a water bath at

that temperature. Check and keep handy the times

Solutions are agitated across the surface of the paper by rolling or rotating the drum. Use a consistent pattern of agitation to prevent unwanted variations in prints.

4 drain the prewet water

Ten seconds before the end of the prewet period, pour out the prewet. Become familiar with your drum; some drums take slightly longer to drain or need a tilt or shake to drain thoroughly.

6 stop bath

Set timer for stop-bath time. Pour in stop bath, start timer, and agitate. Ten seconds before the end of the period, pour out the stop bath.

5 development

Set timer for development time. Pour in developer, start timer, and agitate as before. Ten seconds before the end of the development period, pour out the developer.

7 bleach-fix

Set timer for bleach-fix time. Pour in bleach-fix, start timer, and agitate. Ten seconds before the end of the period, pour out bleach-fix. The drum can now be opened.

8 wash

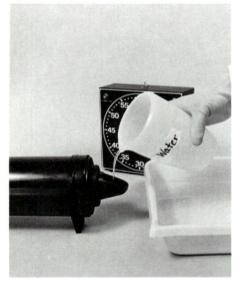

Set timer for 30 seconds. Fill drum with wash water, set timer, and agitate. Ten seconds before the end of the period, pour out the wash water. Repeat at least three times.

10 dry

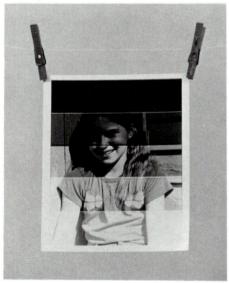

Sponge or squeegee excess water gently from print and hang or place in dust-free place to dry. Warm air, as from a hair dryer, will hasten drying. Do not use a hot drum dryer.

Alternate procedure 9 | tray washing

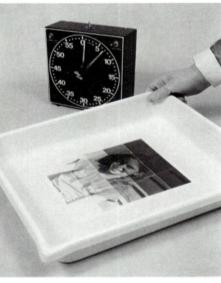

Remove print carefully from drum after bleach-fix; place in a tray of water. Wash by rocking the tray, after 30 seconds dump and refill. Repeat at least three times. Extra washing improves print stability.

11 clean up

Wash all equipment that has come in contact with chemicals. Be particularly careful to wash and dry the processing drum thoroughly so that no trace of bleach-fix remains.

Tube Processing a Color Print in Kodak Ektaprint 2 Chemicals

processing	time	amount of solution for tube size			
step	-	8 × 10	11 × 14	16 × 20	
prewet	30 sec	500 ml	1000 mi	1500 ml	
developer	3 ¹ / ₂ min at 91° F (32.8° C) is recommended. See manu- facturer's instructions for other time/temperature combinations.	70 ml	130 ml	260 ml	
stop bath	30 sec	70 ml	130 ml	260 ml	
bleach-fix	60 sec at 80 to 91° F (26.7 to 32.8° C) or 90 sec at 68 to 79° F (20.0 to 26.1° C)	70 ml	130 ml	260 ml	
wash	Repeat 4 times: 30 sec each time. Repeat additional times for increased print stability	500 ml	1000 ml	1500 ml	
dry	Not over 205° F (96° C)				

Some processing tubes will not hold the indicated volume of water. If so, fill with as much water as possible.

Troubleshooting Problems: Prints from Color Negatives

If you are not happy with a color print, the problem can often be cured by correcting the exposure or filtration of the print; see Judging Density and Color Balance in a Print Made from a Negative (pages 247–249). Inconsistent or improper processing can also cause trouble; see below. For general difficulties, see Troubleshooting Camera and Lens Problems (page 83), Print Problems (page 181), and Flash Problems (page 288).

High contrast, cyan stain, and/or high cyan contrast (pink highlights with cyan shadows)

Cause: Developer too concentrated, developer or prewet contaminated with bleach-fix, developer time too long and/or temperature too high.

Low contrast (especially magenta-pink highlights with green shadows)

Cause: Developer too dilute, not enough volume of developer, not enough agitation, incorrect developer time and/or temperature.

Magenta-blue streaks

 $\pmb{Cause:}$ Inadequate stop-bath action (stop bath was exhausted or contaminated, or no stop bath was used)

Pink streaks

Cause: Water on print prior to processing due to inadequate drying of tube.

Light and dark streaks

Cause: Prewet not used, not enough developer agitation, processor tube not level.

Bluish blacks

Cause: Developer too dilute, too short developer time, prewet not fully drained.

Judging Density in a Print Made from a Negative

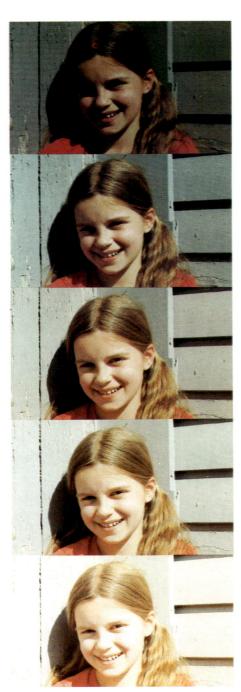

1 stop too dark

Give $\frac{1}{2}$ the previous exposure: close enlarger lens 1 stop or multiply exposure time by .5

1/2 stop too dark

Give $\frac{3}{4}$ the previous exposure: close enlarger lens $\frac{1}{2}$ stop or multiply exposure time by .75

correct density

1/2 stop too light Give 1½ times the previous exposure: open enlarger lens ½ stop or multiply exposure time by 1.5 Judging a color print is similar to judging a black-and-white print in that you have to judge two characteristics separately. In a black-and-white print you judge density first, then contrast. In a color print, you **judge density first** (*shown at left*), then color balance (*see pages 248–249*).

The color balance of a test print will probably be off, so try to disregard it and look only at the density, or darkness, of the print. Look for the exposure that produces the best overall density in midtones such as skin or blue sky. Important shadow areas should be dark but with visible detail, textured highlights should be bright but not burnedout white. Some local control with burning and dodging may be needed (see page 250).

The illumination for judging a color print affects not only how dark the print looks but also its color balance. Ideally you should evaluate prints using light of the same intensity and color balance under which the print finally will be viewed. Since this is seldom practical, some average viewing conditions have been established. Fluorescent tubes, such as Westinghouse Living White bulbs or General Electric Deluxe Cool White bulbs, are recommended. You can also combine tungsten and fluorescent light with one 75-watt tungsten bulb used for every two 40-watt Deluxe Cool White fluorescent tubes. You should examine prints carefully, but when judging density, don't view a print very close to a very bright light. Average viewing conditions are likely to be less bright, and the final print may then appear too dark.

1 stop too light Give twice the previous exposure: open enlarger lens 1 stop or multiply exposure time by 2

Judging Color Balance in a Print Made from a Negative

Almost always, the first print you make from a negative can be improved by some change in the color balance, done by changing the filtration of the enlarger light. If your enlarger has a dichroic head, just dial in the filter change. If you are using CP or CC filters, you must replace individual filters in the pack. Decide what color is in excess in the print and how much it is in excess, then change the strength of the appropriate filters accordingly. Ordinarily it is best to evaluate dry prints, since wet prints have a bluish color cast and appear slightly darker than they do after drying.

You can check your print against pictures whose colors are shifted in a known direction, such as the **ringaround test chart** on the opposite page. The chart helps identify basic color shifts, but printing inks seldom exactly match photographic dyes.

A better method for evaluating prints is to look at them through colored **viewing filters** to see which filter improves the color balance. Kodak makes a Color Print Viewing Filter Kit for this purpose.

Find the viewing filter that makes the print look best. Hold the filter several feet away from the print and the light source. Flick the filter in and out of your line of vision as you look at light midtones in the print, such as light grays or flesh tones, rather than dark shadows or bright highlights. Follow the directions with the filters but, in general, change the enlarger filtration half the value of the viewing filter. If you lay the filter on top of the print, the color change increases. If the print looks best this way, change the enlarger filtration the same value as the viewing filter.

To correct the color balance of a print

made from a negative, **make the opposite color change in the enlarger filtration from the color change you want in the print.** In other words, if you want to remove a color from a print, add that color to the enlarger filtration. Almost always, you should change only the magenta or yellow filters, either subtracting the viewing filter color that corrects the print or adding the complement (the opposite on the color wheel) of the viewing filter color that corrects. See chart and color wheel at right. Kodak's Color Print Viewing Kit also tells you exactly which colors to change.

The cure for a print with too much magenta is to add—not decrease—the magenta in the filter pack; more magenta in the printing light produces a print with less of a magenta cast. A green viewing filter visibly corrects a print that is too magenta; add magenta (the complement of green) to the filter pack.

Similarly, excess blue is corrected by lightening the filter that absorbs blue, the yellow filter; the filter pack will then pass more blue light, so the print (reacting in an opposite direction) will show less blue. A yellow viewing filter visibly corrects a too-blue print; subtract yellow (the complement of blue) from the filter pack.

Color printing is a skill that is easily learned but that requires both experience and written information from a book or manufacturer's literature. Once you have made a few prints, not only is written information easier to understand but the whole process of printing becomes easier. Help from someone who knows how to print and who can help you judge your prints is invaluable.

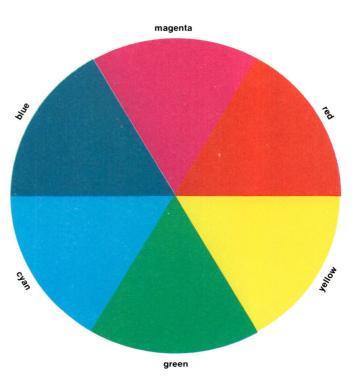

The primary colors of light are shown here arranged in a circle—a color wheel. Each color is composed of equal amounts of adjacent colors (red is composed of equal parts of magenta and yellow). Each color is complementary to the color that is opposite (magenta and green are complementary).

Balancing a Print Made from a Negative

To adjust the color balance of a print made from a negative, change the amount of the subtractive primary colors (magenta, yellow, and cyan) in the enlarger printing light. Usually, changes are made only in magenta and yellow (M and Y).

Print is	Do this	Could also do this	
Too magenta	Add M	Subtract C + Y	
Too red	Add $M + Y$	Subtract C	
Too yellow	Add Y	Subtract $C + M$	
Too green	Subtract M	Add C + Y	
Too cyan	Subtract $M + Y$	Add C	
Too blue	Subtract Y	Add $C + M$	

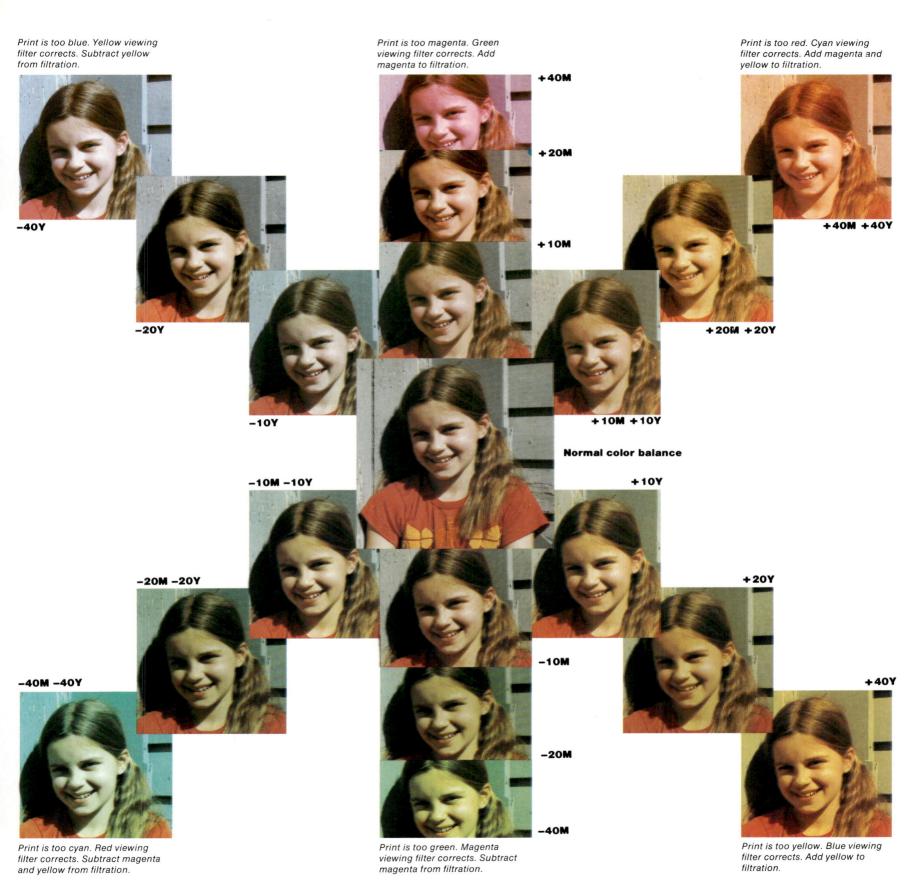

10/Color 249

More About Color Balance/Print Finishing

After you change the filtration of a test print, you may then need to make a **final exposure change**, because the filtration affects the strength of the exposing light and thus the density of the print. When feasible, adjust aperture rather than time.

Dichroic filters need minimum exposure adjustment. See the manufacturer's literature or make no adjustment for yellow filter change and 1 percent adjustment for each 01M change. CP or CC filters require exposure adjustment for changes in both filter density and the number of filters. See the manufacturer's literature or Kodak's Color Darkroom Dataguide, which contains a computing dial that simplifies calculation of new exposures with Kodak materials. As a rough guide, ignore yellow changes, adjust exposure 20 percent for every 10M change, then adjust 10 percent for changes in the number of filters (including yellow).

Try not to end up with all three subtractive primaries (Y, M, C) in your filter pack. This condition produces **neutral density**—a reduction in the intensity of the light without any accompanying color correction—and may cause an overlong exposure. To remove neutral density without changing color balance, subtract the lowest filter density from all three colors.

70Y	30M	10C	working pack
10Y	10M	10C	subtract
60Y	20M		new pack

Dodging and burning in a color print is feasible to some extent, as in blackand-white printing, to lighten or darken an area. For example, you may want to darken the sky or lighten a face or shadow area. If you dodge too much, an area will show loss of detail and color (smoky-looking is one description), but some control is possible. You can also change color balance locally. To improve shadows that are too blue, which is a common problem, keep a blue filter in motion over that area during part of the exposure. Burning in can cause a change in color balance in the part of the print that receives the extra exposure. If a burned-in white or very light area picks up a color cast, use a filter of that color over the hole in the burning-in card to keep the area neutral. Try a CC30 or CC50 filter of the appropriate color. CP filters should not be used for this purpose.

Like black-and-white prints, color prints may need **spotting** to remove white or light specks caused by dust on the negative. Retouching colors made for photographic prints come in liquid or cake form. Either can be used to spot out small specks. The dry cake colors are useful for tinting large areas. Black spots on a print are more difficult to correct. One way is to apply white opaquing fluid to the spot, then tint to the desired tone with colored pencils.

For **mounting**, dry-mount tissue is usable, but low temperatures are recommended for RC paper, no higher than 210° F (99° C). Since the thermostat settings on dry-mount presses are seldom accurate, use the lowest setting that is effective. Preheat the press, the mount board, and the protective cover sheet placed on top of the print, then insert the print for the minimum time that will fuse the dry-mount tissue to both print and mount board.

Color prints fade over time, particularly on exposure to ultraviolet light. Prints will retain their original colors much longer if protected from strong sources of ultraviolet light such as bright daylight or bright fluorescent light.

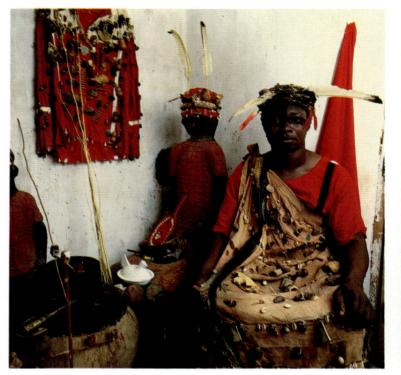

PHYLLIS GALEMBO: Osun Priest, Nigeria, 1985

For a project to document the artifacts of certain African religions, Phyllis Galembo photographed a priest and his ritual shrine objects. Galembo says she got the best results when she participated in whatever was happening, as well as photographing. If people asked her to join a dance or eat with them, she was happy to do so because it made everyone more relaxed.

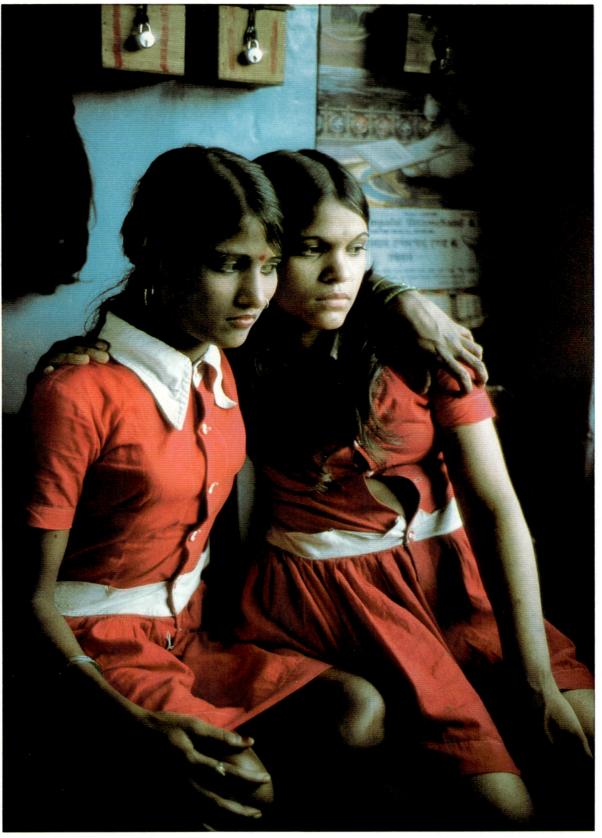

Mary Ellen Mark is a photojournalist who seeks to show people "immersed in their environments" here, a sensitive portrait of two prostitutes in Bombay's Falkland Road brothel area. Above the women's heads are the wooden boxes in which each puts her daily earnings. "I look for a sense of irony," she says, "of humor and sadness at the same time." Compare the effect of the women's indirect glances with that of the direct gaze in the portrait opposite.

MARY ELLEN MARK: Two Women, Bombay, India, 1978 251

Making a Color Print from a Transparency

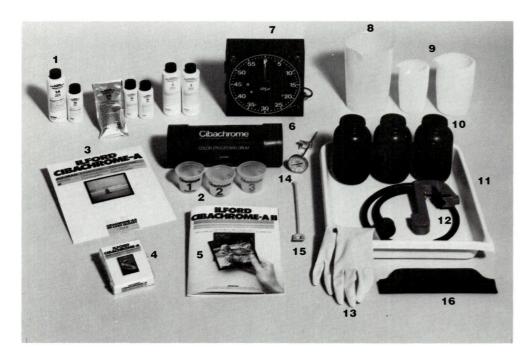

- 1 processing chemicals
- 2 measuring cups or small graduates
- 3 color reversal printing paper
- 4 | filters or enlarger with dichroic head
- 5 manual
- 6 processing drum
- 7 | timer
- 8 half-gallon waste container
- 9 mixing graduates
- 10 solution storage bottles
- 11 washing tray
- 12 washing siphon
- 13 gloves
- 14 thermometer
- 15 stirring rod
- 16 soft rubber squeegee or photographic sponge

Color prints can be made from transparencies (slides) as well as from negatives. You can make a positive print directly from a positive color transparency with materials like Cibachrome-A II paper processed in P-30 chemicals or Kodak Ektachrome 22 paper processed in Ektachrome R-3000 chemicals.

Cibachrome-All paper and P-30 chemistry are shown here. Cibachrome prints are noted for their brilliant, saturated colors, good detail and sharpness, and excellent color dye stability. For best results, print from a fully exposed transparency with saturated colors and low to normal contrast. The paper is inherently somewhat contrasty, so starting with a contrasty transparency often leads to considerable print dodging or burning in or even the need for masking (sandwiching the transparency in register with a black-and-white contact negative made on film such as Kodak Pan Masking Film 4570). The

transparency should be absolutely clean because specks of dust on it will appear as black spots on the print. Clean the transparency carefully before you place it in the enlarger.

Two types of paper are available: a glossy-surface paper on a polyester base dries to a high-gloss finish; this "paper" is more accurately called a print material, because it does not have a paper base. A pearl-surface paper on a resin-coated (RC) paper base dries to a slightly stippled, less glossy finish. The pearl surface is not as likely as the glossy surface to show fingerprints or surface scratches and is suitable for general printing. However, the polyester base of the glossy print material provides better color stability and is the preferred choice to meet museum standards of archival preservation.

See general instructions for color printing on page 240. From time to time, manufacturers change materials and the specifications for their use, so be sure your printing paper and chemicals are designed to be used together and that you have current instructions.

Begin by preparing the solutions. Be particularly careful with color processing chemicals. Mix chemicals in a wellventilated area. Wear rubber gloves to prevent contact of the chemicals with your skin. Do not pour Cibachrome chemicals directly down the drain; the bleach is corrosive and must be mixed with the other solutions to neutralize it for disposal. This is done by draining the spent processing solutions into the same plastic container in the order that they are used.

Your first print should be a test to determine exposure and filtration (see manufacturer's instructions). Unlike printing from a negative, greater exposure will make the print lighter, and heavier filtration will add more of that filter's color to the print (see page 254).

1 Clean the transparency carefully and place it in the enlarger's film carrier. Depending on the carrier, you may have to remove a 35mm slide from its mount. Expose your first test print.

 2 Curl the exposed print toward the emulsion side and put it into a dry, clean drum. Seal the drum. You can now turn on the room lights.

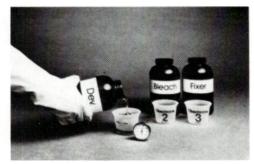

3 Adjust temperatures and measure out solutions —developer, water rinse, bleach, fixer—into individual cups or graduates. Note the times for each processing step. Follow the sequence of steps 4, 5, and 6 for each solution.

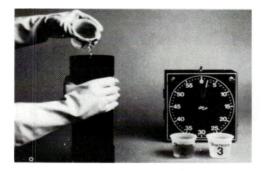

4 | For each stage of processing, set the timer and empty the cup of solution into the drum. When using the Cibachrome drum, start timer when drum is laid on its side. Solutions do not contact the print until then.

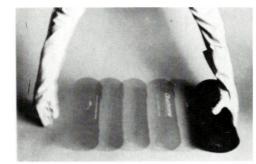

5 | A consistent agitation pattern is important. Roll the drum smoothly back and forth on a level, even surface or use a motorized base.

6 | At the end of each process time, drain the drum for 15 sec into the same half-gallon plastic waste container. Full drainage of the drum is important. Do not discard the solutions until the end of the processing.

7 | Fill the drum with water and carefully remove the print. Wash the print in rapidly flowing water for 3 min. Handle the print carefully; the surface is soft and delicate while wet.

8 | Squeegee the print to prevent water spots but do so gently to avoid damaging the print. Evaluate the print after drying. It will look somewhat red while it is still damp.

9 | Dry the print in a dust-free place. Hang the print, place on an absorbent surface, or for fast drying, use a hair dryer on the warm setting. Do not use a hot drum dryer.

Judging a Print Made from a Transparency

Evaluating a reversal print—one made from a transparency or slide—is similar in many ways to evaluating a print made from a negative (see pages 247–249). View the print when it is dry in light similar to that under which you will view the finished print. Evaluate and adjust density first, because what looks like a problem in filtration may simply be a print that is too dark or too light. Evaluate color balance by examining the print with viewing filters or by comparing the print against ringaround prints (*right*).

The most important difference between reversal printing and negative/ positive printing is in the response to changes in exposure or filtration. Reversal materials respond the same way that slide film does when you expose it in the camera. If the print is too dark, increase the exposure (don't decrease it as you would in negative/positive printing). Adjust the color balance by making the same change in the filter pack that you want in the print. Adding a color to the filter pack will increase that color in the print; decreasing a color in the pack will decrease it in the print. For example, if a print is too vellow, remove Y from the filtration (see chart and prints at right).

The suggested beginning **filter pack** for a print made from a transparency may have yellow and cyan filtration. (This is different from the beginning pack for a print made from a negative, which has yellow and magenta filtration.) If so, try to adjust the balance by changing only the Y and C filtration to avoid the neutral density caused by having all three primary colors in the same pack (see page 250).

One thing is the same in both processes: keep notes—on the print, on the negative envelope, or in a notebook. Print is too magenta. Green viewing filter corrects. Add yellow and cyan to filtration.

normal color balance

Print is too yellow. Blue viewing filter corrects. Sub-

tract yellow from filtration.

Print is too cyan. Red viewing filter corrects. Subtract cyan from filtration.

Print is too blue. Yellow

yellow to filtration.

viewing filter corrects. Add

Print is too green. Magenta viewing filter corrects. Subtract yellow and cyan from filtration.

Balancing a Print Made from a Slide

	Print is	Do this	Could also do this
To adjust the color balance of a print made from a positive transparency, change the amount of the subtractive primary (yellow, cyan, and magenta) filtration. Make changes first in Y or C filtration.	Too dark Too light Too red Too yellow Too green Too cyan Too blue	Increase exposure Decrease exposure Add Y + C Add C Subtract Y Subtract Y + C Subtract C Add Y	– Subtract M Subtract Y + M Add C + M Add M Add Y + M Subtract C + M

ANDREA BLANCH: It's Raining, 1981

The setting for a fashion photograph can help convey the style of a garment and something about the type of person who might wear it. Andrea Blanch favors a realistic approach to fashion and avoids complicated lighting and artificial settings, which are not as much a part of fashion photography as they once were. For an article on raincoats, the setting was a flower market in Paris. A model holds a bunch of flowers upside down, a gesture the photographer once saw a woman make in real life. The picture was taken on an overcast day with light from a reflector card added to illuminate the model's face, a rain machine to add raindrops, and probably a filter over the lens to reduce the blue cast of light in the shade.

Instant Color Film

Instant color pictures are a favorite with photographers because the processing takes care of itself and within seconds a finished print is ready. Although processing instant color film is very simple for the user, the chemistry on which the film is based is extremely complex. It involves a multilayered negative of light-sensitive silver halides and developer dyes sandwiched with printing paper and an alkaline developing agent when the print is pulled from the camera. Integral films such as Polaroid's Spectra and Time-Zero films are even more complex; the processing takes place within the print itself.

Barbara Bordnick (photograph opposite) particularly likes Polaroid for portraits of celebrities. "You're asking these people to perform in the one capacity they're least comfortable in, and that is the role of themselves. They feel very naked." With Polaroid, Bordnick turns the shoot into a more reassuring one for the sitter. "The image comes out right then, my assistant who sees it first exclaims, 'Ohhh!' Then we all go running back and look at it, and the subject hears this whole hullabaloo and it's sort of like telling somebody, 'Look at this fabulous image of you!' "

For a close-up of a dancer, Clint Clemens hung his 8×10 view camera upside down from a camera stand in order to get the camera close to the floor, then shot using Polaroid Polacolor ER 8 \times 10 film. Photographing an object in motion—like a dancer's feet-can be difficult with a view camera because at the moment of exposure, you are not looking through the lens or even through a viewfinder. The instant feedback from the Polaroid let Clemens shoot until he got the results he wanted. Clemens leaves nothing to chance: to get the colors he wanted in the dancer's tights and leg warmers. he purchased them new, but to get them to look well-worn, which he also wanted, he pulled threads loose until the fabric looked properly "distressed." More on pages 8–9 about Clemens and how he works.

CLINT CLEMENS: Victoria Pulkkinen, Dancer, 1982

Barbara Bordnick's portrait of Helen Humes conveys a monumentality that matches the reputation of the great jazz singer. Bordnick shot from a relatively low angle that filled most of the picture with the powerful spread of Humes's red dress. She removed all other elements such as hands or background that might have attracted attention, except for the two flowers that help bring the viewer's eye to the singer's face.

BARBARA BORDNICK: Jazz Singer Helen Humes, 1977

CLAUDE NURIDSANY and MARIE PERENNOU: Tulip, 1973

Back lighting can make translucent objects glow. To produce this back-lighted close-up of a tulip, the photographers removed a petal to open a clear view of the pistils and stamen in the center of the flower. They placed a flash unit behind the flower and arranged reflectors in front of it. The back petals of the tulip diffused and softened the light from the flash; the reflectors bounced some of the light onto the front and center of the flower. The flower seems to glow from within, an effect enhanced by its warm, flamelike tones. The closeup was shot half life size on the original transparency, reproduced here about $3 \times$ life size.

11 Lighting

Y. R. OKAMOTO: Arnold Newman Photographing President Lyndon B. Johnson, 1963

▲ When Arnold Newman was asked to make a portrait of President Lyndon B. Johnson in the Oval Office at the White House, Newman was given 90 minutes to arrange his equipment, but only 15 minutes for the actual shooting. He covered the windows with cloths to block unwanted light, mounted two view cameras—a 4 × 5 and an 8 × 10—and arranged his lights and reflectors, using an assistant as a stand-in. Here, Newman is coaxing the President into the poses and facial expressions he wants, as a Secret Service man watches from the doorway in the background.

The lighting setup looks complicated, but its intention is simple—to illuminate the subject in a way that resembles ordinary daytime lighting. This type of lighting looks natural and realistic because it is the kind people see most often. It consists of one main source of light coming from above, usually from the sun, but here from the large umbrella reflector. It also has fill light that lightens shadow areas. In nature, this is light from the entire dome of the sky or from other reflective surfaces; here it comes from the smaller light sources.

Direction of Light 260 Degree of Diffusion: From Hard to Soft Light 262 Light as You Find It—Outdoors 264 Light as You Find It—Indoors 265 The Main Light: The Most Important Source 266 The Fill Light: To Lighten Shadows 268 Simple Portrait Lighting 270 Multiple-Light Portrait Setups 272 Lighting Textured Objects 274 Lighting Reflective Objects 275 Lighting Translucent Objects 276 Lights and Other Lighting Equipment 277 Lighting with Flash 278 Flash Equipment 280 Using Automatic Flash 281 **Controlling Flash Exposure Manually 282 Basic Flash Techniques** 284 Flash Plus Daylight 286 What Went Wrong? 288 Using Lighting 289

Any kind of lighting has certain basic characteristics. The **direction** of light (*pages 260–261*) and its **degree of diffusion** (*pages 262–263*) are important because they affect the extent and intensity of the shadows on a subject's surface that reveal texture and suggest volume. The **color** of light is important when you use color film, because "white" light sources, such as a light bulb, a flash unit, or the sun, can be relatively reddish to relatively bluish in color. Although the eye adapts to color changes so that most light sources appear neutral in color, color film will record even minor color differences and can give a photograph an unwanted reddish or bluish cast. More about the color of light has little effect on the lighting but can affect an image in other ways. For example, the dimmer the light, the more you need to use a long shutter speed or open the lens to a wide aperture, with the potential for blurred motion or shallow depth of field.

The type of light source is less important than what the light is doing to the subject. This chapter shows how to understand the effects of lighting on a subject and how to use lighting to get the results you want.

Direction of Light

Paradoxically, the direction of light is important because of—**shadows**, specifically those that are visible from camera position. Light, except for the most diffuse sources, casts shadows that can emphasize texture and volume or can diminish them. The main source of light —the sun, a bright window in a dark room, a flash unit—illuminates the side of the subject nearest the light and casts shadows on the opposite side.

When looking at the lighting on a scene, you need to take into account not only the direction of the light (and the shadows it casts), but also the position of the camera (will those shadows be visible in the picture). Snapshooters are sometimes advised to "stand with the light over your shoulder." This creates safe but often uninteresting front lighting in which the entire subject is evenly lit, with few shadows visible because they are all cast behind the subject. Compare front lighting with side or back lighting in which shadows are visible from camera position (photographs, this page and opposite).

There is nothing necessarily wrong with front lighting; you may want it for some subjects. Nor does side or back lighting enhance every scene. But before you shoot, take a moment to consider your alternatives. Will moving to another position show the scene in a more interesting light? Can you move the subject relative to the light, or maybe move the light to another position? Outdoors, you have little control over the direction of light, except for waiting for the sun to move across the sky or in some cases by moving the subject. If you set up lights indoors, you have many more options.

back lighting

RAY McSAVANEY: Yosemite National Park, 1983

Back lighting comes toward the camera from behind the subject (or behind some part of the subject). Shadows are cast toward the camera and so are prominent, with the front of the subject in shadow. Back lighting can make translucent objects seem to glow (see the back-lit flower on page 258) and can create rim lighting, a bright outline around the subject (see the last photo on page 267).

Side lighting comes toward the side of the subject

ture and volume. Early morning and late afternoon are favorite times for photographers to work out-

doors, because the low position of the sun in the

sky produces side lighting and back lighting.

and camera. Shadows are prominent, cast at the side of the subject, which tends to emphasize tex-

side lighting

SERGIO LARRAIN: Cactus

toward the subject. The front of the subject is evenly lit with minimal shadows visible. Surface details are seen clearly, but volume and textures are less pronounced than they would be in side lighting where shadows are more prominent. Flash used on camera is a common source of front lighting.

Front lighting comes from behind the camera

front lighting

Degree of Diffusion: From Hard to Soft Light

direct light

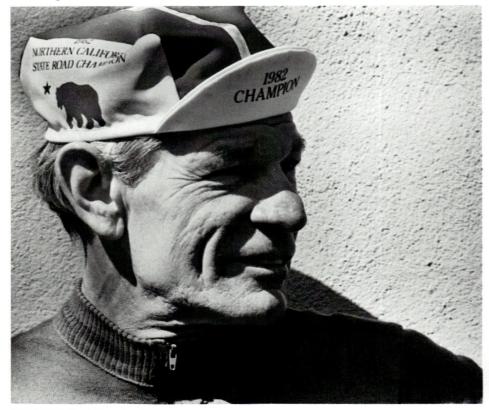

ETTA CLARK: Bicycle Champion, 1985

directional-diffused light

FREDRIK D. BODIN: Young Girl, Norway, 1975

Next to its direction, the most important characteristic of lighting is its degree of diffusion, which can range from contrasty and hard-edged to soft and evenly diffused. When people refer to the "quality" of light, they usually mean its degree of diffusion.

Direct light creates hard-edged, dark shadows. It is specular: its rays are parallel (or nearly so), striking the subject all from one direction. The smaller the light (relative to the size of the subject) or the farther the light is from the subject, the sharper and darker the shadows will be. The sharpest shadows are created by a point source, a light small enough or far away enough that its physical size is irrelevant.

A spotlight is one source of direct light. Its diameter is small, and it often has a built-in lens to focus the light even more directly. If you think of a performer on stage in a single spotlight, you can imagine an extreme case of direct light: lit areas very light, shadows hard-edged and black unless there are reflective areas near the subject to bounce fill light into the shadows (*more about fill light on pages 268–269*).

The sun on a clear day is another

source of direct light. Although the sun is large in actual size, it is so far away that it occupies only a small area of the sky and casts sharp, dark shadows. It does not cast direct light when its rays are scattered in many directions by clouds or other atmospheric matter: then its light is directional-diffused or even fully diffused.

Diffused light scatters onto the subject from many directions. It shows little or no directionality. Shadows, if they are present at all, are relatively light. Shadow edges are indistinct, and subjects seem surrounded by light.

diffused light

Direct light (opposite page, left), with its dark, hard-edged shadows, illuminates subjects that are in the sun on a clear day. Directional-diffused light (opposite page, right) combines qualities of direct and diffused light: shadows are visible, but not as orominent as in direct light. Here, the girl was indoors with the main light coming from a large window to her right, but with other windows bouncing light into the shadows.

DANNY LYON: Sparky and Cowboy (Gary Rogues), 1965

Sources of diffused light are broad compared to the size of the subject—a heavily overcast sky, for example, where the sun's rays are completely scattered and the entire sky becomes the source of light. Fully diffused light indoors would require a very large, diffused light source close to the subject plus reflectors or fill lights to further open the shadows. Tenting (*page 275*) is one way of fully diffusing light.

Directional-diffused light is partially direct with some diffused or scattered rays. It appears to come from a definite direction and creates distinct shadows, but with edges that are softer than those of direct light. The shadow edges change smoothly from light to mediumdark to dark, and the shadows tend_to have visible detail.

Sources of directional-diffused light are relatively broad. Indoors, windows or doorways are sources when sunlight is bouncing in from outdoors rather than shining directly into the room. Floodlights used relatively close to the subject are also sources; their light is even more diffused if directed first at a reflector and bounced onto the subject (like the umbrella light on page 259) or if partially scattered by a diffusion screen placed in front of the light. Outdoors, the usually direct light from the sun is broadened on a slightly hazy day, when the sun's rays are partially scattered and the surrounding sky becomes a more important part of the light source. Bright sunlight can also produce directional-diffused light when it shines on a reflective surface such as concrete and then bounces onto a subject shaded from direct rays by a tree or building.

Light as You Find It—Outdoors

directional

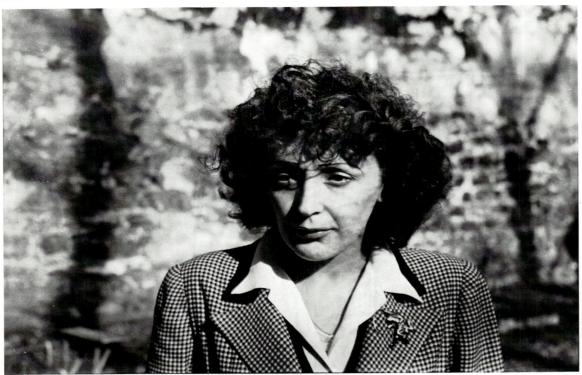

HENRI CARTIER-BRESSON: Edith Piaf, 1946

What kind of light will you find when you photograph outdoors? It may be any of the lighting situations shown on the preceding pages, so it is important to stop for a moment to look at the light and see how it affects the photograph.

A clear, sunny day creates bright highlights and dark, hard-edged shadows (*this page, top*). On a sunny day, take a look at the direction the light is coming from. You might want to move the subject or move around it yourself so the light better reveals the subject's shape or texture as seen by the camera. If you are relatively close to your subject —for example, when making a portrait —you might want to lighten the shadows by adding fill light or by taking the person out of the sun and into the shade where the light is not so contrasty. diffused

On an overcast day, at dusk, or in the shade (*this page, bottom*), the light will be diffused and soft. This is a revealing light that illuminates all parts of the scene. It can be a beautiful light for portraits, gently modeling the planes of the face.

The light changes as the time of day changes. The sun gets higher and then lower in the sky, affecting the direction in which shadows fall. If the day is sunny, many photographers prefer to work in the early morning or late afternoon; when the sun is close to the horizon, it casts long shadows and rakes across the surface of objects, increasing the sense of texture and volume. Because direct light outdoors can produce prominent shadows (this page, top), it is important to notice how such light is striking a subject. In diffused light outdoors, such as in the shade of a building, light is soft and revealing (this page, bottom). Outdoors, if the light isn't right, sometimes you can wait for the sun to change position. Sometimes you can move the subject or add fill light. You can't change light outdoors, but you can at least observe it and work with it.

WALKER EVANS: Sharecropper's Daughter, Hale County, Alabama, 1935

Light as You Find It—Indoors

directional

Shooting toward a bright window indoors will back light a subject so that the side facing the window is much brighter than the side facing the camera (this page, top). Diffused light indoors occurs when light comes from several different directions, such as from windows on more than one side of a room or from numerous light fixtures (this page, bottom).

Light indoors can be contrasty or flat, depending on the source of light. Near a lighting fixture or window, especially if there are not many in the room, the light is directional and contrasty, with bright areas fading off quickly into shadow (*this page, top*). The contrast between light and dark is often so great that you can keep details in highlights or shadows, but not in both. If, however, there are many light fixtures, the light can be diffused and flat, illuminating all parts of the scene evenly (*this page, bottom*).

When shooting indoors, it is important to meter carefully and expose for the most important parts of the picture. The eye adapts easily to variations in

JEB (JOAN E. BIREN): Darquita and Denyeta, Alexandria, Virginia, 1979

light; it can glance at a light area then quickly see detail in a nearby dark area. But there will often be a greater range of contrast indoors than film can record.

Light indoors is often relatively dim. If you want to use the existing light and not add flash or other light to a scene, you may have to use a slow shutter speed and/or a wide aperture. Use a tripod at slow shutter speeds or brace your camera against a table or other object so that camera motion during the exposure does not blur the picture. Focus carefully, because there is very little depth of field if your lens is set to a wide aperture.

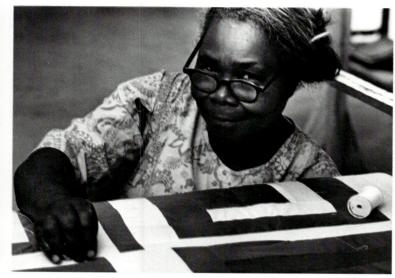

BOB ADELMAN: Mrs. Mattie Ross, Alberta, Alabama, 1970

The Main Light: The Most Important Source

Front lighting. With the light placed as near the lens axis as possible (here just to the right of the camera), only thin shadows are visible from camera position. This axis lighting seems to flatten out the volume of the subject and minimize textures.

Side lighting. Sometimes called "hatchet" lighting because it can split a subject in half. This type of lighting emphasizes facial features and reveals textures like that of skin. The light is at subject level, directly to the side.

High side lighting. A main light at about 45° to one side and 45° above the subject has long been the classic angle for portrait lighting, one that seems natural and flattering. It models the face into a three-dimensional form.

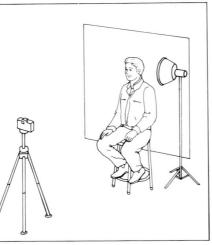

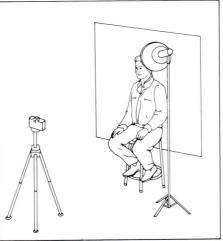

Making a photograph by natural or available light is relatively easy. You begin with the light that is already there and observe what it is doing to the subject. But where do you begin when making a photograph by artificial light, using lights like photofloods or electronic flash that you bring to a scene and arrange yourself?

Since the most natural-looking light imitates that from the sun—one **main light** source casting one dominant set of shadows—the place to begin is by positioning the main light. This light, also called the **key light**, should create the only visible shadows, or at least the most important ones, if a natural effect is desired. Two or three equally bright lights producing multiple shadows create a feeling of artificiality and confusion. The position of the main light affects the appearance of texture and volume (see pictures above). Flat frontal lighting (first photograph) decreases both texture and volume, while lighting that rakes across surface features (as seen from camera position) increases it. Natural light usually comes from a height above that of the subject, so this is the most common position for the main source of artificial light. Lighting from a very low angle can suggest mystery, drama, or even menace just because it seems unnatural. The demon in a horror movie is often lighted from below. **Top lighting.** A light almost directly above the subject creates deep shadows in the eye sockets and under the nose and chin. This effect is often seen in pictures made outdoors at noon when the sun is overhead.

Under lighting. Light from below produces oddlooking shadows because light in nature seldom comes from below. Firelight is one source. High-tech scenes, such as by a computer monitor, are a modern setting for under lighting.

Back lighting. A light pointing at the back of a subject outlines its shape with a rim of light like a halo. Position a back light carefully so it does not shine into the camera lens and fog the film overall, and so the fixture itself is not visible.

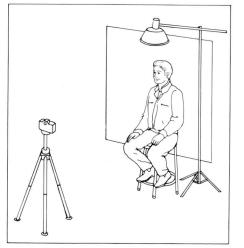

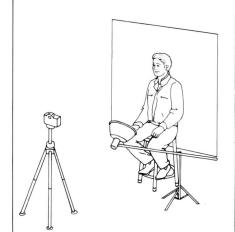

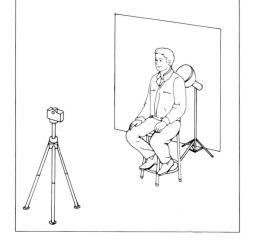

Most photographs made with artificial light employ more than one light source. Almost always a fill light or reflector is used to lighten shadows (*page 268*). Sometimes, an accent light is used to produce bright highlights, and a background light to create tonal separation between the subject and the background. Pages 272–273 show lighting setups using these lights.

Some types of lighting have been traditionally associated with certain subjects. Side lighting has long been considered appropriate for masculine portraits because it emphasizes rugged facial features. Butterfly lighting was often used in the past for idealized portraits of Hollywood movie stars. The lighting is named for the symmetrical shadow underneath the nose, similar to, though not as long as, the one in the top-lighting photograph, above. The main light is placed high and in front of the subject, which smoothes skin texture, while producing sculptured facial contours (see page 273, far right).

Although lighting is only one element in a photograph, it does influence the emotional character as well as the factual data of an image. The pictures above show how the mood of a photograph can be influenced merely by changing the position of one light. If photographs never lie, some of those above at least bend the truth about the subject's personality.

The Fill Light: To Lighten Shadows

When you look at a contrasty scene, your eve automatically adjusts for differences in brightness: as you glance from a bright to a shadowed area, the eye's pupil opens up to admit more light. But photographic film does not make such adjustments, and can record only a limited range of tones. If you expose highlights correctly in a contrasty scene, shadows will be very dark; if shadows are properly exposed, highlights will be very light. Fill light is one solution if you want to add light to shadow areas to reduce contrast and bring out details that would otherwise be lost. Fill light is useful with most artificial lighting and some scenes in daylight where you are close enough to the subject to effectively lighten shadows. (It is not necessary, of course, to always lighten shadows; dark shadows can be a plus in a photograph. See page 342.)

A reflector is a simple, effective, and inexpensive way to add fill light. A reflector bounces the main light into areas where it is needed (pictures opposite). A simple reflector, or flat, can be made from a piece of stiff cardboard, 16 \times 20 inches or larger, with a soft matte white finish on one side. The other side can be covered with aluminum foil that has first been crumpled and then partially smoothed flat. The white side will give a soft, diffused, even light suitable for lightening shadows in portraits, still lifes, and other subjects. The foil side reflects a more brilliant, harder light.

A floodlight or flash can also be used

for fill lighting. A light source used as a fill is generally placed close to the lens so that any secondary shadows will not be visible. The fill is usually not intended to eliminate the shadow altogether, so it is normally of less intensity than the main light. It can have lower output than the main light, be placed farther away from the subject, or have a translucent diffusing screen placed in front of it. See pages 286–287 for how to use a flash for fill with daylight.

A black "reflector" is useful at times. It is a sort of antifill that absorbs light and prevents it from reaching the subject. If you want to darken a shadow, a black cloth or card placed on the opposite side of the subject from the main light will remove fill light by absorbing light from the main light.

You can roughly judge if shadows are so dark that they need fill light by squinting while looking at the scene or viewing the scene through the camera's lens with the aperture stopped down. This makes shadow areas appear darker and thus more noticeable. But the best way is to measure the light with an exposure meter. If important shadow areas, like the shaded side of a face, measure three or more stops darker than midtones, they will be very dark or even black in a print (see opposite page, left photo). Color transparencies need fill light even more than prints do. As little as two stops difference between highlights and shadows can make shadows look very dark.

The difference between the lit side of

a subject and the shadow side is sometimes given as a ratio. The higher the ratio, the greater the contrast. A 1:1 ratio means the lit side is no lighter than the shadow side-in fact, there are no significant shadows. Doubling the ratio is equivalent to a one-stop change between highlights and shadows. With a 2:1 ratio, the lit side is twice as light as the shadow side (a one-stop difference between meter readings for each side), which will make shadows visible but very light. A 4:1 ratio (with the lit side four times-two stops-lighter than the shadow side) will render shadows darker, but still show texture and detail in them. Portraits are conventionally made at a 3:1 to 4:1 ratio, with the lit side of the face between one and onehalf and two stops lighter than the shadowed side. At an 8:1 (lit side three stops lighter than shadows) or higher ratio, some detail is likely to be lost in highlights, shadows, or both.

To measure the lighting ratio, meter the lit side, then the shadow side, and count the number of stops difference between them. With a reflected-light meter, you can either meter directly from the subject or from a gray card held close to the subject. With an incident-light meter, point the meter first toward the main light from subject position, then toward the fill. If there is too much difference between the lit side and shadows, move the fill light closer to the subject or move the main light farther away.

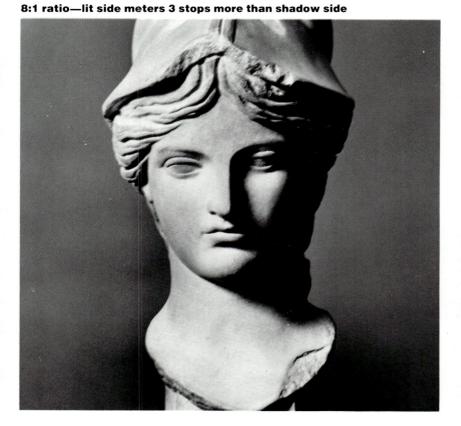

3:1 ratio—lit side meters $1\frac{1}{2}$ stops more than shadow side

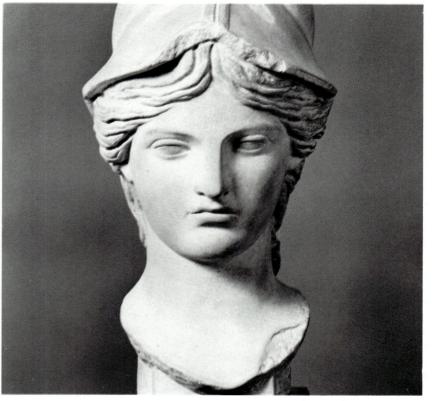

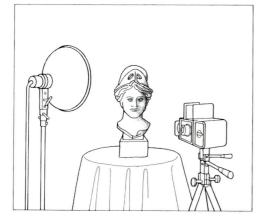

No fill light. A single floodlight is positioned at about 45° above and to the left of the sculptured head (see drawing above). The side lighting on the statue brings out its rounded contours but leaves one side of the face darkly shadowed.

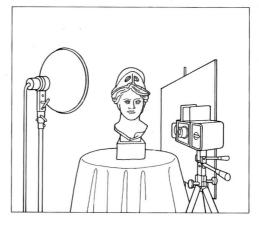

With fill light. A flat piece of white matte cardboard has been placed to the right of the head, held in a clamp on a stand, and angled so that the light bounces back into the shadow areas on the cheek and chin to add fill light.

Simple Portrait Lighting

You don't need a complicated lighting arrangement for portraits—or many other subjects. In fact, often the simpler the lighting, the better. Jill Krementz, who has made many portraits of writers (three are shown here), prefers to keep setups as simple as possible. "I think it is very important for the subject to be relaxed, even happy," she says. "For that reason I prefer not to use a tremendous amount of equipment. Lights, tripods, all the paraphernalia of the 'professional' has the effect of turning the session into a stilted portrait sitting."

Outdoors, **open shade** or an **overcast sky** provides a soft, even light (*photograph this page*). The person is not lit by direct sunlight, but by light reflected from the ground, from clouds, or from nearby surfaces such as a wall. Open shade or overcast light is relatively bluish, so if you are shooting color film, a 1A (skylight) or 81A (light yellow) filter on the camera lens will warm the color of the light by removing excess blue.

Indoors, **window light** is a convenient source of light during the day (*photograph opposite, top*). Contrast between lit and shaded areas will be very high if direct sunlight falls on the subject, so generally it is best to have the subject lit only by indirect light bouncing into the room. Even so, a single window can be a contrasty source of light, causing those parts of the subject facing away from the window to appear dark.

A main light plus reflector fill is the simplest setup if you want to arrange the lighting yourself (*photograph opposite, bottom*). Bouncing the light into an umbrella reflector, rather than lighting the subject directly, softens the light, makes it easier to control, and may even eliminate the need for fill. open shade

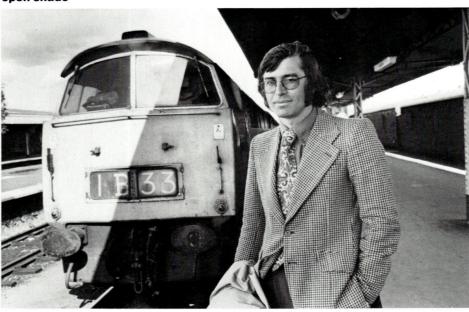

JILL KREMENTZ: Paul Theroux, Taunton Railway Station, England, 1973

In open shade outdoors, a wall, tree, or other object blocks the direct rays of the sun, and the subject is lit only by softer, indirect light. The shade of a train platform made a good setting to photograph writer Paul Theroux for the jacket of his book The Great Railway Bazaar.

Keep an eye on the amount of contrast between lit and shaded areas when you are photographing in window light, which can be quite contrasty. Light bouncing off the walls provided some fill light for this picture. A reflector opposite the window can bounce even more fill light onto the side of the subject away from the window. Here, Maya Angelou might be in the act of reciting one of her poems.

the state between lt is betwee

JILL KREMENTZ: Maya Angelou, Wichita, Kansas, 1975

A single main light—photoflood or flash bounced into an umbrella reflector, with reflector on the other side, is a simple lighting setup indoors. The position commonly used for a portrait main light is about 45° to one side and 45° above the subject. Philip Roth, author of Portnoy's Complaint, often writes about situations that are bitterly comic. His expression is suitably bemused.

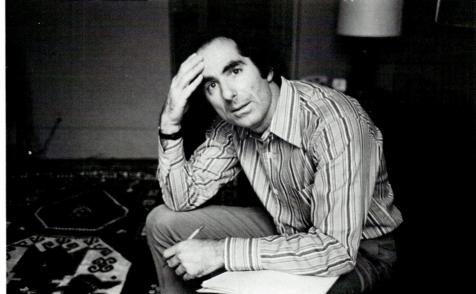

JILL KREMENTZ: Philip Roth, New York City, 1972

main light plus fill

window light

Multiple-Light Portrait Setups

Conventional **portrait lighting** is realistic but flattering. If you have ever gone to a portrait studio to have your picture made, the photographer may have arranged the lights somewhat as in the diagrams shown here. These lighting setups model most faces in a pleasing manner and can be used to improve some features—for example, using broad lighting to widen a thin face.

A typical studio portrait setup uses a moderately long camera lens so that the subject can be placed about 6 feet from the camera; this avoids the distortion that would be caused by having the camera too close to the subject. The subject's head is often positioned at a slight angle to the camera—turned just enough to hide one ear. The first photograph shows short or narrow lighting where the main light is on the side of the face away from the camera. This is the most common lighting, used with average oval faces as well as to thin down a too-round face.

The photograph opposite, second from right, shows a broad lighting setup where the side of the face turned toward the camera is illuminated by the main light. This type of lighting tends to widen the features, so it is used mainly with thin or narrow faces. The last setup shows butterfly lighting; the main light is placed high—directly in front of the face.

Photographers frequently use a softer, more diffused lighting for portraits than that shown here, as in the fashion shot on page 400. A typical setup is a diffused main light placed close to the camera (such as a light bounced into an umbrella reflector) plus a fill light or reflector card. Such lighting is soft, attractive, and easy to use. However, when you don't want such even, shadowless light, you can use lights to create a more dramatic and complex effect (*see page 407*).

short lighting

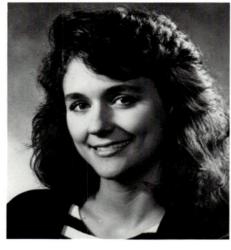

Short lighting places the main light on the side of the face away from the camera. The next four photographs show the separate effect of each of the four lights in this setup. Photofloods were used here. Flash units can be used instead, but when you are learning lighting, the effects of different light positions are easier to judge with photofloods.

short lighting: main light

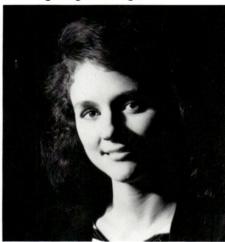

The main light *in* a short lighting setup is on the side of the face away from the camera. Here a 500-watt photoflood is placed at a 45° angle at a distance of about 4 feet. The main light is positioned high, with the catchlight, the reflection of the light source in the eyes, at 11 or 1 o'clock.

short lighting: fill light

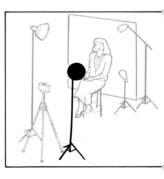

The fill light, a diffused 500-watt photoflood, is close to the camera lens on the opposite side from the main light. Since it is farther away than the main light, it lightens but does not eliminate the shadows from the main light. Catchlights from the fill are usually spotted out in the final print.

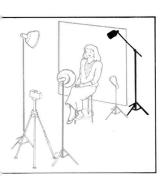

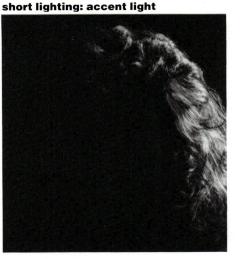

The accent or back light (usually a spotlight) is placed high behind the subject, shining toward the camera but not into the lens. It rakes across the hair to emphasize texture and bring out sheen. Sometimes a second accent light places an edge highlight on hair or clothing.

short lighting: background light

The background light helps separate the subject from the background. Here it is a small photoflood on a short stand placed behind the subject and to one side. It can be placed directly behind the subject if the fixture itself is not visible in the picture.

broad lighting

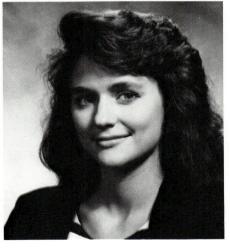

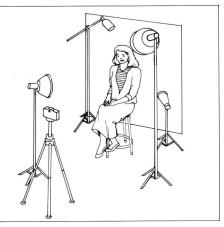

Broad lighting places the main light on the side of the face toward the camera; again the main light is high so the catchlight is at 11 or 1 o'clock. The main light in this position may make the side of the head; often the ear, too bright. A "barn door" on the light (see page 277) will shade the ear. butterfly lighting

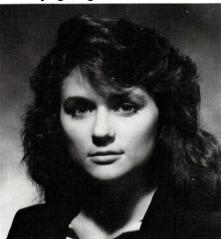

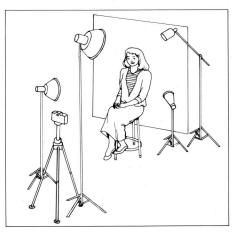

Butterfly lighting is conventionally used as a glamour lighting. The main light is placed directly in front of the face, positioned high enough to create a symmetrical shadow under the nose but not so high that the upper lip or the eye sockets are excessively shadowed.

Lighting Textured Objects

Lighting for a textured object depends on whether you want to emphasize texture. Every paint stroke shows in the photograph at right because the light is raking across the object at a low angle to the surface, creating shadows that underline every bump and ripple. The same principle can be put to work with any textured object, such as rocks, textured fabrics, or facial wrinkles. Simply aim a source of direct light so it skims across the surface, choose a time of day when the sun is at a low angle in relation to the object, or arrange the object so light strikes it from the desired direction.

Shadows must be seen if the texture is to be prominent, which is why side or back lighting is used when a pronounced texture is desired: the shadows cast will be visible from camera position. A light pointed at an object from the same direction as the lens, called axis light, may also produce shadows, but they will be just barely visible from camera position, if at all. Axis light tends to produce the least sense of texture (see first photograph, page 266, and diagrams at right). If you want to minimize textures in a portrait because your subject is self-conscious about facial wrinkles, place the main light close to the lens so the subject is in axis light.

side lighting

back lighting

axis lighting

Texture is emphasized in a photograph when light skims across the surface at a low angle and produces shadows that are visible from camera position. For most objects this requires side or back lighting. Axis lighting, which comes from the camera direction, produces the least texture.

SEBASTIAN MILITO: Doorknob, 1970

Lighting Reflective Objects

The cornet (left) was so shiny that it reflected images of the camera and lights that the photog-

rapher needed to shoot it. To solve the problem, Fil Hunter isolated the horn inside a light tent (see drawing above). The horn and its background are lit evenly and diffusely with two spotlights shining through the thin material of the tent, which itself makes a pleasing and simple pattern of reflections in the horn's shiny surfaces. The camera, looking in through the opening in the tent from the shadows outside, stays out of the picture, as do other potentially distracting reflections. Photographing objects with glossy surfaces can be like photographing a mirror. Highly polished materials such as metal, ceramic, or plastic can reflect every detail of their surroundings, a distracting trait when the surroundings include such irrelevant items as lights, photographer, and camera. Sometimes reflections work well in a photograph, making interesting patterns or giving information about the surface quality, but often it is necessary to eliminate at least some of them.

Reflections can be controlled. To some extent this can be done by moving the equipment or the object around until reflections are no longer distracting. If the reflections must be reduced still further, a polarizing filter will help if the reflecting surface is not metallic (see page 106). Sometimes polarizing screens are used on the lights as well. You can also use a special dulling spray available in art supply stores. Use it sparingly to avoid giving the surface a flat, lifeless look. Another solution is to tent the object, that is, surround it partially or completely with plain surfaces like large sheets of translucent paper that are then lighted and whose reflections in the object are photographed (diagram at left). You can also hang strips of paper just outside the picture area to place reflections where you want them. When checking a shiny object for reflections, through-the-lens viewing is best. Even a slight change in position can change the pattern of reflections.

FIL HUNTER: Cornet, 1982

Lighting Translucent Objects

Try lighting translucent or partially transparent objects from behind glassware, ice, thin fabrics, leaves and flowers, for example. The light can seem to shine from within, giving the object a depth and luminance that could not be achieved with flat frontal lighting (see flower, page 258). If you illuminate the background (as in the lighting setup below) instead of shining the light directly on the object, the lighting will be soft and diffused. Glassware is almost always lighted from behind since frontal illumination usually causes distracting reflections.

A row of crystal glasses (right) is softly lighted from the back by two large spotlights whose joined beams bounce off a sheet of seamless white paper, as shown above. The shadow that surrounds the bases of the glassware provides contrast with the brilliance of the reflected light and lends an air of cool elegance to the photograph.

ERICH HARTMANN: Crystal Glassware

Lights and Other Lighting Equipment

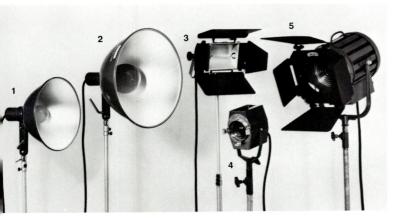

- 1 500-watt photoflood in 12-inch reflector
- 2 1,000-watt photoflood in 16-inch reflector
- 3 1,000-watt quartz floodlight with barn doors
- 4 200-watt spotlight
- 5 750-watt spotlight with barn doors

Types of lights

Photofloods have a tungsten filament, like a household bulb, but produce more light than a conventional bulb of the same wattage. The bulbs put out light of 3200K or 3400K color temperature for use with indoor color films. The bulbs have a relatively short life, and put out an increasingly reddish light as they age.

Quartz-halogen bulbs contain a gas that prolongs the life of their tungsten filament. They (and their lamp housing fixtures) are much more expensive than photofloods, but last much longer and maintain a constant color temperature over their life. Quartz bulbs are color balanced for indoor color films.

Flash equipment ranges from large studio units that power multiple heads to units small enough to clip onto or be built into a camera (see page 280). Flash is used with daylight color films.

Depending on its housing, any of the above can be a **floodlight**, which spreads its beam over a wide angle, or a **spotlight**, which has a lens in its housing that focuses the light into a concentrated beam. A spotlight often is adjustable so the light can be varied from very narrow to relatively wide.

Reflectors and light-control devices

Bowl-shaped reflectors are used with photo lamps to concentrate the light and point it toward the subject. Some bulbs have a metallic coating on the back of the bulb that eliminates the need for a separate reflector.

A **snoot** is a tube attached to the front of a lamp housing to narrow its beam. It is used to highlight specific areas.

A **reflector flat** is a piece of cardboard or other material used to bounce light into shadow areas (see pages 268–269).

An **umbrella reflector** is used on a main light to produce a wide, relatively diffused light. The light source is pointed away from the subject into the umbrella, which then bounces a broad beam of light onto the scene. Umbrella reflectors come in various surfaces such as silvered for maximum reflectivity, soft white for a more diffuse light, and gold to warm skin tones. See the lighting setup with umbrella on page 271, bottom.

A **flag** or **gobo** is a small panel usually mounted on a stand and positioned so it shades some part of the subject or shields the camera lens from light that could cause flare. Barn doors are a pair (or two pairs, as shown in the photograph at left) of black panels that mount on the front of a light source. They can be folded at various angles in front of the light and like a flag are used to block part of the illumination from the subject or lens.

Diffusers and filters

A diffusion screen, often a translucent plastic, is placed in front of a light to soften it and make shadows less distinct. The material must be heat resistant if used with tungsten bulbs. The screen may clip onto a reflector or fit into a filter holder.

A lightbox or softbox completely encloses one or more lamps and produces a soft, even light. See the very large lightbox shown on page 8.

A tent is a translucent material that wraps around the subject instead of around the light source. Lights shine on the outside of the tent, which passes through a very diffused and even illumination. See the tent diagrammed on page 275.

A filter holder on the front of a reflector can accept filters that change the color of the light, diffusion screens that soften it, or polarizing screens that can remove glare or reflections.

Supports for lights and other devices

Light stands hold a lamp, reflector, or other equipment in place. The basic model has three folding legs and a center section that can be raised or lowered.

A cross arm or boom attaches to a vertical stand to position a light at a distance from the stand. Some are counterbalanced to compensate for the weight of the light.

An **umbrella mount** attaches to a light stand and has a bracket for an umbrella reflector, plus another for the light that shines into the umbrella.

Background paper or **seamless** is not strictly speaking lighting equipment but is a common accessory in a studio setup. It is a heavy paper that comes in long rolls, 4 feet or wider, in various colors to provide a solid-toned, nonreflective backdrop that can be extended down a wall and across the floor or a table without a visible break. If the paper becomes soiled or wrinkled, fresh paper is unrolled and the old paper cut off. The roll is supported on two upright poles with a cross piece that runs through the hollow inner core of the roll. A roll of seamless is shown on page 10, bottom.

Lighting with Flash

Flash units provide a convenient means of increasing the light, indoors or out. Electronic flash, also called strobe, has mostly replaced the earlier flashbulb. except with some amateur cameras and for a few specialty uses. The light of an electronic flash unit comes from a tube filled with xenon or other inert gas. which glows brightly for an instant when subjected to a surge of electricity. A unit can be fired many thousands of times before the tube burns out, unlike a flashbulb, which fires only once. In either case, the flash has to be synchronized with the camera's shutter so that it fires when the shutter is fully open. Types of flash equipment and accessories are described on page 280.

Some electronic flash units control exposure automatically by regulating the length of the flash. After the flash is triggered, light striking the subject is reflected back to a light-sensitive cell, or sensor, mounted on the flash unit or in the camera. When enough light for correct exposure has been reflected back to the sensor, it cuts off the flash. The duration of the flash in an automatic unit may vary from as long as 1/400 second to as short as 1/50,000 second. See page 281 for how to use automatic flash.

Manually controlled electronic flash units put out a consistently bright flash for a fixed length of time—usually about $\frac{1}{1000}$ second. Exposure is controlled by the photographer adjusting the size of the lens aperture based on the distance from flash to subject; the greater the distance, the weaker the illumination that reaches the subject and the wider the aperture that is needed. See pages 282–283 for how and when to use flash manually.

A camera-mounted flash unit is convenient to carry and use. The light from the flash illuminates whatever is directly in front of the lens. But flashon-camera pointed directly at the subject (or any single light that is positioned very close to the lens axis) creates a nearly shadowless light; the result is a flatness of modeling and lack of texture that may not be desirable for every subject. There is nothing necessarily wrong with this type of lighting— Weegee was a master of its use (see photograph, opposite)—but there are other positions for the flash (see pages 284–285).

The burst of light from electronic flash is very brief. Even 1/1000 second, which is a relatively long flash duration, will show most moving subjects sharply, a great advantage in many situations (see photograph, this page). The disadvantage is that the flash is so brief that you can't see how the light affects the subject-for example, where the shadows will fall. Some studio flash units avoid this problem by the addition of a modeling light, a small tungsten light positioned close to or even built into the flash unit and used as an aid in positioning the flash. Even without a modeling light, however, you will eventually be able to predict the effects of various flash positions.

News photographers find flash particularly useful. They often have to work fast in an unfamiliar setting to record action while it is happening. Not only does flash stop the motion of a moving subject, but it prevents any blur caused by hand holding the camera. The light is portable and predictable; unlike existing lighting, which may be too dim or otherwise unsuitable, flash delivers a measured and repeatable quantity of light anywhere the photographer takes it. Studio photographers also like flash because it stops motion, plus it has easily adjustable and consistent output and is cooler than heat-producing tungsten lights.

LOIS GREENFIELD: Dancer David Parsons, 1983

Flash stops motion: an understatement for the photograph above. The burst of light from a flash is so brief—usually faster than the fastest shutter speed on a camera—that it shows most moving subjects sharply. When Lois Greenfield photo-graphed dancer David Parsons, she didn't want to photograph a choreographed moment from a particular dance. Instead, she set up a strobe and had him "hit shapes" so she could photograph the dancer's movement in the studio as a separate art.

Weegee (Arthur Fellig) specialized in street scenes in New York City—here, a close encounter between denizens of two different worlds. ''I am often asked,'' he wrote, ''what kind of Candid Camera I use—there really is no such thing—it's the photographer who must be candid.'' He always was.

Weegee almost always used direct flash on camera, a harsh, two-dimensional lighting that reveals every detail with a headon and merciless burst of light -a perfect illumination for his subject matter. The picture also shows that light rapidly gets dimmer as the distance from the light source to the subject increases. This is why the three people in the foreground are adequately exposed while the background is almost black; by the time the light from the flash reached the background, it was too dim to illuminate it.

Flash Equipment

In the early days of flash photography, taking pictures was something of a gamble. Flash powder, an early source of artificial light, was a dangerously explosive mixture that could easily burn or blind the photographer. Not until the 1930s did flash photography become simple and safe with the mass production of flashbulbs. Today's flash units provide a measured quantity of light in a convenient and easy-to-use form.

To synchronize flash and shutter so that the flash is lit when the shutter is open, an electrical connection is needed between them. If a camera has a socket in which a flash is inserted directly, the connection is made within the socket. Some cameras have a hot shoe, a bracket on top of the camera that both attaches a suitable flash unit and has a built-in electrical connection to the shutter. Other cameras have a synchronization socket (a PC terminal) to which one end of an electrical wire, called a PC cord or synch cord, is connected; the other end of the cord attaches to the flash. Consult the manufacturer's instructions for the way to synchronize your flash and camera.

Electronic flash is synchronized to fire when the shutter is fully open because the flash reaches its peak brilliance almost instantly and has a very brief duration. A camera with a leaf

Flashbulbs

shutter (for example, a view camera) can be used with electronic flash at any shutter speed when the camera is set for X synch. A camera with a focal-plane shutter (a single-lens reflex camera) is used with electronic flash at relatively slow shutter speeds since the shutter on most models fully opens at only 1/60 second or slower. Some models synch with flash at faster speeds.

Synchronization with flashbulbs depends on the type of bulb. Flashbulbs have a slight delay between ignition and the peak of usable light. The most common bulbs, Class M, have a medium peak delay. A camera with a leaf-type shutter can be used with an M bulb at any shutter speed when the camera is set for M synch; however, the full light from the bulb will not be used if the shutter speed is faster than the usable duration of the flash (about 1/60 second). A focal-plane shutter can be set to X synch and used with Class M bulbs at slow shutter speeds (up to about 1/30 second). Class FP (focal-plane) bulbs have a flash of long duration and uniform brightness to provide even illumination for focal-plane shutters at all shutter speeds. Class S (slow peak) bulbs give the maximum light output and are used either at very slow shutter speeds (about 1/15 second) or are fired after the shutter is manually opened.

flash bulb and reflector flash cube

A flashbulb consumes its filaments when flashed and can be used only once. Bulbs are often used in reflectors that have a polished finish.

A flash cube or flash bar contains several bulbs that fire one at a time. The bulbs are built into a single unit with a reflector behind each bulb and a plastic shield in front.

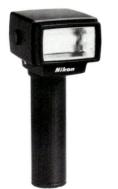

An automatic flash has a light-sensitive cell and electronic circuitry that determines the duration of the flash needed by measuring the light reflected back from the subject. Some units can also be operated manually.

A dedicated (or designated) flash is always an automatic flash and is designed to be used with a particular camera. In automatic operation, the flash sets the camera's shutter to the correct speed for flash and activates a signal in the viewfinder when the flash is ready to fire. Do not use a flash dedicated for one camera on any other unless the manufacturer says they are compatible. The camera, flash, or both may be damaged.

A hot-shoe flash has a mounting foot that slips into the hot-shoe bracket on top of a camera. The hot shoe provides an electrical connection that fires the flash when the camera shutter is released. Some hot-shoe units, like the one shown here, have a head that tilts so the flash can be used on the camera but still provide indirect bounce light.

A handle-mount flash puts out more light than a typical hot-shoe unit. Its "potato masher" handle serves as a grip and can hold batteries to power the unit.

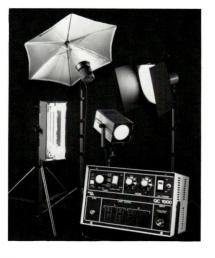

Studio flash units are

powerful devices that fire one or more flash heads when triggered either by a cord connection or by a flash slave eye, a sensor that fires a unit when it detects a pulse of light from a primary unit that is synchronized with the camera. A modeling light, a small built-in tungsten light, helps to position the direction of the flash head.

Using Automatic Flash

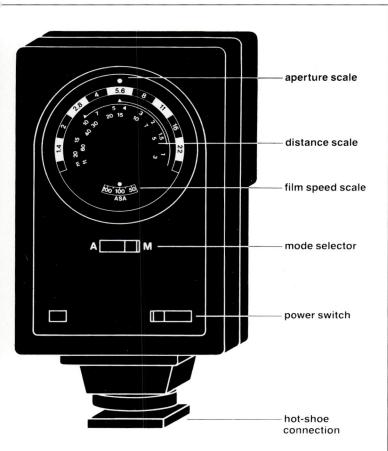

Using an automatic flash on camera is very simple, but models vary in design and operation, so check the manufacturer's instruction book before shooting. The more automatic the flash or camera, the fewer settings you have to adjust for ordinary automatic operation.

- Set the camera shutter-speed dial to the correct speed for flash operation. Attach the flash to the camera's hot-shoe bracket and turn the flash on, or activate a unit built into the camera.
- 2 | Set the flash mode selector (if there is one) for automatic operation.
- 3 | Set your film speed into the flash calculator dial.
- 4 | On the calculator dial find the correct lens aperture for flash operation (some flash units offer a choice of apertures). Set the lens aperture accordingly.
- 5 | Focus the camera. The calculator dial will show the range of distances (for example, 3–20 ft) within which the flash will automatically produce a correct exposure for an average subject. Shoot only after the flash signals that it is charged and ready to fire.

An **automatic flash** controls the exposure for you. You have to do little more than attach the unit and make a few adjustments (not even that much with some models), then shoot (*see the box at left*). Within the working range of distances, the flash adjusts itself automatically to produce the correct exposure for most subjects. You can spend more time with the subject and less with your equipment because you don't have to reset the lens aperture every time the distance changes from flash to subject.

When doesn't automatic flash work well? Mostly in the same scenes where you have to be careful with any exposure metering. If the subject does not

fill enough of the center of the frame and is close to a much lighter background, such as a white wall, the subject may be underexposed and too dark. If the subject is against a much darker background, such as outdoors at night, it may be overexposed and too light. The flash sensor, like the sensor in an averaging exposure meter, reads the brightness of the scene overall and computes a correct overall exposurebut one that may be wrong for just the part of the scene that is of interest to you. See page 288 for troubleshooting flash problems in general and pages 282-283 for how to set flash exposures manually.

TERRY EILER: Foxhounds at a Field Trial, Carroll County, Virginia, 1978

Automatic flash works well as long as the main subject fills the central part of the frame. Adjust the exposure or use the flash on manual if the subject is relatively small against a much darker or lighter background.

Controlling Flash Exposure Manually

With **manual flash exposure** you adjust the lightness or darkness of the picture by opening up or stopping down the lens aperture. Even if you have an automatic flash, you may want manual operation when the background is much lighter or much darker than the subject, with multiple flash setups, off-camera flash, or bounce flash, or simply for greater control of the lighting.

The farther away an object is from a light source, the less light it receives. To find the correct aperture, measure the distance from your flash to your subject and divide it into the **guide number** (the manufacturer's rating for the flash when used with a given film speed). The result will be the lens f-stop to use (see opposite, top).

Guide numbers are only guides. If you

consistently underexpose flash shots, the power of the unit may be overrated; use a lower guide number. If you consistently overexpose, use a higher number. If the room where you are photographing is very small, with white walls and ceilings, close down the aperture one stop. If the room is very large or you are using the flash outdoors at night, open up the aperture one stop.

With **bounce flash**, the flash-tosubject distance is the distance the light travels. This is measured from the flash to the reflecting surface to the subject, not straight from flash to subject (see opposite, bottom). You must also open the lens a bit more to allow for light absorbed by the reflecting surface. A white, painted wall or ceiling might need an extra half-stop exposure, white curtains or an acoustic tile ceiling a full extra stop, and a darker surface even more. An umbrella reflector designed for photographic use, like the one on page 259, may not need additional exposure because so little light is absorbed by the reflecting surface. Bracket your exposures to be safe.

A **flash meter** is often used by studio photographers or other professionals. It is similar to an ordinary exposure meter but is designed to read the brief, intense burst of light from flash, which ordinary meters cannot. A flash meter simplifies exposure calculations in situations such as multiple light setups, with bounce flash, or if cumulative firings are used to build an exposure.

If your flash has a calculator dial, it will do the arithmetic of manual exposure calculation for you.

- 1 Set your film speed into the calculator dial.
- 2 | Find the distance from flash to subject. You can estimate the distance or read it off the distance scale on the lens after you focus on the subject. (The distance for bounce flash is measured from flash to reflecting surface to subject.)
- 3 Set your lens to the aperture that is opposite that distance on the calculator dial. Set your shutter speed to the one that will synchronize your camera with flash.

On the dial shown here, the film speed is 100 and the distance to the subject is 15 feet (about $4\frac{1}{2}$ meters). The camera aperture should be set to f/5.6.

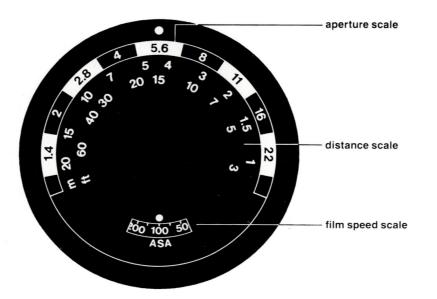

calculating a direct flash exposure

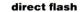

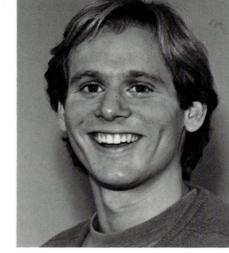

Flash manufacturers measure the power of a unit and assign it a guide number, a rating for the flash when used with a given film speed. The more powerful the flash, the higher its guide number. To set a flash exposure manually, divide the distance from flash to subject into the guide number for your film. The result is the lens aperture to use. Often manufacturers list two guide numbers for each film speed: one if you measure the flash-tosubject distance in feet and the other if you measure in meters.

The farther a subject is from the flash, the less light it will receive and the wider the aperture needed to keep exposure constant. The level of light drops rapidly as the distance increases between light and subject; at twice a given distance from a light source, an object receives only one-fourth the light. This is the inverse square law: intensity of illumination is inversely proportional to the square of the distance from light to subject.

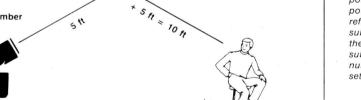

calculating a bounce flash exposure

In a bounce flash exposure, the flash is not pointed directly at the subject. Instead it is pointed at another surface such as a ceiling or reflector, which then reflects the light onto the subject. To calculate a bounce exposure, estimate the distance from flash to reflecting surface to subject. Divide that distance into the flash guide number to get the aperture to which you should set your lens.

bounce flash

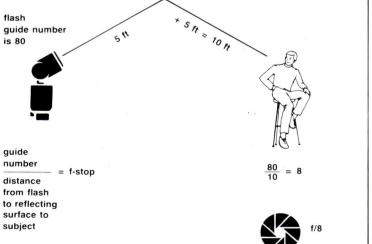

Basic Flash Techniques

The easiest way to light a scene with flash is with direct flash on camera, a flash unit mounted on the camera and pointed directly at the subject (*shown this page*). More likely than not, you will get an adequately exposed picture if you just follow the simple instructions that come with the unit. The trouble is that this type of lighting is rather bland; the subject looks two-dimensional with texture and volume flattened out by the shadowless, frontal lighting. The fault lies not with the flash but with its position so close to the camera lens.

You can get more varied and interesting lighting with the flash in other positions, as shown opposite. The goal is the same as with photofloods, to make the lighting resemble natural illumination. Since almost all natural lighting comes from above the subject, good results come from a flash held above the level of the subject or bounced in such a way that the light comes from above. Light that comes from one side is also effective and usually more appealing than light that falls straight on the subject from the direction of the camera.

While the main light should be dominant, natural lighting, whether indoors or outdoors, rarely strikes a subject exclusively from one direction. For example, shadows may be filled in by light bounced off the ground or other surfaces. You can do the same with flash. Bouncing the main light onto the subject from another surface will diffuse some of the light and create softer shadows (see opposite, center and right). A diffusing screen over the flash head has a somewhat similar effect.

The duration of a flash burst is too short to see the effect of different positions while shooting. You have to aim the flash carefully so that the light doesn't create odd shadows or distracting reflections.

Direct flash on camera. This is the simplest method, one that lets you move around and shoot quickly. But the light tends to be flat, producing few of the shadows that model the subject to suggest volume and texture.

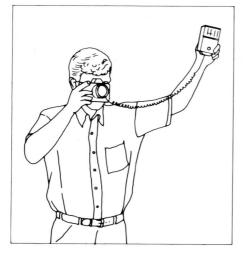

Direct flash off camera. Compared to on-camera flash, this produces more of a three-dimensional feeling. The flash is connected to the camera by a long synch cord and held at arm's length above and to the side. Attaching the flash to a light stand frees both hands for camera operation. Point the flash carefully at the most important part of the subject. You can't see the results as you shoot, so it's easy to let your aim wander.

Flash bounced from above. Bounce light is softer and more natural-looking than direct flash. The flash can be left on the camera if the flash has a head that swivels upward. In a room with a relatively low ceiling, the flash can be pointed upward and bounced off the ceiling (preferably neutral in color if you are using color film). A bounce-flash accessory simplifies bounce use: a card or miniumbrella clips above the flash head and the light bounces off that.

Flash bounced from side. For soft lighting, with good modeling of features, the light can be bounced onto the subject from a reflector or lightcolored wall (as neutral as possible for color film). Pages 282–283 show how to set a bounce flash exposure manually. You can use a flash unit in automatic mode if it has a sensor that points at the subject even when the flash head is swiveled up or to one side for bounce lighting.

Flash Plus Daylight

Flash can be used as a fill light outdoors. A sunny day is a pleasant time to photograph, but direct sunlight does not provide the most flattering light for portraits. Facing someone directly into the sun will light the face overall but often causes the person to squint. Turning someone away from the light can put too much of the face in dark shadow. Flash used as an addition to the basic exposure can open up dark shadows so they show detail (photographs this page). It is better not to overpower the sunlight with the flash, but to add just enough fill so that the shadows are still somewhat darker than the highlights-for portraits, about one or two stops (see box below).

Color reversal film, in particular, benefits from using flash for fill light. The final transparency is made directly from

Flash-Plus-Daylight Exposures

You can use flash outdoors during the day to decrease the contrast between shaded and brightly lit areas.

- 1 | Set both camera and flash to manual exposure operation. Set your camera shutter speed to the correct speed to synchronize with flash. Focus on your subject.
- 2 Meter the lighter part of the scene. Set your lens to the f-stop that combines with your shutter synchronization speed to produce a correct exposure for the existing light.

For a natural-looking fill light, you need to adjust the light from the flash so that it is about one stop less than that on the scene overall. There are several ways to do this depending on the equipment you have.

If a flash has adjustable power settings

After doing steps 1 and 2 above, let's assume that your film speed is ISO/ASA 100, your basic exposure is 1/60 sec at f/16, and the subject is 6 feet away (the distance can be read on the camera's lens barrel after focusing).

3 | Set in the film speed (100 in this example) on the flash calculator dial.

4 Line up on the dial the flash-to-subject distance (6 ft) with the camera f-stop (16).

the film in the camera, so it is not pos-

sible to lighten shadows by dodging

lighten shadows on a partly shaded

subject, flash can increase the light on

a fully shaded subject that is against a

brighter background (opposite page,

left). Without the flash, the photogra-

pher could have gotten a good expo-

sure for the brighter part of the scene or

for the shaded part, but not for both.

Flash was used to reduce the difference

day is used simply to lighten shadows

so they won't be overly dark. But you can also combine flash with existing

light for more unusual results (oppo-

Ordinarily, flash outdoors during the

in brightness between the two areas.

In much the same way as it is used to

them during printing.

site page, right).

5 Note the power setting that the dial indicates (such as full power. 1/2 power. 1/4 power). This setting will make the shaded area as bright as the lit area, a rather flatlooking light. To get the flash-filled shadows one stop darker than sunlit areas, set the flash to the next lower power setting (for example from full power to 1/2 power).

If a flash does not have adjustable power settings

Do steps 1, 2, and 3. Locate the f-stop (from step 2) on the flash calculator dial and find the distance that is opposite it. If you position the flash that distance from the subject, the light from the flash will equal the sunlight. To decrease the intensity of the light, drape one or two layers of white handkerchief over the flash head. Sometimes it's feasible to move the flash farther from the subject to decrease the amount of light reaching it (multiply the original distance by 1.4 for a one-stop difference between lit and shaded areas, multiply by 2 for a two-stop difference).

sunlit subject without fill

sunlit subject with flash fill

Shadows can be very dark in a sunlit scene, so dark that film will not record details in both the shadows and in brightly lit areas (left, top). For portraits or close-ups, such as flowers in nature, fill light will lighten the shadows and preserve detail in them (left, bottom).

Flash is also useful to lighten a nearby, fully shaded subject if in is against a much lighter background. With the flash you can get a good exposure for both the shaded and the lighter areas (opposite, left).

no flash—exposed for shaded foreground

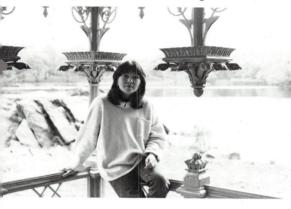

o flash—exposed for sunlit background

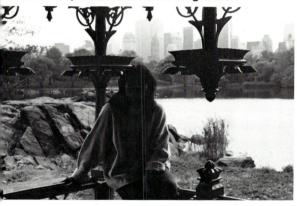

xposed for sunlit background lus flash to lighten shaded foreground

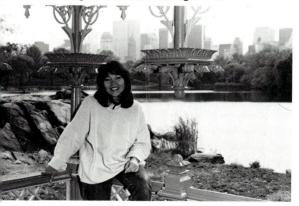

RICHARD MISRACH: Ocotillo, 1975

Richard Misrach combined two exposures—one with existing light, the other with flash—to create this image of a desert plant in its own pool of light. First he made a 5-second exposure with the light existing at dusk after the sun had gone down but while there was still a glow in the sky. Then he "fried" the plant in the foreground with a flash exposure. If he had exposed just for the sky, the plant would have been only a silhouette against the sky. If he had exposed just with flash, the sky would have been black. The combined exposures record a scene that is only visible with a camera.

What Went Wrong?

Troubleshooting Flash Problems

Until you have used flash often, it is difficult to tell exactly what effect its light will have. Shadows and reflections are nonexistent until the flash goes off, and even then they disappear too fast to be seen. The film records them, though, sometimes with the results shown here. See also Troubleshooting Camera and Lens Problems (page 83), Negative Problems (page 151), and Print Problems (page 181).

Unwanted reflections

Cause: Shooting at a shiny surface like glass that is parallel to the camera. Light from the flash reflected back into the lens (top photograph).

Prevention: When photographing scenes that include reflective shiny objects such as windows, mirrors, paneled walls, or metal surfaces, move the camera and/or the flash to one side so that you shoot or illuminate the scene at an angle to the reflecting surface (see second photograph). Eyeglasses can reflect the light; prevention same as for red eye, below.

Red eye—a person's or animal's eyes appear red in a color picture.

Cause: Light from the flash reflecting from the blood-rich retina inside the eye.

Prevention: Have the subject look away from the camera or move the flash away from the camera.

Unwanted shadows

Cause: Flash positioned off camera at an angle that caused shadows you didn't predict (see third photograph).

Prevention: Sighting along a line from flash to subject will help predict how shadows will be cast. A small tungsten light positioned close to the flash will also help; large studio flashes have such modeling lights built in for just this purpose.

Only part of frame exposed

Cause: Too fast a shutter speed with a camera that has a focal-plane shutter. The flash fired before the shutter was fully open (bottom photograph).

Prevention: Set your shutter to the correct speed for flash synchronization. Most single-lens reflex cameras have focal-plane shutters that synchronize at 1/60 sec (a few synchronize as fast as 1/200 sec). Check manufacturer's instructions.

Moving subject partly blurred

Cause: In addition to the flash-lit image, strong existing light in the scene recorded an image that

showed the subject in motion. The part of the subject lit by the flash is sharp, other parts lit mainly by the existing light are blurred.

Prevention: *Dim the existing light or shoot when the subject isn't moving so much.*

Subject too dark

Cause: Underexposure—too little light reached the film.

Prevention: If this happens once in a while, you may have made a simple error in flash or camera settings or shot before the flash ready light signalled that the unit was fully charged and ready to fire. In manual exposure, increase the exposure about a stop for scenes shot outdoors at night or in a large room like a gymnasium; the relatively dark surroundings absorb light that would otherwise bounce back to add to the exposure.

If your flash pictures are frequently too dark, your flash is putting out less light than you (or the manufacturer) think it is. If your flash has a calculator dial, decrease the film speed ratings that you set into it. Every time you cut the film speed in half you increase the exposure by one stop. For example, if your film speed is ISO/ASA 100 but you set 50 into the calculator dial, your pictures will get one stop more exposure. If you use a guide number to calculate exposure manually, divide the guide number by 1.4 for every stop you want the exposure increased.

Subject too light

Cause: Overexposure—too much light reached the film.

Prevention: Occasional overexposure may be due to an error in flash or camera settings. In manual exposure, close down the aperture about a stop when shooting in small, light-colored rooms to compensate for excess light bouncing back from walls and ceiling. If your flash pictures are usually overexposed, your flash is putting out more light than its nominal rating. Double the film speed or multiply the guide number by 1.4 for every stop you want exposure decreased.

Part of scene exposed correctly, part too light or too dark

Cause: Parts of the scene are at different distances from the flash. Parts that are farther away are darker than those that are close because the farther that light travels from the flash, the dimmer it becomes.

Prevention: *Try to group important parts of the scene at about the same distance from the flash.*

unwanted reflection—shot head-on

no reflection-shot at an angle

unwanted shadows

only part of frame exposed

Using Lighting

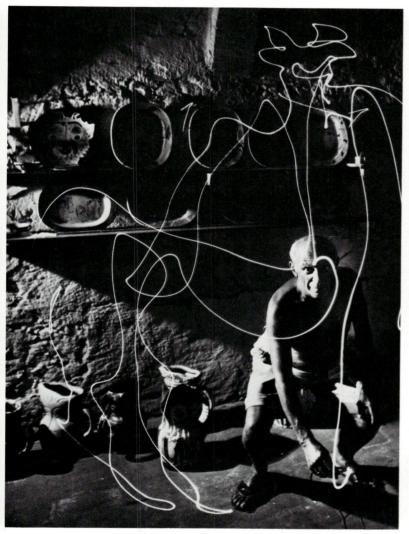

GJON MILI: Centaur by Picasso, Vallauris, France, 1949

The fanciful centaur drawn by Pablo Picasso exists only on film (above). The artist traced it in total darkness with a flashlight bulb while Gjon Mili kept his camera shutter open. Just before the drawing was complete, Mili triggered a flash, placed to the left. The flash caught Picasso at the end of the downstroke that completed his drawing.

ARCHIE LIEBERMAN: Motorola Design Engineers, Semiconductor Products Division, Motorola Inc., 1982

For a corporate report for Motorola, Inc., Archie Lieberman wanted to convey a high-tech image of the company. At one of Motorola's plants, Lieberman found a group of design engineers working at light tables. He chose the location in part because of the dramatic lighting he saw there. He used only the light existing in the room, bracketing his exposures so he could select the best one later—one shot at the exposure he thought might be best, a second with one stop less exposure, and a third with one stop more.

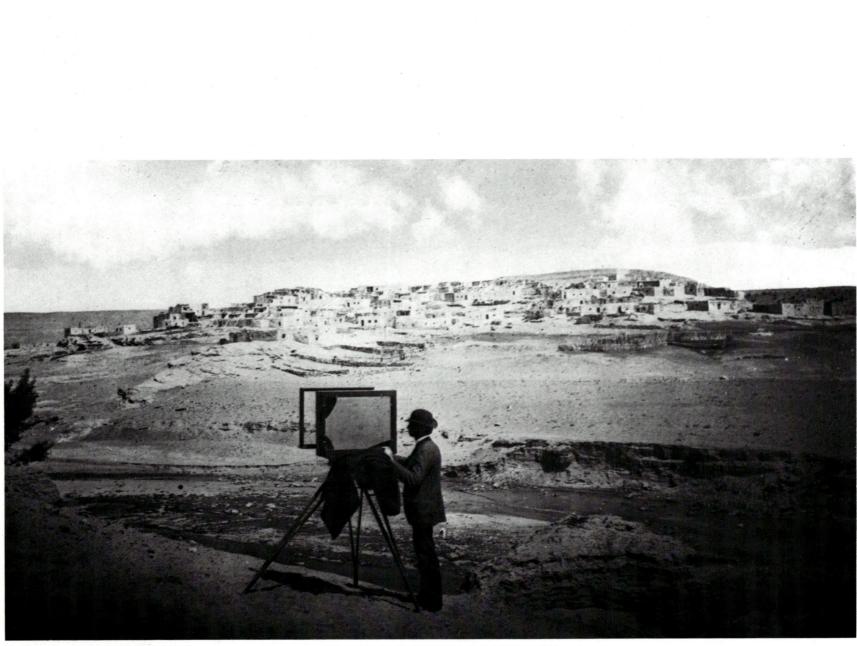

 $\label{eq:photographic} PHOTOGRAPHER \, \text{UNKNOWN: William Henry Jackson with his 20 \times 24-inch \ camera \ photographing \ Zuni \ Pueblo \ near \ Laguna, \ New \ Mexico, \ c. \ 1877$

12 View Camera

Inside the Modern View Camera 292 View Camera Movements 294 Rise and Fall 294 Shift 296 Tilt 298 Swing 300 Controlling the Plane of Focus 302 Controlling Perspective 304 Dealing with Distortion 306 What to Do First—and Next 307 Loading and Processing Sheet Film 308 Using a View Camera 310

In today's world of small, hand-held cameras that are fast working and convenient to use, why would a photographer use a bulky, heavy, slow-working **view camera**—a camera that has few or no automatic features, that must almost always be used with a tripod, that shows you an image that is upside down and backward and so dim that you need to put a dark cloth over the camera and your head to see it? The answer is that the view camera does some jobs so well that it is worth the trouble of using it.

A view camera's **movements** give you an extraordinary amount of control over the image. The camera's back (film plane) and front (lens board) can be independently moved in a number of directions: up, down, or sideways, tilted forward or back, swiveled to either side. These movements can change the area of the scene recorded on the film, change the most sharply focused subject plane, increase or decrease the depth of field, and alter perspective and distortion.

The **large film size** that can be used is also an advantage. The most common size is 4×5 inches; 5×7 , 8×10 inches, and sometimes larger sizes are also used. (Comparable European sizes range from 9×12 cm to 18×24 cm and larger.) While modern small-camera films ($1 \times 1\frac{1}{2}$ inches is the size of 35mm film) can make excellent enlargements, the greatest image clarity and detail and the least grain are produced by a contact print or a moderate enlargement from a large-size negative.

A view camera is the most satisfactory camera to use when control of the image is vital, as in architectural or product photography. Some photographers use a view camera in all but the fastest-moving situations because they feel that its benefits—the control gained, plus the detail a large-size negative records—more than compensate for any disadvantages.

In the early days of photography, a practical method of enlarging an image had not yet been devised. So if you wanted a big print, you made a big negative. Opposite: William Henry Jackson's 20 × 24-inch view camera was a standard size used for making scenic views. Jackson had to transport not only the view camera but as many 20 × 24-inch glass plates as he needed to make all the photography, see pages 364–365.)

12/View Camera

292

Inside the Modern View Camera

The ability of a view camera to change and control an image is due to its movements. Unlike most cameras, which are permanently aligned so that lens and film are exactly parallel, a view camera can be deliberately unaligned. The movements and their effects, explained on the following pages, are easier to understand if you have a view camera at hand so you can demonstrate the effects for yourself.

Rise, fall, and shift (also called slide) move the entire front or back of the camera in a flat plane. Rise moves the front or back up, fall moves the front or back down, shift moves the front or back to the left or right.

Tilt and swing move the front or back of the camera at an angle. Tilt moves the front or back around a horizontal axis: it tips either one forward or backward. Swing is a movement around a vertical axis; it twists the front or back

To make full use of a view camera's movements, you must use it with a lens of adequate covering power: that is, a lens that produces a large image circle. gets larger-as the lens is stopped down.

of the camera to the left or right.

parts

A lens

- **B** aperture scale
- C shutter-speed scale
- D lens board
- E lens-board-adjustment knob
- F front standard
- G front-standard-adjustment knob

movements

1 back-rise

2 back-fall

3 front-rise

4 front-fall

5 back-shift left

7 front-shift left

6 back-shift right

8 front-shift right

10 back-tilt forward

12 front-tilt forward

13 back-swing left

15 front-swing left

17 front focusing

18 back focusing

14 back-swing right

16 front-swing right

11 front-tilt backward

9 back-tilt backward

H shutter-release cable

M back-adjustment knob

- J bellows
- K | tripod mount
- L ground-glass viewing screen
- N back
- O back standard
- P back-standard-adjustment knob
- Q dark slide
- **R** film holder
- S film sheet

This simplified cutaway of a view camera makes ► clear its basic relationship to all cameras: it is a box with a lens at one end and a sheet of film at the other. Unlike other cameras, however, the box is not rigid. The front face, to which the lens is fastened, can be moved independently-up or down, forward or back-by loosening a pair of knobs (E). A second pair of knobs (M) permits similar movements of the back. Knobs (as in G and P) permit front or back to be shifted, swung, or focused. The camera-back (N) can be rotated to take a picture in either a horizontal or a vertical format. In addition, different sizes of film can be used by substituting film holders and camerabacks that are designed for those sizes. The front end of the camera will accept different lenses. Extra bellows can be inserted for extreme extensions in close-up work: or if the focal length of the lens is so short that the regular bellows cannot be squeezed tight enough, a bag bellows can be used (shown on page 302).

 A lens with good covering power (producing a large image circle) is needed for view camera use. Camera movements such as rise, fall, or shift move the position of the film within the image circle (as shown at left), so the lens should produce an image that is larger than the actual size of the film. The corners of the viewing screen should be checked before exposure to make sure the camera movements have not placed the film outside the image circle, vignetting the picture (dotted lines).

As shown below, a lens projects a circular image that decreases in sharpness and brightness at the edges. If a camera has a rigid body, the image circle needs to be just large enough to cover the size of the film being used. But a view camera lens must produce an image circle larger than the film size so that there is plenty of room within the image circle for various camera movements. If the movements are so great that the film comes too close to the edge of the image circle, the photograph will be vignetted—out of focus and dark at the edges. Covering power increases-the usable image circle

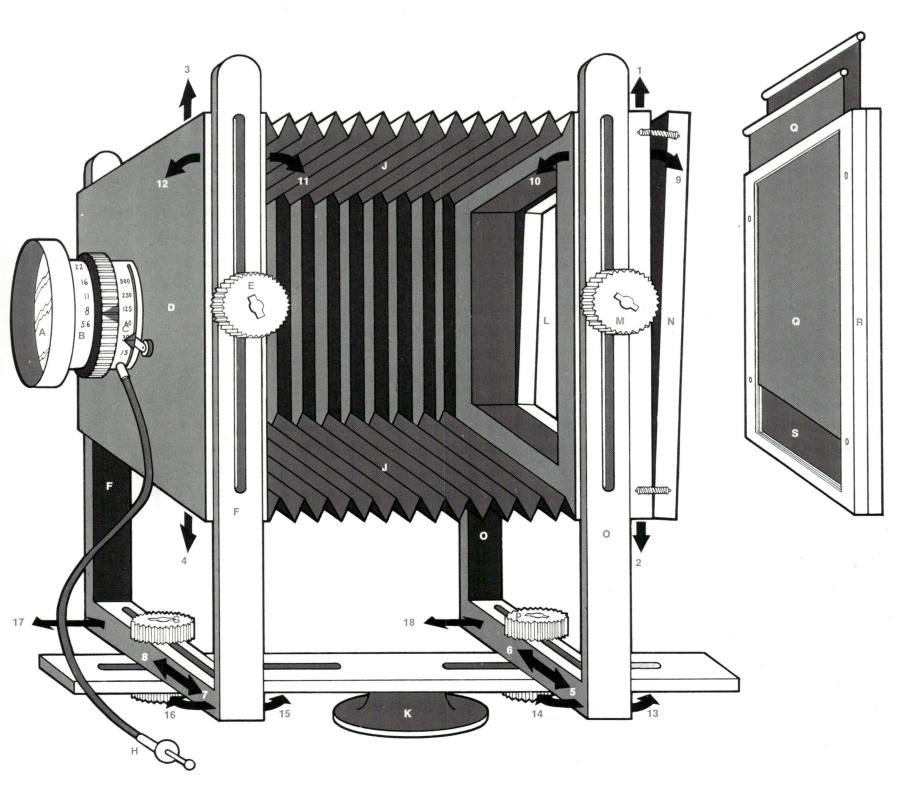

View Camera Movements Rise and Fall

controls zeroed

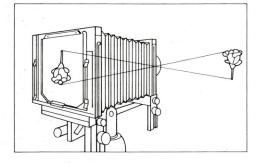

back-rise or front-fall

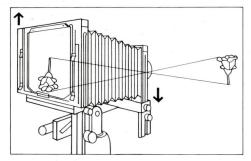

back-fall or front-rise

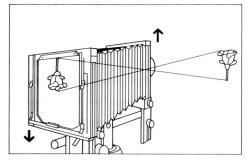

The diagrams above show how rise or fall of the camera's front or back changes the position of the image on the negative. In the top diagram, the object being photographed appears in the center of the ground-glass viewing screen. It is inverted (upside down and reversed left to right). In the center diagram, the object has been moved to the bottom of the viewing screen (the top of the picture when viewed right side up); this is accomplished by either raising the back or lowering the lens. To move the object to the top of the viewing screen (the bottom of the actual picture), lower the back or raise the lens (bottom diagram).

It is easier to understand the effect each movement can have on a photograph if you first look at a picture where no movement has been set into any part of the camera. This has been done with the first cube at right. Camera position was centered on the cube. All controls were set at zero. Focus was on the top front edge.

The result is an image that falls in the center of the picture frame. The cube's top front edge, being closest to the camera, is the largest. It is also the sharpest, since it lies along the focal plane. The two visible surfaces of the cube fall away in size and sharpness at an equal rate. If you compare this reference cube to the photographs of it that follow, you can see the changes in its shape, sharpness and position that take place as a result of camera movements.

Rise, an upward movement, and fall, a downward movement, of the camera's front or back, change the placement of the image on the film by changing the position of film and lens relative to each other. Moving the back moves the film to include various parts of the image circle. Moving the front moves the image circle so that a different part of it falls on the film.

Rise or fall of the back changes the location of the image but does not affect its shape. The effect is not unlike cropping a photograph during printing —the amount of the object shown or its position within the frame may change but not the shape of the object itself. Front movement changes the point of view and to some extent the shape. In these pictures, the change in shape is too slight to be seen in the cube, but the difference in point of view is visible in the change of relationship between the cube and the small post. Rise and fall are up or down movements. Rise or fall of the front or back changes the position of the image in the frame. Rise or fall of the front also affects the position of foreground and background objects relative to each other.

For the sake of simplicity, the pictures and text at right relate not to the inverted (upside down and backwards) image seen on the ground-glass viewing screen, but to the photograph as you would see it after it was printed. The diagrams at left show the image as you would see it while you were focusing and adjusting the camera.

reference cube

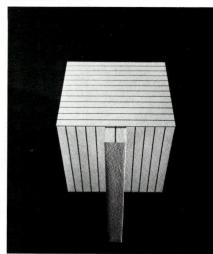

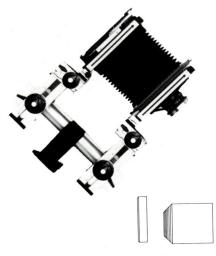

The reference cube was shot with all camera adjustments set at zero position, looking down from an angle of 45°. This puts the cube in the center of the film and produces a symmetrical figure.

back-fall

front-rise

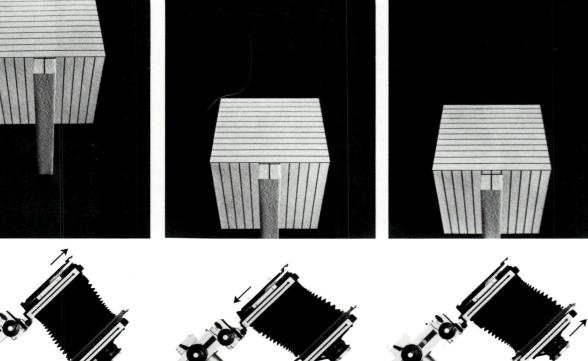

front-fall

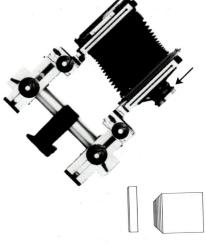

Raising the back of the camera moves the cube higher on the film without changing its shape. Nor does this movement affect the position or shape of the small post that has been centered exactly in front of the cube, with its top in line with the cube's front edge as comparison with the photograph of the reference cube shows. Lowering the back of the camera lowers the position of the cube on the film. Other than that, as before, there is no change in the shape of the cube or in its relationship with the post. This happens because the film, though raised or lowered, still gets the same image from the lens, which has not moved relative to the original alignment of cube and post. Raising the lens lowers the image of the cube on the film. In this its effect is the same as back-fall. However, lens movement causes a change that does not occur with back movement: it affects the relationship between cube and post because the lens is now looking at them from a slightly different position. Compare the apparent height of the post here with its height in the two pictures at left. A drop in the lens raises the image on the film. Lens movement also affects the space relationship between cube and post. Now the post top appears to have moved above the front edge of the cube, whereas in the previous picture it dropped below the edge.

Shift

controls zeroed

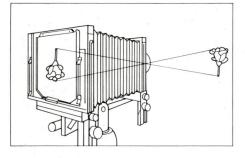

back-shift left or front-shift right

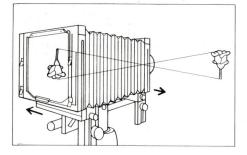

back-shift right or front-shift left

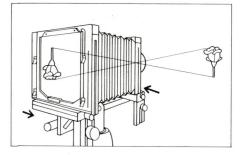

In the diagrams above, the position of the cube on the negative is moved by shifting the camera's front or its back to the side. In the top diagram, the controls are zeroed and the image is in the center of the viewing screen. In the center diagram, the object has been moved to the right side of the viewing screen (left side of the actual photograph) by moving the camera-back to the left or the lens to the right. To move the object to the other side of the picture, move the back to the right or the lens to the left (bottom diagram). Shift, a sideways movement of either the front or the back of the camera, is the same as rise and fall except the movement takes place from side to side. If you were to lay the camera on its side and raise or drop the back, you would produce the same effect as backshift.

The reason that rise and fall are the same as shift is that neither changes the angle between the planes of film, lens, and subject. Raise, lower, or shift the back of the camera, and the film is still squarely facing the lens; the only difference is that a different part of the film is now directly behind the lens.

Since shift is simply a sideways version of rise and fall, the results are similar. Back movement to the left moves the subject to the left; back movement to the right moves it to the right. Left or right lens movements have just the opposite results. Image shape does not change with back-shift, but it does change slightly with front-shift.

Again in common with rise and fall, shift of the lens affects the spatial relationship of objects because the lens views them from a different point. The examples at right illustrate these movements, with the reference cube included for comparison.

Remember that the cubes are shown here right side up as they would appear in the final prints. On the ground glass the image is inverted as shown in the diagrams at left. Shift is a sideways movement. Shift of the front or back changes the position of the image in the frame. Shift of the front also affects the position of foreground and background objects relative to each other.

reference cube

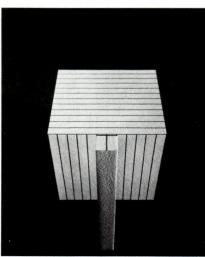

Shift, like rise and fall, has no perceptible effect on the shape of an object. Compare the reference cube with the four cubes to the right of it. While the cubes move back and forth on the film, they continue to look very much the same.

back-shift right

front-shift left

A camera equipped with a back that can move the film from side to side, as well as up and down, can place an object wherever desired on a sheet of film. Here a shift of the cameraback to the left moves the cube to the left on the film.

A rightward movement of the camera-back moves the image to the right. Comparison of this picture with the previous one reveals that there has been no change in the shape of either the cube or the post in front of it. Their spatial relationship has remained unchanged also, despite the movement of the image on the film. Moving the lens to the left moves the image on the film to the right. It also changes the relationship of post to cube. Since the lens actually moves to left or right, it views the two objects from a slightly different position, and so one object appears to have moved slightly with respect to the other. Check the position of the post against the vertical lines on the cube in this picture and the next to confirm this change.

A rightward movement of the lens, as above, (1) moves the image to the left and (2) changes the relationships in space between objects. To summarize: if you want to move the image on the film but otherwise change nothing, raise, lower, or shift the back. If you want to move the image and also change the spatial relationship of objects, raise, lower, or shift the lens.

front-shift right

Tilt

controls zeroed

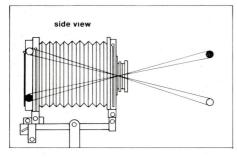

back-tilt of camera-back

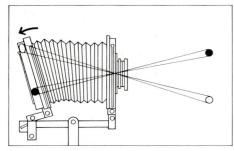

forward-tilt of camera-back

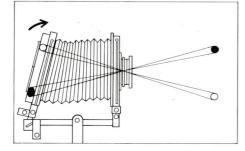

The diagrams above show how the shape of objects can be changed by tilting the cameraback. In the top diagram, two objects of identical size, placed the same distance from the camera, are being photographed. When the camera controls are zeroed, the objects appear the same size on the viewing screen. In the center diagram, the camera-back has been tilted back. Now when the image leaves the lens, it has to travel farther to reach the top of the viewing screen than it does to reach the bottom. As the light rays travel, they spread apart, increasing the size of the object on the top of the viewing screen (the bottom of the actual photograph). To increase the size of an object on the bottom of the viewing screen, tilt the camera-back forward (bottom diagram).

The preceding pages show that rise, fall, and shift have little or no effect on the shape of an object being photographed because they do not change the angular relationship of the planes of film, lens, and object. But what happens with **tilt**, **an angled forward or backward movement** of either the camerafront or camera-back? That depends on whether you tilt the front or back of the camera.

Tilting the back of the camera changes the shape of the object considerably and changes the focus somewhat. Tilting the front of the camera changes the focus significantly without changing the shape of the object.

To understand why this happens, look again at the reference cube. In that picture the bottom of the film sheet was the same distance from the lens as the top of the film sheet. As a result, light rays coming from the lens to the top and the bottom of the film traveled the same distance, and the top back edge and the bottom front edge of the cube are the same size in the photograph. But change those distances by tilting the camera-back, and the sizes change. The rule is: the farther the image travels inside the camera, the larger it gets. Since images appear upside down on film, tilting the top of the camera-back to the rear will make the bottom of an object bigger in the photograph (diagrams, left).

A tilt of the camera-front does not change distances inside the camera and thus does not affect image size or shape, but it does affect focus by altering the lens's focal plane. Tilting the lens will bring the focal plane more nearly into parallel with one cube face or the other and thereby will improve the focus on that face and worsen it on the other. Tilt is an angled forward or backward movement. Tilt of the back mostly affects the shape of an object, and so helps to control convergence. Tilt of the front mostly affects the plane of focus, and so helps to control depth of field.

reference cube

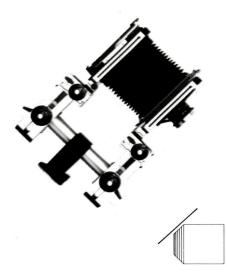

Checking the reference cube again, note that the 45° angle of view has produced an image that falls off in both size and sharpness at an equal rate on both the top and the front faces. As a result the two faces are exactly the same size and shape. Note also that the vertical lines on the front face are not parallel, but converge (come closer together) toward the bottom. back-tilt of the camera-back

forward-tilt of the camera-back

back-tilt of the camera-front

forward-tilt of the camera-front

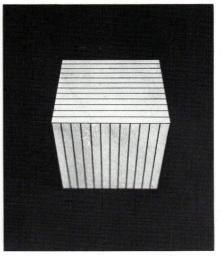

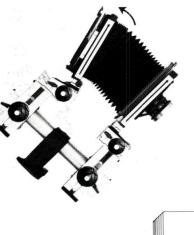

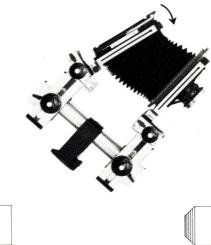

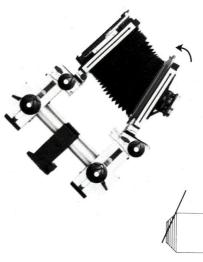

When the back of the camera is tilted so that the top of the film is farther away from the lens than in the reference shot, this movement enlarges the bottom of the cube and tends to square up its front face, bringing its lines more nearly into parallel. At the same time, this tilt has moved the bottom of the film closer to the lens than it was in the reference shot, shrinking the top back edge of the cube so that it converges more than before. If the back of the camera is tilted the other way, so that the top of the film is forward and the bottom is moved away from the lens, the top of the cube tends to square up and the front bottom converges more. Squaring up one face of the cube results in increasing light loss and increasing fuzziness toward the far edge of the squared face. In this case the back edge of the top face is affected. In the picture at left the bottom edge of the front face is affected. When the lens is tilted, there is no change in the distance from lens to film; thus there is no change in the shape of the cube. However, there is a distinct change in focus. Here the lens has been tipped backward. This brings its focal plane more nearly parallel to the front face of the cube, pulling all of it into sharp focus. The top of the cube, however, is now more blurred than in the reference shot. If the lens is tilted forward, the top of the cube becomes sharp and the front more blurred. The focus control that lens-tilt gives can be put to good use when combined with back-tilt. Look again at the two back-tilt shots at the left; their squared—and blurry—sides could have been made much sharper by tilting the lens to improve their overall focus.

Swing

controls zeroed

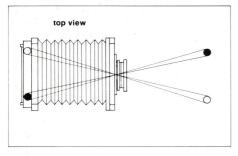

left-swing of camera-back

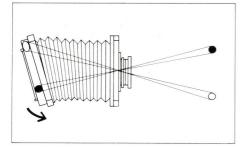

right-swing of camera-back

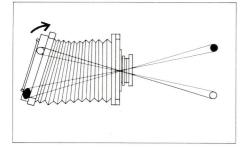

Swinging the camera-back changes the shape of objects by changing the angle between the camera-back and the lens. This top view of a camera shows why. As with back-tilt, if part of an image has to travel farther to reach the camera-back, it will increase in size. In the top diagram, both objects are the same size and the camera's controls are zeroed. In the center diagram, the image on the left side of the viewing screen (the right side of the actual photograph) has been increased in size by swinging the camera-back to the left. To change the size of the image on the right side of the viewing screen, swing the camera-back to the right (bottom diagram). Swing, an angled left or right movement of either the front or the back of the camera, has different effects depending on whether the front or back is swung.

Swinging the back of the camera, like tilting the back, moves one part of the film closer to the lens while moving another part farther away. This produces changes of shape in the image plus some change in focus (*diagrams, left*).

Swinging the front of the camera swivels the lens to the left or right and as a result skews the focal plane of the lens to one side or the other. The general effect is to create a sharply defined zone of focus that travels at an angle across an object. A close look at the two right-hand cubes on the opposite page reveals this. There is a narrow diagonal path of sharp focus traveling across the top of each cube and running down one side of the front.

The practical applications of the four camera movements are virtually endless. For example, assume that the reference cube is a house with a large garden in front of it. Raising the back of the camera (page 295, first picture) will raise the image on the film and show more of the garden. Or assume that you wish to increase the apparent height of the house. Tilting the back of the camera toward the front (page 299, second picture) is one way to produce that effect. The following pages show how swings, tilts, rises, and shifts can be applied in real situations to solve specific photographic problems.

Swing is an angled left or right movement. Swing of the back mostly affects the shape of an object, and so helps to control convergence. Swing of the front mostly affects the plane of focus, and so helps to control depth of field.

reference cube

Comparing the reference cube to the pictures at right shows the distortions in shape that can be made by changing the angle of film to lens. Compare the cube with the first two pictures on its right. If you didn't understand the process by which such changes can be made, it would be hard to know that these swing shots —or the two back-tilt shots on the previous page—are all of the same object, taken from the same spot with the same camera and lens.

left-swing of the camera-back

right-swing of the camera-back

left-swing of the camera-front

right-swing of the camera-front

This movement of the camera-back swings the left side of the film away from the lens and the right side closer to it, making the left side of the cube smaller and the right side larger. (Remember, the image is inverted on the ground glass.) This effect is the same as tilt, but sideways instead of up and down.

Here the right side of the film is swung away from the lens and the left side closer to it. The results are the opposite of those in the previous picture. In both of them it can be seen that there is a falling off of sharpness on the "enlarged" edges of the cube. This can be corrected by swinging the lens or by closing the aperture a few stops to increase depth of field. Since it is the lens that is being swung, and not the film, there is no change in the cube's shape. However, the position of the focal plane has been radically altered. In the reference shot it was parallel to the near edge of the cube, and that edge was sharp from one end to the other. Here the focus is skewed. Its plane cuts through the cube, on a course diagonally across the top and down the left side of the cube's face.

Here is the same phenomenon as in the previous picture, except that the plane of sharp focus cuts the cube along its right side instead of its left. This selectivity of focus, particularly when tilt and swing of the lens are combined, can move the focal plane around very precisely to sharpen certain objects and throw others out of focus. For a good example of this, see page 303.

Controlling the Plane of Focus

The photograph above is partly out of focus because the camera-back (line aa') and lens plane (line bb') are parallel to each other but not to the subject plane (line cc').

Tilling the front of the camera forward so that the lens plane is more nearly parallel to the subject plane brings the entire page into sharp focus. The diagrams show a loose bag bellows on the camera instead of a regular accordion bellows.

Controlling the plane of focus—the part of a scene that is most sharply focused—is easy with a view camera. Not only can you see on the ground-glass viewing screen exactly where the plane of focus is, but you can adjust its position by tilting or swinging the front of the camera and so the lens.

With a camera that does not have swings and tilts, the lens plane (the front of the camera) is always parallel to 302 the film plane (the back of the camera), and the plane of focus is parallel to both. You increase the depth of field (the area near the plane of focus that will also be sharp) by stopping down the lens aperture.

h

The disadvantage of using a camera without swings and tilts becomes evident when photographing something that is not parallel to the camera, like the rare book above. You must angle the camera down at the book. If you focus on the part of the book close to the camera, the top of the book is blurred and vice versa. A compromise focus on the middle of the page might not give enough depth of field even if you stopped the lens all the way down.

A view camera can get around this problem. The plane of the subject that is most nearly parallel to the plane of the lens will be the sharpest in the pic-

With the camera's back and front in zero position, a close-up shot of some spilled beans requires that the lens be stopped down for both the foreground beans and those in the jar to be perfectly sharp. This also brings the other jars into focus which the photographer did not want.

A simple swing of the camera-front to the right brings the lens plane parallel to the receding pile of beans—all the way from the right foreground back through the tipped-over jar. Now the photographer can focus on the beans and open up the lens to its maximum of f/5.6, which throws the other jars out of focus and directs attention to the beans.

ture. As shown above, you can increase the sharpness of the book page by tilting the camera-front forward so that the lens is more nearly parallel to the page. If the page is still not completely sharp, stopping down the lens aperture will increase the depth of field so that more of the page will be sharp.

Furthermore, if you adjust a view camera so that the planes of film, lens, and subject all meet at a common point, the subject plane will be completely sharp, even if the plane of the subject is not parallel to the plane of the lens and if the lens is opened to its widest aperture. This phenomenon (named the Scheimpflug rule, after its discoverer) is diagrammed on the opposite page. Fortunately, you don't have to calculate the hypothetical meeting point of the planes (you will be able to see on the ground glass when the image is sharp). but it does explain why a plane can be sharp even if it is not parallel to the lens.

If you want only part of the picture to be sharp, this too is adjustable with a view camera. By swinging or tilting the camera-front, the plane of focus can be angled across the picture, as in the photographs above of the spilled beans.

Controlling Perspective

A view camera is often used in architectural photography for **controlling perspective.** It is almost impossible to photograph a building without distortion unless a view camera is used. You don't *have* to correct the distortion, but a view camera provides the means if you want to do so.

Suppose you wanted to photograph the building at right with just one side or face showing. If you leveled the camera and pointed it straight at the building, you would show only the bottom of the building (first photograph, right). Tilting up the camera shows the entire building but introduces a distortion in perspective (second photograph): the vertical lines seem to come together or converge. This happens because the top of the building is farther away and so appears smaller than the bottom of the building. When you look up at any building, your eyes also see the same converging lines, but the brain compensates for the convergence and it usually passes unnoticed. In a photograph, however, it is immediately noticeable. The view camera cure for the distortion is shown in the third photograph. The camera is adjusted to remain parallel to the building (eliminating the distortion), while still showing the building from bottom to top.

Another problem arises if you want to photograph a building with two sides showing. In the fourth photograph, the vertical lines appear correct but the horizontal lines converge. They make the near top corner of the building seem to jut up unnaturally sharp and high in a so-called **ship's-prow effect**. Swinging the back more nearly parallel to one of the sides (usually the wider one) reduces the horizontal convergence and with it the ship's prow (*last photograph*).

Photographer Philip Trager uses a view camera for his architectural work, such as the photograph on page 310. Here he demonstrates its usefulness. Standing at street level and shooting straight at a building produces too much street and too little building. Sometimes it is possible to move back far enough to show the entire building while keeping the camera level, but this adds even more foreground and usually something gets in the way.

Tilting the whole camera up shows the entire building but distorts its shape. Since the top is farther from the camera than the bottom, it appears smaller; the vertical lines of the building seem to be coming closer together, or converging, near the top. This convergence gives the illusion that the building is falling backward—an effect particularly noticeable when only one side of the building is visible.

To straighten up the converging vertical lines, keep the camera-back parallel to the face of the building. To keep all parts of the building in focus, make sure the lens is parallel to the camera-back. One way to do this is to level the camera and then use the rising-front or falling-back movements or both. Another solution is to point the camera upward toward the top of the building, then use the tilting movements—first to tilt the back to a vertical position (which squares the shape of the building), then to tilt the lens so it is parallel to the camera-back (which brings the face of the building into focus). You may need to finish by raising the camera-front somewhat.

In this view showing two sides of a building, the camera has been adjusted as in the preceding picture. The vertical lines of the building do not converge, but the horizontal lines of the building's sides do, since they are still at an angle to the camera. This produces an exaggeratedly sharp angle, called the ship's-prow effect, at the top left front corner of the building.

Two more movements are added, as shown in this top view of the camera. The ship's-prow effect is lessened by swinging the camera-back so it is parallel to one side of the building. Here the back is parallel to the wider side. The lens is also swung so it is parallel to the camera-back, which keeps the entire side of the building in focus. It is important to check the edges of the image for vignetting when camera movements are used.

Dealing with Distortion

Every attempt to project a three-dimensional object onto a two-dimensional surface results in a distortion of one kind or another. Yet cleaning up distortion in one part of a photograph will usually produce a different kind of distortion in another part. The book and orange in the two still lifes at right are examples of this. In the first picture, shot from above with all camera adjustments at zero, the book shows two kinds of distortion. Since its bottom is farther away from the camera than the top, the bottom looks smaller. Also the book seems to be leaning slightly to the left. These effects would have been less pronounced if the camera had been farther away from the book-the farther away an object is from a lens, the smaller are the differences in distance from the lens to various parts of the object. It is these differences that cause distortions in scale.

Can distortion be corrected? It can with a view camera, using a combination of tilt, swing, and fall. Back-tilt of the camera-back straightens the book's left edge. A left-swing of the cameraback squares up the face of the book. Since these changes enlarged the image somewhat, back-fall was added to show all of the book.

In the result a less distorted picture? That depends. The book is certainly squared up nicely, as if were being looked at head on, but the spine, oddly enough, is still visible. Furthermore, the round orange of the first picture has now become somewhat melon-shaped. All pictures contain distortions; what you must do is manipulate them to suit your own taste.

With camera settings at zero, a downward view of a book makes the upper part seem larger than the lower part—just as the top front edge of the cube on page 298 looks larger than the bottom edge. The book also appears to be tipping to the left. The orange, on the other hand, a sphere seen straight on in the center of the picture, appears normal.

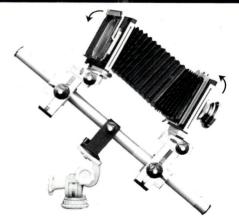

The book is straightened by back-tilt and leftswing of the back, but this forces the orange out of shape. These back movements also affected the focus; it was necessary to back-tilt the lens and swing it to the left to bring the lens—and so the plane of focus—into better line with the book's face.

What to Do First—and Next

Because a view camera is so adjustable, its use requires the photographer to make many decisions. A beginner can easily get an I-don't-know-what-todo-next feeling. So here are some suggestions.

1. Set up the camera and zero the controls. Set the camera on a sturdy tripod, attach a cable release to the shutter mechanism, point the camera toward the scene, zero the controls, and level the camera (*below left*). Open the shutter for viewing and open the lens aperture to its widest setting. You will almost always need to use a focusing cloth to see the image clearly (*center*).

2. Roughly frame and focus. Adjust the back for a horizontal or vertical for-

mat and roughly frame the image on the ground glass. Roughly focus by adjusting the distance between the camerafront and camera-back. The closer you are to the subject, the more you will need to increase the distance between front and back.

3. Make more precise adjustments. To change the shape or perspective of the objects in the scene, tilt or swing the camera-back. You may also want to move the position of the image on the film by adjusting the tripod or using the rising, falling, or shifting movements. Now check the focus (*right*). If necessary, adjust the plane of focus by tilting or swinging the lens. You can preview the depth of field by stopping down the lens diaphragm.

4. Make final adjustments. When the image is the way you want it, tighten all the controls. Check the corners of the viewing screen for possible vignetting. You may need to decrease some of the camera movements (especially lens movements) to eliminate vignetting.

5. Make an exposure. Close the shutter, adjust the aperture and shutter speed, and cock the shutter. Now insert a loaded film holder until it reaches the stop flange that positions it. Remove the holder's dark slide to uncover the sheet of film facing the lens, make sure the camera is steady, and release the shutter. Replace the dark slide so the all-black side faces out. Your exposure is now complete.

leveling camera

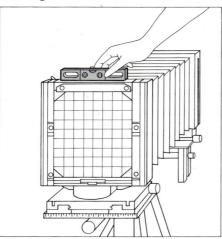

Zero the controls and level the camera before making any other adjustments. Zeroing is important because even a slight tilt or swing of the lens, for example, can distinctly change the focus. A spirit level, like a carpenter uses, levels the camera. Vertical leveling is important if you want the camera to be parallel to a vertical plane such as a building face. Horizontal leveling (above) is vital; without it the picture may seem off balance even if there are no horizontal lines in the scene.

using focusing cloth

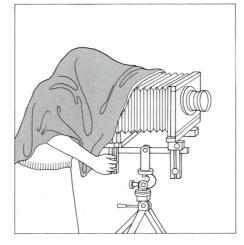

The view camera's ground glass shows a relatively dim image. A focusing cloth that covers the camera-back and your head makes the image much more visible by keeping out stray light. You may not need the cloth if the subject is brightly lighted in an otherwise darkened room, but in most cases it is a necessity. Some photographers like a twolayer cloth—black on one side and white on the other—to reflect heat outdoors and to double as a fill-light reflector.

checking focus

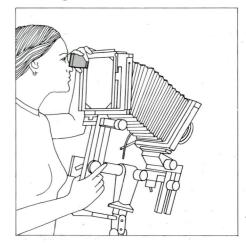

A hand-held magnifier, sometimes called a loupe, is useful for checking the focus on the ground glass. Check the depth of field by examining the focus with the lens stopped down. The image will be dim but can usually be judged if you let your eyes become accustomed to the lower level of illumination. Using a focusing cloth helps. Examine the ground glass carefully for vignetting if camera movements (especially lens movements) are used.

Loading and Processing Sheet Film

Using sheet film is easy once you have practiced the procedures a few times, but do pay attention to some important details. Film is loaded in total darkness into sheet-film holders that accept two sheets of film, one on each side. Each sheet is protected by a light-tight dark slide that is removed after the holder is inserted in the camera for exposure. The film must be loaded with the emulsion side out: film loaded with the backing side out will not produce a usable image. The emulsion side is identified by a notching code; when the film is in a vertical position, the notches are in the upper right-hand (or lower lefthand) corner when the emulsion side of the film faces you. After exposure but before you remove the holder from the camera, insert the holder's slide with the all-black side facing out; this is the only way to tell that the film has been exposed and to avoid an unintentional double exposure. Some points on loading film holders are given in the pictures and captions on this page.

Developing sheet film follows the same basic procedure as developing roll film, except three tanks or trays are used—for developer, stop bath, and fixer. Some photographers add a fourth step, a water presoak before development. The film is agitated and transferred from one solution to the next in total darkness; it is not feasible to do this with just one tank as is possible with roll film. Fill tanks with enough solution to more than cover the film in the hanger. Fill trays deep enough for the number of sheets to be developed one inch is probably a minimum.

Check the instructions carefully for the proper development time. The time will depend on whether you use intermittent agitation in a tank or constant agitation in a tray.

dusting holders

It is a good idea to dust the film holders each time before loading them. This is much less trouble than trying to etch off a dark spot on your print caused by a speck of dust on the unexposed film. A soft, wide paintbrush (used only for this purpose) or an antistatic brush works well. Dust both sides of the dark slide, under the film guides, and around the bottom flap.

checking film insertion

The film is inserted in the bottom (flap) end of the holder underneath narrow metal guides. If you rest your fingers lightly on top of the guides you can feel even in the dark if the film is loading properly. Also make sure that the film is inserted all the way past the raised ridge at the flap end. When the film is in, hold the flap shut with one hand while you push the dark slide in with the other.

checking notching code

Sheet film has a notching code—different for each type of film—so you can identify it and determine the emulsion side. The notches are always located so the emulsion side is facing you when the film is in a vertical position and the notches are in the upper right-hand corner. Load the film with the holder in your left hand and the film in your right with your index finger resting on the notches. (If you are left-handed you may want to load with the holder in your right hand and the film in your left.)

unexposed/exposed film

The dark slide has two different sides—one all black, the other with a shiny band at the top—so you can tell if the film in the holder is unexposed or exposed. When you load unexposed film, insert the slide with the shiny side out. After exposure, reinsert the slide with the all-black side facing out. The shiny band also has a series of raised dots or a notch so you can identify it in the dark.

loading hangers

Tank development using film hangers is a convenient way to develop a number of sheets of film at one time. The hanger is loaded in the dark. First spring back its top channel. Then slip the film down into the side channels until it fits into the bottom channel. Spring back the top channel, locking the film in place. Stack loaded hangers upright against the wall until all the film is ready for processing.

tank development

Hold the stack of loaded hangers in both hands with your forefingers under the protruding ends. Don't squeeze too many hangers into the tank; allow at least ½ inch of space between hangers. To start development, lower the stack into the developer. Tap the hangers sharply against the top of the tank to dislodge any air bubbles from the film (this is not necessary if the film has been presoaked in water before development). Make sure the hangers are separated.

tank agitation

Agitation for tank development takes place for about 8 sec, once for each minute of development time. Lift the entire stack of hangers, completely out of the developer. Tip it almost 90° to one side to drain the developer from the film. Replace it in the developer. Immediately lift the stack again and tilt almost 90° to drain to the opposite side. Replace in solution. Make sure the hangers are separated. Always remove and replace hangers slowly.

tray development

Tray development is easy if you have just a few sheets of film to process. Fan the sheets so that they can be grasped quickly one at a time. Hold the film in one hand. With the other hand take a sheet and completely immerse it, emulsion side up, in the developer. Repeat until all sheets are immersed. (A water presoak before development is useful to prevent the sheets from sticking to each other.) Touch the film as little as possible especially the emulsion side—to avoid scratches.

tray agitation

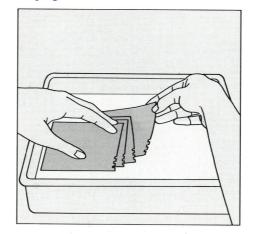

All the film should be emulsion side up toward one corner of the tray. Slip out the bottom sheet of film and place it on top of the pile. Gently push it under the solution. Continue shuffling the pile of film a sheet at a time until the end of the development period. If you are developing only a single sheet of film, agitate by gently rocking the tray back and forth, then side to side.

washing and drying

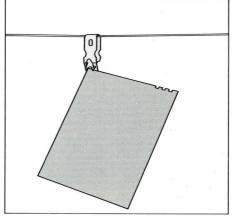

Film in hangers can be washed and then hung up to dry right in the hangers or it can be dried on a line as shown above. Separate the film enough so that the sheets do not accidentally stick together. A few loose sheets of film at a time can be washed in a tray, but the water flow must be regulated carefully to avoid excessive swirling that could cause scratching.

Using a View Camera

PHILIP TRAGER: New York, 1979

Above and opposite, two photographs that demonstrate why many photographers like to use a view camera. The front and back of the camera are adjustable, which gives extensive control over the perspective and sharpness of an image. For example, in the photograph above, Phil Trager raised the front instead of tilting up the camera, which gave the height he wanted to show but prevented convergence of vertical lines; then he swung the camera-back to the left to avoid excessive convergence of horizontal lines; and swung the camera-front to the left to align the plane of focus with the front of the buildings so that the entire row of buildings was sharp. Michael A. Smith used an 8 × 10 view camera for ► the photograph opposite. The large film size that a view camera accepts can record subtle details of texture and tonality that a small-format negative cannot, details that are even more evident in an original print than in a book reproduction.

MICHAEL A. SMITH: Canyon de Chelly, Arizona, 1975

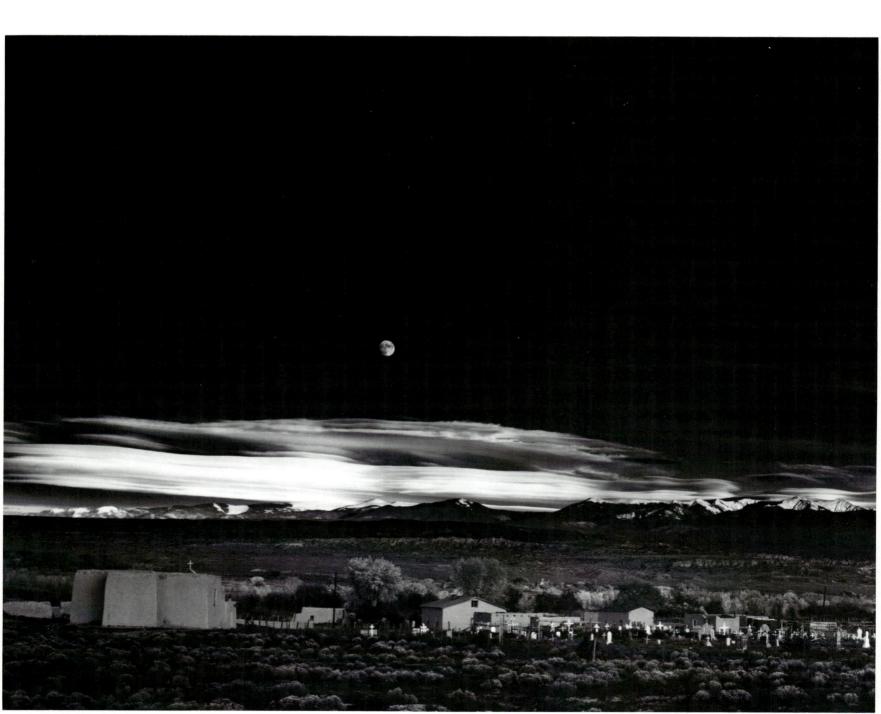

ANSEL ADAMS: Moonrise, Hernandez, New Mexico, 1941 312

13 Zone System

The Zone System Scales 314 Using the Zone Scale While Metering 316 How Development Controls Contrast 318 A Full-Scale Print 320 Using the Zone System 322 Putting It All Together 324

Have you ever looked at a scene and known just how you wanted the final print to appear? Sooner or later every photographer does. Sometimes the image turns out just the way you expected, but as often as not for the beginning photographer, the negative you end up with makes it impossible to produce the print you had in mind. For example, the contrast range of a scene (the difference between its lightest and darkest parts) is often greater than the contrast range of photographic materials. The scene may have a greater range of tones than the negative can record or the paper can print. The result is highlights so light and/or shadows so dark that details in them are completely lost.

The **Zone System** is a method conceived by Ansel Adams (*photograph* opposite) and Fred Archer for controlling the black-and-white photographic process. It applies the principles of **sensitometry** (the measurement of the effects of light on light-sensitive materials) to organize the many decisions that go into exposing, developing, and printing a negative. Briefly, it works this way. You make exposure meter readings of the luminances (the lightness or darkness) of important elements in the scene. You decide what print values (shades of gray) you want these elements to have in the final print. Then you expose and develop the film to produce a negative that can, in fact, produce the print you had visualized.

Luminances in a scene can be pegged to precise values through the systematic application of an old photographic rule of thumb: **expose for the shadows and develop for the highlights.** Exposure largely controls density and detail in thin areas of the negative (which produce dark or shadow areas in the print), whereas exposure *plus* development affect negative density and detail in the dense areas (which produce light areas in the print). In effect, development controls contrast in a negative, and you can increase contrast by increasing development or decrease it by decreasing development. Pages 318–319 explain this further.

The Zone System allows you to visualize how the tones in any scene will look in a print and to choose either a literal recording or a departure from reality. Even if you continue to use ordinary exposure and development techniques, understanding the Zone System will help you apply them more confidently. This chapter is only a brief introduction to show the usefulness of the Zone System. Other books that tell how to put it into full use are listed in the Bibliography.

Ansel Adams remains the acknowledged master of the grand landscape. His great vistas are mythic images that reinforce our romantic ideals of nature. Adams was a superb technician who controlled his medium completely to amplify and bring to life the tonalities in an image. No book reproduction can convey the range of tones in the original print, from the glowing brilliance of the clouds and crosses to the subtle detail in the dark shadows. The photograph is everything that we imagine such a scene might look like in reality and for many of us will forever serve as a substitute.

The Zone System Scales

subject values (luminances)

low meter reading

high meter reading

To control the value (lightness or darkness) of an area, you must first find a way to name and describe how light or how dark the area is. The Zone System has four scales to use for this purpose (*right*).

Subject values. The steps on this scale describe the amounts of light reflected or emitted by various objects in a scene. Subject values or luminances can be measured by a reflected-light meter: a low or dark subject value produces a low meter reading; a high or light subject value produces a high meter reading.

Negative-density values. Divisions of this scale describe the amounts of silver in various parts of the negative after it has been developed. Clear or thin areas of a negative have little or no silver; dense areas have a great deal of silver. These values can be measured by a densitometer, a device that gauges the amount of light stopped or passed by different portions of the negative.

Print values. These steps describe the amounts of silver in various parts of a print. The darkest areas of a print have the most silver, the lightest areas the least. These values can be measured by a reflection densitometer if desired but are ordinarily simply evaluated by eye in terms of how light or dark they appear.

Zones. This scale is crucial because it links the values on the other three scales. It provides fixed descriptions of values to which subject values, negative-density values, and print values can be compared. Each zone is one stop away from the next (it has received either twice or half the negative exposure).

Familiarizing yourself with the divisions of the zone scale (*opposite page*) is particularly important because it gives you a means of visualizing the final print: the zones aid you in examining subject values, in deciding how you want them to appear as print values, and in then planning how to expose and develop a negative that will produce the desired print.

The zone scale on the opposite page has 11 steps and is based on Ansel Adams's description of zones in his book *The Negative.* Some commonly photographed surfaces are listed in the zones where they are often placed if a realistic representation is desired; average lighttoned skin in sunlight, for example, appears realistically rendered in Zone VI.

Zone 0 (zero) relates to the deepest black print value that photographic printing paper can produce, resulting from a clear area (a low negative-density value) on the corresponding part of the negative, which in turn was caused by a dark area (a low subject value) in the corresponding part of the scene that was photographed.

Zone X relates to the lightest possible print value—the pure white of the paper base, a dense area of the negative (a high negative-density value) and a lighttoned area in the scene (a high subject value).

Zone V corresponds to a middle gray, the tone of a standard-gray test card of 18 percent reflectance. A reflected-light exposure meter measures the lightness or darkness of all the objects in its field of view and then gives an exposure recommendation that would render the average of those tones in Zone V middle gray.

There are, of course, more than 11 shades of gray in a print—Zone VII, for example, represents all tones between Zones VI and VIII—but the 11 zones provide a convenient method of visualizing and identifying tones in the subject, the negative, and the print.

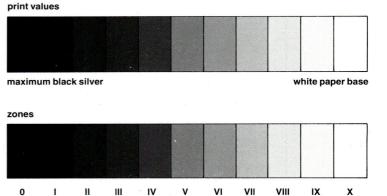

The Zone System has four scales that describe the lightness or darkness of a given area at the various stages in making a photograph. The divisions of the scales are labeled with roman numerals to avoid confusions with f-stops or other settings.

Subject values are measured when metering a scene and range from dark shadows to bright highlights. Each value meters one stop from its neighbor. Only eleven subject values are shown here (top scale), but more will be present in a high-contrast scene, such as a brightly sunlit location that also contains deeply shadowed areas. The same location on a foggy or overcast day will contain fewer than eleven values.

Negative-density values are those present in the developed negative. Film can record a somewhat greater number of values than the eleven shown here (second scale from top).

Print values are those visible in the final print (second scale from bottom). Printing paper limits the usable range of contrast. Black-and-white printing paper can record about eleven steps from maximum black to paper-base white.

Zones (bottom scale) tie the other values together. They permit you to plan how light or dark an area in a subject will be in the final print.

In Ansel Adams's original version of the Zone System, he divided the zone scale into ten segments (0–1X). When he retested newer film and paper, he revised the zone scale to eleven segments (0–X). The information here is based on his last published version of the system.

Zone X. Five (or more) stops more exposure than Zone V middle gray. Maximum white of the paper base. Whites without texture: glaring white sur- faces, light sources.				
Zone IX. Four stops more exposure than Zone V middle gray. Near white. Slight tonality, but no visible texture: snow in flat sunlight, the lightest wood at right.				
Zone VIII. Three stops more exposure than Zone V middle gray. Very light gray. High values with deli- cate texture: very bright cement, textured snow, highlights on light-toned skin.				
Zone VII. Two stops more exposure than Zone V middle gray. Light gray. High values with full tex- ture and detail: very light surfaces with full sense of texture, sand or snow with acute side lighting.				
Zone VI. One stop more exposure than Zone V middle gray. Medium-light gray. Lighted side of average light-toned skin in sunlight, light stone or weathered wood, shadows on snow in a scene that includes both shaded and sunlit snow.				
Zone V. Middle gray. The tone that a reflected- light meter assumes it is reading and for which it gives exposure recommendations. 18 percent reflectance neutral-gray test card, clear north sky, dark skin.		Ó		
Zone IV. One stop less exposure than Zone V mid- dle gray. Medium-dark gray. Dark stone, average dark foliage, shadows in landscapes, shadows on skin in sunlit portrait.				
Zone III. Two stops less exposure than Zone V middle gray. Dark gray. Shadow areas with full texture and detail: very dark soil, very dark fabrics with full texture, the dark boards at right.				
Zone II. Three stops less exposure than Zone V middle gray. Gray-black. Darkest area in which some suggestion of texture will appear in the print.		0	0	
Zone I. Four stops less exposure than Zone V middle gray. A near black with slight tonality but no visible texture.				
Zone 0. Five (or more) stops less exposure than Zone V middle gray. Maximum black that photo- graphic paper can produce. The opening to a dark interior space, the open windows at right.				

Using the Zone Scale While Metering

When you are standing in front of a subject and visualizing how it might look as a black-and-white print, you have to take into account that ordinary photographic materials given normal exposure, development, and printing cannot record with realistic texture and detail the entire range of luminances (subject tones) in many scenes. For example, a scene in bright sunlight can generally be rendered with texture and detail in either dark shadows or bright highlights but not both. Usually, you have to choose those areas in which you want the most detail in the print and then expose the negative accordingly.

You can accurately visualize the black-and-white tones in the final print by using the zone scale described on the preceding pages plus a reflectedlight exposure meter, either hand-held or built into a camera. (An incident-light meter cannot be used because it measures the light falling on the scene and you will need to measure the luminances of individual areas.)

When you meter different areas, you can determine where each lies on the zone scale for any given exposure. Then, by adjusting the negative development if necessary (*pages 318–319 tell how*), you can produce the print value (shade of gray) that you want each area to have in the final print. Metering must be done carefully to get consistent results. Try to read areas of more or less uniform tone; the results from an area of mixed light and dark tones will be more difficult to predict. A spot meter is useful for reading small areas or those that are at a distance.

The meter does not know what area is being read or how you want it rendered in the print. It assumes it is reading a uniform middle-gray subject tone (such as a neutral-gray test card of 18 percent reflectance) and gives exposure recommendations accordingly. The meter measures the total amount of light that strikes its light-sensitive cell from an area, then, taking into account the film speed, it calculates f-stop and shutter speed combinations that will produce sufficient negative density to reproduce the area as middle gray in a print.

If you choose one of the f-stop and shutter-speed combinations recommended by the meter, you will have placed the metered area in Zone V and it will reproduce as middle gray in the print (print Value V). By altering the negative exposure you can **place** any one area in any zone you wish. One stop difference in exposure will produce one zone difference in tone. For example, one stop less than the recommended exposure places a metered area in Zone IV; one stop more places it in Zone VI.

Once one tone is placed in any zone, all other luminances in the scene fall in zones relative to the first one depending on whether they are lighter or darker and by how much. Suppose a medium-bright area gives a meter reading of 7 (see meter and illustration, near right). Basing the exposure on this value (by setting 7 opposite the arrow on the meter's calculator dial) places this area in Zone V. Metering other areas shows that an important dark wood area reads two stops lower (5) and falls in Zone III, while a bright wood area reads three stops higher (10) and falls in Zone VIII.

A different exposure could have been chosen, causing all of the zones to shift equally lighter or darker (*illustrations, far right*). For instance, by giving one stop more exposure you could have lightened the tones of the dark wood, placing them in Zone IV instead of III, but many of the bright values in the lightest wood would then fall in the undetailed white Zone IX. The Zone System allows you to visualize your options in advance. Each position on an exposure meter gauge measures a luminance (subject value) one stop or one zone from the next position. Suppose that metering a medium-toned area gives a reading of 7. Setting 7 opposite the arrow on the calculator dial places this area in Zone V. A lighter area meters 10, so it falls three zones lighter, in Zone VIII. A dark area meters at 5 and falls in Zone III. The first area metered will appear in the print as middlegray print Value V, the bright wood as very light gray print Value VIII, and the dark wood as dark-gray print Value III (with standard negative development and printing).

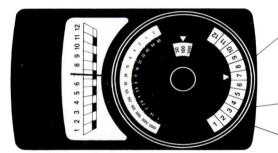

Using Exposure Settings to Count Zones

What do you do if you can't read the difference in subject values (and so, the difference in zones) directly off the meter dial, as you can with the meter above? If you are using a meter built into a camera, the viewfinder often displays the exposure setting—the aperture and shutter-speed combination—for a given reading. You can find the various zones if you count the number of stops between exposure settings for different areas.

Suppose that metering the scene at right suggests exposures of f/5.6 at $\frac{1}{60}$ sec for one area and f/16 at $\frac{1}{60}$ sec for a lighter area. In this example, f/16 gives three stops less exposure than f/5.6 (f/5.6 to f/8 is one stop less; f/8 to f/11, two stops; f/11 to f/16, three stops). Placing the first area in Zone V will cause the other to fall three zones higher in Zone VIII.

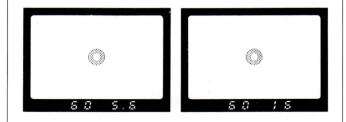

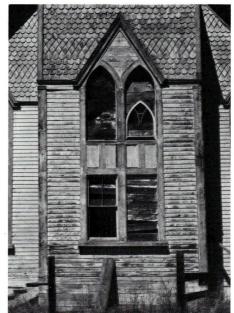

one stop more negative exposure than photograph, left

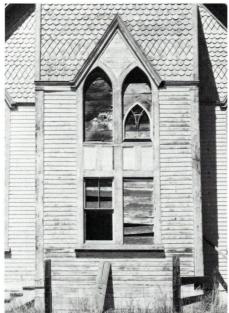

One stop difference in negative exposure creates one zone difference in all areas (if other factors remain the same). The negative exposure for the top print was one stop less than that given to the photograph at left. The negative exposure for the bottom print was one stop more than that for the photograph at left. All the values changed one zone with one stop difference in negative exposure.

317

How Development Controls Contrast

You can, with careful metering and exposure choice, place any one subject value in any zone you desire. You can also predict in which zones the other subject values will fall. But exposure is still only half the story in producing a negative. Development can also be used to adjust certain values and, as a result, to control the overall contrast of the negative. You may want to decrease contrast if the subject has a greater range of values than the paper can print. Or if the subject has only a narrow range of values, you may want to increase contrast so that the print doesn't look flat and dull.

The most common way to adjust contrast is to change the contrast grade of the paper-print a high-contrast negative on a low-contrast paper and vice versa. But another way is to change the development time of the negative. In general, increasing the negative's development time increases its overall contrast range, while decreasing the development time decreases contrast. There are advantages to adjusting the negative's contrast. A negative that prints with a minimum of dodging and burning on a normal-contrast grade of paper is easier to print than, for example, a contrasty negative with dense highlight values that require considerable burning in even on a low-contrast grade of paper. And some scenes are so contrasty that the negative does not print well even on the lowest-contrast grade of paper.

A film's response to changes in development time is strong in the areas of greatest exposure (high, light values) and weak in areas of little exposure (low, shadow values). This happens because the developer quickly reduces to silver the relatively few silver halide crystals that were struck by light in the slightly exposed shadow areas. Development of shadow areas is completed long before all the crystals in the greatly exposed highlight areas are converted to silver. The longer a negative is developed (up to a limit), the greater the silver density that develops in high values, while the shadow densities remain about the same. And the greater the difference between high-value and low-value densities, the greater the contrast.

Development control of high values can be quite precise. If an area is placed in Zone VIII during exposure, it will produce a negative-density Value VIII if the film is given normal development. That same area could be developed to a negative-density Value VII with less development or to a negative-density Value IX with more development.

The process by which subject values increase to higher values on the negative through increased development time is termed Normal-Plus development, or **expansion**, since the contrast range of the negative is increased or expanded. The opposite process, in which subject values (and contrast) are reduced by decreasing the development time, is called Normal-Minus development, or **contraction**.

In Zone System terms, **N** stands for normal development. With normal development, values remain where they were placed or fell during exposure; an area falling in Zone VII would appear as a negative-density Value VII and (given normal printing) as print Value VII.

N + 1 (normal-plus-one) indicates expanded development; a Zone VII value would be increased one zone to Zone VIII (*diagram, opposite*). N + 2 indicates a greater expansion; a Zone VII value would be increased two zones. N - 1 (normal-minus-one) indicates contracted development; a Zone VII value moves one zone down to Zone VI, N - 2 is a greater contraction.

Although the upper values shift considerably with changes in development time, the lower values change little or not at all. Middle values change somewhat, although not as much as the upper ones. Therefore, the low density values in a negative (dark or shadow areas in the original scene) are the result of the amount of exposure, while high density values are the product of both exposure and development. Changing the development time is simple with sheet film, since each exposure can be given individual development. With roll film, changing the contrast grade of the paper is often more practical.

The length of time a negative is ► developed has an important effect on the contrast. The three versions of this scene received identical negative exposures and identical printing: only the development time was changed.

Center, normal development was given to the negative.Top, more development time expanded the contrast by increasing the density of the high values in the negative. As a result, high values, such as the sidewalk, are lighter in the print. Bottom, less development time decreased the contrast by decreasing the density of high values, which now appear darker in the print. Low shadow values were set during exposure and remained the same with any development.

expansion (increased development)

normal development

contraction (decreased development)

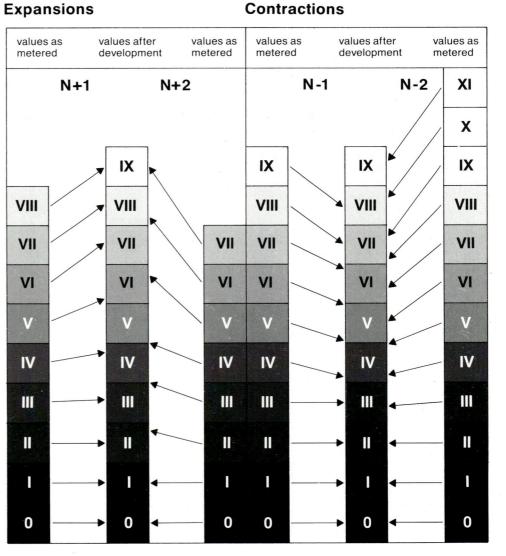

If a negative is given normal development, the densities of various areas in the negative will correspond to the relative luminances of those areas in the original scene. But if the development time is increased (N + 1 or N + 2 in the chart above), the differences between densities will be expanded, especially in the upper zones, V to IX,

and the contrast of the negative will be increased. If development time is decreased (N - 1 or N - 2), the differences between densities will be decreased, especially in the upper zones, so negative contrast overall will be decreased. See page 324 for how much to increase or decrease development.

A Full-Scale Print

Often (although not always) photographers want to make a **full-scale print** with normal contrast; that is, with a full range of values from black through many shades of gray to white and with considerable texture and detail showing in important areas.

If that is your goal, then the darkest area in which you want at least a minimum sense of detail should be no darker than Zone II; for full texture and detail, the area should be no darker than Zone III. The lightest area for minimum detail should be no lighter than Zone VIII; for full texture and detail, it should be no lighter than Zone VII. Areas lighter or darker than this will be at the edge of the printing paper's ability to render detail.

Begin by placing the most important shadow area. It is worse to underexpose a negative than to overexpose one because dark values are affected only by exposure, and no darkroom wizardry can add details to an important shadow area if inadequate exposure was given to the film. If you used the Zone System to calculate the exposure for the scene at right, you could place the dark wood boards in the windows in Zone III by metering them, then giving two stops less exposure than the meter calls for (remember that meters calculate exposures for Zone V; see page 316). Suppose the boards read 5 on the meter gauge. Placing 5 opposite the arrow on the calculator dial (the Zone V position) would place the boards in Zone V. Since you want the boards in Zone III, place 5 two stops from the calculator arrow toward underexposure, as shown at right.

Then see where the important light areas fall. Light values are affected by both exposure and development. Some small, very light areas might read 10 on the meter dial and fall in Zone VIII, while larger light-toned areas might read 9 and fall in Zone VII. Is this the way you want the print to look? If so, developing the film normally would produce a negative that, when printed on a normalcontrast grade of paper, would show the dark boards as dark but with good detail, the lightest areas just showing texture, and the larger light-toned areas light but with full detail.

Suppose the scene was more contrasty and the dark boards metered 5, large light-toned areas metered 10, and the lightest boards metered 11. If you placed the dark boards in Zone III, the lightest areas would fall in near white Zone IX, while much of the scene would fall in very light gray Zone VIII. Giving N-1 (contracted) development would reduce the lightest areas to Value VIII and other light areas to a fully textured Value VII, while the Value III dark boards would not change. The contrast would have been decreased by reducing the development time. The negative would print well on a normal-contrast grade of paper with the important areas rendered as you visualized them.

Another way to decrease the contrast would be to plan to use a low-contrast grade of paper during printing. The advantage of analyzing the exposure in Zone System terms is that you know in advance what the range of contrast is in the scene in terms of the print's ability to show detail.

In a photograph that is a portrait, the face is often the first area a viewer notices, so it is important to meter skin tones carefully and see that they will have the desired rendering—either by placing them in the zone where you want them or seeing that they fall there, or by developing them to that value. Normal values for the sunlit side of a face are V for dark skin, VI for mediumlight skin, and VII for very light skin. The shaded side of a face in sunlight usually appears normally rendered as Value IV.

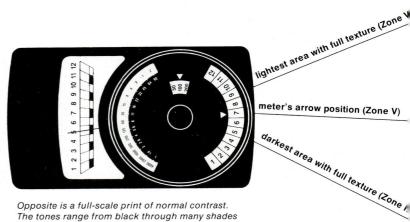

Opposite is a full-scale print of normal contrast. The tones range from black through many shades of gray to white, and full texture is visible in both the darkest and lightest areas in which texture is important. Some readings that you might have registered for the scene are shown on the meter above. Dark board areas metered at about 5. They were placed in Zone III (the darkest value that can show full texture) by positioning the meter arrow (which indicates Zone V) two stops higher on the calculator dial. Large light-toned areas metered 9 and fell in Zone VII (light but with full texture). Smaller, even lighter areas metered 10 and fell in Zone VIII (very light gray). A spread of four or five zones between the darkest textured shadow and the lightest textured white will produce a fullscale, rich print on a normal-contrast grade of paper.

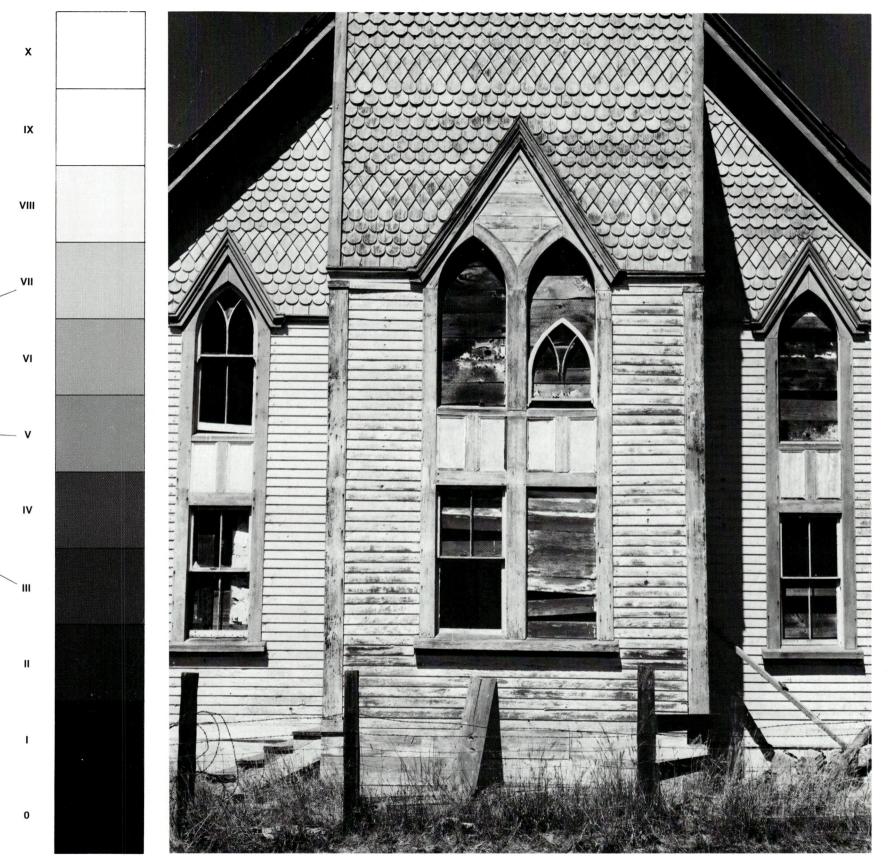

Using the Zone System

MORLEY BAER: Window Cornice Detail, San Francisco, c. 1966

Using the Zone System makes it possible to plan the exposure and development that will produce the tonal range you want in a negative and print. Morley Baer made the photograph at left for a book on Victorian houses in San Francisco. Baer says that he often has to expand contrast when shooting in the hazy sunlight that is common in San Francisco.

He metered the shadow just under the window cornice, an area that he wanted to be dark but still showing detail, and placed that area in Zone III. Then he metered the lightest area in which he wanted to retain good detail; it fell only in Zone VI, which would have made the scene too flat. To correct this, Baer increased the development time to give the scene a one-zone expansion. Another option that he sometimes takes is to plan to print the scene on a more contrasty grade of paper.

Too much contrast was the problem in the scene opposite. Chris Rainier's photograph taken from inside a cave looking out demonstrates the extreme contrast control that the Zone System makes it possible to plan exactly. Rainier wanted the shadows on the top and left side of the central rock to print as Print Value III, dark but with texture. He wanted the highlights on the bright rock surfaces to be almost Print Value VIII, very light, but still showing texture. When he metered the two areas, and placed the shadows in Zone III, the highlights fell in Zone XIII and would have been completely white if he had exposed and developed the negative normally.

Instead, he planned for a five-zone contracted development. He used a highly diluted developer that produces very low contrast. The resulting negative printed on a normal contrast paper; it required no dodging and just a slight amount of burning in to intensify the black tones in a few parts of the print. Personal testing is essential for best use of the Zone System. Ansel Adams's books give full details (see Bibliography).

CHRIS RAINIER: Cave, Southwest Desert, Arizona, 1982

Putting It All Together

The Zone System procedure has three basic steps.

Step 1: Meter the most important area in the scene and place it in the zone where you want it rendered. Often this is the darkest area in which you want full texture (usually Zone III). Placing a value determines your exposure.

Step 2: Meter other areas (especially the lightest area in which you want full texture) to see in which zones they **fall** in relation to the area you have placed.

Step 3: Visualize the final print and make exposure and development choices. If you want the negative-density values to correspond to the relative luminances of various areas in the scene, develop the negative normally. Change the development time if you want to change the densities of the upper values while leaving the lower values about the same. Increasing the time increases the negative densities of the high values (which will make those areas lighter in the print) and also increases the contrast. Decreasing the development time decreases the negative densities of the high values (they will be darker in the print) and decreases the contrast.

You could also plan to print on a contrast grade of paper higher or lower than normal to control densities and contrast. A change of one printing paper contrast grade causes about a one-zone shift in the high values (when low values are matched in tone).

Testing is the best way to determine normal development time and to establish the changes in development needed to move a value from one zone to another. The tests, covered in detail in the books listed in the Bibliography, establish five standard elements for the individual photographer: actual film speed, normal development time, expanded development times, contracted development times, and standard printing time. Personal testing is recommended since cameras, meters, films, enlargers, papers, developers, and personal techniques all differ and affect the results.

However, here are some **rough guidelines for expanded and contracted development** that you can use without testing and that will be helpful for approximate control of contrast. First, use the manufacturer's stated film speed rating to calculate the exposure. For normal development, use one of the manufacturer's suggested time and temperature combinations.

For N + 1 expanded development, increase the development time by half. If the recommended development time is 8 minutes for a given film-developertemperature combination, then the high values can be shifted up one zone each by a 12-minute development. For N + 2 expansion, double the development time.

Compared to other films, Kodak T-Max films require less of an increase in development time to produce a comparable change in negative density; increase the time about half as much as you do with other films.

For N - 1 contracted development, which will shift the high values downward one zone each, develop for threequarters of the normal time. For N - 2contraction, develop for two-thirds of the normal time.

Changing the development time is easy with view camera photography, where sheets of film can be processed individually. But it can also be valuable with **roll film** even though a whole roll of exposures is processed at one time. Sometimes a single image or situation is so important that it deserves special development; the other images on the roll will probably still be printable, possibly on a different grade of paper. Or an entire roll may be shot under one set of conditions and so can be exposed and processed accordingly. Be cautious with increased development of roll film, grain will increase too.

With roll film, Zone System metering and control of negative contrast is often combined with changes in printingpaper contrast. The primary objective is to give enough exposure to dark areas to produce printable densities in the negative while at the same time keeping bright areas from becoming too dense to be printable. For example, if you are shooting on the street on a generally sunny day and trial metering indicates about one stop too much contrast (that is, with shadows placed in Zone III, the high values in which you want full detail fall in Zone VIII or IX), contracted development for the entire roll will be useful. Most of the frames shot will print on a normal-contrast grade of paper; those shot under more contrasty conditions will print on a low-contrast grade; those shot in the shade (now low in contrast because of contracted development) will print on a high-contrast grade.

With color materials, the Zone System provides a way to place a specific value and check where other values will fall. With color negatives, place the most important shadow value, just as vou would with a black-and-white negative; overly bright highlights can usually be burned in later during printing. Correct exposure is vital with color transparencies because the film in the camera is the final viewing product. High values in a transparency lose texture and detail more easily than shadows do, so meter and place the most important light area rather than shadows. If you want a light area to retain texture, place it no higher than Zone VII. Changing development time to control contrast is not recommended for most color materials.

Although most viewers ► would assume that the tree in the foreground (opposite) was sunlit. Ansel Adams reported that the scene was in shadow and the light was soft and diffused. "Normal exposure and development." he wrote, "would have produced a rather flat and gray image." Instead he visualized the scene with greater contrast. He gave the film N + 2 expanded development, then printed the negative on a higher-than-normal contrast paper.

"I have tried to visualize all my pictures before taking them. I think all photographers do that but it takes a long time to be in total command of the technique. [Some photographers] don't understand the way that the lens 'sees' and the film 'sees.'.... You just have to 'look' at the world like this or you are lost."

ANSEL ADAMS: Aspens, Northern New Mexico, 1958

CECIL BEATON: Eileen Dunne, 1940

14 Seeing Photographs

JACK MANNING: Harlem Boy with Cymbals, 1938

Opposite and above are two photographs that differ in composition but are equally effective. Above, a member of a band at a settlement house was photographed as part of the Harlem Document project organized by the Photo League in the 1930s. Part of the picture's dynamic appeal is that the subject is off center, which often makes a more interesting composition than positioning the same subject dead center in the frame. Also, instead of just staring at the camera, the child is doing something, which adds life and interest to a portrait.

Opposite, a young English victim of World War II recuperates in a hospital from shrapnel wounds suffered during a German bombing. The child is doing nothing but clutching her doll and staring at the camera—but there is an enormous difference between a revealing look and a blank one. And in this case, the symmetrical positioning in the center of the frame adds to the impact by reinforcing the direct confrontation with the child. Basic Choices: Content 328 Basic Choices: Framing the Subject 330 Basic Choices: Backgrounds 332 Basic Design: Spot/Line 334 Basic Design: Shape/Pattern 336 Basic Design: Emphasis/Balance 338 More Choices: Using Contrasts of Sharpness 340 More Choices: Using Contrasts of Light and Dark 342 More Choices in Framing 344 More Choices: Perspective and Point of View 346 Looking At—and Talking About—Photographs 348

How do you learn to make better pictures? Once you know the technical basics, where do you go from there? Every time you make an exposure you make choices, either deliberately or accidentally. Do you show the whole scene or just a detail? Do you make everything sharp from foreground to background or have only part of the scene in focus? Do you use a fast shutter speed to freeze motion sharply or a slow shutter speed to blur it? These are only some of your choices, and you can't expect to get immediate control over all of them. Photography is an exciting and sometimes frustrating medium just because there are so many ways to deal with a subject.

So your first step is to see your options, to see the potential photographs in front of your camera. Before you make an exposure, try to visualize the way the scene will look as a print. Looking through the viewfinder helps. The scene is then at least reduced to a smaller size and confined within the edges of the picture format, just as it will be in the print. As you look through the viewfinder, imagine you are looking at a print, but one that you can still change. You can eliminate a distracting background by making it out of focus, by changing your position to a better angle, and so on.

When you look at a photograph—one of your own or someone else's try to see how the picture communicates its visual content. Photography transforms the passing moment of a three-dimensional event into a frozen instant reduced in size on a flat piece of paper, often in black and white instead of color. The event is abstracted, and even if you were there and can remember how it "really" was, the image in front of you is the tangible remaining object. This concentration on the actual image will help you visualize scenes as photographs when you are shooting.

Edward Weston said, "Good composition is only the strongest way of seeing the subject. It cannot be taught because, like all creative effort, it is a matter of personal growth." It cannot be taught, but it *can* be learned by looking at photographs, responding to them, asking questions, looking at a scene, trying something, seeing how it looks—and trying again.

Basic Choices: Content

Do you want the whole scene or a detail? One of the first choices you have to make is how much of a scene to show. Whether the subject is a person, a building, or a tree, beginners often are reluctant to show anything less than the whole thing. If you look at snapshot albums, you will see that people often photograph a subject in its entirety-Grandpa is shown from head to toe even if that makes his head so small that you can't see his face clearly. In many cases, however, it was a particular aspect of the subject that attracted the photographer's attention in the first place, perhaps the expression on the face of the person, the peeling paint on the building, or a bent branch of the tree.

Get closer to your subject. "If your pictures aren't good enough, you aren't close enough," said Robert Capa, a war photographer known for the intensity and immediacy of his images. This simple piece of advice can help most beginning photographers improve their work. Getting closer eliminates distracting objects and simplifies the contents of a picture. It reduces the confusion of busy backgrounds, focuses attention on the main subject, and lets you see expressions on people's faces. (See photographs, right.)

What is your photograph about? Instead of shooting right away, stop a moment to decide which part of a scene you really want to show. You might want to take one picture of the whole scene, then try a few details. Let the content determine the size of important objects. Is your picture about the look of an entire neighborhood, about what it's like to walk by a single house in the neighborhood, or about the detail on the gate in front of a house? Sometimes you won't want to move closer, as in photographing a prairie landscape where the spacious expanse of land and sky is important or in making an environmental portrait where the setting reveals something about the person.

Before you bring the camera to your eye, try to visualize what you want the photograph to look like. Then move around a bit as you look through the viewfinder. Examine the edges of the image frame. Do they enclose or cut into the subject the way you want? (More about the frame on pages 330– 331 and 344–345.) In time, these decisions come more intuitively, but it can be useful at first to work through them deliberately.

What do you want the subject of your photograph to be? Above, the photographer wanted to show the family members but stood so far back that the picture seems more like one of the back yard. Below, by moving closer, the photographer turned the same scene into an appealing family portrait.

RICHARD E. AHLBORN: Boots, Paradise Valley, Nevada, 1978

A detail of a scene can tell as much as and sometimes more than an overall shot. Right, part of the life of a working cowboy, a buckaroo, from Paradise Valley, Nevada. Below, the end of a cattle drive to the 96 Ranch's Hartscrabble camp in Paradise Valley.

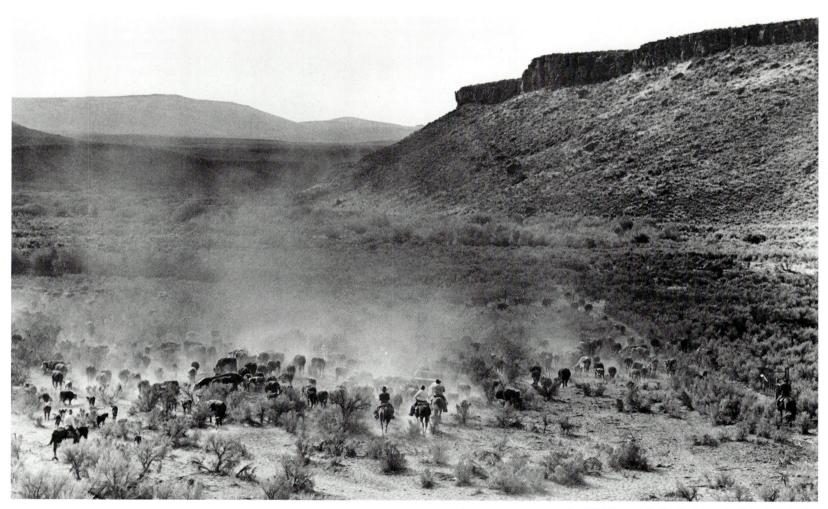

CARL FLEISCHHAUER: Herding Cattle, Paradise Valley, Nevada, 1978

Basic Choices: Framing the Subject

The **frame** (the edges of a picture) isolates part of a larger scene. Photography is different from other visual arts in the way in which a picture is composed. A painter starts with a blank canvas and places shapes within it. A photographer generally uses the frame of the viewfinder or ground glass to select a portion of the surrounding visual possibilities.

Choices have to be made, consciously or not, about how you crop into a scene and how the edges of the frame relate to the portion of the scene that is shown.

You can leave considerable space between the frame and a particular shape, bring the frame very close so it almost touches the shape, or use the frame to cut into the shape. You can position an edge of an object or a line within an object so that it is parallel to one edge of the frame or position it at an angle to the frame. Such choices are important because the viewer, who can't see the surroundings that were left out of the picture, will see how the frame meets the shapes in the print. There is no need to be too analytical about this. Try looking at the edges of the viewfinder image as well as at the center of the picture and then move the frame around until the image you see through the viewfinder seems right to you. You can also cut a small rectangle in an 8 \times 10-inch piece of black cardboard and look through the opening at a scene. Such a frame is easier to move around and see through than a camera and can help you visualize your choices.

Judicious cropping, as in the photograph of the young boy at right, can strengthen a picture, but awkward cropping can be distracting. Ordinarily it is best not to cut off the foot of someone in motion or the hand of someone gesturing, but the deliberate use of such unconventional cropping can be effective. Some pictures depend on the completion of a gesture or motion and are difficult or impossible to crop successfully; try cropping off parts of the dancers, opposite, for example.

Portrait photographers recommend that you do not crop a person at a joint, such as a wrist or knee, because that part of the body will look unnaturally amputated or will seem to protrude into the picture without connection. It can also seem awkward if the top of a head or an elbow or a toe just touches the edge of the frame. Generally, it is better to crop in slightly or to leave a space.

Should your picture be horizontal or vertical? It is common for beginners to hold a 35mm camera horizontally, and only seldom to turn it to a vertical position. Unless you have a reason for doing otherwise, hold the camera horizontally for a horizontal subject, vertically for a vertical one. Otherwise, you are likely to create empty space that adds nothing to the picture. A horizontal format shows width side to side (see page 340). while a vertical format shows height or depth near to far (see page 333). Even if your film format is square, you may later want to crop the picture to a rectangular format.

JOE WRINN: Boy in School, 1977

Cropping with a purpose can add impact to a picture. Above, cropping the adult to a directing arm plus shooting from the child's height lets the viewer enter this scene from the child's point of view.

How does the frame of a photograph (its edges) enclose a subject? How much space, if any, is needed around a subject? You may overlook framing when you are shooting, but it will be immediately evident in the final picture. Right, try cropping slightly into a foot or hand of the female dancer. Try to find any way to crop this picture that improves it.

Basic Choices: Backgrounds

The **background** is part of the picture. Although some photographs are made to show an overall view or a texture or pattern, and so have no single subject, most photographs have a particular object or group of objects as a center of interest. When we look at a scene we tend to focus our attention on whatever is of interest to us and ignore the rest, but the lens includes everything within its angle of view. What do you do when your subject happens to be in front of a less interesting or even distracting background?

If background objects don't add anything to a picture except visual clutter, do what you can to eliminate them or at least to minimize their importance. Usually it is easiest to change your position so that you see the subject against a simpler background (see right). Sometimes you can move the subject instead.

Even a busy background will call less attention to itself if it is blurred and indistinct rather than sharply focused. Set your lens to a wide aperture if you want to make the background out of focus while keeping the subject sharp. This works best if the background is relatively far away and you are focused on a subject that is relatively close to the camera. (See pages 72–73 for more about controlling the depth of field, the area that is sharp in a photograph.) The viewfinder of a single-lens reflex camera shows you the scene at the lens's widest aperture; if you examine the scene through the viewfinder you will get an idea of what the background will look like at that aperture. Some lenses have a preview button that stops down the lens so you can see depth of field at any aperture.

Use the background when it contributes something. Even though many photographs could be improved by shooting closer to the subject, don't always zero in on a subject or you may cut out a setting that makes a picture come alive. An environmental portrait like the one on page 3 uses the background to tell you something about the subject. Backgrounds can give scale to a subject, or vice versa. And some backgrounds are what the picture is all about (see opposite page).

What's in the background? In a photograph, objects that are far apart in depth can appear to be close together if they are in the same line of sight. Check the background before you take a picture, or you may end up with a distracting background that was easy to overlook while you were shooting but that will be hard to ignore in a print. Top, a classic example: a person with a tree (or telephone pole or lamp or other unrelated object) growing out of her head. Below, choosing another angle and moving in slightly closer produced a less distracting background.

Some backgrounds make it worthwhile to set yourself up and wait until someone walks in front of them. Above, a Paris policeman crosses the entrance to an abandoned night spot, L'Enfer (Hell).

ROBERT DOISNEAU: Cabaret L'Enfer, Boulevard de Clichy, Paris, 1952

Basic Design: Spot/Line

What good is design? Most photographs are not constructed but are taken in a pre-existing environment from which the photographer, often working quickly, must select the best views possible. Nevertheless, it is still important for photographers to understand design concepts such as spot, line, shape, pattern, emphasis, and balance because certain elements of design are powerful in their ability to direct a viewer's attention.

Knowing, for example, that a single small object—a spot—against a contrasting background attracts attention will help you predict where attention will go in a photograph. Even if you want to work fast and intuitively rather than with slow precision, some basic knowledge about design will help you fine-tune and speed up your responses to a scene, and it will make you better able to evaluate your own and other people's work.

A single element of design seldom occurs in isolation. Although one can talk about the effect of a spot, for example, other design elements are almost always present, moderating each other's effect. Attention might be drawn by a spot and then attracted away by a pattern of lines elsewhere in the print. The simpler the subject, the more important any single element becomes, but one element rarely totally dominates any composition. The human element may attract the most attention of all; people will search out human presence in a photograph despite every obstacle of insistent design.

Any small shape, not necessarily a round one, can act as a **spot** or **point**. The word *spotlight* is a clue to the effect of a single spot against a neutral or contrasting background: it draws attention to itself and away from the surrounding area. This can be good if the spot itself is the subject or if in some way it adds interest to the subject. But a single spot can also be a distraction. For instance, a small bright object in a dark area can drag attention away from the subject; even a tiny, dark dust speck can attract attention if it is in a blank sky area.

The eye tends to connect two or more spots like a connect-the-numbers drawing. If there are only two spots, the eye continues to shift back and forth between them, sometimes a confusing effect if the eye has no place on which to settle attention. If there are three or more spots, suitably arranged, the brain will make shapes—a triangle, a square, and so on—out of them.

A **line** is a shape that is longer than it is wide. It may be actual or implied, as when the eye connects a series of spots or follows the direction of a person's gaze. Lines give direction by moving the eye across the picture. They help create shapes when the eye completes a shape formed by a series of lines. In a photograph, lines are perceived in relation to the edges of the film format, which are very strong implied lines. This relationship is impossible to ignore, even when the lines are not near the edges of the print.

According to some theories, lines have psychological overtones: horizontal (calm, stability); vertical (stature, strength); diagonal (activity, motion); zigzag (rapid motion); curved (gracefulness, slowness). Horizontal objects, for example, tend to be stable, so we may come to associate horizontality with stability. In a similar way, yellows and reds conventionally have overtones of warmth by way of their associations with fire. However, such associations vary from person to person and are as much dependent on the subject as on any inherent quality in a line.

JOHN SEXTON: Bleached Branch and Bush, Mono Lake, California, 1986

The line of the bleached branch in the foreground makes a strong path that is easy for the eye to follow, especially because the light branch contrasts with the darker background. How does your eye move along the thin, interweaving lines of the bush?

The eye tends to connect two or more spots into a line or shape, and above, the spots formed by the dark hardware against the light cabinets are an insistent element. Russell Lee often used direct flash on camera, especially in his work, as here, for the Farm Security Administration (see page 372). Lee liked direct flash because it rendered RUSSELL LEE: Hidalgo County, Texas, 1939

details sharply and was easy to use. It also produces minimal shadows and so tends to flatten out the objects in a scene into their graphic elements. The scene above has a harsh, clean brightness that is appealing in its austerity and to which the direct flash contributed.

Basic Design: Shape/Pattern

A shape is any defined area. In life, a shape can be two-dimensional, like a pattern on a wall, which has height and width; or three-dimensional, like a building, which has height, width, and depth. In a photograph, a shape is always two-dimensional, but tonal changes across an object can give the illusion of depth. Notice in the illustration at right how flat the large leaf, with its almost uniform gray tone, looks compared with the light and dark ridges of the smaller leaf. You can flatten out the shape of an object entirely by reducing it to one tone, as in a silhouette. The contour or edge shape of the object then becomes dominant, especially if the object is photographed against a contrasting background (see page 125).

A single object standing alone draws attention to its shape, while two or more objects, such as the leaves at right, invite comparison of their shapes, including the shape of the space between them. The eye tends to complete a strong shape that has been cropped by the edge of the film format; such cropping can draw attention repeatedly to the edge or even out of the picture area. Try cropping just into the left edge of the large leaf to see this effect.

Objects that are close together can be seen as a single shape. Objects of

equal importance that are separated can cause the eye to shift back and forth between them, as between two spots. Bringing objects closer together can make them into a single unit; for example, the women on the opposite page. Portrait studio photographers try to enhance the feeling of a family as a group by posing the members close together, often with some physical contact, such as placing one person's hand on another's shoulder. Notice how The Critic (*page 279*) is separated from the society women by space as well as by social standing.

Groupings can be visual as well as actual. Aligning objects one behind the other, intentionally or not, can make a visual grouping that may be easy to overlook when photographing a fast-moving scene but which will be readily apparent in a photograph.

The repetition of spots, lines, or shapes in a **pattern** can add interest and unite the elements in a scene, as do the small, dark squares in the photograph on page 335. A viewer quickly notices variations in a pattern or the contrast between two patterns, in the same way that contrast between colors or between light and dark attracts the eve.

PAUL CAPONIGRO: Two Leaves, 1963

What route does your eye follow when it looks at the photograph above? One path might be up the right edge of the larger leaf, up the curved stem, around the smaller leaf to its bright tip, then down again to make the same journey. Take a small scrap of white paper and put it over the bottom tip of the larger leaf. Does your eye follow the same path as before, or does it jump back and forth between what are now two bright spots?

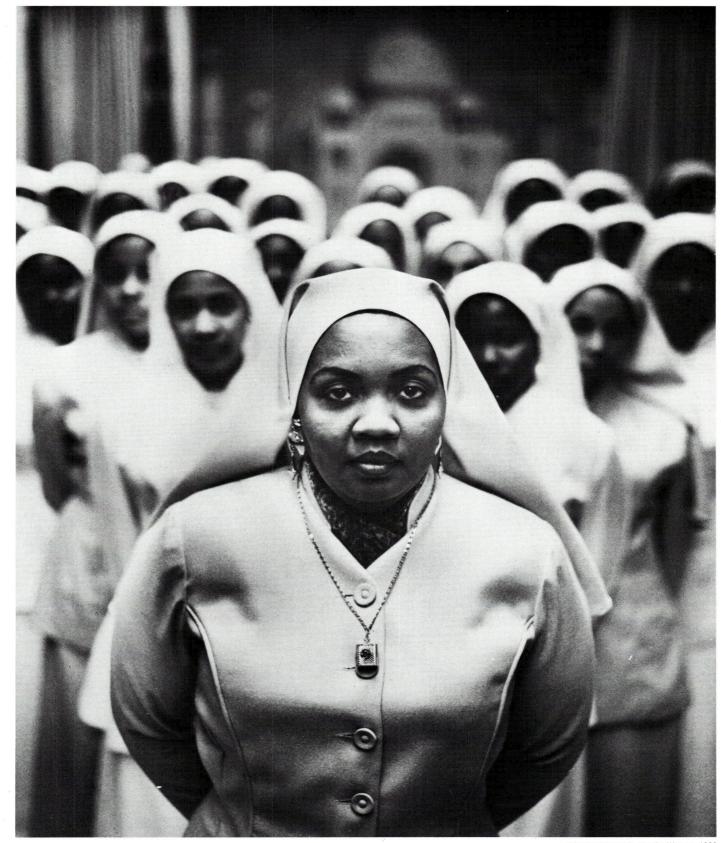

A group of Black Muslim women form a solid band behind one of their leaders. Gordon Parks photographed relatively closer to the woman in front than to the others, which made her appear larger; being closer to her also reduced the depth of field so that when Parks focused on her, only she was sharp. The individual identities of the other women have been submerged by their being out of focus and by the repeated shapes of their headdresses forming a pattern. The picture clearly identifies the leader and makes a visual statement about the solidarity of her followers.

GORDON PARKS: Muslim Women, 1962

Basic Design: Emphasis/Balance

Emphasis on an element will direct attention to it. If too many parts of a photograph demand equal attention, a viewer won't be sure what to look at first. How do you emphasize some part of a photograph or play down another so that the viewer knows what is important and what isn't?

Contrast attracts attention. The eye quickly notices differences such as sharp versus unsharp, light versus dark, large versus small. If you want to emphasize a subject, try to show it in a setting against which it stands out. Viewers tend to look at the sharpest part of a picture first, so you can call attention to a subject by focusing it sharply while leaving other objects out of focus (see pages 340–341). The contrast of light and dark also adds emphasis; a small object can dominate a much larger background if it is of a contrasting tone or color.

Camera angle can emphasize a subject. If unnecessary clutter draws attention away from your subject, get closer. Shooting closer to an object will make it bigger while eliminating much of the surroundings. Sometimes shooting from a slightly higher or lower angle will remove unnecessary elements from the camera's angle of view.

Use surrounding parts of the scene to reinforce emphasis. Objects that are of secondary interest, such as fences, roads, or edges, can form sight lines directed to the subject (*right, top*). The point at which two lines (real or implied) intersect attracts notice (*see page 343*), as does the direction in which people are looking. You may be able to find something in the foreground to frame the main subject and concentrate attention on it (*see opposite page*). A dark object may be easier than a light one to use as a frame because lighter areas tend to attract the eye first, but this is not always the case.

People know when a picture is in balance even if they can't explain why. A picture that is balanced does not call attention to that fact, but an unbalanced one can feel uncomfortably off center or top-heavy. Visually, dark is heavier than light, large is heavier than small, an object at the edge has more weight than at the center (like a weight on a seesaw), and a picture needs more apparent weight at the bottom to avoid a top-heavy feeling. Except in the simplest cases, however, it is difficult to analyze exactly the weights and tensions that balance a picture, nor do you need to do so. A viewer intuitively weighs complexities of tone, size, position, and other elements, and you can do the same as you look through the viewfinder. Ask yourself if the viewfinder image feels balanced or if something isn't quite right that you would like to change. Move around a bit as you continue to look through the viewfinder. Even a slight change can make a big difference in a scene.

A centered, symmetrical arrangement, the same on one side as it is on the other, will certainly feel balanced and possibly satisfyingly stable, but it also may be boring. Some tension in a picture can be an asset. Perfect balance, total harmony, and exact symmetry make little demand on the viewer and consequently can fail to arouse interest. Try some off-center, asymmetrical arrangements; they risk feeling unbalanced but may succeed in adding impact (*right, bottom*).

ROY CLARK: Troublesome Creek, Kentucky, 1965

A man crosses a footbridge over Troublesome Creek in Kentucky. Lines formed by the sides and planks of the bridge focus attention on the man, as does his placement near the center of the picture. The quiet scene gets added interest from the man's dark form against the lighter boards of the bridge, his foot just raised in midstep, and the house in front of him as his visible destination.

R. O. BRANDENBERGER: Skier, Idaho, 1966

An off-center, asymmetrical composition can have a dynamic balance that is absent from a centered, symmetrical one. Take some sheets of white paper and lay them over the bottom and right side of the photo above so that the skier is centered in the frame. The picture is still interesting but lacks the headlong rush that it has when the long slope of the hill and the trees far below are visible.

To emphasize your main subject, you can use a foreground object as a frame. A portrait of the actor James Dean, made in the year of his death, uses the dark shadows of a stairwell to frame him in a diamond-shaped patch of light. Dean's image was full of contradictions—tough and sensitive, DENNIS STOCK: James Dean in Light and Shadow, 1955

boyish and manly, polite and wild—and the photograph echoes this in its split between light and dark, face only half visible, head shown both straight on and profiled in the shadow cast on the wall. In ordinary life, if your eyes are reasonably good, you seldom have to consider whether things are sharp or not. The human eye, like a camera lens, must refocus for objects at different distances, but the eye scans and refocuses so quickly that you rarely are aware of the process. The sharpness of a photograph or of its various parts, however, is immediately noticeable.

People tend to look at the sharpest part of a photograph before they look at parts that are less sharp. If a photograph is sharp overall, the viewer is more likely to see all parts of it as having equal value (*see below*). You can emphasize some part of a subject by making it sharper than the rest of the picture (*see page 71*). **Depth of field** affects sharpness from near to far. If you focus on an object and set your lens to a wide aperture, you will decrease the depth of field (the acceptably sharp area) so that the background and foreground are more likely to be unsharp. Or you can use a small aperture to have the picture sharper overall.

Motion can be photographed either sharp or blurred. In life, moving objects appear sharp unless they are moving extremely fast, such as a hummingbird's wings. In a photograph, you can use a fast shutter speed to freeze the motion of a moving object. Or you can use a slow shutter speed to deliberately blur the motion—just enough to indicate movement or so much that the subject's shape is altered (see opposite page, left). Although the sharpest part is usually emphasized because the viewer tends to look there first, occasionally, blurred motion attracts attention because it transmits information about how fast and in what manner the subject is moving.

If you change to a faster shutter speed to show motion sharp, you have to open to a larger aperture to keep the exposure the same. Since a larger aperture gives less depth of field, you may have to decide whether the sharpness of a moving object is more important than the sharpness of depth of field. It may be impossible to have both. (To review the relation of shutter speed and aperture, see pages 48–49.)

U.S. DEPARTMENT OF AGRICULTURE: Family and Food, 1981

Pictures that convey data are often sharp overall. The United States Department of Agriculture photographed (left to right) Cynthia, John, Clint, and Valerie Schnekloth of Eldridge, Iowa, surrounded by the two and a half tons of food an average American family of four consumes in a year.

HERBERT LIST: Training in the State Ballet School, East Berlin, 1966

In his photograph of dancers, Herbert List used a relatively slow shutter speed. The contrast between the blur of the moving dancers and the sharpness of those that are not moving makes the blurred areas look even more in motion than if all the dancers had been blurred. Photographs such as this give an impression of time and movement that belies the term "still" photograph.

U.S. DEPARTMENT OF AGRICULTURE: Hydraulic Engineer, 1964

A hydraulic engineer watches the flow of water through a plastic model. Photographing a moving subject at a very fast shutter speed or lighting the subject with flash (which has a very short duration) can show a moving subject more sharply than we normally see it. Here, the crispness of the moving water compared to the slightly out-offocus engineer in the background includes the man in the scene but concentrates attention on the water. The presence of the man is also subordinated by having only part of his face visible.

More Choices: Using Contrasts of Light and Dark

Contrast between light and dark draws a viewer's eye. A farmer's hands against a dark background, the outline of a leafless tree against a bright sky, a rim of light on someone's hair, a neon sign on a dark street—light not only illuminates a subject enough to record it on film but by itself can be the subject of a photograph.

Contrast sets off one part of a scene from another. Would you put a black ebony carving against a dark background or a light one? The dark background might make a picture that would be interesting for its somber tones. The light one would make a setting against which the carving would stand out prominently, just as a dark background contrasts with and sets off light tones (photograph, page 347, left). If you squint as you look at a scene, you can often get a better idea of what the tones will look like in a print and whether you should change your angle or move the subject to position it against a better background.

Contrast between two objects may be more apparent in color than in black and white. A red flower against green leaves is distinctly visible to the eye but may merge disappointingly into the foliage in a black-and-white print. The brightness of the flower is very similar to that of the leaves even though the colors are different. (See information on filters, pages 104–105 and 107.)

Light along the edge of an object can

make its shape stand out. If you chose to work with a dark background for an ebony statue, you could use edge lighting to make sure the statue didn't merge into the shadows behind it. Studio photographers often position a light so that it spills just over the edge of a subject from the back, making a bright outline that is effective against a darker background. Outdoors, the sun can create a similar effect if it illuminates the back or side of an object rather than the front.

Shadows or highlights can be shown as separate shapes. The contrast range of many scenes is too great for photographic materials to record realistically both dark shadows and bright highlights in one picture. This can be a problem, but it also gives you the option of deliberately using detailless shadows or highlights as independent forms.

You can adjust contrast somewhat during film processing and printing. Once film has been processed, the relative lightness or darkness of an area is fixed on the negative, but you can still change tones to some extent during printing by such techniques as changing the contrast grade of the paper or printing filter, burning in (adding exposure to darken part of a print), and dodging (holding back exposure to lighten an area). Contrast control with black-and-white prints is relatively easy; color prints allow less manipulation.

JUDY DATER: Maggi Wells, 1970

Film may show shadows as darker than they seemed during shooting. Our eyes make adjustments for differences in light level, but film can record details in only a fixed range of brightnesses. So a photograph may record shapes of light and dark that in life we find easy to overlook. Above, a portrait that is more than just a silhouette of someone's profile against a lighter background. The portrait is expressive and informative, even though—and partly because—the face is hidden.

The photography firm of Hedrich-Blessing has specialized in architectural photography since 1929. The firm is noted for its ability to produce dramatic photographs that are also truthful renditions of a building's features. Here, the image is strongly oriented toward the point where the lines

BILL HEDRICH: Oakton Community College, Des Plaines, Illinois, 1981

of the building cross with the building's own shadow. Notice how the photographer has placed two people at the crossing point and has positioned the people at right so their shadows line up with the edge of the building.

More Choices in Framing

Placement of the subject within the frame can strengthen an image. If you look at a scene through a camera's viewfinder as you move the camera around, you will probably see several choices for positioning the subject within the frame of the film format: dead center or off to one side, high or low, at one angle or another. Placement can draw attention to or away from a part of a scene. It can add stability or create momentum and tension. Some situations move too fast to allow any but the most intuitive shooting, but often you will have time to see what the effect will be with the subject in one part of the frame rather than another.

The most effective composition arises naturally from the subject itself. There are traditional formulas for positioning the center of interest (see box, right), but don't try to apply them rigidly. The goal of all the suggestions in this chapter is not to provide a set of rules but to help you become more flexible as you develop your own style. The subject may also have something to say if you can hear it. Minor White, who was a teacher as well as a photographer, used to tell his students to let the subject generate its own composition.

The horizon line-the dividing line between land and sky-is a strong visual element. It can be easy, without much thought, to position the horizon line across the center of a landscape, dividing a scene into halves. Some photographers divide a landscape this way as a stylistic device, but unless handled skillfully, this can divide a picture into two areas of equal and competing interest that won't let the eye settle on either one. One suggestion for placement is to divide the image in thirds horizontally, then position the horizon in either the upper or lower third (photograph, this page). You can also try putting the horizon very near the top or the bottom of the frame.

Stop for a moment to consider what you want to emphasize. A horizon line toward the bottom of the frame emphasizes the sky. A horizon toward the top lets you see more of the land but still includes the strong contrast of sky. Omitting the horizon altogether leaves the eye free to concentrate on details of the land. Even if no horizon line is visible, a photograph can feel misaligned if the camera is tilted to one side. Unless you want to tilt a picture for a purpose, always level the camera from side to side. (More about tilting on page 403.)

Motion should usually lead into, rather than immediately out of, the image area. Allow enough space in front of a moving subject so it does not seem uncomfortably crowded by the edge of the frame. The amount of space depends on the scene and your own intention. In a photograph, the direction in which a person (or even a statue) looks is an implied movement and reguires space because a viewer tends to follow that direction to see what the person is looking at. Although it is usually best to allow adequate space, you can deliberately create tension to add interest to some scenes by framing a subject so that it looks or moves directly out of the picture area.

A subtler tension may be added simply by movement of a subject from right to left. Westerners read from left to right; therefore, a subject with strong left-to-right movement may seem slightly more natural or comfortable to a Westerner than a subject with strong right-to-left motion. You can see if you get this effect by looking at the photograph of the skier on page 338 and then looking at it in a mirror to reverse the subject's direction.

Compositional Formulas

In the 19th century, rules of photographic composition were proposed based on techniques used by certain painters of the period. The rule of thirds, for example, was (and still is for some photographers) a popular compositional device. Draw imaginary lines dividing the picture area into thirds horizontally, then vertically. According to this formula, important subject areas should fall on the intersections of the lines or along the lines. A person's face, for example, might be located on the upper left (theoretically the strongest) intersection, a horizon line on either the upper or lower horizontal line, and so on.

Try such formulas out for yourself. Experimenting with them will make you more aware of your options when you look at a scene, but don't expect a compositional cure-all for every picture. Look at photographs that work well, such as the one opposite or on page 63, to see if they fit a particular rule. If they don't, what makes them successful images?

ROBERT BRANSTEAD: Along the Snake River, Wyoming, 1971

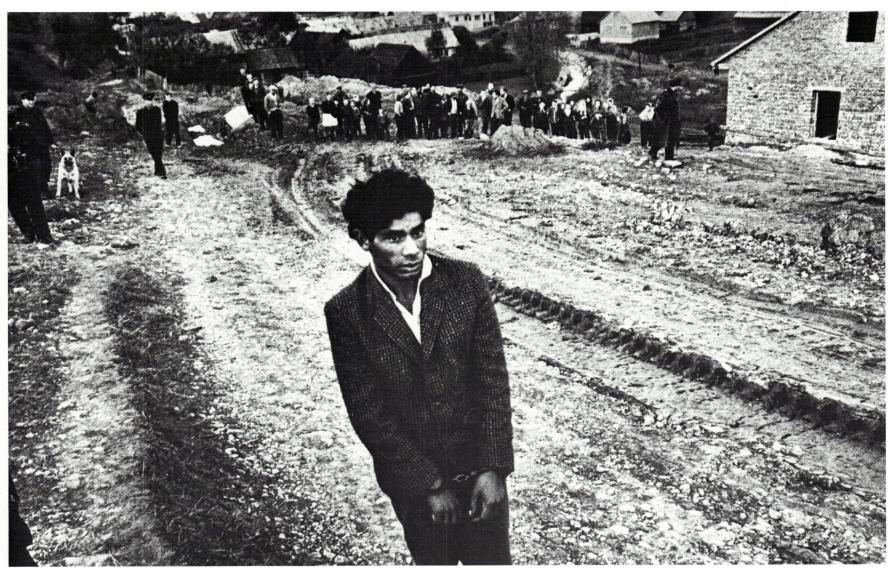

 The conventional placement for a horizon line in a landscape is more or less in the upper (or lower) third of the picture. (The unusual lightness of the grass and trees is due to the use of infrared film. See pages 100–101.) The most extraordinary photographs merge composition with content on a level that rules do not explain. Above, one of many photographs made by Josef Koudelka showing Gypsies of Eastern Europe. The man, having been found guilty of murder, is on the way to the execution ground.

JOSEF KOUDELKA: Czechoslovakia, 1963

John Szarkowski wrote about this photograph, "The handcuffs have compressed his silhouette to the shape of a simple wooden coffin. The track of a truck tire in the earth, like a rope from his neck, leads him forward. Within the tilted frame his body falls backward, as in recognition of the terror."

More Choices: Perspective and Point of View

Perspective creates an illusion of three dimensions in a two-dimensional photograph. The relative distance of objects from the lens and from each other is the most direct control of perspective. The brain judges depth in a scene mostly by comparing the size of objects in the foreground with that of objects in the background; the bigger the apparent difference in the size of similar objects, the greater the distance between them seems to be. Move some object (or some part of it) very close to the lens, and it will look much bigger and therefore much closer than the rest of the scene. Parallel lines that appear to converge (to meet in the distance) are a strong indicator of depth (see photograph, page 411). The convergence is caused by the nearer part of the scene appearing bigger than the farther part.

Other factors affect perspective to a lesser degree. A sharply focused object may appear closer than out-of-focus ones. Side lighting enhances the impression of volume and depth, while front lighting or a silhouette reduces it. The lower half of a picture appears to be (and generally is) closer than the upper half. Overlapping objects also indicate which is closer. Warm colors (reds and oranges) often appear to come forward, while cool colors (blues and greens) appear to recede. In general, light-toned objects often appear to be closer than dark ones, with an important exception: atmospheric haze makes objects that are farther away lighter in tone than those that are closer, and a viewer recognizes this effect as an indication of distance in a landscape. Another factor is less consciously perceived by many people but still influences their impression of depth: objects appear to rise gradually relative to a viewer's position as they approach the horizon (see landscape, this page).

Photographs of landscapes often fail because the photographer was unable to convey an impression of depth. This is why people have to resort to words when they show you their vacation snapshots: they have to tell you how wonderful the scenery was because their pictures make even the Grand Canyon look flat and boring. To extend the impression of depth, especially in landscapes but also in any scene, try some or all of the following. Position some object in the foreground; if similar objects (or others of a known size) are farther away, the viewer will make the size comparisons that indicate depth. This technique can also add interest to an otherwise bland scene. Position the horizon line in the upper part of the picture. Introduce lines (particularly converging ones), such as a road or a fence, that appear to lead from foreground to background.

An eye-level **point of view** is unobtrusive in a photograph, but shooting from higher or lower than eye level is more noticeable. Photographing an object by looking up at it can give it an imposing air as it looms above the viewer. Vertical lines, as in a building, appear to converge when the camera is tilted up, increasing the feeling of height. Looking straight down on a subject produces the opposite effect: objects are flattened out. See photographs, opposite.

A moderate change in camera angle up or down can give a slight shift to the point of view, making a subject appear somewhat bigger or somewhat smaller without unduly attracting the viewer's attention. When you approach a scene, don't always shoot at eye level or in the first position from which you saw the subject. Look for interesting angles, the best background, or other elements that could add interest.

MARION POST WOLCOTT: Fields of Shucked Corn, West Virginia, 1940

One of the standard recommendations for landscape photography is, "Put something in the foreground to give the scene depth." The reason that this device is used so often is that it does give a feeling of depth. Our perception of depth is mostly due to size comparisons between near and far objects, and in the photograph above, it is easy to compare the size of the fence rails in the foreground with those at the end of the field.

It is your handling of whatever you put in the foreground that can rescue a well-used device of this sort from being a cliché. So many photographers have sighted along a fence or randomly included a branch of a tree across the top of a scene that it can be hard to see past the device itself. Here, the device gains interest because the line of the fence also draws the eye from the foreground deeper into the scene, and then down the rows of corn even farther away.

DAVID MOORE: Sisters of Charity, Washington, D.C., 1956

Looking straight down on a subject can appear to flatten space and reduce a subject to its graphic elements. Above, David Moore looked down from an airport mezzanine at a group of nuns. Their white coifs stand out in flowerlike shapes against their black robes.

DOROTHEA LANGE: Lettuce Cutters, Salinas Valley, California, 1935

Dorothea Lange, like Marion Post Wolcott, made many photographs for the Farm Security Administration to document the plight caused by the Depression of the 1930s. Lange's photographs often had an almost epic quality. Above, seemingly impassive as statues, members of a gang of migrant laborers bend to a crop of lettuce. Shooting from a low point of view can create an intimacy with a subject as the photograph—and so the viewer—joins the scene instead of impassively observing it from above. See also the Lange photograph on page 373.

Looking at — and Talking About — Photographs

Photographs are made in order to convey a certain vision or idea, perhaps the beauty of a transcendent landscape or the gritty look of a downtown street. Even snapshots are not made randomly: "I was in Paris" is a typical message from a snapshot. What vision or idea can be found in a particular photograph, and what graphic elements convey it to the viewer? You may never know exactly what the photographer intended, but you can identify the meaning that a photograph has for you. Following are some questions you can ask yourself when you look at a photograph. You don't need to ask every question every time, but they can give you a place to start. The box at right lists some terms that can help describe visual elements.

1. What **type of photograph** is it? Sometimes this is clear from the context: an advertising photograph in an ad, a news photograph on the front page. A caption or title can provide useful information, but look at the picture first so that the caption does not limit your response.

2. What can you tell (or guess) about the **photographer's intention**? For example, is an advertising photograph intended to convey specifics about the product? Or is it meant to say something about the beautiful (or macho or lovable) people who use this product, with the implication that if you use it you will look and feel just like they do?

3. What **emphasis** has the photographer created and how has that been done? For example, has selective focus been used so that the most important part of the scene is sharp, while less important parts are not?

4. Do **technical matters** help or hinder the image? For example, is the central element — perhaps someone's expression — lost in extraneous detail because the photographer was not close enough?

5. Are **graphic elements** such as tone, line, or perspective important? What part of the photograph do you look at first? How does your eye move around the photograph? Does it skip from one person's face to another, follow a curved line, keep returning to one point?

6. What else does the photograph reveal besides what is immediately evident? If you spend some time looking at a photograph, you may find that you see things that you did not notice at first. A fashion photograph may give information about styles but say even more about the social roles that men and women play in our culture. A scientific photograph of a distant star cluster may have been made to itemize its stars but can also inspire you with the beauty and mystery of the universe.

7. What **emotional or physical impact** does the photograph have? Does it induce sorrow, amus.ment, peacefulness? Does it make your skin crawl, your muscles tense up, your eyes widen?

8. How does this photograph relate to others made by the same photographer, in the same period, or of the same subject matter? Is there any historical or social information that helps illuminate it? Is there a connection to art movements? Such knowledge can lead to a fuller appreciation of a work.

One caution when talking or writing about photographs: avoid obfuscation. In other words, speak plainly. Don't try to trick out a simple thought in fancy dress, especially if you don't have much to say. See how you actually respond to a photograph and what you actually notice about it. A clear, incisive observation is vastly better than a vague, rambling dissertation.

Visual Elements

Following are some of the terms that can be used to describe the visual or graphic elements of a photograph. See the page cited for an illustration (and often a discussion) of a particular element.

Light

Frontlit: Light comes from camera position, few shadows (page 261 right)
Sidelit: Light comes from side, shadows cast to side (page 261 left)
Backlit: Light comes towards camera, front of subject shaded (page 260)
Direct light: Hard-edged, often dark, shadows (page 262 left)
Directional-diffused light: Distinct, but soft-edged shadows (page 262 right)
Diffused or revealing light: No, or almost no, shadows (page 263)
Silhouette: Subject very dark against light background (page 125)
Glowing light: Light comes or seems to come from subject (page 258)

Tone and contrast

High key: Mostly light tones (page 124) Low key: Mostly dark tones

Full scale: Many tones of black, gray, and white (page 173 top)
High contrast: Very dark and very light areas, with few middle grays (page 339)
Low contrast: Mostly middle grays (page 264 bottom)

Texture

Emphasized: Usually due to light hitting the subject at an angle (page 274) **Minimized:** Usually due to light coming from camera position (page 335)

Focus and depth of field

Sharp overall (page 340, soft focus (page 376)

Selective focus: One part sharp, others not (page 77)

Shallow depth of field: Short distance between nearest and farthest sharp areas (page 71)

Extensive depth of field: Considerable distance between nearest and farthest sharp areas (page 70)

Frame: The way the edges of the photograph meet the shapes in it (pages 330 and 331)

Viewpoint

Eye-level (page 346)

Overhead (page 347 left), **low level** (page 347 right), or other **unusual** point of view (page 15)

Space and perspective

Shallow space: Most objects seem close together in depth (page 230)

Deep space: Objects seem at different distances in space (page 231)

Positive space or figure: The most important form.

Negative space or ground: That which surrounds the figure. Figure and ground are not always fixed and can reverse (page 342)

Compressed perspective or telephoto effect: The scene seems to occupy an unusually shallow depth (page 80)

Expanded perspective or wide-angle distortion: Parts of the scene seem stretched or positioned unusually far from each other (page 81)

Line

Curved (page 221), straight (page 325), broken (page 339)

Horizontal (page 312), vertical (page 325), diagonal (page 343)

Balance: An internal, physical response. Does the image feel in balance or does it tilt or feel heavier in one part than another?

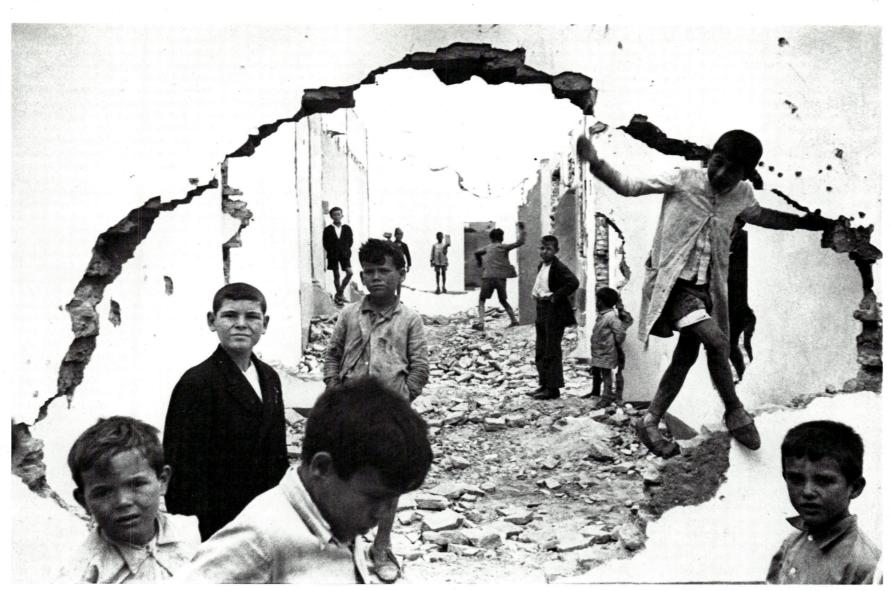

Henri Cartier-Bresson sought what he called "the decisive moment," that instant when the visual and psychological elements in a scene reach their expressive peak. The moment he captured here is of some boys apparently playing among ruined buildings. The photograph has an oddly unsettling feeling. What contributes to this unease?

One boy is balanced as if flying through an opening in a wall, another seems to throw something, others stand separate, lounging aimlessly as if they were unemployed workers rather than children at play. Some of the boys frown at the camera; one boy in the foreground seems to be ducking his head away from it. No one looks childishly carefree. The diffused light looks thin and wintry. Most of the boys are wearing shorts, but have their shirts buttoned to the neck and hands in pockets, as if against the cold.

The broken wall in the foreground is oddly ambiguous in space, sometimes seeming near, sometimes far. If you look at the entire wall and the figures in front of it, it is obvious that the wall is in the foreground. However, the jagged, dark arch of the opening in the wall can also be seen as if the print itself were torn away, which makes the top of the print visually fall to the background. Depth is strongly implied by the relatively great difference in sizes of the children, but the patch of sky in the farthest background also shifts in position, both far away, as we know it to be, and near, as lighttoned objects often appear to be. The image frame includes the whole arch but cuts off most of the boys in the foreground, while the curve of the arch echoes the visual curve of the boys' positions. The result is a strangely dislocated space, like that found in many Surrealist paintings.

HENRI CARTIER-BRESSON: Children Playing in Ruins, Seville, Spain, 1933

Cartier-Bresson had studied painting and had been strongly influenced by modern art, especially Cubism and Surrealism. The Surrealists sought the fantastic in the ordinary and commonplace and particularly liked the way the camera transforms a scene into a two-dimensional, monochromatic image that is both like and unlike the original one. Cartier-Bresson did not arrange his photographs. He had a small, lightweight Leica rangefinder camera, which he used inconspicuously and quickly, "like an extension of the eye." He shot intuitively, "out to capture the fugitive moment [when] all the interrelationships involved are on the move."

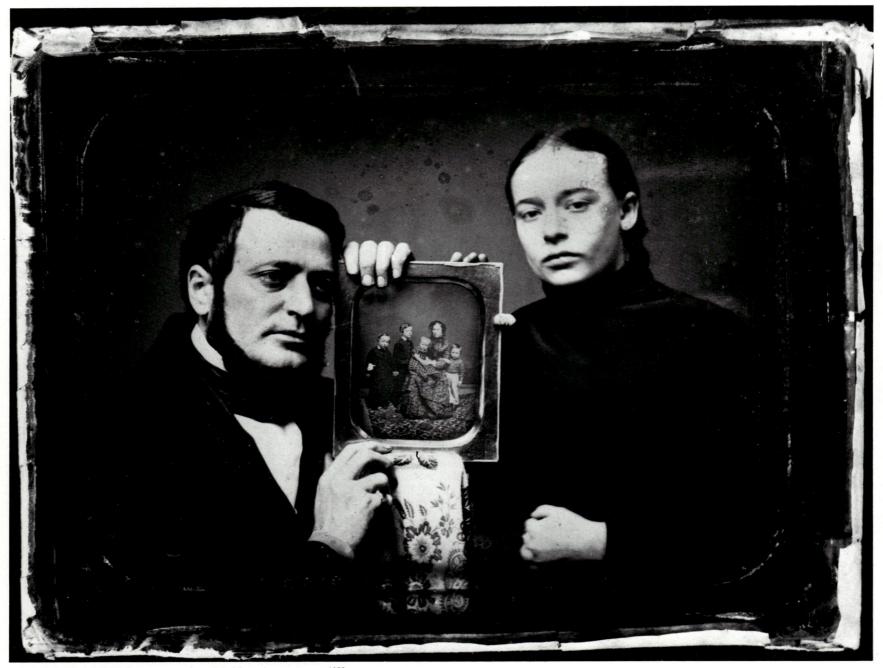

PHOTOGRAPHER UNKNOWN: Daguerreotype of couple holding a daguerreotype, c. 1850

History of Photography

The Invention of Photography 352 Daguerreotype: "Designs on Silver Bright" 354 **Calotype: Pictures on Paper 356** Collodion Wet-Plate: Sharp and Reproducible 358 Early Portraits 360 Images of War 362 Early Travel Photography 364 Gelatin Emulsion/Roll-Film Base: Photography for Everyone 366 Time and Motion in Early Photographs 368 The Photograph as Document 370 Photography and Social Change 372 Photography as Art in the 19th Century 374 Pictorial Photography and the Photo-Secession 376 The Direct and Unmanipulated Image 378 The Quest for a New Vision 380 Photography as Art in the 1950s and Beyond 382 Photojournalism 384 History of Color Photography 390

Of all the many inventions of the 19th century—the electric lamp, the safety pin, dynamite, and the automobile are just a few—the invention of photography probably created the most astonishment and delight. Today most people take photographs for granted, but early viewers were awed and amazed by the objective records the camera made: "We distinguish the smallest details; we count the paving-stones; we see the dampness caused by the rain; we read the inscription on a shop sign...."

Photography gradually took over what previously had been one of the main functions of art—the recording of factual visual information, such as the shape of an object, its size, and its relation to other objects. Instead of having a portrait painted, people had "Sun Drawn Miniatures" made. Instead of forming romantic notions of battles and faraway places from paintings, people began to see firsthand visual reports. Photographs recorded images that the unaided eye could not see and social miseries that the eye did not *want* to see. And photography began to function as an art in its own right.

This chapter touches on only a few of the categories into which the history of photography can be divided. Other categories, equally interesting, and many photographers have been omitted only because of limitations of space. Other chapters, however, show additional work.

In the 19th century, photographs of people who were dead or unable to be present were often included in family photographs. It is tempting to try to interpret the relationships among the people shown opposite. The man holds the daguerreotype carefully, his fingers loose and relaxed; he even touches his head to the frame. The woman makes a minimum of contact with the photograph with her right hand and clenches her left hand into a fist. She stares directly into the lens, the corners of her mouth pulled down, unlike the man, who softly gazes into space as if recalling a dear memory. The photograph is revealing, but still unexplained.

The Invention of Photography

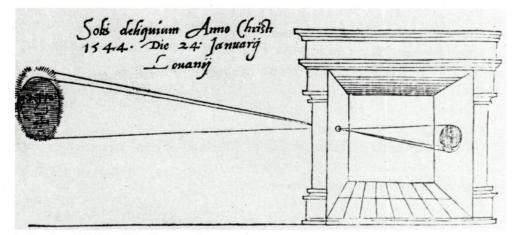

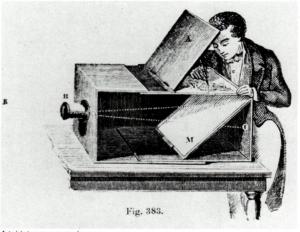

A solar eclipse, 1544, first published illustration of a camera obscura

"The wish to capture evanescent reflections is not only impossible, as has been shown by thorough German investigation, but the mere desire alone, the will to do so, is blasphemy. God created man in His own image, and no manmade machine may fix the image of God." Thus thundered a German publication, Leipziger Stadtanzeiger, in 1839 in response to the first public announcement of the invention of a successful photographic process. The Stadtanzeiger held that if such wise men of the past as Archimedes and Moses "knew nothing of mirror pictures made permanent, then one can straightway call the Frenchman Daguerre, who boasts of such unheard of things, the fool of fools." Such a supreme disbelief is surprising, since most of the basic optical and chemical principles that make photography possible had long been established.

The **camera obscura** was the forerunner of the modern camera. Since at least the time of Aristotle, it had been known that rays of light passing through a pinhole would form an image (*page 56*). The 10th-century Arabian scholar Alhazen described the effect in detail and told how to view an eclipse of the sun in a camera obscura (literally, "dark chamber"), a darkened room with a pinhole opening to the outside.

By the time of the Renaissance, a lens had been fitted into the hole to improve the image, and the camera obscura was becoming smaller and more portable; it shrank from a fixed room to a small hut. to a kind of sedan chair, to a small tent, and finally to a small box that could easily be carried about (above). In the 16th century, Giovanni Battista della Porta suggested in his book Natural Magic that artists use a camera obscura. "If you cannot paint, you can by this arrangement draw [the outline of the images] with a pencil. You will have then only to lay on the colours. This is done by reflecting the image ... on to a drawing-board with paper." The suggestion was taken up with enthusiasm because the realistic portraval of objects and their correct positioning to create an illusion of depth were important goals of artists in the Western

A tabletop camera obscura

world at that time. The camera obscura became such a useful aid that by the 18th century an art expert was writing, "The best modern painters among the Italians have availed themselves greatly of this contrivance; nor is it possible that they should have otherwise represented things so much to the life."

As yet, however, there was no way to fix the camera obscura image permanently. The darkening of certain silver compounds by exposure to light had been observed as early as the 17th century, but the unsolved and difficult problem was how to halt this reaction so that the image would not darken completely. At the beginning of the 19th century, Thomas Wedgwood, son of the famous British potter, was the first to attempt to record the images created by a lens in a camera obscura. He was unsuccessful with the camera image, but he did make negative silhouettes of leaves and insect wings by placing them on white paper or white leather sensitized with silver nitrate and exposing them to the sun. The paper darkened where it was exposed to light

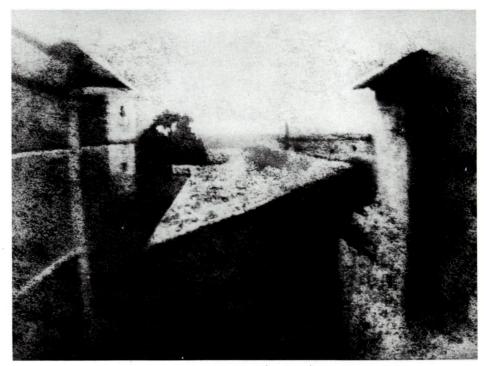

JOSEPH NICÉPHORE NIÉPCE: View from His Window at Gras, c. 1826

Long before the invention of photography, many artists used a camera obscura as an aid in drawing. An image that the artist could trace was formed as rays of light passed through a pinhole opening or a lens. The tabletop model shown works exactly like a modern reflex camera; the rays are reflected by a mirror onto a ground-glass viewing screen.

Niépce produced the world's first photographic image—a view of the courtyard buildings on his estate (right) in about 1826. It was made on a sheet of pewter covered with bitumen of Judea, a kind of asphalt that hardened when exposed to light. The unexposed, still soft bitumen was then dissolved, leaving a permanent image. The exposure time was so long (8 hr) that the sun moved across the sky and illuminated both sides of the courtyard.

but not where it was shielded by the object placed on top. Wedgwood tried many ways to make these silhouettes permanent, but nothing worked. When light struck the images, they began to darken like the rest of the coating.

Although Wedgwood had been working along the right lines with his investigations of silver compounds, silver played no part at all in the first permanent picture that can be called a true photograph. This was made no later than 1826 by Joseph Nicéphore Niépce, a gentleman inventor living in central France. Niépce had become interested in the new process of lithography, which at that time required that drawings first be copied by hand in reverse onto a printing plate. Niépce decided to devise an automatic method of transferring drawings and soon extended that idea to an attempt to take views directly from nature using the camera obscura. Niépce first experimented with silver chloride, but by the early 1820s he had turned his attention to bitumen of Judea, a kind of asphalt that hardened when exposed to light.

Niépce dissolved the bitumen in lavender oil, a solvent used in varnishes, then coated a sheet of pewter with the mixture. He placed the sheet in a camera obscura aimed through an open window at his courtyard and exposed it for eight hours. The light forming the image on the plate hardened the bitumen in bright areas and left it soft and soluble in dark areas. Niépce then washed the plate with lavender oil. This removed the still-soft bitumen that had not been struck by light. Niépce had succeeded where Wedgwood had failed; he had found a way to remove the unexposed and still light-sensitive material so that the image remained permanent.

The result (*above*), which Niépce called a **heliograph** (from the Greek *helios*, "sun," and *graphos*, "drawing"), was crude, but it spurred him to continue his experiments. Meanwhile news of his work reached another Frenchman, Louis Jacques Mandé Daguerre. Daguerre had developed a popular attraction, the Diorama, a spectacle in which famous scenes, such as panoramas of the Swiss Alps, were re-created with illusionary effects through the use of huge translucent paintings and special lighting. Daguerre used the camera obscura in sketching scenes for the Diorama and had also become interested in trying to preserve its images. He wrote Niépce suggesting an exchange of information and eventually became his partner in 1829.

The mid-19th century was ripe for an invention like photography. In Western countries a rising middle class with money to spend wanted pictures, especially family portraits, which until then only the rich had been able to afford. In addition, people were interested in faraway places; they traveled to them when they could and bought travel books and pictures when they couldn't. Niépce did not live to see the impact that photography was to have. He died in 1833, several years before Daguerre perfected a process that he considered different enough from Niépce's to be announced to the world as the daauerreotype.

Daguerreotype: "Designs on Silver Bright"

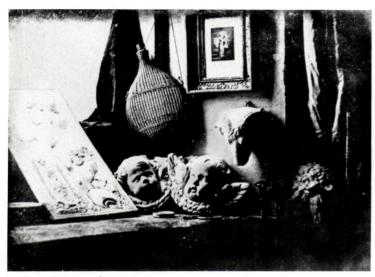

LOUIS JACQUES MANDÉ DAGUERRE: Still Life in the Artist's Studio, 1837

The response to the daguerreotype was sensational. After experimenting for many years, both with Niépce and alone, Daguerre was finally satisfied with his daguerreotype process, and it was announced before the French Academy of Sciences on January 7, 1839. A French newspaper rhapsodized: "What fineness in the strokes! What knowledge of chiaroscuro! What delicacy! What exquisite finish!... How admirably are the foreshortenings given: this is Nature itself!" A British scientist was more specific: "The perfection and fidelity of the pictures are such that on examining them by microscopic power, details are discovered which are not perceivable to the naked eye in the original objects: a crack in plaster, a withered leaf lying on a projecting cornice, or an accumulation of dust in a hollow moulding of a distant building, are faithfully copied in these wonderful pictures." A daguerreotype viewed close up is still exciting to see. Several are reproduced here, but no printing process conveys the luminous tonal range and detail of an original.

The daguerreotype was made on a highly polished surface of silver that was plated on a copper sheet. It was sensitized by being placed, silver side down, over a container of iodine crystals inside a box. Rising vapor from the iodine reacted with the silver, producing the light-sensitive compound silver iodide. During exposure in the camera, the plate recorded a latent image: a chemical change had taken place, but no evidence of it was visible. To develop the image the plate was placed, silver side down, in another box containing a dish of heated mercury at the bottom. Vapor from the mercury reacted with the exposed areas of the plate. Wherever light had struck the plate, mercury formed a frostlike amalgam, or alloy, with the silver. This amalgam made up the bright areas of the image. Where no light had struck, no amalgam was formed; the unchanged silver iodide was dissolved in sodium thiosulfate fixer, leaving the bare metal plate, which looked black, to form the dark areas of the picture.

Almost immediately after the process

PLATT D. BABBITT: Group at Niagara Falls, c. 1855

was announced, daguerreotype studios were opened to provide "Sun Drawn Miniatures" to a very willing public. By 1853 an estimated three million per year were being produced in the United States alone—mostly portraits but also scenic views.

The daguerreotype was very popular in its time, but it was a technological dead end. There were complaints about the difficulty of viewing, for the image could be seen clearly only from certain angles. The mercury vapor used in the process was highly poisonous and probably shortened the life of more than one daguerreotypist. But the most serious drawback was that each plate was unique; there was no way of producing copies except by rephotographing the original. What was needed was a negative-positive process where any number of positive images could be made from a single negative. Just such a process had already been invented.

The earliest known daguerreotype (far left) is by the inventor of the process, Louis Daguerre. The exposure was probably several minutes long much less than the 8 hr required by Niépce's heliograph. The enthusiastic reception of Daguerre's process extended to poetry: "Light is that silent artist / Which without the aid of man / Designs on silver bright / Daguerre's immortal plan." Niagara Falls (near left) was already a world-famous tourist attraction when Platt Babbitt made this daguerreotype about 1855.

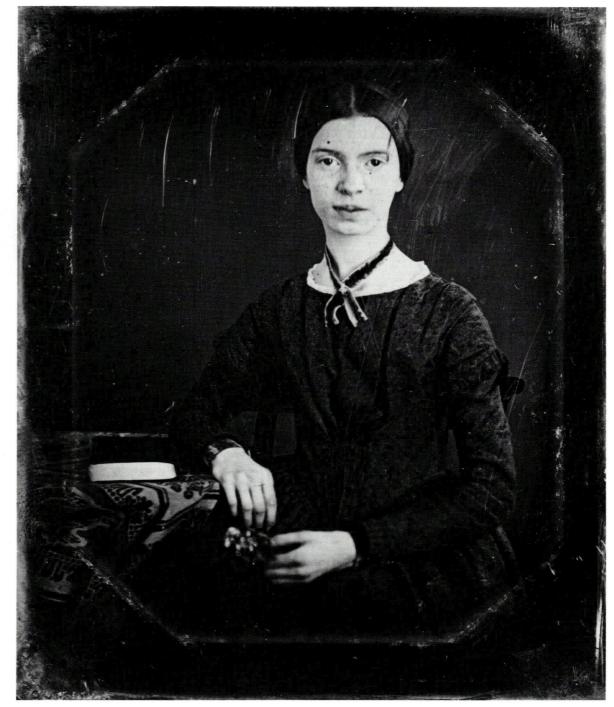

PHOTOGRAPHER UNKNOWN: Emily Dickinson at Seventeen, c. 1847 355

It was in America that the daguerreotype reached the height of its popularity. Millions of Americans, famous (right) and obscure, had their portraits made. Although the exposure time was reduced to less than a minute, it was still long enough to demand a quiet dignity on the part of the subject. This portrait, taken by an itinerant daguerreotypist, is the only known photograph of the 19th-century poet Emily Dickinson. Just like her poems, it seems direct on the surface but elusive on more intimate levels. Dickinson later described herself as "small, like the wren; and my hair is bold, like the chestnut burr; and my eyes, like the sherry in the glass that the guest leaves."

Calotype: Pictures on Paper

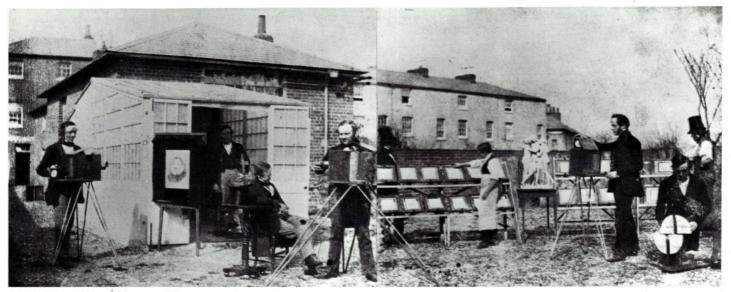

Talbot's photographic establishment, c. 1844

On January 25, 1839, less than three weeks after the announcement of Daguerre's process to the French Academy, an English amateur scientist, William Henry Fox Talbot, appeared before the Royal Institution of Great Britain to announce that he too had invented a way to fix the image of the camera obscura. Talbot was a disappointed man when he gave his hastily prepared report; he admitted later that Daguerre's prior announcement "frustrated the hope with which I had pursued, during nearly five years, this long and complicated series of experiments -the hope, namely, of being the first to announce to the world the existence of the New Art-which has since been named Photography."

Talbot's first experiments had been similar to Wedgwood's; he had made negative silhouettes by placing objects on paper sensitized with silver chloride and exposing them to light. Then he experimented with images formed by a camera obscura. The light-sensitive coating used in his early experiments was exposed long enough for the image to become visible during the exposure.

In June 1840 Talbot announced a technique that not only shortened the exposure time considerably but also became the basis of modern photographic chemistry: the sensitized paper was exposed only long enough to produce a latent image, which then was chemically developed. Talbot reported that nothing could be seen on the paper after exposure, but "the picture existed there, although invisible; and by a chemical process . . . it was made to appear in all its perfection." To make the latent negative image visible, Talbot used silver iodide (the light-sensitive element of the daguerreotype) treated with gallo nitrate of silver. He called his invention a calotype (after the Greek kalos, "beautiful," and typos, "impression").

Talbot realized the value of having photographs on paper rather than on metal: his images were easily reproducible. He placed the fully developed paper negative in contact with another sheet of sensitized paper and exposed both to light, a procedure now known as contact printing. The dark areas of the negative blocked the light from the other sheet of paper, while the clear areas allowed light through. The result was a positive image on paper resembling the natural tones of the original scene.

Because of its reproducibility, the calotype had a major advantage over the one-of-a-kind daguerreotype. It never became widely popular, however, primarily because the calotype image seemed inferior to many viewers. The fibers in the paper produced a soft, slightly textured photograph that has been compared to a charcoal drawing. The calotype is beautiful in its own way, but viewers comparing it to a daguerreotype were disappointed in its lack of sharp detail.

Some of the activities at Talbot's establishment in Reading, near London, are shown in this early calotype taken in two parts and pieced together. At left, an assistant copies a painting. In the center, possibly Talbot himself prepares a camera to take a portrait. At right, the technician at the racks makes contact prints and another assistant photographs a statue. At far right, the kneeling man holds a target for the maker of this photograph to focus on. The prints for the first book to be illustrated with photographs, The Pencil of Nature, were made at Reading. In a "Notice to the Reader," Talbot gave his assurance that "The plates of the present work are impressed by the agency of light alone, without any aid whatever from the artist's pencil. They are the sun pictures themselves, and not, as some persons have imagined, engravings in imitation.'

In a brief but productive collaboration between 843 and 1847, landscape painter David Octavius ill and photographer Robert Adamson made elegant use of the soft texture characteristic of the calotype's paper negative, basing their compositions on broad masses of light and shade. Their otographs of mid-19th-century Scotland include asterfully composed portraits that almost always splay character and naturalness, despite the fact that their subjects were braced to prevent move-

ment during long exposures.

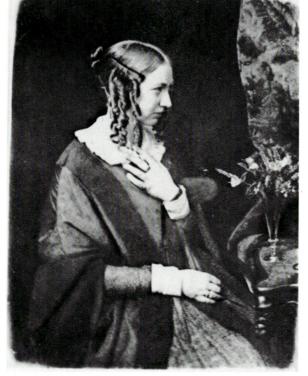

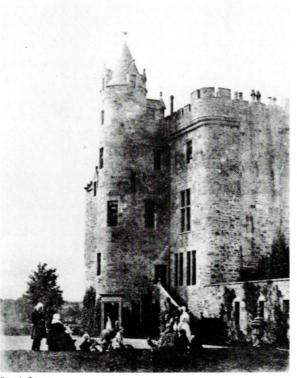

DAVID OCTAVIUS HILL and ROBERT ADAMSON: 1843-1847

Collodion Wet-Plate: Sharp and Reproducible

The collodion wet-plate process had many advantages, but convenience was not among them. The glass plates on which the emulsion was spread had to be coated, exposed, and developed before the emulsion dried, which required transporting an entire darkroom to wherever the photograph was to be made. A photographer described a typical load that an amateur might use: "I reached the railway station with a cab-load consisting of the following items: A $9'' \times 11''$ brass-bound camera weighing 21 lbs. A water-tight glass bath in a wooden case holding over 90 ozs. of solution [nitrate of silver] and weighing 12 lbs. A plate box with a dozen $9'' \times 11''$ plates weighing almost as many pounds. A box 24" \times 18" \times 12" into which were packed lenses, chemicals, and all the hundred-and-one articles necessary for a hard day's work, and weighing something like 28 lbs. [A tripod] over 5 ft in length. It weighed about 5 lbs. Lastly, there was the tent, that made a most convenient darkroom, about $40'' \times 40''$ and $6^{1/2}$ ft high, with ample table accommodation; the whole packed into a leather case and weighed over 40 lbs . . . a load of about 120 lbs."

A photographer in the field, c. 1865

The **collodion wet-plate** process combined so many advantages that despite its drawbacks virtually all photographers used it from its introduction in 1851 until the development of the gelatin dry plate about 30 years later. It had the best feature of the daguerreotype sharpness—and the best of the calotype—reproducibility. And it was more light sensitive than either of them, with exposures as short as five seconds.

For some time, workers had been looking for a substance that would bind a light-sensitive emulsion to a glass plate. Glass was better than paper or metal as a support for emulsion because it was textureless, uniformly transparent, and chemically inert. A cousin of Niépce, Abel Niepce de Saint-Victor, found that egg white could be used, but since his albumen glass plates required very long exposures the search for a better substance continued. Even the slime exuded by snails was tried. One suggested material was the newly invented collodion (nitrocellulose dissolved in ether and alcohol), which is sticky when wet and dries into a tough, transparent skin. Frederick Scott Archer, an English sculptor who had been making calotypes of his sitters to use as studies, discovered that the collodion was an excellent basis for an emulsion. But the plate had to be exposed and processed while it was still wet.

Coating a plate required skill-nimble fingers, flexible wrists, and practiced timing. A mixture of collodion and potassium iodide was poured onto the middle of the plate. The photographer held the glass by the edges and tilted it back and forth and from side to side until the surface was evenly covered. The excess collodion was poured back into its container. Then the plate was sensitized by being dipped in a bath of silver nitrate. It was exposed for a latent image while still damp, developed in pyrogallic acid or iron sulfate, fixed, washed, and dried. All this had to be done right where the photograph was

taken, which meant that to take a picture the photographer had to lug a complete darkroom along (*above*).

Collodion could be used to form either a negative or a positive image. Coated on glass, it produced a negative from which a positive could be printed onto albumen-coated paper (*opposite*, *top*). If the glass was backed with a dark material like black velvet, paper, or paint, the image was transformed into a positive **ambrotype** image (*opposite*, *bottom*), a kind of imitation daguerreotype. Coated on dark enameled metal it also formed a positive image—the durable, cheap **tintype** popular in America for portraits to be placed in albums, on campaign buttons, and even on tombs.

By the 1860s the world had millions of photographic images; 25 years earlier there had been none. Photographers were everywhere—taking portraits, going to war, exploring distant places and bringing home pictures to prove they had been there.

A popular home entertainment during the 1850s and 1860s was looking at stereographic photographs like the one at right. If two photographs are taken side by side and then viewed hrough a stereoscope (a device that presents only one photograph to each eye), the impression is of a three-dimensional image. The stereo cards were inexpensive enough for almost everyone to own, and millions were sold. Rather like television oday, stereographs brought the world into every person's home.

"Oh, infinite volumes of poems that I treasure in this small library of glass and pasteboard!" exclaimed Oliver Wendell Holmes of his collection of stereographs. With it, he wrote, "I stroll through Rhenish vineards, I sit under Roman arches, walk the streets of once-buried cities, I look into the chasms of Alpine glaciers, and on the rush of wasteful cataracts. I pass, in a moment, from the banks of the Charles to the ford of the Jordan."

TIMOTHY H. O'SULLIVAN: Ruins of Canyon de Chelly, 1875

An ambrotype (right) is a collodion-on-glass negative backed with a dark material such as black cloth or varnish. Half of the plate shown here has not been backed and looks like an ordinary negative. The dark backing behind the other half causes a positive image to appear.

Early Portraits

People wanted portraits. Even when exposure times were long and having one's portrait meant sitting in bright sunlight for several minutes with eyes watering, trying not to blink or move, people flocked to portrait studios to have their likenesses drawn by "the sacred radiance of the Sun." Images of almost every famous person who had not died before 1839 have come down to us in portraits by photographers such as Nadar and Julia Margaret Cameron (right). Ordinary people were photographed as well-in Plumbe's National Daguerrian Gallery, where hand-tinted "Patent Premium Coloured Likenesses" were made, and in cut-rate shops where double-lens cameras took them "two at a pop." Small portraits called cartes-de-visite were immensely popular in the 1860s (opposite). For pioneers moving West in America, the pictures were a link to the family and friends they had left behind. Two books went West with the pioneers-a Bible and a photograph album.

After seeing some daguerreotype portraits, the poet Elizabeth Barrett wrote to a friend in 1843, "several of these wonderful portraits ... like engravings-only exquisite and delicate beyond the work of graver-have I seen lately-longing to have such a memorial of every Being dear to me in the world. It is not merely the likeness which is precious in such cases-but the association and the sense of nearness involved in the thing . . . the fact of the very shadow of the person lying there fixed for ever! ... I would rather have such a memorial of one I dearly loved, than the noblest artist's work ever produced. I do not say so in respect (or disrespect) to Art, but for Love's sake. Will you understand?even if you will not agree?" The couple on the opening page of this chapter would have understood.

JULIA MARGARET CAMERON: Sir Henry Taylor, c. 1865

André Adolphe Disdéri, popularizer of the carte-de-visite

Cartes-de-visite were taken with a camera that exposed only one section of the photographic plate at a time. Thus the customer could strike several different poses for the price of one. At left is shown a print before it is cut into separate pictures. People collected cartes-de-visite in albums, inserting pictures of themselves, friends, relatives, and famous people like Queen Victoria. One album cover advised: "Yes, this is my Album, but learn ere you look; / that all are expected to add to my book. / You are welcome to quiz it, the penalty is, / that you add your own Portrait for others to quiz." André Adolphe Disdéri, who popularized these multiple portraits, is shown above on a carte-de-visite. Carte portraits became a fad when Napoleon III stopped on the way to war to pose for cartes-de-visite at Disdéri's studio.

Images of War

ROGER FENTON: Cavalry Camp, Balaklava, 1855

Photographs of war made such scenes more immediate for those at home. Until the invention of photography, wars often seemed remote and rather exciting. People learned details of war only from delayed news accounts or even later from returning soldiers or from paintings or poems. The British campaigns in the Crimean War of the 1850s were the first to be extensively photographed. It was a disastrous war for Great Britain. The ill-fated Charge of the Light Brigade was only one of the catastrophes; official bungling, disease, starvation, and exposure took more British lives than did the enemy. However, Roger Fenton, the official photographer, generally showed views of the war (*above*) as idealized as Tennyson's poem about the Charge.

Not until the American Civil War did many photographs appear that showed a less romantic side of war (*opposite*). Mathew B. Brady, a successful portrait photographer, conceived the idea of sending teams to photograph the war. Photographing during a battle was hazardous. The collodion process required up to several seconds¹ exposure and the glass plates had to be processed on the spot, which made the photographer's darkroom-wagon a target for enemy gunners. Although Brady had hoped to sell his photographs, they often showed what people wanted only to forget. Brady took only a few, if any, photographs himself, and some of his men (Alexander Gardner and Timothy H. O'Sullivan among them) broke with him and set up their own operation. But it was Brady's idea and personal investment that launched an invaluable documentation of American history.

Roger Fenton took many picturesque views of the Crimean War such as the one at left. The Charge of the Light Brigade, a military blunder that needlessly took the lives of hundreds of soldiers, occurred during this war. The famous charge was immortalized in Tennyson's equally famous poem. Like Fenton's views, the poem deals only with the palatable aspects of war:

Half a league, half a league. Half a league onward, All in the valley of Death Rode the six hundred. "Forward, the Light Brigade! Charge for the guns!" he said: Into the valley of Death Rode the six hundred.

When can their glory fade? O the wild charge they made! All the world wonder'd. Honour the charge they made! Honour the Light Brigade. Noble six hundred!

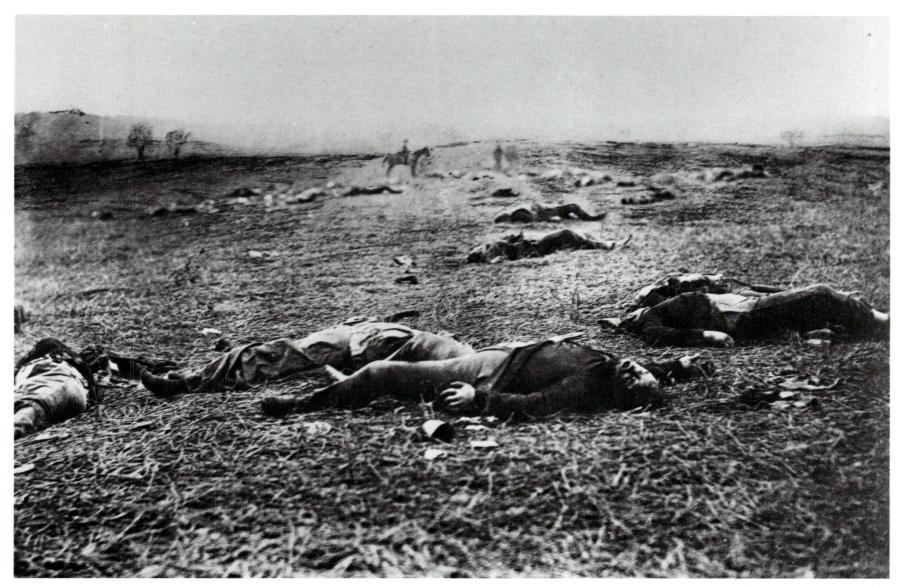

TIMOTHY H. O'SULLIVAN: A Harvest of Death, Gettysburg, July 1863

Another view of war was shown by Civil War photographers such as Brady, Gardner, and O'Sullivan (above). Oliver Wendell Holmes had been on the battlefield at Antietam searching for his wounded son and later saw the photographs Brady made there: "Let him who wishes to know what war is look at this series of illustrations.... It was so nearly like visiting the battlefield to look over these views, that all the emotions excited by the actual sight of the stained and sordid scene, strewed with rags and wrecks, came back to us, and we buried them in the recesses of our cabinet as we would have buried the mutilated remains of the dead they too vividly represented."

Early Travel Photography

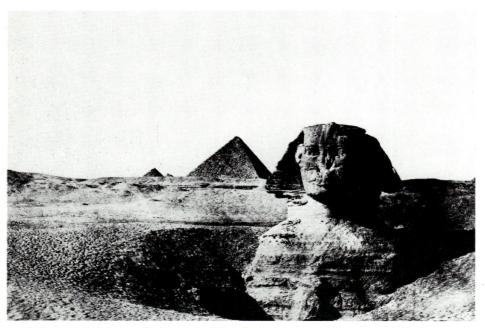

Expeditions to take photographs of faraway places were begun almost as soon as the invention of photography was announced. In addition to all the materials, chemicals, and knowledge needed to coat, expose, and process their photographs in remote places, expeditionary photographers also had to have considerable fortitude. Timothy H. O'Sullivan, whose darkroom on a boat appears opposite, described an area called the Humboldt Sink: "It was a pretty location to work in, and viewing there was as pleasant work as could be desired; the only drawback was an unlimited number of the most voracious and particularly poisonous mosquitoes that we met with during our entire trip. Add to this . . . frequent attacks of that most enervating of all fevers, known as the 'mountain ail.' and you will see why we did not work up more of that country."

MAXIME Du CAMP: The Sphinx and Pyramids, Egypt, 1851

In the mid-19th century, the world seemed full of unexplored wonders. Steamships and railroads were making it possible for more people to travel, but distant lands still seemed exotic and mysterious and people were hungry for photographs of them. There had always been drawings portraying unfamiliar places, but they were an artist's personal vision. The camera seemed an extension of one's own vision; **travel photographs** were accepted as real, faithful images created by a mechanical process.

The Near East was of special interest. Not only was it exotic, but its association with biblical places and ancient cultures made it even more fascinating. Within a few months of the announcement of Daguerre's process in 1839, a photographic team was in Egypt. "We keep daguerreotyping away like lions," they reported, "and from Cairo hope to send home an interesting batch." Since there was no way of reproducing the daguerreotypes directly, they had to be traced and reproduced as copperplate engravings. With the invention of the calotype and later the collodion processes, actual pictures from the Near East taken by photographers such as Maxime Du Camp (*above*) and Francis Frith were soon available.

One of the most spectacular regions of all, the western United States, was not much photographed until the late 1860s. Explorers and artists had been in the Rocky Mountain area long before this time, but the tales they told of the region and the sketches they made were often thought to be exaggerations. After the Civil War, when several government expeditions set out to explore and map the West, photographers accompanied them, not always to the delight of the other members of the expeditions. "The camera in its strong box was a heavy load to carry up the rocks," says a description of a Grand Canyon trip in 1871, "but it was nothing to the chemical and plate-holder box, which in turn was featherweight compared to the imitation hand organ which served for a darkroom." Civil War photographers O'Sullivan (opposite) and Gardner both went West with government expeditions. William Henry Jackson's photographs of Yellowstone helped convince Congress to set the area aside as a National Park, as did the photographs of Yosemite made by Carleton Eugene Watkins.

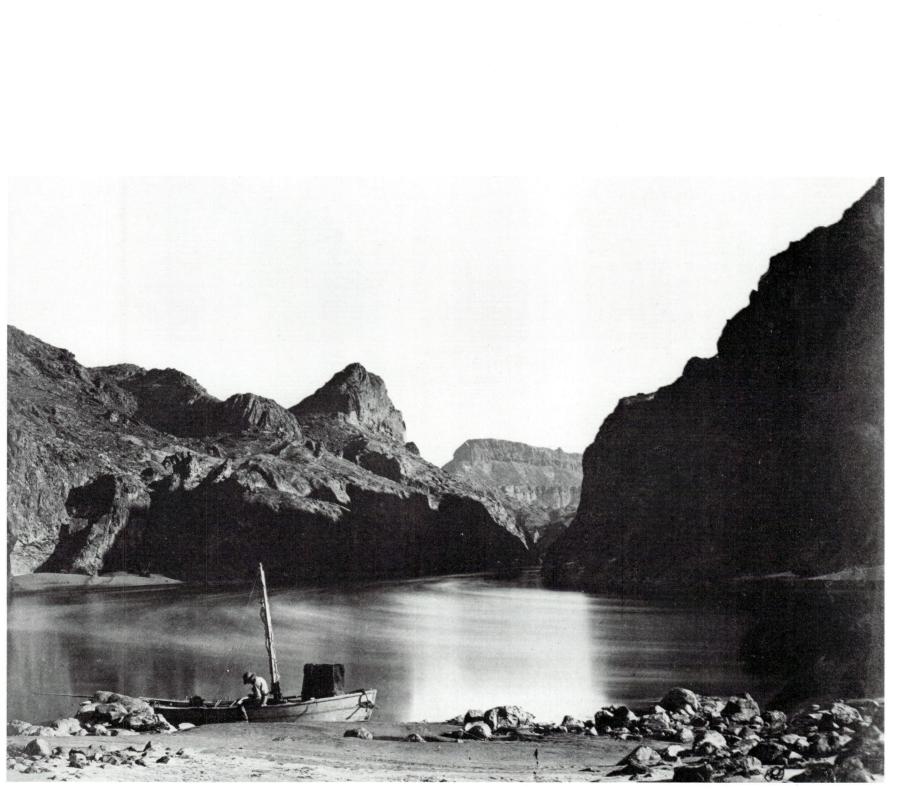

TIMOTHY H. O'SULLIVAN: Black Canyon, Colorado River, 1871

Gelatin Emulsion/Roll-Film Base: Photography for Everyone

Until the 1880s, few photographs were made by the general public. Almost everyone had been photographed at one time or another, certainly everyone had seen photographs, and probably many people had thought of taking pictures themselves. But the technical skill and the large quantity of equipment needed for the collodion wet-plate process restricted photography to the professionals and the most dedicated amateurs. Even they complained of the inconvenience of the process and made many attempts to improve it.

By the 1880s, the perfection of two techniques not only made possible a fast, dry plate but also eliminated the need for the clumsy, fragile glass plate itself. The first development was a new **gelatin emulsion** in which the light-sensitive silver salts could be suspended. It was based on gelatin—a jellylike substance processed from cattle bones and hides. It retained its speed when dry and could be applied on the other invention—rolls of film. **Roll film** revolutionized photography by- making it simple enough for anyone to enjoy.

Much of the credit for popularizing photography goes to one man, George Eastman, who began as a bank clerk in Rochester, New York, and built his Eastman Kodak Company into one of the country's foremost industrial enterprises. Almost from the day Eastman bought his first wet-plate camera in 1877, he searched for a simpler way to take pictures. "It seemed," he said, "that one ought to be able to carry less than a pack-horse load."

Many people had experimented with roll film, but no one was able to produce it commercially until Eastman invented the equipment to mass-produce film. The result was Eastman's American Film, a roll of paper coated with a thin gelatin emulsion. The emulsion had to be stripped from the opaque paper backing to provide a negative that light could shine through for making prints. Most photographers had trouble with this operation, as the negative often stretched when removed from the paper, so the film was usually sent back to the company for processing.

The new film created a great stir among photographers, but it had little immediate meaning for the general public since the heavy, expensive view camera was still necessary for taking pictures. But roll film made possible a new kind of camera-inexpensive, light, and simple to operate-that made everyone a potential photographer. Eastman introduced the Kodak camera in 1888. It came loaded with enough film for 100 pictures. When the roll was used up, the owner returned the camera with the exposed film still in it to the Eastman company in Rochester. Soon the developed and printed photographs and the camera, reloaded with film, were sent back to the owner.

The roll-film Kodak became an international sensation almost overnight. With the invention by Hannibal Goodwin of a truly modern roll film (a transparent, flexible plastic, coated with a thin emulsion and sturdy enough to be used without a paper support), a new photographic era, of simple, light cameras and easy-to-handle roll film, had begun. The Eastman Kodak Company knew very early who would be the main users of its products, and it directed its advertising accordingly: "A collection of these pictures may be made to furnish a pictorial history of life as it is lived by the owner, that will grow more valuable every day that passes."

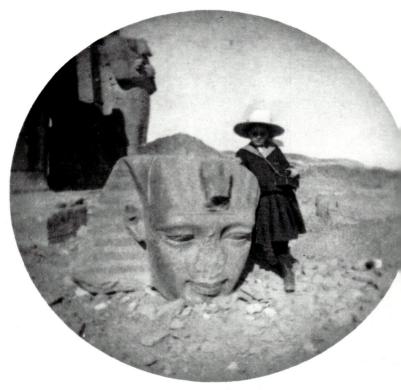

PHOTOGRAPHER UNKNOWN: Ruth at Thebes, c. 1890

Striking a casual pose that was to be repeated in countless tourist snapshots, a camera-carrying girl traveling in Egypt arranged herself by a stone head of Ramses II as a companion immortalized the scene in the round frame that early Kodak cameras produced (above). The photographer is unknown, but the handwritten note in the album from which this picture came indicates that the girl's name was Ruth. Compared to the photograph of the sphinx and pyramids on page 364, this snapshot of a traveler in a middy blouse and wearing a Kodak brings the mysteries of unknown lands down to human size and suddenly makes them seem much less mysterious.

George Eastman, who put the Kodak box camera on the market and thereby put photography into everybody's hands, stands aboard the S.S. Gallia in the act of using his invention (left). Roll film made the camera small enough to carry easily. Fast gelatin emulsions permitted ½5-sec exposures so subjects did not have to strain to hold still. The Kodak slogan was, aptly, "You press the button, we do the rest."

FRED CHURCH: George Eastman with a Kodak, 1890

Time and Motion in Early Photographs

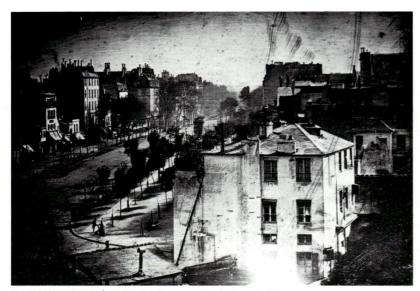

LOUIS JACQUES MANDÉ DAGUERRE: Boulevard du Temple, Paris, 1839

EDWARD ANTHONY: Broadway, 1859

Today, photographers using modern high-speed films consider a one-second exposure relatively long. But photographers using earlier processes had to work with much slower emulsions, and an exposure of several seconds was considered quite short. People or objects that moved during the exposure were blurred or, if the exposure was long enough, disappeared completely; busy streets sometimes looked deserted (*above left*) because most people had not stayed still long enough to register an image.

Stereographic photographs (half of a pair of images is shown above right) were the first to show action as it was taking place, with people in midstride or horses and carts in motion. This was possible because the short-focal-length lens of the stereo camera produced a bright, sharp image at wide apertures and thus could be used with very brief exposure times. "How infinitely superior to those 'cities of the dead' with which we have hitherto been compelled to content ourselves," commented one viewer.

These "instantaneous" photographs recorded such a short moment of time that they revealed aspects of motion that the unaided eye was not able to see. Some of the arrested motions were so different from the conventional artistic representations that the photographs looked wrong. A galloping horse, for example, had often been drawn with all four feet off the ground -the front legs extended forward and hind legs extended back. Eadweard Muybridge was a pioneer in motion studies. When his photographs of a galloping horse, published in 1878, showed that all four feet were off the ground only when they were bunched under the horse's belly, some people thought that Muybridge had altered the photographs. Using the new, fast gelatin emulsion and specifically constructed multi-lens cameras, Muybridge compiled many studies of different animals and humans in action (right).

The busy streets of a Parisian boulevard (above, left) appear depopulated because of the long exposure this daguerreotype required. Only a person getting a shoeshine near the corner of the sidewalk stood still long enough to be recorded; all the other people, horses, and carriages had blurred so much that no image of them appeared on the plate. By contrast, the relatively fast collodion process combined with the fast lens of a stereo camera froze the action on another busy street (above, one of a pair of stereo views).

The pictures at right were part of Eadweard ► Muybridge's project Animal Locomotion, which analyzed the movements of humans and many animals. This sequence was made with three cameras, each with 12 lenses and shutters synchronized to work together so that each stage of the movement was recorded simultaneously from three sides.

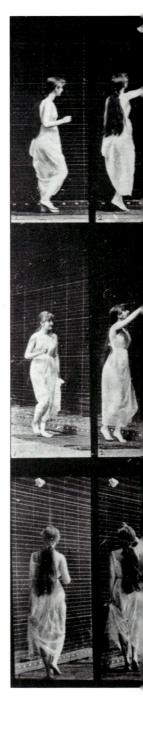

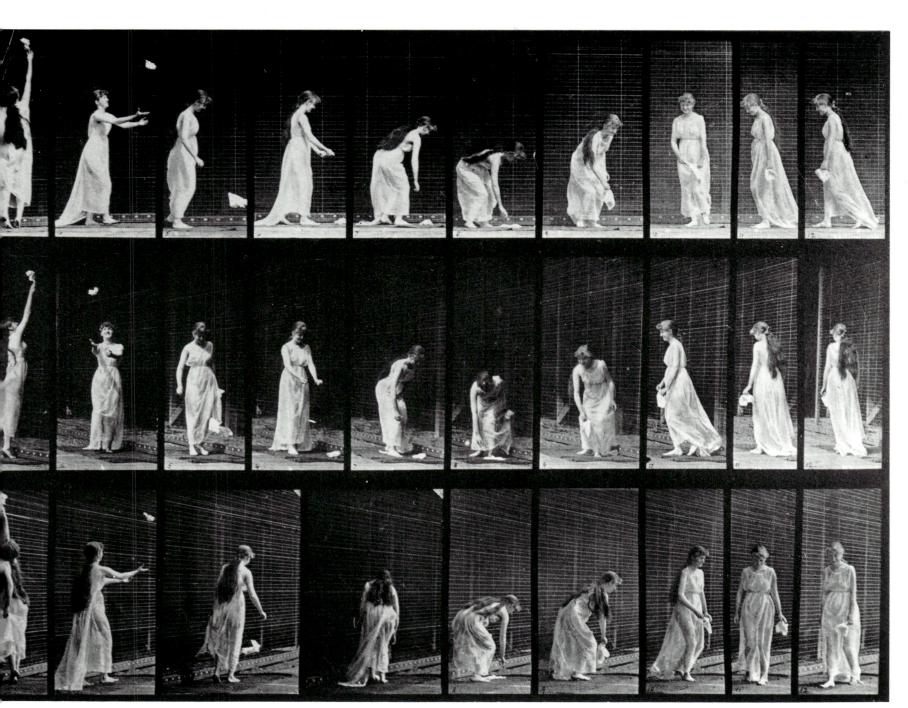

EADWEARD MUYBRIDGE: Motion Study, c. 1885

The Photograph as Document

To early viewers, the most wonderful aspect of photography was its ability to show an immense amount of literal and exact detail. "This is the Daguerreotype!...There is not an object... which was not in the criginal [scene]; and it is impossible that one should have been omitted. Think of that!" Faith in the camera as a literal recorder gave rise to a belief, still persisting today, that the camera does not lie; and it provides photographs themselves with the great psychological strength of appearing to tell the truth.

Photographs can be documents on many levels. Most snapshots record a particular scene or event simply to help the participants remember it later. A news photograph implies that this is exactly what you would have seen if you had been there yourself. On another level, a photograph can record reality and at the same time communicate the photographer's comment on that reality. Lewis W. Hine said of his work: "I wanted to show the things that had to be corrected. I wanted to show the things that had to be appreciated." His statement describes the use of photography as an instrument of social change and a style that has come to be known as documentary (see pages 372-373).

Eugène Atget considered his photo-

graphs to be documents, but his work, done in the early part of this century. went beyond simple records. A sign on his door read "Documents pour Artistes," and according to a friend, Atget's ambition was "to create a collection of all that which both in Paris and its surroundings was artistic and picturesque. An immense subject." Atget made thousands of photographs of the streets, cafés, shops (opposite), monuments, parks, and people of the Paris he loved. His pictures won him little notice during his lifetime; he barely managed to eke out a living by selling them to artists, architects, and others who wanted visual records of the city. Many photographers can record the external appearance of a place, but Atget did more than that. He conveyed the atmosphere and mood of Paris.

August Sander chose to document a people—the citizens of pre–World War II Germany. His pictures were not meant to reveal personal character but to show the classes making up German society of that period. He photographed laborers (*right*), soldiers, businesspeople, provincial families, and other types, all formally posed. The portraits are so utterly factual and unsentimental as to be chilling at times; the individual disappears and only the type remains.

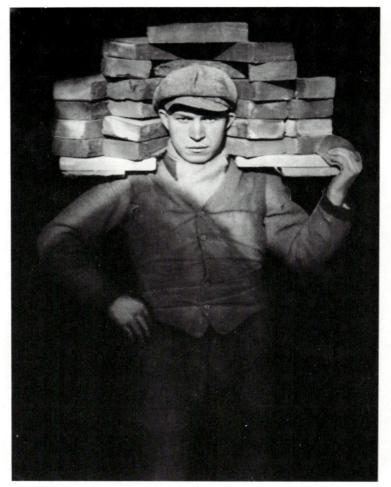

AUGUST SANDER: Laborer, 1927

August Sander's photographs are documents of social types rather than portraits of individuals. This photograph of a Cologne laborer with a load of bricks was one of hundreds of studies Sander made of the types he saw in pre–World War II Germany. Holding his pose as if standing still for a portrait painter, the subject displays his trade with dignity and without becoming a stereotype. The man has paused between taking up his burden and laying it down, but there is no indication of time or even place. In fact, the background is deliberately absent; Sander eliminated it from the negative.

Eugène Atget artfully revealed the essence of Paris while seeming merely to document its external appearance. Here the shop window display and the dummies merge so that the photograph seems to show a ghostly view of Paris populated only by a group of urbane and smartly dressed mannequins.

EUGÈNE ATGET: Magasin, avenue des Gobelins, 1925

Photography and Social Change

Photography has been called the mirror with a memory; in addition to merely reflecting the world, it can also mirror it with a purpose. Jacob Riis, a Danishborn newspaper reporter of the late 19th century, was one of the first to use photography for **social change**. Riis had been writing about the grinding brutality of life in New York City's slums and began to take pictures to show, as he said, what "no mere description could, the misery and vice that he had noticed in his ten years of experience ... and suggest the direction in which good might be done."

Lewis W. Hine was a trained sociologist with a passionate social awareness, especially of the abuses of child labor (*right*). This evil was widespread in the early 20th century, and Hine documented it to provide evidence for reformers. With sarcastic fury he wrote of " 'opportunities' for the child and the family to . . . relieve the over-burdened manufacturer, help him pay his rent, supply his equipment, take care of his rush and slack seasons, and help him to keep down his wage scale."

The photographers of the Farm Security Administration recorded the Depression of the 1930s, when the nation's entire economic structure was in deep trouble and farm families were in particular need. Assistant Secretary of Agriculture Rexford G. Tugwell realized that the government's program of aid to farmers was expensive and controversial. To prove both the extent of the problem and the effectiveness of the cure, he appointed Roy Stryker to supervise photographic coverage of the program. Stryker recruited a remarkable band of talent, including Dorothea Lange (see opposite), Walker Evans, Russell Lee, Marion Post Wolcott, Arthur Rothstein, and Ben Shahn. Their work produced a classic collection of documentary photographs.

LEWIS W. HINE: Victim of a Mill Accident, c. 1910

tween 1908 and 1921, Lewis Hine made 5,000 bures for the National Child Labor Committee cumenting the abuses of child labor. This onemed boy, a casualty of a mill accident, posed for ne in about 1910. "We don't have many accints," one foreman said at the time. "Once in a life a finger is mashed or a foot, but it doesn't nount to anything."

DOROTHEA LANGE: Woman of the High Plains, Texas Panhandle, 1938

In showing the plight of "one third of a nation" ring the Depression of the 1930s, the documenry photographers of the Farm Security Administration produced a monumental collection of images. Dorothea Lange had a unique ability to photograph people at the moment that their pressions and gestures revealed their lives and feelings.

ange's captions for her FSA pictures often suplied verbatim what her subject had told her. For he photograph at right, "The worst thing we did vas when we sold the car, but we had to sell it to t, and now we can't get away from here. . . . You can't get no relief here until you've lived here a ar. This county's a hard county. They won't help bury you here. If you die, you're dead, that's all."

Photography as Art in the 19th Century

Almost from the moment of its birth, photography began staking out claims in areas that had long been reserved for painting. Portraits, still lifes, landscapes, nudes, and even allegories became photographic subject matter. Some artists bristled at the idea of **photography as an art form.** In 1862 a group of French artists formally protested that photography was a soulless, mechanical process, "never resulting in works which could . . . ever be compared with those works which are the fruits of intelligence and the study of art."

Photographers resented such assertions, but they in turn simply regarded photography as another kind of painting. The oldest known daguerreotype (*page 354*), taken by Daguerre himself in 1837, reveals this clearly. It is a still life self-consciously composed in the style of neoclassical painting.

Many photographers adapted styles of painting to the photographic print. From the 1850s through the 1870s there was a rage for illustrative photographs similar to a storytelling style of painting popular at the time. Julia Margaret Cameron, in addition to producing elegant and powerful portraits (page 360), indulged in romantic costume scenes such as illustrations for Tennyson's The Idylls of the King. Oscar G. Reilander pieced together 30 negatives to produce an allegorical pseudopainting entitled The Two Ways of Life-one way led to dissolution and despair, the other to good works and contentment.

At the time, the most famous and commercially the most successful of those intending to elevate photography to an art was Henry Peach Robinson. Robinson turned out many illustrative and allegorical **composite photographs.** These were carefully plotted in advance and combined several negatives to form the final print (*photograph and drawing, right*). Robinson became

HENRY PEACH ROBINSON: Fading Away, 1858

Inspired by romantic literature, the British photographer Henry Peach Robinson perfected a composite photographic technique that allowed him to produce imaginary scenes. Fading Away (above) was staged by posing models separately and piecing together the images. Robinson usually planned such compositions in considerable detail: at right, a half-finished composite for another print shows a cutout photograph of a reclining woman superimposed on a preliminary pencil sketch.

HENRY PEACH ROBINSON: Preliminary sketch with photograph inserted, c. 1860

PETER HENRY EMERSON: Gathering Water Lilies, 1885

Peter Henry Emerson rejected the methods of the High Art photographers and insisted that photography should not imitate art but should strive for a naturalistic effect that was not artificially contrived. He illustrated his theories with his own photographs of peasants on the East Anglian marshes in England. the leader of a so-called High Art movement in 19th-century photography, which advocated beauty and artistic effect no matter how it was obtained. In his *Pictorial Effect in Photography*, Robinson advised: "Any dodge, trick and conjuration of any kind is open to the photographer's use.... It is his imperative duty to avoid the mean, the bare and the ugly, and to aim to elevate his subject, to avoid awkward forms and to correct the unpicturesque."

By the 1880s a new movement was coming to the fore led by Peter Henry Emerson, the first to campaign against the stand that "art" photographers had taken. He felt that true photographic art was possible only through exploiting the camera's unique ability to capture reality in a direct way (*left*). He scorned the still-popular pictorial school, and its practices of composite printing, costumed models, painted backdrops, and sentimental views of daily life.

Emerson laid down his own rules for what he called naturalistic photography: simplicity of equipment; no "faking" by means of lighting, posing, costumes, or props; free composition without reliance on classical rules; and no retouching ("the process by which a good, bad or indifferent photograph is converted into a bad drawing or painting"). He also promoted what he believed was a scientific focusing technique that imitated the way the eye perceives a scene: sharply focused on the main subject, but with the foreground and especially the background slightly out of focus.

Although Emerson later became convinced that photography was not an art at all but only "a handmaiden to science and art," his earlier ideas had already influenced a new generation of photographers who no longer felt the need to imitate painting but began to explore photography as an art in its own right.

Pictorial Photography and the Photo-Secession

Is photography an art? Photographers were still concerned with this question at the turn of the century, and the pictorialists, or art photographers, wanted to separate their photographs from those taken for some other purpose-ordinary snapshots, for example. The American Amateur Photographer suggested: "If we had in America a dignified 'Photographic Salon,' with a competent jury, in which the only prizes should be the distinction of being admitted to the walls of the 'Salon,' we believe that our art would be greatly advanced. 'Art for art's sake' should be the inspiring word for every camera lover." The pictorial movement was international. Exhibitions and salons where photographs were judged on their aesthetic and artistic merits were organized by the Vienna Camera Club, the Linked Ring Brotherhood in England, the Photo-Club de Paris, the American Photo-Secession, and others.

Many pictorialists believed the artistic merits increased if the photograph looked like some other kind of art charcoal drawing, mezzotint, or anything other than photography—and they patterned their work quite frankly on painting, especially the work of the French Impressionists, for whom mood and a sense of atmosphere and light were important. The pictorialists favored mist-covered landscapes and soft cityscapes; light was diffused, line was softened, and details were suppressed (*right*).

To achieve these effects, pictorialists often used printing techniques to which handwork was added—for example, gum-bichromate printing, where the image was transferred onto a thick, soft, often tinted coating that could easily be altered as the photographer wished. One critic was delighted: "The results no longer have anything in common with what used to be known as

GERTRUDE KÄSEBIER: Blessed Art Thou Among Women, c. 1900

Works by pictorialist photographers at the turn of the century often resembled impressionist paintings, with light and atmosphere more important than sharp details. Gertrude Käsebier created many scenes that depicted the relationships between women and children, including some of their more complex and contradictory aspects.

ALFRED STIEGLITZ: The Steerage, 1907

Although Alfred Stieglitz championed pictorialist works that resembled paintings, his own photographs (except for a brief early period) did not include handwork or other alterations of the direct camera image. Above, the patterns made by the people and machinery compelled him to make this photograph. "I saw a picture of shapes and underlying that the feeling I had about life."

photography. For that reason, one could proudly say that these photographers have broken with the tradition of the artificial reproduction of nature. They have freed themselves from photography. They have sought the ideal in the works of artists. They have done away with photographic sharpness, the clear and disturbing representation of details, so that they can achieve simple, broad effects." Not everybody agreed. This did not fit at all into Peter Henry Emerson's ideas of naturalistic photography: "If pure photography is not good enough or 'high' enough ... by all means let him become an artist and leave us alone and not try and foist 'fakes' upon us.''

In America, one person, Alfred Stieglitz, was the leader and catalyst for pictorialists, and his influence on photography as an art form is hard to overestimate. For more than 60 years he photographed (left), organized shows, and published influential and avantgarde work by photographers and other artists. In his galleries-the Little Galleries of the Photo-Secession (later known simply by its address, 291), the Intimate Gallery, and An American Place-he showed not only what he considered the best photographic works but also, for the first time in the United States, the works of Cézanne, Matisse, Picasso, and other modern artists. In his magazine Camera Work, he published photographic criticism and works whose only requirement was that they be worthy of the word art. Not only did he eventually force museum curators and art critics to grant photography a place beside the other arts, but by influence, example, and sheer force of personality he twice set the style for American photography: first toward the early pictorial impressionistic ideal and later toward sharply realistic, "straight" photography (see pages 378-379).

The Direct and Unmanipulated Image

an art form combined an objective view of the world with personal meaning. "Look at the things around you, the immediate world around you. If you are alive it will mean something to you, and if you care enough about photography, and if you know how to use it, you will want to photograph that meaningness."

Paul Strand's straight approach to photography as

PAUL STRAND: White Fence, 1916

While many pictorialists were making photographs that looked very much like paintings, a few were seeking ways to use characteristics unique to the photographic process itself. They wanted to return to the direct and unmanipulated photographs that characterized so much of 19th-century imagery. In 1917 Stieglitz devoted the last issue of Camera Work to Paul Strand, whose photographs he saw as representing a powerful new approach to photography as an art form. Strand believed that "objectivity is of the very essence of photography.... The fullest realization of this is accomplished without tricks of process or manipulation, through the use of straight photographic methods."

Stieglitz's own photographs were direct and unmanipulated. He felt that many of them were visual metaphors, accurate representations of objects in front of his camera and at the same time external counterparts or "equivalents" of his inner feelings. Since 1950, Minor White (*pages 89, 411*) carried on and expanded Stieglitz's concept of the equivalent. For White, the goal of the serious photographer was "to get from the tangible to the intangible" so that a straight photograph of real objects functions as a metaphor for the photographer's or the viewer's state of mind.

Straight photography, which dominated photography as an art form from the 1930s to the 1950s, is exemplified by Edward Weston. He used the simplest technique and a bare minimum of equipment: generally, an 8×10 view camera with lens stopped down to the smallest aperture for sharpness in all parts of the picture and contact-printed negatives that were seldom cropped. "My way of working—I start with no preconceived idea-discovery excites me to focus-then rediscovery through the lens-final form of presentation seen on ground glass, the finished print previsioned complete in every detail of texture, movement, proportion, before exposure-the shutter's release automatically and finally fixes my conception, allowing no after manipulationthe ultimate end, the print, is but a duplication of all that I saw and felt through my camera." Weston's photographs were both objective and personal. "Clouds, torsos, shells, peppers (opposite), trees, rocks, smokestacks are but interdependent, interrelated parts of a whole, which is life." Many other photographers, such as Ansel Adams (pages 312, 325), Paul Caponigro (page 336), Imogen Cunningham (page 95), and Tina Modotti (page 108), have used the straight approach.

Edward Weston wrote about this photograph: "It is classic, completely satisfying—a pepper—but more than a pepper: abstract, in that it is completely outside subject matter."

EDWARD WESTON: Pepper No. 30, 1930

The Quest for a New Vision

MAN RAY: Solarization, 1929

The beginning of the 20th century was a period of great revolution in many areas, including science, technology, mathematics, politics, and also the arts. Movements like Fauvism, Expressionism, Cubism, Dada, and Surrealism were permanently changing the meaning of the word *art*. The Futurist art movement proposed "to sweep from the field of art all motifs and subjects that have already been exploited . . . to destroy the cult of the past . . . to despise utterly every form of imitation to extol every form of originality." At the center of radical art, design, and thinking was the Berlin Bauhaus, a school to which the Hungarian artist László Moholy-Nagy came in 1922. He attempted to find new ways of seeing the world and experimented with radical uses of photographic materials in an attempt to replace 19th-century pictorialist conventions with a "new vision" compatible with modern life. Moholy explored many ways of expanding photographic vision, through photograms, photomontage (*opposite, far right*), the Sabattier effect (often called solarization), unusual angles (*opposite, near right*), optical distortions, and multiple exposures. He felt that "properly used, they help to create a more complex and imaginary language of photography."

Another artist exploring new art forms was Man Ray, an American expatriate in Paris. He was drawn to Dada, a philosophy that commented on the absurdities of modern existence by introducing even greater absurdities. "I like contradictions," he said. "We have never obtained the infinite variety and contradictions that exist in nature." Like Moholy, Man Ray used many techniques, including solarizations (*above*) and photograms (*page 206*).

LÁSZLÓ MOHOLY-NAGY: From the Radio Tower, 1928

Photographers such as László Moholy-Nagy and Man Ray used many techniques in their explorations of real, unreal, and abstract imagery. The dark lines along the woman's hand (opposite) as well as other altered tones are due to solarization, exposing the image to light during development. In the photograph above, the extreme angle of the camera pointing straight down onto a snow-covered courtyard merged the walkways, trees, and building into a single abstract design. The photomontage (right) combines pieces of several photographs. Moholy defined photomontage as "a tumultuous collision of whimsical detail from which hidden meanings flash," a definition that fits this ambiguous picture.

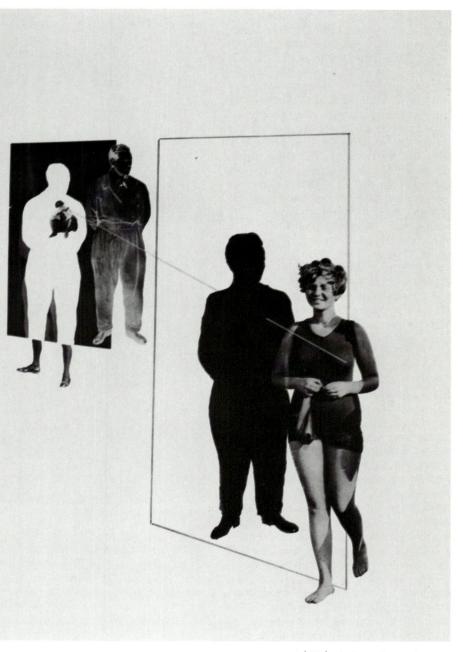

LÁSZLÓ MOHOLY-NAGY: Jealousy, 1927

Photography as Art in the 1950s and Beyond

A tremendous growth has taken place in the acceptance of photography as an art form, a change that started in the 1950s. Since then, photography has become a part of the college and art school curriculum; art museums have devoted considerable attention to photography; art galleries opened to sell only photographs, while photography entered other galleries that previously had sold only paintings or other traditional arts; and magazines such as *Artforum* and *Art in America* began to regularly publish photographs and essays about the medium.

American work of the 1950s was often described in terms of regional styles. Chicago was identified with the often abstract work of Aaron Siskind (right) and Harry Callahan. The West Coast was linked to the so-called straight photographers, such as Ansel Adams (pages 312 and 325) and Minor White (pages 89 and 411). New York was thought of as the center for social documentation, such as by photographers in the politically active Photo League (page 327). Meanwhile, tied to no region, Robert Frank, a Swiss, was traveling across the United States photographing his own view of life in the 1950s (opposite).

As an increasing number of colleges and art schools in the 1960s offered photography courses, often in the art departments of the schools, a cross-fertilization of ideas took place between photographers and artists working in traditional art media. Some painters and other artists integrated photographs in their work or sometimes switched to photography altogether. Some photographers combined their images with painting, printmaking, or other media. Older photographic processes were revived, such as cyanotyping (page 216) and platinum printing (pages 184-185).

AARON SISKIND: Chicago 30, 1949

Minor White used to say that in the 1950s photographers functioning as artists were so few that they used to clump together for warmth. Today, photography continues to develop in many directions, but the long battle over whether photography was an art, a battle that had been waged almost from the invention of the medium, seems finally to have been resolved. The winners were those who said it could be. Aaron Siskind was active as a documentary photographer during the 1930s, but as he later recalled, "For some reason or other there was in me the desire to see the world clean and fresh and alive, as primitive things are clean and fresh and alive. The so-called documentary picture left me wanting something." His best-known work consists of surfaces abstracted from their normal context (above), such as peeled and chipped paint or posters on walls. The subject of the photograph is the shapes, tonality, and other elements that appear in it, not the particular wall itself.

When Robert Frank's work was published in 1959, it was attacked by critics for its ironic view of America, but it was to exert a great influence on both the subject matter and style of photography as an art form. Like Frank's photographs, the works of Diane Arbus, Lee Friedlander, Garry Winogrand (page 403), and others were personal observations of some of the peculiar and occaROBERT FRANK: Bar, New York City, 1955

sionally grotesque aspects of American society. Above, a glimpse inside a New York bar is an unsettling comment on the emptiness of modern society. Jack Kerouac wrote in his introduction to Frank's book, The Americans, "After seeing these pictures you end up finally not knowing any more whether a jukebox is sadder than a coffin."

Photojournalism

Today we take photojournalism for granted, and whatever the news event -from a prizefight to a war-we expect to see pictures of it. But news and pictures were not always partners. Drawings and cartoons appeared only occasionally in the drab 18th-century press. The 19th century saw the growth of illustrated newspapers such as the Illustrated London News and, in America, Harper's Weekly and Frank Leslie's Illustrated Newspaper. Because the various tones of grav needed to reproduce a photograph could not be printed simultaneously with ordinary type, photographs had to be converted into drawings and then into woodcuts before they could appear as news pictures. The photograph merely furnished material for the artist.

The perfection in the 1880s of the halftone process (diagram, right) permitted photographs and type to be printed together, and photographs became an expected addition to news stories. "These are no fancy sketches," the Illustrated American promised, "they are the actual life of the place reproduced upon paper." The photo essava sequence of photographs plus brief textual material (pages 386-387)came of age in the 1930s. It was pioneered by Stefan Lorant in European picture magazines and later in America by a score of publications such as Life and Look (the cover of the first issue of Life appears on page vi). Today, although the heyday of the picture magazine has passed, due in part to competition from television, photographs remain a major source of our information about the world.

Early cameras were relatively bulky, and the slowness of available films meant that using a camera indoors required a blinding burst of flashpowder. Not until the 1920s did photographers get a small camera able to take pictures easily in dim light. The first of these cameras the Ermanov to be followed soon by the Leica, had a lens so fastf/2-that unobtrusive candid shooting became practical. Erich Salomon (below) was one of the pioneers of such shooting, with a special talent for dressing in formal clothes and crashing diplomatic gatherings, where his camera let him record those in power while they were preoccupied with other matters, such as at the 1931 meeting (right) of German and Italian statesmen. In tribute to Salomon, the French foreign minister. Aristide Briand, is said to have remarked, "There are just three things necessary for a League of Nations conference: a few foreign secretaries, a table and a Salomon."

PETER HUNTER: Erich Salomon, 1929

ERICH SALOMON: Visit of German Statesmen to Rome, 1931

The halftone process converts the continuous shades of gray in a photograph into distinct units of black and white that can be printed with ink on paper. First, the original (above left) is rephotographed through a "screen"—a plate of clear plastic crosscut with a grid pattern. The grid breaks the continuous tones of the picture into dots (above right). This scheme of dots is then transferred chemically onto a printing plate.

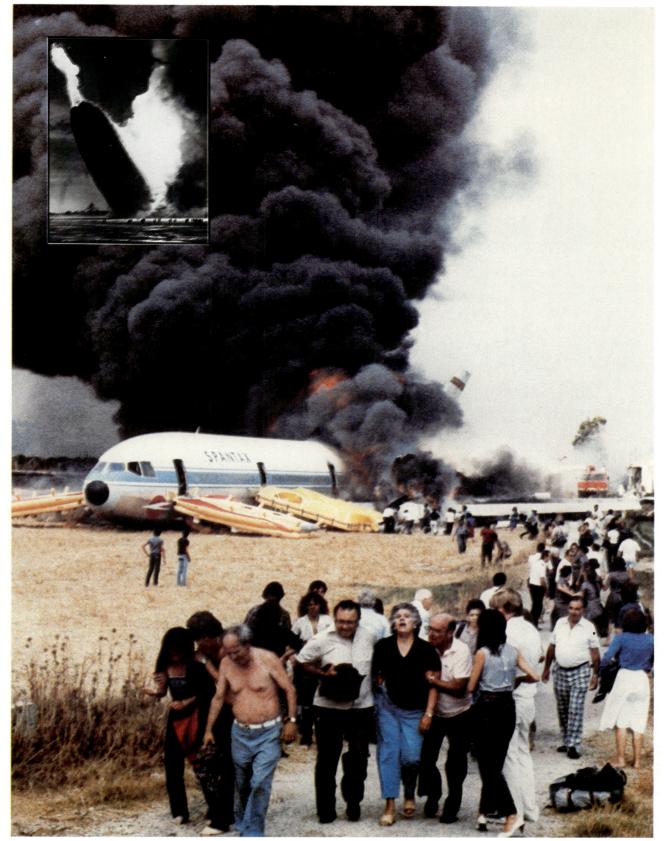

WERNER VOIGHT: Spantax Crash, Malaga, Spain, September 13, 1982 (Inset) MURRAY BECKER: Hindenburg Crash, Lakehurst, New Jersey, May 6, 1937

The Disaster Photo—one of the staples of news photography: the stunned survivors in the foreground, the crashed plane or burning house or flood waters in the background. Many news photographs show us the world in standardized ways or patterns, but the best reveal the particulars, the uniqueness of a scene.

The disaster photo at right is a classic of its kind. A black cloud of smoke billows from the big jet crashed in the background. The plane lies in the stubble of a field, looking as out of place and helpless as a beached whale. The picture combines the intensity of the moment with strong graphic composition as the survivors, some grieving, others in shock, move along a path curving to the foreground. One can imagine the photograph as a still from a disaster movie, set up to evoke emotion plus have pictorial appeal.

Inset: An equally powerful photograph of the 1937 crash of the dirigible Hindenburg. The tiny figures near the aircraft give some idea of its size, 800 feet long. The press had turned out to record what was supposed to be a routine landing, though still enough of a novelty in air travel to be covered. Instead they were witness to an astounding catastrophe as the huge craft burst into flames and exploded.

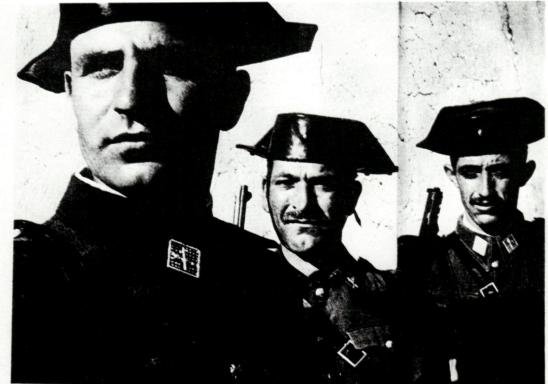

GUARDIA CIVII. Insee sheri men, enforcers of nations is are Franco's rural policy. Due to rol countryside, are feared by people in villages, which also have local policy

VILLAGE SCHOOL Golds are tangled in separate classes from thebox. Fournemannand on the tasktere handle all papels, as more as 200 in sometric between the ages of 6 and 11.

 IAMILY DINNER
 The Currels out thick, bean and portrosoup from common pot on due floor of their kitchen. The father, mether and bear kitchen all share the one beforem.

Spanish Village cosmons

A CHRISTENING tracher today have a track the prior Den Marriel drive the board

THE THREAD MARKER A peacest scenario monotons the labors of locally grown flax as due point them in a long strand which is spain tight to the specific registic them surgest around a.

CONTINUED ON NEXT PAGE 127

The photo essay—pictures plus supporting text was the mainstay of mass-circulation picture magazines such as Life and Look. Above and opposite are four pages from Spanish Village, photographed for Life by W. Eugene Smith, whose picture essays are unsurpassed in their power and photographic beauty.

W. EUGENE SMITH: From Spanish Village, 1951

126

"I try to do work that affects people," Smith said. "I try to lead them with my photographs so that they can draw their own conclusions." Smith was

intensely committed to his work. "I never made any picture, good or bad, without paying for it in emotional turmoil."

History of Color Photography

Daguerre himself knew that only one thing was needed to make his wonderful invention complete-color. "There is nothing else to be desired," he wrote, "but the presentation of these children of light to the astonished eye in the full splendour of their colors." He and Niépce both experimented with various means of recording color without significant success. In 1850 an American minister and daguerreotypist, Levi L. Hill, made some color daguerreotypes, apparently by accident. Unfortunately, he was not able to reproduce the circumstances that had caused his materials to produce colors.

After several other false starts, one of the first successes was demonstrated in 1861 by the British physicist James Clerk Maxwell. To illustrate a lecture on color vision, he devised a way to recreate the colors of a tartan ribbon. He had three negatives of the ribbon made, each through a different color filter red, green, and blue. Positive blackand-white transparencies were made and projected through filters like those on the camera. When the three images were superimposed, they produced an image of the ribbon in its original colors.

Maxwell had demonstrated additive color mixing, in which colors are produced by adding together varying amounts of light of the three primary colors, red, green, and blue. In 1869, an even more significant theory was made public. Louis Ducos du Hauron and Charles Cros, two Frenchmen working independently of each other, announced almost simultaneously their researches in subtractive color mixing. In subtractive mixing, the basis of present-day color photography, colors are created by combining cyan, magenta, and yellow dyes (the complements of red, green, and blue). The dyes subtract colors from the "white" light that contains all colors. (More about additive

and subtractive theory on pages 222–223.) There were many variations of Ducos du Hauron's basic subtractive process in which three separately dyed images were superimposed to form a full-color image. They include his own three-color carbon process (*right, top*), the carbro process (*opposite*), and modern dye transfer printing.

The first commercially practical color was an additive process. In 1907, two French brothers, Antoine and Louis Lumière, marketed their Autochrome process. A glass plate was covered with tiny grains of potato starch dyed redorange, green, and violet, in a layer only one starch grain thick. Then, a lightsensitive emulsion was added. Light struck the emulsion after passing through the colored grains. The emulsion behind each grain was exposed only by light from the scene that was the same color as that grain. The result after development was a full-color transparency (right, bottom).

The greatest advance in making color photography practical was perfected by Leopold Mannes and Leopold Godowsky, two musicians and amateur photographic researchers who eventually joined forces with Eastman Kodak research scientists. Their collaboration led to the introduction in 1935 of Kodachrome, a subtractive process in which a single sheet of film is coated with three layers of emulsion, each sensitive to one primary color (red, green, and blue). A single exposure produces a color image (see page 224).

Today it is difficult to imagine photography without color. The amateur market is huge, and the ubiquitous snapshot is always in color. Commercial and publishing markets use color extensively. Even photography as an art form, which has been in black and white for most of its history, now often is in color.

LOUIS DUCOS du HAURON: View of Angoulême, France, 1877. Three-color carbon print

ARNOLD GENTHE: Helen Cooke Wilson in a California Poppy Field, c. 1908. Autochrome

Louis Ducos du Hauron's threecolor carbon process required three separate black-and-white negatives, one for each of the primary colors red, green, and blue. Each image was dyed the color of its primary and then superimposed to form a full-color image.

The Autochrome process was popular at the turn of the century with pictorialists who liked its graininess and subdued colors. The dots of color that composed the image blended at a normal viewing distance into a full range of colors, not unlike the effect that pointillist painters created with individual dots of paint.

The carbro process preceded the development of Kodachrome and other modern color films. Like Ducos du Hauron's three-color carbon print (opposite, top), carbros required three black-and-white negatives made with three different color filters. A cumbersome "oneshot'' camera was used. Light passed through a lens into the camera to an arrangement of mirrors that split the light so that all three negatives were made simultaneously. To make a print, the negatives were converted into three layers of dyed gelatin that were mounted in register on a white backing. Here, two famous movie stars pose for a soft-drink advertisement made by Nickolas Muray, one of the earliest and best of color advertising photographers.

NICKOLAS MURAY: Fredric March and Claudette Colbert, 1933. Carbro print

SANDI FELLMAN: Kintaro and Maple Leaves Tattoo, 1984

16 Portfolio

This chapter is a sampler of photographs. Its purpose, like the selection of all the pictures in this book, is to show the broad potential of photography. Whatever your goal in photography is, looking at the best of other people's work is an excellent way to improve your own pictures.

The understanding of a particular photograph, like the understanding of a piece of music, a poem, or a painting, is enhanced when you consider *how* the work means in addition to *what* it means. For example, the appreciation of music is intensified if you know something about its craft, such as harmony, counterpoint, rhythm, and the other elements of musical composition. Photographs, like music, have elements of composition such as structural, tonal, or color relationships, point of view, illusionistic space, and other visual characteristics (*see pages 326–349*). Photographers use these pictorial elements to suggest a feeling or mood or to state an idea.

Photographers also work from a variety of philosophical attitudes. Some are picture-*makers:* they build their photographs like tableaux and control or sometimes even physically make every part of their picture. Others are picture-*takers:* they prefer to select or frame their images from the flux of the world around them. Some alter the photographic image or photographic materials and may use nonphotographic media such as drawing, painting, or printmaking. Others believe that a direct and unmanipulated photograph is inherently the most satisfying.

Knowledge about the photographer, technique, or situation will help you as a viewer to respond more intelligently to a photograph, but ultimately you have to trust your own response to the picture itself. And any photograph—from a snapshot to a work of art—if examined openly and without prejudice, can help you to see with a more sophisticated eye.

Sandi Fellman often uses richly textured fabrics and other sensuous, visually complex elements in her work. Opposite is one of a series of photographs she made on the Japanese art of tattoo. She saw these elaborate tattoos as "an inversion of what I do in my photographs, which is to surround the figure with external decoration." The photographs both fascinate and repel; the viewer may admire the work of the tattoo artist, but flinch at the use of a human canvas. The motif of this tattoo is Kintaro, a hero in Japanese folklore, who is depicted wrestling with a giant carp. Fellman has posed her subject grasping his own sides just as Kintaro grasps the fish.

GREGORY HEISLER: Low Riders, Santa Ana, California, 1979

Gregory Heisler combined electronic flash and available light to make this glossy portrait of two people and their 1947 Fleetline Chevrolet. The picture was made in dim light at dusk. While the car slowly backed up, Heisler set off two batterypowered flash units, then left the shutter open for 2 sec more. The image is sharp where the car and riders were lit by the flash; the image is streaked and blurred where available light provided the illumination, as on the front fender and in the reflections in the chrome strips.

The inevitable end of all industrial products, even the glossiest, is documented above. In 1972 the Environmental Protection Agency (EPA) hired photographers to illustrate environmental problems and to show what the EPA was doing about them, in much the same way that the Farm Security Administration hired photographers to document government activity during the Depression of the 1930s.

BILL SHROUT: Cars Crushed for Recycling, Flowood, Mississippi

Notice how pictures can be affected by other images nearby: placing these two opposite each other adds a wry comment to the Heisler picture by showing the car's possible fate.

JOAN SALINGER: Magic, 1988

Digital image processing lets Joan Salinger stretch, warp, color, and generally reassemble photographs to her liking. Above, she made a photograph of herself looking at a picture on the wall. Using a computer equipped with graphics software, she emptied the parts of the image she did not want, replicated her image into the picture frame, and added sand, sky, graphic symbols, and color. Salinger has always been interested in mixing graphics with photography; a computer lets her do so at will. See also the photograph opposite and on page 217.

Joel Slayton has had a long-standing interest in combining pictures, text, markmaking, and image manipulation. Originally he did this by printing small editions of his own books. A computer lets him explore his interest even further. "Think of a computer as a visual synthesizer. It lets you bring together visual effects to produce images that are all but unattainable by any other means."

Above, he layered a face, words, and graphics into a composite portrait, one of a series he made of

JOEL SLAYTON: Untitled, 1981

people who were working with him on digital image processing. Slayton made the image on an early computer graphics system developed at the Visible Language Workshop at the Massachusetts Institute of Technology. At the time, relatively few people had access to digital image processing. Since then, interest in the medium has risen dramatically as the quality of image resolution has increased and the price of equipment and software has come down.

ERNST HAAS: Boys Playing Handball, New York City, 1974

Photography is the perfect instrument for capturing a passing instant, a gesture, a movement. Above, two boys are playing handball. Their movements are fluid, almost dancelike, as is the scrawl of graffiti across the wall.

In waters that are high from monsoon rains, a truck driver has stopped to wash his truck, then himself. The whole scene is a meeting of land and water. The truck and its reflection seem to float on the water. A flooded palace sits in the back-ground. The man's arm dissolves into his gesture.

JAN GROOVER: Untitled. 1978 398 The objects in Jan Groover's still life are common house plants and kitchen utensils, but the subject of the photograph is its compositional elements the shapes, colors, scale, and placement of the objects and their relationship to the rectangle of the picture format.

László Moholy-Nagy's photographs as well as his work in painting and other media are concerned not only with the shapes of objects but with the nature and use of light itself. The colored light transmitted by the strips of colored plastic or the shadows cast by the pins are as important a part of this still life as the objects themselves. Moholy-Nagy described much of his work as "only a paraphrase of the original problem, light." More about Moholy-Nagy appears on pages 380–381. See also work by Barbara Kasten on pages i, 10, and 11.

ELLEN FORBES BURNIE: Fashion Illustration, 1988

The best fashion photographs—of adults or children—use the model as more than just a clotheshanger for the outfit. The personality of the model can help sell the product as much as or more than the details of the product itself. Here the solemn, direct gaze of the model and her little-girl gesture with the skirt are sweet without being cloying. Her feet dangling above the floor add an extra childlike note.

Even advertising photographs that concentrate on the product often seek to convey an impression of the lifestyle for which the product is intended. Nana Watanabe, a fashion and beauty photographer, created a casual but elegant still life of shoe, handbag, and gloves for an advertisement. The subtext is: If you own these products, you will be casual but elegant, too.

NANA WATANABE: Fashion Illustration, 1984

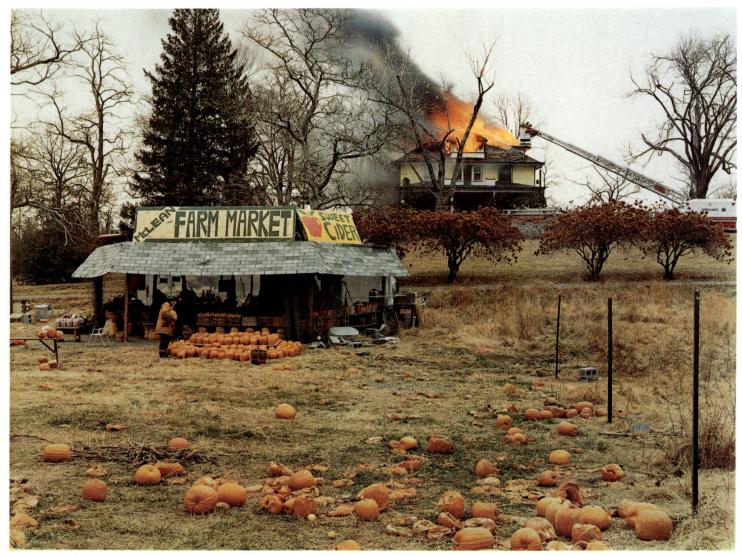

JOEL STERNFELD: McLean, Virginia, 1978

Nero fiddled while Rome burned; this fireman is selecting a pumpkin. Joel Sternfeld merely provides the location; the viewer has to finish the story—or simply accept the scene as the apparently humorous but unexplained event that it is. The coolly formal composition adds a note of irony: this might have been a setup such as one does for pastoral landscapes, but here it has gone awry.

Many of Garry Winogrand's pictures involve unusual confrontations. This one depicts a threeway face-off between humans and animals at the Bronx Zoo, with all participants apparently equally intrigued by the event. Winogrand exploited the camera's ability to collect facts. He said, "Photography is about finding out what can happen in the

GARRY WINOGRAND: Zoo, New York, 1962

frame. When you put four edges around some facts, you change those facts. The frame creates a world and photography is about [that] world." When asked why his images were tilted, he replied, "What tilt? There's only a tilt if you believe that the horizon line must be parallel to the horizontal edge. That's arbitrary."

FRANK GOHLKE: Grain Elevators and Lightning Flash, LaMesa, Texas, 1975

Pictorial beauty exists in places where it may not be evident at first. It is relatively easy to appreciate a photograph of a colorful seascape or a sweeping vista of mountains and clouds, but grain elevators, railroad yards, and other seemingly ordinary scenes can also be poetic and majestic.

Frank Gohlke's photographs are carefully composed scenes of epic scale that are rich in detail and tonality, such as the grain elevators, left, or the desolated area around Mount St. Helens after its eruption.

BERENICE ABBOTT: Jersey Railroad Yard, 1932

Berenice Abbott says she fell in love with New York and could have worked all her life photographing it. Here, the skyline of the city stands like a distant mountain range behind the New Jersey railroad yards that are just west of the city across the Hudson River. Abbott skillfully orchestrated a complex scene in which no single element dominates. As you look at the print, try to notice the path your eye follows. It may slide up and down the shiny rails, then jump from one white spot to another, to return to the rails.

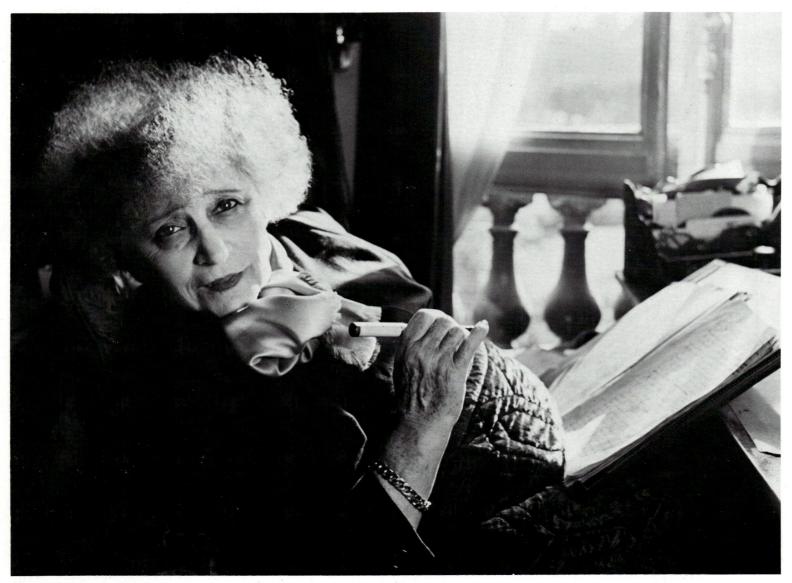

LOUISE DAHL-WOLFE: Colette, Paris, 1951

Environmental portraits, those that show people in their ordinary surroundings, seem to reveal information about character. It feels as if we know more about the women here because they are shown in their own surroundings. The photographer, however, is usually in control of which objects are included in the frame of the photograph and so can shape the impression that the viewer has of a subject.

Louise Dahl-Wolfe is best known for her fashion photography, which appeared frequently in Harper's Bazaar from 1936 to 1958. She was an innovator in bringing a naturalness and intimacy to fashion photography that replaced the rather artificially polished glamour of the preceding era. She also made many portraits, like this one of the French writer Colette late in her life working propped up in bed. Although Colette seems to have paused in the midst of writing a sentence to look at the camera for just a moment. Dahl-Wolfe was a perfectionist in her work and would not simply have walked into the room and snapped the shutter.

Yousuf Karsh's portraits include presidents, popes, and most of the century's greatest musicians, writers, and artists, including the painter Georgia O'Keeffe (right). This portrait is typical of Karsh's work, conveying very strongly the sitter's public image, that is, what we expect that particular person to look like. Karsh generally photographs people in their own environments but imposes on his portraits his distinctive style: carefully posed and lighted setups, rich black tones, often with face and hands highlighted.

YOUSUF KARSH: Georgia O'Keeffe, 1956

Portfolio: continued

Serial imagery, sequences, and photo essays release the photographer from the confinement of a single picture. They can show variations of a single photograph or theme, show the same scene from different angles or at different times, bring together different images to make a particular statement, or, as here, tell a story.

Duane Michals tells stories that are seldom literal, but always relevant. "Photography to me is a matter of thinking rather than looking," he says. "It's revelation, not description." His photographs are often accompanied by titling or captions. Notice that you need the title of this story in order to understand it.

DUANE MICHALS: Death Comes to the Old Lady, 1969 408

I LOOK AT THIS PICTURE AND I KNOW MY MOTHER KNEW THAT WE WORE THE BE AND WE LOVED HER.

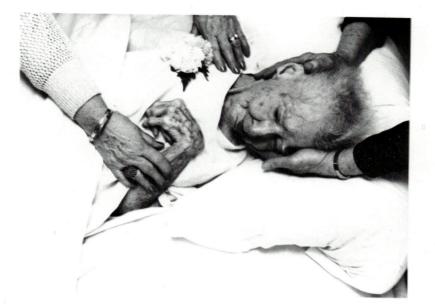

THIS IS MY MOTHER HELPLESS IN HER FINAL DAKS. SHE WAS WAITING AND TRYING HARD TO DIE SHE HAD LIVED TOO LONG

THE NORSING HOME GAVE HER THE CARE SHE REQUIRED. BUT I WISH I COULD HAVE KEPT HER HOME WITH ME-LINE A ROSE KENNEDY.

IT is ALL Economics AND TIME - IF ONLY I WERE Rich

E Que H. Sheen DAUGHTER OF MARY & SULLIVAN 1885 - 1985 SCHILDREN 17 GRANDCHILDREN 28 GREAT GRANDCHILDREN

Jim Goldberg asks the people in his photographs to add a written commentary to their picture. While you might comprehend this photograph without the words, they are a poignant addition that greatly intensifies the emotional content of the picture.

GEORGE A. TICE: Country Road, Lancaster, Pennsylvania, 1961

George Tice had been attracted several times to this country roadway, but had not been satisfied with the results until late one afternoon when a single car appeared, backlit by the setting sun. He printed the picture on high-contrast grade 5 printing paper, then gave the print additional exposure to darken the fields that surrounded the road. The result is a believable scene but with an air of mystery. As Tice saw the final print: "The road is narrowed at both ends. To each side lie unfathomable depths. The driver is not sure where he is going. He is alone."

Minor White often saw the sublime in the ordinary, and here infrared film with its altered tonalities aids in the expression of a landscape that becomes a dreamscape. The perspective of the converging lines of road and trees funnels the eye down the road to the dark mountains beyond. The repeated shadows of the trees reinforce the depth

MINOR WHITE: Road and Poplar Trees, Upstate New York, 1955

in the scene as the distance between them apparently diminishes. There is no sure way to make a landscape like this happen out of a road lined with trees, no matter what film you use. The landscape itself has to cooperate. White often put forth his basic rule of composition: let the subject generate its own composition.

Credits continued from page ii

Art, New York, given anonymously. 112: David F. Warren / U.S. Department of Agriculture; Henry Groskinsky. 114: Walker Evans / courtesy Library of Congress. 115: Jack Sal / Michael Belenky / BL Books, Inc. 116: Fredrik D. Bodin. 117: Flint Born. 118: Rick Steadry. 119: John Upton. 120: Lou Carrano; Robert Walch and Lou Carrano. 121: Jack Sal / Michael Belenky / BL Books, Inc. 123: Lisl Dennis. 124: Ray McSavaney. 125: John Loengard.

Chapter 6 126: Paul Caponigro. 128: Ken Kay. 131: Scott Goldsmith. 132: Ken Kay; Alan Oransky (third from left). 133: Ken Kay. 134: Jack Sal / Michael Belenky / BL Books, Inc.; Ken Kay; Alan Oransky. 135: Chauncey Bayes; Ken Kay. 136: Ken Kay; Chauncey Bayes (center). 137: Ken Kay; Chauncey Bayes (right). 138: Ken Kay; Alan Oransky (right). 140: Eastman Kodak Co., Kodak Research Laboratory, Rochester, New York. 141– 142: Robert Walch. 143: David Arky; Sebastian Milito. 145: Arthur Taussig. 147: Rick Steadry; Michele McDonald. 148: Jim Stone. 149: William Gedney; Sebastian Milito (right). 150: Sebastian Milito. 151: Alan Oransky; Sebastian Milito (bottom).

Chapter 7 152: Kenneth Josephson / collection of Art Institute of Chicago. 153: Arthur Taussig. 154–155: Ken Kay. 158: Dmitri Kessel. 160: Chauncey Bayes; Ken Kay. 161: Chauncey Bayes (upper left, upper center); Ken Kay (upper right, bottom row). 162–170: Ken Kay. 172–173: Jim Stone. 175: Arthur Taussig. 176: Jules Zalon; John Loengard. 177: Jules Zalon (top); John Loengard (left); Ken Kay (right). 178: Ken Kay; Chauncey Bayes. 179: John Loengard; Ken Kay. 180: © Arnold Newman; Rick Steadry. 182: George A. Tice. 184–185: Sebastian Milito.

Chapter 8 186: Olivia Parker. 188: Al Freni (top); courtesy Doran Enterprises, Inc. (left); Alan Oransky (right). 189: Rick Steadry. 190–191: Ken Kay. 192: Jack Sal / Michael Belenky / BL Books, Inc. 193–195: Ken Kay.

Chapter 9 196–197: Steve Bronstein. 199–200: Ken Kay. 201: Stephen Brown; Fil Hunter. 202: Ken Kay. 203: Ralph Weiss, 205: Engraving by Samuel Sartain, after Gustave Doré. 206: © 1988 ARS New York / ADAGP. 207: Sebastian Milito (left); Yale Joel (right); Jack Sal (bottom). 209: Arthur Taussig / Carol Linam. 210–215: Fred Burrell. 216: Betty Hahn. 217: Todd Walker; Scitex America Corp. 218: Joyce Neimanas / courtesy Center for Creative Photography, University of Arizona. 219: Jerry N. Uelsmann.

Chapter 10 220: Michael Skott / Jeanne Skott, stylist. 221: Joe Polivka / courtesy Kraft, Inc. 222– 223: Sebastian Milito. 224: Robert Crandall; Herb Orth. 227–228: Sebastian Milito. 230: Richard Steinberg. 231: © David Muench. 232: Emil Schulthess and Emil Spühler / Black Star. 233: © 1980 Dick Durrance II. 234: David Moore / Black Star. 235: Peter deLory. 236: Fil Hunter. 237: © Eve Arnold / Magnum. 238: Harold Feinstein. 239: Michael Geiger. 241–247, 249: Donald Dietz. 250: Phyllis Galembo. 251: Mary Ellen Mark / Archive. 252: Alan Oransky. 253: Al Freni. 254: Donald Dietz. 255: Andrea Blanch. 256: Clint Clemens. 257: Barbara Bordnick.

Chapter 11 258: Claude Nuridsany / Marie Pérennou. 259: Y. R. Okamoto / courtesy Lyndon Baines Johnson Library. 260: Ray McSavaney. 261: © Werner Bischof / Magnum; © Sergio Larrain / Magnum. 262: Etta Clark, from Growing Old is Not for Sissies; Fredrik D. Bodin. 263: © Danny Lyon / Magnum. 264: © Henri Cartier-Bresson / Magnum; Walker Evans / courtesy Library of Congress. 265: © 1979 JEB (Joan E. Biren): © Bob Adelman / Magnum. 266-267: Jack Sal / Michael Belenky / BL Books, Inc. 269: Henry Groskinsky. 270-271: @ 1988 Jill Krementz, 272-273: David Arky, 274: Sebastian Milito. 275: Fil Hunter. 276: © Erich Hartmann / Magnum. 277: Al Freni. 278: © Lois Greenfield, 279; Arthur Fellia (Weegee) / Weegee Collection. 280: Ken Kay (left); Canon USA, Inc. (upper right); courtesy Berkey Marketing Companies (second from top, bottom); courtesy Nikon Inc. (third from top). 281: Terry Eiler / American Folklife Center. 283: Jack Sal / Michael Belenky / BL Books, Inc. 284-285: David Arky. 286: Jack Sal / Michael Belenky / BL Books, Inc. 287: Jack Sal / Michael Belenky / BL Books, Inc.; Richard Misrach / courtesy Fraenkel Gallery, San Francisco and Fotomann, Inc., New York. 288: Elizabeth Hamlin; John Upton (third from top). 289: Archie Lieberman for Motorola, Inc.

Chapter 12 290: Courtesy Robert A. Weinstein. 292: Arthur Taussig. 294–301: Ken Kay. 302: Donald Dietz. 303: Ken Kay. 304: Philip Trager; Ken Kay. 305: Philip Trager; Ken Kay. 306: Ken Kay. 311: Michael A. Smith.

Chapter 13 312: Ansel Adams / courtesy Trustees of Ansel Adams Publishing Rights Trust. All rights reserved. 315, 317: John Upton. 319: Rick Steadry. 321: John Upton. 322: © Morley Baer. 323: Chris Rainier. 325: Ansel Adams / courtesy Trustees of Ansel Adams Publishing Rights Trust. All rights reserved.

Chapter 14 326: Cecil Beaton / courtesy Sotheby's London. 327: Jack Manning, from "Harlem Document." 328: Linda Bartlett. 329: Richard E. Ahlborn / American Folklife Center; Carl Fleischhauer / American Folklife Center. 330-331: Joe Wrinn. 332: John Senzer. 333: Robert Doisneau, 334: © John Sexton, 335: Russell Lee / courtesy Library of Congress. 336: Paul Caponigro. 337: Gordon Parks. 338: Roy Clark / U.S. Department of Agriculture; R. O. Brandenberger / U.S. Department of Agriculture. 339: © Dennis Stock / Magnum. 340: U.S. Department of Agriculture. 341: Herbert List Estate / Max Scheler; U.S. Department of Agriculture. 342: © 1970 Judy Dater. 343: Bill Hedrich. 344: Robert Branstead / U.S. Department of Agriculture. 345: © Josef Koudelka / Magnum. 346: Marion Post Wolcott / courtesy Library of Congress. 347: David Moore; Dorothea Lange / © City of Oakland, Oakland Museum, California. 349: © Henri Cartier-Bresson / Magnum.

Chapter 15 350: One-quarter plate daguerreotype (3¹/₄ × 4¹/₄^{''}) / collection of Museum of Modern Art, New York, gift of Virginia Cuthbert Elliott. 353: Gernsheim Collection, Harry Ransom Humanities Research Center, University of Texas at Austin. 354: Collections of Société Française de Photographie; International Museum of Photography at George Eastman House. 355: Amherst College Library. 356: Courtesy Lee Boltin Picture Library. 357: G. R. Rinhart Collection. 359: Timothy H. O'Sullivan / courtesy Library of Congress; Joel Snyder / Division of Photographic History, Smithsonian Institution. 360: Crown Copyright Victoria and Albert Museum. 361: Bibliothèque Nationale / Eddy Van der Veen. 362:

Gernsheim Collection, Harry Ransom Humanities Research Center, University of Texas at Austin. 363: Timothy H. O'Sullivan / courtesy Library of Congress. 364: Courtesy Arnold Crane Collection, Chicago, Illinois, 365: Timothy H. O'Sullivan / courtesy Library of Congress. 366-367: International Museum of Photography at George Eastman House, 368: Bayerisches Nationalmuseum; International Museum of Photography at George Eastman House. 369: International Museum of Photography at George Eastman House. 370: © Estate of August Sander / courtesy Sander Gallery, New York. 371: Gelatin-silver print $(9^{1}_{16} \times 6^{1}_{4})$ by Berenice Abbott, 1940 / collection of Museum of Modern Art, New York, gift of Edward Steichen. 372: International Museum of Photography at George Eastman House. 373: Dorothea Lange / © City of Oakland, Oakland Museum, California. 374: Collection of Royal Photographic Society; Gernsheim Collection, Harry Ransom Humanities Research Center, University of Texas at Austin. 375: Gernsheim Collection, Harry Ransom Humanities Research Center, University of Texas at Austin. 376: Platinum print on Japanese tissue ($93_{\%} \times 51_{2}$ '') by Gertrude Käsebier / collection of Museum of Modern Art, New York, gift of Mrs. Hermine M. Turner, 377: Photogravure (artist's proof: 73/4 × 61/2") by Alfred Stieglitz from Camera Work, no. 36. 1911 / collection of Museum of Modern Art, New York, gift of photographer. 378: Gravure (611/16 × 811/16") by Paul Strand, from Camera Work, no. 49-50, June 1917 / collection of Museum of Modern Art, New York, given anonymously. 379: Edward Weston / © 1981 Arizona Board of Regents, Center for Creative Photography. 380: © 1988 ARS New York / ADAGP. 381: Courtesy Hattula Moholy-Nagy and International Museum of Photography at George Eastman House. 382: Aaron Siskind. 383: Robert Frank / collection of Museum of Fine Art, Houston, Texas. 384: © Peter Hunter / Magnum (left); Erich Salomon / courtesy Bildarchiv Preussischer Kulterbesitz, Berlin, West Germany (upper right); Time-Life Books (lower right). 385: Werner Voight / SIPA Press; Murray Becker / Associated Press / Wide World (inset). 386-387: W. Eugene Smith / Life Magazine © 1951 Time Inc. 388: International Museum of Photography at George Eastman House; Arnold Genthe / courtesy Library of Congress. 389: International Museum of Photography at George Eastman House.

Chapter 16 390: Sandi Fellman. 392: Gregory Heisler. 393: Bill Shrout. 394: Joan Salinger. 395: Joel Slayton / Visible Language Workshop, Massachusetts Institute of Technology. 396: © Ernst Haas. 397: Mitch Epstein. 398: Jan Groover. 399: Courtesy Hattula Moholy-Nagy and International Museum of Photography at George Eastman House. 400: Ellen Forbes Burnie. 401: Nana Watanabe. 402: © Joel Sternfeld / courtesy Pace / MacGill Gallery, New York. 403: © 1984 Estate of Garry Winogrand / courtesy Fraenkel Gallery, San Francisco, and Estate of Garry Winogrand. 404: Courtesy Bonni Benrubi Fine Arts, New York City. 405: Berenice Abbott / Commerce Graphics Ltd., Inc. 406: Louise Dahl-Wolfe Trust. 407: © Karsh, Ottawa. 408: Duane Michals, 409: Jim Goldberg, 410: George A. Tice. 411: Courtesy Minor White Archive / © 1982 Trustees of Princeton University

Drawings by: Nicholas Fasciano; Pierre Haubensak; Jean Held; PC&F, Inc.; John Svezia.

Glossary

- aberration An optical defect in a lens causing it to form an image that is not sharp or that is distorted. See astigmatism, barrel distortion, chromatic aberration, coma, field curvature, pincushion distortion, sherical aberration.
- acid A substance with a pH below 7. Since an acid neutralizes an alkali, a stop bath is usually an acidic solution that stops the action of the alkaline developer.
- additive color A way to produce colors of light by mixing light of the three additive primary colors —red, green, and blue. Varying proportions of the additive primaries can be combined to create light of all other colors, including white, which is a mixture of all wavelengths
- AE See automatic exposure.
- AF See automatic focus.
- agitate To move a solution over the surface of film or paper during development so that fresh liquid comes into contact with the surface.
- albumen Egg white. Used in early photographic emulsions as a coating for glass plates and, more commonly, for printing paper.
- alkali A substance with a pH above 7. Developers are usually alkaline solutions.
- **ambrotype** A collodion wet-plate process in which the emulsion was coated on a glass plate. The negative image produced was visible as a positive image when the glass was backed with a dark material.
- angle of view The area seen by a lens or viewfinder or read by a light meter.
- aperture The size of the lens opening through which light passes. The relative aperture is measured as the focal length of the lens divided by the diameter of the aperture; this is expressed as an f-number: f/8, f/11, and so on.
- **aperture-priority** A mode of automatic exposure in which the photographer selects the aperture and the camera sets the shutter speed that will produce the correct exposure.
- archival processing Processing designed to protect a print or negative as much as possible from premature deterioration caused by chemical reactions.
- artificial light Light from an electric lamp, a flash bulb, or electronic flash. Often describes lights that the photographer has set up to illuminate a scene.
- **ASA** A numerical rating that describes the sensitivity of a film to light. The ASA rating doubles as the sensitivity of the film doubles.
- **astigmatism** A lens aberration or defect that is caused by the inability of a simple lens to focus oblique rays uniformly.
- automatic exposure A mode of camera operation in which the camera adjusts the shutter speed, the aperture, or both to produce the correct exposure. Abbreviated AE.
- automatic flash An electronic flash unit with a light-sensitive cell and electronic circuitry that measures the light reflected back from the subject and terminates the flash when the exposure is correct.
- **automatic focus** A system by which the camera adjusts its lens to focus on a given area, for example, whatever is at the center of the image. Abbreviated AF.

ambient light See available light.

- Av Abbreviation of aperture value. Used on some camera information displays as a shortened way to refer to aperture settings (f-stops).
- available light The light that already exists where a photograph is to be made, as opposed to light

brought in by the photographer. Often implies a relatively dim light. Also called ambient light or existing light.

axis lighting Light pointed at the subject from a position close to the camera's lens.

B See bulb.

- **back lighting** Light that comes from behind the subject toward the camera.
- **barrel distortion** A lens aberration or defect that causes straight lines to bow outward, away from the center of the image.
- **bellows** A flexible, light-tight and usually accordion-folded part of a view camera between the lens board in front and the viewing screen in back. Also used on a smaller camera when the lens must be positioned farther than normal from the film.
- **bleed mount** To mount a print so that there is no border between the edges of the print and the edges of the mounting surface.
- **blocked up** Describes highlight areas that lack normal texture and detail. Due to excess contrast caused by, for example, overexposure or overdevelopment.
- blotters Sheets of absorbent paper made expressly for photographic use. Wet prints dry when placed between blotters.
- **bounce light** Light that does not travel directly from its source to the subject but is first reflected off another surface.
- **bracket** To make several exposures, some greater and some less than the exposure that is calculated to be correct. Bracketing allows for error and permits selection of the best exposure after development.
- brightness Strictly speaking, a subjective impression of the lightness of an object. The correct term for the measurable quantity of light reflected or produced by an object is *luminance*. *See luminance*.
- **broad lighting** Portrait lighting in which the main source of light illuminates the side of the face turned most toward the camera.
- **built-in meter** A reflected-light exposure meter built into a camera so that light readings can be made directly from camera position.
- **bulb** A shutter setting marked *B* at which the shutter remains open as long as the shutter release is held down.
- **burn in** To darken a specific area of a print by giving it additional printing exposure.
- **butterfly lighting** Portrait lighting in which the main source of light is placed high and directly in front of the face.
- cable release A long coiled wire with a plunger at one end and a socket at the other that attaches to a camera's shutter release. Pressing the plunger releases the shutter without touching (and possibly moving) the camera.
- calotype The first successful negative/positive photographic process; it produced an image on paper. Invented by Talbot; also called Talbotype.
- **camera** A picture-taking device usually consisting of a light-tight box, a film holder, a shutter to admit a measured quantity of light, and a lens to focus the image.
- camera obscura Latin for "dark chamber": a darkened room with a small opening through which rays of light could enter and form an image of the scene outside. Eventually, a lens was added at the opening to improve the image, and the room shrank to a small, portable box.

carte-de-visite A small portrait, about the size of a visiting card, popular during the 1860s. People often collected them in albums.

cartridge See cassette.

- **cassette** A light-tight metal or plastic container that permits a roll of 35mm film to be loaded into a camera in the light. Also called a cartridge.
- catchlight A reflection of a light source in a subject's eye.
- **changing bag** A light-tight bag into which a photographer can insert his or her hands to handle film when a darkroom is not available.
- characteristic curve A diagram of the response to light of a photographic material, showing how increasing exposure affects silver density during development. Also called the D log E curve, since density is plotted against the logarithm of the exposure.
- chromatic aberration A lens defect that bends light rays of different colors at different angles and therefore focuses them on different planes. chrome A color transparency.
- chromogenic film Film in which the final image is composed of dyes rather than silver.
- circle of confusion The tiny circle of light formed by a lens as it projects the image of a single point of a subject. The smaller the diameters of all the circles of confusion in an image, the sharper the image will be.
- **close-up** A larger-than-normal image that is formed on a negative by focusing the subject closer than normal to the lens with the use of supplementary lenses, extension tubes, or bellows.
- close-up lens See supplementary lens.
- **cold-light enlarger** A diffusion enlarger that uses a fluorescent tube instead of a tungsten bulb as the light source.
- **collodion** A transparent, syrupy solution of pyroxylin (a nitrocellulose) dissolved in ether and alcohol. Used as the basis for the emulsion in the wet-plate process.
- **color balance** 1) A film's response to the colors of a scene. Color films are balanced for use with specific light sources. 2) The reproduction of colors in a color print, alterable during oriniting.
- color cast A trace of one color in all the colors in an image.
- color compensating filters Gelatin filters that can be used to adjust the color balance during picture taking or in color printing. More expensive than acetate color printing filters, they can be used below the enlarger lens if the enlarger has no other place for filters. Abbreviated CC filters.
- **color printing filters** Acetate filters used to adjust the color balance in color printing. They must be used with an enlarger that can hold filters between the enlarger lamp and the negative. Abbreviated CP filters.
- **color temperature** A numerical description of the color of light. It is the temperature in degrees Kelvin (K) to which a perfect black-body radiator (an object that does not reflect any light falling on it) would have to be heated to produce a given color.
- **color temperature meter** A device for estimating the color temperature of a light source. Usually used to determine the filtration needed to match the color balance of the light source with that of standard types of color film.
- **coma** A lens aberration or defect that causes rays that pass obliquely through the lens to be focused at different points on the film plane.

- **complementary colors** 1) Any two colors of light that when combined include all the wavelengths of light and thus produce white light (*see additive color*). 2) Any two dye colors that when combined absorb all wavelengths of light and thus produce black (*see subtractive color*). A colored filter absorbs light of its complementary color and passes light of its own color.
- **condenser enlarger** An enlarger that illuminates the negative with light that has been concentrated and directed by condenser lenses placed between the light source and the negative.
- **contact printing** The process of placing a negative in contact with sensitized material, usually paper, and then passing light through the negative onto the material. The resulting image is the same size as the negative.
- contamination Traces of chemicals that are present where they don't belong, causing loss of chemical activity, staining, or other problems.
- continuous tone Describes an image with a smooth gradation of tones from black through grav to white.
- **contrast** The difference in darkness or density between one tone and another.
- contrast filter A colored filter used on a camera lens to lighten or darken selected colors in a black-and-white photograph. For example, a green filter used to darken red flowers against green leaves.
- **contrast grade** The contrast that a printing paper produces. Systems of grading contrast are not uniform, but in general grades 0 and 1 have low or soft contrast; grades 2 and 3 have normal or medium contrast; grades 4, 5, and 6 have high or hard contrast.
- **contrasty** Describes a scene, negative, or print with very great differences in brightness between light and dark areas. Opposite: *flat.*
- **convergence** The phenomenon in which lines that are parallel in a subject, such as the vertical lines of a building, appear nonparallel in an image.
- **cool** Refers to bluish colors that, by association with common objects (water, ice, and so on), give an impression of coolness.
- correction filter A colored filter used on a camera lens to make black-and-white film produce the same relative brightnesses perceived by the human eye. For example, a yellow filter used to darken a blue sky so it does not appear excessively light.
- coupled rangefinder See rangefinder.
- **covering power** The area of the focal plane over which a lens projects an image that is acceptably sharp and uniformly illuminated.
- **crop** To trim the edges of an image, often to improve the composition. Cropping can be done by moving the camera position while viewing a scene, by adjusting the enlarger or easel during printing, or by trimming the finished print.
- curvilinear distortion See barrel distortion, pincushion distortion.

cut film See sheet film.

- **daguerreotype** The first practical photographic process, invented by Daguerre and described by him in 1839. The process produced a positive image formed by mercury vapor on a metal plate coated with silver iodide.
- **darkroom** A room where photographs are developed and printed, sufficiently dark to handle light-sensitive materials without causing unwanted exposure.

dark slide See slide (2).

daylight film Color film that is balanced to produce accurate color renditions when the light source illuminating the photographed scene has a color temperature of about 5500K, such as in midday sunlight or with electronic flash or a blue flashbulb.

- dedicated flash An electronic flash unit that, when used with certain cameras, will automatically set the correct shutter speed for use with flash and will trigger a light in the viewfinder when the flash is charged and ready to fire. Also called designated flash.
- **dense** Describes a negative or an area of a negative in which a large amount of silver has been deposited. A dense negative transmits relatively little light. Opposite: *thin*.
- **densitometer** An instrument that measures the darkness or density of a negative or print.
- **density** The relative amount of silver present in various areas of film or paper after exposure or development. Therefore, the darkness of a photographic print or the light-stopping ability of a negative or transparency.
- **depth of field** The area between the nearest and farthest points from the camera that are acceptably sharp in an image.
- depth of focus The small range of allowable focusing error which will still produce an acceptably sharp image when a lens is not focused exactly.
- designated flash See dedicated flash.
- **developer** A chemical solution that changes the invisible, latent image produced during exposure into a visible one.
- development 1) The entire process by which exposed film or paper is treated with various chemicals to make an image that is visible and permanent. 2) Specifically, the step in which film or paper is immersed in developer.
- **diaphragm** The mechanism controlling the brightness of light that passes through a lens. An iris diaphragm has overlapping metal leaves whose central opening can be adjusted to a larger or smaller size. See aperture.
- dichroic head An enlarger head that contains yellow, magenta, and cyan filters that can be moved in calibrated stages into or out of the light beam to change the color balance of the enlarging light.
- diffuse Scattered, not all coming from the same direction. For example, sunlight on a cloudy day.
- diffusion enlarger An enlarger that illuminates the negative by scattering light from many angles evenly over the surface of the negative.
- digital image processing A method of image editing in which a picture is reduced to digital information that can be read and manipulated by a computer, and subsequently reformed as a visible image.
- **DIN** A numerical rating used in Europe to describe the sensitivity of film to light. The DIN rating increases by 3 as the sensitivity of the film doubles.
- diopter An optician's term to describe the power of a lens. In photography, it mainly indicates the magnifying power and focal length of a supplementary close-up lens.
- distortion 1) A lens aberration that causes straight lines at the edge of an image to appear curved. 2) The changes in perspective that take place when a lens is used very close to (wideangle effect) or very far from (telephoto effect) a subject.
- **dodge** To lighten an area of a print by shading it during part of the printing exposure.
- dropout An image with black and white areas only and no intermediate gray tones. Usually made by using high-contrast lith film.
- dry down To become very slightly darker and less

contrasty, as most photographic printing papers do when they dry after processing.

- dry mount To attach a print to another surface, usually cardboard, by placing a sheet of drymount tissue between the print and the mounting surface. This sandwich is placed in a heated mounting press to melt an adhesive in the tissue.
- **DX coding** A checkered or bar code on some film cassettes. The checkered code can be automatically scanned by a suitably equipped camera for such information as film speed and number of frames. The bar code is read by automatic film processing equipment for film type, processing procedure, and so on.
- ease! A holder to keep sensitized material, normally paper, flat and in position on the baseboard of an enlarger during projection printing. It usually has adjustable borders to frame the image to various sizes.
- El See exposure index.
- electromagnetic spectrum The forms of radiant energy arranged by size of wavelength ranging from billionths of a millimeter (gamma rays) to several miles (radio waves). The visible spectrum is the part that the human eye sees as light: wavelengths of 400 to 700 nanometers (billionths of a meter), producing the sensation of the colors violet, blue, green, yellow, and red.
- electronic flash A tube containing gas that produces a brief, brilliant flash of light when electrified. Unlike a flashbulb, an electronic flash unit is reusable. Also called a strobe.
- emulsion A light-sensitive coating applied to photographic films or papers. It consists of silver halide crystals and other chemicals suspended in gelatin.
- enlargement An image, usually a print, that is larger than the negative. Made by projecting an enlarged image of the negative onto sensitized paper.
- enlarger An optical instrument ordinarily used to project an image of a negative onto sensitized paper. More accurately called a projection printer because it can project an image that is either larger or smaller than the negative.
- etch To remove a small, dark imperfection in a print or negative by scraping away part of the emulsion.
- **EV** See exposure value.
- existing light See available light.
- **exposure** 1) The act of letting light fall on a lightsensitive material. 2) The amount of light reaching the light-sensitive material; specifically, the intensity of light multiplied by the length of time it falls on the material.
- **exposure index** A non-standard film speed rating similar to an ISO/ASA rating. Abbreviated EI.
- exposure meter An instrument that measures the amount of light falling on a subject (incidentlight meter) or emitted or reflected by a subject (reflected-light meter), allowing aperture and shutter speed settings to be computed. Commonly called a light meter.
- exposure value A system originally intended to simplify exposure calculations by assigning standardized number values to f-stop and shutter speed combinations. More often, used simply as a shorthand way of describing the range of light levels within which equipment operates. For example, a manufacturer may describe a meter as operating from EV -1 to EV 20 (4 sec at f/1.4 to 1/2000 sec at f/22, with ISO/ASA 100 film).
- extension tubes Metal rings that can be attached between a camera body and lens for close-up work. They extend the lens farther than normal

from the film plane so that the lens can focus closer than normal to an object.

- factor A number that tells how many times exposure must be increased to compensate for loss of light (for example, due to use of a filter).
- Farmer's reducer A solution of potassium ferricyanide and sodium thiosulfate that is used to decrease the amount of silver in a developed image
- fast Describes 1) a film or paper that is very sensitive to light; 2) a lens that opens to a very wide aperture; 3) a short shutter speed. Opposite: slow
- ferrotype To give a glossy printing paper a very high sheen by drying the print with its emulsion pressed against a smooth metal plate, usually the hot metal drum or plate of a heat dryer.
- fiber-base paper Formerly the standard type of paper available; now being replaced to a certain extent by resin-coated papers. Printed instructions for washing, drying, and so forth refer to fiber-base papers unless resin-coated papers are specifically mentioned.
- field curvature A lens aberration or defect that causes the image to be formed along a curve instead of on a flat plane.
- fill light A source of illumination that lightens shadows cast by the main light and thereby reduces the contrast in a photograph.
- film The material used in a camera to record a photographic image. Generally it is a light-sensitive emulsion coated on a flexible acetate or plastic base.
- film holder A light-tight container to hold the sheet film used in a view camera.
- film plane See focal plane.
- film speed The relative sensitivity to light of a film. There are several rating systems: ISO/ASA (the most common in the United States and Great Britain), DIN (common in Europe), and others. Film speed ratings increase as the sensitivity of the film increases.
- filter 1) A piece of colored glass, plastic, or other material that selectively absorbs some of the wavelengths of light passing through it. 2) To use such a filter to modify the wavelengths of light reaching a light-sensitive material.
- filter factor See factor.
- fisheye lens A lens with an extremely wide angle of view (as much as 180°) and considerable barrel distortion (straight lines at the edges of a scene appear to curve around the center of the image).
- fixer A chemical solution (sodium thiosulfate or ammonium thiosulfate) that makes a photographic image insensitive to light. It dissolves unexposed silver halide crystals while leaving the developed silver image. Also called hypo.
- flare Unwanted light that reflects and scatters inside a lens or camera. When it reaches the film, it causes a loss of contrast in the image
- flash 1) A light source, such as a flashbulb or electronic flash, that emits a very brief, bright burst of light. 2) To blacken an area in a print by exposing it to white light, such as from a penlight flashlight.
- flash bar or flash cube A lighting device containing several very small flashbulbs and producing several separate flashes before the unit is discarded.
- flashbulb A bulb containing a mass of aluminum wire, oxygen, and an explosive primer. When the primer is electrically fired, it ignites the wire, which emits a brief burst of brilliant light. A flashbulb is used once and then discarded.

flash meter An exposure meter that measures

the brightness of flash lighting to determine the correct exposure for a particular setup.

- flat 1) A scene, negative, or print with very little difference in brightness between light and dark areas. Opposite: contrasty. 2) See reflector.
- floodlight An electric light designed to produce a broad, relatively diffused beam of light.
- f-number A number that equals the focal length of a lens divided by the diameter of the aperture at a given setting. Theoretically, all lenses at the same f-number produce images of equal brightness. Also called f-stop or relative aperture.
- focal length The distance from the lens to the focal plane when the lens is focused on infinity. The longer the focal length, the greater the magnification of the image.
- focal plane The plane or surface on which a focused lens forms a sharp image. Also called the film plane.
- focal-plane shutter A camera mechanism that admits light to expose film by moving a slit or opening in a roller blind just in front of the film (focal) plane.
- focal point The point on a focused image where the rays of light intersect after reflecting from a single point on a subject.
- focus 1) The position at which rays of light from a lens converge to form a sharp image. 2) To adjust the distance between lens and image to make the image as sharp as possible.
- focusing cloth A dark cloth used in focusing a view camera. The cloth fits over the camera back and the photographer's head to keep out light and to make the ground-glass image easier to see
- fog An overall density in the photographic image caused by unintentional exposure to light or unwanted chemical activity.
- frame 1) The edges of an image. 2) A single image in a roll of film.
- f-stop The common term for the aperture setting of a lens. See f-number.
- full-scale Describes a print having a wide range of tonal values from deep, rich black through many shades of gray to brilliant white.
- gelatin A substance produced from animal skins and bones, it is the basis for modern photographic emulsions. It holds light-sensitive silver halide crystals in suspension.
- glossy Describes a printing paper with a great deal of surface sheen. Opposite: matte.
- graded-contrast paper A printing paper that produces a single level of contrast. To produce less or more contrast, a change has to be made to another grade of paper. See variable-contrast paper.
- graininess In an enlarged image, a speckled or mottled effect caused by oversized clumps of silver in the negative.
- gray card A card that reflects a known percentage of the light falling on it. Often has a gray side reflecting 18 percent and a white side reflecting 90 percent of the light. Used to take accurate exposure meter readings (meters base their exposures on a gray tone of 18 percent reflectance) or to provide a known gray tone in color work
- ground glass 1) A piece of glass roughened on one side so that an image focused on it can be seen on the other side. 2) The viewing screen in a reflex or view camera.
- guide number A number used to calculate the f-setting (aperture) that correctly exposes a film of a given sensitivity (film speed) when the film is used with a specific flash unit at various dis-

tances from flash to subject. To find the f-setting, divide the guide number by the distance.

- gum-bichromate process An early photographic process revived by contemporary photographers. The emulsion is a sensitized gum solution containing color pigments. The surface can be altered by hand during the printing process.
- halftone An image that can be reproduced on the same printing press with ordinary type. The tones in the photograph are screened to a pattern of dots (close together in dark areas, farther apart in light areas) that give the illusion of continuous tone.
- hanger A frame for holding sheet film during processing in a tank.
- hard 1) Describes a scene, negative, or print of high contrast. Opposite: soft or low contrast. 2) Describes a printing paper emulsion of high contrast such as grades 5 and 6.
- heliography An early photographic process. invented by Niépce, employing a polished pewter plate coated with bitumen of Judea, a substance that hardens on exposure to light.
- highlight A very bright area in a scene, print, or transparency; a very dense, dark area in a negative. Also called a high value.
- hot shoe A bracket on the top of the camera that attaches a flash unit and provides an electrical connection to synchronize the camera shutter with the firing of the flash.
- hyperfocal distance The distance to the nearest plane of the depth of field (the nearest object in focus) when the lens is focused on infinity. Also the distance to the plane of sharpest focus when infinity is at the farthest plane of the depth of field. Focusing on the hyperfocal distance extends the depth of field from half the hyperfocal distance to infinity.
- hypo A common name for any fixer; taken from the abbreviation for sodium hyposulfite, the previous name for sodium thiosulfate (the active ingredient in most fixers).

hypo clearing agent or hypo neutralizing agent See washing aid.

- illuminance The strength of light falling on a given area of a surface. Measurable by an incident-light (illuminance) meter.
- illuminance meter See incident-light meter. incandescent light Light emitted when a sub-
- stance is heated by electricity: for example, the tungsten filament in an ordinary light bulb
- incident-light meter An exposure meter that measures the amount of light incident to (falling on) a subject.

indoor film See Type A film, tungsten film.

- infinity The farthest position (marked ∞) on the distance scale of a lens. It includes all objects at the infinity distance (about 50 feet) from the lens or farther. When the infinity distance is within the depth of field, all objects at that distance or farther will be sharp.
- infrared The band of invisible rays just beyond red, which people perceive to some extent as heat. Some photographic materials are sensitized to record infrared
- instant film A film such as Polaroid Time-Zero that contains the chemicals needed to automatically develop an image after exposure without the need for darkroom development.
- intensification A process increasing the darkness of an already developed image. Used to improve negatives that have too little silver density to make a good print.

interchangeable lens A lens that can be

removed from the camera and replaced with another lens, usually of a different focal length.

inverse square law A law of physics stating that the intensity of illumination is inversely proportional to the square of the distance between light and subject. This means that if the distance between light and subject is doubled, the light reaching the subject will be only one quarter of the original.

ISO A film speed rating similar to an ASA rating.

Kelvin temperature See color temperature. key light See main light.

- **latent image** An image formed by the changes to the silver halide grains in photographic emulsion upon exposure to light. The image is not visible until chemical development takes place.
- latitude The amount of over- or underexposure possible without a significant loss in the quality of an image.
- **leaf shutter** A camera mechanism that admits light to expose film by opening and shutting a circle of overlapping metal leaves.
- **lens** A piece or several pieces of optical glass shaped to focus an image of a subject.
- **lens shade** A shield that fits around a lens to prevent unwanted light from hitting the front of the lens and causing flare. Also called a lens hood.
- light meter See exposure meter.
- **light-tight** Absolutely dark. Protected by opaque material, overlapping panels, or some other system through which light cannot pass.
- **line print** An image resembling a pen-and-ink drawing, with black lines on a white background (or white lines on a black background). It is made with high-contrast lith film. Also called tone line print.
- lith film A type of film made primarily for use in graphic arts and printing. It produces an image with very high contrast.

local reduction See reduction (3).

- **long lens** A lens whose focal length is longer than the diagonal measurement of the film with which it is used. The angle of view with such a lens / film size combination is narrower at a given distance than the angle that the human eye sees.
- **luminance** The light reflected or produced by a given area of a subject in a specific direction. Measurable by a reflected-light (luminance) meter.

luminance meter See reflected-light meter.

- **macro lens** A lens designed for taking close-up pictures.
- macrophotograph See photomacrograph.
 main light The principal source of light in a photograph, particularly in a studio setup, casting the dominant shadows and defining the texture and volume of the subject. Also called key light.
- **manual exposure** A nonautomatic mode of camera operation in which the photographer sets both the shutter speed and the aperture.
- **manual flash** A nonautomatic mode of flash operation in which the photographer controls the exposure by adjusting the size of the camera aperture.
- **mat** A cardboard rectangle with an opening cut in it that is placed over a print to frame it. Also called an overmat.
- **mat knife** A short knife blade (usually replaceable) set in a large, easy-to-hold handle. Used for cutting cardboard mounts for prints.
- **matte** Describes a printing paper with a relatively dull, nonreflective surface. Opposite: *glossy*.

- **middle gray** A standard average gray tone of 18 percent reflectance. *See gray card.*
- **midtone** An area of medium brightness, neither a very dark shadow nor a very bright highlight. A medium gray tone in a print.
- **modeling light** A small tungsten light built into some flash units. It helps the photographer judge the effect of various light positions because the duration of flash light is too brief to be judged directly.

mottle A mealy gray area of uneven development in a print or negative. Caused by too little agitation or too short a time in the developer.

narrow lighting See short lighting.

- **negative** 1) Any image with tones that are the reverse of those in the subject. Opposite: positive. 2) The film in the camera during exposure that is subsequently developed to produce a negative image.
- **negative carrier** A frame that holds a negative flat in an enlarger.
- **negative film** Film that produces a negative image on exposure and development.
- **nonsilver process** A printing process that does not depend on the sensitivity of silver to form an image. For example, the cyanotype process, in which the light-sensitive emulsion consists of a mixture of iron salts.
- **normal lens** A lens whose focal length is about the same as the diagonal measurement of the film with which it is used. The angle of view with this lens / film size combination is roughly the same at a given distance as the angle that the human eye sees clearly.
- **notching code** Notches cut in the margin of sheet film so that the type of film and its emulsion side can be identified in the dark.
- **one-shot developer** A developer used once and then discarded.
- **opaque** Describes 1) any substance or surface that will not allow light to pass; 2) a paint used to block out portions of a negative so that they will not allow light to pass during printing.
- **open up** To increase the size of a lens aperture. Opposite: *stop down*.
- orthochromatic Film that is sensitive to blue and green but not to red wavelengths of the visible spectrum. Abbreviated ortho.
- **overdevelop** To give more than the normal amount of development.
- overexpose To give more than normal exposure to film or paper. The resulting silver density is often too great for best results.
- **oxidation** Loss of chemical activity due to contact with oxygen in the air.
- pan 1) To follow the motion of a moving object with the camera. This will cause the object to look sharp and the background blurred. 2) See panchromatic.
- **panchromatic** Film that is sensitive to all (or almost all) wavelengths of the visible spectrum. Abbreviated pan.
- **parallax** The difference in point of view that occurs when the lens (or other device) through which the eye views a scene is separate from the lens that exposes the film.
- PC connector See synch cord.
- PC terminal The socket on a camera or flash unit into which a PC connector (synch cord) is inserted.
- **perspective** The apparent size and depth of objects within an image.
- **photoflood** An incandescent lamp that produces a very bright light but has a relatively short life.

- **photogram** An image formed by placing material directly onto a sheet of sensitized film or printing paper and then exposing the sheet to light.
- **photomacrograph** A close-up photograph that is life size or larger. Also called macrophotograph.
- **photomicrograph** A photograph that is taken through a compound microscope.
- **photomontage** A composite image made by cutting out and assembling parts of several photographs.
- **pincushion distortion** A lens aberration or defect that causes straight lines to bow inward toward the center of the image.
- **pinhole** 1) A small clear spot on a negative usually caused by dust on the film during exposure or development or by a small air bubble that keeps developer from the film during development. 2) The tiny opening in a pinhole camera that produces an image.
- **pixel** Short for picture element, the basic unit of computer-usable information in digital image processing.
- **plane of critical focus** The part of a scene that is most sharply focused.
- plate In early photographic processes, the sheet of glass or metal on which emulsion was coated. platinum print A print in which the final image is
- formed in platinum rather than silver. polarizing filter A filter that reduces reflections
- from nonmetallic surfaces such as glass or water by blocking light waves that are vibrating at selected angles to the filter.
- **positive** Any image with tones corresponding to those of the subject. Opposite: *negative*.
- **posterization** An image with a flat, posterlike quality. High-contrast lith film is used to separate the continuous gray tones of a negative into a few distinct shades of gray.
- **presoak** To soak film briefly in water prior to immersing it in developer.
- press camera A camera that uses sheet film, like a view camera, but which is equipped with a viewfinder and a hand grip so it can be used without being mounted on a tripod. Once widely used by press photographers, it has been replaced by 35mm cameras.
- **primary colors** Basic colors from which all other colors can be mixed. *See subtractive, additive.*
- print 1) A photographic image, usually a positive one on paper. 2) To produce such an image from a negative by contact or projection printing.
- **printing frame** A holder designed to keep sensitized material, usually paper, in full contact with a negative during contact printing.
- programmed automatic A mode of automatic exposure in which the camera sets both the shutter speed and the aperture that will produce the correct exposure.
- **projection printing** The process of projecting an image of a negative onto sensitized material, usually paper. The image may be projected to any size, usually larger than the negative.
- **projector** An optical instrument for forming the enlarged image of a transparency or a motion picture on a screen.
- **proof** A test print made for the purpose of evaluating density, contrast, color balance, subject composition, and the like.
- **push** To expose film at a higher film speed rating than normal, then to compensate in part for the resulting underexposure by giving greater development than normal. This permits shooting at a dimmer light level, a faster shutter speed, or a smaller aperture than would otherwise be possible.

rangefinder 1) A device on a camera that mea-

sures the distance from camera to subject and shows when the subject is in focus. 2) A camera equipped with a rangefinder focusing device. Abbreviated RF.

- **raster streak** A dark streak in photographs of television-screen or computer-monitor images, caused by using too fast a shutter speed.
- **RC paper** See resin-coated paper. rear nodal points The point in a lens from which
- lens focal length (distance from lens to image plane) is measured. Undeviated rays of light cross the lens axis and each other at this point.
- reciprocity law The theoretical relationship between length of exposure and intensity of light, stating that an increase in one will be balanced by a decrease in the other. For example, doubling the light intensity should be balanced exactly by halving the exposure time. In fact, the law does not hold true for very long or very short exposures. This reciprocity failure or reciprocity effect causes underexposure unless the exposure is increased. It also causes color shifts in color materials.
- reducing agent The active ingredient in a developer. It changes exposed silver halide crystals into dark metallic silver. Also called the developing agent.
- reduction 1) A print that is smaller than the size of the negative. 2) The part of development in which exposed silver halide crystals forming an invisible latent image are converted to visible metallic silver. 3) A process that decreases the amount of dark silver in a developed image. Negatives are usually reduced to decrease density. Prints are reduced locally (only in certain parts) to brighten highlights. Opposite: *intensification*.
- **reel** A metal or plastic reel with spiral grooves into which roll film is loaded for development.
- reflected-light meter An exposure meter that measures the amount of light reflected or emitted by a subject. Sometimes called a luminance meter.
- reflector 1) A reflective surface, such as a piece of white cardboard, that can be positioned to redirect light, especially into shadow areas. Also called a flat. 2) A reflective surface, often bowlshaped, that is placed behind a lamp to direct more light from the lamp toward the subject.
- reflex camera A camera with a built-in mirror that reflects the scene being photographed onto a ground-glass viewing screen. See single-lens reflex, twin-lens reflex.
- relative aperture See aperture.
- **replenisher** A substance added to some types of developers after use to replace exhausted chemicals so that the developer can be used again.
- resin-coated paper Printing paper with a waterresistant coating that absorbs less moisture than uncoated paper, consequently reducing some processing times. Abbreviated RC.
- **reticulation** A crinkling of the gelatin emulsion on film that can be caused by extreme temperature changes during processing.
- reversal A process for making a positive image directly from film exposed in the camera; also for making a negative image directly from a negative or a positive image from a positive transparency.
- reversal film Film that produces a positive image (a transparency) on exposure and development. **RF** See rangefinder.
- **roll film** Film that comes in a roll, protected from light by a length of paper wound around the film. Loosely applies to any film packaged in a roll rather than in flat sheets.

Sabattier effect A partial reversal of tones that

occurs when film or paper is reexposed to light during development. Commonly called solarization.

- **safelight** A light used in the darkroom during printing to provide general illumination without giving unwanted exposure.
- selective-contrast paper See variable-contrast paper.
- sharp Describes an image or part of an image that shows crisp, precise texture and detail. Opposite: *blurred or soft.*
- **sheet film** Film that is cut into individual flat pieces. Also called cut film.
- short lens A lens whose focal length is shorter than the diagonal measurement of the film with which it is used. The angle of view with this lens/ film combination is greater at a given distance than the angle seen by the human eye. Also called a wide-angle or wide-field lens.
- **short lighting** A portrait lighting setup in which the main source of light illuminates the side of the face partially turned away from the camera. Also called narrow lighting.
- **shutter** A mechanism that opens and closes to admit light into a camera for a measured length of time.
- **shutter-priority** A mode of automatic exposure in which the photographer selects the shutter speed and the camera sets the aperture that will produce the correct exposure.
- silhouette A scene or photograph in which the background is much more brightly lit than the subject.
- silver halide The light-sensitive part of common photographic emulsions; the compounds silver chloride, silver bromide, and silver iodide.
- single-lens reflex A camera in which the image formed by the taking lens is reflected by a mirror onto a ground-glass screen for viewing. The mirror swings out of the way just before exposure to let the image reach the film. Abbreviated SLR.
- **slave** An electronic flash unit that fires when it detects a burst of light from another flash unit.
- **slave eye** A sensor that detects light to trigger a slave flash unit.
- **slide** 1) A transparency (often a positive image in color) mounted between glass or in a frame of cardboard or other material so that it may be inserted into a projector. 2) A protective cover that is removed from a sheet film holder when film in the holder is to be exposed. Also called dark slide.
- **slow** Describes 1) a film or paper that is not very sensitive to light; 2) a lens whose widest aperture is relatively small; 3) a long shutter speed. Opposite: *fast*.
- SLR See single-lens reflex.
- **sodium thiosulfate** The active ingredient in most fixers.
- soft 1) Describes an image that is blurred or out of focus. Opposite: sharp. 2) Describes a scene, negative, or print of low contrast. Opposite: hard or high contrast. 3) Describes a printing paper emulsion of low contrast, such as grade 0 or 1.
- solarization A reversal of image tones that occurs when film is massively overexposed. See Sabattier effect.
- speed 1) The relative sensitivity to light of film or paper. 2) The relative ability of a lens to admit more light by opening to a wider aperture.
- spherical aberration A lens defect that causes rays that strike at the edges of the lens to be bent more than rays that strike at the center.
- spot To remove small imperfections in a print caused by dust specks, small scratches, or the like. Specifically, to paint a dye over small white blemishes.

- spotlight An electric light that contains a small, bright lamp, a reflector, and often a lens to concentrate the light. Designed to produce a narrow beam of bright light.
- **spot meter** A reflected-light exposure meter with a very small angle of view, used to measure the brightness of a small portion of a subject.
- stereograph A pair of photographs taken side by side and seen separately by each eye in viewing them through a stereoscope. The resulting image looks three-dimensional
- stock solution A concentrated chemical solution that is diluted before use.
- stop 1) An aperture setting on a lens. 2) A change in exposure by a factor of two. One stop more exposure doubles the light reaching film or paper. One stop less halves the exposure. Either the aperture or the exposure time can be changed. 3) See stop down.
- stop bath An acid solution used between the developer and the fixer to stop the action of the developer and to preserve the effectiveness of the fixer. Generally a dilute solution of acetic acid; plain water is sometimes used as a stop bath for film development.
- **stop down** To decrease the size of a lens aperture. Opposite: *open up*.
- strobe 1) Abbreviation of stroboscopic. Describes a light source that provides a series of brief pulses of light in rapid succession. 2) Used loosely to refer to any electronic flash.
- subtractive color A way to produce colors by mixing dyes that contain varying proportions of the three subtractive primary colors—cyan, magenta, and yellow. Each dye subtracts its color from white light, leaving a balance of colored light. Dyes that absorb all wavelengths of light produce black.
- supplementary lens A lens that can be added to a camera lens for close-up work. It magnifies the image and permits focusing closer than normal to an object.
- **synch cord** An electrical cord connecting a flash unit with a camera so that the two can be synchronized. Pronounced "sink." *See synchronize*.
- **synchronize** To cause a flash unit to fire at the same time as the camera shutter is open.
- **synchro-sun** A way to use flash lighting as fill light in a photograph made in direct sunlight. The flash lightens the shadows, decreasing the contrast in the scene.

T See time.

- tacking iron A small, electrically heated tool used to melt the adhesive in dry-mount tissue, attaching it partially to the back of the print and to the mounting surface. This keeps the print in place during the mounting procedure.
- taking lens The lens on a camera through which light passes to expose the film.
- tank A container for developer or other processing chemicals into which film is placed for development.
- telephoto effect A change in perspective caused by using a long focal length lens very far from all parts of a scene. Objects appear closer together than they really are.
- telephoto lens Loosely, any lens of very long focal length. Specifically, one constructed so that its effective focal length is longer than its actual size. See long lens.
- tenting A way to light a highly reflective object. The object is surrounded with large sheets of paper or translucent material lighted so that the object reflects them and not the lamps, camera, and other items in the studio.

- thin Describes a negative or an area of a negative where relatively little silver has been deposited. A thin negative transmits a large amount of light. Opposite: *dense*.
- **time** A shutter setting marked *T* at which the shutter remains open until reclosed by the photographer.
- **tintype** A collodion wet-plate process in which the emulsion was coated onto a dark metal plate. It produced a positive image.

TLR See twin-lens reflex.

- tone 1) To change the color of a print by immersing it in a chemical solution. 2) The lightness or darkness of a particular area. A highlight is a light tone, a shadow is a dark tone.
- **transparency** An image on a transparent base, such as film or glass, that is viewed by transmitted light. *See slide (1).*
- **tripod** A three-legged support for a camera. Usually the height is adjustable and the top or head is movable.
- tungsten film Color film balanced to produce accurate color renditions when the light source that illuminates the scene has a color temperature of about 3200K, as do many tungsten lamps. Sometimes called Type B film. See Type A film.
- tungsten light Light such as that from an ordinary light bulb containing a thin tungsten wire that becomes incandescent (emits light) when an electric current is passed along it. Also called incandescent light.
- Tv Abbreviation of time value. Used on some camera information displays as a shortened way to refer to shutter speed settings.
- twin-lens reflex A camera in which two lenses are mounted above one another. The bottom (taking) lens forms an image on the exposed film. the top (viewing) lens forms an image that reflects upward onto a ground-glass viewing screen. Abbreviated TLR.

Type A film Color film balanced to produce accu-

rate color renditions when the light source that illuminates the scene has a color temperature of about 3400K, as does a photoflood. *See tung-sten film.*

Type B film See tungsten film.

- ultraviolet The part of the spectrum just beyond violet. Ultraviolet light is invisible to the human eye but strongly affects photographic materials. underdevelop To give less development than normal
- **underexpose** To give less than normal exposure to film or paper. The resulting silver density is often less than necessary for best results.
- value The relative lightness or darkness of an area. Low values are dark; high values are light. variable-contrast paper A printing paper in
- which varying grades of print contrast can be obtained by changing the color of the enlarging light source, as by the use of filters. Also called selective-contrast paper. See graded-contrast paper.
- view camera A camera in which the taking lens forms an image directly on a ground-glass viewing screen. A film holder is inserted in front of the viewing screen before exposure. The front and back of the camera can be set at various angles to change focus and perspective.
- viewfinder 1) A small window on a camera through which the subject is seen and framed. 2) A camera that has a viewfinder, but not a rangefinder (which shows when the subject is focused).
- viewing lens The lens on a camera through which the eye views the subject.
- viewing screen In a reflex or view camera, the ground-glass surface on which the image is seen and focused.
- vignette To underexpose the edges of an image. Sometimes done intentionally but more often

caused accidentally by a lens that forms an image covering the film or paper only partially.

- warm Reddish colors that by association with common objects (fire, sun, and so on); give an impression of warmth.
- washing aid A chemical solution used between fixing and washing film or paper. It shortens the washing time by converting residues from the fixer into forms more easily dissolved by water. Also called hypo neutralizing (or clearing) agent.
- wet-plate process A photographic process in which a glass or metal plate was coated with a collodion mixture, then sensitized with silver nitrate, exposed, and developed while the collodion was still wet. It was popular from the 1850s until the introduction of the gelatin dry plate in the 1880s.
- wetting agent A chemical solution used after washing film. By reducing the surface tension of the water remaining on the film, it speeds drying and prevents water spots.
- white light A mixture of all wavelengths of the visible spectrum. The human eye sees the mixture as light that is colorless or white.
- wide-angle distortion A change in perspective caused by using a wide-angle lens very close to a subject. Objects appear stretched out or farther apart than they really are.
- wide-angle lens See short lens. working solution A chemical solution diluted to the correct strength for use.
- **zone focus** To preset the focus of a lens so that some future action will take place within the limits of the depth of field.
- Zone System A way to plan negative exposure and development to achieve precise control of the darkness of various areas in a print.
 zoom lens A lens adjustable to a range of focal lengths.

Bibliography

This bibliography is only a sampling of the literature of photography, which is so extensive that it requires two volumes of its own: *Photographic Liteerature* and *Photographic Literature* 1960–1970, edited by Albert Boni (Dobbs Ferry, NY: Morgan & Morgan, 1962 and 1972). The Boni bibliographies list more than 32,000 works under 2900 headings and include works on photographic techniques, theory, chemistry, physics, history, biography, aesthetics, and many other subjects.

A useful listing of information is available from the Eastman Kodak Co. (Rochester, NY 14650). Their Index to Kodak Information lists the more than 800 books and pamphles that they publish for a variety of photographic interests ranging from Good Color Pictures—Quick and Easy to Photography Under Arctic Conditions.

Technical Information: Basic

This book is a basic introductory text in photography, and you will find that other basic textbooks generally cover the same topics. However, you may want to consult one or more additional beginner's texts because individual texts explain material in individual ways and may emphasize different points. The following books are of about the same level of difficulty as this one.

Craven, George M. Object and Image: An Intro-

duction to Photography. Englewood Cliffs, NJ: Prentice-Hall, 1975. Explores various styles reportorial, symbolistic, and so on.

- Davis, Phil. *Photography*, 4th ed. Dubuque, IA: William C. Brown, 1982. Covers technical material more extensively than the others.
- Horenstein, Henry. Black and White Photography: A Basic Manual, 2nd ed. Boston: Little, Brown, 1983.

London, Barbara. A Short Course in Photography. Glenview, IL: Scott, Foresman, 1987.

Technical Information: Advanced or Specialized

The following books will be useful when you are familiar with the basic material in this text.

Adams, Ansel. The New Ansel Adams Photography Series, with Robert Baker. The Camera, 1980; The Negative, 1981; The Print, 1983; Polaroid Land Photography, 1978. Boston: New York Graphic Society. Also, from the earlier Basic Photo Series: Natural-Light Photography, 1971; Artificial-Light Photography, 1968. Boston: New York Graphic Society. Stresses full technical control of the photographic process as an aid to creative expression.

_____. Examples: The Making of 40 Photo-

graphs. Boston: New York Graphic Society, 1983.

- Carroll, John S. *Photographic Lab Handbook*, 5th ed. New York: Amphoto, 1979.
- Cavallo, Robert M. and Stuart Kahan. *Photography: What's the Law?* 2nd ed. New York: Crown, 1979. Ignorance of the law is no defense.
- Clerc, L.P. *Photography: Theory and Practice*. Garden City, NY: Amphoto, 1973. A detailed technical reference.
- Crawford, William. The Keepers of Light. A History and Working Guide to Early Photographic Processes. Dobbs Ferry, NY: Morgan & Morgan, 1979. The history of early photographic media such as the ambrotype, cyanotype, platinum print, gum bichromate print, and others, plus clear directions on how to make these prints yourself.
- Eastman Kodak Co. *Quality Enlarging in Color.* Rochester, NY: Eastman Kodak Co., 1988. Useful information on how to make color prints in general using Kodak materials in particular.
- Eaton, George T. *Photographic Chemistry*. Dobbs Ferry, NY: Morgan & Morgan, 1965. Understandable without formal training in chemistry or physics.
- Gassan, Arnold. Handbook for Contemporary Photography. Athens, OH: Handbook Co., 1974. A general, advanced workbook with information on nonsilver processes.

- Herwig, Ellis. *The Handbook of Color Photography*. New York: Amphoto, 1982.
- International Center of Photography. *Encyclopedia* of Photography. New York: Crown, 1984. Alphabetical arrangement of biographical, historical, and technical information.
- Keefe, Lawrence E., Jr., and Dennis Inch. The Life of a Photograph. Archival Processing, Matting, Framing and Storage. Boston: Focal Press, 1984.
- Kobre, Kenneth. *Photojournalism: The Professionals' Approach*. Stoneham, MA: Focal Press, 1980. A comprehensive and readable overview of equipment, techniques, and approaches used by photojournalists.
- Langford, Michael J. Advanced Photography, 4th ed. Stoneham, MA: Focal Press, 1980.
- Larmore, Lewis. Introduction to Photographic Principles. New York: Dover Publications, 1965. An inexpensive paperback covering basic chemical and physical theory.
- Morgan, Douglas O., David Vestal, and William L. Broecker, eds. *Leica Manual*. Dobbs Ferry, NY: Morgan & Morgan, 1973. Useful information about a specific camera and 35mm photography in general. Other manufacturers also publish comprehensive manuals.
- Nadler, Bob. The Color Printing Manual. New York: Amphoto, 1978.
- Neblette, C.B. *Photography: Its Materials and Processes*. New York: Van Nostrand Reinhold, 1962. A complete, general reference to photographic technology.
- Picker, Fred. The Zone VI Workshop: the Fine Print in Black and White Photography, Garden City, NY: Amphoto, 1974. Introduction to Zone System exposure plus the author's personal printing techniques.
- Pittaro, Ernest M., ed. *Photo-Lab Index*. Dobbs Ferry, NY: Morgan & Morgan, updated yearly. An extensive looseleaf storehouse of information provided by manufacturers of photographic products. Contains full descriptions of their materials and recommended procedures for their use.
- Sealfon, Peggy. The Magic of Instant Photography. Boston: CBI Publishing, 1983.
- Stone, Jim, ed. Darkroom Dynamics: A Guide to Creative Darkroom Techniques. Stoneham, MA: Focal Press, 1979. Illustrated instructions on how to expand your imagery with multiple printing, toning, hand coloring, high contrast, and other techniques.
- _____. A User's Guide to the View Camera. Glenview, IL: Scott, Foresman, 1987.
- Todd, Hollis N., and Richard D. Zakia. *Photographic Sensitometry: The Study of Tone Reproduction*. Dobbs Ferry, NY: Morgan & Morgan, 1969. Measuring, analyzing, and applying data on the effects of light on photographic materials.
- White, Minor. *Zone System Manual*. Dobbs Ferry, NY: Morgan & Morgan, 1972. How to use the Zone System as a creative tool.

History, Criticism, Collections

- Barrow, Thomas F., Shelley Armitage, and William E. Tydeman, eds. *Reading Into Photography: Selected Essays,* 1959–1980. Albuquerque: University of New Mexico Press, 1982.
- Berger, John. *About Looking*. New York: Pantheon, 1980.
- Booth, Pat. ed. *Master Photographers: The World's Great Photographers on Their Art and Technique.* New York: Clarkson N. Potter, 1983.
- Browne, Turner, and Elaine Partnow. Macmillan Biographical Encyclopedia of Photographic Art-

ists and Innovators. New York: Macmillan, 1983. Several thousand biographies: a Who's Who of photography.

- Buckland, Gail. Reality Recorded: Early Documentary Photography. Boston: New York Graphic Society, 1974.
- Coleman, A. D. *Light Readings: A Photography Critic's Writings* 1968–1978. New York: Oxford University Press, 1979.
- Coe, Brian. Cameras, from Daguerreotypes to Instant Pictures. New York: Crown, 1978. A wellillustrated and complete history of the camera.
- Earle, Edward W., ed. *Points of View: The Stereograph in America—A Cultural History*. Rochester, NY: Visual Studies Workshop Press, 1979.
- Eauclaire, Sally. *The New Color Photography*. New York: Abbeville Press, 1981. An attempt at a critical vocabulary for color photographs.
- Edey, Maitland. Great Photographic Essays from Life. Boston: New York Graphic Society, 1978. Twenty-two photographic essays including work by Abbott, Adams, Bourke-White, Cartier-Bresson, and others.
- The Family of Man. New York: The Museum of Modern Art, 1955. Edward Steichen organized this show, which was probably the most publicized and widely seen photographic exhibition ever mounted.
- Gernsheim, Helmut, and Alison Gernsheim. *The History of Photography 1685–1914*. New York: McGraw-Hill, 1969. A detailed history "from the camera obscura to the beginning of the modern era." Considerable information on European, particularly British, photography.
- Green, Jonathan, ed. *Camera Work: A Critical Anthology.* Millerton, NY: Aperture, 1973. Extensive selections from *Camera Work*, "the photographic quarterly published by Alfred Stieglitz, illustrating the evolution of the avant garde in American art and photography from 1903– 1917."
- Hill, Paul and Thomas Cooper. *Dialogue with Photography*. New York: Farrar, Straus and Giroux, 1979. Interviews with 21 major figures in photography, including Beaton, Cartier-Bresson, Cunningham, Doisneau, Kértèsz, Man Ray, Newhall, W. E. Smith, Strand, and M. White.
- Hodgson, Pat. Early War Photographs. Boston: New York Graphic Society, 1974. The first 50 years of war photography including coverage of the Crimean War and the American Civil War.
- Hurley, F. Jack. Portrait of a Decade: Roy Stryker and the Development of Documentary Photography in the Thirties. Baton Rouge: Louisiana State University Press, 1972.
- Jammes, André, and Eugenia P. Janis. *The Art of French Calotype*. Princeton, NJ: Princeton University Press, 1983. A scholarly work on Second Empire photography, elegantly produced.
- Life Library of Photography, rev. ed. New York: Time-Life Books, 1981–1983. Seventeen volumes plus yearbooks (1973–1981), all profusely illustrated. The books generally contain historical material and technical information and discuss current trends.
- The Literature of Photography Series. New York: Arno Press, 1973. Sixty-two long out-of-print technical manuals, historical accounts, and aesthetic treatises, including, for example, the 1858 American Hand Book of the Daguerreotype, which gives "the most approved and convenient methods for preparing the chemicals and combinations used in the art." Other publishers that have reprinted early photographic books include Morgan & Morgan (Dobbs Ferry, NY) and Dover Publications (New York).
- Lyons, Nathan, ed. Photographers on Photogra-

phy: A Critical Anthology. Englewood Cliffs, NJ: Prentice Hall, 1966. Twenty-three well-known photographers (1880s to 1960s) discuss their own work and photography in general.

- McQuaid, James, ed. An Index to American Photographic Collections. Boston: G. K. Hall, 1982. A comprehensive list of public collections: photographers (19,000) by institution (450) and vice versa.
- Maddow, Ben. Faces: A Narrative History of the Portrait in Photography. Boston: New York Graphic Society, 1977. Massive and comprehensive.
- Mitchell, Margaretta K. *Recollections: Ten Women* of *Photography*. New York: The Viking Press, 1979. Pictures and recollections by Abbott, Bernhard, Dahl-Wolfe, and others.
- Naef, Weston J., and James N. Wood. *Era of Exploration: The Rise of Landscape Photography in the American West, 1860–1885.* New York: The Metropolitan Museum of Art, 1975. Extensive treatment of the subject with emphasis on the photographers Watkins, O'Sullivan, Muybridge, Russell, and Jackson.
- Newhall, Beaumont. The Daguerreotype in America, 3rd ed. New York: Dover Publications, 1976.
- _____. Latent Image: The Discovery of Photography. Garden City, NY: Doubleday, 1967. An interesting account of early photographic research and discoveries.

_____, ed. *Photography: Essays and Images.* New York: The Museum of Modern Art, 1980.

- O'Neal, Hank. A Vision Shared: A Classic Portrait of America and its People, 1935–1943. New York: St. Martin's Press, 1976.
- Petruck, Peninah R., ed. The Camera Viewed: Writings on Twentieth Century Photography. Vol. 1: Photography Before World War II. Vol. 2: Photography After World War II. New York: E. P. Dutton, 1979. A worthwhile anthology of hard-tofind writing.
- Pollack, Peter. *The Picture History of Photography*. New York: Harry N. Abrams, 1969. Useful for its many illustrations.
- Rosenblum, Naomi. A World History of Photography. New York: Abbeville Press, 1984.
- Rudisill, Richard. Mirror Image: The Influence of the Daguerreotype on American Society. Albuquerque: University of New Mexico Press, 1971. Fascinating social history of the cultural, commercial, and social effects of the daguerreotype on mid-19th century America.
- Scharf, Aaron. Art and Photography. Baltimore: Penguin Books, 1974. The interrelationship of photography and painting.
- Sontag, Susan. On Photography. New York: Farrar, Straus and Giroux, 1977. The relation of photography to art, reality, and other matters.
- Szarkowski, John. Looking at Photographs. New York: The Museum of Modern Art, 1973. Szar-
- kowski discusses 100 pictures from the museum's collection. An insightful, very readable, and highly recommended book.

Scene. New York: Dover Publications, 1964; reprint of 1938 edition. A detailed account of photography's introduction and growth in the United States between 1839 and 1889.

Tucker, Anne. *The Woman's Eye.* New York: Knopf, 1973. Biographies and statements of ten American women photographers and a portfolio of photographs by each. The book explores "the role played by sexual identity both in the creation and the evaluation of photographic art."

Witkin, Lee, and Barbara (Upton) London. *The Photograph Collector's Guide*. Boston: New York Graphic Society, 1979. Information of general photographic interest as well as for collectors, such as: biographical entries with illustrations for over 200 photographers; lists of over 8000 other photographers, museums, galleries, and so on.

Individual Photographers

The photographers listed below have pictures in this book.

Berenice Abbott

_____. Berenice Abbott: Photographs. New York: Horizon Press, 1970.

_____. Changing New York. Text by Elizabeth McCausland. New York: E. P. Dutton, 1939. Reprinted as New York in the Thirties. New York: Dover Publications, 1973.

Ansel Adams

_____. Ansel Adams: Images 1923–1974. Foreword by Wallace Stegner. Boston: New York Graphic Society, 1974.

_____. Yosemite and the Range of Light. Intro. by Paul Brooks. Boston: New York Graphic Society, 1979.

Bob Adelman

_____. *Down Home*. New York: McGraw-Hill, 1972.

Eve Arnold

In China. New York: Knopf, 1980. Unretouched Women. New York: Knopf, 1976.

Eugène Atget

Abbott, Berenice. *The World of Atget.* New York: Horizon Press, 1964.

The Work of Atget. Ed. by John Szarkowski and Maria Morris Hambourg. New York: Museum of Modern Art, and Boston: New York Graphic Society. Vol. 1: Old France, 1981. Vol. 2: The Art of Old Paris, 1982. Vol. 3: The Ancien Regime, 1983. Vol. 4: Modern Times, 1984.

Morley Baer

Olmsted, Roger, and T. H. Watkins. *Here Today:* San Francisco's Architectural Heritage. San Francisco: Chronicle Books, 1968.

Cecil Beaton

_____. *The Best of Beaton.* Intro. by Truman Capote, New York: Macmillan, 1968.

. Beaton. Ed. James Danziger. New York: Viking, 1980.

JEB (Joan E. Biren)

. Eye to Eye: Portraits of Lesbians. Washington, DC: Glad Hag Books, 1979.

Werner Bischof

_____. Japan. New York: Simon & Schuster, 1955.

Margaret Bourke-White

_____. Portrait of Myself. New York: Simon & Schuster, 1963.

Silverman, Jonathan. For the World to See: The

Life of Margaret Bourke-White. New York: Viking, 1983.

Julia Margaret Cameron

Gernsheim, Helmut. *Julia Margaret Cameron: Her Life and Photographic Work.* Millerton, NY: Aperture, 1975.

A Victorian Album: Julia Margaret Cameron and Her Circle. Ed. by Graham Ovenden. New York: Da Capo, 1975.

Paul Caponigro

_____. Paul Caponigro. Millerton, NY: Aperture, 1972.

______. Landscape. New York: McGraw-Hill, 1975. _____. The Wise Silence. Ed. by Marianne Fulton. Boston: New York Graphic Society, 1983. Henri Cartier-Bresson

_____. *Henri Cartier-Bresson.* Millerton, NY: Aperture, 1976.

_____. Henri Cartier-Bresson: Photographer. Essay by Yves Bonnefoy. Boston: New York Graphic Society, 1979.

_____. The Decisive Moment. New York: Simon & Schuster, 1952.

Imogen Cunningham

. . . . Photographs 1910–1973. Intro. by Margery Mann. Seattle: University of Washington Press, 1974. Dater, Judy. Imogen Cunningham: A Portrait.

Boston: New York Graphic Society, 1979. L. J. M. Daguerre

Gernsheim, Helmut and Alison. L. J. M. Daguerre: The History of the Diorama and the Daguerreotype. London: Secker & Warburg, 1956. Bibliography. U.S. ed., New York: Dover, 1968.

Louise Dahl-Wolfe

Judy Dater

and Jack Welpott. *Women and Other Visions*. Dobbs Ferry, NY: Morgan & Morgan, 1975.

Bruce Davidson

_____. *East 100th Street.* Cambridge, MA: Harvard University Press, 1970.

Lisl Dennis

Robert Doisneau

Maxime Du Camp

Flaubert in Egypt: A Sensibility on Tour—A Narrative Drawn from Gustave Flaubert's Travel Notes and Letters. Trans. and ed. by Francis Steegmuller. Boston: Little, Brown, 1972. Includes photographs and extracts from Du Camp's descriptions of the trip.

P. H. Emerson

Newhall, Nancy. P. H. Emerson: The Fight for Photography as a Fine Art. Millerton, NY: Aperture, 1975.

Turner, Peter, and Richard Wood. *P. H. Emerson: Photographer of Norfolk*. Boston: Godine, 1975.

Elliott Erwitt

_____. Photographs and Anti-Photographs. Texts by Sam Holmes and John Szarkowski.

Boston: New York Graphic Society, 1972. ———. Recent Developments. Intro. by Wilfred Sheed, New York: Simon & Schuster, 1978.

Walker Evans

_____. American Photographs. Intro. by Lincoln Kirstein. New York: Museum of Modern Art,

_____. Walker Evans. New York: Museum of Modern Art, 1971.

_____. Walker Evans. Photographs for the Farm Security Administration 1935–1938. Intro. by Jerald C. Maddox. New York: Da Capo Press, 1975. An illustrated catalog of photographic prints available from the Farm Security Administration Collection in the Library of Congress.

Agee, James, and Walker Evans. *Let Us Now Praise Famous Men.* Boston: Houghton-Mifflin, 1969.

Andreas Feininger

Sandi Fellman

Thomas. New York: Abbeville Press, 1986. Roger Fenton

Hannavy, John. *Roger Fenton of Crimble Hall.* Boston: Godine, 1976.

Carl Fleischhauer

Marshall, Howard, and Richard E. Ahlborn. Buckaroos in Paradise: Cowboy Life in Northern Nevada. Lincoln: University of Nebraska Press, 1981. Photographs by Fleischhauer and others.

Robert Frank

_____. Les Américains. Ed. by Alain Bosquet. Paris: Delpire, 1958. U.S. ed., *The Americans*. Intro. by Jack Kerouac. New York: Grove, 1959. Rev. eds., Millerton, NY: Aperture, 1969, 1978. _____. *The Lines of My Hand*. New York: Lustrum, 1972. Enlarged Japanese edition, Tokyo:

Yugensha, 1972. Phyllis Galembo

. Pale Pink. Rochester, NY: Visual Studies Workshop, 1983.

Jim Goldberg

Lois Greenfield

Ewing, William. *Dance and Photography*. New York: Henry Holt, 1987. Contains a section on her work.

Jan Groover

_____, *Jan Groover.* Intro. by Jane Livingston. Washington, DC: Corcoran Gallery of Art, 1976.

_____. *Photographs*. Intro. by Alan Trachtenberg. Purchase, NY: Neuberger Museum, 1983. Ernst Haas

. *The Creation.* New York: Viking, 1971. Rev. ed. 1983.

Charles Harbutt

. *Travelog.* Cambridge, MA: MIT Press, 1974.

Bill Hedrich

David O. Hill and Robert Adamson

Bruce, David. Sun Pictures: The Hill / Adamson Calotypes. Boston: New York Graphic Society, 1974.

An Early Victorian Album: The Hill / Adamson Collection. Ed. and intro. by Colin Ford. Commentary by Roy Strong. London: Cape, 1974. U.S. ed., New York: Knopf, 1976.

Lewis W. Hine Gutman, Judith M. Lewis W. Hine and the American Social Conscience. New York: Walker & Co., 1967

Rosenblum, Walter, Naomi Rosenblum, and Alan Trachtenberg. *America & Lewis Hine: Photographs 1904–1940*. Millerton, NY: Aperture, 1976. Henry Horenstein

Kenneth Josephson

. *Kenneth Josephson.* Chicago: Museum of Contemporary Art, 1983.

Art Kane

_____. Faces of Our Time. Toronto: University of Toronto Press. 1976.

Gertrude Käsebier

Homer, William Inness. A Pictorial Heritage: The Photographs of Gertrude Käsebier. Wilmington: Delaware Art Museum, 1979. Barbara Kasten

David Hume Kennerly

_____. Shooter. New York: Newsweek Books, 1980.

André Kertész

_____. André Kertész: Sixty Years of Photography 1912–1972. New York: Grossman Publishers, 1972.

_____. A Lifetime of Perception. New York: Abrams, 1982.

Joseph Koudelka

_____. *Gypsies.* Millerton, NY: Aperture, 1975. Jill Krementz

. The Writer's Image: Literary Portraits. Boston: Godine, 1980.

Dorothea Lange

Russell Lee Hurley, F. Jack. *Russell Lee: Photographer*. Dobbs Ferry, NY: Morgan & Morgan, 1978. Herbert List

_____. *Photographs* 1930–1970. Intro. by Gunter Metken. Munich: Schirmer/Mosel, 1976. Danny Lyon

_____. Conversations with the Dead. New York: Holt, Rinehart & Winston, 1971.

_____. Pictures From the New World. Millerton, NY: Aperture, 1981.

Man Ray

Penrose, Roland. *Man Ray.* Boston: New York Graphic Society, 1975.

Schwarz, Arturo. *Man Ray: The Rigour of Imagination.* New York: Rizzoli, 1977.

Mary Ellen Mark

. Falkland Road: Prostitutes of Bombay. New York: Knopf, 1981.

_____. Ward 81. New York: Simon & Schuster, 1979.

Susan Meiselas

El Salvador: Work of Thirty Photographers. Text by Carolyn Forché. Ed. by Harry Hattison, Susan Meiselas, and Fae Rubenstein. New York: Writers and Readers Publishing Cooperative, 1983.

Duane Michals _____. Sleep and Dream. New York: Lustrum

Press, 1984.

New York: Winter Press, 1971. Gion Mili

chard Misrach

Tina Modotti

Brenner, Anita. *Idols Behind Altars*. New York: Harcourt, Brace, 1929. Photographs by Modotti and Edward Weston.

Frida Kahlo and Tina Modotti. Essays by Laura Mulvey and Peter Wollen, and others. London: Whitechapel Art Gallery, 1982.

László Moholy-Nagy

Photographs of Moholy-Nagy. Ed. by Leland D. Rice and David W. Steadman. Claremont, CA: Galleries of the Claremont Colleges, 1975.

David Muench

_____. Washington Shores. Portland, OR: Graphic Arts Center 1981

_____. Sierra Nevada. Portland, OR: Graphic Arts Center, 1979.

Nickolas Muray

Eadweard Muybridge

Arnold Newman

_____. One Mind's Eye. Boston: Godine, 1974.

Joyce Neimanas. Text by Sarah J. Moore. Tucson: University of Arizona, Center for Creative Photography, 1984.

Timothy H. O'Sullivan

American Frontiers: The Photographs of Timothy H. O'Sullivan, 1867–1874. Ed. by Joel Snyder. Millerton, NY: Aperture, 1981. Gardner, Alexander. Gardner's Photographic Sketch Book of the War. 2 vols. Washington, DC: Philip & Solomons, 1866. 45 albumen prints by O'Sullivan. Reprint, 1 vol. New York: Dover, 1959.

Paul Outerbridge _____. Photographs. Ed. by Graham Howe. New

York: Rizzoli, 1980.

_____. Paul Outerbridge: A Singular Aesthetic, Photographs and Drawings 1921–1941. Ed. by Elaine Dines. Santa Barbara, CA: Arabesque Books, 1983.

Olivia Parker

Gordon Parks

_____. A Poet and His Camera. New York: Viking, 1968.

Jeffrev Rotman

______. Beneath Cold Seas: Exploring Cold Temperate Waters of North America. Text by Barry W. Allen. New York: Van Nostrand-Reinhold, 1983. ______. Undersea Life. Text by Joseph S. Levine. New York: Stewart, Tabori & Chang, 1985.

Jack Sal

_____. Jack Sal: Mark/Making. Greenfield Center, NY: Combinations Press, 1981.

Erich Salomon ______. Erich Salomon. Millerton, NY: Aperture,

1978.

August Sander

August Sander: Photographs of an Epoch, 1904–1959. Text by Robert Kramer and Beaumont Newhall. Millerton, NY: Aperture, 1980.

Aaron Siskind

_____. *Places.* New York: Light Gallery and Farrar, Straus & Giroux, 1976.

_____. Harlem Document, Photographs 1932– 1946. Providence, RI: Matrix, 1981.

Chiarenza, Carl. Aaron Siskind, Pleasures and Terrors. Boston: New York Graphic Society, 1982

Michael A. Smith

Landscapes 1975–1979. Revere, PA: Lodima Press, 1979.

W. Eugene Smith

_____. W. Eugene Smith: Master of the Photographic Essay. Ed. and with commentary by Wil-

York: Holt, Rinehart & Winston, 1975. Joel Sternfeld

_____. American Prospects: Photographs. New York: Times Books, 1987.

Alfred Stieglitz

trait. Ed. by Waldo Frank, et al. Rev. ed. Millerton, NY: Aperture, 1979.

Lowe, Sue Davidson. Stieglitz: A Memoir / Biography. New York: Farrar, Straus & Giroux, 1983. Dennis Stock

_____. California Trip. New York: Grossman, 1970.

_____. *A Haiku Journey.* Tokyo: Kodansha, and New York: Harper & Row, 1975.

by Calvin Tomkins. Millerton, NY: Aperture, 1976.

Jammes, André. William H. Fox Talbot: Inventor

Buckland, Gail. Fox Talbot and the Invention of

New Brunswick, NJ: Rutgers University Press,

George A. Tice Photographs 1953-1973.

Bibliography

421

of the Negative-Positive Process. New York:

Newhall. Millerton, NY: Aperture, 1977.

Photography. Boston: Godine, 1980.

William Henry Fox Talbot

Macmillan 1974

George A. Tice

1975

Time in New England. Ed. by Nancy

Paul Strand Paul Strand: Sixty Years of Photographs. Profile _____. Urban Romantic. Boston: Godine, 1982. Philip Trager

______. Photographs of Architecture. Middletown, CT: Wesleyan University Press, 1977. ______. New York. Intro. by Louis Auchincloss. Middletown, CT: Wesleyan University Press,

Middle 1980.

Jerry N. Uelsmann

______, Jerry N. Uelsmann: Silver Meditations. Intro. by Peter C. Bunnell. Dobbs Ferry, NY: Morgan & Morgan, 1975.

______. Jerry N. Uelsmann. Twenty Five Years: A Retrospective. Text by James L. Enyeart. Boston: New York Graphic Society, 1982.

Todd Walker

_____. *Photographs.* Intro. by Julia K. Nelson. Carmel, CA: Friends of Photography, 1985. Weegee (Arthur Fellig)

_____. Weegee. Ed. by Louis Stettner. New York: Knopf, 1977.

_____. The Daybooks of Edward Weston. 2 vols. Millerton. NY: Aperture. 1973.

Maddow, Ben. *Edward Weston: Fifty Years.* Millerton, NY: Aperture, 1973. Bibliography. Another ed., Boston: New York Graphic Society, 1978.

Minor White

_____. *Mirrors Messages Manifestions*. Millerton, NY: Aperture, 1969.

Minor White: Rites & Passages. Text by James Baker Hall. Millerton, NY: Aperture, 1978.

Garry Winogrand _____. The Animals. New York: Museum of Mod-

ern Art, 1969.

_____. Public Relations. Texts by Tod Papageorge and John Szarkowski. New York: Museum of Modern Art, 1977.

Marion Post Wolcott

_____. Marion Post Wolcott: FSA Photographs. Carmel, CA: The Friends of Photography, 1983.

Periodicals

A useful reference book that is in many libraries began as *An Index to Articles on Photography*, 1977, by William S. Johnson, Visual Studies Workshop Press. It appeared in that form again in 1978 and then appeared as the *International Photography Index:* 1979, by Johnson with Susan E. Cohen (Boston: G. K. Hall). Following behind the year being indexed by several years, this publication includes approximately 7000 entries culled from over 100 foreign and domestic periodicals. As of this writing, the indexes for 1980 and 1981 have been published and 1982 is in progress.

- American Photographer, 1515 Broadway, New York, NY 10036. Photography in all its forms; fame and fortune given an edge over fine art, with an emphasis on contemporary American work.
- Aperture, Elm Street, Millerton, NY 12546. A superbly printed quarterly dealing with photography as an art form; founded by Minor White.

Artforum, 65 Bleecker Street, New York, NY 10012. This magazine, Art in America, and Artnews have occasional articles about photography as an art form in addition to reviews of photographic shows.

Art in America, 850 Third Avenue, New York, NY 10022. Included in the subscription is their annual guide to galleries, museums, and artists,

a useful art-world reference. Artnews, 5 West 37th Street, New York, NY 10018.

- History of Photography, University of Texas Press, P.O. Box 7819, Austin, TX 78712. Academic and
- technical, but unique. Industrial Photography, 50 West 23rd Street, New

York, NY 10010. Modern Photography, 825 Seventh Avenue. New

York, NY 10019. Along with *Petersen's* and *Popular Photography, Modern* is predominantly a magazine for hobbyists, mixing information about equipment and materials with portfolios and how-to articles.

Petersen's Photographic, 8490 Sunset Boulevard, Los Angeles, CA 90069.

- Photo Communique, P.O. Box 129, Station M, Toronto, Ontario, Canada M6S 4T2. Canadian, but not exclusively so.
- Photographer's Forum, 614 Santa Barbara Street, Santa Barbara, CA 93101. Geared toward students and others seeking photographic careers; includes school profiles.
- Photomethods, One Park Avenue, New York, NY 10016. For commercial and industrial photographers.
- Popular Photography, 1515 Broadway, New York, NY 10036. The editors also publish the Photography Annual, portfolios by well-known and emerging talent.
- Print Collector's Newsletter, 72 Spring Street, New York, NY 10012. Regular articles on photography.
- The Rangefinder, P.O. Box 1703, Santa Monica, CA 90406. Primarily for the professional studio portrait and wedding photographer.

Many institutions and non-profit groups involved with photography publish periodicals for their membership. Many cater to a specialized or regional interest, and they often serve as a springboard to national visibility for younger writers and photographers.

- Afterimage, 31 Prince Street, Rochester, NY 14607. A tabloid-format monthly from the Visual Studies Workshop. Includes scholarly articles on photography, film, and video; listings of shows, events, publications, and opportunities nationwide.
- Archive, The Center for Creative Photography, University of Arizona, 843 East University Boulevard, Tucson, AZ 85719. Scholarly and occasional.
- ASMP Professional Business Practices in Photography, American Society of Magazine Photographers, 205 Lexington Avenue, New York, NY 10016. A guide for the working professional, including suggested rates and sample contracts.
- Center Quarterly, Catskill Center for Photography, 59A Tinker Street, Woodstock, NY 12498.
- CMP Bulletin, California Museum of Photography, University of California, Riverside, CA 92521. A bimonthly report on exhibits, activities, collections, and research of the CMP.
- Contact Sheet, Light Work, 316 Waverly Avenue, Syracuse, NY 13210.
- Exposure, Society for Photographic Education, P.O. Box 1651, FDR Post Office, New York, NY 10150. A periodical from an organization concerned with the teaching of photography, especially as a fine art.
- Image, George Eastman House, 900 East Avenue, Rochester, NY 14607. Illustrated articles covering the curatorial interests of the museum, 19th and 20th century photography, and the histories of cinema and cameras.
- News Photographer, National Press Photographers Association, 3200 Croasdaile Drive, Durham, NC 27705. For working and student photojournalists.
- Photographica Journal, 520 W. 44th Street, New York, NY 10036. A joint publication of several historical societies, primarily of interest to the camera collector.
- Professional Photographer, The Professional Photographers of America, Inc., 1090 Executive Way, Des Plaines, IL 60018. Emphasis on portraits, weddings, and commercial photography.
- Quarterly, San Francisco Camerawork, 70 12th Street, San Francisco, CA 94103.
- Spot, The Houston Center for Photography, 1441 West Alabama, Houston, TX 77006. Reviews of books and regional exhibitions; Texas photographers.
- Untitled, Friends of Photography, 101 The Embarcadero, San Francisco, CA 94105. A four-timesyearly publication, it is more often a beautifully printed monograph than a magazine, and is always of exceptional quality.
- Views, Photographic Resource Center, 602 Commonwealth Avenue, Boston, MA 02215. A tabloid-format journal of New England photography.

Page numbers in italics refer to illustrations of the subject or by the photographer mentioned.

Abbott, Berenice, 405 Accelerator, in developer, 140 Accent light, 267, 273 Acid-free paper, 183, 187, 195 Acids, handling of, 130 Adams, Ansel, 56–58, 118, 208, *312*, 313, 314, 324, *325*, 378, 382 Adamson, Robert, 357 Adelman, Bob, 265 Additive color, 222 Advertising photography, 2–3, 8–9, 12– 13, 18–19, 196, 289, 389, 401 Agency, picture, 29 Agitation: of black-and-white prints, 163, 167, 168, 169, 170, 171; of color prints, 244, 253; of film, 135, 136, 137, 139; importance of, 148; of sheet film, 308-309 Ahlborn, Richard E., 329 Albumen, 358 Alhazen, 352 Aluia, Vito, 8 Ambrotype, 358, 359 Angle of view: with fisheye lens, 68-69, and lens focal length, 60-61, 62, 64, 65.66 Animal Locomotion, 368, 369 Anthony, Edward, 368 Antistatic brush, 154, 161, 308 Aperture, 32, 44-45; and depth of field, 33, 46-49, 72-73; and light, 44; relative. 72: selector. 33: and shutter speed combinations, 48-49 Arbus, Diane, 383 Archer, Fred, 313 Archer, Frederick Scott, 358 Architectural photography, 11, 304– 305, 310, 322, 343 Archival print processing, 183 Arky, David, 78–79 Arnold, Eve, 237 Artist, photographer as, 10, 374, 380, 382 Art/Personal vision, 10–11, 54, 95, 126, 173, 206, 216, 217, 218, 219, 287, 349, 374, 375, 376, 377, 378, 379, 380, 381, 382, 383, 408, 409. Many other photographs might be listed in this category, for example, the landscape on page 411. ASA rating, 92 Atget, Eugène, 370, *371* Autochrome process, *388*, 389 Automatic exposure, 109, 113, 115; overriding, 113, 116, 124 Automatic flash, 281; overriding, 282 Automatic focus, 38, 76; overriding, 76 Automatic versus manual operation, 31 Averaging meter, 112 Axis lighting, 274. See also Front lighting Babbitt, Platt D., 354, 355 Background, 332-333; contrasting, 334.342 Background light, 267, 273 Background paper, 277 Back light, see Accent light Back lighting, 258, 260, 265, 267, 274 Baer, Morley, 322 Balance: as design concept; as visual element, 348. See also Color balance Barbaro, Daniele, 58 Barkley, Brigitte, 28 Barn doors, for lights, 277 Beaton, Cecil, 326 Becker, Murray, 385 Bellows: bag-type, *302;* for close-ups, 198, *200,* 201, 202; in view cameras, 34, 293

Bellows extension factor, 202 Bernstein, Lois, 24-25

Biren, Joan E. (JEB), 265 Bischof, Werner, 261 Bitumen of Judea, 353 Blanch, Andrea, 255 Bleach, in color processing, 224 Bleaching, 189, 213 Bleed mounting, 190-191 Blotter, use of for drying prints, 188 Blur, 42. See also Motion, of camera; Motion, of subject Bodin, Frederik D., 262 Boom, 277 Bordnick, Barbara, 256, 257 Bounce light, 236, 270, 272; from flash, 282, 283, 284, 285 Bourke-White, Margaret, vi, 1, 70 Bracketing, 202, 235; for hard-to-meter scenes, 122, 123; with infrared film, 100 Color film, 221; characteristics of, 225; Brady, Mathew B., 362 color balance of, 225, 226–227; day-Brandenberger, R. O., 338 Branstead, Robert, 344 Brightness, see Luminance* Broad lighting, 272, 273 Bromide drag, 148 Bronstein, Steve, 196, 197 Built-in meter, 109, 112, 113, 115, 116 Burnie, Ellen Forbes, 400 Burning in, 168, 176, 178-179; color prints, 250 Burrell, Fred, 210 Butterfly lighting, 267, 272, 273 Cable release, 50, 51 Callahan, Harry, 382 Callahan, Sean, 28 Calotype, 356-357 Camera, 31-53; basic parts of, 32-33; caring for, 85; choosing, 52-53; how to hold, 50-51; problems, 83; viewfinder, 35 Camera(s), types of: box-type, 366-367; pinhole-type, 57; point-and-shoot, 52; rangefinder, 35, 52; single-lens reflex, 33, 36, 53; twin-lens reflex, 37, 53; view, 10, 34, 53, 291-311 Camera obscura, 56, 58, 352-353 Camera Work, 377, 378 Cameron, Julia Margaret, 360, 374 Capa, Robert, 328 Caponigro, Paul, 126, 336, 378 Carbon printing, 388, 389 Carbro process, 388, 389 Careers in photography, 1-27 Cartes-de-visite, 360, 361 Cartier-Bresson, Henri, 62, 63, 264, 349 Catadioptric lens, 68 Catchlight, 272, 273 Changing bag, 100, 132 Characteristic curve, of film, 90-91 Chemicals: for archival print processing, 183; for black-and-white film processing, 129, 139; for black-and-white print processing, 171; for color print processing, 240, 252; contamination of, 130; exhaustion of, 148-149; handling of, 130; safety with, 130; for toning, 182. See also specific chemicals and processes Chromogenic film, 88, 92, 93, 140 Church, Fred, *367* Cibachrome materials, 252-253 Circles of confusion, 57, 70, 72 Clark, Etta, 262 Clark, Roy, 338 Clemens, Clint, 8-9, 256 Close-up photography, 95, 198-203, 258, 379; with bellows, 200, 201, 202; depth of field in, 198; exposure for, 202; with extension tubes, 200, 201, 202; with macro lens, 201; with supplementary lens, 199 Cold-mount tissue, 190

Coley, Jennifer B., 29 Collage, 218 Collodion wet-plate process, 358-359, 362, 366, 368 Color(s), 221-258; additive, 222, 388; complementary, 104, 222, 248; cool, 226, 231, 346; primary, 222, 248; subtractive, 222–223, 388; warm, 226, 230.346 Color analyzer, 240 Color balance, 221, 225, 226–235; and color casts, 230–231; in color print, 248–249, 250, 254; filters for, 227, 228-229; and light source, 226-229; and reciprocity effect, 234-235; and time of day, 232-233 Color compensating (CC) filter, 229, 240 light, 225, 226–227; developing, 238; exposure, 235, 236; film speed and grain in, 225; filters for, 227, 228-229; indoor, 226; infrared, 100; instantprint, 256–257; and light source, 226– 229; negative-type, 225; professional, 225; pushing, 146; reversal-type, 225; tungsten-balanced, 225, 226–227; Type A, 225, 226; Type L/Type S, 225. See also Film Coloring, hand, 216 Color materials, image layers in, 224 Color photography, history of, 388–389 Color printing, 238–254; from negative, 242–250; judging print made from negative, 247–250; judging print made from transparency, 254; and print finishing, 250; problems, 246; from transparency, 252-254 Color-printing (CP) filters, 240 Color temperature, 226 Color temperature meter, 110 Color wheel, 248 Complementary colors, 104, 222, 248 Composite photographs, 374 Composition, photographic, 327-349, 391; backgrounds and, 332-333; content and, 328-329; contrast in, 342-343; design elements and, 334-339; framing (cropping) and, 328-331, *344–345*; perspective and point of view in, *346–347*; sharpness in, 340– 341; visual elements in, 348 Compound lens, 59 Condenser enlarger, 156-157 Contact printing, 160–163 Contact sheet, 160 Contamination: in black-and-white printing, 181; in color printing, 244; and drying of prints, 188; preventing, 130 Content, of photograph, 328-329 Continuous-tone copy, 204 Contraction, in Zone System, 318-319, 322-323. 324 Contrast: in black-and-white print, 172-173; and color film, 236–237; and type of enlarger, 156; fill light for reducing, 268-269; and film development time, 142-145; and lighting, 262-265; and printing paper, 172-177, 342; problems in print, 181; as visual element, 342-343, 348 Contrast filters, 104 Contrast grade of paper, 174–176 Convergence, *304–305*, 346, 411 Copying, *204–205* Copy stand, 204 Cornering, in mounting, 195 Corporate photography, 2-3, 18, 19 Correction filters, 104-105 Coupled rangefinder, 35, 38, 39 Cropping, 180, 330-331

Cros, Charles, 388 Cross arm (for light stand), 277 Cross-screen lens attachment, 104 Cultural research, photographic, 20-21 Cunningham, Imogen, 95, 378 Cut film, 92 Cyanotype process, 216, 382 Daguerre, Louis Jacques Mandé, 352, 353, 354–355, 356, 368, 374, 380 Daguerreotype, 350–351, 353, 354–355, 356, 360, 364, 368, 374; color, 388 Dahl-Wolfe, Louise, 406, 407 Daitz, Evelyne, 29 Dance photography, 256, 278, 331, 341 Darkroom equipment: for black-andwhite printing, 154-155; for collodion wet-plate process, 358, 364; for color printing, 240-241; for developing film, 128–129 Dater, Judy, 50-51, 342 Davidson, Bruce, 2–3, 62 Daylight: color film, 225, 226–227; flash photography and, 286-287 deLory, Peter, 235 Dennis, Lisl, 14-15, 123 Density, 88, 90; in black-and-white negative, 142-145; in black-and-white print, 172-173; in color print, 247 Depth, perception of, 346. See also Perspective Depth of field, 70-71, 340; and aperture, 46-49, 72-73; in close-up photography, 198; control of, 72–75; and lens focal length, 63, 64, 66, 72–73; preview button, 46; previewing, 48– 49; scale on lens, 46–47, 74–75; as visual element, 348. See also View camera Design, basic elements of, 334-339 Developer: for black-and-white film, 129, 139; for black-and-white prints, 171; effect of on negative, 140-141; exhausted, 148-149; for lith film, 211; one-shot, 130; for pushing film, 146; replenishing, 130 Developing process: agitation in, 135, 148 (see also Agitation); for blackand-white film, 128-139; for blackand-white prints, 155, 160, 168-171; for color film, 238; for color prints, 240-246, 252-253; and exposure, 144-145; fresh solutions for, 148-149; pushing, 146-147; for sheet film, 308-309; time and temperature, 142-143 Diaphragm, 32, 44-45 Dichroic filtration, 176, 240 Diffused light, 262-265, 272 Diffusion of light, degree of, 259, 262-263 Diffusion enlarger, 156 Diffusion screen, 263, 277, 284 Digital image processing, 217, 394, 395 DIN rating, 92 Diopter, 199 Directional-diffused light, 262-263 Direction of light, 259, 260-261, 264-265 Direct light, 262, 264; from flash, 279, 283, 284–285, 335 Disdéri, André Adolphe, 361 Distortion: with fisheye lens, 68; and lens-to-subject distance, 64, 66-67, 78-81; view camera control of, 298-301, 304-306; with wide-angle lens, 66 Documentary photography, 6–7, 20, 21, 25, 62, 67, 86, 237, 250, 281, 326, 327, 329, 335, 337, 345, 347, 370–371, 372-373, 393, 405. See also Photoiournalism

Fiber-base printing paper, 158, 159, 171, Dodging, 168, 176-177, 178-179; in 183; drying, 188; dry mounting, 190 Fill light, 264, 267, 268–269, 270–271, color prints, 250 Doisneau, Robert, 333 Double exposure, 83 272; with flash outdoors, 286-287 Drake, James, 97 Film, 32; characteristics of, 92; chromogenic, 88, 92, 93, 140; developing roll Dropout, 210 Drying: black-and-white prints, 170, flim, 128-139; developing sheet film, 188; color prints, 246, 253; film, 138, 309-309; format of, 92; negative-type, 149 92; professional, 92, 225; pushing, 96, Dry mounting, 187, 190–192 DuCamp, Maxime, 364 146-147; response to light, 88-91; reversal-type, 92; roll-type, 92; sheet-Ducos du Hauron, Louis, 388, 389 type, 92, 308; speed, 92-97; storing and handling, 92; 35mm, 92; for view camera, 291, 308 Duke, Dana, 2 Durrance, Dick, II, 233 Dust, 149, 154, 181 Film, black-and-white: filters for, 104-107; high-contrast, 90, 92, 210–215; Dye couplers, 224 Dyes, spotting: for black-and-white prints, 189; for color prints, 250 infrared, 92, 98-99; 100-101. 411: instant-print, 92, *102–103;* lith, 210, 211; orthochromatic, *98;* panchro-Dye transfer printing, 388 mátic, 98-99 Eastman, George, 366, 367 Film, color, see Color film Editors, picture, 28-29 Film advance mechanism, 32 Eiler, Terry, 281 Film holder, for sheet film, 308 El rating, 92 Film notching code, 308 Electromagnetic spectrum, 87 Film plane, 58 Film speed, 92; and color film 225; fast, Electronic flash, 278, 280. See also 96-97; and grain, 93, 94, 96; medium-Flash speed, 94; pushing, 96, 146-147; Electronic still photography, 52 Emerson, Peter Henry, 375, 377 Emphasis, as design concept, 338–339 slow, 94-95 Filters: for black-and-white film, 104-Emulsion: of black-and-white film, 88, 107; for black-and-white variable-98-99; of color film, 224; gelatin, 366 contrast paper, 176-177; for color Enlarger, 154, 156-157; for color printfilm, 227, 228-229; for color printing, ing, 240; condenser-type, 156; diffu-240; and exposure, 107; for infrared sion-type, 156 Enlarger lens, 156, 157 film, 100 Filters, types of, 107, 229; color-compensating (CC), 229, 240; colored, 104; color-printing (CP), 240; con-Enlarging, 164–165 Environmental portrait, 332 Epstein, Mitch, 397 Erwitt, Elliott, 74 trast, *104;* correction, 104–*105;* fluorescent, *228*–229; gelatin, 104; glass, 104; neutral-density, 104, 107, 229; polarizing, 104, *106*–107, 229, Etching, *189* Evans, Walker, *114, 264,* 372 275; viewing, for color printing, 248 Filter factor, 107 Exhaustion, chemical, 148-149 Expansion, in Zone System, 318-319, Filter holder: on enlarger, 177; on lens, 104; on light, 277 322. 324 Exposure, 48-49, 90, 109-125; automatic, 109, 113, 115, 116, 124; brack-Fingerprints, on prints, 181 Finishing and mounting prints, 187-195 eting, 122, 123, 202, 235; of close-ups, 202; of color film, 235, 236; and Fisheye lens, 68, 69 development, 144-145; with filters, Fixer: for black-and-white film, 129, 107; and flash lighting, 278-279, 281-139; for black-and-white prints, 171; 283, 286; of hard-to-meter scenes, effect of on negative, 140-141, 122; latitude, 236. See also Density exhausted, 148-149; rapid, 141; used Exposure meter, 110-111; averaging, in processing prints, 160 112; built-in, 109, 112, 113, 115, 116; Flag, for lighting setup, 277 center-weighted, 112; color tempera-Flare, 82 ture, 110; flash, 110, 282; hand-held, Flash, 278-288, 335, 392; automatic, 281; basic techniques, 284-285; 110, 115, 116; incident-light, 110, 114-115, 116, 268; and lighting ratio, bounce, 282-283, 284-285; with color film, 226, 229; with daylight, 286–287; dedicated, 280; electronic, 268; and metering average scenes, 114–115; and metering scenes with high contrast; 116–117; and metering 280; equipment, 280; and exposure, 278–279, 282–283; guide number, specific tones, 118-119; multi-zone, 112; reflected-light, 110, 112, 114-282, 283; and motion, 278; problems, 115, 116, 118, 124, 268; spot-type, 288; synchronizing with shutter, 280 110, 120; substitution readings with, Flashbulb, 280 121 Flash cube (for flash bar), 280 Exposure modes, with automatic cam-Flashing, 178 Flash meter, 110, 282 era, 113 Flash powder, 280 Exposure value (EV), 110 Extension tubes, 198, 200, 201, 202 Flat (reflector), 268 Fleischhauer, Carl, 20-21, 329 Fading, of prints, 181 Floodlight, 277 Fluorescent (FL) filter, 228–229 Fluorescent lighting, 228–229 f-number, see f-stop Fall, see View camera, movements Fall (exposure calculation), see Zone System Focal length, see Lens focal length Focal plane, 58, 60 Farmer's Reducer, 189, 213 Farm Security Administration, 335, 347, 372-373 Focal-plane shutter, 41 Fashion photography, 255, 400, 401 Focal point, 58, 59 Fast: film, 96-97; lens, 44 Focus: and depth of field, 70-75, 77; Feininger, Andreas, 30, 31, 80 Feinstein, Harold, 238 Fellig, Arthur, (Weegee), 278, 279 Fellman, Sandi, 390, 391 Fenton, Roger, 362

plane of critical, 70; uneven in print, 181; view camera control of, 302-303; as visual element, 348 Focusing: automatic, 76; with coupled rangefinder, 38-39; during enlargement, 165; with ground-glass viewing

with rangefinder/viewfinder cameras 35; with single-lens reflex camera, 36; with twin-lens reflex camera, 37; with view camera, 34, 307; zone, 74 Focusing cloth, 34, 307 Focusing control (mechanism), 32, 33 Fogging, of print, 82, 181 Food photography, 220, 221, 230 Frame, in photographic composition, 180, 330-331, 344-345; as visual element. 348 Frank, Robert, 382, 383 Freelance photography, 4 Friedlander, Lee, 383 Frith, Francis, 364 Front lighting, 260, 261, 266 f-stop, 44, 45, 72. See also Aperture Full-scale print, 172–173 Galembo, Phyllis, 250 Galleries, photographic, 29 Gardner, Alexander, 362, 364 Geiger, Michael, 238, 239 Gelatin emulsion, 88, 366-367 Genthe, Arnold, 388 Gervais, Lois, 18-19 Ghosting, 82 Glassware, lighting for, 276 Gloss, of print, 158, 159, 188 Gobo, 277 Godowsky, Leopold, 388 Gohlke, Frank, 404 Goldberg, Jim, 409 Goldsmith, Scott, 131 Goodwin, Hannibal. 366 Graded-contrast printing paper, 158, 159, 174-175 Grain: of color film, 225; and film development, 145; and film speed, 93, 94, 96 Graubner, Oscar, 1 Gray card, 121 Gray, middle, see Middle gray Greenfield, Lois, 278 Groover, Jan, 398 Ground-glass viewing screen, 32, 34, 36, 37, 38, 307 Guide number, for flash, 282, 283 Gum-bichromate printing, 376 Haas, Ernest, 396 Hahn, Betty, 216 Hair, John, 28 Hairston, Sherita, 24 Halftone process, 384 Hand coloring, 216 Hand-held meter, 110, 115, 116 Harbutt, Charles, 86 Hardener, in fixer, 141 Hart, Russell, 101 Hartmann, Erich, 276 Hedrich, Bill, 343 Heisler, Gregory, 392 Heliograph, 353 High-contrast film, 90, 92, 210-215 High side lighting, 266 Hill, David Octavius, 357 Hill, Levi L., 388 Hine, Lewis W., 370, 372, 373 Hing, Lewis W., 370, 372, 373 Hinging, in mounting, 195 History of photography, 351–389 Horenstein, Henry, 77 Horizon line, 334, 345, 346, 403 Horizontal format, 330 Hot-shoe flash, 280 Hunter, Fil, 275 Hunter, Peter, 384 Hydroquinone, 140 Hyperfocal distance, 74 Hypo, 141. See also Fixer Hypo clearing agent/hypo neutralizer, see Washing aid

screen, 38; with infrared film, 100;

Illuminance, 110

Illustration, photographic, 2, 3, 18-19, 69. 196. 340

Incident-light meter, 110, 114-115, 116; and lighting ratio, 268 Indoor color film, 226 Indoor lighting, 265 Industrial photography, 22–23 Infinity (lens setting), 47; and focusing, 74-75 Infrared film, 92, 98-99, 100-101, 411 Instant-print film, 92, 102-103, 256-257 Intensification: of negatives, 150; toning prints for, 182 Interchangeable lens, 33, 41, 84 Inverse square law, 283 looss, Walter, Jr., 26-27, 50-51, 65 ISO rating, 92 Jackson, William Henry, 290, 291, 364 JEB (Joan E. Biren), 265 Jenkins, Dan, Jr., 26 Josephson, Ken, 152 Kane, Art, *81* Karsh, Yousuf, *40*7

Käsebier, Gertrude, 376 Kasten, Barbara, i, 10-11 Kauffman, Mark, 71 Kelvin scale, 226 Kennerly, David Hume, 67 Kertész, André, 54 Key light, see Main light Kilgus, Kurt, 10 Kodachrome, introduction of, 388 Koudelka, Josef, 345 Krementz, Jill, 270-271

Landscape and nature, 75, 126, 182, 231, 232–233, 260, 261, 311, 312, 323, 325, 334, 344, 346, 365, 411 Lange, Dorothea, 347, 372, 373 Larrain, Sergio, 261 Latent image, 88, 224, 356 Latitude, exposure, 236 Leaf shutter, 40-41 Lebeck Robert, 96 Lee, Russell, 335, 372 Lens, 32, 55-85, 84; attachments, 104; caring for, 82, 85; choosing, 84-85; for close-ups, 199, 201; compound, 59; covering power, 292; for enlarger, 156, 157; extra-fast, 85; fast, 44; interchangeable, 33, 41, 84; problems, 82-83; slow, 44; for view camera, 292 Lens(es), types of: catadioptric, 68; fisheye, 61, 68, 69; long, 64-65; macro, 68, 198, 201; macro zoom, 201; mirror, 68; normal, 62-63; retrofocus, 66; short, *66*–67; soft-focus, 68; sup-plementary, 198, *199;* telephoto, 42, 64; wide-angle, *66–67;* zoom, 68 Lens coatings, 82 Lens focal length, 60-67; and angle of view, 61; and cropping, 180; and depth of field, 72-73; and film size, 85; long, 64-65; and magnification, 61-61; normal, 62-63; and perspective, 78-79; short, 66-67 Lens shade, 82, 83, 85 Lieberman, Archie, 289 Life magazine, vi, 1, 384, 386–387 Light: accent, 267, 273; back, 273; background, 267, 273; bounced, 263, 270, 272, 284, 285; color of, 259; and color film, 226; degree of diffusion of, 259, 262–263; diffused, 262–265, 272; direct, 262, 264; direction of, 259, 260-261, 264-265; directionaldiffused, 262-263; fill, 264, 267 268-269, 270-271, 272; fill, with flash outdoors, 286-287; intensity of, 259; key, 266; main, 266-267, 272; main, plus fill, 270-271; main, with flash. 284-285; modeling, 278, 280; as visual element, 348; wavelength of, 87; window, 265, 270-271 Lightbox, 277 Lighting, 259, 289; axis, 274; back, 258, 260, 265, 267, 274; broad, 272, 273;

butterfly, 267, 272, 273; for copying, 205; diffused, 272; equipment for, 277; with flash, 278-288; front, 260, 261, 266; high side, 266; indoors, 265; in open shade, 270; outdoors, 264; with overcast sky, 270; for portraits, 270-273; ratio, 268-269; of reflective objects, 275; short, 272-273; side, 260, 261, 266, 267, 274; of textured objects, 274; top, 267; of translucent objects, 276; under, 267 Light meter, see Exposure meter Lights, types of, 277 Light stand, 277 Light tent, 275, 277 Line: as design concept, 334–335; as visual element, 348 Line copy, 204, 205 Line print, 213 Line print, 213 List, Herbert, 341 Lith film, 210, 211 Lithograph, 216 Lithography, 353 Local reduction, 189 Loengard, John, 125 Long lens, 64-65 Looking at—and talking about—photo-graphs, 348-349 Look magazine, 384, 386 Lorant, Stefan, 384 Loupe, 307 Lumière, Antoine, and Louis, 388 Luminance, 110 Lynn, Bob, 28 Lyon, Danny, 263 Mackie lines, 208-209 Macro-lens, 68, 198, 201 Macrophotograph, 198 Macro zoom lens, 201 Magnification: in close-up photography, 198-201; and lens focal length, 60 - 61Magnifier, focusing, 243 Main light, 266–267, 272; plus fill, 270– 271; with flash, 284-285 Mannes, Leopold, 388 Manning, Jack, 327 Man Ray, 206, 207, 380, 381 Mark, Mary Ellen, 251 Marshall, Howard W., 20 Mat cutter, 193, 194 Mat knife, *190, 191* Maxwell, James Clerk, 388 McDonald, Michele, 147 McIntosh, Bill, 16 McSavaney, Ray, 124, 260 Medium-speed film, 94 Meiselas, Susan, 6-7 Meters, exposure, see Exposure meters Metol, 140 Michals, Duane, 408 Microprism, 38 Microscope, used in photography, 22-23, 198 Middle gray, 112, 114, 118, *119* Mili, Gjon, *289* Milito, Sebastian, *274* Mirror lens, 68 Misrach, Richard, 287 Mockli, Urs, 4 Modeling light, 278, 280 Modotti, Tina, *108,* 109, 378 Moholy-Nagy, László, 206, 380, 381, 399 Monopod, 50 Moore, David, 234, 235, 347 Motion of camera: panning, 42, 43; preventing unwanted, 50-51 Motion of subject: in early photographs, 368-369; and film speed, 96-97; and flash, 278; and shutter speed, 42-43, 48-49; as visual element, 340-341, 344 Mounting and matting prints, 187, 190-195; bleed mounting, 190-191; color prints, 250; dry mounting, 187, 190-

192; materials, 187; mounting press,

190; mounting with border, 192; over-matting, 193–195; tacking iron, 190 Mounting press, 190 Muench, David, 231 Multi-image productions, 12-13 Multiple imagery, 218–219 Muray, Nickolas, 389 Museum board, 187 Muybridge, Eadweard, 368, 369 Nadar, 360 Naturalistic photography, 375, 377 Naythons, Matthew, 6 Negative: black-and-white, 89; color, 224, 238; contrasty, 144, 145; dense, 144, 145; developing black-andwhite, 127-151; effect of developer and fixer on, 140-141, 144-145; effect of exposure on, 90-91, 144-145; emulsion side of, 161; flat, 144-145; intensification of, 150; problems, 151; reduction of, 150; thin, 144, 145 Negative carrier, 157, 164 Negative film, 92, 225 Neimanas, Joyce, 218 Neubauer, John, 68 Natural density, in color printing, 250 Neutral-density filters, 104, 107, 229 Newman, Arnold, *180, 259* Newman, Pete, 18 Newspaper photography, 24-25. See also Documentary photography; Photojournalism Niépce, Joseph Nicéphore, 353, 355, 388 Normal lens, 62-63 Notching code, for sheet film, 308 Nuridsany, Claude, 258 Okamoto, Y. R., 259 Ollman, Arthur, 29 Opaque (retouching fluid), 213 Open shade, 270 Orthochromatic film, 98 O'Sullivan, Timothy H., 359, 362, 363, 364, 365 Outdoor lighting, 264 Overexposure, 90 Overmatting, 193–195 Oxidation, 130 Packo, Robert, 69 Palladium printing, 184 Panchromatic film, 98-99 Panning, 42, 43 Parallax error, 34, 35, 37, 52 Parker, Olivia, 186, 187 Parks, Gordon, 337 Pattern, as design concept, 336-337 Pentaprism, 36 Perennou, Marie, 258 Perspective, 78-81, 346-347; with fisheye lens, 69; with long lens, 64-65; with short lens, 66-67; with view camera, 304-305; as visual element, 348 Peterson, Bob, 12-13 Photoelectric cell, 110 Photo essay, 384, 386–387 Photoflood, 277 Photogram, 10, 206-207, 380 Photographs, looking at-and talking about, 348-349 Photography, careers in, 1-27 Photojournalism, vi, 1, 4, 24, 25, 71, 96, 103, 131, 279, 330, 384-387. See also Documentary photography Photo League, 327, 382 Photomicrograph, 22–23, 198 Photomicrograph, 22–23, 198 Photomontage, 380, 381 Photo-Secession, 377 Pictorial photography, 376-377 Picture agency, 29 Picture editors, 28-29 Pinhole: camera, 56, 57; in camera obscura, 352

Pixel. 217 Place (exposure calculation), see Zone System Plane of critical focus, 70 Plane of focus, control of with view camera, 302–303 Platinum print, 182, 183, *184–185* Point, as design concept, 334–335 Point-and-shoot camera, 52 Point of view, 346-347 Point source (of light), 262 Polarizing filter, 104, *106*–107, 229, 275 Polarizing screen, 275 Porta, Giovanni Battista della, 352 Portfolio, showing, 28-29 Portrait lens, 68 Portrait photography, 16, 256, 270; early, 354, 355, 357, 360-361; lighting for, 270-273; long lens for, 64; softfocus lens for, 68 Portraiture, 17, 30, 81, 101, 125, 180, 210, 250, 251, 257, 262, 263, 264, 265, 270, 271, 339, 342, 355, 357, 360, 370, 380, 406, 407 Posterization, *214–215* Post Wolcott, Marion, *346*, 372 Powell, Duane, 101 Premium printing paper, 159 Preservative, in developer, 140 Presoaking film, 139 Primary colors, 222, 248, 388 Print: drying, 188; full-scale, 172-173; judging test, *172–173;* mounting, 187–195; problems, 181; spotting, 189; toning, 182 Print dryers, 188 Printing and processing: archival, 183; black-and-white, 153-183; contact sheet, 160-163; equipment for, 154-157; final print, 168-170; summary, 171; test patches for, 172; test print, 166-167, 172-173 Printing and processing, color, see Color printing Printing paper, 153, *158*–159; charac-teristics of, *158*–159; color, 240, 252; color (of black-and-white papers), 159; color sensitivity, 159; and con-trast, 158, 159, 172-177; fiber-base, 158, 159, 171, 183, 188, 190; glossy surface, *158*, 159, 188; graded-con-trast, 158, 159, 174–*175;* latitude, 159; matte surface, *158*, 159; platinum, 182, 183, *184–185;* premium, 159; resin-coated (RC), 158, 159, 171, 188, 190; size, 159; speed, 159; storage, 158; texture, 159; variable-contrast, 158, 159, 176-177; weight, of paper stock, 159 Professional films, 92, 225 Processing drum, for color printing, 240, 241 Product photography, 8, 275, 276 Proof, 160 Pushing film, 96, 146-147 Quartz-halogen bulb, 277 Rainier, Chris, 322, 323 Rangefinder, coupled, 35, 38, 39 Rangefinder camera, 35, 52; for closeup photography, 198 Ratio: of chemical solutions, 130; of lighting, 268, 269 Ray, Man, see Man Ray RC papers, see resin-coated (RC) paper Reciprocity effect, 122; in close-ups, 202; with color film, 234-235; in color printing, 242; in copying, 205 Red eve. 288 Reducing agent, in developer, 140 Reduction: of negatives, 150; of prints, 189 Reflected-light meter, 110, 112, 114,

115, 116, 118, 124; and lighting ratio,

268

Reflective objects, lighting for, 275 Reflections: from colored surfaces, 230; with flash photography, 288; and polarizing filter, 106; in reflective objects, 275 Reflector(s), 263; black, 268; flat, 277, umbrella, 259, 270–271, 277; for fill light, 268-269 Reflex camera, *see* Single-lens reflex camera; Twin-lens reflex camera Refraction, 58–59 Rejlander, Oscar G., 374 Relative aperture, 72 Resin-coated (RC) printing paper, 158, 159, 171, 183; drying, 188; dry mounting, 190 Restrainer, in developer, 140 Reticulation, 151 Retrofocus lens, 66 Reversal film, 92, 225 Riis, Jacob, 372 Ringaround, color test chart, 248, 249, 254 Rise, see View camera, movements Robinson, Henry Peach, 374-375 Roll film, 92; in early photography, 366-367; processing, 128-139. See also Film Ross, Alan, 102 Rothstein, Arthur, 372 Rotman, Jeff, 4-5 Sabattier print, 208-209, 380, 381 Safelight: for black-and-white printing, 155; for color printing, 242; fogging of printing paper, 172 Saint-Victor, Abel Niépce de, 358 Sal, Jack, 207 Salinger, Joan, 394 Salomon, Erich, 384 Sander, August, 370 Scheimpflug rule, 302, 303 Schulthess, Emil, 232-233 Scientific photography, 22, 23 Scott, Mel, 29 Scratch lines, on prints, 181 Seamless, 277 Selective-contrast printing papers, see Variable-contrast printing papers Selenium toning, 182 Serial imagery, 408 Sexton, John, 334 Shadows: and exposure, 116, 118, 236; and flash, 284, 286–287, 288; and lighting, 260–269, 274; and time of day, 232; use of, *342–343* Shahn, Ben, 372 Shape, as design concept, 336-337 Sharpness: as visual element, 340-341. See also Depth of field; Motion Sheet film, 92; loading and processing, 308-309 Shift, see View camera, movements Ship's-prow effect, 304-305 Short lens, 66-67 Showing your work, 28-29 Short lighting, 272-273 Shrout, Bill, 393 Shutter, 32, 40-41; focal-plane, 41; leaf, 40 - 41Shutter speed, 40; and aperture combinations, 48-49; with flash, 280; and motion, 42-43, 48-49, 340-341; selector, 33 Side lighting, 260, *261, 266,* 267, 274 Silhouette, *125, 342* Silkscreen, 216 Silver halides, 88 Single-lens reflex camera, 32, 33, 36, 53; and automatic focus, 76; for close-up photography, 198; for copying, 204; and depth-of-field preview, 46 Siskind, Aaron, 382 Skin tones: color casts on, 230; metering, 118 Skott, Michael, 220

Sky: burning in, 178, photographing, 104, 105, 106, 116 Slayton, Joel, 395 Slide, see Transparency Slide show, see Multi-image productions Slow: film, 94-95; lens, 44 Smith, Michael A., 310, 311 Smith, W. Eugene, 386-387 Snoot, 277 Social change, and photography, 372-373 Sodium thiosulfate, 141, See also Fixer Softbox, 277 Soft-focus lens or attachment, 68, 104 Solarization, 208-209, 380, 381 Space, as visual element. 348 Split toning, 187 Sports photography, 26–27, 65, 77, 97, 146, 147, 338 Spot, as design concept, 334-335 Spotlight, 277 Spot meter, 110, 120. See also Exposure meter Spotting, 189; color prints, 250 Spühler, Emil, 232-233 Stains: on black-and-white print, 181; on color print, 246 Static marks, 151 Steinberg, Richard, 230 Stelck, Doug, 22 Stereographic photographs, 359, 368 Sternfeld, Joel, 402 Stieglitz, Alfred, 377, 378 Still life, i, 10, 186, 230, 239, 398, 399 Stock, Dennis, 339 Stone, Jim, 173 Stop, as measure of exposure, 44. See also f-stop Stop bath: for black-and-white film,

129, 139; for black-and-white prints, Straight photography, 377, 378-379

Strand, Paul, 378

Streaks: in negative, 83; in color prints, 246 Strobe, see Electronic flash Stryker, Roy, 372 Substitution reading, 121 Subtractive color, 222, 223 Supplementary lens: for close-ups, 198, 199; for copying, 204 Swing, see View camera, movements Synch cord, 280 Synchronization, of flash and shutter, 280 Szarkowski, John, 345 Tacking iron, 190 Talbot, William Henry Fox, 356 Taylor, Dick, 12 Tele-extender (teleconverter), 64

Telephoto effect, 78, 80 Telephoto lens, 42, 64

Television image, how to photograph, 122 Temperature: and black-and-white print processing, 160; and color print pro-cessing, 240; and film processing,

129, 142-143 Tenting, 275, 277 Test patches, for black-and-white printing, 172

Texture: of printing paper, 159; as visual element, 348

Textured objects, lighting for, 274 35mm film, 92

Through-the-lens metering: for close-ups, 198, 202; with filters, 107

Tice, George A., 182, 184-185, 410 Tilt, see View camera, movements Time, and film processing, 129, 142-

143

Tintype, 358

Tone, as visual element, 348 Toning, black-and-white prints, 182; for archival print processing, 183 Top lighting, 267

Trager, Philip, 304-305, 310 Translucent objects, lighting for, 276 Transparency, color (slide), 224, 226, 229; and exposure latitude, 236; prints from, 252-254 Travel photography, 14-15, 123; early,

364-365 Tripod, 50, 51; for close-up photography, 198; for copying, 204; with view

camera, 307 Tungsten-balanced color film, 225, 226

Twin-lens reflex camera, 32, 37, 53; for close-up photography, 198; and depth-of-field preview, 47 Type A film, 225, 226 Type L/Type S film, 225

Uelsmann, Jerry N., 219 Umbrella reflector, 259, 270-271, 277 Umbrella mount, 277

Under lighting, 267 Under water photography, 4–5

Vandyke print, 216 Variable-contrast printing paper, 158, 159, 176–177

Vertical format, 330 View camera, 32, 34, 53, 290-311; for

close-up photography, 198; for copy-ing, 204; and depth-of-field preview, 46; and distortion, 306; focusing, 307; lens for, 292; lens movement, 295-296, 299; leveling, *307;* movements, 291, 292, *293, 294–301;* parts of, 292, 293; and perspective control, 304-305; and plane-of-focus control, 302-303; rise and fall, 294-295; sheet film

for, 92, 291, 308; shift, 296-297;

swing, 300-301; tilt, 298-299; using,

310-311 Viewfinder, 38 Viewfinder camera, 35, 52; and depthof-field preview, 47 Viewing filters, for color printing, 248 Viewing systems, 32, 34, 35, 36, 37 Viewpoint, as visual element, 348 Vignetting, 82, 83, 292 Visible spectrum, 87 Visual elements, 348 Voight, Werner, 385 Voltage control, for color printing, 240

Walker, Todd, 217 War photography, early, 362-363 Washing: black-and-white film, 139, 149; black-and-white prints, 171 Washing aid, 138, 139, 149, 171 Watanabe, Nana, 401 Watkins, Carleton Eugene, 364 Wedding photography, 16 Wedgwood, Thomas, 352-353 Weegee, 278, 279 Weinberg, Matt, 22-23 Weiss, Ralph, 203 Weston, Edward, 94, 327, 378, 379 Wet plate, see Collodion wet-plate process Wetting solution, 138 White, Minor, *89*, 344, 378, 382, *411* White light, 87, 222, *223, 226* Wide-angle distortion, 66, 78, 81 Wide-angle lens, 66-67 Wide-angle lefts, 00-07 Wilson, Joyce, 16-17 Window light, 265, 270-271 Winogrand, Garry, 383, 403 Wrinn, Joe, 103, 330, 331

Zone focusing, 74

Zone system, 313–325; basic steps, 324; with color film, 324; and contrast control, 318-319; and full-scale print, 320-321; metering, 316-317; place and fall, 316-317; with roll film, 324; scales, 314-315; using, 322-323 Zoom lens, 68; macro, 201